MICHELANGELO

I. YOUTH

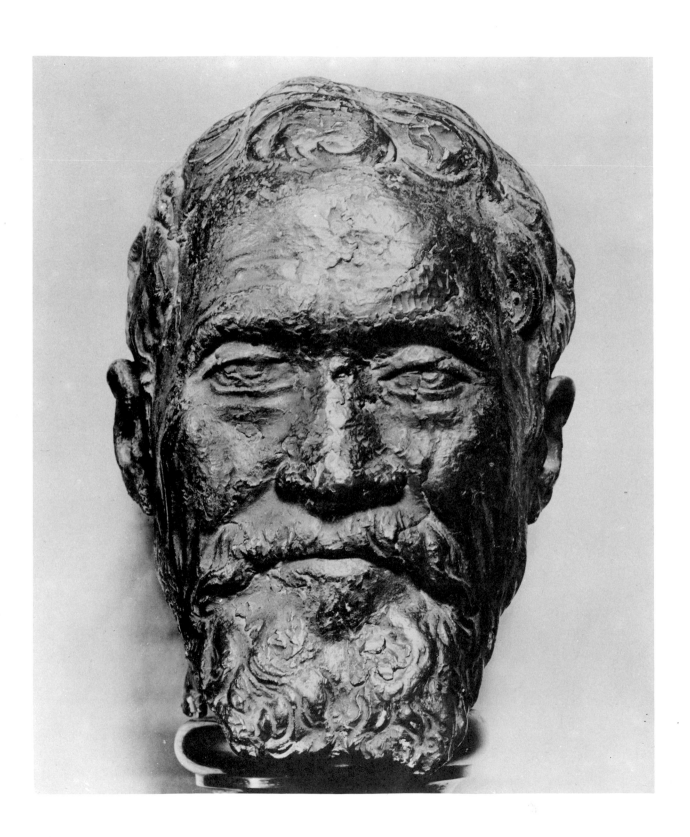

THE YOUTH OF MICHELANGELO

By CHARLES DE TOLNAY

PRINCETON UNIVERSITY PRESS · PRINCETON

MCMLXIX

SECOND EDITION, REVISED, 1947

SECOND PRINTING, WITH FOREWORD, 1969

COPYRIGHT, 1943, BY PRINCETON UNIVERSITY PRESS

ALL RIGHTS RESERVED

LIBRARY OF CONGRESS CATALOG CARD NUMBER: 62-4630

PRINTED IN THE UNITED STATES OF AMERICA

BY PRINCETON UNIVERSITY PRESS AT PRINCETON, NEW JERSEY

THE FIRST EDITION OF THIS BOOK WAS

PUBLISHED WITH THE ASSISTANCE OF A GRANT

AWARDED BY THE AMERICAN COUNCIL OF LEARNED SOCIETIES

FROM A FUND PROVIDED BY

THE CARNEGIE CORPORATION OF NEW YORK

To R. B. de T.

FOREWORD

THE five volumes of this series, written between 1940 and 1959 and published between 1943 and 1960, are reissued here without modification except for the replacement of a number of photographs.

Addenda and corrigenda for these five volumes will appear as an appendix in the sixth volume, now in preparation, on Michelangelo as architect.

The author wishes to express his special thanks to Princeton University Press and to its Director, Mr. Herbert S. Bailey, Jr., for the decision to reissue this work, which has been long unavailable.

CHARLES DE TOLNAY

Firenze
Casa Buonarroti
October 1968

ACKNOWLEDGMENTS

THE author is indebted to the Carnegie Corporation of New York, which, through the American Council of Learned Societies, has generously supported the publication of this book. He also wishes to thank the director of the Institute for Advanced Study, Dr. Frank Aydelotte, and the chairman of the Department of Art and Archaeology of Princeton University, Professor Charles Rufus Morey, who have been helpful in facilitating the publication of this work.

The Bibliothèque Nationale in Paris, the Cabinet des Dessins of the Louvre, the Institut d'Art et d'Archéologie of the University of Paris, the Biblioteca Apostolica Vaticana, the library of the Uffizi, the Biblioteca Nazionale in Florence, the Biblioteca Laurenziana in Florence, the Department of Drawings in the British Museum, the Ashmolean Museum in Oxford, the Royal Library at Windsor, the Albertina in Vienna, the Institute for Advanced Study, and last but not least, the Marquand Library of Princeton University, have all facilitated the author's research. Other acknowledgments are mentioned in the appropriate place in the Critical Catalogue and in the notes.

We wish to express our sincere thanks to Miss Mary Ann Farley who has kindly lent her assistance in the translation of the book, and also to Miss Margot Cutter and Miss Elizabeth Hill for their kind assistance in many different ways.

CONTENTS

APPENDICES

INTRODUCTION

IN MICHELANGELO there is a very marked dualism between the "social being" and his spiritual and artistic personality. Externally timid, of a bourgeois simplicity, leading a modest and solitary life, he was in his soul obsessed with a dream of heroic grandeur. Never did he attempt to raise his daily life to the level of his ideal, nor did he ever attempt to incorporate immediately in his works the experiences of his daily life. His innate Platonism wished to keep the two far apart. Thus the biography of Michelangelo forms the most complete contrast to his artistic thoughts. It seems proper, therefore, to treat separately the history of Michelangelo's life and his artistic development.

In the first part of this book an attempt is made to reconstruct the exterior circumstances of the life of Michelangelo, the Florentine bourgeois. The presentation is based on the primary sources, that is, on the correspondence of Michelangelo (not only on the published letters but on letters not hitherto published and preserved in the family archives in Florence) and on documents.[1] Condivi, Vasari and Varchi, the contemporary biographers of Michelangelo who give much apocryphal artistic gossip, are critically considered in second place.[2] This procedure differs from that followed hitherto and may give a less entertaining view of the personality of Michelangelo, while having perhaps the advantage of showing more clearly his strong and simple character.

Behind the daily life, and the relation of the man to his geographical and social milieu, lies the real life—with which indeed, this book is chiefly concerned—that is, the life of the spirit. It develops according to its own hidden laws; it is "documented" only by the actual works of art. The second part of the book thus deals with the artistic development of the master. There are many works on Michelangelo the artist, but there seems to be still lacking a presentation which considers the form and content of his work as an inseparable unity. The great critics of the past have analyzed style and form in Michelangelo as if they had an existence separate from the content. More recent writers have interpreted the subject matter as if the works were simple illustrations of intellectual abstractions.

In this book Michelangelo's works are considered neither as mere solutions of formal problems nor as allegories. We have rather attempted to show in them the mutual dependence of form and content. The formal motif or the subject matter is only a point of departure; during the execution of the work the artist, perhaps partly unconsciously, infuses into it his experience of life in order to create an image of existence, which reveals to us a fundamental law of life.

Past research on Michelangelo done by the author is summarized in the critical catalogue. The reproductions, which were in great part taken according to the author's direction, will, it is hoped, help to substantiate the critical observations in the text and catalogue.

This second edition is a revised reprint of the first edition of 1943. Only minor changes were made in the text and a few additions can be found on pp. 263ff. In the section of illustrations three reproductions have been inserted.

LIFE

Exact information concerning the financial status of the Buonarroti is known only from 1427 on.[10] In this year Michelangelo's grandfather Lionardo and his brother Michele were owners of a house in the Santa Croce quarter, of which they rented two rooms. They owned a second house (which was rented), and also two farms, one at Settignano, which had been in the family since 1345 and which was to play a role later in Michelangelo's life,[11] and one near San Lorenzo alle Ruose. The two brothers lived together with their mother and the wife of Lionardo. Their half brother, Simoni Buonarroti, had a house near by.

Later on we find Michele and Lionardo separated. The former seems to have been financially successful, for he bought two houses in 1470. Lionardo, on the other hand, apparently had money troubles, for he contracted to rent his home to his son-in-law. With him began the financial decay of the family.

A close relationship existed between the sons of Lionardo, Francesco and Lodovico. The latter was to be the artist's father. The two brothers were married at the same time and established a communal household with their wives and mother, Alessandra, repeating the collective form of life of their ancestors. They first rented a house in the city, in the *popolo di San Romeo* for which they paid the modest rental of eight florins. They rented out the little family farm at Settignano, which was at this time their only undisputed property. They claimed ownership of a house in the *popolo di San Jacopo tra le fosse*, which formerly belonged to their uncle Michele, but which at this time was unjustly in the hands of a certain Giusto d'Anghiari.

We find the two brothers by 1481 in a slightly better position. They rented a house in the Via dei Bentaccordi in the *popolo Sant'Apollinare*. This was the property of their brother-in-law, Filippo di Tommaso Narducci, to whom they paid a rental of ten florins. Narducci was a dyer, who lived in Pisa. He seems to have been fairly well off, as he owned a house in the Castello di Prato as well as the one he rented to the Buonarroti brothers (see "Denunzia dei Beni," 1470). At this time Lodovico and Francesco possessed the disputed house in the *popolo di San Jacopo tra le fosse* as well as the Settignano farm.

In 1498 we find the brothers located in a rented apartment in the Via di San Proculo in the *popolo di San Pietro Maggiore*, for which they paid twelve florins. In addition to the Settignano farm and the house in *San Jacopo tra le fosse*, they now owned a second small house, also in this *popolo*.

Michelangelo's uncle Francesco (1434-1508) was a money-changer by trade but it appears that his business was very modest since he declared in the "Denunzia dei Beni" that his "shop" consisted of an outdoor counter in front of Or San Michele, which he had in partnership with a certain Orlando di Ser Guasparre, and of a second table which he rented from a cloth-cutter named Amatore, since he could not "remain at the first table in the event of rain" ("Denunzia dei Beni" of 1480 and 1481). He held several public offices for short periods. He was *Castellano di Gorzano* (1459), and twice elected

as one of the twelve *Buonomini* (1466 and 1473), and finally was *Gonfaloniere* in 1474. Francesco seems to have been a very simple man who, like his brother Lodovico, disdained the arts. Later he, as well as the artist's father, was to oppose Michelangelo in the choice of a career.[12]

Lodovico (June 11, 1444-ca. Summer 1534), the father of Michelangelo, lived on his small inheritance until his son became wealthy and for the most part supported him. From time to time he held modest civic positions.[13] He would have liked to lead a leisurely life, spent half in the country at Settignano and half in the city where he could attend to his public duties. He considered work unworthy of a gentleman, an old and common belief among Mediterranean peoples. He expressed this opinion to Lorenzo the Magnificent when the latter out of gratitude to his son gave him the position of customs official, saying, "I have never done anything and have lived up to now from my modest income, which comes from the few possessions I have inherited from my ancestors . . . " (Condivi, pp. 22*ff*). Although possessed of a certain respect for economical living (Frey, *Briefe*, pp. 1-2) he had a penchant for prodigality. While he was *Podestà* of San Casciano (September 22, 1510-March 22, 1511) this once led him to spend some money of Michelangelo's, without permission.

The fatherly advice which he gave to Michelangelo is a mixture of naive prejudice and old superstition, rather pedantically expressed and not free from an involuntary humor; for example, when he says, "Economy is good, but misery is bad since it is a vice displeasing to God and to one's fellowman" (Frey, *Briefe*, pp. 1*ff*). Very comic is Lodovico's hygienic advice: "Above all take care of your head, keep it moderately warm and never wash yourself; allow yourself to be rubbed but don't wash yourself" (Frey, *Briefe*, p. 2). [Addenda, No. 1]

The rather narrow-minded father of Michelangelo was never much concerned with things of the intellect, including art. At first he considered his son's choice of a career unworthy of the family's social position. Later he thought of it merely as a source of money.

Certain characteristics of Lodovico are to be found, transformed it is true, in his great son. These are the violent, easily aroused temper, pride in his family and a certain indecision in action; also we find in Michelangelo his father's conventional religiosity (cf. Frey, *Briefe*, p. 69), his prudence and distrustfulness (Wolf, p. 66: "non si può fidare di persona"), and, finally, his kind heart toward the poor and unhappy (Wolf, p. 68).

By his first wife, Francesca di Neri di Miniato del Sera, to whom he was married between the years 1472-1481, Lodovico had five sons. Concerning this woman, the mother of Michelangelo, we have no information. [Addenda, No. 2]

Lionardo (November 16, 1473-ca. April 1510), the eldest son, entered the Dominican Order in Santa Caterina in Pisa on July 4, 1491. He seems to have been a partisan of Savonarola (Frey, *Q.F.*, pp. 12 and 14).[14] After having passed some time at Viterbo

he fled to Rome in 1497 (see Milanesi, p. 3). He had troubles with the Order. He was ejected, possibly because of his partisanship for Savonarola. In 1510 we find him in Florence in the convent of San Marco. He died in Pisa.

Michelangelo (March 6, 1475-February 18, 1564) was the second son, but because his brother was in the priesthood he was considered by his family as the eldest. As we shall see, his father Lodovico was a "negative master" from a spiritual and artistic point of view. The child was to feel vaguely that in doing the contrary of what his father wished, he was on the right road. But this did not prevent him from feeling a profound veneration for Lodovico as father and head of the household. He felt himself superior to his younger brothers in the family hierarchy and he treated them as his subordinates. All his life he busied himself with the affairs of his family. Though declaring that he himself is living in great poverty, he nevertheless generously gives assistance whenever father or brothers ask for money. Of this there is ample evidence; the family correspondence is usually concerned with financial matters. Where money was concerned Michelangelo was, as it were, the conscience of the family, making up as best he could for the carelessness in this respect of his father and brothers.[15] In contrast to the wavering morals of his family Michelangelo appears a man of honor; respectable through and through, he corrects the mistakes of others, helping them with money when necessary. Yet he knows how to look out for his own rights as well.

The third son, Buonarroto (May 26, 1477-July 2, 1528), was the favorite brother of the artist. He started out apparently as joint owner, together with a certain Donato di Bertino, of a banking firm, from which the first page of an account book is still preserved. He was then employed in the wool shop of Lorenzo Strozzi, near Porta Rossa. Later on, he and another brother, Giovansimone, were owners of a bottega for which Michelangelo had furnished the money (Frey, *Briefe*, p. 1; Milanesi, p. 109).[16] The cloth industry was at that time the most important of Florentine commercial activities, as well as the oldest. The wool guild was founded at the beginning of the thirteenth century (we have documents concerning it from 1212 on). The Florentines brought the wool from France and Flanders and improved it by a refining process.[17] This guild had considerable influence on the artistic life of the city, since it superintended the decoration of Or San Michele, Santa Maria del Fiore and San Giovanni. It was a sort of patron of artists and we shall see that Michelangelo himself received a commission in 1503 from the guild. During the Middle Ages we find several members of the Buonarroti in the register of this guild.[18]

Michelangelo's brother Buonarroto held public office several times. He was elected to the *Buonomini* in 1513 and 1525. In November and December of 1515 he was a *Prior* of Florence (Frey, *Briefe*, p. 27). At that time Pope Leo X gave him the title of *Conte Palatino*. In 1517 he was *Podestà* of Castel Focojano (Frey, *Q.F.*, p. 70), and in 1521, *Gonfaloniere*.

Buonarroto was a fairly naive person, but possessed of an egotistical and mercenary

character. That he wished to marry for money is proved by a letter of reprimand to him from Michelangelo (Milanesi, p. 102). Other letters show that Buonarroto spent Michelangelo's money in Florence carelessly and against the artist's wishes (Milanesi, pp. 108, 109). The success in art of the latter was considered by Buonarroto from an egoistic point of view as we see by a letter to Michelangelo, in which he says, "I learn that you have good hope for your affairs. May God will that your affairs go well because it is also for our good fortune." (Frey, *Briefe*, p. 42).

The fourth son of Lodovico was Giovansimone (March 11, 1479-January 9, 1548). According to a family tradition, he devoted himself to letters. It is said that he produced some poetry but we have no remains by which to test the merit of his verse.[19] It appears that he was associated for a time in the cloth business with Buonarroto (Frey, *Briefe*, p. 1; Milanesi, p. 109). Documents indicate that he behaved badly toward his father and Michelangelo, despite the fact that the latter supported him. Once he set fire to the house and farm at Settignano (Milanesi, p. 150). Michelangelo's letter, full of disappointment, threats, and reprimands to Giovansimone, is one of the strongest expressions of anger by the artist (Milanesi, p. 150). [Addenda, No. 3]

Michelangelo's youngest brother was Gismondo (January 22, 1481-November 13, 1555). According to the same family tradition he was in the army.[20] He is supposed to have suffered from an illness and retired to Settignano about 1531 (?), where he lived a peasant's life (Frey, *Briefe*, p. 308; Milanesi, p. 197). Later, at the advice of Michelangelo, he returned to Florence.

The father of Michelangelo married a second time. This wife was Lucrezia di Antonio di Sandro Ubaldini da Gagliano (m. 1485, and d. July 8/9, 1497). It is supposed that the "brother Matteo," of whom we know only by one letter from him to Michelangelo, is a son of Lucrezia.[21]

The only brother of Michelangelo who married was Buonarroto. He had four children by his second wife, Bartolommea della Casa, of whom two died in infancy. Of the two who lived there was a son Lionardo, the only masculine descendant of the Buonarroti family.[22] The other child was a daughter, Francesca.[23] Michelangelo loved his nephew dearly and tried by his wise counsel and reproof to make him a worthy member of the house of Buonarroti. He found him a wife of noble Florentine family, one Cassandra Ridolfi. Francesca he married to Michele Guicciardini, also a famous name in Florence. Unfortunately, his nephew was not worthy of Michelangelo's interest and affection, and proved heir to the mediocre traits of his ancestors.

The indetermined vacillating social rank of the decayed Buonarroti explains to some extent certain traits in Michelangelo's character. In his letters he continually stresses his noble descent. Sentences such as "we are citizens descended from a noble house" (Milanesi, p. 197) appear frequently in his correspondence, especially during old age.[24] He, who in his youth always signed letters "Michelagniolo, scultore," protested in his

old age against being addressed thus. He said, "I was never a painter or sculptor like those who have shops. . . . I have always taken care not to do this for the honor of my father and my brothers, although I have served three popes. But I was forced to do that" . . . (Milanesi, p. 225).[25]

One of the main efforts of his entire life was to reestablish the former social prestige and wealth of his house. "I was always thinking to restore my family, but I had no brothers who were worth it" (Milanesi, p. 197).[26] He judged his brothers severely and even scorned them, but still felt strongly the fraternal bonds. He appreciated their being in spite of their faults Buonarroti Simoni. Throughout his life he accumulated property by continually buying farms and houses.[27] He put aside much money, but actually lived in misery[28] and worked like a slave—this for the benefit of his family. Again and again in letters throughout his life (Milanesi, p. 150) are found sentences such as "I live under the greatest strain and with a thousand difficulties. . . . I live in poverty" (Milanesi, p. 47). His sacrifices were not in vain, for from his time the Buonarroti were considered to belong to the highest aristocracy in Florence, up to their extinction in the nineteenth century (1860). But never again did the house of Buonarroti produce a genius.[29]

The feeling of inferiority characteristic of the *déclassé* may also be responsible for the fact that his relations with others lacked the self-confidence and ease of adjustment of those of unquestioned social eminence. Toward his superiors he wavers between the extremes of unapproachable pride and a submission in which he sometimes loses all dignity. It is only with his inferiors that he is able to associate with complete ease; toward the *popolo minuto* he is always full of rare kindness.[30]

He must have inherited his ideal of independence from his ancestors. He was an old-fashioned Guelph. From time to time, when external circumstance permitted, the old flame of Florentine patriotism that burned deep within him, burst forth.[31] But Michelangelo's inherited republican spirit was in conflict with the actual social structure of his environment. He was born when Florence was a *Signoria*, ruled by the Medici, and during his whole life was constrained to serve either this family, or, when in Rome, the popes. They alone could give him the opportunity of realizing his great plans, and Michelangelo in return had often to deny his republican sentiment, sometimes under rather humiliating conditions.[32]

He loved Florence passionately and complained when he had to leave the city for a short time.[33] He wished to be buried in Florence beside his father (Milanesi, p. 534). And yet the proverbial envy and gossip of the Florentines was not spared him. "Never have I associated with more ungrateful and arrogant people than the Florentines" (Milanesi, p. 47). While he was absent from the city, gossipy citizens spread the rumor, first in 1508 and later in 1545, that he was dead. Michelangelo reports laconically: "I hear that they have said there, that I am dead. It is a matter of small importance, for I am still alive" (Milanesi, pp. 11, 18, 502).

[8]

But although he really felt at home only in Florence, he spent the last thirty years of his life in Rome. Never able to think of Rome as his home, he was tormented by homesickness for Florence and a return there was always in his plans (for instance, in 1557 he expressed the desire to return to Florence; Milanesi, p. 542). And yet he never went back. It was not only because Paul III had extraordinary commissions for him (Cosimo de' Medici also made him magnificent offers in Florence), but by working for the papal court he felt that he was saving his soul.

This much seems clear: in order to fulfill his spiritual vocation, he was over and over again forced to sacrifice those things which meant most to him as a social being—his republican opinions, his love for Florence, sometimes even his friends, and in his old age his ideas for an internal reform of the church.

The relationship with the *popolo minuto*, a heritage of his immediate ancestors, is evident in Michelangelo's character. His nature is plebeian, hardy and robust. While he would have been welcome among the elite, and popes and rulers strove for his favor, he liked to spend his time with simple people. He is spontaneously drawn to the weak and humble, to the people of the street, such as poor stonecutters, to impoverished citizens and to mediocre artists who need his help (see note 28 and Appendix III). He knows the spirit and humor of the people; he himself possesses their cleverness, prudence and cunning.[34] He shares with them a taste for good wine and a modest way of life (see note 26); he loves his easygoing religious belief, holds fast to his superstitions and loves independence. He has the modesty and kindness of the common people, "la modestia e la mansuetudine, . . . e bontà incomparabile"—as Graziano Abate says in a letter (April 13, 1518; see Appendix IV)—but also its secret pride in its skill, in its handicraft. (See Michelangelo's letter to Giuliano da San Gallo, May 2, 1506; Milanesi, pp. 377f.)

On the other hand, he felt the need for contacts with cultivated and learned persons who could inspire his spirit and from whom he could learn through liberal conversation (Condivi, p. 198; Vasari, 1568, p. 245). This desire to perfect his culture, and not social snobbishness, explains the fact that one finds him associated with the upper clergy and with secular members of the nobility.[35]

Yet beyond his inherited *popolo minuto* surface there was concealed in Michelangelo a mysterious force which caused a struggle within the artist, and made him suffer deeply from existence in itself and the limitations of time and space. There is in him something volcanic; at times this elemental power breaks forth, so violently that he feels it as fate. From this conflict is born "l'ardente desio" which carries him far away into the realm of absolute truth. There is in him a reaching toward the heights, "al ciel sempre son mosso" . . . "al cielo aspiro." The human greatness of his character perhaps lies in his having succeeded in suppressing his inherited personality and in having become the docile and humble organ of his spiritual vocation.

As a type Michelangelo is not a simple artisan as were the artists of the fifteenth century, nor is he yet the artist-prince that is to come in the late sixteenth century. He is rather the artist-philosopher, with a predilection for solitude, and he liked to accentuate the seriousness of his profession, by a sober manner of life.[36] That which Leonardo had recommended (*Trattato della Pittura*, par. 63), that the artist live in solitude the better to concentrate on the essence of things, Michelangelo realized in his own life. His remoteness and solitary life are a consequence of this asceticism. He suffered from his renunciation but he was glad of this because suffering seemed to him a moral purification. "E più mi giova dovè più mi nuoce" (Frey, *Dicht.* XLII); "mille piacer non vaglion un tormento" (Frey, *Dicht.* LXXIV).

The yearning for the metaphysical heights remains during all his long life the directing force of his being. It appeared under different aspects, first as Platonism and later as Christianity. But it is always the same detachment from the world, the same ardor for absolute truth, the same desire to reach to the "upper regions" where the essence of existence is revealed. Thus considered, Michelangelo's inner development itself appears, as we shall see, as a kind of work of art in which we find all the typical stages of man's spiritual elevation.

Frontispiece The physical aspect of his head, as shown in the bust by Daniele da Volterra in the Castello Sforzesco in Milan, reveals his dual nature.[37] It has a faun-like character; noteworthy are the high cheek bones, round bony forehead, flattened nose, dry, wrinkled skin, thin lips and curly forked beard. But this sensual face is ravaged by an inward fire and betrays a spiritual suffering. We see this in the tired eyes, the bitter droop of the lips and the lines around the mouth.

II. EARLY CHILDHOOD

ON March 6, 1475, Lodovico Buonarroti made the following entry in his family book of records: "I recall that today this sixth of March, 1474 [in our calendar, 1475] there was born to me a male child; I named him Michelagnolo and he was born Monday morning before four or five o'clock and he was born to me when I was *Podestà* at Caprese, and he was born at Caprese. The witnesses were those named below. I had him baptised on the eighth of the same month, in the church of Santo Giovanni di Caprese. Here are the witnesses." There follows a list of nine names, all inhabitants of Caprese.[38] (The last two sentences of the entry were obviously added later.)

Michelangelo was therefore born in the little town of Caprese, situated at the top of a picturesque hill near the *valle della Singerna*, a tributary of the Tiber, in Tuscany. The old *podesteria* where Michelangelo was born is called today the Casa Clusini.[39] From 1389 Caprese had been under the rule of Florence. In the constitution of Caprese it was explicitly stated that "the *Podestà* of Caprese must be a citizen of Florence, a *popolare* and a Guelph." Therefore Michelangelo's father must have belonged to the Guelph party. In 1428, the two *podesteria* of Caprese and Chiusi were united; henceforth there was only one *Podestà* for the two and he resided in one of the two places, being represented in the other by a notary. Lodovico Buonarroti was the one hundred sixty-ninth *Podestà* of Caprese.

Michelangelo could not have had any memory of his birthplace, for twenty-five days after his birth his father's six months' term as *Podestà* was finished. Lodovico went to Florence and gave his son to be nursed by a woman in Settignano, where as we know, he had a small piece of land and a house. Michelangelo's nurse is said to have been the daughter of a stonecutter and also the wife of one.[40] In later years Michelangelo is said to have told Vasari: "Giorgio, if there is some good in me, it is because I was born in the subtle atmosphere of your country of Arezzo. Along with the milk of my nurse I received the knack of handling chisel and hammer, with which I make my figures."[41] If this anecdote contains a germ of truth, then it shows at least that Michelangelo was conscious of being a provincial and not an urbanite, and that he considered his genius as a providential gift. His predilection for vigor, simplicity and grandeur, his disdain for the precious and decadent art around him and his gift for seizing with the form the elemental forces which created it, could perhaps be explained in some measure by this kinship which he claims with the soil.

We do not know with certainty the date on which Michelangelo left Settignano to go to live with his father and uncle in the somber house in the Via dei Bentaccordi in the quarter of Santa Croce.[42] Probably it was when the artist entered school at the age of ten years. His father wanted him to study letters (Condivi, p. 12). He placed him in the grammar school of a certain Francesco da Urbino.[43] But the child seemed to have no interest in school. "The boy preferred to go into churches, to copy paintings,

rather than to learn grammar in school; he often ran away from school to go where artists were painting; he worked preferably with those who drew rather than with those who studied," says Varchi,[44] in accord with Condivi (p. 12) and Vasari (1568, p. 13).

It is said that Michelangelo's choice of an artistic career did not please Lodovico Buonarroti and his brother Francesco. The father, a "rather old-fashioned" person,[45] thought that art was "a low thing" not worthy of the ancient Buonarroti family (Vasari, 1568, p. 13). He did not see the "difference between a sculptor and a stonecutter" (Condivi, p. 22). "And therefore," says Condivi (p. 14), "the father and the uncle maltreated him [Michelangelo] and often strenuously beat him." We recognize in these accounts the typical motif of youthful independence as shown by a genius in the choice of his profession, a motif which has been found since antiquity in almost all the legendary biographies of great men. Also a conflict between the voice of his spiritual vocation and his environment is traditionally present. The young genius, in his revolt against the latter, takes on the character of a "spiritual hero."[46] We may suppose that this conventional belief in the spirit of independence and rebellion as shown in the young genius usually corresponds to a basic truth. In the case of Michelangelo we may be rather sure of this.

The disdain of Michelangelo's family for an artistic career is understandable if we consider the social position of artists in Florence at the end of the fifteenth century. There was no distinction between ordinary trades and the arts at this time. The artist was still, as in the Middle Ages, an artisan. He belonged to a guild, but not a special one. In Florence, painters were associated with the guild of physicians, druggists and shopkeepers. Sculptors belonged to the goldsmiths' guild. Not until Leonardo did the struggle of the artists, to raise their social status, begin. Then during the sixteenth century—partly through Michelangelo's prestige—they succeeded in being advanced from the *artes mechanicae* to the *artes liberales*.[47]

A turning-point in Michelangelo's life came when he freed himself from the fetters of family convention and, following the voice of creative genius, abandoned ancestral tradition. In his early groping for orientation, he is said to have found aid in the person of Francesco Granacci, six years his senior and a pupil of Domenico Ghirlandaio (Condivi, p. 12; Vasari, 1568, p. 13).[48] Apparently Granacci had no influence on the creative development of Michelangelo, but he was important in bringing him into contact with the artistic circles of Florence. He brought the young artist drawings from Ghirlandaio (Vasari, 1568, p. 13) and from time to time took him to his master's studio. The sudden appearance of Granacci in the life of the young Michelangelo brings in another typical motif of the legendary biography of a genius—that is, providence introduces to him a man who discovers his talents and aids in their development.[49] We have no reason to doubt the truth of the assistance of Granacci; we know from documents that he was an intimate friend of the artist.

Genius is not a product of its milieu, but finds by affinity the milieu suited to its

development, or creates a milieu around itself. Michelangelo's milieu from now on is no longer the dark, poor apartment in the Via dei Bentaccordi but artistic Florence with its churches and palaces filled with ancient and modern art treasures; the gleaming beauty of the Piazza del Duomo with the marble Baptisterium and Campanile, where the greatest artists throughout the centuries had contributed to form a veritable museum of Tuscan sculpture. Here were the sculptured bronze doors of Andrea Pisano and of Ghiberti, and the marble statues of Donatello. Beyond that, his milieu is Florence, framed by hills and cut by the shining ribbon of the Arno, with its cubical buildings grouped around the mighty dome of Brunelleschi, its crystalline atmosphere so clear that even distant outlines are not dimmed. This world of pure abstract forms, where spirit seems to reign over matter, where a hidden geometry seems to underlie every form, is the true milieu in which Michelangelo is at home. It is the austere Florence of the medieval *Comune*.

He was, however, completely untouched by the festive and feminine side of the city, the Florence of the Signoria. The façades of the churches, richly encrusted as though overhung with lace, the delicate ornamentation of the courtyards, the surrounding landscape, with its beautiful silver-green olive trees trembling in the wind, the dark cypresses and pines in the villa gardens, found no echo in his soul.

III. APPRENTICESHIP IN THE STUDIO OF
THE BROTHERS GHIRLANDAIO

IN the records of Domenico Ghirlandaio, Vasari (1568, p. 15) saw this entry written in the hand of Lodovico Buonarroti in the year 1488: "I recall that today the first of April, I, Lodovico di Lionardo di Buonarota placed Michelagnolo my son in apprenticeship to Domenico and Davit di Tommaso di Currado for the three years to come according to the conditions that the said Michelagnolo must stay with the above the aforesaid time to learn to paint, and to do exercises, in these the above-named will direct him. And the said Domenico and Davit are to give him in these three years twenty-four florins *di suggello*, the first year six florins, the second year eight florins, the third year ten florins, in all, the sum of ninety-six lire."[50]

The surprising elements of this contract are: first, that Michelangelo was thirteen years old when he entered the studio of Ghirlandaio, whereas generally an apprentice registered at the age of ten; second, that even during the first year he received a salary, while the rule was that an apprentice should work for nothing during this period; third, that Michelangelo was to "paint" immediately, while ordinarily instruction began with learning to draw.[51]

Michelangelo's relatively late entry into the studio may be explained by his father's forcing him to continue in the Grammar School of Francesco da Urbino until his thirteenth year. We may deduce from the other two irregularities in the contract that Michelangelo had had some experience in art before entering Ghirlandaio's studio. Proof of this ability is a drawing still preserved on the wall of a room in the house of the Buonarroti at Settignano, which hypothetically may be dated in this period.[52]

Art instruction as given in the painters' studios of fifteenth century Florence was based on practical advice and not on general rules and canons. A master communicated to his apprentices the results of his experience and his technical knowledge, and these were transmitted from studio to studio. The basis for all artistic instruction was "drawing." The student had to practice drawing in different techniques—silver point or pen, for example, on white or colored paper. He had to learn to draw from the works of his master or from those of other celebrated masters. He was also instructed in perspective and anatomy. There exists no fifteenth century document concerning general rules for composition.[53]

In the famous Ghirlandaio workshop around 1480, we find among the list of apprentices, Bugiardini, Francesco Granacci, Ridolfo Ghirlandaio. The other most celebrated studio in Florence at the time was that of Cosimo Rosselli, where Piero di Cosimo, Fra Bartolommeo and Albertinelli received their training. The method of instruction in both these workshops seems to have been similar to the one followed in the school of Verrocchio which had flourished a short time before and where Leonardo, Perugino and Lorenzo di Credi were apprentices. Leonardo, in his *Trattato*

della Pittura (ed. Ludwig, par. 47 to 49) speaks of the mode of instruction then customary in the ateliers, and we find that this agrees in all essential points with that followed at the end of the century, as described above.

Condivi and Vasari mention several drawings which Michelangelo made during his apprenticeship to Ghirlandaio.[54] From the titles of these lost drawings we gather that Michelangelo followed the conventions of his day, in drawing both from his master and other celebrated artists and from nature. He reworked in pen a drawing of Ghirlandaio representing some draped female figures; he made a copy of Schongauer's engraving of the Temptation of Saint Anthony, and of several drawings by old masters, whose names are not given. He also made a copy of a head after Ghirlandaio, and from nature a sketch of the scaffolds which stood in the Choir of Santa Maria Novella at the time.

These drawings by the young Michelangelo seem to have been a departure from the sweet and tender style usual in the late Quattrocento. Vasari reports that Ghirlandaio was "dismayed by the new manner and the new imitation" of Michelangelo[55] and expressly mentions (1568, p. 17) the "nuovi lineamenti nella maniera" of Michelangelo's earliest drawings, adding that it was wonderful to see the difference between his style and that of Ghirlandaio, and the former's superiority. Vasari notes that in one case Michelangelo outlined a drawing of another pupil of Ghirlandaio "con penna più grossa." We can see from this casual observation that the characteristic considered novel in Michelangelo's style was the power of the lines. This conclusion is supported by the earliest preserved drawings (Nos. 1-6). 67-77

Ghirlandaio's art does not seem to have had a deep influence on the young Michelangelo, who was already too independent to imitate his master. Furthermore, according to Condivi (p. 16), there appears to have been some discord between master and pupil. However, the year he spent in Ghirlandaio's studio seems not to have been wasted. It was probably during this time, as we shall see, that he embraced the monumental and massive plastic conception of his true artistic ancestors, Giotto and Masaccio (Nos. 2-6). 68-77

IT was fortunate for Michelangelo's artistic development that in spite of a three years' contract he was able to leave the *bottega* of Ghirlandaio after only one year's stay, and to continue his studies in a much more stimulating environment. In 1489 Lorenzo the Magnificent took the youthful artist into his newly founded "free art school" in the Giardino of the Casino Mediceo.[56]

We have very little knowledge of exactly how this art school was constituted. It was located on the Via Larga, opposite the Monastery of San Marco. Our earliest extant representation of the Casino and garden is found in Stefano Bonsignori's plan of Florence, dated 1584.[57] No. 49 on the plan shows the "Casino del gran Duca" in the midst of a garden. In front of the building is a sort of loggia surrounding a square court. In a fresco by Ottavio Vannini (1585-1643) in the Pitti Palace (Museo degli Argenti) is represented the entrance to the Casino, with Lorenzo de' Medici seated among his young protegés. There is, to be sure, a question whether this fresco of the seventeenth century has any documentary value.

The most detailed references to the school of the Giardino Mediceo that we possess are given by Vasari in his *Vita di Torrigiano*.[58] According to this biographer, the garden was "filled with antique and good sculptures." "The loggia, the garden-paths and all rooms [of the Casino] were ornamented with figures and pictures such as were to be found neither in Italy nor outside Italy." Vasari also mentions that drawings, cartoons and models by Donatello, Pippo [Brunelleschi], Masaccio, Paolo Uccello, Fra Giovanni [Angelico], Fra Filippo and others were kept here. In addition there was a celebrated collection of antique gems. Since no inventory of the Giardino and Casino Mediceo is preserved, it is no longer possible to say what particular antique and Renaissance works of art were in this collection. Vasari says further that "all these works of art constituted, so to speak, a school and academy for the young painters and sculptors and especially for the young men of nobility."[59]

The school was under the supervision of Bertoldo di Giovanni, who was also curator of the art works exhibited in the garden. Bertoldo, a pupil of Donatello, was an ardent lover and connoisseur of antique art. He himself made a copy of an antique battle sarcophagus which is preserved today in the Bargello (the ancient original is in the Campo Santo in Pisa). It is probable that he encouraged his pupils to make similar copies.[60]

The method of teaching in this "garden" school seems to have been completely different from that followed in the studios. Here was nothing of the schoolmaster discipline of the dark *botteghe*. Surroundings were of festive splendor, calculated to awaken by their beauty the artistic instincts of the students, who could easily and freely receive their inspiration from the works on exhibition. Among the pupils of this first "free art-school" are mentioned: F. Granacci (b. 1469), Torrigiani (b. 1472),

Giovanfrancesco Rustici (b. 1474), Giuliano Bugiardini (b. 1475/76), Baccio da Montelupo (b. 1469).[61] All these later became well known masters. In their youth they followed for the most part the "classical style" and in their late period became mannerists. Almost all of the sculptors in the group later came under the influence of Michelangelo.

Michelangelo seems to have entered the Giardino Mediceo at the same time as his friend Granacci. Here he was able to devote himself to the study of great art without material worries (for we know that Lorenzo gave grants to poor youths).

It was probably partly due to this foundation of Lorenzo de' Medici that art in Italy lost its character of a metier and took on new dignity and freedom. For Michelangelo art was no longer common handicraft (although he always stressed perfection of execution), but a free spiritual action motivated by an inner creative need. Later Michelangelo was to turn in contempt from artists who kept a *bottega*. (See note 25.)

In this atmosphere Michelangelo made his earliest essays in sculpture as we know them, namely certain round figures in clay (all lost today) after models with which he was provided by Bertoldo, and the head of an old faun in marble, bearded and laughing, which he copied after an antique fragment in the Giardino (Condivi, p. 20; Vasari, 1568, pp. 23 and 25). Even on the basis of the description given by Condivi and Vasari it becomes clear that Michelangelo was not satisfied with a servile copy of his antique prototype, but that he "complemented the model with his phantasy."[62] In the fresco of Ottavio Vannini, already mentioned, one recognizes in the right foreground the young Michelangelo, showing Lorenzo his faun's head. The head here represented is reminiscent of antique sculptures, for example, a head of a faun preserved in the Vatican. From Vannini's fresco, our one extant representation of this lost work of Michelangelo, it is not possible to get any idea of the artist's creative intention or of the stylistic and technical qualities of the work.[63]

Michelangelo's prestige grew rapidly in the eyes of his patron and he became his favorite protegé.[64] He was installed in Lorenzo's palace in the Via Larga and was treated "like one of his own sons." From 1490 to April 8, 1492 (when Lorenzo died), Michelangelo lived in the Palazzo Medici, allegedly eating daily at Lorenzo's table with the latter's children and "other distinguished persons" (Vasari, 1568, p. 25).

THE Palazzo Medici in the Via Larga[65] is no larger or richer than the homes of other outstanding families of the period, such as the Ruccellai, the Pitti or the Strozzi. They all have a dual character, on the exterior being sober, staid and strong, still reminiscent of Trecento palazzi with their fortress-like aspect. Inside however we find airy arcades, with an atmosphere of refinement and hedonism. These palaces might well be symbols of their owners, powerful and harsh on the one side, beauty-loving and poetic on the other.

At this time the Palazzo Medici was filled with valuable pictures, frescoes (partly still preserved), ancient and Renaissance sculptures, gold, silver and crystal treasures, and books.[66] The ruler of Florence, who loved princely splendor and solemnity, was none the less heir to many of the bourgeois virtues of his merchant-forefathers. He was acquainted with philosophy and history and knew Latin and Greek although he composed in Italian. In the house dwelt his wife, Clarice Orsini and their children: Piero, who was to succeed him and was later driven from Florence; Giovanni, who was to become Pope Leo X; Giuliano, the later Duc de Nemours, and four daughters, Lucrezia, Luigia, Maddalena, Contessina.[67]

The tutor of the children was Angelo Poliziano, a humanist and poet. He is said to have inspired Michelangelo to execute the Battle of the Centaurs (II, 4).

3-6

The greatest minds of the time were frequent visitors at the Palazzo Medici. We find such names as Cristoforo Landino, commentator of Virgil's Aeneid and of Dante's Divina Commedia and author of the celebrated neoplatonic *Disputationes Camaldulenses*, of which the ideas later inspired the thoughts of Michelangelo; Marsilio Ficino, philosopher and theologian, translator and commentator of Plato, Proclos and Porphirius, and author of the *Theologia Platonica*, whence came the idea of the deification of man by his own force, which played so great a role in the thoughts of Michelangelo during the execution of the Sistine ceiling; Girolamo Benivieni, the poet of Platonic love and author of the *Canzone de lo Amore Celeste* and Pico della Mirandola, humanist and follower of Plato and Aristotle, interpreter of the Old Testament and connoisseur of the wisdom of the Orient. This inspiring group served as a sort of spiritual fount to Michelangelo. To them he owes his concept of esthetics, which is based on the adoration of earthly beauty as the reflection of the divine idea; his ethics, which rests upon the recognition of the dignity of mankind as the crown of creation; his religious concept, which considers paganism and Christianity as merely externally different manifestations of the universal truth. Here was laid the foundation for his struggle away from the deceptive world of appearance toward the realm of absolute truth. It was in this milieu that he created the two earliest marble works preserved to us: the Virgin of the Stairs and the Battle of the Centaurs, both of classical

1 and 3 inspiration.

His life was to follow the typical course of the lives of men about Lorenzo de' Medici. His friendship with Tommaso Cavalieri was to be in truth a love-passion without anything impure, and recalls such spiritual associations as those between Lorenzo and Poliziano, between Pico and Benivieni, between Marsilio Ficino and Bembo.[68] His Platonic love for Vittoria Colonna was like the love of Lorenzo for Simonetta, which itself was nothing but a repetition of Dante's love for Beatrice and Petrarch's for Laura. Even his late conversion to Christianity as the final redeeming truth was foreshadowed by the late conversions of Lorenzo, Poliziano, Ficino, and Pico. But in spite of the striking parallel there is a very great difference. For Lorenzo and his pleasure-loving circle conversion came suddenly, with the advent of Savonarola, and necessitated a complete spiritual transformation—a denial of their past way of life. With Michelangelo, on the other hand, the whole course of his life had, in a sense, prepared the way for it. It is true that the religious conversion of his old age appeared to himself (as we see from his late religious poems) as a definite break with all his past. He looks upon all his previous life as a long error and deeply repents of carelessly lost time. However if we take into account the fact that Platonism and Christianity are not opposites but are unified by their transcendent spirituality, then it appears that the aged Michelangelo was mistaken in believing that he had to repudiate all his past, for this past was really a spiritual prelude to his Christian period. Viewed in this light his conversion came as the logical fulfilment of his spiritual aspirations.

ON April 8, 1492, Lorenzo de' Medici died in his villa in Careggi. It is said that on his death-bed he conversed with Angelo Poliziano and Pico della Mirandola about the immortality of the soul. Also present was Savonarola, the Dominican who by this time fully ruled the common people of Florence.[69]

Lorenzo's death brought for Michelangelo a complete reversal in circumstances. It meant for him the loss of a paternal benefactor as well as of his artistic and spiritual milieu. From the security and comfort of a princely court he now had to return to the poverty of his father's house. Probably in the hope of bettering the position in which he now found himself, he sought to attract attention with a spectacular work. We learn that he bought a larger-than-life-size marble block (four braccia high) to make for his own pleasure a Hercules (XIV).[70] We also learn that he applied himself to studies in anatomy. The Prior of Santo Spirito is supposed to have given him the opportunity to dissect corpses.[71] This was a great favor at the time, for the dissection of corpses was subject to the approval of the civil authorities.[72] In return Michelangelo is said to have made for the Prior a less-than-life-size wooden Crucifix (XIII).[73] It seems that the Hercules reawakened the interest of Piero de' Medici, who had known Michelangelo during youth at his father's table. He invited the artist to live in the palace again (Condivi, p. 28), but the only known commission which he gave Michelangelo was for a snow-statue in the court of the Palazzo Medici, probably on January 20, 1494, when, as Landucci reports, the largest quantity of snow in memory had fallen.[74]

The true importance of this period in the development of Michelangelo was the fact that a new spiritual perspective opened to him through the ardent sermons which Savonarola was making at this time in Santa Maria del Fiore. Very likely Michelangelo heard them himself during the years 1493 and 1494. It was not, however, chiefly the religious principles and political doctrines of Savonarola which impressed him. It seems rather that he was seized by the personality of the man himself. The purity of the soul of the Dominican, the ardor with which he gave himself to his ideal, his disdain for the baseness of the world, his need of an interior renewal by asceticism, and finally, his prophetic gift are traits that Michelangelo himself possessed to a certain degree. The tendencies of the artist's own soul were fortified by contact with the great religious leader.

In 1493 Savonarola prophesied the punishment of Florence by the "scourge of God," and the resulting tension was increased by the growing political disorder in the city.

Before October 14, 1494, shortly after the spread of a rumor that the soldiers of the victorious French King were to plunder Florence,[75] Michelangelo suddenly disappeared from the city. This is his first flight.[76] Condivi explains it in an incredible anecdote which tells of the apparition to a certain Andrea Cardiere[77] of Lorenzo's

spirit prophesying the banishment of his son Piero, whereupon Cardiere advised Michelangelo to flee. The situation in Florence seems a likely explanation of the panic which must have come over Michelangelo. Doubtless alarmed by the terrifying predictions of Savonarola, he felt himself in danger, especially as a friend of the Medicis, against whom the people were now turning. He had to choose between loyalty in his service to the Medici, risking the development of his genius, and taking to flight in order to choose a place where there was hope for more favorable artistic conditions. Instinct guided him to the latter.

Similar flights are repeated three times in the course of his life. In 1506 he fled from Rome to Florence; on September 21, 1529, from besieged Florence to Venice; in September 1556 from Rome to Spoleto. These escapes are actually symptoms of a sense of responsibility for his genius which seems to be constantly present in Michelangelo. At the first indications of approaching danger, he takes to flight.[78]

A LETTER from Ser Amadeo to his brother Adriano (at that time a sculptor in Naples) proves that Michelangelo's flight from Florence took place before the fourteenth of October (date of the letter) and that Piero de' Medici, uninformed of his departure, was vexed by it.[79]

Fate almost seems to have had a hand in directing Michelangelo's flight to Upper Italy. He went first to Venice by way of Bologna, but we know that he soon returned to the latter city where he stayed a little more than a year (Condivi, p. 36), that is, until the end of 1495.[80] The shortness of his stay in Venice is not surprising, for nothing was less compatible with his own artistic ideal than the festive, mercurial, outward pomp of Venetian art and the radiant, light-saturated atmosphere of this city, which seems to rock on the waves of the Adriatic. It was not by chance that Michelangelo immediately went back from Venice to Bologna; he returned to the latter city because he found there what his spirit needed.

Bologna la Grassa, situated in the midst of a fruitful, hilly landscape, with gigantic, sprawling churches and palaces of rosy brick and friable stone arrayed about its two great ancient brick towers with their bold silhouette, had an aspect completely opposite to that of Florence with its hard, precise forms, or to Venice of the mirages; the amplitude and massiveness of its forms struck a responsive chord in Michelangelo. The small model of the city of Bologna which he put in the hand of his Saint Petronius shows how Michelangelo conceived the city. We find that he exaggerates the massiveness of the block-like buildings and transforms to squat, stunted forms the tall towers that dominate them.

But, as we shall see later, more important for his creative development was the opportunity of coming face to face in Bologna with the artistic works of Jacopo della Quercia, his true spiritual ancestor (III, 7).

Evidence of Michelangelo's early fame lies in the fact that he found in Bologna a patron in the person of the nobleman Gianfrancesco Aldovrandi (III, 3). This man played an important role in the political life of his city, being variously in the service of the Bentivoglio and Pope Julius II. In Aldovrandi's house, where Michelangelo lived as a guest, the young artist is said to have devoted himself to the study of the great poets of the "lingua volgare," Dante, Petrarch, and Boccaccio (Condivi, p. 34; Vasari, 1568, p. 35). Their influence is perceptible in his poetry. The earliest verses, which date from some years later, are especially reminiscent of Petrarch.[81]

Gianfrancesco Aldovrandi seems to have obtained for Michelangelo the sole artistic commission with which he was engaged during his short stay at Bologna, namely, the completion of the statuary decoration of the sepulcher of San Domenico in the church of the same name (Condivi, p. 34). Niccolò dell'Arca had been making the statuettes of the lid when he died on March 2, 1494, about eight months before Michelangelo's

arrival. To Michelangelo fell the honorable, if artistically modest, assignment of executing the three missing statuettes (III, 3). He may have been attracted to the task 7-20 partly because he could engage in rivalry with the artists who had worked on the monument before him and who were among the greatest in Italy: Niccolò Pisano, Fra Guglielmo and Niccolò dell'Arca. Also he may have felt it an honor to work on the decoration of the monument to the founder of the Dominican Order to which Savonarola belonged as well as his older brother Lionardo. In his effort to express certain moral sentiments in his figures at San Domenico one is tempted to recognize the influence of the fervent voice of the Dominican who before his appearance in Florence had spent seven years in this same convent (1475-1482) and whose memory must have been still fresh there at this time. Of course, the modest task offered no opportunity for the full exercise of Michelangelo's artistic genius.

VIII. FLORENCE, THE FREE REPUBLIC

THE exact date on which Michelangelo left Bologna to return to Florence is not known, but it was probably near the end of 1495, after the political situation of Florence had again become stable for a short time.[82] Charles VIII, King of France, experienced at this time his first defeats, and Florence was apparently no longer in danger of being plundered by the French troops.

On the twenty-sixth of June, 1495, a new Signoria was installed in accordance with Girolamo Savonarola's reform concerning the political constitution of Florence.[83] Savonarola wished to change the moral customs of the Florentine people by a reform of the political state. He said in one of his sermons: "un regno quanto sarà più spirituale, tanto sarà più forte e migliore, perchè essendo più propinquo a Dio, partecipando più dello spirito e del divino, bisogna che sia migliore e più stabile e più perfetto."[84] Later Savonarola in his "Trattato circa il reggimento e governo della città di Firenze" developed in detail his political doctrines which had been in actual practice in the government of Florence since 1495.

The spirit of the Savonarolean republic was completely Christian and the ideal ruler of it was Christ. In contrast with the political systems of the Middle Ages (St. Thomas Aquinas) however, it was not a rigid and abstract theocracy. Savonarola counted on human weaknesses and made use of his extensive knowledge of mankind. He tried to integrate in a religious frame the constitution of Venice, transformed and adapted to the Florentine past.[85]

In this Florence of Savonarola there was reserved only a modest place for the arts, and Michelangelo after returning to the city was given no commissions from the new government. This may explain why we find him again linked with the Medicis at this time, more exactly with the branch of the family which during the reign of Piero belonged to the center of the dissatisfied elements and who now played an important role in public affairs. These Medicis were Lorenzo di Pierfrancesco and Giovanni di Pierfrancesco, the grandsons of Cosimo's brother, Lorenzo.

Michelangelo stood in intimate relation to Lorenzo di Pierfrancesco, as is attested by a letter (Milanesi, p. 375). It has even been suggested (Frey, *Ma.* I, p. 224) that after his return from Bologna, Michelangelo lived with Lorenzo di Pierfrancesco and not with his own father. The two Medici brothers owned a garden place on the square of San Marco beside the Giardino Mediceo (Frey, *Q.F.*, p. 35). Probably Michelangelo had his studio here at this time.

During the half year that he spent in Florence (until June 1496) he limited himself to the execution of two small statuettes, which are antithetical in their subject and inspiration. These works were a child St. John the Baptist (xv), a work commissioned by Lorenzo di Pierfrancesco de' Medici, and a sleeping Cupid (xvi).[86]

The tender qualities of plump, childish forms had a special attraction for him after

his sojourn in Bologna and his intimate contact with the works of della Quercia, and we shall see that up to his Bacchus Michelangelo retains this predilection. Both statu- ettes are today lost, and all attempts to reconstruct them must remain pure hypotheses, *165 and 167* unless more evidence concerning them comes to light.[87]

As we have seen, the Florence of Savonarola gave Michelangelo no opportunity to develop his creative faculties and we may suppose that he had plans of again leaving the city and of going to a place that would offer him more opportunities. As Northern Italy, from which he had recently returned, had not favored his talents, he now seems to have thought of going into central Italy. That he sold his statuette of the Sleeping Cupid through the services of a middleman to an art dealer in Rome, Baldassarre del Milanese, seems to be a consequence of his intention to go to the Eternal City and not the reason for his doing so, as Vasari and Condivi believed.

Baldassarre seems to have offered the figure for sale as an antique work and to have had great success with it.[88] (Probably he offered the work to the great collector, the Cardinal Riario, among others, but there is no proof that the latter bought it.)

The success of his Cupid may have encouraged Michelangelo's wish to go to Rome in the expectation of getting important commissions there. He wanted to buy the Cupid back because he thought the price too low, but Baldassarre angrily refused to sell him the statue, which he called his own property (Milanesi, p. 375). Some of Michelangelo's Florentine friends in Rome took his part in an effort to settle the dispute but without success; also Michelangelo hoped that the Cardinal Riario would take his side in this affair.[89] This Cardinal was a great connoisseur whose works of art were exhibited in his recently completed Palazzo later called "della Cancelleria," the most sumptuous palace in the Rome of the day. His antique collection, was, along with that of the Cardinal della Rovere (later Pope Julius II), the greatest then existing in Rome.[90] It seems that Michelangelo hoped to have other commissions from the Cardinal when he was once settled in Rome.

IX. QUATTROCENTO ROME

ON June 25, 1496,[91] Michelangelo, then a youth of twenty-one, arrived for the first time in the papal city with several letters of recommendation from Lorenzo di Pierfrancesco de' Medici, among which was one to the Cardinal Raffaele Riario.[92] On the very day of his arrival the youth looked around in Rome at the Cardinal's bidding and informed him on the following day of his impressions. These he expresses in just one short sentence in a letter to Lorenzo di Pierfrancesco de' Medici: "Indeed it seems to me there are many beautiful things here."[93] The youth whose imagination was full of wonderful thoughts for his artistic future and who in his art wished to rival the ancients, does not seem to have had great admiration for the Rome of the Borgia Pope, Alexander VI.

The ruins of ancient Rome towering in the midst of vineyards and fallow fields gave the impression of picturesque desolation. The low medieval churches were lost amidst these grandiose ruins with which their pink brick campaniles harmonized so well. An impression of poverty and abandonment was increased by the presence of a rustic manner of life which flourished among the most brilliant structures of the past. The Forum Romanum was used as a swinemarket. In the Colosseum and the Theater of Marcellus were taverns and miserable small shops, while the Thermae served as dens for thieves.[94] The few palaces built in the Quattrocento (such as the Palazzo di Venezia, the Palazzo Capranica and the newly finished Palazzo Riario called now della Cancelleria) stood here and there in the enormous expanse of the city.

The papal court was now the seat of the city's intellectual life, although humanism actually had here no more indigenous roots than did painting, sculpture and architecture; everything was brought in from without.[95] Consequently there was a heterogeneous character in art and literature determined by the chance origin of the artists and scholars invited to Rome.

The art of the *nova urbs* was mainly a creation of Tuscan and Umbrian masters. We find the lovely, finely wrought but modest sculpture of the Pollaiuolo and Mino da Fiesole. The paintings of Ghirlandaio, Botticelli, Rosselli, Filippino Lippi, Perugino and Pinturicchio decorated the chapels of the medieval churches and the walls of the pope's quarters and the Sistine Chapel in the Vatican. At the time in Rome there was a more antiquarian than artistic interest in ancient works.[96]

During the early part of his stay in Rome, Michelangelo had no studio of his own, as we learn from his own words: "Io non ò comodità . . . perchè io sto in casa altri" (Milanesi, p. 5); however the young artist was not long in finding distinguished patrons among the high clergy and aristocracy of the city.[97] Immediately after his arrival in Rome Cardinal Riario bought him a marble block for a life-size figure which he intended to begin on July 4, 1496.[98] On July 1 of the following year it seems to have been finished, if we may relate to this work his remarks in the letter of this date in

which he says that he cannot depart for Florence until he is rewarded for his labor for the Cardinal.[99] We do not know with certainty what this figure represented; probably it was the Bacchus (IV, 8). From another letter, of August 19, 1497, we learn that Piero de' Medici, who was an exile from Florence and lived in Rome with his brother, the Cardinal Giulio, gave Michelangelo a commission for a marble figure. Michelangelo bought the marble but never began the figure because, he claims, Piero did not "keep his promise." Therefore he "made a figure for his own pleasure" from another marble block which he bought for five ducats.[100]

The most generous of Michelangelo's patrons in Rome, however, was Jacopo Galli. He was descended from a wealthy and notable Roman family and had a fine literary education. In the garden of his house in the Rione Parione near the church of San Lorenzo in Damaso he had a rich collection of antiques which had been collected by his ancestor, Giovanni Galli (IV, 3). Jacopo Galli owned a bank where Baldassarre Balducci, a friend of Michelangelo's, was employed.[101]

Jacopo Galli bought the Bacchus by Michelangelo (IV, 3). He also bought an Apollo or Cupid from him (XVII) and it was he who arranged for Michelangelo to execute the Pietà (V, 3) for the French Cardinal, Jean Bilhères de Lagraulas. The contract for this work was signed August 27, 1498. Jacopo Galli reserved a place of honor in his antique collection for Michelangelo's Bacchus, which indicates that this connoisseur believed that the works of the young artist ranked high even amidst classical art. Also the fact that the Pietà was ordered for one of the chapels of San Pietro shows the great esteem in which the religious art of Michelangelo was held even at this early period.

Finally we have knowledge of one more work which is mentioned by Vasari, who says that during his Roman period Michelangelo made a drawing (cartoon) for the Stigmatization of St. Francis which was carried out in tempera by the "barber of Cardinal Riario" and placed in the first chapel on the left in San Pietro in Montorio (XVIII). This work is now lost.[102]

During this first stay in Rome Michelangelo seems to have had no direct relations with the Pope and his court. Perhaps the spirit of the place did not exactly suit him. In the Curia at this time there was a strong movement against Savonarola at the head of which stood Mariano da Genazzano, Generale degli Agostiniani. The Dominican was being accused of heresy in Rome as well as later in Florence. Though Michelangelo was not a direct partisan (*piagnone*) in the matter, we know that he "always had a very great love for Savonarola and remembered his actual voice" (Condivi, p. 204), a report which seems confirmed by a letter which a *garzone* wrote to Buonarroto Buonarroti from Rome on March 10, 1498.[103] This letter seems to be in answer to a lost one from the latter in which he spoke of Savonarola. In his reply the *garzone* describes to Buonarroto the feeling against Savonarola in the papal Curia where the Dominican was decried as an "eretico marcio"; he also reports that Fra Mariano was spreading evil tales about Savonarola.[104]

[27]

The name of this *garzone* was Piero d'Argiento, as G. Poggi has recently convincingly demonstrated. Cf. Poggi, *Michelangiolo Buonarroti nel IV Centenario del Giudizio Universale*, Florence 1942, pp. 113*ff.* Piero was in the service of Michelangelo from January 1498 to June 1509. (Before *Poggi* the letter was always erroneously considered as written by Michelangelo in disguised handwriting.)

Savonarola, whose importance in the human development of Michelangelo has already been mentioned, seems to have no direct influence on the latter's conception of art. In fact, a chasm separates the ideas of the two in this respect. The former is above all else a moralist who opposed pagan themes and nudity and who thinks that the end of art is to teach moral principles and strengthen religious convictions.[105] Michelangelo, during the very years of Savonarola's influence, executed the nude Cupid and Bacchus. As compared to the fiery Dominican he has no wish to teach or to take a position against evil or for good; he aims only to bring out the ideal content of life.

The sojourn of five years in Rome passed without any great human experience for Michelangelo. It was the period during which he perfected his metier. His observation became more concise, his manner of expression richer and more exact, and the form of his work more minute and detailed.[106] Finesse and precision are Florentine qualities which Michelangelo was able to develop at this time because they were greatly admired by the Roman patrons. Although more perfect than before, his work of this period lacks the warmth of the Bolognese period.

FOR Michelangelo the Roman years at the end of the fifteenth century were less a pilgrimage to the home of classical culture than an opportunity to develop his Florentine sculptural genius and thus prepare for his self-assertion as an artist when he returned home in the spring of 1501 at the age of twenty-six.[107]

Florence was at this time the safest and calmest place in a chaotic Italy. This security was due to an alliance with Louis XII of France. None of the petty tyrants had the courage to attack Florence and thus arouse the enmity of France. But the countryside around the city was plundered and sacked—"and so we have fire all around us" says the chronicler Landucci.[108] The peasants fled within the walls of Florence. The city took on its ancient role of fortress and protector, where justice, order and security were found. On the other hand, the new Signoria of Florence took no action against the sacking of the surrounding country and this passivity was severely criticized by one group of citizens. Finally on August 4, 1501, it was decided to change the constitution. The term of office of *Gonfaloniere*, which till then had been two months, was changed to one of lifetime duration in imitation of the office of the Doge in Venice. On November 1, 1502, the first *Gonfaloniere* for life, Pietro Soderini, an admirer of Michelangelo, was solemnly installed in the Palazzo. It was hoped that a new epoch in the life of the Republic was about to begin (Landucci).

Here in the midst of democratic Florence Michelangelo was entrusted with large commissions, and it is significant that these came to him now, not only from distinguished individuals, but directly from the city magistrates, or the ancient and still important corporations: the Operai of Santa Maria del Fiore gave him the order for the marble David; the consuls of the Arte della Lana charged him with the execution of twelve Apostles for the Cathedral, and the Signoria, through the intermediary of *Gonfaloniere* Soderini, gave him the commission for the bronze David and for the Battle of Cascina.[109]

Some of Michelangelo's commissions at this time seem related to the political ideals of the new republic. He received the commission for the marble David on August 16, 1501, twelve days after the change in the constitution and thus it is probable that the Operai of Santa Maria del Fiore intended to have incarnated in the work the ideal of justice and right that was to govern the city from now on (VI). At any rate, that some such interpretation was placed upon the statue by contemporaries is attested later on by Vasari, who considered it the symbolic representation of the "governo giusto."[110]

This commission seemed to Michelangelo so attractive that he even neglected another order that he had received more than two months before, from one of the highest church dignitaries, Cardinal Francesco Piccolomini, later Pope Pius III, who charged him with making fifteen statuettes for the Piccolomini altar in the cathedral of Siena. Michelangelo had this work executed by Baccio da Montelupo, evidently because he wished to devote himself solely to the David. It is true that throughout his life his

conscience rebuked him for this deception, and sixty years later he was still troubled about it (XXIII).

232 The glorification of the Florentine victory over the Pisans in the Cascina battlepiece also seems to have symbolic meaning, and at the same time to have been inspired by the actual historical event (XX). Florence was at war with Pisa in the summer of 1504. On June 29, the Florentines sacked Pisa; on July 19 near Livorno the ships of Florence were victorious over those of Genoa which were carrying wheat to Pisa. On July 28 the Florentines carried off the livestock of the Pisans. This series of events came just before the commissioning of the fresco ca. August 1504 (Milanesi, p. 426) which was to represent the greatest victory by Florence over Pisa, that of Cascina. Perhaps it was also considered an augury for future victories. Two years later (August 5, 1506) the Florentines did win another great battle against their ancient enemies.[111]

When Michelangelo came back to Florence at the turn of the century, Leonardo, more than twenty years older than he, dominated the artistic taste of the city.[112] His cartoon of the St. Anne was exhibited in Santissima Annunziata and fascinated artists and connoisseurs alike (Vasari). Michelangelo's work seems like a protest on the part of the traditional Florentine powers against the new concept of beauty. Reminiscent of rugged stonecutters work is the art of Michelangelo at this time. He seems to have deliberately turned to the Florentine past. It is notable that almost all the works of this period are derived at least in part from Donatello.

However, Michelangelo not only refuted Leonardo—he also learned from him. In the structure of the paintings of the Quattrocento, it is the mathematically constructed space that determines the form and the size of the figures. Leonardo abolished this conception, but without returning to the conception of the Trecento, where the surface is all-important. It is the plastic and organic form developed according to its own inherent law which in Leonardo determines the spatial composition. This new conception was in the direction of Michelangelo's own tendencies. Thus during the Florentine epoch in spite of all his aversion to Leonardo's general concept of beauty, we observe that he learned much from the older master. This is witnessed by the three tondi, those

50, 54, 59 of Bartolommeo Pitti, Taddeo Taddei and of Doni, whose group compositions are inspired by Leonardo's St. Anne, although completely transformed in a sculptural sense.

In the artistic rivalry between Leonardo and Michelangelo, the powerful and rugged style of the latter took precedence over Leonardo's sweet ideal of beauty.

Where to put the marble David was the main artistic problem in Florence at the time (1504; see text, pp. 96ff). All the important artists of the city took sides, arousing the entire population to interest. The exhibition of the cartoon for the Cascina was an event of major importance and attracted the whole city to view it. An external sign of the honor which Florence paid to Michelangelo is to be seen in the decision of the building administration of the cathedral (Opera del Duomo) in 1503 to have a house

built as dwelling and atelier for the artist on the corner of the Via Pinti and Via della Colonna in the quarter of Santa Croce from a model by Simone del Pollaiuolo in collaboration with Michelangelo himself.

To this Florence, divided between partisans of Leonardo and of Michelangelo, came Raphael in October 1504. He arrived from Perugia, wholly imbued with the "aria angelica et molto dolce" of Perugino (see document of the fifteenth century publ. by Müller-Walde, in *J.d.p.K.* 1897, p. 165). He found his mission in harmonizing the apparently irreconcilable concepts of art, as found in the two rivals, and in popularizing their ideas. This he could achieve by disregarding the existential aspect of the arts of Michelangelo and Leonardo. He felt the power of Michelangelo's forms but did not realize their content. He felt the harmony and grace of Leonardo but overlooked the fact that a law of nature revealed itself therein. He adapted to a free Leonardesque contraposto the violent struggling attitudes of Michelangelo's figures, as we see from his drawings made after the marble David, the Bruges Madonna, the three Tondi, the *200, 219, 222,* Cascina battlepiece and the St. Matthew.[113] *223, 245*

IT seems that Michelangelo had hardly finished his cartoon (Milanesi, p. 426) when Julius II invited him to Rome to execute a work still larger than his previous orders at Florence, namely his own tomb. This was probably at the suggestion of Giuliano da San Gallo.

This second short Roman period (March 1505) exhibits the decisive turn in Michelangelo's youthful development. He who had drawn his powers from his home city, and who at the turn of the century had spoken its artistic language as did no other, now gives up regionalism. The Florentine becomes universal. From this moment begins a new epoch for him and for European art in general.

The papal city of 1505 was a different Rome from that which Michelangelo had visited nine years before. In both appearance and spirit it had greatly changed. No longer a quattrocentesque, provincial town, this Rome was designed by the reigning Julius II to become the very "capital of the world" and the mission of the church-state that of "ruling the very universe."[114]

Rome is now a true art center, that attracts and holds the best artists of Italy.[115] A new cult of the antique is born, not merely of antiquarian interest, but based on an affinity in spirit with the powerful and majestic Rome of ancient times. In his tomb Julius II wishes his Caesarian dreams to be translated into marble and desires that the tomb surpass in grandeur and ambition anything done in Rome.[116] It was to be a memorial to the fame of the Pope-Emperor.[117] Unlike traditional Roman church tombs, which are constructed against the wall, this was to be a free-standing mausoleum with forty over-life-size figures and many reliefs, and "by beauty and pride and great ornamentation" was "to surpass all antique and imperial tombs" (Vasari, p. 63).

Michelangelo selected the "new Choir" of Bernardo Rossellino in St. Peter's as the location for the Tomb of Julius. This Choir had been begun under Nicholas V, but was still unfinished. The artist made drawings, of which one was chosen by the Pope, on the basis of which the contract was drawn up (Milanesi, p. 426 and p. 429). Michelangelo never realized this grandiose plan. The monument which stands today in San Pietro in Vincoli is only a reduced version of it. Nevertheless, his work on this first project of the Julius Tomb was highly important in Michelangelo's development; his rugged Florentine forms henceforth take on the fullness and majesty of Roman art.

The new "gigantic style" that was to reign in European art of the sixteenth century had its inception in the style of Michelangelo as found in the first project for the Julius Tomb. Here his own innate tendencies met with a peculiarly favorable combination of external circumstances: the historical moment as found in the opening of the reign of Julius II, the great Pope-Emperor, the milieu or the ancient city of Rome newly aware of its imperial heritage, and finally the ambitiousness of the task itself—all converged to encourage his aspiration toward a monumental type of creation.

XII. CARRARA

AFTER the contract for the tomb was agreed upon, Michelangelo went to Carrara to secure the marble. He spent eight months there (probably from April to December).[118]

Some light is thrown on this period by two contracts. On November 12, 1505 (Milanesi, p. 630) he engaged two shipowners in Lavagna to stand ready until November 20 at the Porto dell' Avenza (near Carrara) to bring 34 *carrate* (wagonloads) of marble to Rome, including two figures (i.e. blocks for 2 figures) of 15 *carrate*. One month later, on December 10, 1505 (Milanesi, p. 631), he made a contract with Guido di Biagio and Matteo Cuccarello for delivery of 60 *carrate*, including four figures, two of eight *carrate*, and two of five *carrate*. All the other pieces were two *carrate* or smaller (for the architecture of the tomb).[119] These blocks were to be cut out according to specifications to be sent by Michelangelo from Florence in January.

It is hard to believe that during the eight months in Carrara, Michelangelo busied himself exclusively with arranging for the marble. It is much more probable that the artist, with the imagination inflamed by the great commission, continued to plan further projects. The sight of the mighty mountain ranges of Carrara, which in their richly articulated shape give the effect of living creatures, and the sharp, clear mountain air must have aroused Michelangelo's creative fantasy, as we see from an anecdote of Condivi's (p. 62) according to which Michelangelo wished to make a Colossus of a huge mountain overlooking the sea, a figure which could be seen by sailors on the water.

EITHER in December 1505 or January 1506 Michelangelo returned to Rome by way of Florence. By the end of the same month he was impatiently awaiting the arrival of his marble shipments from Carrara, which had been held up by contrary winds and high water in the Tiber. Blocks from one ship had arrived but were now sunk below the river which had recently overflowed. He complains of this "great misfortune" in a letter to his father (Milanesi, p. 6). In the same letter he asks his father to send him certain drawings which he had left packed up in Florence. He also requested to have transported "quella Nostra Donna di marmo," that is, the Bruges Madonna, from the studio in his father's house and asked that no one be allowed to see it (Milanesi, p. 7). This last remark indicates that the artist was conscious of the original character of this work.

Michelangelo had meanwhile established a residence and studio in a house near the Piazza di San Pietro "dietro a Santa Caterina" (Milanesi, p. 493). He had summoned workers from Florence (garzoni) to help in executing the tomb. Suddenly his preparations are blasted.

According to Michelangelo's account of the matter, in April 1506 he heard that Julius told a jeweler, in the presence of the master of ceremonial (Paris de Grassis), that he "did not wish to pay out another cent (*baioco*) for big or little stones" (Milanesi, p. 377). When Michelangelo came to the papal court on Holy Saturday, April 11, to get some money, he was told to "come back Monday" (April 13). On four successive days he returned and was each time again refused a visit with the Pope.

On Friday the artist was, he says, actually "thrown out" ("io fui . . . cacciato via"; Milanesi, p. 377). He continues in this letter "he who threw me out [the *palafreniere*; Milanesi, p. 493] told me that he knew me, but that he had the order to act thus."

As we have seen, Michelangelo chose the "New Choir" as location for the Tomb. The Pope agreed on this point, but wished to go further and reconstruct the whole of the church. He accepted the plans of Bramante for this project. The work on the whole church must have seemed more pressing to Julius than the execution of his Tomb which was to be placed in it. And so he ignored Michelangelo's request for expense money, as has been described. On April 17, 1506, Michelangelo left Rome secretly and went to Florence (Milanesi, pp. 377 and 493).[120]

His flight may be easily attributed to disappointment at having to leave the Tomb project in mid-air, and also his humiliation at the papal court. But in a letter to Giuliano da San Gallo he hints at another reason: "There is also another matter about which I do not wish to write" (Milanesi, p. 377). If he had remained, he declares, he would have had to execute his own tomb earlier than the Pope's. When we find that one day after his flight (April 18, 1506), the cornerstone of the new St. Peter's was laid by Bramante, we may surmise this event to have influenced Michelangelo to leave the city, as it may well have seemed a personal defeat to him.

The four months that Michelangelo passed at Rome were characterized by the conflict between his creative aspirations and the exterior circumstances which opposed their achievement, ending with complete disillusionment when he found that he could not realize his project.

There is, however, an important happening at this time, which influenced the artistic development of Michelangelo. During this sojourn he saw the Laocoön which had been excavated January 14, 1506, a short time after his arrival in Rome (Bottari, *Raccolta* III, p. 474). The pathos of the suffering expressed by the twisted bodies of this group must have seemed to Michelangelo as a kind of justification in antique art of that which he himself had sought to express since his earliest efforts. A fine drawing, (No. 35), probably of this time, represents a youth twisted by grief, and is evidently *125* inspired by the Laocoön. But it is not until later that the full effect of the antique group is revealed, chiefly in the Sistine ceiling and the Last Judgment.

No longer under the obligation which had bound him to the Tomb project, Michelangelo is apparently a free man in Florence and could go back to the different works which he had left unfinished before going to Rome, notably the execution of the twelve Apostles in marble. It seems that when he returned to Florence, he intended to finish these projects. We hear that in May 1506 he is again at work (letter of Giovanni Balducci May 9, 1506; Gotti, II, p. 52) probably on the St. Matthew, destined for the cathedral (XI). To this statue he gives the aspect of a slave from the Julius Tomb. Evidently he could not put aside his dreams for the great project. It had lit the flame of his genius, and by this time it was so essential a part of his inner development that he felt driven to carry on with it.

Contact with Rome was still maintained. Charged by the Pope, Giuliano da San Gallo wrote a letter to Michelangelo shortly after his flight to Florence, in which he said that Julius II disapproved very much of the artist's sudden departure and that he was ready to hold to his agreement about the Tomb if Michelangelo would return (letter is lost; content in Milanesi, p. 377). On May 2, 1506, Michelangelo answered from Florence to Giuliano (Milanesi, p. 377). He declares that he would be glad to carry on work on the Tomb but preferred to do this in Florence, claiming that it could be done more cheaply there. He wanted to have the marble blocks for the project brought to Florence, both those already delivered to Rome and those waiting in Carrara. Then he would send the pieces of sculpture to Rome one by one, as he completed them. He declares he would "work better and with greater love in Florence because he would not be bothered with so many matters." This last probably refers to the assignment of St. Peter's to Bramante.

The wish of the Pope, as first reported by Giuliano da San Gallo, that Michelangelo return to Rome to finish his work, is also expressed by Giovanni Balducci, in his already mentioned letter of May 9, 1506 (Gotti, II, p. 52), and Balducci privately recommends that the artist do so. From another letter (May 10, 1506) written by Pietro Roselli (Vol. II, Appendix No. 1) we learn that, perhaps in order to make this return to Rome more inviting (and probably at the advice of Giuliano da San Gallo), Julius had another project in mind for Michelangelo, that of painting the Sistine ceiling. Roselli reports that in discussing the award of this project to Michelangelo, Bramante declared that the sculptor would not accept it, because he wished to work only on the Tomb.

In spite of these persuasive letters, Michelangelo did not wish to go back to Rome. This fact is explained by Condivi (p. 76) and Vasari (1568, p. 77) as being due to his anger against the Pope and his fear of him. Giovanni Balducci, in his letter (Gotti, II, p. 52) says that he supposes that the "prudence" of Michelangelo will dictate his decision concerning a return. But it is possible that Michelangelo acted on an obscure

feeling that his genius could not develop in the midst of the intrigues of the papal court, and that he needed solitude in which to work.

Very likely at this time Michelangelo met in the home of Gianozo Salviati, a certain Tommaso di Tolfo, an Italian who lived in Turkey, and who was then in service to the Sultan Bajezid VI (1481-1512). We learn from a letter by Tommaso written in 1519 to Michelangelo (Frey, *Briefe*, p. 137) that Michelangelo had suggested, as he says, "about fifteen years" before (more likely thirteen years i.e. at this time) that he (Tommaso) take steps to procure an invitation for him to go to Turkey.[121] This seems to have so worried Julius II that he now insisted more strongly that Michelangelo return. He sends a *breve* on July 8, 1506 (Steinmann, *Sixtinische Kapelle* II, p. 695) in which he summons Michelangelo to return to Rome.[122] This is without result. The artist fears that he is being lured into a trap and that the Pope will punish him if he returns to Rome. Pietro Soderini, *Gonfaloniere* of Florence at that time, notes that "Michelangelo is so frightened that, despite the Pope's *breve*, it would be necessary for the Reverendissimo di Pavia [Francesco Alidosi] to write a letter . . . and promise Michelangelo safety and freedom from bodily harm" (Gaye II, p. 83). There follows further correspondence to gain an assurance of safety from the Pope. Thus the letter of Soderini to his brother Cardinal of Volterra, July 28, 1506 (Gaye II, p. 84) in which he says he had urged Michelangelo to return to Rome but the latter had no confidence until the Cardinal would promise him "something certain." Likewise a letter from the Signoria of Florence August 31, 1506, to the Cardinal of Pavia (Gaye II, p. 85) which asks him to recommend Michelangelo to the Pope. But for two months there is no answer, probably due to the campaign which Julius II began on August 26 to restore the lost provinces of the Church.[123] However, as soon as Julius had conquered Bologna (November 11, 1506), he had the Cardinal of Pavia answer the Signoria (November 21; Gaye II, p. 91).

Julius wants Michelangelo to come to Bologna because "he would like to have some works done by him" there. The Signoria answers November 27, 1506, that Michelangelo was leaving immediately for that city and again recommends him to the Cardinal (Gaye II, p. 93). Michelangelo's distrust was still not completely quieted and he seems to have wanted some other assurances, as attested by another letter from Soderini recommending him to the Cardinal of Volterra (also November 27, 1506, Gaye II, p. 91). Then Michelangelo finally departed for Bologna.

THE reconciliation between the Pope and Michelangelo probably took place on November 29, 1506, in the Palazzo dei Sedici in Bologna.[124] Michelangelo "with a rope about his neck," had to beg for pardon (Milanesi, p. 427). Then a contract was drawn up, by which the artist was to execute a seated bronze figure of Julius II, larger-than-life size, for the façade of S. Petronio (Milanesi, p. 427).[125]

This commission may well have been considered a disappointment to the artist, whose mind was still full of ideas for the Tomb. He told the Pope that bronze work "non era mia arte" (Milanesi, p. 427). In fact, he undertook the statue only to please the pontiff, "per bon rispetto," as he says in a letter to Buonarroto (Milanesi, p. 63).

Michelangelo's studio was set up in the "pavaglione" behind S. Petronio.[126] The Pope made one visit to him there on January 29, 1507 (Milanesi, pp. 65-67). Michelangelo secured the services of three Florentines to help with the bronze-pouring. One of them, Lapo d'Antonio di Lapo, received permission to go to Bologna on December 10, 1506 (Milanesi, p. 8). The two others were Ludovico del Buono, called Lotti, and Pietro Urbano. Lapo spread the tale in Bologna that it was he "who made the statue," and in addition tried to cheat Michelangelo. The latter chased him away "like a dog" (Milanesi, p. 8). For revenge Lapo took Ludovico with him.[127] Michelangelo thereupon sought to engage the services of Maestro Bernardino, armorer of the Republic of Florence. He came to Bologna May 26, 1507 (Milanesi, p. 76).

While working on the statue, Michelangelo lived in a poor room and slept in the same bed with his three helpers;[128] he worked with "grandissimo disagio e con faticha istrema" (Milanesi, p. 88). He is very irritable about the life in Bologna in general. People there think him incapable of executing the statue (Milanesi, p. 88); the climate is wretched, "nowhere in the world could it be hotter," and he says "wine is expensive and poor, like everything else, and so the life here is bad" (Milanesi, p. 84). Homesickness for Florence possesses him, "a me par mille anni di venirne" (Milanesi, p. 84). He feels the political situation to be insecure, claiming that the Pope did not leave the city in good order (Milanesi, p. 149).[129]

The statue was unveiled March 18, 1508, above the portal of S. Petronio and destroyed about four years later (December 30, 1511) upon the return of the Bentivoglio. According to the extant descriptions of the work it belonged to the traditional type of the papal honor-statues, but without the conventional dignity of pose. In Michelangelo's figure, the right hand was raised in a violent gesture which looked more like a curse than a blessing; the left hand held a key (XXI, 2).[130]

As he had made of the St. Matthew a kind of chained slave figure, in the same way he expressed in the Julius statue another dream for the Tomb, that of the large seated figure type, such as he intended to place on the first register above the slaves.

247

Shortly after the dedication of the statue, Michelangelo returned hurriedly to Florence. That this must have been before March 11, 1508, we know from the reply by a Bolognese friend, Fra Lorenzo Viviani,[131] to a letter now lost, written by Michelangelo in Florence on that date.

This Fra Lorenzo was a Florentine by birth and a preacher of the Dominican order.[132] He seems to have had a certain amount of humanistic education for he quotes Dante and, at the end of his letter, Livy. From the joking, intimate tone of this hitherto unpublished letter, which at times makes allusions not wholly clear, we see that Fra Lorenzo and Michelangelo were on very friendly terms. In this letter an interesting light is thrown on the political situation in Bologna, where shortly after Michelangelo's departure, disorder again broke out. We also learn something of Michelangelo's circle of friends in Bologna (1506-1507). These friends, probably simple garzoni, had arranged a "carnascialino" in honor of Michelangelo before his departure for Florence.[133]

It is characteristic of the artist's religious feeling at this time that he had requested Fra Lorenzo to pray and to fast for him, probably for good fortune on his journey home.[134] The artist frequently requested such prayers. In a letter of May 26, 1507 (Milanesi, p. 76) he asks his father to have prayers said for the success of his bronze-pouring. On November 10, 1507, he wrote (Milanesi, p. 88): "I believe someone's [perhaps Fra Lorenzo's] prayers have helped me and kept me in good health." In such phrases we recognize a traditional religious feeling of trust in the prayers of others. It is not until his old age that prayer took on for him a deep spiritual significance; then it was a direct communion with God.

In commenting on the uncertain political situation in Bologna, Fra Lorenzo defines his concept of *Fortuna*: "In my opinion the more one possesses, the more cares he has and therefore there is nothing better for man to do than to content himself with what Fortuna gives him . . . and to accept it." Here we have the medieval fatalistic concept of Fortuna as Fatum, which symbol was the wheel whose rotation blindly decides the destiny of man, conceived as an unfree tool. But in the next sentence the writer switches to the Renaissance concept of Fortuna, when he says: "I do not say, however, that one should wait for manna from heaven but that one should help himself in every just and decent way, for nothing else remains behind us except the reputation of a virtuous man." Here man is master of his fate, as L. B. Alberti said "Fortuna per se doubtless always was and always will be infinitely silly and infinitely weak for him who opposes her."[135] The new Renaissance symbol of Fortuna is a sailboat, steered by a man.[136] Fra Lorenzo in combining these two differing concepts came very close to Michelangelo's own concept of Fate, which as we shall see is made up of these two elements. In his art he portrayed physical beauty and perfection of man as did no other artist, and emphasized man's superiority in Nature. This heroic type, created by antiquity and the Italian Renaissance, with Michelangelo, however, is deprived of its optimistic aspect, for Michelangelo shows man, the perfect creation, as ruled by powers beyond him—not in

the medieval sense, but identified with the cosmic powers of the universe which direct the destiny of the individual. This concept of fate is unique with Michelangelo. That of the next generation (see Giordano Bruno, *Degli eroici furori*) renews the optimistic Renaissance view, in which the heroically intensified ego rules the transcendent powers.

It is noteworthy that Michelangelo enjoyed the company of the religious. That they had a certain influence on his spiritual development is witnessed not only by the letter under discussion, but by other, partly unpublished, correspondence (e.g., the letter from Fra Lorenzo delle Colombe, where the conception of love as found in Michelangelo's poetry is expressed; see Appendix IV).

XVI. RETURN TO FLORENCE

FROM this letter we also get an idea of Michelangelo's impressions of Florence on his return there at the beginning of March 1508. Michelangelo is living "in peace and quiet," for the conditions in the city are now settled; he believes himself "free of Rome" (the Julius Tomb). Apparently he intends to settle down for a while and try to complete the works he had left unfinished in Florence (Apostles), also to put the family finances in order. On March 18, 1508 (Gaye II, p. 477) he rents for a year the house in the Borgo Pinti which the Operai di Santa Maria del Fiore had had built especially for him when he was to execute the twelve Apostles for the cathedral in 1503-1504. But at the end of March or early April, Julius II again called him to Rome,[137] this time to take on the project of painting the Sistine ceiling which, as we know, was first envisaged by the Pope two years earlier.[138] Before his departure for Rome on March 13, 1508, Michelangelo was declared of age by his father (recorded March 28, 1508; Steinmann, *Sixtinische Kapelle*, II, p. 697).

He was thirty-three years old, his youth was past, and he was about to begin a new epoch in his life.

NOTES TO PART I

1. See Appendices and notes 13, 16, 20, 23, 27, 35 and 36 and XI. 3. None of the unpublished correspondence is dated earlier than 1508.

2. Strictly considered, even the opinions of the artist in regard to his own past are sometimes legendary—the important thing is to distinguish in this legendary tradition the characteristic traits concerning his personality as an artist.

3. Concerning the genealogy of the Buonarroti Simoni, see Filippo Buonarroti, *Descrizione*, pp. 87*ff*. See also Passerini in Gotti, II, pp. 15*ff*, and Frey, *Q.F.*, pp. 6*ff*.

In the Biblioteca Nazionale in Florence a letter from Filippo Buonarroti to Cavaliere Girolami is preserved (see Frey, *Q.F.*, p. 10) in which he claims that in 1228 there lived the ancestors of the family, Buonromano and Buonarrota; they were sons of Berlinghieri and grandsons of Bernardo. Counting thirty years to a generation he reckons that the first known ancestor, Bernardo, lived ca. 1138. Michelangelo himself seems to have assumed that his family had lived in Florence for three hundred years: "Arei ben caro che questo nome Buonarroto non mancasse in casa, sendoci durato già trecento anni in casa" (Milanesi, p. 299); and: "Abbiamo pagato trecento anni le gravezze a Firenze" (Milanesi, p. 436).

In the Buonarroti archives there are preserved some documents, partly unpublished, concerning the Buonarroti family. But none of these documents goes back further than 1351. They are preserved in the following volumes: Cod. XXII, Antenati di Michelangelo, Documenti vari, 1351-1471; Cod. XXIII, Carteggio di Lodovico a suo figlio Sigismondo; Cod. XXIV, Lodovico e Francesco Buonarroti, Conti di Amministrazione; Cod. XXV, Fratelli di Michelangelo, Fra Leonardo Domenicano e Buonarroto; Cod. XXVI, Carteggio e altri documenti di Buonarroto; Cod. XXVIII, Carteggio di Gismondo Buonarroti; Cod. XXIX, Fratelli di Michelangelo; Gismondo e vari documenti.

4. "Dico adunque che quel Buonromano e quel Buonarroto . . . vendon case a Buonarrota, lor zio, nel popolo di San Firenze [in the S. Croce quarter] . . . l'anno 1228" (see the letter, cited in note 3 above, from Filippo Buonarroti to Cav. Girolami, written ca. 1636).

5. How closely Michelangelo was bound to this quarter is seen in several letters to his nephew, Lionardo. When the latter wished to buy a house in Florence with Michelangelo's money, the artist advised him to buy if possible "in our quarter" ("nel quartier nostro" . . . "nel quartier nostro in via Ghibellina"; Milanesi, pp. 184, 197, 199).

According to the "Denunzia dei Beni" of 1534, Michelangelo owned two houses in the Via Ghibellina in the S. Croce district and a lot in Via Mozza, purchased in 1518, in the same quarter (Frey, *Denunzia*, pp. 189*ff*). For the quarters of Florence, see B. Varchi, *Storia Fiorentina*, Florence, ed. 1843, II, p. 106.

6. The only churchman in the family before Michelangelo's brother Lionardo was Fra Bene, a Dominican (ca. 1284-1344).

7. See R. Davidsohn, *Geschichte von Florenz*, Berlin, 1896*ff*, II, pt. I, pp. 29*ff*.

8. The Buonarroti family seems to have been Guelph from the beginning. In 1260, Michele di Buonarrota di Bernardo was "Consigliere nell' esercito de' Guelphi." In 1392, Buonarrota was a "Capitano di Parte Guelpha." See Filippo Buonarroti, *Descrizione*, pp. 87*ff*. (Only one Buonarroti is known to have been a Ghibelline—Zetto, in the middle of the thirteenth century.)

9. The Buonarroti as *Priori* in the quarter of S. Croce are mentioned in the following years: 1343, 1355, 1366, 1371, 1390, 1397, 1404, 1426, 1456, 1469, 1515 (see Frey, *Q.F.*, p. 13).

They are mentioned as *Gonfalonieri* in the following years: 1326, 1346, 1364, 1386, 1402, 1413, 1424, 1475, 1521 (see Frey, *Q.F.*, p. 14).

They are mentioned as *Buonomini* in the following years: 1357, 1369, 1371, 1388, 1400, 1424, 1451, 1455, 1459, 1461, 1466, 1473 (Lodovico), 1473 (Francesco, his brother), 1513, 1525 (see Frey, *Q.F.*, p. 14).

For the history of these offices and their duration, see *Serie dei Senatori Fiorentini*, Florence, 1722.

10. See "Denunzia dei Beni," S. Croce Quarter, published for the years 1427, 1457, 1469 in Frey, *Q.F.*, pp. 14ff; for the years 1470, 1480-1481, 1498, 1534 in Frey, *Denunzia*, pp. 189ff. The account of the family financial situation given in the text is based on these documents.

11. The property at Settignano is described in the "Denunzia dei Beni" of 1470 as follows: "Un podere chon chasa da Signore e da lavoratore posta nel popolo di Santa Maria Asetti" (in Settignano). The master's house still exists and is called Villa Michelagniolo. It is completely restored but in one of the rooms of the main floor there is still preserved a drawing, probably by the youthful Michelangelo, which we shall discuss later (see pp. 68f).

12. Concerning the uncle, Francesco, cf. Filippo Buonarroti, *Descrizione*, pp. 87ff. That the uncle was opposed to Michelangelo's choice of a career is reported by Condivi, p. 14.

13. The following characterization of the father is based on the correspondence. In 1473 Lodovico was one of the *Buonomini*; in September 1474, he was elected for six months *Podestà* in the small hamlets of Caprese and Chiusi (at that time under the domination of Florence), a post which his own father, Lionardo, had occupied in 1424 (Filippo Buonarroti, *Descrizione*). About 1492, Lorenzo the Magnificent made Michelangelo's father *Ragioniere ordinario e straordinario della Dogana* (Gotti, II, p. 31), but it appears that he did not make out too well, for, although he was not involved in politics, he was dismissed from his position in 1494. On September 22, 1510, he was elected *Podestà* of S. Casciano for six months. In 1512, Lodovico had new difficulties. He was fined sixty ducats (cf. Vol. II, Appendix No. 83).

On June 1, 1525, Lodovico was elected to the post of *Podestà* of Castelfranco for six months. He returned there for a second time in 1529, but left during the siege of the city and fled to Pisa for safety. He died at Settignano ca. Summer, 1534.

In the Archivio Buonarroti there are three hitherto unpublished letters from Lodovico to Michelangelo.

The first, written in Florence and addressed to Michelangelo in Carrara, is a short letter dated July 23, 1516, which is important because it shows that Michelangelo was in Carrara at this date. (From the fourth to the tenth of July Michelangelo had still been in Rome, then he was going to Carrara, and in the beginning of August, we know that he was again in Florence. See Frey, *Briefe*, p. 29.) The main part of the letter is as follows: "Questi versi per cagione che più giorni fa tu fussi qui, secondo avevi scritto. . . . Arei caro avisassi la cagione non se' venuto."

The second unpublished letter from Michelangelo's father in Settignano to Michelangelo in Florence is dated December 4, 1522. It seems that he wishes to sell a "monte" (a sort of credit) so that Michelangelo may be repaid for some money of his, which Lodovico had spent in a suit brought by his sister-in-law Cassandra against the Buonarroti family. Monna Cassandra di Cosimo Bartoli (d. July 3, 1530) was the widow of Francesco Buonarroti, brother of Lodovico. She brought suit against Lodovico and his sons, because they refused to accept the inheritance (consisting of debts) of their brother and uncle, Cassandra's husband. Cassandra is mentioned in several letters of Michelangelo (Milanesi, pp. 11, 12, 14). We publish here the main part of this letter: ". . . sai ch'io ti feci procuratore a potere vendere quel poco del monte, tanto ti pigliassi e' tua denari. . . . e' denari si dette alla Cassandra . . . bisogna vendere el Monte."

[43]

The third unpublished letter of Lodovico (without date and place, perhaps written in 1528) to Michelangelo in Florence relates his surprise that Michelangelo has not yet bought the "monte" (credit) for the children of Buonarroto (Lionardo and Francesca) as he had promised, and urges him to do so. The main part of this letter follows: "Mi maraviglio molto che tu non abbi comperato el Monte a figliuoli di Buonarroto, come promettesti, secondo mi dicie ser Antonio. Tu ai fatto un danno di parecchi fiorini. Non so la cagione. Io mi credevo che tu avessi comperato, come promettesti: parmi abbi fatto grande male. Io non pensavo che mi bisogniasse mai più venire a Firenze: da poi che io veggo mi bisognia, verrò di certo a fare e' fatti mia."

14. On Lionardo, see Filippo Buonarroti, *Descrizione*, pp. 87ff, who says he was a "domestico di Savonarola." [Addenda, No. 4]

15. The father, for instance, refuses to pay his debts to a certain shopkeeper (Milanesi, p. 4); and Buonarroto, on one occasion at least, was apparently planning some improper business transaction from which Michelangelo dissuaded him (Milanesi, p. 109).

16. On Buonarroto, see Filippo Buonarroti, *Descrizione*, pp. 87ff. The fact that all the public offices due the family fell to Buonarroto, the third son, may be explained by the fact that Fra Lionardo, as a churchman, and Michelangelo, as a busy artist, would never accept them.

The venture in the banking firm probably preceded the entrance into Strozzi's wool-shop. This hypothesis is supported by the character of the handwriting on the account-book leaf, which is still Quattrocentesque. Furthermore, the drawing by Michelangelo on this same sheet (No. 32) is in the style of about 1505 and hence the leaf cannot be dated as by Frey (*Handz.*, text p. 18) after 1513.

In the Archivio Buonarroti there are two unimportant hitherto unpublished letters from Buonarroto in Florence. One is to Michelangelo in Settignano and dated June 9, 1518. We publish here the main part of this letter: "Ò parlato a Piero Francesco e dice avuto risposta del mascalzone e che gli cederà la casa d'acordo, ma vuole aspettare un suo figliuolo."

The other, to Michelangelo in Pietrasanta, is dated July 30, 1518, and concerns certain stonecutters ("scarpellini") who Buonarroto says have cheated Michelangelo.

17. For the history of the cloth industry see: A. Doren, *Entwicklung und Organisation der Florentiner Zünfte im 13.ten und 14.ten Jahrhundert,* Leipzig, 1897; and *idem, Studien aus der Florentiner Wirtschaftsgeschichte,* I, Stuttgart, 1901; Georges Renard, *Histoire du travail à Florence,* Paris, 1913; and R. Ciasca, *L'arte dei Medici e speziali nella storia e nel commercio fiorentino del secolo XII al XV,* Florence, 1927.

18. In 1346 a Buonarrota is mentioned as Consul dell' Arte della Lana; in 1347, Filippo, and in 1352 Simone Buonarroti held the same office.

19. Filippo Buonarroti, *Descrizione*, p. 89, says that "Giovan Simone (era) poeta piacevole."

20. Filippo Buonarroti, op. cit., says: "Sigismondo fu uomo d'arme e fu comissario a Modigliana quando passò Lutrech nel 1527."

On the other hand we learn from a letter of Lodovico dated February 16, 1526, that Gismondo was at that time in the "bottega di Jacopo Gian Figliazzi."

There are two unimportant unpublished letters from Gismondo in the Archivio Buonarroti, both undated. In the first (probably June 1523) he writes from Settignano to Michelangelo in Florence: "Non ò parlato a Buonarroto . . . di quella cosa mi dicesti domenica. . . ."

In the second letter Gismondo (no place given) writes about the selling of a "monte" (credit).

21. Concerning Matteo, see Frey, *Q.F.*, p. 12.

22. For Michelangelo's relations with his nephew, Lionardo, we have much good information from his long correspondence preserved in the Archivio Buonarroti. The first letter is dated September 25, 1540 (Milanesi, p. 161; Milanesi, however, overlooked the date on the reverse side); the last letter is that of December 28, 1563 (Milanesi, p. 362). Lionardo's letters to Michelangelo, no longer preserved, seem to have been written illegibly for Michelangelo asks him to give up writing to him if he cannot learn to write (Milanesi, p. 210). From Michelangelo's letters we learn that Lionardo cannot be credited with too much tact and carefulness for his uncle, who later left him his entire fortune. For example, Lionardo sends his uncle a "present" of such rough shirts that Michelangelo writes that there is no peasant in Rome who wouldn't be ashamed to wear them (Milanesi, p. 162).

23. Concerning Francesca Buonarroti, see Gotti, I, p. 207. There are several hitherto unpublished letters in the Archivio Buonarroti concerning Francesca, daughter of Buonarroto and niece of Michelangelo. There are also some letters from her husband Michele di Niccolò Guicciardini. Here follows the principal parts of these letters.

(a) 1529. August 25. Sora Francesca Badessa del Mº di Boldrone (?) to Michelangelo in Florence.

She asks Michelangelo for ten ducats and says: "La Francesca ista bene e a voi si racomanda infinite volte."

(b) 1537. August 2. Giovan Francesco Fattucci, from Florence, to Michelangelo in Rome.

"Ò la vostra et mi piace la diligentia dello Angiolino. Idio voglia la possa condurre a buon fine. Feci l'ambasciata a Madonna Margherita, la quale ebbe molto per male la vostra paura et io non n'ò niente di paura, perchè il Papa pare che abbia più paura da presso che da lungi, pure Idio vi aiuti. . . ." Here follow a few sentences concerning Francesca Buonarroti and the property of Pozzolatico which Michelangelo wished to give as her dowry to Michele Guicciardini. (The first sentence of this letter is published by Frey, *Dicht.*, p. 528, No. 88.) Giovan Francesco Fattucci was "Cappellano" of Santa Maria del Fiore in Florence.

(c) 1537. November 3. Giovan Francesco (Fattucci), from Florence, to Michelangelo in Rome.

". . . secondo me fareste grande utile alla casa vostra a riscuotere Pozolatico, il quale vi dà pane, vino, olio, legne. . . ."

(d) 153(7)/38. March 7. Michele di Niccolò Guicciardini in Florence, to Michelangelo in Rome.

". . . la Francesca vostra e nostra ha partorito in questa mattina a 11 ore ½ un bel figliuolo mastio, e abbiamo gli posto nome Gabbriello Maria. . . ." Michele di Niccolò Guicciardini was the husband of Francesca, the daughter of Michelangelo's brother Buonarroto. She married Michele Guicciardini in 1538.

(e) 1538. May 2. Giovan Francesco (Fattucci) in Florence, to Michelangelo in Rome.

". . . io v'ò scritto di riscuotere il podere di Pozolatico; voi me ne scrivesti, et che io ne intendessi quello ne diceva Giovan Simone et Donato . . . io per la parte mia non vorrei da voi altro, se non quando avete qualche madrigale, che voi me ne facessi parte et ancora vorrei che voi non pigliassi dispiacere di cosa che io vi scriva. . . ." (Fattucci was apparently interested in some madrigals by Michelangelo. See also Frey, *Dicht.*, p. 528, No. 88, where the same Fattucci asks for sonnets by Michelangelo.)

[45]

(f) 1540. October 23. Michele di Niccolò Guicciardini in Florence to Michelangelo in Rome.

". . . Sono consigliato a fare una compagnia che sia cosa di utile e onore. . . ."

(g) 1540. October 30. Giovan Francesco (Fattucci) in Florence to Michelangelo in Rome. This letter concerns the dowry which Michelangelo intended to give to Michele di Niccolò Guicciardini for Francesca Buonarroti, his wife.

24. For example: "Noi siamo pure cittadini discesi di nobilissima stirpe" (Milanesi, p. 197); "Siamo antichi cittadini fiorentini e nobili quant' e ogni altra casa" (Milanesi, p. 237); "Noi siam antichi cittadini fiorentini" (Milanesi, p. 271); "Sono cittadino fiorentino, nobile, e figliolo d'omo dabbene" (Milanesi, p. 492), etc.

25. See, besides Milanesi, p. 225, Milanesi, p. 172, where Michelangelo also refuses to be addressed as sculptor.

The legend of the descent of the Buonarroti from the Count of Canossa and thus from Emperor Henry II (whose wife, Matilda, was a Canossa)—spread during Michelangelo's own lifetime by the official biographers, Condivi, Vasari, Varchi—is based only on a letter from Count Alessandro Canossa to Michelangelo, dated October 8, 1520 (best edition, Frey, Q.F., p. 6). The letter is addressed to Michelangelo as "parente honorabile" and in a postscript he says that he had found among his old papers that a Simone da Canossa had been *Podestà* of Florence; but that this Simone da Canossa was in any way related to the Buonarroti Simoni cannot be proved at all. After 1534, Count Alessandro visited Michelangelo in Rome. In 1548 Michelangelo wrote laconically to Lionardo: "nel libro dei contratti v'è una lettera del conte Alessandro da Canossa . . . il quale me venne già a visitare a Roma come parente" (Milanesi, p. 216). Frey (loc. cit.) assumes that Michelangelo himself had raised the question of the possible relationship and that the count's letter is in reply. This thesis seems doubtful in view of the tone of Michelangelo's letter to Lionardo which shows that Michelangelo placed no great faith in the possibility. The improbability of the relationship was first pointed out by G. Campori, *Gli artisti Italiani e stranieri negli stati Estensi*, Modena, 1855, p. 100. See also Frey, *Ma.*, I, pp. 10, 11.

26. "Mi son sempre ingegniato di risuscitar la casa nostra, ma non o avuto frategli da ciò" (Milanesi, p. 197).

27. A statement of Michelangelo's fortune in 1534 is to be found in Frey, *Denunzia*, p. 189. The extent of his fortune at the time of his death is given in the inventory of his house, published by Gotti, II, pp. 148ff. That Michelangelo's family was quite poor during his youth is attested by his letter to his nephew (Milanesi, p. 275): "non mi vo' distender piu a narrarti la miseria in che io trovai la casa nostra."

In the Archivio Buonarroti there are several hitherto unpublished letters to Michelangelo which deal with questions of property and finance. We publish here the main parts of these letters.

(a) (1517) 1518. March 18. Lionardo Buoninsegni, in Florence, to Michelangelo in Carrara.

". . . per niente non dobbiate lassarvi uscire di mano la casa delli Vernacci per insino alla somma di ducati 1300. . . ." Lionardo Buoninsegni was perhaps a relative of Domenico Buoninsegni. This is the only letter by him in the Buonarroti archives. It refers to Michelangelo's intention of buying a house.

(b) 1518. May 20. Baroncello Baroncelli in Florence, to Michelangelo "a Pisa o dove fussi."

". . . desideroso di farvi piacere sono stato desto per vedere di trovare uno sito che sia secondo il gusto vostro . . . situato in luogo che ogni gran cosa facilmente vi conduce, e gran piazza a l'intorno . . . di lunghezza di braccia 120, largo braccia 44 in circa, gran ceppo di

casa . . . di spese di ducati 650." It is possible that the lot mentioned in this letter is that on the Via Mozza which Michelangelo bought on November 24 of the same year. Baroncello Baroncelli is not mentioned elsewhere in the Michelangelo correspondence.

(c, d) We know that in March 1521, Michelangelo learned that a house of Giulio Forteguerri in the Via Mozza was for sale. Concerning this he writes to Gusto di Matteo Allegri "calzolaio in Pistoia" to ask if he could have the house at a fair price (Milanesi, p. 417).

In the Archivio Buonarroti are two unpublished answers from Gusto in Pistoia to this letter of the artist in Florence. In the first, from March 18, 1521, he declares that the owner does not wish to sell the house "che voi già mi ragionasti" but offers it for sale nevertheless. He asks Michelangelo if he wants to buy it now. In a second letter (March 25, 1521) he repeats this question.

(e) 15 (37)/38. March 16. Giovan Francesco (Fattucci) in Florence, to Michelangelo in Rome.

". . . sono . . . vostre facende et d'importanza et maxime circha el podere di Piero Tedaldi; et dico che se voi volete lasciare andare il podere, che voi ne perderete molto di grosso. . . ." Michelangelo bought the land of Piero di Bartolo Tedaldi in March 1519 (Wolf, pp. 52ff). It seems from this letter that he now intends to sell it.

(f, g, h) By a decree of September 1, 1535, Pope Paul III transferred to Michelangelo the ownership and income for life from the Passo del Pò, near Piacenza. The revenue amounted approximately to 550 ducats a year. Michelangelo allocated it to Francesco di Giovanni Durante of Piacenza. See Frey, *Briefe*, p. 343, where a summary is given. See also Milanesi, p. 604; Steinmann, *Sixtinische Kapelle*, II, pp. 771f; and Maurenbrecher, pp. 149ff, p. 155, note 3 and p. 287.

In the Archivio Buonarroti are three unpublished letters concerning the Passo del Pò by Francesco di Giovanni Durante.

1537. January 4. Francesco di Giovanni Durante (n.p.) to Ma., in Rome.

". . . me responde circa o lo instromento fato fra nui esser erore de li due mesi in due mesi, dice ogni sei mesi; non è errore, salvo ne la copia mandata a la Sig.a V.; lo originalle sta bene circa che Va Sa recorda avermo mi per obligato in forma de Camera. V.S. sia segura che ale bande nostre non se stilla talle cosa, salvo se non fusse persona fallitta. Del resto non se cerca talle obligatione e per questo non è sta fato lo instromento de quella sorte: niente de manco perchè V.S. ha scrito de voler talle obligo verso de mi, dubitando forse che ancora mi non sia fallitto, quella a ragione da un cantto, ma non del altro: ma per assicurare V.S. io ho fato lo tuto de quanto ha ricercato quella non averia già fato in altra persona che me avesse donato scuti 50, per onor mio non per altro e quando non sia idoneo la obligatione fata per mi, io sono per far più grande e Roma e Napolo, ancora in Spagna non bastando. De questo son sempre al servitio de quella con la roba e la persona. Chi volle bene pagare volle bene assigurare. de questo non abiate altra opinione de mi, non son per mancare a quella. Così vollesse Dio la guerra non me dasse fastidio a mi, per sino a quest'ora son de pezo (perso?) scudi 50, niuno me volle remediar per questo. Io son per fare mio debito, a tutti conti non mancare, e dei due mesi in due mesi siate securo che io pago a M^r Agustino da Lodo e sempre pagarò non vedendo altro in contrario de la Sig^a V."

The second letter is from September 6, 1538 and the third from October 8, 1541 (". . . S. S. ha dato lo posto a uno milanese chiamato Me. Nicolo Pusterla . . ."). The latter concerns the transference of the Passo del Pò to Niccolò Pusterla, descendant of the original owners.

28. Michelangelo's modest way of life is attested by Condivi, p. 206, who states that he was always very sober, regarded eating as necessity rather than pleasure, and especially when he

was working contented himself with a piece of bread. Vasari reports the same (1568, p. 299), with the slight difference that Michelangelo contented himself with a little "bread and wine." The correctness of these statements is attested by a menu of Michelangelo, preserved in the Archivio Buonarroti and published by the writer in *Art Quarterly*, III, 1940, pp. 240ff.

That Michelangelo was not altogether indifferent to the quality of good wine may be seen from his letter of August 10, 1507 (Milanesi, p. 84). He writes from Bologna to his brother Buonarroto in Florence: "El vino ci è caro come costà, ma tristo quant' è può, e similmente ogni altra cosa, i' modo che e' c'è un cativo essere."

29. For the history of the Buonarroti family after Michelangelo's death, see Passerini, in Gotti, II, pp. 20ff. [Addenda, No. 5]

30. Michelangelo's attitude toward contemporary artists is revealing in this connection. While his relations with such eminent figures as Leonardo, Bramante and Raphael were strained and unfriendly because of his own unwillingness to have dealings with them, we find him in close friendship with mediocre artists such as, in his youth, Granacci (Milanesi, pp. 8, 73, 79), and Baccio d'Agnolo, the architect (Milanesi, pp. 73, 79). In Rome, Giuliano da Sangallo was his confidant (Milanesi, pp. 73, 79, 83, 84, 85, 86, 87, 89, and 91). His kindness toward Antonio Mini, his apprentice, is well known. See Dorez, *Nouv. Recherches*, I, pp. 448ff. To the letters published in Frey, *Briefe* and in Dorez's article we add in the Appendix III an unpublished letter by Antonio Mini and two by Giovanbattista Mini, uncle of Antonio. Other illustrations of Michelangelo's readiness to help mediocre artists have been pointed out in Appendix III.

31. For example, during the siege of Florence in 1529, he served the Republic (gratuitously in the beginning) as a military engineer (see the author, *Michelangelo Studies*). Again in 1544 he offered, through his friend Luigi del Riccio, to execute without payment an equestrian statue of the King of France to be erected in the Piazza dei Signori; this, on condition that the King would drive the Medici out of the city and restore Florence to its old freedom (Gaye, II, p. 296).

32. When, for example, the Florentine Republic was defeated by the Medici in 1529, Michelangelo went in hiding until Pope Clement VII granted him amnesty; and later, when he was settled in Rome, he wrote letters denying his friendship with Republican Florentine immigrants with whom he was actually in contact (Milanesi, pp. 211, 279, 289).

33. "It seems to me a thousand years before I can go back," he wrote from Bologna in 1507 (Milanesi, p. 84). In Venice he is filled with nostalgia: "I am consumed by a desire to return [to Florence]" (Milanesi, p. 457).

34. Evidence of Michelangelo's humor is to be found in a series of burlesque poems (Frey, *Dicht.*, 9, 68, 81, 161), as well as in his correspondence with his Roman friends, especially Luigi del Riccio (see Steinmann, *Luigi del Riccio*, Florence, 1932). Examples of his prudence: his letter of September 15, 1509, to his father (Milanesi, p. 32), and his letter of September 5, 1512, to Buonarroto (Milanesi, p. 107) in which he advises him, in view of the uncertain political conditions in Florence, to: "abandonare la roba e ogni cosa; perchè molto più vale la vita che la roba; e se non avete danari da levarvi di costà, andate allo Spedalingo e fatevene dare; e se io fussi in voi, io leverei tutti e' danari che lo Spedalingo à di mio, e verrei a Siena. . . . Siate e' primi a fugire." Again, during his illness in October of 1547, he was cared for in Strozzi's house in Rome, and when the news came to Florence that he had accepted the hospitality of this émigré, he wrote to Lionardo that he had been in Strozzi's house but had stayed in the room of Luigi del Riccio (Milanesi, p. 221); but he gave Strozzi the two Slaves (Louvre) out of gratitude.

35. In his youth Michelangelo had had relations with the Florentine nobility; Giovanni da Ricasoli (Milanesi, p. 75) and Filippo Strozzi (Milanesi, pp. 73 and 75) were his friends. In the Archivio Buonarroti is an unpublished letter (without date) from Giovanni da Ricasoli in Florence to Michelangelo in Pietrasanta (probably from 1518) in which he says: "volio mi faciate comperare libre 150 di lino." Concerning his relationship to Tommaso de' Cavalieri, see Steinmann and Pogatscher, "Dokumente und Forschungen zu Michelangelo," *Rep. f. Kw.*, XXIX, 1906, pp. 496ff. Concerning Vittoria Colonna, see J. Wyss, *Vittoria Colonna*, Frauenfeld, 1916—with bibliography.

36. The desire of Michelangelo for solitude is illustrated by two unpublished letters in the Archivio Buonarroti from Donato del Sera in Petrognano to Michelangelo in Florence. Donato has rented for the artist a house in Petrognano and he assures him July 7, 1523: ". . . non arete persona che vi dia fastidio, che qui non è cittadini grossi, e più libero sarete qui che non siate in casa vostra . . . montiate a cavallo e ne vegnate coll'apportatore sanza manco. . . ."

In the second letter, from July 10, 1523, he writes: "Io vi conforto a ogni modo a venire fino qua. . . . Qua troverete una fresca stanza e un bel paese. . . ."

Petrognano was situated near Dicomano. Donato del Sera is mentioned in the following letters from Fattucci: Frey, *Briefe*, pp. 214, 227, 228, 232, and in one letter from Salviati, Frey, *Briefe*, p. 255. Concerning Michelangelo's penchant for solitude cf. Vasari, 1568, pp. 244f.

Giannotti (*De' giorni che Dante consumò nel cercare l'Inferno e 'l Purgatorio*, ed. D. R. de Campos, Florence, 1939, pp. 66ff) reports that once Michelangelo explained to him and others why he led a solitary life and refused to lunch even with his dearest friends.

37. Concerning the deformation of Michelangelo's nose in his youth (ca. 1489), cf. Condivi, p. 212: "il naso [di Michelangelo è] un poco stiacciato, non per natura, ma percioche essendo putto, un chiamato Torrigiano di Torrigiani, huomo bestiale et superbo, con un pugno quasi gli staccò la cartilagine del naso." Cf. also Vasari, 1568, p. 29 and p. 322 and Cellini, *Vita*, p. 30. For a description of Michelangelo's physiognomy cf. Vasari, 1568, p. 258.

For portraits of Michelangelo, see Steinmann, *Die Porträt-Darstellungen Michelangelo's*, Leipzig, 1913; and F. La Cava, *Il Volto di Michelangelo*, Bologna (1925). The best characterizations of the man Michelangelo are: F. Gundelfinger, "Michelangelo und Leonardo," *Preussische Jahrbücher*, 1907, pp. 34ff; Romain Rolland, *Vie de Michelange*, Paris, 9th ed., 1924 (inaccurate, however, in its account of facts); Justi, *Ma.*, *N.B.*, pp. 361ff.

38. The *Libro delle Ricordanze* of Lodovico Buonarroti is not preserved. In the Archivio Buonarroti, Codex XII, folio 26, there is, however, preserved a copy of Michelangelo's birth registration. It is reproduced in facsimile in G. Chinali, *Caprese e Michelangelo Buonarroti*, Arezzo, 1904, Plate following p. 260. The best edition is by Frey, *Q.F.*, pp. 3f. From Michelangelo's correspondence we learn that at least twice he had his nephew Lionardo get him copies of his birth certificate and send them to Rome. On April 14, 1548, he writes to Lionardo: "Vorrei, che mi mandassi la mia natività, come mi mandasti un' altra volta, appunto, come sta in su libro di nostro padre, perchè l'ò perduta" (Milanesi, p. 223).

Chinali, op. cit., pp. 260f, assumes that the copy of the birth-registration in the Archivio Buonarroti may perhaps be identical with one of those which Lionardo sent to Michelangelo. Frey, loc. cit., doubts this, and believes the copy in the Archivio to be from the late seventeenth century. However, the handwriting of the copy is typical of the sixteenth century and thus Chinali's hypothesis has a certain probability.

39. See Chinali, op. cit. Chinali believes that the room in the *Casa Comunale* designated

as Michelangelo's birthroom is not actually the right one. (In 1875, on the occasion of the centennial, a marble plate with an inscription was erected in his room.) On the basis of newly found documents Chinali proves that not until after 1489 did the *Podesteria* occupy the present *Casa Comunale*. Earlier it was housed, according to Chinali, in the *Casa Clusini*, the present dwelling-house of the *Medico Comunale*, to the left of the entrance of the *Casa Comunale*. (A reproduction of the Casa Clusini is to be found in Chinali, op. cit., no. 272.)

For the connection between Florence and Caprese in the Middle Ages, see C. Guasti, *Capitoli del Comune di Firenze*, Firenze, I, pp. 357*ff*, 371, 440, and 481; and Chinali, op. cit., passim. Chinali's book is the only study on Michelangelo's connection with the town of Caprese which is based on personal investigation of the documents. (Wittkower's disapproving criticism of this work in Steinmann, *Michelangelo Bibliographie, sub* Chinali: "Unkritische Ausführungen über Caprese," seems completely unfounded.)

40. Condivi (p. 12): "La balia fu figliuola d'uno scarpellino et similmente in uno scarpellino maritata." Vasari (1568, p. 13) takes over this report.

41. Vasari (1568, p. 13): "Giorgio, si [s'i'] ho nulla di buono nell' ingegno, egli è venuto dal nascere nella sottilità dell' aria del vostro paese d'Arezzo, cosi come anche tirai dal latte della mia balia gli scarpegli el [e'l] mazzuolo, con che io fo le figure." The second part of the sentence is taken over freely from Condivi (p. 12).

Caprese is not, as stated here, in the country of Arezzo but in the Valle della Singerna. Vasari doubtless would like to flatter himself by claiming Michelangelo his countryman.

42. On the house, 7 Via dei Bentaccordi (on the corner of the Via dell' Anguillara), there is now a marble plaque with the following inscription: "Casa | dove Michelangelo Buonarroti | nato a Caprese in Casentino | visse gli anni della sua giovinezza." (Frey, *Ma.*, I, p. 5, doubts the authenticity of this claim and believes that the house was nearer the Piazza de' Peruzzi, but he offers no proof.)

43. We have no further information about the "Scuola di Gramatica" of Francesco da Urbino (Condivi, p. 12; Vasari, 1568, p. 13). That Michelangelo possessed a certain knowledge of Latin is proved by the Latin fragments copied by him on several of his drawings; e.g. Frey, *Handz.*, 13a: "Deus in nomine, tuo salvum me fa[c] . . . ," fragment of Ps. 53:3; Frey, *Handz.*, 54: "Valle lochus chlausa toto michi nullus in orbe" (identified with Petrarch's Latin elegy on Vaucluse in a letter to Philippe de Cabassoles, Bishop of Cavaillon, by Panofsky, *Iconology*, p. 179, note 22). On the other hand, Frey (*Q.F.*, p. 16) claims that Michelangelo certainly understood no Latin. He bases this on an apocryphal letter (Milanesi, p. 489) in which mention is made of Donato Giannotti's Dialogue, *De' giorni che Dante consumò nel cercare l'Inferno e'l Purgatorio*, and in which Michelangelo speaks of his intention of learning Latin at the age of seventy. Frey cites further the fact that contracts in Latin had to be translated for Michelangelo; for example, Milanesi, pp. 626, 636, etc. These arguments do not seem conclusive since the letter is apocryphal and Giannotti's dialogue is a literary work. It is very probable that Michelangelo did not know Latin well, but had a certain rudimentary knowledge of it.

44. See Varchi, *Orazione*, p. 11*f*.

45. Condivi (p. 10): "Lodovico di Lionardo Buonarroti, huomo religioso e buono e piu tosto d'antichi costumi che nò."

46. Concerning the typical motifs of biographies of great artists and their derivation from antiquity, see E. Kris und O. Kurz, *Die Legende vom Künstler*, Vienna, 1934, pp. 25*ff*.

47. For the social position of artists in Florence in the fifteenth century, see J. Mesnil, *La*

Civilisation Florentine au 15ième siècle, Paris (Mercure de France), 1909; M. Wackernagel, *Der Lebensraum des Künstlers in der florentinischen Renaissance*, Leipzig, 1938, pp. 356*ff*; A. Blunt, *Artistic Theory in Italy, 1450-1600*, Oxford, 1940, pp. 48*ff*.

48. The date of Granacci's birth, erroneously proposed by Milanesi as 1477, has been corrected to 1469 by G. Fiocco, "La data di nascita di F. Granacci e un' ipotesi Michelangiolesca," *Riv. d'Arte*, XII, 1930, pp. 193*ff* and XIII, 1931, pp. 109*ff*.

49. Concerning the typical motif found in biographies of great artists and of the discovery of their talent by another older artist, see E. Kris und O. Kurz, op. cit., pp. 36*ff*.

50. The contract between Lodovico Buonarroti and the brothers Ghirlandaio is lost. The copy in Vasari (1568, p. 15) is as follows: "Ricordo questo di primo d'Aprile, come io Lodovico di Lionardo di Buonarota acconcio Michelagnolo mio figliuolo con Domenico e Davit di Tommaso di Currado per anni tre prossimi a venire con questi patti e modi, chel [che'l] detto Michelagnolo debba stare con i sopradetti detto tempo a imparare a dipignere et a fare detto essercizio, e ciò i sopradetti gli comanderanno; e detti Domenico e Davit gli debbon dare in questi tre anni fiorini ventiquattro di sugello, el primo anno fiorini sei, el secondo anno fiorini otto, il terzo fiorini dieci, in tutta la somma di lire 96."

51. The Florentine ateliers of the fifteenth century, their organization and their conduct, are described by J. Mesnil, *L'Education des peintres florentins au 15ième siècle*, reprinted from: *Revue des Idées*, 1910 (Sept. 15). The essay is based on the statutes of the corporations, the attested contracts between master and pupil (published by G. Milanesi, *Nuovi Documenti per la Storia dell' Arte Toscana*, Florence, 1901), and on the artists "Ricordi."

52. The drawing by Michelangelo in Settignano is treated more fully in part II of this volume (p. 69) and No. 1. *67*

53. The teaching method in the Florentine ateliers is best reported by J. Mesnil, op. cit., in note 51, and Max Dvořák, *Geschichte der italienischen Kunst*, Munich, 1927, I, pp. 124*ff*.

54. See Condivi, pp. 14*ff*, and Vasari, 1568, pp. 17*ff*. On September 7, 1535, Vasari sent to Pietro Aretino a black-chalk drawing of a St. Catherine by Michelangelo (Vasari, ed. Milanesi, VIII, p. 266, and Frey, *Lit. Nachlass*, p. 36). Aretino writes, before January 6, 1537, that Michelangelo made the drawing of St. Catherine while still a child, and praises its quality. This drawing is now lost.

55. "Domenico [Ghirlandaio] rimase sbigottito della nuova maniera e della nuova imitatione" (Vasari, 1568, p. 69).

56. According to Condivi (p. 20) Michelangelo one day was taken to the Giardino dei Medici in San Marco by Granacci; however, according to Vasari (1550, p. 21, and 1568, p. 21) Ghirlandaio, at the request of Lorenzo the Magnificent sent his two best students, Michelangelo and Granacci, to the Giardino. The Giardino Mediceo was purchased in 1480 by Lorenzo de' Medici for his wife, Clarice (see the Denunzia de' Beni di Lorenzo, 1480, published by Frey, *Q.F.*, p. 62). It was planned as a dwelling for his widow in case he died first. Not until after Clarice's death on July 30, 1488, could the school take its place in the Giardino (Frey, *Q.F.*, p. 63). Thus the establishment of the school must have been very recent at the time of Michelangelo's entrance into it, and must have taken place during the period of his study with Ghirlandaio. The only mention of the garden and its anticaglie in Lorenzo's correspondence is from the year 1490 (see Frey, loc. cit.).

57. The plan of Florence by Stefano Bonsignori, 1584, is published in G. Boffito and A. *198a* Mori, *Piante e vedute di Firenze*, Florence, 1926, plate following p. xvi. Although this plan is dated from 1584, it is based on an older drawing for it shows the Giardino before the reconstruction by Buontalenti in 1576.

58. Vasari's "Vita di Torrigiano," ed. Milanesi, IV, pp. 256ff, and Vasari, 1568, pp. 322ff.

59. Vasari, 1568, p. 322: "era come una scuola et academia a i giovanetti pittori e scultori . . . e particolarmente a i giovani nobili." Vasari, however, could not have known the original disposition of the works of art in the Garden. [Addenda, No. 6]

60. W. Bode, *Bertoldo und Lorenzo dei Medici*, Freiburg i.B., 1925, especially pp. 122ff.

61. The list of the pupils at the Giardino is given by Vasari, "Vita di Torrigiano" (1568, p. 324). The list, however, is not wholly trustworthy for it contains the names of such artists as Niccolò Soggi, Lorenzo di Credi, and Andrea Sansovino, who at this time were certainly not in Florence (see Frey, *Q.F.*, p. 64).

62. Condivi (p. 20) says concerning the head of the faun: "di sua fantasia suplendo tutto quello che nel antico mancava. . . ." Vasari (1568, p. 25) adds more details: "fuor' della antica testa di sua fantasia gli haveva trapanato la bocca e fattogli la lingua e vedere tutti i denti."

63. Concerning the faun-mask in the Bargello falsely ascribed to Michelangelo see XII.

64. See Vasari, 1568, p. 23.

65. For the Palazzo Medici (begun ca. 1444, completed ca. 1452) see A. Warburg, *Ges. Schriften*, pp. 165ff and 366ff; and K. H. Busse, Der Pitti Palast, *J.d.p.K.*, LI, 1930, pp. 110ff.

66. For the inventory of the collection of the Palazzo Medici, see E. Müntz, *Les précurseurs de la Renaissance*, Paris, 1888; and idem, *Les collections des Medicis*, Paris, 1888. An extract of the inventory is published in Frey, *Q.F.*, pp. 40ff.

67. For Lorenzo the Magnificent there is no modern biography. Our account is based on A. Fabroni, *Vita di Lorenzo dei Medici*, Pisa, 1784, 2 vols.; A. von Reumont, *Lorenzo de' Medici*, Leipzig, 1874-1883, 2 vols.; G. Pieraccini, *La stirpe de' Medici di Cafaggiolo*, Florence (1924), 3 vols. The best description of the character and court life of Lorenzo is to be found in Philippe Monnier, *Le Quattrocento*, 4th ed., Paris, 1924, II, pp. 25ff.

Concerning Lorenzo's preference for the "lingua volgare" see Catalogue, p. 177.

68. For the friendly relations between Lorenzo and Poliziano, Pico and Benivieni, Ficino and Bembo, see Philippe Monnier, op. cit., II, pp. 95ff.

69. Concerning the date of Lorenzo's death, see A. Fabroni, *Vita di Lorenzo dei Medici*, Pisa, 1784, II, p. 199, where there is also published the letter of Poliziano to Jacopo Antiquario giving an account of Lorenzo's death. [Addenda, No. 7]

As evidence of Savonarola's popularity may be cited the fact, reported in Landucci, that since Lent, 1491, he had been preaching in the Cathedral of Florence, S. Marco being too small to accommodate his audience, which now numbered 15,000.

70. See Part II, p. 81 and XIV.

71. The Prior of S. Spirito was called Maestro Nicholaio di Giovanni di Lapo Bichiellini. Some notes on him are to be found in Frey, *Q.F.*, pp. 107ff.

72. As late as the fourteenth century the doctors in Florence still made only two dissections a year (see Mesnil, *L'Education des peintres florentins*, p. 9). According to Vasari (ed. Milanesi, III, p. 295) Antonio Pollaiuolo was the first of the artists to dissect corpses. This dissection of corpses gave artists the chance to obtain exact information about the location of the muscles and their function. We learn from Condivi that the famous Realdo Colombo, court doctor to Julius III and professor of anatomy in the Sapienza (in 1559), sent to Michelangelo, ca. 1550-1551, the corpse of a Negro of perfect proportions, which the artist dissected in Condivi's house (see Frey, *Ma.*, I, p. 135).

73. Concerning the lost crucifix and its reconstruction, see Part II, pp. 80f and XIII.

74. For Piero de' Medici il Fiero, see the documents and letters in Frey, *Q.F.*, pp. 73ff and

Ma., I, pp. 150*ff*. That Michelangelo was invited back to the Medici house by Piero, as well as the story of the snow statue, is reported by Condivi (p. 28) and after him by Vasari (1568, p. 29).

75. In the war that was going on, Savonarola and the Florentine people were on the side of the French King, while the ruler Piero de' Medici sympathized with the King of Naples. When the French fleet defeated the fleet of the King of Naples September 11, 1494, at Rapallo, Piero's situation became precarious. (See Landucci, *Diario* sub Sept. 11, 1494.) On October 4 the King of France sent two envoys to Florence to ask the Signoria on which side the Florentines stood. They gave no definite answer (Landucci, *Diario* sub October 4, 1494, says their answer was "confus"). The envoys then left Florence and there arose a rumor that the French King had sworn to let his soldiers plunder the city.

76. For Michelangelo's flight from Florence to Upper Italy before October 14, 1494, see G. Poggi, "Della prima partenza di Michelangelo Buonarroti da Firenze," *Riv. d'Arte*, IV, 1906, pp. 33*ff*. The letters of Ser Amadeo, in Florence, to his brother Adriano di Giovanni, in Naples, published for the first time by Poggi, are republished by Frey, *Q.F.*, p. 120. Frey, loc. cit., dates Michelangelo's flight ca. October 10 or 11, 1494. The letter in question says in part: "Sapi, che Michelagnolo ischultore dal giardino sene ito a Vinegia sanz dire nula a Piero, tornando lui in chasa; mi pare, che Piero l'abia auto molto male."

77. For Andrea Cardiere, see Condivi, pp. 30*f*. Michelangelo is said to have fled with "due compagni" (Condivi, p. 32). Vasari omits the story about Cardiere from his second edition and simply says (1568, p. 35) that Michelangelo went to Bologna and then to Venice, since he was afraid that something sinister would happen to him as a friend of the Medici.

78. Concerning Michelangelo's flights, see L. Dorez, *Nouv. Recherches*, II, pp. 209*ff*. In the uncertain political and social situation of the time flight does not seem to have been considered evidence of cowardice but of prudence. Thus, for example, Leonardo da Vinci writes in his notebooks the following maxims: "Paura over timore è prolungamento di vita," and "chi teme i pericoli, non perisce per quegli" (see E. Solmi, *Leonardo da Vinci, Frammenti letterari*, Florence, 1913, pp. 202*ff*, cited from Dorez, op. cit.).

79. Concerning these letters see note 76.

80. Michelangelo rode away from Florence before October 14, 1494 (according to Frey, on October 10 or 11). In about three days he was in Bologna. (The length of time which it took him to get to Bologna from Florence may be deduced from the unpublished notices by Buonarroto on the backs of Michelangelo's letters from Bologna, in the Archivio Buonarroti, in which he notes the date of arrival of the letters—usually three days after the sending; for example, Milanesi, p. 63: sent on January 22, 1507, received January 25; Milanesi, p. 71: sent March 26, received March 29.) About four or five days later Michelangelo arrived in Venice. Here he remained "pochi giorni" (Condivi, p. 32). The second arrival in Bologna took place probably at the end of October. He remained there "poco più d'un anno" (Condivi, p. 36), and thus probably returned to Florence near the end of the year 1495.

This chronology based on Condivi is contradicted by a notice in Vasari's "Vita di Cronaca," ed. Milanesi, IV, pp. 448, 457, where he says that already in June-July, 1495, Michelangelo was in Florence and a member of the commission with Leonardo, Giuliano da San Gallo, Baccio d'Agnolo, and Cronaca which advised on the construction of the great Council Hall of the Palazzo Vecchio. (The decision of the Signoria to undertake this construction was voted on July 15, 1495; see Gaye, I, p. 584.) That this report by Vasari is false, not only for Michelangelo but also for Leonardo, who in the summer of 1495 was in Milan, has been proved by Frey, *Q.F.*, p. 122, with good arguments.

81. Michelangelo's earliest preserved poems date from the beginning of the Cinquecento (1501). They are very strongly influenced by Petrarch; influence of Poliziano and Lorenzo the Magnificent is also apparent. These poems are: Frey, *Dicht.*, nos. 1, 2, 5, 6 in part, 7, 8, 166 I-IV. Michelangelo's poetry will be treated more fully in Volume v where we will seek to rectify Frey's chronology (see Frey, *Dicht.*, passim; and *Ma.*, I, pp. 164*ff*). At this point we should like to remark that we would date the poem, Frey, *Dicht.*, 163, *Stanze in praise of country life*, early, around 1506-1508, whereas Frey places it in Michelangelo's "old age"— around 1556. Disregarding the style which is obviously influenced by Poliziano, the hand-writing of the manuscript points unquestionably to 1506-1508. Michelangelo's grand-nephew already in his notes on Michelangelo's poems (ca. 1623) dated this one in the youthful period; Thode followed him, while all the other scholars, under the influence of Frey's authority, put it in the late period.

Concerning Frey, *Dicht.*, 69, we can likewise not accept Frey's dating of around 1534-1535. On the basis of the handwriting it seems certain that the first half of this poem is from the early period (1506-1508), while the second three stanze were added around 1520.

82. At the end of 1495 or in January 1496 Michelangelo arrived in Florence where he remained about half a year; on June 25, 1496, he was already in Rome.

83. See Landucci, *Diario*, sub. June 26, 1495.

84. See G. Savonarola, *Prediche e Scritti*, ed. Mario Ferrara, Milan, 1930, p. 139.

85. See Savonarola, ed. M. Ferrara, op. cit., pp. 131*ff*.

86. Frey (*Q.F.*, pp. 122*f*), believing that half a year seems too short a time for the completion of both the Giovannino and the Cupid, assumes that the Giovannino was already begun in Florence before the flight to Bologna and was completed after the return to Florence.

87. Compare our attempts at reconstruction of the two works in the Catalogue of Lost Works, pp. 198*ff*.

88. That the statuette of Cupid was sold in Rome as an antique work, is confirmed by the two letters of Count Antonius Maria de Mirandula to Isabella d'Este of Mantua of June 27, 1496, and July 23, 1496, respectively (published in Frey, *Q.F.*, p. 137). In the first letter he says in regard to the Cupid: "chi lo tene antiquo et chi moderno" (i.e. there was dispute at the time whether the work was antique or modern). After this the truth was disclosed and in the second letter he then reports: "Quel Cupido è moderno, et lo maestro che lo ha facto, e qui venuto."

89. The situation as described here on the basis of Michelangelo's own contemporary account (Milanesi, p. 375) contradicts Condivi (p. 36) and Vasari (1568, p. 37), according to whom the statue was bought by Cardinal Riario from Baldassarre as an antique work, but shortly afterwards the fraud was discovered. The story gives the first biographers an opportunity to moralize about the vanity of those who judge by appearance, and to criticize the Cardinal for his failure to appreciate a great work of art merely because it was not antique. They expressed their conviction that the works of their contemporary Michelangelo yield nothing to those of antiquity.

The criticism of the Cardinal by Condivi and Vasari is wholly groundless, for it is known that he was a great connoisseur of art.

Also false is the accusation by Condivi and Vasari that Cardinal Riario gave no commission to Michelangelo during his stay with him, "since he [the Cardinal] knew little about art." The letter by Michelangelo cited above proves that immediately after his arrival in Rome the Cardinal entrusted him with the execution of a marble statue.

90. Concerning the antique collection of Cardinal Riario, cf. P. G. Hübner, *Le statue di Roma*, Leipzig, 1912.

91. The date of Michelangelo's departure for Rome may be established as about June 20 or 21, 1496, on the basis of the dates on the reverse of the letters which Buonarroto received from him from Rome, from which it appears that the journey from Florence to Rome took four or five days (for example, Milanesi, p. 104: sent July 24, 1512, received July 28, 1512; Milanesi, p. 108: sent September 18, 1512, received September 23, 1512).

92. See the letter of Michelangelo of July 2, 1496 (Milanesi, p. 375). Here we learn that Michelangelo presented himself to Cardinal Riario with a letter from Lorenzo di Pierfrancesco. Another letter he presented to Paolo Rucellai (di Pandolfo). A third letter was addressed to Baldassarre del Milanese.

93. The Cardinal suggested that Michelangelo "andasse a veder certe figure." This can only refer to antique statuary. See Milanesi, p. 375. In the same letter, Michelangelo reports: "Certo mi pare ci sia molte belle cose."

94. For Rome under the Borgia, see Philippe Monnier, *Le Quattrocento*, Paris, 1924, I, pp. 179*ff*; Albertini, "Memoriale," 1510; Aldovrandi, *Delle statue antiche*; Rodolfo Lanciani, *Storia degli scavi di Roma*, Rome, 1902-1903, 2 vols.; Hübner, *Le statue di Roma*, Leipzig, 1912.

95. See Philippe Monnier, op. cit.

96. The collections of antique statuary in Rome attest this antiquarian interest. The largest were those of Cardinal Rovere and Cardinal Riario. See Hübner, op. cit. An idea of what antique monuments and fragments Michelangelo was able to see during this first Roman stay may be gathered from the Roman sketchbooks of Giuliano da San Gallo in the Vatican (published in C. Hülsen, *Libro di Giuliano da Sangallo*, Leipzig, 1910; Cod. Vat. Selecti) and in Siena (published by Falb, Florence, 1902), and from the *Codex Escurialensis* (by a pupil of Ghirlandaio; published by Egger, Vienna, 1906).

97. In spite of his success Michelangelo does not neglect his family obligations. He was visited in Rome by two of his brothers; Fra Leonardo came to him from Viterbo in poverty after being forced to hang up his robe—"gli era stato tolto la cappa" (before July 1, 1497; Milanesi, p. 3). It is not certain whether flight was due to his partisanship for Savonarola (Savonarola was excommunicated in May 12, 1496), as Michelangelo's grand-nephew assumes in his genealogical letter (Frey, *Q.F.*, p. 16). See also Frey, *Ma.*, I, p. 281. Michelangelo gave the fugitive money for the journey home to Florence (Milanesi, p. 3).

On August 11 or 18, 1497 (Milanesi, p. 4) Buonarroto arrived in Rome, apparently to speak to Michelangelo about their father's financial troubles. Lodovico had lost his second wife, Michelangelo's stepmother, on July 8, 1497, and was being threatened by a certain Antonio Consiglio Cisti to whom he owed 90 gold florins, a debt which Lodovico wished to avoid paying. Michelangelo declared himself ready to help his father, "benchè io n' abbi pochi [denari]" (Milanesi, p. 4). The matter was not finally settled until March 1, 1502, by the payment of the sum.

Buonarroto made a second visit to Rome before December 13, 1500 (Frey, *Briefe*, p. 1*ff*). Michelangelo promised to furnish money for setting up a business for Buonarroto and Giansimone and asked his father to look for a suitable shop.

We learn also that Michelangelo was living in great economy and poverty (Frey, *Briefe*, p. 1*ff*).

Also mentioned is Michelangelo's first assistant, Piero di Giannotto, i.e. d'Argiento (cf. p. 28).

According to Condivi (p. 38) Michelangelo had lodgings in the house of a nobleman near the palace of Cardinal Riario. When he speaks of the Bacchus, however, Condivi reports (p. 40) that Michelangelo executed it in the house of Jacopo Galli. If our hypothesis, that

the block bought for Michelangelo by the Cardinal is that from which he executed the Bacchus, is true this statement by Condivi cannot be correct. It is possible that Michelangelo himself suggested this version since it would conceal the fact of the refusal of the statue by the Cardinal.

98. "Abiamo comperato uno pezo di marmo d'una figura del naturale" (Milanesi, p. 375).

99. ". . . e partir no mi voglio, se prima io non son sodisfatto e remunerato della fatica mia" (Milanesi, p. 3). Probably the severe criticism of the Cardinal Riario as an art-connoisseur, as given by Condivi and repeated by Vasari, was inspired by Michelangelo himself through bitterness over the difficulties with the Cardinal mentioned here.

100. "Io tolsi a fare una figura da Piero de' Medici e comperai il marmo: poi noll'ò mai cominciata, perchè no' mi à fatto quello mi promesse: per la qual cosa io mi sto da me, e fo una figura per mio piaciere" (Milanesi, p. 4). The figure referred to is probably the Apollo-Cupid which Jacopo Galli later bought.

101. Baldassarre Balducci is mentioned by Michelangelo in a letter (Milanesi, p. 60).

102. The Stigmatization of St. Francis is not mentioned by Condivi. However, Vasari in his first edition, p. 39, says Michelangelo did the painting. In the second edition (p. 41), he says that the barber painted it (this may be an invention on Vasari's part, as Frey, *Ma.*, I, p. 277, assumes). Today, in the chapel, in place of the lost work is the fresco by Giovanni de' Vecchi representing the same subject. Varchi, *Orazione*, p. 16, also mentions the Stigmatization.

103. See Milanesi, p. 59.

104. All other proofs of Michelangelo's regard for Savonarola cited in the literature turn out to be unconfirmed after closer investigation. The letter to Lorenzo di Pierfrancesco de' Medici, addressed to Botticelli (Milanesi, p. 375) is not actually written in Michelangelo's hand and thus cannot be used to prove any intimate connection of Michelangelo with Botticelli (who was a *piagnone*). In a letter to Piero Gondi, dated January 26, 1524 (Milanesi, p. 434), Michelangelo takes his position against the *piagnoni* and uses the word in a pejorative sense. The all too far-reaching conclusions in Thode, Bode, Kraus, and Grimm in regard to Michelangelo's connection with Savonarola have already been refuted by Frey, *Ma.*, I, p. 188, and *Q.F.*, p. 115.

105. In regard to Savonarola's views on art, see Frey, *Ma.*, I, pp. 184*ff.* For the influence of Savonarola on Florentine art, see G. Gruyer, *Les illustrations des écrits de Savonarola*, Paris, 1879; and W. Bode, *Flor. Bildh.*, pp. 321*ff.*

106. See Wölfflin, *Jugendwerke*, pp. 21*ff.*

107. The exact date of the return to Florence is not known. The declaration by Michelangelo concerning the contract with Cardinal Piccolomini for his monument in Siena is dated [in Florence], May 22, 1501. The entire correspondence between May 1501 and March 1505 is lost.

108. We learn from the chronicles of the period (Landucci, *Diario*) that Cesare Borgia and Vitellozzo Vitelli plundered and sacked the countryside around Florence (May 2, 1501, and May 20, 1501). We hear of disorders in Pisa, Arezzo, Pistoia, Siena, Borgo San Sepolcro in the years 1502-1503.

109. The only order from a church dignitary came from the outside, from the Cardinal of Siena for the Piccolomini altar. The only private commissions were for the three Tondi, executed for Bartolommeo Pitti, Taddeo Taddei, and Agnolo Doni.

110. See Vasari, 1568, pp. 49 and 51: ". . . si come egli [*scil.* David] haveva difeso il suo popolo e governatolo con giustizia, così chi governava quella città dovesse animosamente

difenderla e giustamente governarla." It may be mentioned here that since the end of the 13th century Hercules was considered as a protector of Florence and appears as such on the old seals of the *Signoria* with the device "Herculea clava domat Fiorentia Prava" (See E. Müntz, *Les précurseurs de la Renaissance*, p. 48).

111. See Landucci, *Diario*, sub respective dates.

112. Leonardo had again been living in Florence since April 1500. He executed at that time the cartoon of St. Ann for the convent of SS. Annunziata. The "sweetness and suavity" of Leonardo's works, so much praised by contemporaries (Isabella d'Este), was a character diffused throughout Florentine art at the turn of the century. We find it, for example, in the religious paintings of Perugino, Lorenzo di Credi, Fra Bartolommeo, Albertinelli, and the young Andrea del Sarto.

113. For Raphael's occupation with Michelangelo, see G. Gronau, *Raffaels Florentiner Tage*, pp. 31-46; and O. Fischel, *Raphaels Zeichnungen*, Berlin 1913-1923, Plates 172 (after the St. Matthew), 181 (Bargello Tondo), 82 and 187 (David), 108 (London Tondo), 81 (Battle of Cascina). See also Panofsky, *Iconology*, p. 173 note.

114. Julius II, formerly Cardinal Giuliano della Rovere, had been elected pope on October 31, 1503. Immediately on the death of his predecessor, Alexander VI, one province after another (Urbino, Pesaro, Camerino, and Venice—which had already conquered a part of Romagna) arose to proclaim their independence from the Church-State. Julius II, when he came into office, was thus faced with the problem of reestablishing the papal authority. As a man of the Renaissance he wished to accomplish this not by an inner spiritual reform of the Papacy but by a restoration of its temporal might. First he arrested Cesare Borgia, who had several times razed the cities of Tuscany, and then decided to regain the lost provinces by the sword.

"Il papa vol esser il dominus e maistro del mondo," says Trevisano, Ambassador of Venice in Rome, in 1510 (Pastor, *Geschichte*, III, p. 687).

The Rome of Julius II was called "Plaza del mundo" by Ferdinand the Catholic, in 1504 (Pastor, loc. cit.).

115. The artists employed by Julius II at the beginning of his pontificate were the architects, Giuliano da San Gallo and Bramante, and the sculptor, Andrea da Sansovino, all working under the inspiration of ancient Roman art. Concerning Julius II as patron of the arts, see Pastor, op. cit., pp. 896*ff* and 913*ff*; and E. Rodocanachi, *La première Renaissance, Rome au temps de Jules II et de Leon X*, Paris, 1912, passim.

116. The lack of contemporary documents makes it now impossible to establish with certainty whether the Pope called Michelangelo to Rome on his own account or whether he was urged to do so by others. In 1524, Michelangelo claims in his letters to Fattucci that the Pope abducted him from Florence—"e levandomi Papa Julio di quà [*scil.* Florence]" (Milanesi, p. 426). In another copy he says more modestly, "andai a star seco . . . [*scil.* Julius]" (Milanesi, p. 429). Vasari (1550 and 1568, p. 63) says, "Michelangelo fu chiamato con gran suo favore da Giulio II, per fargli fare la sepoltura sua." Condivi (p. 62) states: "fu a Roma da Papa Giulio II chiamato . . . Venuto dunque a Roma, passaron molti mesi, prima che Giulio II si risolvesse in che dovesse servirsene. Ultimamente gli venne in animo di fargli fare la sepoltura sua." On the other hand, in his life of Giuliano da San Gallo, Vasari (ed. Milanesi, IV, p. 282) says that Giuliano "confortò il papa all' impresa [*scil.* the Tomb], aggiungendo che gli pareva che per quello edifizio si dovesse fabbricare una cappella a posta, senza porre quella nel vecchio S. Piero." Giuliano da San Gallo's role in the matter of the Tomb is treated fully by Justi, *Ma.*, pp. 204*ff*.

117. The conception of the tomb as a memorial to the fame of the deceased had been prevalent from the time of the Early Renaissance. For example, Leonardo's projects for the equestrian statue of Francesco Sforza prove that it, too, was to serve as a tomb.

The history of the Julius Tomb will be fully treated in Volume IV.

118. The contract is lost. We base our account mainly on the letters Milanesi, p. 426; and Maurenbrecher, *Aufzeichnungen*, p. 67.

119. December 18, 1505 (Gaye, II, p. 477) he voided the contract for the twelve Apostles for the cathedral of Florence, evidently in order to devote himself entirely to the Tomb of Julius II. The house built for him in Florence is at the same time rented to someone else (Gaye, loc. cit.).

120. Later, in an apocryphal letter (copy by L. del Riccio) which must be dated 1542 (Milanesi, pp. 489*ff*), Michelangelo claims to have sent the following letter to the Pope by a certain Agostino Scalco: "Blessed Father: I was thrown out of the palace today by your Holiness; wherefore I inform you that from now on if you want me you can look for me elsewhere than in Rome" (Milanesi, p. 493). In the same letter he also claims that he commissioned a carpenter named Cosimo and a stonecutter who lived with him to go to the Jew and sell everything in his Roman house. After the Pope got his letter he sent five men riding after him, who overtook him in Poggi Bonzi about three o'clock in the morning and gave him a letter from the Pope which said: "under penalty of our displeasure return to Rome on sight of this letter." Michelangelo answered the Pope: "whenever he wants me to do what I undertook to do I will return. Otherwise let him not hope to get me back." It is doubtful whether this presentation of the story is correct.

On January 27, 1506 (Gaye, II, p. 253) Michelangelo bought an estate with vineyards, orchards, woods, and a house in Pozzolatico. It is the first property which he ever got, apparently out of his savings from his Florentine works and perhaps from the advance from the Tomb. When later Julius II's heirs accused him of having enriched himself with the money the Pope gave him for the Tomb (Milanesi, p. 491) they refer perhaps to this purchase.

121. See F. Sarre, "Michelangelo und der türkische Hof." *Rep. f. Kw.*, vol. 32, 1909, pp. 60*ff*.

122. Condivi, Vasari (1568, p. 77), and "Michelangelo" in an apocryphal letter of 1542 (Milanesi, p. 493) speak of three *brevi*, but only one is preserved dealing with this affair, and contemporary correspondence affords no proof of others. On August 18, 1506, Julius sent to the Signoria a *breve* which however does not directly refer to Michelangelo (Steinmann, *Sixtinische Kapelle*, II, p. 696).

123. On September 13, 1506, Julius II marched into Perugia, whose ruler, Gian Paolo Baglioni, surrendered the city without fighting. On October 29, 1506, Giovanni Bentivoglio, ruler of Bologna, was driven from the city and on November 11, 1506, Julius, with the help of French troops, marched into the city in triumph.

124. The second stay in Bologna lasted somewhat less than a year and a half, approximately from November 29, 1506, to the beginning of March 1508. That the reconciliation took place in the Palazzo dei Sedici is a supposition by Frey (Studien zu Michelangelo, *J.d.p.K.*, XVI, 1895, pp. 91*ff*); Condivi (p. 78) describes the picturesque meeting of Pope and artist at which the Cardinal di Volterra was also present. The latter took Michelangelo's part unskillfully and was insulted by the Pope for it.

125. The contract is lost, but is mentioned in Michelangelo's letter to Fattucci (Milanesi, p. 427).

126. See B. Podestà, "Notizie intorno alle due statue erette in Bologna a Giulio II" in: *Atti e memorie della R. Deputazione di storia patria nelle provincie di Romagna*, vol. VII, Bologna, 1868, pp. 107*ff*.

127. We learn from the correspondence that these two helpers then complained against Michelangelo to his father in Florence. Michelangelo then explained the whole matter and absolved himself in the letters (Milanesi, pp. 8-10).

128. "Son qua in una cativa stanza, e ho comprato un letto solo, nel quale stiàno quattro persone," December 19, 1506 (Milanesi, p. 61).

129. The Pope left Bologna on February 22, 1507. The Bentivoglio sought to retake the city in May 1507, but unsuccessfully. Perhaps Michelangelo's remark refers to this. See Milanesi, p. 149 note.

130. For the reconstruction of the statue, cf. Catalogue, pp. 219*f*. Besides the bronze statue, Michelangelo may also have executed the stucco statue for the Palazzo degli Anziani during this stay in Bologna; see the Catalogue. Moreover, we learn from Michelangelo's correspondence with Buonarroto that he had a dagger made for Pietro Aldobrandini by the best master for such things in Bologna; see Catalogue, p. 223.

131. The letter is published in the Appendix IV. This is the only preserved letter of Fra Lorenzo Viviani.

132. That Fra Lorenzo was a Florentine by birth and belonged to a preaching order, he himself reveals in the letter. Probably he was a Dominican.

133. Mentioned are a certain Piero and a Lorenzo. The former is probably Pietro Urbano (?).

134. However, we learn from the letter that the trip was rather difficult and that he fell off his horse.

135. L. B. Alberti, Della tranquillità dell' Anima, *Opere volgari*, pp. 113*ff*.

136. Concerning the Fortuna-Fatum concept in the Middle Ages and the use of the wheel as a symbol of it, see Warburg, *Ges. Schriften*, I, pp. 129*ff* and 356*ff*; Doren, "Fortuna im Mittelalter und in der Renaissance," *Vorträge der Bibliothek Warburg*, I, 1922-23, pp. 71*ff*; and E. Cassirer, *Individuum und Kosmos in der Philosophie der Renaissance*, Leipzig, 1927, pp. 79*ff*.

The old fatalistic concept of the Middle Ages still lived on in the fifteenth century in less educated circles. We find it, for example, in the chronicler Landucci. The new concept of man seems to be limited to the smaller circle of humanists; it finds its purest expression in Alberti, Giannozzo Manetti, Pico della Mirandola, Marsilio Ficino, Carolus Bovillus, and at the end of the century in Giordano Bruno (see Cassirer, loc. cit.).

137. The document calling him to Rome is not preserved. Michelangelo speaks of it in his letter to Fattucci (Milanesi, p. 427) without giving the exact date. The *breve* of Julius II must have been sent near the end of March or the beginning of April. On June 30, 1508, Piero Soderini, in a letter to Giovanni Ridolfi (Steinmann, *Sixtinische Kapelle*, II, p. 700), mentions that Michelangelo was summoned from Florence by a *breve* from the Pope, but the date is not given.

138. See the letter of May 10, 1506, by Pietro Roselli to Michelangelo (Steinmann, *Sixtinische Kapelle*, II, p. 695).

ARTISTIC DEVELOPMENT

INTRODUCTION

"Les grands artistes n'ont jamais fait qu'une seule oeuvre, ou plutôt n'ont jamais que refracté à travers des milieux divers, une même beauté qu'ils apportent au monde." These words of Proust cannot be better illustrated than in the work of Michelangelo. He seems throughout his life to have been haunted by a single vision. Each of his creations, of the same unique quality, carries with it the message of an unknown and superior world.

There is in Michelangelo no gradual emancipation from a school tradition toward freedom and originality. In the earliest works is the seed of all his future development and from the first we see the marks of his powerful personality. His art has no direct continuation—his many poor imitators saw in him only the "virtuoso," disregarding the essential quality of his creation. He stands like a solitary giant, dominating his century.

But if one regards his work at a distance, its relation with the distant past and with future centuries becomes apparent. The true sources of his conception of the world lie in the most fundamental beliefs of ancient Italy. It is the view *sub specie aeternitatis* of mankind and of destiny delivered from the contingencies of *"hic et nunc"* which one finds first expressed in early Mediterranean myths and cults, and which later haunted the greatest poets, painters and sculptors of the peninsula—Dante, Giotto, Giovanni Pisano, della Quercia, Masaccio, Donatello, all true ancestors of Michelangelo.

His opposition to his epoch served only to help him express with more precision and force what he wished to say. He detached himself from the three great trends of the day—the lyric "romanticism," bourgeois naturalism and scientific realism. The first sprang from the "international style" which had flourished throughout the courts of Europe at the end of the fourteenth and beginning of the fifteenth century. This refined and elegant art corresponded to the taste of the *Signoria*. It was the style of Botticelli and Filippino Lippi in painting and Mino da Fiesole in sculpture. We find in their work a predilection for the arabesque in figure composition which is sometimes reminiscent of tapestry, sinuous contours, an archaizing stylization in landscape. Religious sensibility is here combined with a sensuality refined and somewhat decadent. For these masters art was a delectation of life.

Domenico Ghirlandaio and Cosimo Rosselli, the painters, and Benedetto da Majano, the sculptor, were among the representatives of the second trend, or the bourgeois naturalism. Their simple and weighty art, adapted to the taste of the day, appeared as a last impoverished flowering of the great indigenous tradition of the medieval *comune* which animated the works of Giotto and Masaccio. Of these they had conserved the essential rules of harmonious arrangement, but their compositions became routine and the excessive richness of details "à la flamande" brought down to a some-

[63]

what trivial level the older abstract and elevated style. Art had become for these artists a flattering mirror of reality.

The third current sprang from the independent, searching spirit of certain great geniuses of the early Renaissance such as Leon Battista Alberti, Paolo Uccello and Andrea del Castagno. In this period the greatest exponent of this artistic tendency was Antonio Pollaiuolo who distinguished himself by careful research in human anatomy and the mechanics of movement. To him art was knowledge.

The young generation of Florentine artists, those born between 1450-1470, already tended, however, toward different ends. Among these were Leonardo, Perugino and Lorenzo di Credi who worked in the school of Verrocchio. A little later in the atelier of Cosimo Rosselli, we find Fra Bartolommeo, Albertinelli, and in that of Ghirlandaio, Bugiardini, Francesco Granacci and Ridolfo Ghirlandaio. These young artists turned from the literal imitation of the material world and aspired to reconcile the vision of reality with an ideal of abstract beauty. They followed a theory which taught the selective approach in representing perfect beauty. Art was for them visualization of a normative world.

Michelangelo, like the rest of his generation, also turned away from the external realism of the fifteenth century, but the world to which he aspired was not one of perfected appearances but "true reality." He himself says later " 'l ver della beltà c'aspiro" (Frey, *Dicht.*, XXXII). He no longer considered the work of art as an imitation of visible reality, nor as the image of a dream world, nor as a means of arriving at knowledge of the universe, but as an embodiment of the very essence of human life and destiny. In this vision of the cosmic law of life in man, he relates himself to the wisdom of ancient Italy.

I. FOUNDATIONS OF THE NEW STYLE

MICHELANGELO, as apprentice of Ghirlandaio, received about the same education as other young artists of the period. The basis of all such training was drawing, "disegno," which was considered, as Vasari said, the parent of all other arts. Drawing in the workshops was done from both nude and draped figures. At the beginning of his training the pupil had to copy after the drawings of his master or other famous artists; later he could draw from nature. We know from Vasari that Michelangelo made such copies during his apprenticeship with Ghirlandaio but in them he proved himself an innovator.

The earliest preserved drawings by Michelangelo, except the Triton of which we shall speak later, are copies after Giotto and Masaccio. The date of their execution cannot be established with certainty, but it is generally supposed, and it seems rightly so, that of the five drawings which form this group (Nos. 2-6) the earliest were executed around 1488 and the others a little later, that is when Michelangelo was studying with Ghirlandaio and in the Giardino Mediceo. In his choice of models there is revealed already a personal penchant. Instead of copying the works of then fashionable artists (such as Botticelli, Filippino Lippi, or Ghirlandaio), he imitated the monumental frescoes of Giotto and Masaccio, artists who lived a long time before him—two hundred and one hundred years, respectively. He turns away, then, by this choice from the refined and decadent art of his contemporaries in order to embrace the most monumental tradition of Florence, the art of the medieval *comune*. In the works of Giotto and Masaccio he could find the beginnings of the concept that he himself was seeking. He has not, however, as an analysis of his copies will show, slavishly imitated the two masters. He completes and develops what in them is only hinted at. In his predecessors the folds of the drapery had always been subordinated to the composition of the group as a whole; taken singly, the figures and the details appear stiff and inorganic. Michelangelo succeeded in expressing with heretofore unknown intensity the effect of thick, pliable stuffs, the sense of controlling weight in them, and of the supporting force of the body, and thereby endowed his figures with a new assurance and monumentality. The relationship between body and drapery as cause and effect, barely indicated by Giotto and Masaccio, becomes the focal point of Michelangelo's studies; and spurred on by the new character which his figures thus acquired, he transforms similarly the heads, conferring upon them a psychic intensity which those of his artistic ancestors had not possessed. Without outward gesture or movement, they are imbued, through sheer weight and plastic volume, with a profound inner vitality which exceeds the limits of the ordinary measures of daily life.

Unlike his contemporaries, who in their drawings usually filled a sheet with a number of small studies, Michelangelo fills each page from top to bottom with one or more large figures copied from the old masters. This practice gives the drawings a certain monumental quality.

68, 72, 74, 76, 77

[65]

69 In a copy from the fresco by Giotto, the *Assumption of St. John* in Santa Croce, for
68 example, he takes two figures (No. 2) and transforms them. Certain details of the
clothing emphasize the structure of the body (at the knee, wrists and shoulder; and the
hat is changed to follow the form of the head). The material of the garments is an
actual stuff, soft and heavy. The belt serves not merely to mark the waist but to blouse
the upper part of the robe. By means of a fold inserted at the edge of the right sleeve,
and a crease at the knees, the garment takes on a real and pliable character. In the
figure itself he emphasizes the elements of bodily resistance. Not satisfied with the
passive position of the feet in Giotto's left-hand figure—which he at first copied exactly,
as can be seen in the drawing—Michelangelo made a *pentimento* to replace the left
foot, thus giving more stability and energy to the pose. He also changed the right hand,
which in Giotto is delicately passive and hardly touches the folds it is supposed to
grasp. Michelangelo draws a more bony hand, which solidly grips the robe. In the figure
leaning forward, he transforms the folds at the waist, giving them more plasticity and
rounded forms which harmonize with the movement of the figure. He differentiates the
facial expressions of the two figures by making one more youthful, and the other older.
In addition, he introduces a new element of contrast in their positions—the younger,
standing, sways slightly back and away from the other.

 Michelangelo even in this very early study represents drapery as a passive substance
with a definite character of its own. He is interested in the mutual relationship be-
tween body and covering and seeks to show each in its full importance, while in the
studies of earlier masters, the drapery had a character which was independent of the
bodily structure beneath. Leonardo (*Trattato*, par. 529*ff*) had criticized the confusion
of using too many folds, a device popular with his contemporaries.

 A new amplitude is found in the St. Peter which Michelangelo copied from the St.
71,72 Peter of Masaccio's *Tribute Money* in the Brancacci Chapel (No. 3). The weight and
volume of the figure are increased by a few telling additions, such as two large folds at
the back, which enlarge the silhouette, some creases and a rounded cuff added to the
sleeve to make it heavier and more palpable. He adapts the drapery not to the static
figure but to the figure in motion. The great rounded folds at the bottom of the robe
are moved forward and are accented by a series of corresponding lines under the arm,
which emphasize its movement. How much ease and freedom lies in this gesture as
compared to that of Masaccio! In the latter all the force of the representation is con-
centrated in the single gesture of handing over the tribute; in Michelangelo the gesture
is merely the simple act of a superior being, full of dignity. The head of Masaccio's
St. Peter, adapted from ancient sculpture, is transformed by Michelangelo into that
of a resigned old man with furrowed face, who has lived and suffered much.

 Even more characteristic of the new Michelangelesque spirit is the copy he made
after a work of Masaccio, probably a fresco, no longer preserved, from the Sagra di
74 S. Carmine as Berenson supposes (No. 4). Of this work there is another copy by an

unknown Florentine artist of the first half of the sixteenth century, preserved in the Casa 73
Buonarroti. This latter would seem to be a more exact copy of the original than Michel-
angelo's. It shows a group of figures, the first of which is enveloped in a large monastic
robe which falls at the back in a series of close, parallel and rounded folds. These
Michelangelo replaced by two large flat folds. The simplicity and weight of their form
contrasts with the gradations of the curving folds which hang from the arm, and which
have sharp corners; and a third fold has been introduced between the large upper
and lower ones. The object of this study is to demonstrate the contrast between the
passive weight of the drapery and the living force of the body beneath which directs it.
The static power of the main figure is reinforced by the vaguely outlined figures
behind it, which Michelangelo has not represented motionless, as in the anonymous
drawing, but animated by light movement. He has also transformed the face of the
main figure from that of a tender youth to a face full of mature power, with aquiline
nose and forceful chin, a face whose bitter, meditative character corresponds to the
grandeur of the ensemble.

A drawing in the British Museum (No. 6) depicts a bearded old man standing and 77
holding in his hand an object, possibly a skull. The most developed of this series of
drawings, it represents perhaps an alchemist [and resembles an analogous drawing
of Dürer (Lippmann, 456)]. It does not, however, seem a copy from any special model,
but an invention of the young Michelangelo in the spirit of his early studies from
the old masters. With clarity and method he establishes here a fundamental distinction
between the folds which express the weight of matter and those which indicate the
form of the body: the former are large and flat and seem to surround the figure like a
sort of tent; the folds which follow the body appear at intervals between. With this
new system of folds Michelangelo is able to give the effect of closed weight and bulk
and yet show the organic forms of the body beneath. This the Italian artists of the
fifteenth century had never achieved. If they wished to show mass and plasticity, the
forms of the body beneath the drapery were lost; if they wished to emphasize the
organic forms, their drapery was no more than a sort of veiling, and the plastic unity
of the whole was sacrificed. Only in Giotto and Masaccio was there a slight attempt
to combine both weight of matter and organic form. Michelangelo was the first to
evolve a real system in this direction, and in so doing reveals the mind of a born
sculptor in marble who wishes both to describe the organic forms and to maintain the
cubic integrity of the primitive block. Indeed he remained faithful to this drapery con-
ception in his marble sculpture up to his last epoch.

In technique Michelangelo follows Ghirlandaio's method of pen-drawing with cross-
hatching. It seems that Ghirlandaio was the first to use systematically this technique in 75
Florence, abandoning the parallel hatching formerly used in Italy. This new hatching,
sometimes heavy, sometimes light, does not necessarily follow the plastic form in

[67]

Ghirlandaio's drawings: it depicts the play of light and shade on the surface of the form, rather than emphasizing the form itself. Michelangelo, by contrast, uses the system of cross-hatching to describe perfectly the plastic forms. He wishes above all to show with complete precision all special elements of the form. He employs systematically hatchings of varying lengths, directions, and spacing. The closest hatchings are used for the cavities, but even here, in the darkest parts, the plastic substance is precisely rendered.

The masters of the Quattrocento had postulated the paper itself either as a neutral background (as in Pollaiuolo), or as light-filled space (as in Ghirlandaio's sketches for the frescoes in S. Maria Novella). Michelangelo, however, considers the white of the paper as a plastic substance—the original surface of a hypothetical block. He realizes the forms by "penetrating" in a succession of planes, by means of a differentiation of hatchings, into the "block," just as he was to do later in sculpture with a chisel.

In the group of drawings which we have just discussed one can see the development of this graphic system. The study from Giotto is still indecisive; its slightly unorderly lines are those of a beginner. In the drawings after Masaccio they become more precise and in the *Alchemist* attain full development. In the latter, a monumental effect is subtly combined with an extraordinary richness of detail. The slightest changes of the surface are made visible by a telling use of cross-hatching.

Through the imitation of Giotto and Masaccio, then, Michelangelo arrived at a new representation of the grandeur and dignity of man. He gave a new life and reality to their figures; he took from his models the majesty of the ensemble but set aside all conventional and typical elements, and added a new accuracy of observation in the details. However, this new quality of realistic detail does not bring the figures of his models to a trivial level (as sometimes in Ghirlandaio), but accentuates the reality of their ideal character.

In the workshops of Florence the nude was drawn sometimes from the model and, as Leon Battista Alberti had recommended in the *Trattato della Pittura* (ed. Papini, p. 60), by giving first the bones, then the muscles, and finally adding the skin. This process had been fully developed in the schools of Verrocchio and of Pollaiuolo. It had the drawback of differentiating bones and muscles more clearly than they appear in reality; these too sharp divisions precluded any soft, lifelike transitions and gave the figures the appearance of anatomical drawings. Leonardo (*Trattato della Pittura*, ed. Ludwig, §111) had already criticized this manner of representation, and found it tending to lack vitality. He suggests giving life to the figures by gestures and movements of the limbs (op. cit., §227). But Michelangelo seems to have been the first to try to represent the fluctuation of vital forces within the body, independent of the outward activity of gesture and movement.

This new concept is already apparent in Michelangelo's earliest preserved drawing,

68
72, 74, 76
77

the *Triton* in Settignano, which he probably executed shortly before entering Ghir- *67*
landaio's studio (No. 1). In the motif of the cloak blown out, sail-like, by the wind, the
drawing recalls certain antique sarcophagi. But here the body is no longer a static
agglomeration of muscles; it is a plastic volume animated by a breath of life—a stream
of vitality which courses through it and determines from within the powerful mass of
the torso. A dynamic force seems to surge up from below, is apprehended in the vibrant
contours of the body and its undulating surface, and terminates in the gesture of the
raised right arm—still somewhat awkwardly indicated. The great vault-like cloak serves
by means of contrast to heighten and set off the powerful plasticity of the body. This
familiar motif, which both for Antiquity and for the Quattrocento had remained
merely ornamental, here becomes an essential element in the composition of plastic
volumes. This new and surprising principle is not, however, followed throughout the
whole body, and we still find traces of the old external realism; for example, in the wiry
arms which are very much in the style of A. Pollaiuolo (see his engravings, B2, p. 4,
and his Hercules slaying the Hydra in the Uffizi).

The nude studies preserved from Michelangelo's youth from around 1501 to 1506
show how this new concept of the human body gradually drives out any trace of the old.

Although to treat here the drawings from the years 1501 to 1506 may seem to antici-
pate somewhat the works of that period, they are yet so revealing as to Michelangelo's
method of work and the constitution of the new style as to justify a discussion of them
at this point. What is more, no drawings from the Bolognese or the first Roman period,
except one, have been preserved.

This solitary drawing (No. 7), probably from the Roman period, is a page in the *78*
Buonarroti Archives which shows a nude figure *écorché* seen from behind, also two
legs and a hand. They are drawn with light flowing lines in pen, and the delicate form
of the legs recalls the finesse of the forms of the Christ in the Pietà of St. Peter's. It *32*
differs from the more concise and penetrating strokes of the drawings made after 1501
in Florence. Thus this page gives us a sample of what the lost drawings of the first
Roman period must have been like.

Among the early drawings of Michelangelo there appear simultaneously a variety of
types. These may be classed, first as *pensieri* or rapid sketches, in which the artist jots
down on paper with a few vigorous strokes a basic idea, such as the pose or the move-
ment for a statue or relief. In such cases the contour dominates; the lines full of dy- *93, 98, 106,*
namic tension both describe the forms themselves and suggest the forces contained *125*
within. The interior modelling is limited to a few rapid strokes. Here Michelangelo
uses a shorthand method where certain abbreviations indicate the different parts of
the body. This was not an entirely new device; it had been familiar to fifteenth century
masters. But Michelangelo succeeded in rendering with a precision heretofore unknown
and with great economy of line, the plastic and dynamic character of the body. This

sobriety of line reveals itself in the tendency to make straight strokes and to avoid curves if possible. There is no calligraphic play whereby the artist's hand gives free rein to vagaries of his temperament. He controls by an extraordinary will the passion which seems to tremble in his lines. His are indeed the sketches of a sculptor; form alone is important and the figures themselves seem to be set out in a void, with complete disregard for any environment.

83,85,87,88,
92,94,112,114

The sculptural spirit of the master is revealed with equal force in a second type of drawing, the detailed studies. In these the contours are lightly indicated, and by contrast, the modelling of interior forms is carried out in a detailed cross-hatching technique. Again Michelangelo considers the white paper in itself as a kind of matter, into which he penetrates in successive planes with his lines, as though working with a chisel in marble. The white areas determine the parts in highest relief; the direction and spacing of the short, powerful hatchings determine the concave forms. At the same time he succeeds in suggesting the play of light and shadow on the forms. It is not, however, a light with an independent existence of its own apart from the form. It seems to owe its existence solely to the undulations of the surface itself. The effect is like that of polished marble; the projecting parts glisten, and the concave parts, forming shadows, are lit by half lights. Michelangelo, as we shall see, was to remain faithful to this luminary principle, or to what may be called a "sculptural light," even in the

127 red chalk drawings of his maturity.

These studies are not, as is generally thought, made from living models, but are recollections of some past work of art in pose and proportions. Usually they go back to antiquity; less frequently to some Renaissance work. By this means he gives his studies an ideal character. To these basically ideal figures, however, Michelangelo always adds his own experience of reality, and herein lies the originality of his method. Up to the fifteenth century an artist might choose between making a study either from nature or a copy from antiquity. These remained for him the two alternatives. Michelangelo achieved for the first time a true synthesis of nature and antiquity: he sought to make statues take on the character of living beings. With him, the ideal form becomes animated as though made of flesh and blood.

The derivation of figures by Michelangelo from the art of antiquity is to be specifically seen in several drawings of this period. Thus the figure at the left on the Louvre drawing (No. 14) in spite of its lively and spontaneous movement is a souvenir of an

88,89,90 ancient statue on the Fontana Cesi in Rome. The main figure in the same Louvre drawing, sometimes thought to be a Mercury and sometimes an Apollo, is really a drawing originally of a Mercury, which Michelangelo reworked into an Apollo, as can be seen by the two different inks. The contraposto of this figure resembles antique statues of the fourth century B.C., but the modelling of the body is completely different from that of the ancient works and was invented by Michelangelo.

92 Another drawing (No. 15) is reminiscent of one of the Dioscuri on ancient sarcophagi

(e.g. the Sidamara sarcophagus). The structure of the body, however, in its organic 91
unity is again explicable only by Michelangelo's direct study of nature. (This drawing
was used in part, as we shall see, by Michelangelo for his marble David: the right leg of 36
the figure, as well as the torso, resembles this statue.)

The studies which are on the recto of the page at Chantilly (No. 17) were done about 94
1503 and include among other figures a nude woman, of whom there are two views,
one from the back and the other in profile. These are drawn from memory, probably
after the central figure of the monument of the three Graces in Siena, an ancient group 95
which Michelangelo could easily have studied there. He follows the same method still:
the pose is antique, while the structure of the body is original with him.

One of the beautiful nude studies in London (No. 23), executed about 1504-1505, 114
in the Cascina period, is reminiscent of the Apollo Belvedere. The pose is an exagger- 113
ated version of that of the antique work. Michelangelo evidently did not wish to imitate
the latter, but rather evoked it in his memory only to give it a new life. The contours
are drawn in light strokes with the extremities barely indicated; the torso, however,
which seems modelled by interior forces, has a masterful quality which surpasses the
drawings considered so far.

The drawing of a nude seen from the back in the Casa Buonarroti (No. 22), was 112
long considered a study from nature until Wilde showed that it was taken from a
Hercules on a sarcophagus at the Lateran, or rather from a wax figure made from this 111
Hercules.

A last example may be found in the figure of a nude youth on a page in the Louvre
(No. 35) who in his violent contortions gives a kind of synthesis of the action motifs 125
of the Laocoön.

We see that Michelangelo looked upon the art of antiquity not as the historical
remains of a past age, as did those (Ghirlandaio, for example) who studied them from
an archeological point of view; nor did he consider antiquity as the dream of a golden
age, a distant Utopia, as did others (Botticelli) who drew their inspiration from ancient
literature. Ancient works of art were for him an expression of the eternal essence of
life. When he gives to his works or drawings a classical character, it is to set them apart
in time and space. Antiquity for him is reality grasped *sub specie aeternitatis*. The
antique thus regarded must inevitably produce results directly contrary to those of
the masters of the Quattrocento. These had tried for a precise imitation of its sculpture,
misunderstanding the while its underlying spirit. Michelangelo, freer and more inde-
pendent with respect to any particular works of antiquity, yet came much closer to their
essential character. He had stored up in his memory a repertory of classical poses and
figures which served him in an infinite number of combinations and transformations
and into which he inserted the wealth of his own knowledge and experience of nature.

In these studies of the nude Michelangelo does not, like artists of the fifteenth
century, attempt to render the appearance of figures with external surface realism. He

aims rather at an ideal rendering of the structure of the human body, considered as an organic unity animated by inner vital forces. It is significant that we find no strictly anatomical drawings by Michelangelo. Bones, muscles and nerves are interesting for him not per se but only in their plastic functions—as forces which model the body.

81,123 The third and last type of drawing consists of the studies in composition (for example, the two compositions of St. Anne, Nos. 9 and 33). These, too, are a sculptor's drawings: composition for Michelangelo concerns only the plastic group without regard for the surrounding space. This last type forms a kind of synthesis of the other two; the artist sets down his basic idea, as in the first type, but executes it in detail by means of cross-hatchings, as in the second.

The chronology of the drawings from the period 1501-1506 has been the subject of much discussion. But on the basis of a few which may be approximately dated with some certainty one may attempt to establish some sort of sequence from which to form an idea of Michelangelo's evolution as a draughtsman (see Catalogue). At the outset, in *83,84,85,87,* 1501, the lines, still somewhat irregular, tend to overrun the forms; later they are *88* systematized, become longer and are generally curved to follow the contours of the form they model. The total impression gains in restraint and homogeneity and at the same time in plastic richness. The lights and darks are now so distributed as to set up a greater contrast, and Michelangelo models the particular forms with reference to the *112,114* modelling of the volume as a whole. The latest drawings in this series (Nos. 22 and 23) offer the best examples of this cross-hatching technique: the lines, longer than in the drawings of around 1501 and slightly curving, give—in combination with the white of the paper—all the richness of surface modelling plus the plasticity of the form as a whole. Yet even here, light and shade, for all the heightened contrast, serve not for pictorial dissolution of form but to reinforce again the volumetric character, and the drawings remain intrinsically plastic.

The artists of the Florentine Renaissance had customarily conceived of drawings either as preparatory studies for a specific work, or as exercises in manual dexterity. For Michelangelo, on the other hand, drawing was in his youth generally independent of any special work to be executed. He used it for the solution of problems of a purely objective kind, such as for the clarification of the plastic mass of the body modelled by its inner tensions, or for the action or pose of a figure, or the grouping of several figures. He has, in fact, left few preparatory studies of details. It may happen that he takes up a *98,99* *pensiero* some years later (cf. for example the No. 18 of ca. 1503, and the Bargello Tondo of ca. 1505); or again he may revert in a drawing to an idea already carried out in marble (for example, the sketch, No. 24, dated, on the evidence of Milanesi, p. 6, *100,102* about January 31, 1506, which is a memory sketch after the Bruges Madonna, executed ca. 1501). An idea already realized can thus become the starting point for new draw-

ings; and such anticipations and revivals occur frequently. Yet even those studies which he did with some particular work in mind (as the study of an arm for the marble David, No. 16, or the arm for the St. Matthew, No. 35) are completely transformed in the 93, 125 execution of the final work. The study of the detail, which had given merely the normative form, is recreated according to the requirements of the ensemble. The "mosaic" method of the ateliers, where the final work was the result of the addition of a number of preparatory studies, is replaced here by ever spontaneous creation.

The abundance of Michelangelo's vision is such that the creative process consists less in the perfecting of an idea, than in the execution of a succession of ideas, each of which is a unity per se. It is not a question of corrections or amplifications but of new creations. He always wishes to create spontaneously. As in his marble statues he approaches the final work by executing "several figures one beneath the other," each having its own artistic value; thus the conceptions in his *pensieri* are more or less autonomous works of art, containing beauties which he would sacrifice to seize upon others in the course of execution. It would therefore be inadequate simply to consider the *pensieri* only as preparations for works; we must look upon them as complements of the works to which they are related.

What is true for the *pensieri* is also valid for the *studi*. They also have their own problems, and even when Michelangelo executes them *ad hoc*, he recreates them completely in the final work.

II. PRIMORDIAL VISIONS OF LIFE AND DESTINY

It is not unusual for an artist to reveal in his earliest creative attempts the whole essence of his genius in embryonic form. Only in a second stage does he try, through the acquisition of technical ability, to make his personal conceptions conform to the requirements of his age, although this sometimes at the expense of his own originality; and in a final period he may then achieve a true integration of external ability with his original artistic vision. Thus in Michelangelo's two earliest marble reliefs, the Virgin of the Stairs and the Battle of the Centaurs, both in the Casa Buonarroti, we see his new art revealed in full.

1, 3

Yet these two works are utterly different in composition, subject, and technique. The Virgin is notable for its quiet and austere spirit, while the Battle seethes with tumultuous life. In the Virgin we find a flat relief dominated by one great figure; in the Battle Michelangelo used high relief and shows a mass of bodies entwined in violent movement. One has a Christian, the other a pagan, subject. In one, Michelangelo concentrates upon Beauty's inner image; in the other, he strives to give expression to the vital forces that throb in him. The Virgin of the Stairs emphasizes more the death-aspect of existence, the Battle of the Centaurs more the life-aspect, actually two sides of the same problem. We shall see that throughout his youth Michelangelo remained true to this method of creating contrasting pairs. The reason may be explained as the need of the artist to express in opposing representations the chief aspects of life which he was only later able to synthesize in his great "encyclopedic" works.

The Virgin in profile is seated on a simple square block of stone. An austere figure with pure features, she seems absorbed in thought and oblivious to the world about her. Realism in portraying face and drapery is avoided. Her profile is "antique," her cloak ideal. A soft veil falls gently around her body. It opens at her lap and the Herculean form of the Child emerges from the cloth as though from the womb of his mother. He is completely enclosed in the silhouette of his mother as a seed in a fruit. The two figures seem indissolubly combined as two manifestations of a single being.

1, 2

Such an interpretation is far from the usual representation of Florentine Madonnas (1, 4). In them, the Virgin is a graceful, rather mundane young mother, looking with tender smile down on her child or out to the spectator. She is represented in customary, everyday relationship to her fellow beings and surroundings. Michelangelo's Virgin, on the contrary, is freed from the *hic et nunc* and spiritually absorbed in austere contemplation of the Absolute.

The figure of the Virgin represents here in the first place the genetrix bringing forth life from her lap, and in addition the Sibyl whose grave and mysterious gaze seems to penetrate the future and to see the tragic destiny of Him to whom she gave birth. She shows no maternal fear or suffering as do the tragic Madonnas of Michelangelo's predecessors (Giovanni Pisano and Donatello). The maternal anxiety for her offspring,

134, 136

[75]

instinctive in every mother, here seems overcome. Knowing the implacable law of existence, she faces it with stoic composure.

2 The Child is a significant invention by Michelangelo in the sense that he is a small "hero" type rather than the usual infant. His muscular form is relaxed but even in its passivity shows great potential power. The back of the Christ Child is turned toward the spectator—something without precedent in the iconography of Italian art.

The utter relaxation of the sleeping Child has a deathlike aspect. His head lies heavily on his shoulder, the small athletic arm falls lifeless and twisted behind the muscular back in an attitude Michelangelo was to use again much later in the dead
131 Christ of his Pietà in the Cathedral at Florence (1, 9). Death is conceived as an integral part of life. It comes not as an enemy from without but is inherent in human existence from birth.

2 The same twofold aspect is found in the children of the background. They seem to be engrossed in play as they spread out a cloth. In reality this is an allusion to the death of Christ, for these children enact the roles of the angels who in some Pietàs hold the holy shroud behind the dead Christ (1, 6).

This "Virago" is a vision of the primordial Mother, as mankind has envisaged her from the beginning of time. In this proud image are renewed many old beliefs of man, which depict woman as both creator of life and keeper of death. Michelangelo has integrated the Christian Mother of God with the Demetrian principle of woman (1, 5).

To this content corresponds a new feeling for form, turning away from the delicate, gracious and pleasing to simplicity, seriousness, and concentration. It is characteristic, as Wölfflin pointed out, that the hands no longer grasp with gracefully spread fingers, but take hold of the cloak with a simple, limp movement.

The composition is for the most part Michelangelo's invention. Representation of
135,136,137 the Madonna in full length in reliefs is an exception in the Florentine Renaissance. The inspirations seem, characteristically, to have come from antique steles.
132 Michelangelo's Virgin of the Stairs recalls certain Greek grave reliefs on which are represented a woman seated, wrapped in a mantle of mourning and sunk in stoic meditation of death. It is possible that the young Michelangelo was familiar with this ancient stele type, in fact, one of them (a poor copy) is still to be found in Florence (once in the
133 Palazzo Medici). Michelangelo's Virgin resembles this ancient composition, the solemnity of which was much nearer his conception than the seated profile Madonnas of the
136 to 139 Quattrocento which were earlier believed to have served as prototypes for the Virgin of the Stairs (1, 7, 8).

Michelangelo does not, of course, follow the ancient images literally. The twilight state of the departed souls represented on the ancient stele is transformed into a grave awareness of destiny on the part of the solitary mother.

Michelangelo chose *rilievo schiacciato*, very flat relief, as the technique best suited to expressing this highly spiritual ideal (1, 11). Donatello had inaugurated its use more

[76]

than half a century before when he wished to accentuate the effect of polished marble surface. He used it, however, in a pictorial spirit, seeking to give in his reliefs the effect of painting. Michelangelo's use of this technique is new. His composition is inspired by the nature and form of the marble; he preserves at the edge a small strip of the original *1* face of the block, which forms a kind of frame about the composition and at the same time indicates the original surface. He constructs his composition by use of gradations in cutting in successive layers which correspond to the structure of the stone itself and each one of which relegates figures to their respective planes. Here we have the trait that is to distinguish all Michelangelo's future work and reveal his nature as that of a truly great sculptor in stone, in that he preserves always the integrity of the material and brings forth the artistic idea inherent in it.

The Battle of the Centaurs and the Lapiths seems to be the antithesis of the Virgin *3 to 6* of the Stairs. The theme of the battle relief is apparently inspired by Ovid's *Metamorphoses* (Bk. xii, l. 210ff), or by the version of them that Boccaccio gives in his *De Genealogia Deorum*, for the three chief motifs correspond to those of the main scenes of the battle described by Ovid, namely, the rape of Hippodameia, the combat of the centaur Eurythion with Perithous, and Theseus defending the latter (ii, 4).

In the midst of these nude fighting bodies stands the figure of the centaur Eurythion. *5* His right hand is raised for a blow, his left still lowered, wrapped in a skin. Theseus stands at his right and seems to be waiting for the blow which he will parry with his *4* raised hand, and then attack with a rock which he holds in the other. Behind Theseus stands a bald, bearded man, reminiscent of portraits of Socrates. He is likewise armed with a huge block, and is coming to the aid of Theseus. In the center a woman—Hippo- *5* dameia—is held prisoner by a Centaur, while Perithous comes to her assistance; he grasps her with one arm at the nape of the neck, seeking to drag her off to save her from the fatal embrace. Perithous, the protagonist of the scene, is shown from the back and is not a prominent figure. Michelangelo subordinates the individual action of the hero to the total event. Other motifs of the battle are developed around the central figure; one is hanging with both arms from the head of his opponent and attempting to pull *6* him down; a woman is clasped from behind by a pair of arms and resists her captor; in *4* the upper left corner there is a bowman, and in the upper right a figure raising a club *6* for a blow; there are fleeing women at the top edge and fallen Centaurs at the bottom, of whom the middle one is especially expressive: the whole weight of his mighty body *5* rests on his right arm in a movement that presages the lying figures of the Times of Day in the Medici Chapel.

Michelangelo used the story, however, only as a pretext to represent the primitive struggle of a race of Titans, who are fighting for their very survival. Actually the relief does not show an ordered battle among definite adversaries in a definite place. It is hardly possible to distinguish Centaurs from Lapiths, and Lapiths from the women.

Instead of the purposeful activity of individuals, we see unchained energies which seem to struggle through these bodies. The movements of these vague and unfinished figures spend themselves in vehement contortion and yet attain no precision in action. The heads, each square, with a low forehead and heavy shock of hair, have a dreamy, almost unconscious, expression.

Battle does not mean here merely a summation of two opposing forces with one victorious and the other vanquished as in all earlier battlepieces since ancient times; it is rather a completely homogeneous, indissoluble event of which the dualism of the forces is only one manifestation. It is Life as a continuous stream of forces which encloses within itself the manifold destinies of individual existences.

The composition is not made up of a grouping together of separate bodies; the bodies seem to be, rather, differentiations of a united whole. (The figures do not separate themselves from their background but all emerge from it.) Bound to the original matter and to one another, the figures seem ramifications of a single organic entity.

3 A simple symmetrical disposition of the figures over the surface is the basis of the composition. The new feature is that this symmetry is not revealed directly but is so skillfully concealed that at first it is not noticed. It is because of this hidden symmetry that the involved knot of figures does not give the effect of unmastered chaos. On the other hand, its rigidity is not apparent and thus does not rob the whole of motion. The four corners and the middle axis are emphasized by a figure in each. From the figures in the two lower corners diagonal lines lead upward, crossing at the head of the chief central figure. From the two figures in the upper corner, two diagonal lines lead downward crossing in the head of the dead Lapith in the center. At the intersection of these two triangles are placed two figures as lateral axes. But this geometrical pattern is overlaid with a great rotary movement, which floods about the central figure. It begins in the upper right background, flows downward through the entwined limbs of the fighters, ascends then from the center toward the left, where it breaks on the opposing impetus of the figures coming from that direction. This whirling movement, expressing the fateful life-stream, realized here for the first time, was to appear again in Michelangelo's later great compositions with many figures, namely, the Battle of Cascina and the Last Judgment.

The sharply projecting plasticity of this relief corresponds to the subject matter. In contrast to the quiet Madonna in low relief, Michelangelo chooses here high relief (*mezzo rilievo*), the artistic principles of which Vasari defined as containing three strata of figures: first a series of whole figures worked out in half-round or more; then a second row partly covered by the first, in lower relief; finally a third stratum, partly concealed by the second in completely flat relief. Vasari specifically says that this is a technique of the ancients (Vasari, ed. Milanesi, Vol. I, p. 156; II, 8). Since Ghiberti's bronze doors this technique had attained a high peak of development in Florence.

From his compatriots Michelangelo inherited the talent for modelling even the smallest figures in a monumental style. However, he differs from the Florentine tradition in striving to preserve the unity of the material. All these figures are modelled in accordance with the convexity of the stone of which they are only *a posteriori* emanations. To make us aware of the unity of the material, Michelangelo never separates the figures completely from the marble—heads, arms, legs, even the forms in the foreground taper off into unworked material. The result is that Michelangelo's figures do not give the impression of being merely applied to the surface as is the case of Roman high *142* reliefs and others of the Renaissance, but on the contrary seem to spring from the *143* material.

The Battle of the Centaurs approaches certain ancient battle reliefs in compositional elements, such as the covering of the entire surface with closely massed bodies, as well as the basic scheme with emphasis of the middle axis and four corners. The insertion of two lateral axes is also to be found in ancient works, as for example, on the sarcophagus in the Museo delle Terme in Rome, which represents the battle of the Romans and *142* Barbarians (II, 5). But in his Battle, as in the Virgin of the Stairs, Michelangelo shows himself no mere imitator of the antique. In the Roman battlepiece just mentioned the warriors are clothed, and thus is lacking the impression of pulsating life which flows through the nude bodies of Michelangelo's figures. Also, there is more space between the figures, and the forms are separated from the background and appear to be applied to the surface. Finally, the Roman relief lacks the sense of whirling movement which pervades and unifies the later work.

In these first two reliefs we see that Michelangelo is masterfully able to vary his instruments according to the melody of his subject.

Michelangelo's entire future evolution seems formulated in these two works. The Virgin of the Stairs anticipates the Sibyls on the Sistine Ceiling, the gestures of her hands are found in the Moses of the Tomb of Julius II. The position of the Christ *129* Child is to reappear in the gigantic figure of Day of the Medici Chapel and his right *130* arm is found in the Pietà in the Cathedral at Florence. The children playing in the *131* background reappear as putti in the Sistine Ceiling. Michelangelo's Battle of the Cascina and the Last Judgment show that he had in mind the same composition which he used for the Battle of the Centaurs, in which he had manifested, moreover, his predilection for representing the flow of vital forces within the human body. All the future art of Michelangelo was a development of the themes of these two early works.

Two great works followed the Virgin of the Stairs and the Battle of the Centaurs. These were a Christ on the Cross, of wood, almost life size, and a marble Hercules, more than life size, both now lost. To judge by the subject matter, Michelangelo was again

preoccupied with life and death aspects of existence, as described above, this time in a monumental way, in separate great free-standing statues.

Michelangelo executed the Christ on the Cross for his friend the prior of Santo Spirito (XIII). The work was originally intended to be placed "over the half-circle of the main altar" (Vasari, 1568, p. 31), a rather indefinite designation that can refer only to the arch situated behind the main altar which formed one of the two entries to the old chancel of the choir. This hypothesis is supported by a drawing by G. A. Dosio in *151* the Museo Topographico in Florence, showing the interior of the Church of Santo Spirito with the old chancel, wherein a crucifix may be recognized on top of the arch in the rear.

The crucifix of Michelangelo was later removed to the sacristy where Richa (1761) *147* saw it. There exists today in the Sacristy of Santo Spirito a sort of armoire dated 1584, in the center of which is a large niche evidently intended as a frame for a crucifix. Probably this piece of furniture originally served as a frame for Michelangelo's crucifix which, according to verbal tradition, disappeared around the beginning of the nineteenth century and was replaced by the present crucifix, made of wood and somewhat *145, 146* smaller than life size. This may well be a fairly accurate copy of Michelangelo's work, at least in the composition.

From the time Michelangelo made his Santo Spirito crucifix (1492) the older axial type of Florentine crucifix is replaced by a new type, in contrapostal position, which greatly resembles the crucifix in Santo Spirito. In the fresco by Perugino in Santa Maria *148* Maddalena dei Pazzi (commissioned in November 1492, hardly more than a few months after Michelangelo had finished his own work, but not unveiled until April 1496) one sees the same position of the body and the same manner of draping the loin-cloth, with the large knot at the right hip. That this work was probably produced under the influence of Michelangelo is indicated by the fact that Perugino in his earlier crucifix (Washington, National Gallery of Art) had followed the old axial type. One can observe in an almost unbroken series the influence of Michelangelo on crucifixes throughout the sixteenth century. The works of Benedetto da Majano in the Cathedral at Florence, of Fra Bartolommeo in the Museum of San Marco, of Albertinelli in the Certosa, of Baccio da Montelupo e.g. in the Badia in Arezzo—up to those of P. Tacca in the Cathedral of Pisa and Prato, in Santa Maria di Carignano in Genoa, and of Giovanni da Bologna *150* in Impruneta and in the Santissima Annunziata in Florence—all show the same Michelangelesque type of Crucifix. One finds that the master used the same disposition of the figure of Christ in certain of his later crucifixes executed around 1545.

It is difficult to draw further conclusions on the basis of this copy, but it seems certain that the contrapostal crucifix introduced by Michelangelo replaced a traditional representation centuries old. The Florentine crucifixes of the first half of the Trecento were Gothic in spirit and influenced by French art. They represented the body of Christ with

knees and head bent in the same direction, which produced a moving effect of pain but did not permit harmonious balancing of the nude body. After the middle of the Trecento the Italian artists replaced the old crucifix type with a new one (cf. Taddeo Gaddi in the refectory of Santa Croce which seems to be the earliest example) in which Christ is shown full face in an axial position with the knees slightly parted. The plastic possibilities of this new conception were suited to the spirit of the Quattrocento, which was absorbed above all in the study of the nude.

Michelangelo goes back to the broken type of Christ's body characteristic of the 145 Middle Ages, with the difference, however, that he turns the head and knees in opposite directions. While thus returning to the expressive power of the medieval type, he introduces at the same time the contrapostal body position, and so gives to the image a balance and harmony that correspond to the spirit of the new classical style.

The Hercules was a marble figure executed by Michelangelo "for his own pleasure" (XIV). Our knowledge of this sculpture comes from an engraving by Israel Sylvestre 152 which shows the Jardin de l' Estang with Michelangelo's statue set up in the middle, on a high pediment bearing the monogram of Henry IV. This engraving reveals only a rear view of the statue. From this we can see that the body was massive, the head small and round; the figure stands in a contrapostal position and leans on the left leg; a lion pelt is fastened at the right shoulder, and hangs down over the left arm. Hercules probably held the apples of the Hesperides in the left hand and in his right a club, which touched the ground beside his right foot. We can discern that the outline of the figure is closed in contrast to figures of Hercules of the Florentine Quattrocento, which are always represented with outspread limbs and one hand resting on the hip, in the position of Donatello's David (cf. Hercules of Pollaiuolo and Bertoldo). Michelangelo's figure is closer to the antique types of the hero, except that the silhouette of his work is even more compact. In the ancient representation, the lion skin hung down vertically from the forearm and formed, together with the club on the other side of the statue, a sort of frame for the body; or else it hung down the back of the figure and was fastened in front at the neck. The idea of letting the lion skin fall diagonally across the figure seems to have been an innovation of Michelangelo's, as a means of emphasizing plastic roundness by the folds of the pelt.

Unfortunately, these few observations based on the poor engraving are all that can be made concerning the statue. It is not possible to say whether Michelangelo attempted to symbolize Fortitude in this early Hercules but it seems quite probable, if one considers that later, in the marble David, he followed this tradition.

III. DIFFERENTIATION OF EMOTIONS

THERE seems to be an interruption in Michelangelo's artistic development after the great promise of the two Florentine reliefs and the two statues; the only commission he had was to execute three small statuettes at Bologna. But these show that inwardly he continued to mature. We see that he is trying to overcome a certain vagueness and lack of precision in psychical characterization; there is now a desire to vary the emotional character of his figures. Only later in Rome does he feel the need to differentiate also in external forms.

It was fortunate that at Bologna he was able to see and study the chief works of Jacopo della Quercia, the most emotional artist of Italy. In the art of della Quercia Michelangelo found a conception which could give him a new assurance in the pursuit of his own ideal. For della Quercia, as for Michelangelo, art was not a realistic reflection of the world of appearances but a transposition of the inner life, the life of the soul, into a plastic form at once passionate and heroic. As early as the beginning of the Quattrocento della Quercia had arrived at a union of the monumental, antique-like forms of the Pisani and the gentle, pleasing curves of the Gothic style, adding to these an entirely personal emotionalism. The soft but full and heavy draperies that sometimes pour like lava over the figures are for della Quercia the immediate expression of the moods of the soul—the figures themselves seem to be incarnated passions. That which Dante and later Alberti had announced as the chief aim of art, namely the direct translation of the "movements of the soul" ("movimenti dell'animo," Alberti) into works was first realized in sculpture by della Quercia, who thus unconsciously prepared the way for Michelangelo.

Only the difference of time and school separates these two spiritual brothers. We still find much of the Gothic stonecutter in the heaviness and rudeness of della Quercia's forms and technique. Michelangelo, on the other hand, is the heir of a great artistic tradition and has at his command technical ability which is richer and more refined. Beside the works of the older sculptor, Michelangelo's Bologna statuettes seem almost delicate.

Confronted with the artistic task of adding the three missing statuettes to the tomb of St. Dominic, which was left unfinished by Niccolò dell'Arca, Michelangelo had to adapt himself to the whole preestablished plan and program (III, 3). On the other hand, he sought, within these limitations, to give expression to his own personal conception. He was not content with conceiving his figures as mere external decoration of the monument, but he drew an inner connection between the idea of the tomb-reliquary and the emotional attitude of his figures: he conceives them as guardians of the holy ashes. Thus he gives all three of his figures a higher spiritual mission, which he differentiates in each figure. If all the figures had been by Michelangelo, there would be today in place of the monotonous row of mild, devout saints, a gallery of "men," each discharging in its own personal manner its superindividual mission. It is the conception

7

of a whole, the parts of which are conceived as emanations of it, which replaces here the older conception in which the whole is a mere addition of individual, mutually independent parts.

8 to 12 Of Michelangelo's three figures on the Arca di San Domenico, the Kneeling Angel seems to have been the first executed. We see much resemblance to his earliest Florentine works: the generalized form of the angel's head is still quite near to the heads in the Battle of the Centaurs.

The most striking characteristic of Michelangelo's kneeling angel as compared to its pendant, the angel of Master Niccolò, is the liturgical solemnity with which the former fulfills his office and honors the founder of the order. He acts as watchful keeper of the grave, holding the candelabrum not in bare hands but in a fold of his garment, in accordance with ecclesiastical custom. His parted lips breathe emotion. The countenance has nothing of the delicate, individualized traits found in the faces of Quattrocento angels. Michelangelo's is an idealized head in which all personalized features are consciously suppressed in order that the generalized character of this being and his complete absorption in his mission may be more definitely accentuated. To this mission is subordinated the whole figure. Michelangelo makes the candelabrum large and heavy in form. He gives a new stability to the pose of kneeling, as contrasted to the light, fleeting movement of the Quattrocento angels. The plastic structure of the body is allowed to be felt through the soft, heavy folds of drapery, whereas in Niccolò's work the clothing is like a curtain behind which the bodily form disappears. It is interesting to compare the backs of these two statues from this point of view. In the work of the earlier master, broad, straight folds fall down in vertical lines and give no hint of the exact position of the members of the body behind them. In Michelangelo's statue the drapery winds about the form, at once enveloping and emphasizing it.

In these soft, swelling folds it is easy to recognize the influence of della Quercia. One finds, for example, similar fold motifs in the figure of the kneeling king in della Quercia's Epiphany, a relief which adorns the architrave of the portal of S. Petronio. Noteworthy are the heavy, vertical folds of the robe which hang down over the raised knee without completely covering the leg, and also the curved folds enveloping the other leg and accentuating its plastic form. On the other hand, Florentine traits are recognizable in the cut of the garment with its closely fitting sleeves, in the concave folds framing the shoulders, in the heavy masses of hair, and in the spiral canalures of the candelabrum, all of which one finds in Luca della Robbia's Angel in the sacristy of the Cathedral in Florence. Michelangelo, however, fits the garment to the body more closely than did della Robbia, by means of a girdle at the hips. In this synthesis of Querciaesque and Florentine elements the Bolognese works of Michelangelo seem a logical development of the tendencies discernible in his first works.

13 to 16 The *élan* which fills the statuette of Saint Petronius seems to be motivated by his sacred mission, raising him almost to a state of exaltation, which finds expression in the

whole attitude of the figure, and in the dishevelled folds of the mantle which, against the law of gravity and as though lifted there by an invisible wind, are flung up and around the body. An impulse toward heaven seems to possess the figure. Starting at the feet, vertical folds of the under robe lead into vertical folds of the mantle, which in turn lead up to the right hand of the saint, whose head is also in this same axis—all of which combines to give this figure, which curves slightly, an *élan* upwards.

It is the first time in the work of Michelangelo that drapery directly adds to the spiritual significance of a figure, and helps express the artist's intellectual conception. In later works this element is still further developed.

Undoubtedly this figure was first inspired by della Quercia's statue of Saint Petronius, which still stands above the main portal of the Church of S. Petronio in Bologna. *160* The contrapostal position of the figure, the soft, swelling folds of the mantle, the intense expression of the bearded face, are all found in the work of della Quercia. But della Quercia's Saint Petronius is only passively moved. He holds the model of the city as an attribute in one hand and without any particular care. It was Michelangelo's idea to *13* make the model the central point of the composition as well as the cause of the emotion of his figure. His saint grasps the model in both hands and holds it with a protective gesture like a precious reliquary. This is not simply an external attribute, but an essential inner property. The saint effaces himself as an individual before this higher mission.

Saint Proculus, the warrior patron of Bologna, is represented by Michelangelo as a *17 to 20* sentinel, in a fit of rage forbidding the vulgus approach to the sanctuary. He has involuntarily seized his mantle with his left hand, while his right arm (of which the hand originally held a lance: III, 1) jerks upward with a reflex movement. The face, with its *20* eyes glaring out of the corners, its low furrowed brow and the fleshy lips, that seem to tremble with indignation, already presages the expression of scorn and anger on the face of the marble David, the Moses and the Brutus. The passion here rules the entire being, *40* whereas in statues of the fifteenth century, even in those figures which were meant to express great emotion, the body remained impassive and signs of inner disturbance appeared only in the visage.

Of the works of the Quattrocento Donatello's Saint George is the most nearly related *162* to Michelangelo's Saint Proculus. The volute-like mantle which hangs down behind the left shoulder of Michelangelo's figure appears to have been made with the image of the Saint George in mind, while the cut of the garment is reminiscent of Donatello's David of the Casa Martelli, now in the Widener Collection. But whereas Donatello concentrates all emotional expression in the countenance, Michelangelo animates the whole form.

With the Saint Petronius and Saint Proculus Michelangelo again created antithetical figures. In the one, we see exaltation through devotion to a sublime mission; in the other, the anger and heroic scorn of a higher being for earthly bonds. Here the adoles-

cent Michelangelo turns with resolution from the sentimental and luke-warm religiosity of his period to embrace the heroic ideal of faith—an attitude which was probably strengthened, as we have said, by contact with the sermons of Savonarola in Florence.

The inspiration from della Quercia's works noted in these figures was to play a leading role in Michelangelo's later creative efforts through the historical scenes of the Sistine Ceiling. This importance of the medieval sculptor is explained by the fact that Michelangelo already had certain tendencies toward the representation of strong emotion in his figures even before he became acquainted with della Quercia's works (cf. Battle of Centaurs). Thus when Michelangelo first met his works he found in them a justification of his own procedure.

When Michelangelo returned from Bologna to Florence to stay about six months, he executed two works, again of antithetical inspiration—a little St. John the Baptist and a Cupid. It seems that both of these were small statuettes representing children. This must have been an attractive theme for Michelangelo, for at this time (still under the influence of della Quercia), he loved the soft inflated mass. Both works are now lost, and all attempts at reconstruction must remain hypothetical.

The little St. John was probably in a contrapostal position with the arm reaching across the breast and the head turning in the opposite direction, a motif which was to return often in later figures by Michelangelo up until the Last Judgment (xv). That there existed a statuette of St. John in the pose described may be deduced, indirectly, it is true, from the echoes which one finds in representation throughout the sixteenth
165 century, for example, in a drawing of the Baptist by Bandinelli in the Louvre (No. 7625), in the St. John statuette by Cortellini in San Domenico of Bologna, and in two
166 statues of St. John by Pietro Bernini in Pizzo Calabria, Chiesa di San Giorgio and in Sant'Andrea della Valle in Rome. Moreover there exists a sketch by Michelangelo him-
110 self, representing a child, in the same pose (No. 34) and this was used by the painter of
278 the Manchester Madonna in London, National Gallery, for a St. John. It is possible that the Louvre drawing (No. 34) is a memory sketch of about 1505-1506 and represents the statue of St. John which the artist had executed about ten years earlier. Such memory-sketches are not infrequent with Michelangelo, as we have noted in a preceding chapter.

If this hypothesis is true we must deduce that Michelangelo profoundly transformed the Florentine type of St. John in giving him a heroic pose, unknown in earlier realistic
163 representations of the saint as, for example, those of Desiderio da Settignano (Bargello)
164 and Benedetto da Majano (Palazzo Vecchio).

The Cupid (xvi) is described in a letter of Anton Maria de Mirandula of 1496, as "a reclining Cupid, sleeping [with his head] supported on one hand—about four spanne [80 cm.] long." A reproduction of the lost Cupid may perhaps be recognized in the

painting of Tintoretto, representing Vulcan surprising Venus and Mars (Munich). *168*
The motif corresponds to the above description, and moreover we know that Tintoretto copied works of Michelangelo from little wax models. Another copy of the same Cupid may be found in the painting of Giulio Romano representing the Childhood of Jupiter *167* (London). As the Cupid of Michelangelo was at Mantua when Giulio Romano worked there, he may well have copied the statuette. The pose of the Cupid in the paintings of Tintoretto and Giulio Romano repeats an antique type. This may have been the first child statuette that Michelangelo copied directly from antiquity, such as we find him doing later in the two Christ Child figures of the tondi of the Bargello and of *216, 218* London. *220, 221*

It is scarcely possible to determine today the importance of these two lost works in the artistic development of Michelangelo.

THE first Roman period does not change the stream of Michelangelo's artistic development. In the Bologna period Michelangelo had found means to differentiate emotional expression. Now there awakes in him the need to render outer forms more sharply and precisely. At Rome he enters into competition with the works of the famous Florentine sculptors of the Quattrocento which were to be found everywhere in the churches of the papal city at that time.

Two works are preserved from the first Roman period: the Bacchus and the Pietà *21, 30* in St. Peter's. The Bacchus seems to be the earlier: it still shows traces of the rather coarse early style and use of the drill, which he later abandoned (IV). The Pietà already shows a new sharpness and firmness in the execution of details (V).

Michelangelo seems to have worked on the Bacchus without external compulsion; he *21 to 29* reached back in it to the greatest task of his Florentine youth, the representation of a nude, male figure of larger than life size. If the Hercules were preserved, the Bacchus would probably be less surprising.

In antiquity, when an intimate acquaintance with the properties of the various deities was presupposed, representations of the gods were limited to generalized types distinguished from one another only by a few attributes. It was the beholder's task to complement them with all the qualities he ascribed to their divine persons. Dionysus was represented as a beautiful youth who resembled sometimes Apollo, sometimes Mer- *173, 174* cury, or perhaps Antinous or simply a young athlete. And yet this was enough to signify to men of antiquity the idea connected with his person, and which found expression in his frenetic cult. His presence induced in believers a state of ecstasy, in which they felt themselves united with the primitive forces of nature.

The Renaissance conception of Bacchus shows him generally as the embodiment of sensuality and the joy of life. Although the Renaissance was familiar with the cult of the "mystic Dionysus" as proved by Boccaccio, Pico della Mirandola and Poliziano, they were fond of representing him as god of pleasure, in a state of drunkenness, swaying and uncertain on his legs. He appears thus in the few Renaissance representations we have of the god.

Michelangelo creates a figure which fully expresses the inner essence of the god *21* Bacchus as cosmic symbol. His figure stands upright but the usual contraposto is transformed into a swaying pose. The soft, fleshy body of the god, in which young manly strength is united with feminine softness, seems filled with some mysterious inner sap. *23* This tellurian sap seems to rise through his limbs and bow his head. The grapes on his head appear to grow there and wed themselves with the locks of his hair. He is a *25, 26* human incarnation of the whole rhythm of natural life with its alternate vigor and lassitude. This is the Dionysus who periodically dies only to come to life again with the spring, like growing vegetation. The death-aspect of his being is expressed in the muzzle of the lion; the reawakening of the vital forces is incarnated in the small, *29*

joyous satyr who nibbles happily at the grapes; the vegetative superabundance of
autumnal Nature is embodied in the god himself, who with his heavy, dull expression,
already seems to pass along into the realm of the unconscious, announcing a new
decline of the vital powers.

Thus Michelangelo's Bacchus is not the representation of a "stumbling wastrel," but
the human incarnation of the life cycle of nature. It is the old theme that Michelangelo
had already announced in the whirling motion of the Battle of the Centaurs, but which
he is now capable of carrying out more distinctly.

This conception of Bacchus was known to the Renaissance, and Michelangelo could
have found his inspiration in the *Genealogia Deorum* of Boccaccio. In interpreting
Bacchus, Boccaccio says that "this god signifies the wine and his mother Semele the
vine itself. The father, Zeus, is warmth. This warmth, together with the moisture of
the earth goes through the vine, ripens the grapes and fills them with juice in the
spring, as a womb in conception. But in the warmth of autumn they burst" (IV, 4).

The composition of the group corresponds to this basic idea: the spectator must look
at the statue from all sides in order to see it completely. The satyr is not at the side of
Bacchus (as in antique pieces) but behind him, and when we see both figures at once,
it becomes evident that they are bound together by a spiral movement which begins
at the muzzle of the lion-skin on the base behind the two figures, turns with the satyr
and rises upward to the cup in the upraised right hand of Dionysus (IV, 1). This is a
resumption of the circular movement found in the lost Hercules (perhaps also in the
lost S. Giovannino) which was later to become an actual spiral, for example, in the
figure of Christ in Santa Maria sopra Minerva and the David-Apollo of the Bargello
(IV, 7). It was used many times by the manneristic sculptors and they called it *figura
serpentinata*; here, however, this manner of composition corresponds to the content,
whereas with the mannerists it is used merely as a device for formal beauty.

A new attention to precision in forms is noticeable in this sculpture. The mastery
with which Michelangelo makes us aware of the delicate play of the muscles beneath
the fleshy parts of the body, the exactitude with which pupils and eyelids are executed,
and with which he indicates the hair of the eyebrows, surpass anything he had previ-
ously done. On the other hand, in the soft, clay-like trunk of the tree, in the rough
profile of the heavy bowl, and the soft locks of hair of Bacchus, and the satyr worked
with a drill, there are still noticeable connections with the style of the Bologna period.

This new realism brings with it a certain weakening of the creative impulse in com-
parison with the first works. Michelangelo's genius expends itself in a multitude of
trouvailles, while the whole perhaps lacks the intensity of life which characterizes his
early works.

The contract for the Pietà in S. Peter's of the twenty-seventh of August 1498, shows
that Michelangelo was to make for the Cardinal Jean Bilhères de Lagraulas "a clothed

Virgin Mary, with the dead Christ in her arms." Jacopo Galli, the owner of the Bacchus, gave assurance in the contract that "this will be the most beautiful work in marble that Rome has ever seen and no other master would today make it better"—a sentence which proves that Michelangelo's reputation was then already firmly established (v).

The theme chosen by the Cardinal was at this time (the nineties of the fifteenth century) especially popular in Italy, and almost all the leading Florentine artists of the day, both painters and sculptors, had treated the subject. In these works the body of Christ always lies stretched out horizontally on the Virgin's knees, while his head and feet are held by St. John and Mary Magdalene respectively. Michelangelo, however, goes back to another, older type of Pietà, created in Italy and independently in Germany at the beginning of the fourteenth century. It is the type of the lone Virgin, who, like a seated Madonna, holds her Son on her lap. The basic idea of this type is the representation of the moment in which the Virgin with the body in her arms recalls the time when she fondled the Christ Child, a scene which the medieval mystics, both in Italy and in the Northern lands, described in moving words. In the older representations the proportions of the body of Christ were usually reduced to those of a child. Michelangelo keeps the natural proportions and achieves the expression of this idea by more subtle means, as for example by the way Mary holds the body of Christ with her right arm under his shoulders, as a child is held—the diagonal band across the breast of the Virgin, a device which serves in other representations of the Madonna as a support for the child Jesus (as in the Virgin of Fra Filippo Lippi in the Louvre, and the drawing of St. Anne by Michelangelo himself, in Oxford). Mary sits *81* with her legs apart and the right foot somewhat raised. Michelangelo amplifies the lap of the Virgin with heavy draperies; the enveloping mantle takes the place of a shroud, *31,32* and flows out onto the ground. On the other hand, he refines the proportions of the body of Christ. He is slender, with delicate wrists and ankles, and a transparent skin. His visage breathes tenderness. Beneath a high forehead which the hair outlines in a *35* triangle, one sees the beautiful curves of the eyebrows, the long, half-closed lids, fine nose, and sensitive mouth framed by a light, downy beard. There is nothing in the youthful works of Michelangelo to predict this turn toward the ideal of grace and tenderness. The body passively adapts itself to the lines of the figure of the Virgin. His *32* feet hang limply down; his head has sunk down over Mary's arm so that the compact- *31* ness of the silhouette of the Virgin is nowhere broken. The fingers of Christ's hand are supported by a fold of the Virgin's mantle while his left foot is held by a little stump *30* of a tree. So Michelangelo accentuates the limpness of the dead body by stressing its dependence on even inanimate objects. There is nothing of the stiffness of contempo- *183,185* rary representations in this figure—it is completely subordinated to the triangular silhouette formed by the Virgin, and thus is achieved a hitherto unattained harmony in a Pietà group.

Since the Middle Ages the fundamental theme of all Pietàs was the *compassio*

Mariae; Michelangelo deeply modifies this aspect of the group, for he no longer emphasizes the motherly sorrow of the Virgin but rather her stoical acceptance of destiny. Death is no longer an unexpected catastrophe but, as in the first Virgin relief, the fulfillment of an inexorable law. Michelangelo's Virgin does not weep, neither does *181,182* she gaze upon the corpse, as in all earlier Pietàs; she only bows her head with half-*183,185* closed eyes and, with a suppressed movement of the left hand, expressive of her obedience to a higher power, quietly yields to the inevitable. All maternal pain is overcome; she is like a sibyl who long before had divined the coming of this hour; she is the Demetrian womb, impassively receiving the dead one to whom she gave life. Life and death are joined again in a cycle.

33,34 The Mother of God in this Pietà has a tender, bud-like, maidenly head, a narrow oval, with a longish fine nose and thin lips, in contrast to all earlier Pietàs where the *181,182* Virgin with her grief-furrowed countenance is represented as a matron. This youthfulness is said to have been criticized by Michelangelo's contemporaries (Condivi, p. 44). Michelangelo is supposed to have defended himself with the argument that a pure woman preserves her youth longer and he wished to symbolize the chastity of the Madonna. Indeed, according to Neo-Platonism, the body is the image of the soul and participates in its inner qualities. The youthfulness of the Virgin in Michelangelo's Pietà thus expresses a moral as well as a physical beauty (cf. Robb, *Neoplatonism*, p. 227).

30 The confused mass of folds over the breast is still reminiscent of the artist's Bolognese *13* style, but the sharp-edged treatment and angularity and the deep concavities surpass even the Bacchus in preciseness. The entire surface is carefully polished; light is reflected softly on the smooth surface of the marble, bringing out a multitude of delicate details.

Michelangelo must have known a drawing or engraving of the "Last Supper," which Leonardo was then in the process of completing in Milan. The idea of the triangular composition, the fine, contemplative head of the Virgin, her gesture of resignation, the diagonal band crossing her breast, as well as the head-type of Christ, with the triangular brow, heavy eyelids and downy beard, can hardly be explained otherwise than by *184* Michelangelo's fascination with the figure of Christ in Leonardo's "Last Supper."

The Pietà and the Bacchus are incarnations under Christian and pagan aspects of the same fundamental laws of existence, as in the first two works of Michelangelo. But here the artist has entered the second stage of his development in which he is chiefly concerned with acquiring complete mastery of his tools. This technical perfection has brought, as an inevitable consequence, a certain loss of conviction in the expression of his original artistic vision.

V. DIFFERENTIATION OF INWARD STRUCTURE: CLASSICAL STYLE

THE five years which Michelangelo was to spend in Florence after his return there in the summer of 1501 were to witness the full development of the tendencies thus far discussed. In Bologna he had achieved the differentiation of emotional expression and in Rome a precision in external details. Now he was to gain complete control in representing the inner plastic structure of the human body. He holds to exactitude and richness of detail but now seeks to subordinate the secondary to the essential. His art takes on a new severity and economy of plastic expression.

To this severity of form corresponds one of spirit. The passive figures of his youth give way to a new heroic race. They no longer seem the victims of forces beyond their control but with strength and resolution are now masters of their own destiny. The period represents a climax in Michelangelo's rationalistic tendencies; the works produced represent his classical style.

On June 19, 1501, in Florence, Michelangelo belatedly signed the contract for his last Roman commission, namely the delivery of fifteen statuettes for the tomb of Cardinal Piccolomini (later Pope Pius II) in the Cathedral of Siena (XXIII). Only four *186 to 194* of these statuettes were delivered and these were made after Michelangelo's drawings but executed by Baccio da Montelupo (with the exception of the St. Peter which *188 to 190* Michelangelo apparently retouched). These works, therefore, give us little indication of Michelangelo's art at the time—except for the severity and simplicity of the straight-falling drapery of the St. Peter, which illustrates the classical trend in his style.

The Sienese commission does not seem to have attracted Michelangelo long, as a much greater one awaited him in Florence, namely, the execution of the "Giant."

The block from which Michelangelo modelled the David had been worked on forty *36 to 43* years earlier (1463) by Agostino di Duccio. It belonged to the Opera del Duomo and was intended to decorate one of the buttresses of the cathedral. Agostino began a "giant" (probably a David) but left the work incomplete. Since then the authorities of the cathedral had been looking for an artist who could finish work on the much-prized marble. One hears that in 1476 the sculptor Antonio Rossellino was asked to complete the work, but he was not successful. In July 1501 the Operai again looked around for a master capable of completing the work, already called the "David." Two months later this master was found, in the person of Michelangelo. In the period between September 1501 and April 1504 he succeeded in producing a thoroughly finished statue from this block, without using any more stone (VI, 3). From the front it is *36* not apparent that the sculpture was made from a block on which other men had already worked. Only the fact that the statue has no lateral views indicates that the block was *38, 39* not chosen by Michelangelo, but by a master of the Quattrocento. Michelangelo would have selected a deeper block. Manual dexterity had always been highly esteemed by the

Florentines, and the bravura with which Michelangelo overcame the handicaps inherent in this work, where for half a century others had failed, astounded the Florentines and brought him enormous popularity. None of his works was so admired by the citizens of Florence as the marble David.

The David theme had been for long associated with the decoration of the cathedral buttresses. Nearly a century before (1408) Donatello had been entrusted with making a marble David for one of them. This work, completed and put in place in 1409, was taken down shortly after (probably because it was too small) and seven years later (1416) was put up in the Palazzo della Signoria at the request of the *Priori*. Thus the originally ecclesiastical work came into the hands of the secular authorities. A quite similar fate was in store for Michelangelo's statue.

The latter has, in the wide-spread pose of the legs and turn of the head, a certain similarity to Donatello's marble David, which is, however, wrapped in the long mantle of a prophet. A document (Poggi, 449) mentions that on the block of Michelangelo's statue, before he started work on it, there was a knot at the breast of the David as planned by Agostino. This would surely indicate that a mantle was to drape the figure. We hear that Michelangelo began work by cutting away this knot; thus the idea of making a nude David from this block is almost certainly his.

Florence already possessed two famous David statues, by Donatello and Verrocchio, not to mention the numerous small bronzes. Very different from one another, they nevertheless all represent the Biblical boy with sword in hand and Goliath's head at his feet, looking modestly down or smiling in consciousness of victory. Michelangelo's composition is completely different. The hero is represented as a young man and not a boy, Goliath's head is absent, and of the traditional attributes only the sling is represented and this is hidden behind his back. Michelangelo deserts the conventional fifteenth century type of David and approaches in his conception certain antique statues of Hercules, such as are found on ancient sarcophagi (for example, the Hercules sarcophagus in the Museo d. Terme) where the position of the legs, the pose of the head, the contrasting gestures of the arms and complete nudity are all found. Michelangelo suppressed all the traits that characterized David as the Jewish hero and made him a figure of more universal significance. The interpretation that David is looking his opponent in the eye ready for battle is obviously inadequate, since the sling hanging open across his back precludes the possibility of any immediate action. It would seem that Michelangelo is seeking to express not a particular transitory moment in David's life, but rather the hero's unchanging character and moral attitude toward life. He is the incarnation of fearless moral strength.

The association here of David with the Hercules type is not surprising when we find that the latter had already played a role in the history of the statue. Agostino di Duccio had executed a gigantic terracotta Hercules for another buttress of the cathedral before he began the "giant" (David). Thus there existed even in the Gothic project an asso-

ciation of the two. This connection is not merely external. Indeed, during the entire Middle Ages and the early Renaissance Hercules and David were considered as co-types and as symbolic personifications of Fortitude. In the medieval period David was called "manu fortis" and Hercules, "manu potens" or "Hercules fortis" (cf. the relief of the Cathedral of Modena, representing Fortitude). Nicola Pisano, when he wished to show Fortitude on the pulpit of the Baptistry of Pisa, copied the antique Hercules 196 type of the sarcophagus of the Museo delle Terme. In the Quattrocento one finds David and Hercules side by side, as the Jewish and pagan types of Fortitude (School of Pollaiuolo). Thus it was only a step for Michelangelo to combine the two figures into one as a symbol of moral fortitude.

The concept of strength as a virtue completely determines the attitude of Michelangelo's David and explains its tense expression. The whole weight of the figure falls 36 on the right leg and the body sways slightly toward this side. The strict verticality of the right side is emphasized by the straight leg, hanging arm and the line of the neck. The head is turned brusquely toward his left side. Thus there exists a contrast between the two sides of the statue: its right side is closed in outline, the left is open and the outline broken by the raised arm. This contrast of sides corresponds to a moral distinction. Whereas the one is characterized by strength and certainty, the other shows itself vulnerable. Certain ancient myths looked upon the right side of the human body as masculine and active, and the left as feminine and passive. The Middle Ages gave a theological interpretation to this distinction, namely, that the strong right side is under divine protection, the weak left exposed to the powers of evil. In the Franciscan book *Meditationes Vitae Christi* there is (as Wilde has pointed out) a paragraph on the Psalms, wherein the difference of the two sides is discussed in relation to David. And finally, Michelangelo himself differentiates the two sides in later works, as for example, the Moses of the Tomb of Julius II.

Michelangelo's David is the incarnation of masculine strength, both physical and spiritual. His face expresses the heroic disdain of the exemplary being over against 40, 41 his everyday surroundings. It is a strong bony face; the broad cheeks are energetically framed by the strongly projecting chin and above by the low forehead, overvaulted by a heavy shock of hair, the locks of which are like tongues of flame. The strong, long nose, with its distended nostrils, as well as the wrinkled brow, with its muscles drawing together over the eyes, the swollen lips in the corners of which contempt and anger seem to quiver, the drawn-up eyelids and deep, large eyes give an expression of defiant fearlessness, recalling the heroic scorn of Proculus, but in a purer, sublimated form. 20

The body of the David was something entirely new for Michelangelo himself. His 42 early concern for rhythmic forces within the body is here replaced by an exact rendition of human anatomy; the richness of forms in bones, muscles, veins, and soft parts in the breast and belly is extraordinary. The finest surface gradations are given; there is an all-pervasive tension as though the body were a veritable reservoir of energies. The

forces which are concentrated in the torso seem to control the limbs as a machine controls its levers.

Every organ of the human body in nature suggests its function by its form even without movement. Michelangelo recognizes this principle. By making intensively visible the essential structure of organs at rest, he is able to suggest potential action. Thus, for *43* example, the right arm which hangs completely passive, is furrowed with bulging veins and the muscles are tensed, suggesting the power of that arm and its kinetic potentiality.

Michelangelo must have made exhaustive studies of the nude before working on this figure. Of the numerous drawings he quite likely made, some are preserved today. One *92* is a study of a nude masculine body (No. 15) whose torso and right leg were followed by Michelangelo for the David. The other drawing is a preliminary sketch *93* for the right arm (No. 16). In both the artist renders masterfully, by means of hatching, the tensed muscles of the body. It is evident that Michelangelo concentrated successively on different parts of the body, and only after finishing with all these detailed studies did he take up again the idea of the statue as a whole.

When the statue was almost completed the Consuls of the Arte della Lana called a meeting (January 25, 1504) to discuss the best place to put the statue. This commission was composed of artists, artisans, and notables of the city. Many celebrated artists were present, e.g. Botticelli and his pupils, Filippino Lippi and Piero di Cosimo; Cosimo Rosselli and Perugino; Leonardo da Vinci; the architects, Giuliano and Antonio da San Gallo and Simone del Pollaiuolo, architect of the Sala del Consiglio, etc.

According to the records of this meeting, thirty persons were invited to express their opinion (*parere*) of whom only nineteen are quoted, plus two *pareri* which are not from any of the original thirty. These records throw an interesting light on the various traditional and progressive artistic tendencies then in vogue in Florence. Concerning the most important opinion of all, however, that of the artist himself, this document gives no direct answer. Michelangelo was not present at the meeting.

It was proposed, first, that the statue be placed by the cathedral, then in the Loggia dei Lanzi, and finally near the Palazzo della Signoria.

A carpenter, Francesco Monciatto, alone displayed reverence for past tradition, proposing to put the figure in the place for which the block had originally been intended, namely, on one of the buttresses of the choir of the cathedral.

A compromise between traditionalism and new tendencies may be recognized in the proposal of artists well along in years, such as Botticelli and Cosimo Rosselli, to place the statue on a high pedestal on the steps of the cathedral on the right, directly in front of the main entrance, "so that it may be seen by passers-by." The wish to keep the statue near the cathedral bespeaks a certain respect for tradition, while in the desire to have it easily visible like a free-standing statue, the new spirit of the Renaissance is revealed.

One progressive view, to remove the statue from the cathedral and erect it in the

Loggia dei Lanzi, which was modestly hinted at by Botticelli, was then taken up by the majority of the *pareri* cited in the document. They argued that the statue, being of soft marble, would be better protected from the weather there. Giuliano da San Gallo proposed placing it either beneath the central arcade of the front or in the middle of the back wall in a black niche which could be made for it. The second herald of the city suggested putting it in the side-arcade opposite the Palazzo, since in the front it would block the way during the ceremonies of the *signori* and *magistrati*. Ten more voices supported this view that the work be placed under the Loggia dei Lanzi, among them, Leonardo da Vinci, who, however, wanted it put "where the balustrade joins the wall" (that is, in the back corner opposite the Palazzo), "con ornamento decente," with fitting ornamentation (referring probably to the base). One notices among the partisans of the Loggia dei Lanzi a certain anxiety for the preservation of works of art which recalls the decisions of certain curators of historic monuments in our own time.

There were three views concerning the placing of the David on the grounds of the Palazzo della Signoria: first, to put it in the courtyard in place of Donatello's David (two *pareri*); second, to put it before the façade of the Palazzo in place of the Marzocco (two *pareri*); and third, to put it in the place of Donatello's Judith, which was likewise in front of the palace to the left of the entrance. This last was the proposal of only one man, Francesco, the first city-herald. He supported it with the superstitious reasoning that the Judith was a fatal omen ("segno mortifero") which had been erected under an evil constellation and had brought misfortune to Florence. Surprising as it may seem, Michelangelo's David was finally put up in this place. This remarkable state of affairs is most probably explained by the assumption that Michelangelo, who was not present at the meeting, preferred this location. This view is indirectly corroborated by the *parere* of Salvestro, a jeweller, who says he would like the statue to be set up near the Palazzo ("intorno al Palazzo") "for the one who made the statue knows better than others which place is most suitable." As a matter of fact, the Judith location seems to have been the most favorable of any of those proposed. The buttress of the cathedral would have been too high, and the steps of the cathedral could have been considered only as a temporary location since the façade was not yet finished. Beneath the arcades of the Loggia it would have been unfavorably lighted and visible only from the front. The courtyard of the palace was too small for this giant and the position of the Marzocco was too much to one side.

Thus the David was set up at last, in place of the Judith, on the Ringhiera, in front of the Palazzo and in line with its tower. This position, with the rough wall of the Palazzo as a background, and the square tower rising above, gave the setting a special impressiveness. The statue was far enough from the wall so as to be visible from all sides, but close enough to the Palazzo to be considered the symbol of *governo giusto*.

The fact that the David was put up in the place of the Judith has been interpreted as an attempt by Michelangelo to normalize the proportions of the giant figure by relating

198b

[97]

it to the enlarged optical frame of the Palazzo. But the new feature of this location of the David was the release of the figure from use as mere ornamentation of the cathedral, and the rebirth of the antique concept of the free-standing statue. The document itself proves that they were seeking a "locus commodus et congruus" so that "it would be easily visible to the passers-by." Placing such a gigantic figure so near the spectator instead of high above on the buttress, gives by itself an optical magnification.

The meeting and discussion concerning the ultimate location of the David indicates the great admiration which the statue aroused among the most varied groups of Florentine artists and citizens. One finds an echo of this admiration in the reports of old local chroniclers who give detailed descriptions of the moving of the statue from the Opera del Duomo to the Palazzo, and its erection there (VI, 1).

The marble David of Michelangelo may be regarded as a sort of synthesis of the ideals of the Florentine Renaissance. In the accurate anatomy one finds the Florentine spirit of scientific investigation; in the vigorous forms and the proud visage is recognizable the heroic conception of man as a free creature and as master of Fate. If any of the old *162* Florentine statues can be mentioned with the David, it is Donatello's St. George. That in this figure some of the traits are presaged, such as the bold glance, the wrinkled forehead and brows, the hanging arm with the closed hand, has long been recognized. But this very comparison shows how timid the old master was and how bold and sure the young Michelangelo.

A second David, now lost, which Michelangelo was to execute on commission from the Signoria for Pierre de Rohan, Maréchal de Gié, was a bronze, life size (XIX). In accordance with the wish of the Maréchal it was "like the one in the court of the Signoria," namely, Donatello's bronze David. While he followed the general lines of the earlier sculpture, Michelangelo here created a completely personal work.

93, 214 Today all that remains of this work is a first sketch by Michelangelo, in the Louvre (No. 16), which was probably made in the summer of 1502 (contract from August 12, 1502). This pen sketch, drawn with wonderful verve, represents a boy standing upright, his head slightly bowed, holding a sword in one hand and a sling in the other hand which rests on his hip; his right foot treads on the head of Goliath. The figure possesses a savage energy, emphasized by the muscular body and the violent contrapostal pose. The toes of his foot are contracted and grip the head of his fallen enemy like the claws of a bird of prey. This superabundance of force and energy is the new element in Michelangelo's bronze David. The Davids of Donatello and Verrocchio are represented in an easy, relaxed contrapostal position, images of the harmonious balance of bodily forces. The battle is finished and they are at rest. In contrast Michelangelo's figure, proud and filled with a superabundance of strength, seems ready for new conquests, and shows the *élan vital*·which eternally renews itself.

Michelangelo's David was placed on a column in the middle of the court of the

Château de Bury in Burgundy. There is an engraving by Ducerceau (1576) showing 210 the courtyard of the Chateau and the statue. Although the David figure is very small in this engraving, nevertheless one can see that it is not identical with the one in the Louvre drawing. David seems to be holding the head of Goliath in his raised left hand, while the sword in his right cuts the silhouette horizontally. Apparently Michelangelo changed his original idea in executing the work. If we have correctly interpreted the figure as reproduced in Ducerceau's engraving, then we are led to conclude that Cellini's statue of Perseus was done under the influence of Michelangelo's bronze 212 David.

The work of Christian inspiration which is antithetical to the pagan-type marble David is the Bruges Madonna. The precise and detailed style, rich in realistic observa- 44 to 49 tion (see the buttons on the sleeve, the brooch, the shoes) seems to indicate that this work was executed a short time after the completion of the Pietà, toward the spring or summer of 1501, in Florence (VII).

The Virgin is seated full-length with the Child, a type very common in Florence in the second half of the Quattrocento and of which we find examples in the tender and charming Madonnas of Antonio Rossellino (Santa Croce in Florence) and of Benedetto da Maiano (Florence, Oratorio della Misericordia; Berlin, Deutsches Museum). The 209 modest dimensions of Michelangelo's Virgin also conform to those of most other Florentine masters. It is the conception and the spirit of Michelangelo's work which are completely different. The Virgin is full-face, in a severe and immobile position, 44 without the charming inclination of the head which is found in nearly all the fifteenth century Virgins. Her solemn mien is accentuated by the grave face with its regular features, by the straight-falling lines of the veil which covers her head in an almost architectural way and by the classic vertical folds of drapery over the breast.

The Christ Child is traditionally seated on the Virgin's lap, but here we find him placed between her knees, surrounded by folds of heavy drapery, and as if protected by the niche formed by the cloak behind his head. This extraordinary disposition of 44, 46 the Child between the knees of the Virgin suggests his being in the maternal womb. At the same time, he is depicted as a small hero, about to disengage himself from the protective womb and to descend into life. One of his feet reaches forward, but he hesitates and draws back a bit timidly to his mother's lap. His arm holds fast to her knee, and she grasps the small hand with a gesture that may be either to hold him back 46 or to press it in farewell. The Infant's head with its plump cheeks and protruding baby 49 mouth expresses childish innocence. The eyelids are half closed and a dreamy expression hovers over the features. Natural instinct urges him to stay in the safety of the maternal womb, but the necessity of his sacred mission impels him to go forth.

The knowledge that the idyl of the common life of mother and child is irrevocably finished and that the tragedy of life is to begin for them both shows itself on the face

of the Virgin. She wears an expression of care, suggested by the lightly contracted brows, the lips slightly thrust forward, and the faint trembling around the chin. Yet a sort of stoic acceptance is there, too.

30 This group is developed organically from Michelangelo's Pietà in St. Peter's, of which certain motifs are found here, as for example the head covered by a simple veil, the draping of the robe over the limb and the one foot resting on a rock.

In the idea of representing the Child in the womb of the Virgin, this work of Michelangelo approaches the old Byzantine type of Platytera to which also is related the strict axiality of the pose. The Platytera, who was represented carrying the unborn child in 208 her womb, showed the child enclosed in a mandorla. Later Byzantine art transformed the mandorla into drapery, and this form was inherited by Western art and sometimes used by Florentine artists. An important example of this type is still preserved in Santa Maria Maggiore in Florence—a Madonna by Coppo di Marcovaldo of the thirteenth century, in which the Child is shown in the Virgin's lap, surrounded by elliptical folds 207 of clothing. Donatello's Madonna in the Santo at Padua is an early Renaissance example of this type.

The Platytera type represents the miracle of the conception of the Christ Child. Michelangelo's work incarnates, in addition, a fundamental natural content. Here the Virgin and Child suggest not merely the beginning and the end of man (birth from the maternal womb and the presentiment of death) as in earlier Madonnas of Michelangelo, but the whole course of human destiny in a few important stages, as the parting of mother and child, and the first steps into the world.

In other works of the same time Michelangelo tested his powers on the problems set up by Leonardo.

When Michelangelo came to Florence in the spring of 1501, Leonardo was exhibiting in the convent of Santissima Annunziata the cartoon for his St. Anne, the Virgin and Christ Child. The new manner of grouping in this composition aroused the admiration of the Florentine art world and exercised a persistent influence on the works of leading Florentine artists of the time (Fra Bartolommeo, Albertinelli, and the young Andrea 81 del Sarto). In a pen-drawing, in Oxford (No. 9), which represents the same subject, Michelangelo reveals his preoccupation with Leonardo's art, and at the same time his instinctive opposition to it. It clearly shows the great gap separating the ideals of the 80 two masters. In Leonardo's composition the figures unfold themselves in a circular movement, their activity following a secret rhythm in which each movement anticipates the next and fills the whole flower-like composition with a tender harmony, to which corresponds the content, the "sweet accord" of souls united by fond family ties.

81 Michelangelo's drawing shows a composition in which the figures are contained in an oblong block set up diagonally. Each figure acts independently of the others—and indeed in opposition to them. The whole is based on dissonances. Each of the figures

remains spiritually isolated and plunged in his own sorrowful world. St. Anne's solemn gaze seems absorbed by a tragic vision, while the Virgin, almost oblivious of the Child in her arm, makes a brusque gesture as though to rid herself of a nightmare. The Child Jesus starts up as if suddenly awakened from a bad dream, and begins to weep. A sad fateful shadow hovers over the group.

Further proof of Michelangelo's interest in the art of Leonardo is given by two folios of pen-drawings also at Oxford. On one there is written in his own hand the word "Le[on]ardo" (No. 10). We find a delicate profile of a handsome youth with soft hair *83* and somewhat effeminate features drawn by Michelangelo in the sinuous manner of Leonardo, and beside this the boldly hatched sketch of a bearded man, wholly virile and Michelangelesque in spirit. (This sketch served later for the head of Joseph in the Madonna Doni.) On the same leaf he copies after Leonardo the rear view of a nude *59* male body with wide-spread legs, only to transform it at once into a figure in his own style. The delicate treatment of the skin and the graceful lineaments of Leonardo are *82* sacrificed. Instead an inner force seems to fill and mold the body.

On the second leaf mentioned is drawn a kind of Triton with a casque on his head *84* (No. 12). The lower part of this figure ends in an undulating fish-type form, of which the calligraphic treatment recalls Leonardo's sketches. Again, however, he represented the rude face of the bearded man—consciously opposing his own style to that of Leonardo.

The two Holy Family tondi from the end of this Florentine period show a departure *50, 54* from the former detailed refinement and multiplicity of forms and there is a tendency toward a monumental and massive style. These are the first works to indicate a new turning away on the part of the artist from the classical, rationalistic ideal of differentiated and precise forms toward greater concentration upon his own inner vision of life. It is significant in this connection that the two tondi remained unfinished, for the retention of a certain vagueness in the details serves to heighten the suggestive power of the whole. We see here the precursors of the mighty works of Michelangelo's early maturity (Sistine Ceiling) and also the foundation of the style of Raphael's Roman Madonnas, and of the Virgins of Fra Bartolommeo and Andrea del Sarto.

Michelangelo transformed Leonardesque ideas in a manner related to Roman antique art, and worked classic motifs directly into his compositions. With the increased breadth and majesty of the forms goes an increase in the fullness of life as depicted in the figures. Yet a certain equilibrium between the form and the spirit which animates it is preserved.

On stylistic grounds it seems probable that Michelangelo executed the two marble tondi representing the Madonna and Child with St. John, which are preserved respectively in the Bargello at Florence and in the Royal Academy of London, after he finished the marble David.

50 to 53 Of the two, the Bargello tondo seems earlier, for its Virgin closely resembles the Bruges Madonna especially in the contrast of the expressions of Mother and Child, the one serious and aware, the other infantile and innocent (VIII, 7). This conception of the two figures is further developed in the Bargello tondo than in the earlier Virgin. The bodily forms are, however, more broadly and massively treated and are thoroughly 51 vital, as opposed to the rather hard, abstract forms of the Bruges Madonna. The head, although of the same type, is wider, and the broad ridge of the nose, the distended 40 nostrils and trembling lips recall the proud face of the David. A tight band around the forehead and encircling head-veil sharply delineate the face. The dress is of firmer material than in the Bruges Madonna. Folds are convex rather than concave. Details are not stressed, whereas the more important structural forms, such as the neck, the 50 upper arms, the waist, and the hips are accentuated. The Madonna is seated on a low, cube-shaped, stone block. The nude Child leans on his mother, and she envelops him in her cloak with a sudden gesture of her arm as though to protect him. With her head 51 raised, Mary's eyes gaze into the distance. She sees danger and seems ready for it. Her prophetic character is given expression symbolically also by the cherubim on the forehead, a device which signifies "gift of higher knowledge" (VIII, 3). (This prophet's glance anticipates directly the Delphic Sibyl.) The Child leans wearily on one arm, 53 which rests on an open book in the Virgin's lap. He seems a true infant unaware of his destiny; over his face plays an innocent smile and he is about to fall fast asleep.

We have here a new compositional pattern: three figures are grouped in a kind of triangle, as in Leonardo, the lower ones, however, representing two antithetical life-principles which are synthesized in the central, uppermost figure. The Christ Child, in 218 the pose of an antique mourning genius (cf. the Phaedra sarcophagus of the Contessa Beatrice in the Campo Santo in Pisa; VIII, 4), is an embodiment of gentle contempla- 52 tion. The little St. John, whose lively happy face with the locks of hair like tongues of flame is modelled by Michelangelo after those of youthful antique satyr and centaur heads (cf. Museo Capitolino; VIII, 4), embodies the active, wild, instinctive life-principle. These polar life-principles, "Apollinian" and "Dionysian" appear both synthesized and sublimated in the Virgin's head. In uniting them, she is endowed with a wisdom by which the totality of life and destiny becomes visible to her.

This compositional pattern, occurring here for the first time in his work, is from then on of fundamental importance for Michelangelo and appears again and again in his chief future works.

It is possible to get some idea of how Michelangelo arrived at this solution from a 98 hasty sketch for the Bargello tondo as preserved at Chantilly (No. 18). The drawing, executed probably already ca. 1503, shows the delicate figure of a woman sitting on a low seat and bent somewhat forward. Her right hand lies in her lap. In a general way the sit- 99 ting position corresponds to the Virgin's attitude in the relief, but in the sketch there is a transitory pose which gives the figure a certain instability entirely absent in the

tondo. Here the momentary and accidental character of an immediate impression from life, as found in the drawing, is transfixed into an enduring and stable monumental symbol. The sense of stability is emphasized by accentuating both the vertical and the horizontal axes in the composition; the former in the erect torso, and frontal position of the Virgin's head as well as in the line of the right arm and the straight fold that falls from the knee; the horizontal is emphasized in the head-dress and in the lines of the right forearm and the thigh. Michelangelo transforms the drapery of the robe at the waist into circular folds swathing the body; he supplements the folds at the feet with a series of circular folds and makes circular the silhouette of the Virgin by placing the figures of two boys one at each side. Thus the round form of the whole composition is most natural and escapes any hint of the artificial character of tondi that preceded it. The composition of Michelangelo in its very structure almost demands the tondo form.

To appreciate Michelangelo's masterly treatment of the tondo form, it is enough to recall works of this kind done by Quattrocento artists. Before Michelangelo, Florentine artists almost always represented in the tondo a composition of half-figure, and in the first half of that century there is no connection between the circular frame and the composition itself. The impression is that of looking through a round window and grasping a chance slice of life. (The tondi of Donatello and Fra Filippo Lippi are examples of this.) In the second half of the Quattrocento artists attempted a certain harmony of line between the composition and the tondo form. In Botticelli the relationship between composition and outer form is, however, purely decorative. The frame cuts the figures below the hips. Michelangelo in the Bargello tondo represents whole figures in the confines of the circle. In this he is doubtless inspired by the two tondi of Signorelli in the Uffizi. Michelangelo, however, by means of recurring curves 224 (cf. the curving folds which fall about the feet of the Virgin and the line of the Virgin's mantle which curves with the arm of the Child) emphasizes the roundness of the forms within the composition, a device which is original with him. He achieves a peculiar grandeur by filling his relatively small marble with a maximum of form.

In this work Michelangelo treats the relief in a new way. The tondo was originally a convex block (VIII, 8). Previously, in the Virgin of the Stairs and the Battle of the 1, 3 Centaurs, Michelangelo had conceived his figures as emanations of the background (unlike masters of the Quattrocento who made a sharp distinction). Here there is that same unity between figures and material, and beyond this a sort of dynamic interchange in which the figures seem to absorb the material of the background or the background to flow into the figures. The classic distinction between high and low relief loses its significance. In Michelangelo's work the relief is treated as the potential of a free figure; and we shall see that the "free figure" is often treated so that it is actually the result of a series of reliefs one below the other (cf. the St. Matthew). The 64, 65 Virgin's figure of the Bargello tondo seems to free itself from the contingencies of the

relief. The background curves inward; the head of the Madonna projects a bit above the frame and thus seems on the way toward becoming a free figure.

54 to 58 The other tondo, now preserved in the Royal Academy in London, was probably executed a little later than the Bargello tondo judging by the composition and the treatment of the drapery (IX, 8). However, the quality of execution in the details is not of the level of the Bargello tondo and it is probable that it was reworked by one of Michelangelo's apprentices. In this composition the three figures are bound together by one action and have approximately the same importance. The Virgin is no longer the dominant element. There is a drawing made by Michelangelo in this period (No.

123 33) of a Holy Family. St. Anne, shown in profile and sitting on the ground, occupies the place which the Virgin was to have in the tondo. She sits with her head bent slightly forward, sunk in meditation and seeming to gaze into a deep abyss. The Virgin, sitting on the lap of St. Anne, turns aside with a sudden movement of fright and presses close against her body the Child to whom she has just been giving the breast. This leaf is probably a preparatory drawing for a tondo which was never executed.

54 The London tondo is more subtly conceived than this drawing. Little St. John playfully approaches the Child Jesus with a fluttering goldfinch in his hands. (A sketch

109 for this figure of St. John is preserved in London, No. 21.) The Child, frightened, takes refuge in his Mother's lap with a broad, stretching movement which Michelangelo took almost exactly from the pose of one of the children of the antique Medea

221 sarcophagus (IX, 5). In this tondo the characters of the two children are again contrasted, as in that in the Bargello. The abrupt diagonal formed by the body of the Child is a dissonant note, disturbing the balance and quietude of the composition. With a sad, sweet gesture, the Virgin wards off the turbulent little St. John. Her thoughts sweep far beyond trifling childish fear to the great and fixed tragedy that awaits her Son.

 The goldfinch motif may be traced to Florentine Madonnas as early as the Trecento. In these works the Christ Child holds the bird in his hand but it is still. It was Michelangelo's idea to dramatize the scene by making the goldfinch beat its wings. Raphael

222, 223 seems to have valued the London relief, for he has imitated it in several works. In his Virgin with the Goldfinch (Florence, Uffizi) he took over the theme but transformed it in a most characteristic way: whereas in Michelangelo's work the goldfinch supplied the reason for a dissonance between the children and a presentiment of fate, in Raphael it becomes the link to a harmonious family scene in which St. John hands the Christ Child a goldfinch which he fondles, while the Virgin looks tenderly and happily on this idyl.

 The correspondence between the tondo shape and the rounded silhouette of the group which fills it is found even more developed in this relief than in the Bargello tondo. In the latter Michelangelo makes his *point de départ* the central figure and completes the composition by the two children which fill in the side space. In the

London tondo the artist moves from the circumference toward the center. He accents the rim of the circle by the bodies of the Virgin and of St. John and connects them at the center by the diagonal of the figure of Christ. The Madonna Doni is to be, as we shall see, a sort of synthesis of these two compositional solutions of the problem of the tondo.

The London tondo has the same technique as the Bargello, but less worked out. The bodies do not project so much from the unworked background which in its incomplete, only "abbozzato"-state is not yet smooth and concave in form as in the Bargello relief.

After having finished the marble David and before beginning the St. Matthew, Michelangelo was charged with executing the panel of the Doni Madonna and the fresco of the Battle of Cascina. These two paintings are different in character from the sculpture of the same period and because of this are here treated together.

In his sculpture Michelangelo always subordinates his plastic conception to the matter itself in confining his figures to the limits of the marble block, subordinating all movement to the unity of the mass. In his painting of the same period, on the other hand, he gives free rein to his inventive genius in representing multiplicity of poses and freedom and complexity of movement. The result is that the paintings of his youth are richer in plastic motifs than his sculpture of the same epoch. But at the same time, the paintings seem artificial and lacking in the spontaneity and simplicity which are so striking in his other youthful works.

Good painting is not with Michelangelo an art *sui generis*; for him, who estimates sculpture superior to painting, it is merely "painted sculpture."

Later, in a letter to Benedetto Varchi (Milanesi, p. 522) Michelangelo formulated his own definition of good painting: "I say that painting seems the better to me the more it tends toward *relievo*, and *relievo* appears the poorer the more it approaches painting." Cellini observes in the same vein (*Trattato*, p. 253), "The greatest praise one can give beautiful painting is when one says 'it seems truly like a relief.'" The "good" picture must, therefore, have a pronounced *relievo* (plasticity). The aims of painting and sculpture are identical, according to this aesthetic. "Painting and sculpture are one and the same thing, since both originate in the same mind," says Michelangelo (Milanesi, p. 522). The essence of sculpture is "that which is made *per forza di levare*" (Milanesi, ibid.). A good sculpture comes into being through the removal of the superfluous material of the block. The unity of the painting composition for Michelangelo does not consist of a fitting together of parts, but rather of a releasing of forms from an imaginary marble block. This compositional principle is, as we shall see, that which is fundamentally new in the Battle of Cascina and the Doni Madonna.

In the autumn of 1503, the Signoria decided to decorate the large council hall (Sala del Consiglio) of the Palazzo with scenes of Florentine victories over Pisa. They con-

tracted with Leonardo to do this work on May 4, 1504. In the spring of the following year this master began work on the frescoes. Sometime after the arrangements with Leonardo were made (before October 31, 1504), Pietro Soderini, then Gonfaloniere della Giustizia, commissioned Michelangelo also to paint a mural in the hall. Michelangelo's cartoon was finished before February 28, 1505 (xx, 1). On May 12, 1506, Leonardo broke off his bargain with the Signoria by relinquishing the sum of money which he had laid down as a sort of guarantee when he signed the contract. This action might well have been motivated by dissatisfaction felt by the artist because a part of the decoration had been entrusted to Michelangelo.

Sources for our knowledge of the lost cartoon by Michelangelo have been quite thoroughly investigated by scholars in the past (xx, 3-6). On two questions, however, there has been much difference of opinion. First, where did Michelangelo intend to place his mural; and, second, how did the composition look?

We know that the Council Hall was transformed and redecorated by Vasari in the 1560's. From his description in the *Vita di Cronaca*, we can get an idea of how it looked before being done over. It was a rectangular hall 61.86 meters long and 22.04 meters wide, thus essentially the same surface size as the present dimensions. However, it was 12 braccia less in height. Around the hall ran a wooden platform with seats for the magistrates: "una ringhiera di legname." At the middle of the east wall was a dais for the Gonfaloniere and the Priors. On each side of this was a door with a window above it. There was an altar at the center of the west wall (with a retable by Fra Bartolommeo) and also a pulpit. There were four windows in the wall (cf. Vasari, ed. Milanesi, iv, pp. 449ff).

From this description it would seem that only the east wall offered space for frescoes, since the west, or altar-wall, was cut up by four windows and the narrow north and south walls by three each. In the 1560's the center window of north and south walls respectively were walled up and the two side windows enlarged. We can today see this reconstruction from the outside of the building and from it we get an idea of the probable form and size of the original windows of the east and west walls. They were fairly small arched windows, with round windows (oculi) above.

The theory that all frescoes were on the east wall contradicts Vasari who says that Michelangelo was instructed to paint "l'altra facciata." Varchi speaks of "una facciata" to be painted. Vasari usually means a whole wall when he uses the expression "facciata" (cf. *Ragionamenti*, Pisa, 1823, p. 250), and it is natural that scholars should have generally assumed that Leonardo and Michelangelo were each assigned an entire lateral wall to paint. But the construction of the hall seems to make this most unlikely. Michelangelo says in a letter of January 1524, to Fattucci "io avevo tolto a fare la metà della sala del Consiglio di Firenze, cioè a dipignere" (Milanesi, p. 426) and the expression "one half of the hall . . . to be painted" (the paintable surface, in other words) can mean half the east wall.

[106]

The east wall, which was the only one suitable for large frescoes, was, as we have seen, divided by two doors and the two windows above them, into three sections. These sections were of different sizes. The middle section was square and the side ones rectangular. Vasari in redecorating the hall followed this old division. One of the doors *226* is still preserved and it determines the frame of the central painting by Vasari, which occupies the middle section. The second door, now walled up, must have determined the other side of the frame. Leonardo's composition for the Battle for the Flag was *238* nearly square in form and must, therefore, have been intended for the middle section. Michelangelo must thus have planned his fresco for one of the adjacent rectangles. An analysis of the composition of his Battle of Cascina may help us to determine for which.

Vasari (1568, p. 378) reports in the *Vita di Aristotile da San Gallo* that this artist made a drawing of Michelangelo's cartoon which was the only copy to represent it completely. In 1542, as the cartoon was already destroyed, Vasari asked Aristotile to make a copy *en grisaille* of his (Aristotile's) drawing, in order "that the memory of this work might remain alive."

This grisaille seems to be the one preserved today in Lord Leicester's Collection at Holkham Hall. There exist several old copies of *parts* of the composition, certain *232* figures and groups. These are all found in the Holkham grisaille and in the same rela- *233 to 235* tionship as in the copies, a fact which tends strongly to establish the accuracy of the former (xx, 5). Also, Vasari's description of the cartoon corresponds to the grisaille in Holkham Hall (except that he also speaks [1568, pp. 57 and 59] of mounted figures which are absent there).

The subject for Michelangelo's fresco was the victory of the Florentine army over that of Pisa, on July 29, 1364. The episode chosen by Michelangelo for his work is described in the chronicle of Filippo Villani (xx, 8). The chief of the Florentine army, Galeotto Malatesta, had his camp on the outskirts of Cascina on the Arno, near Pisa. Because of the great heat the soldiers had removed their armor; some were bathing in the river, some lay in the sun, or refreshed themselves in some other way. The captain, who was well along in years and not completely recovered from a three-day fever, had gone to bed, and failed to notice that the Pisan forces, under Giovanni dell' Aguto, were near. The camp was unguarded . . . then Manno Donati, suddenly aware of the possible danger, began to arouse the soldiers and to cry "We are lost!" Approaching the captain with these words, he asked that he, Bonifazio Luzio, and three others be entrusted with protecting the camp. Up to this point Michelangelo illustrated the text almost exactly. The chronicle goes on to say that Donati fortified the camp at its weakest points. After the Pisans had made three sham attacks, Donati and his men fell upon the enemy's flank and routed them.

The battle of Cascina came to be regarded by republican-minded Florentines as a symbol of the victory of the Guelph party. The day of the battle was the feast of St. Victor and thereafter the Guelphs chose him as their second patron, after St. Barnabas. They

[107]

made the day an annual Guelph holiday. Michelangelo, a republican by conviction and Guelph by descent, was well chosen by the Signoria to commemorate this victory.

We may assume that Michelangelo took part in selecting the theme of the fresco. Instead of the actual battle, the moment is chosen in which Manno Donati appears among the bathing and resting soldiers with the cry "We are lost!" The choice of this moment gave him the opportunity of representing a large number of nude figures in varied movement. In thus depicting the approach of a fateful hour, the danger seems all the greater for being invisible. There are no masses of enemy in the background at the moment when Manno Donati cries "Siamo perduti!". Michelangelo, as is typical of his historical paintings (cf. Deluge of the Sistine Ceiling), emphasizes the *inward* event, here the panic which possesses the souls of the Florentines in this momentous hour, rather than the outward event of actual battle.

It is possible, as Justi and Suter suppose, that Michelangelo at first had the intention of competing with Leonardo in representing a battle with horsemen (xx, 5). In fact, there exists a rapid sketch showing a battle scene of cavalry (No. 19). This should not be considered as a project for a background scene of the actual cartoon. In its symmetrical composition, it seems rather to be a *pensiero* of the period when Michelangelo intended his fresco to be a battle with horsemen. But in the final work he confined himself to the field in which he himself excelled.

The cartoon represents the nude in manifold forms. It was vastly admired by contemporaries as a compendium of knowledge of the human body. Cellini called it "the school of the world." The painting is much more than this, however—like the Doni Madonna, it is an example of painting conceived according to the principles of sculpture.

The figures, and the rocky ledge on which they stand, seem to be carved from a great trapezoidal block of marble. The figures are divided into several groups. To the right and left the composition is balanced by two triangular groups of three figures, all in the most varied positions. Between there is a middle group made up of five figures, which form two overlapping triangles, of which the heads of Donati and Malatesta are the summits. Each of these three groups in the foreground is supplemented by complementary figures behind. Two figures accompany each of the lateral groups and four figures form a background for the central group. All these figures are on three different planes of the imaginary trapezoidal block.

Michelangelo slightly upsets the symmetry of this architectonic conception by setting the central group slightly to the right, so that this side seems somewhat heavier and more compact. Evidently he planned the composition to go on the left oblong field of the east wall and, therefore, wished to guide the eye of the spectator from left to right, i.e. in the direction of the central field which was to be occupied by Leonardo's Battle for the Flag. The right oblong field was probably destined for another scene by Leo-

nardo, which was to show the cavalcade on the right side and on the left the battle of the bridge. Several sketches by Leonardo for this composition still exist.

By their action the figures of Michelangelo's cartoon have the quality of living beings yet their sculptural aspect endows them with a monumental, superhuman character. They seem fixed in a kind of apotheosis, in the attitude of celebrated antique statues (xx, 9). This twofold nature gives to the historical event an "eternal" validity. This "conquest of time" in art by means of transforming living types into "statues" had an immense influence in the sixteenth century, both in Italy and in the North, up to the time of Rubens.

The depicting of a scene of nude warriors was not new to Florence. There are the "arabesques" in etchings of A. Pollaiuolo, and Verocchio's lost drawing of a battlepiece. But Michelangelo was the first to give a monumental and "antique" aspect to the subject.

Michelangelo's composition may seem a bit artificial beside that of Leonardo. But it is really unfair to compare the two directly without first understanding the artist's intention in each case. Leonardo represents the battle as a dramatic event, and the struggling warriors and horses as driven by the passion of anger. It is a collision of unleashed forces which results in a whirlwind movement transposed into human and animal forms. For Leonardo the physical laws of the forces of the universe reveal themselves through the phenomenon of the battle. Michelangelo, on the other hand, grasps the metaphysical content in this historical event, the Fatum, and fixes the figures in frozen poses, putting them beyond all time; not man in his dependence on nature, but man and his destiny is the problem.

Each of the two Battles influenced deeply the painting of the following century. It is interesting to note that Rubens, in addition to making a copy of the Battle of Anghiari, studied in Mantua the fragments of Michelangelo's Battle of Cascina.

We may gather the intentions of Michelangelo the painter with more certainty from the Madonna Doni, which is preserved in the original, executed ca. summer 1503 for Agnolo Doni (x). This painting shows that the artist wished to represent in this panel true form, "la vera forma," that is, "form around which one can move."

59 to 62

The figures of the Madonna, St. Joseph and the Christ Child seem to have been carved from one large cylindrical block and the movements of the figures are contained within this imaginary boundary. A series of circles is employed in the depicting of the forms, circles which begin at the base with the limbs of the Virgin, continue round the figure of St. Joseph and follow the raised arms of Mary and the left shoulder of St. Joseph to the small circle formed by the two arms of the Child. This accentuates the roundness of the group, and enables the eye to grasp the plastic form. The low wall in the second plane, upon which lean the Ephebian youths, curves behind the Holy Family to form a sort of niche, and emphasizes the sculptural quality of the foreground

group. The relationship of the background figures leads the eye from left to right and finishes in the figure of the little St. John at the right, who looks up at the Christ Child in a three-quarter profile position that anticipates that of the Virgin.

The whole composition is thus built up in circles seen in perspective and, being enclosed in a circular frame, it gives the impression of a sphere, a kind of glass ball into which one looks.

In this painting the Holy Family has a character more pagan and classical than Christian. The Virgin is represented as a virile heroine. With nude muscular arms she holds the Child at her shoulder, with the gesture of vase-carriers in ancient sculpture. The Child is not shown as the gentle Saviour but as an Olympian athlete type, with a band of victory about his curly hair; and Joseph is more a tragic poet than the simple carpenter. With his broad brow, bald pate and heavy hair hanging over his ears, he resembles ancient portraits of Euripides.

This iconography has a special significance. The motif of a figure standing on the shoulders of another is an age-old way of representing the victory of a new principle over an older one which has prepared the way for it. In medieval cathedrals sometimes the apostles stood thus upon the shoulders of the prophets, in order to symbolize the origin of the New Covenant from the Old, and the superiority of the New. By birth the Virgin and St. Joseph belong to the Old Covenant and by their relationship to Christ, they are of the New. Here, with Jesus placed high on the shoulder of his mother, Michelangelo apparently wishes to show that the principle embodied in Christ, while dependent on that of Mary and Joseph, at the same time surpasses it. The Child gazes down with a thoughtful and understanding expression at his mother's adoring face full of hope for the future, as though fully conscious of his mission. In former representations of the little Jesus by Michelangelo, he was shown as an innocent child.

A low wall separates the foreground group from a second plane which rolls out behind them, and where we see several curly-headed nude youths, of slender, supple beauty. Behind this there is a bare mountain landscape, bathed in bluish light, a landscape which Michelangelo may have intended to recall the coast of Carrara. One of the Ephebian youths embraces another, while a third seems to court the favor of the one embraced. Two other youths at the left gaze dreamily upon the scene. The entire group, in their perfect athletic beauty and submission to sensuality, seem to represent the pagan world, a world incapable of grasping the noble ties of love that bind the Holy Family. The "moral" contrast between the foreground group and the figures in the background is an old tradition in the representation of this subject, both in Italy and in the North. Michelangelo may have been influenced by Signorelli's tondo in the Uffizi, where nude youthful figures likewise appear in the background. In Signorelli's work, to be sure, the nude figures are the shepherds of the New Testament. Michelangelo introduces them rather as contrasts to the Holy Family.

If the figures of the background thus represent the world *ante legem* while the world

sub lege is embodied in Joseph and Mary and *sub gratia* in Jesus at the summit, then it is logical that St. John, who "prepared the way" for Christ should be the link between the pagan and Christian worlds, and so he is shown gazing ecstatically at his Lord, while still corporally of the Old World—the "world" behind the first wall. The spherical composition which we have described is not only formal but has a symbolic significance as well. The "globe of the world" is here, and in it we see the three main epochs of human development.

The technique of the painting and the coloring show that Michelangelo really intended to represent the figures as if done in sculpture. He excludes the softly enveloping *chiaroscuro* used by his contemporaries. The contours of the nude parts of the figures are fixed with a sharp red outline. Light serves to mold the figures plastically. It is reflected from the cool, hard flesh tones as though from polished marble. The shadows, never so deep as to hide any of the plastic surface, are lit by reflection.

In the Doni Madonna, for the first time, color values are logically subordinated to the plastic appearance of the forms. Harmony among the colors does not exist, in the Venetian sense, nor is there any "atmospheric" unity. Each color is subordinated only to the original ivory tone of marble, which shines through it and establishes a kind of unity among them all. The colors are mobile, changing in tone and hue, and playing on the surface as though never quite assimilated to the matter itself. The Virgin's pink robe inclines toward a bright yellow in the convex parts, her bright blue mantle turns into white where it is arched, and its green lining becomes golden yellow. This gives the effect of exceeding clarity of tone and a marble-like coolness, while a subtle play of contrast between the colors heightens the special quality of beauty in each: the pink of the Virgin's blouse is contrasted with the blue brooch at her bosom and the light blue of her mantle with the little piece of pink gown which emerges from under it on the ground.

VI. RETURN TO THE VISION OF PRETERHUMAN FORCES

THE conception of the St. Matthew, the last of the youthful works preserved by Michelangelo, goes back to his classical Florentine period. On April 24, 1503, he signed a contract with the consuls of the Arte della Lana to execute twelve apostles for the cathedral at Florence (XI, 3). It seems that Michelangelo made some preparatory sketches at that time, of which only one is preserved. This sketch (No. 19) represents a figure in profile, with one foot resting on a raised base, in "antique" drapery which leaves the arms bare. In his left hand he apparently holds a book, while he carries the other to his chin in a thoughtful gesture, which we find later in the Naason lunette of the Sistine Ceiling and in the Pensieroso of the Medici Chapel. The ensemble of the pose and drapery is reminiscent of statues of ancient orators. The calm pose and contemplative spirit of the figure as well as the severe rectilinear folds of drapery are completely typical of Michelangelo's works of the classic period.

A great distance lies between this sketch and the unfinished marble St. Matthew on which the artist worked about three years later (XI, 8). The apostle is a figure of massive proportions, with powerful neck and limbs, and bearded head. The tendency toward amplitude in forms noted in the preceding tondi is here fully developed. However, equilibrium between the enlarged forms and an increased vitality of the figure that was achieved in the others does not exist in the St. Matthew, where the vitality is completely overwhelming.

The calm position of the figure in the sketch is transformed in the pose in the St. Matthew, where the body seems seized in a sort of convulsion. The leg is drawn up in an uncontrolled reflex movement; the head twists violently, with wide opened eyes and a mouth which seems to groan. His hands seek a place of support. The left elbow is pressed against his side and the left hand clutches with trembling fingers the large book under his arm. The thumb of the right hand is thrust into his belt and his other fingers grip his robe.

The figure of the St. Matthew expresses a sort of eruption of uncontrolled and deep-seated natural forces in man, which not only determines the position of the members but seems to have produced their very forms. His immense limbs break through the slight drapery like flowing lava. There is nothing here of the knowing anatomy of the David. Instead, Michelangelo suggests in the bodily forms of the St. Matthew, wherein anatomical exactitude is largely suppressed, the ebb and flow of vital forces which carry on rhythmically within the human body. In life we see mainly the immobile aspect of the body, although its physiology constantly reminds us of the fundamental law of its rhythmic nature. Michelangelo actually tries to show this inward rhythm. He gives a softness and flowing contours to the limbs and swells them with a sort of vital sap. He subordinates external accuracy to the inward vision of truth which possesses him. In view of this, it is not wholly surprising that Michelangelo did not complete

63 to 66

103

63

66

this statue. He could not better express what he wished than in its vague and unfinished forms.

242
The figure of the St. Matthew has been associated many times with the Laocoön (and the Pasquino) which it recalls by its twisted movement and suffering expression (XI, 5). But in the antique works, the exterior reason for the suffering is visible. Michelangelo on the other hand has represented a primordial suffering, the moment when the soul is seized by superhuman cosmic forces, which destroy its individuality—and the conflict of submission to these forces creates the struggling sufferance of the figure.

When we remember that Michelangelo at this time was haunted by ideas for the slaves of the Tomb of Julius II, we can understand better the spiritual content as well as the physical structure of this statue. Strangely for an apostle, this figure expresses the idea of torment and seems enchained. In the slaves of the Tomb of Julius II are found the same twisted pose and facial expression. In the first project for the Julius Tomb the position of the figure at the left side of the façade is very close to the St. Matthew. We shall see that the slaves of the Julius Tomb are conceived by Michelangelo as souls imprisoned in their bodies, and not as allegories of the defeated arts or of the defeated provinces as Condivi and Vasari believed.

64, 65
Vasari (1568, p. 55) points out the unfinished statue of St. Matthew as an example that "teaches the sculptors how figures may be made from marble without mutilating them." Michelangelo began by tracing the contours of the front view of the figure on the face of the rectangular block. He then proceeded to cut away from the most projecting parts (the head, the left hand, left knee) and then cut successively deeper into the marble, bringing out the lower parts of the figure. The advantage of this method is that the artist always has the whole of the main view of the statue before his eyes. The side views are not developed separately but result as the main view progresses, and are determined by its character. After having disengaged the forms in the rough from the material, he returns to them, several times, thus bringing them ever nearer to completion, while simultaneously working on the whole. As a result, at any stage in the process of his work, Michelangelo has produced a thorough work of art. As has been accurately said of his method in modelling a statue, "Michelangelo makes several figures one beneath the other" (XI, 9). Another result of this method is that the figure seems enclosed in its own space, namely, that of the block. In the process of execution this "stone-space" (Hildebrand) may disappear materially but it remains artistically as the limit of the life space of the figure. This fact gives to such figures a certain isolation and loneliness. They live in their own space, not in our space.

This technique, which is inspired by the nature of marble, is in contrast with the customary technique used previously by Florentine sculptors who worked all around the block, bit by bit. The sculptor using this method was often obliged to add pieces to the marble, since he did not completely conceive the design in the block. Michelangelo himself later gave (1547, Milanesi, p. 522) his own precise definition of sculpture fol-

lowing Alberti and Leonardo: "I conceive sculpture to be that which is made by taking away"—"per forza di levare"—(that is, in contrast to the technique of painting which is done by the process of addition, "per via di porre"). Vasari (ed. Milanesi, I, p. 148) takes up the definition of Michelangelo when he says: "Sculpture is an art which by taking off that which is superfluous from the material reduces it to that form of body which is designed in the idea of the artist." Then he gives an accurate description of the method of Michelangelo and takes a position against that previously used, declaring it erroneous and barbaric. Benvenuto Cellini in his *Trattato della Scultura* (p. 228) also gives a very similar description of Michelangelo's technique and of his tools.

After the clear and rational Florentine period Michelangelo again plunges into the preterhuman sphere where primordial life forces are revealed. The St. Matthew is a kind of return to his starting point (the Battle of the Centaurs) and marks the end of a period of his life. But at the same time it is also a beginning of a second cycle in his evolution.

From the preterhuman sphere he is again driven to clarity and reason, and in the Sistine Ceiling tries to dominate the blind forces which he had called forth in the St. Matthew.

CONCLUSION

THE analysis of Michelangelo's work given above finds corroboration in the ideas which he himself expressed on art and by which he sought to justify his own artistic activity. We may attempt to reconstruct broadly his general theory of art on the basis of his poetry and of certain writings of the time.

According to Michelangelo's poetry true artistic inspiration is not derived from the material world. The visible beauty of the universe is but a "mortal velo" (Frey, *Dicht.*, LXXXVII) which has value only in reflecting the divine idea (Frey, *Dicht.*, XXXI). When external beauty—"il bel di fuor" (Frey, *Dicht.*, LXXIX)—penetrates into the soul by means of the mortal eyes—"occhi mortali" (Frey, *Dicht.*, XXXII)—it is transformed there into the "heart's image"—"l'imagine del cor" (Frey, *Dicht.*, LXII)—which is superior to the other: "L'inmagin dentro crescie" (Frey, *Dicht.*, XXXIV; VI). Appearance becomes truth "'l ver della beltà" (Frey, *Dicht.*, XXXII), and the outward image is "transcended into the universal form"—"trascende nella forma universale" (Frey, *Dicht.*, LXXIX). This transfiguration is due to the divine nature of the soul (Frey, *Dicht.*, XIX; LXXXVII) which even in the body lives "sol per divina legge" (Frey, *Dicht.*, LXXIII, 14).

The contemplation of true beauty carries the soul to metaphysical heights (Frey, *Dicht.*, XCIV), "che narrar mal puossi in questa vita" (Frey, *Dicht.*, LXIV). Toward this exalted state Michelangelo had aspired since his youth: "al ciel sempre son mosso" (Frey, *Dicht.*, CIX, 19), "al cielo aspiro" (Frey, *Dicht.*, CIX, 104). This "heaven" for which he yearns so ardently ("ardente desio," Frey, *Dicht.*, CIX, 101) is peopled not by the celestial hierarchy of saints and angels, but by the "immortal forma" (Frey, *Dicht.*, CIX, 105)—the eternal archetypes of existence.*

The scattered notes of Michelangelo are greatly augmented by a small book, relatively little known, by one of his immediate followers, Vincenzo Danti. In his *Trattato delle perfette proporzioni* (Firenze, 1567) Danti, as had Michelangelo, declares that the artist should not directly copy the visible world ("ritrarre"), but should recreate it ("imitare") according to the intentions of nature, that is, "imitare la perfetta forma intenzionale della natura." "In our mind is created the perfect form intended by nature, which we then seek to express by figures, either in marble, in color or otherwise." The artistic "concetto" is therefore the inward image which the artist makes for himself of the intention of nature.†

* Concerning the influence of the neo-platonic metaphysics on Michelangelo's poetry, cf. L. v. Scheffler, *Michelangelo*, Berlin, 1892; Borinski, *Die Rätsel Michelangelos*, Berlin, 1908; E. Panofsky, *Idea*, Berlin, 1924, pp. 64*ff* (who, following Varchi, emphasizes also the Aristotelian influence on Michelangelo's theory of art); N. A. Robb, *Neoplatonism*, pp. 239*ff*; A. Blunt, *Artistic Theory in Italy*, Oxford, 1940, pp. 58*ff*.

† Therefore, the "subjective intention" of the artist is identified with the "objective intention" of nature, a point of view very characteristic of sixteenth century esthetic.

R. W. Lee, "The Humanistic Theory of Painting," *Art Bulletin*, XXII, 1940, pp. 203*ff*, speaks in detail of the doctrine of imitation in the Renaissance. He distinguishes in his excellent work, the old "exact imitation" from the new "ideal imitation." In the latter, following L. Dolce, he mentions two ways: "by selecting the fairest parts from a number of individuals to produce a composite figure more perfect than commonly exists" and by

In a lecture on two poems of Michelangelo given in the Accademia of Florence in 1546, and approved by Michelangelo (Milanesi, p. 524) Benedetto Varchi gave a definition of the relation of artistic idea to form as follows: "Art is nothing but the inward image of the object to be depicted, an image which is in the soul, that is, in the artists' imagination. This image is the principle which determines the form created in the matter, and so it is the first principle or 'causa efficiens' of everything that one creates." Varchi emphasizes the fact that the "concetto" in Michelangelo has the same significance as the "idea" of the Greeks, the "exemplar" of the Latins, and the "modello" of the Italians, and corresponds moreover with the "forma agens" of Aristotle.

This theory of Michelangelo transposes interest from the external to the internal, considering the visible form as the emanation of its "idea." It creates a new dimension in the main concepts of artistic theory of the Renaissance. For artists before Michelangelo, Ghiberti's definition, "only proportion makes beauty" (ed. Schlosser, p. 105), was valid. For Michelangelo beauty is the suitability of the form to the idea, for "beauty depends on the final end." "In those parts which are best suited to their purpose, one sees beauty manifestly resplendent" (Danti). The concept of proportion which up to this time had been based on the relation of quantitative measurements, is now used in a qualitative sense, namely for the correspondence of the object to the "idea" inherent in it. "In the correct adaptation of the form to the idea consists proportion." A stable quantitative proportion does not exist. "The body is mobile from beginning to end, that is, it has no stable proportions . . . all members change in breadth and length during motion" (Danti).

Condivi (p. 192) reports that Michelangelo "intended to write an ingenious theory, thought out during long practice." The biographer did not know of what this theory consisted, but he adds "I know that when he [Michelangelo] read Albrecht Dürer it seemed to him a very weak thing . . . for to tell the truth, Alberto only takes up the measurements and the variations [of age and sex] in the body, things about which one can give no certain rules . . . he says nothing about that which would be most important, human actions and movements." The changing mobility of the body and the resultant differing proportions as described by Danti seems to have been one of the main points of the theory about which Michelangelo had in mind to write.

If "classic art" such as that of Raphael is a conciliation of external reality with the ideal of beauty, then it may be said the art of Michelangelo which wishes to embody only the pure idea of existence, subordinating to it all the elements of the visible world, belongs fundamentally to the spiritual domain of Platonism.

studying the "faultless antique." A third way should be added, by which visible nature is surpassed through the "imitation of the intention of nature," which is spoken of by V. Danti. Danti's book was used for the reconstruction of Michelangelo's theory of art by Tolnay, *Codex Vaticanus*, pp. 181ff, and in "La théorie d'art et Michelange," in *Deuxième Congrès International d'Esthétique et de Science de l'Art*, Paris, 1937, II, pp. 23ff.

CRITICAL CATALOGUE

INTRODUCTION TO THE CATALOGUE

In this Critical Catalogue, we attempt to bring together the essential information concerning the original works (preserved and lost) of Michelangelo's youth. These data are based upon the author's research, carried out for the most part in Italy, France, England, Germany, and Austria, and upon the results obtained by previous critics.

Each work has been examined in various aspects: present condition, attribution, history, iconographical subject, inspirations which may have played a part in the creation of each work, attempts to determine the proper place of each work in the evolution of the master's art, information concerning the technique, and finally enumeration of a few important copies. In this arrangement we have adopted the method followed by *L'Inventaire critique et détaillé du Départment des Peintures du Musée du Louvre*, by Edouard Michel and Mlle. Hélène de Vallée, which is, in our opinion, the most complete catalogue of works of art in existence.

At the end we include a catalogue of works which are apocryphal, or falsely attributed to Michelangelo.

Some facts mentioned in the previous text concerning the work of Michelangelo will be repeated in this catalogue accompanied by documentary proofs, bibliography or both.

CATALOGUE OF ORIGINAL SCULPTURE
AND PAINTING

I. VIRGIN OF THE STAIRS

Florence, Casa Buonarroti.
Low relief.
H. 55.5 cm.; W. 40 cm.

(1) CONDITION: Excellent, except for the marble border which is broken in the two upper corners. The border is now concealed by a modern wooden frame. Through the kind permission of Commendatore Giovanni Poggi, director of the Casa Buonarroti, it has been possible to remove this frame and photograph for this work the relief in its original state. [1,2]

(2) ATTRIBUTION: Not signed. It was mentioned for the first time in the second edition of Vasari (1568, p. 27). The attribution to Michelangelo has never been questioned except for Charles Holroyd (*Michelangelo*, p. 89) and Ernst Benkard (*Michelangelo's Madonna an der Treppe*, Berlin, 1933, passim). Benkard, with insufficient arguments, attributes the relief to the School of Bandinelli. But the grandeur of the conception of the whole and the quality of plastic execution, as well as the presence here in embryonic form of many elements which anticipate Michelangelo's later work (see below), establish it without doubt as an original from the artist's early period.

(3) HISTORY: Vasari (1568, p. 27) says: "Lionardo [Buonarroti—Michelangelo's nephew], non è molti anni, che haveva in casa per memoria di suo zio una Nostra Donna di basso rilievo di mano di Michelagnolo di marmo, alta poco piu d' un braccio . . . Questa donò Lionardo poi al *duca Cosimo Medici* [Cosimo I]." This gift was probably made between 1566 and 1567 at the time when Vasari was preparing the last two volumes of the second edition of his work (Kallab, *Vasaristudien*, p. 295; Benkard, op. cit., p. 68).

In 1584, Borghini (*Riposo*, III, p. 51) writes: "E questa [Nostra Donna] è in mano del serenissimo *Francesco Medici Granduca* nostro."

In 1617 the relief once more became the property of the Buonarroti family, being presented by Cosimo II to "Michelangiolo il Giovane quando questi faceva in propria casa una Galleria Michelangiolesca" (see Fanfani, *Spigolatura*, p. 33; Cavallucci, *Ricordo al Popolo Italiano*, 1875, p. 177); Bocchi-Cinelli (*Le Bellezze di Firenze*, p. 349): "Evvi [in the house of Lionardo Buonarroti] ancora una Madonna in marmo di basso rilievo . . . la quale fece Michelagnolo." Described as in the same place by Bottari in Borghini, III, p. 51, note 2, "Questo bassorilievo fu donato *da Cosimo II* al detto Michelagnolo il Giovane [son of Lionardo, nephew of Michelangelo], che lo pose nella terza stanza della [sua] galleria dove tuttavia si conserva insieme con un getto di bronzo." See finally, the note by Fabbrichesi (*Guida*): "No. 14, Cosimo Buonarroti a légué la maison [Casa Buonarroti] avec les collections à la ville de Florence le 9 février 1858."

(4) SUBJECT: Two distinct types of representation of the Madonna were in vogue

during the fourteenth century in Tuscany. In the first she appears simply as the Mother of Christ (Mütterliche Madonna), without attributes, and as such derived in type from Byzantine icons of the beginning of the twelfth century and destined generally for private veneration [C. Weigelt, "Über die 'Mütterliche' Madonna in der italienischen Malerei des 13. Jahrhunderts," *Art Studies*, vi (1928), pp. 195*ff*, and V. Lasareff, "Studies in the iconography of the Virgin," *Art Bulletin*, xx (1938), pp. 26*ff*]. The second type is hieratic with the attributes of the Queen of Heaven (i.e. the throne, crown, and nimbus) and the Child assumes the attitude of the Blessing Saviour. During the fifteenth century these two types appear side by side and sometimes even in the work of one artist, as for example Donatello, whose Madonna of the Casa Pazzi represents the bourgeois type and Madonna dello Santo at Padua, the hieratic one. Generally, however, the two types intermingle and in the second half of the fifteenth century particularly, artists frequently combined a Virgin, figured as a young bourgeois woman, with a Child, represented as the Blessing Saviour (cf. works by Filippino Lippi, Ghirlandaio, Verrocchio, Botticelli, Mino da Fiesole, Luca della Robbia).

In Michelangelo's relief all the conventional attributes of the Regina Coeli, with the exception of the nimbus, are omitted and the artist has returned to a type rare in Tuscany in the fifteenth century—that of the "virgo lactans." This type, known in Byzantine art (Lasareff, op. cit., p. 26) is found in Italy in the first quarter of the fourteenth century, as for example in Ambrogio Lorenzetti's "Madonna del Latte" in Siena (Seminario arcivescovile), and then disappears to be found again in northern art during the fourteenth and especially at the beginning of the fifteenth centuries. Yet Michelangelo's Child is shown sleeping on the breast of the Virgin and the Madonna is not represented in purely maternal aspect with the usual gesture of tenderness. The artist portrays instead a sibylline type. Her relation to the child is prophetic rather than emotional: Her sadness foreshadows his tragic fate. Death inherent in life, as it is revealed here in the Child, is a thought which Michelangelo expressed (according to Vasari, 1568, p. 252) in these words: "se la vita ci piace, essendo anco la morte di mano d'un medesimo maestro, quella non ci dovrebbe dispiacere." Courajod ("Récentes acquisitions du Musée de la Sculpture Moderne au Louvre," *G.d.B.A.*, xxiii, 1881, p. 199) describes her as follows: "La Vierge reveuse, grave, triste, presque hautaine, le regarde inquietement fixé devant elle, semble avoir un presentiment de son malheur comme une vision de l'avenir. Nous n'avons plus devant nous la Mère gracieuse, rieuse, insouciante, inconsciente, que Rosellino, le Maiano, Mino, etc., nous ont tant de fois fait contempler dans son impassible rayonnante sérénité. Ici tout est generalisé; le visage n'est plus un portrait mais un type d'expression raisonné. Le vêtement est devenue draperie, sa siège n'est plus une chaire finement décorée. C'est un cube indéterminé . . . l'idéale a fait irruption dans l'art redevenue classique."

(5) Religious conceptions of ancient Italy had already identified "Woman" with "Mother Earth" (Terra Mater) and had thus considered her in the dual aspect of her

function—as the force which gives birth to new life and, at the same time, as the Mistress of the Dead. See for example the prayer entitled *Precatio Terrae Matris*, which reads as follows: "Alimenta vitae tribuis perpetua fide, et cum recesserit anima, in te refugiemus." This double role of the Terra Mater is found in Ennius and Lucretius. In ancient Roman cults there is a tendency to identify all the goddesses with the Terra Mater, and all the gods with the Coelus (cf. Varro, *Antiquitates rerum divinarum*, Lib. 16). Concerning the religious conceptions of Terra Mater, see Altheim, *Römische Religionsgeschichte*, Leipzig, 1931, pp. 12ff; Wissowa in Roscher, v, pp. 331ff; A. Dietrich, *Mutter Erde*, 2nd ed., 1912, passim; E. Strong, "Terra Mater or Italia?", *Journal of Roman Studies*, xxvii (1937), pp. 114ff; F. Cumont, *Les religions orientales dans le Paganisme Romain*, Paris, 1929, pp. 54ff.

The antique conception of prescience of death as a power of Woman is taken up by popular belief during the Middle Ages in Italy; and in the sermons of such preachers as Bernardino da Siena (ca. 1430) the Virgin is endowed with this sibylline faculty. The idea is repeated in the sermons of other popular preachers and finds its most forceful expression in Savonarola. He called this prophetic faculty "il vero lume." This faculty was at first not considered heretical by the Church. At the end of the fifteenth and the beginning of the sixteenth century, the preachers, travelling through Italy, were accustomed to insert prophecies in their sermons. Erasmus of Rotterdam in his *Ecclesiastes sive de arte concionandi*, iii, notes with astonishment this custom. The fifth council of the Lateran in 1516 finally decided to forbid all prophecies in sermons. (cf. Mario Ferrara, *Girolamo Savonarola, prediche e scritti*, Milan, 1930, pp. 42f.)

San Bernardino states that the Virgin possessed to the highest degree the sum of prophetic knowledge disseminated through all the prophets and patriarchs (Vol. i, First Sermon): "Secondo che dicono i dottori, Maria fu dotata di quattro cognoscimenti sopra tutte le altre criature: Primo cognoscimento è corporale. El secondo cognoscimento è razionale. Terzo cognoscimento è spirituale. El quarto cognoscimento è increato divinale. . . . E tanto fu questo cognoscimento di Dio che raggunandi insieme tutti i cognoscimenti che mai ebbe niuno in questa vita, o vuoi propheti, o vuoi patriarchi . . . tutti ragunati costoro insieme da una parte, e ponendo quelli di Maria sola dall' altra parte, sono più quelli di Maria incomparabilmente, che quelli di tutti gli altri . . . Ella ebbe tanto cognoscimento di Dio e di ciò che Idio dece mai, che Ella intese ogni cosa . . . E indi David, vedendola per spirito di profezia, disse di lei: 'In lumine tuo videbimus lumen' . . . come tu vedi per lo lume del sole, così Maria tutto vide per lo lume dello intelletto suo, che sempre era acordato co la volontà di Dio" (San Bernardino, *Le Prediche Volgari*, ed. L. Banchi, Siena, 1880).

Savonarola, in a sermon (no. 43) delivered on Good Friday, 1494, about two years after the execution of the relief of the Virgin of the Stairs, said, "Lei [Maria] era dotta nelle scritture, et sapeva le Prophetie che havevano dette et prophetate e' propheti di Christo, nella legge: et lei tanto ancora era illuminata di lume di prophetia, più che

gli altri propheti: et era piena di tutte le gratie Gratio date, come tengano tutti e Dottori: et però sapeva che 'l figliuolo doveva patire in quanto huomo, questa passione." (*Prediche sopra Job*, 1494, ed. Venezia, 1545, pp. 374*ff*; see Steinmann, *Madonnenideal*, pp. 169*ff*.)

If, in artists independent of Michelangelo's influence, we find examples of this representation of the Virgin with the Child on her knees who takes the attitude of the Pietà Christ, we may understand it as a derivation of the same popular sermons. For example, in the Madonna attributed to Giovanni Bellini in the Academy at Venice, we find this suggestion of the union of two moments in the lives of the Madonna and Christ (cf. Körte, *Deutsche Vesperbilder*, pp. 111*ff*). Michelangelo himself used this idea again in his "Madonna del Silenzio."

2 (6) The motif in the background of the children holding up a drapery is derived in type from the motif of the angels holding the Holy Shroud in certain representations of the Pietà in the fifteenth century (e.g. Pietà of Donatello in Padua, S. Antonio). Its introduction here then suggests again the prophetic anticipation of the tragic fate of Christ. Contrary to the spirit of the relief this motif has been interpreted heretofore either as a realistic genre motif, as by Justi (*Ma., N.B.*, p. 36), who says the boys are attaching a drapery to the wall to protect the evening siesta from the wind; or they were interpreted in a purely formal way, as by Steinmann (*Madonnenideal*, pp. 169*ff*), who says that the children on the stairs seem to have no other purpose than to fill the void of the surrounding space and that there is no spiritual connection between them and the main group.

The two children apparently at play, in the left background, serve to emphasize by contrast the gravity of the Virgin's figure in the foreground. The contrast between the playful ingenuousness of the children and the gravity of the Madonna is taken up again later by Michelangelo, for example in the tondo of the Bargello. That there is no question here of a conventional Virgin and Child, but a composition with prophetic anticipation of the Pietà, we have already pointed out in *Michelangelostudien*, p. 110.

(7) ANALOGIES: Strzygowski (*Studien*, pp. 207*ff*) was the first to note the resemblance of the Virgin of the Stairs to the seated women in sepulchral reliefs of antiquity. One of these reliefs, a mediocre copy after a Greek original of the fourth century, to which Wölfflin called attention, was until recently embedded in one of the walls of the

133 courtyard of the Palazzo Medici-Riccardi (see Strzygowski, op. cit., p. 216, note). The position of the woman in this poorly preserved example, seated on a rectangular block-like bench, her legs seen in profile, one of her hands lifting a veil, the other resting on her knees, is closer to the work of Michelangelo than those rare fifteenth century examples of the Madonna seated in profile in which it has been generally desired to find the prototype of this composition. The grave aspect of the antique sepulchral reliefs was appropriate from every point of view to the solemn, prophetic Madonna type which Michelangelo wished to represent. Although this antique relief is a very

inferior work, nevertheless it testifies to the fact that the antique motif of the Seated Woman was directly accessible to Michelangelo. It is probable, however, that he had occasion to see in the Medici collection a better example of this type. Among the Greek sepulchral reliefs which Michelangelo could not have known directly are to be found even more striking analogies. See, for example, a late fifth century B.C. stele of Ampharete and a grandchild, Athens (Kerameikos Museum, found 1932), where the entire group is similar. Other examples of the pose are found in G. von Kieseritzky und Watzinger, *Griechische Grabreliefs aus Sud-Russland*, Berlin, 1909, Pl. XII, nos. 157, 160, 164, 169, 171, 178; and A. Conze, *Attische Grabreliefs*, Berlin, 1893-1922, Pl. XVIII. We reproduce for comparison a Greek stele of the fourth century B.C. preserved in *132* the Munich Glyptothek.

It can be noted further that the very thin drapery, as here in the Madonna's cloak, was considered during the fifteenth century as a characteristically antique motif (see Warburg, *Botticelli*, p. 11).

Aside from the sepulchral reliefs certain analogies with seated figures on antique gems and coins can be seen. See Justi, *Ma., N.B.*, p. 35; A. Hekler, "Michelangelo und die Antike," *Wiener Jahrb. für Kunstgeschichte*, VII (1930), p. 204.

Finally, there are certain resemblances to antique statues of Demeter, particularly in the drapery which may be compared to the Demeter in the British Museum attributed to Praxiteles.

The motif of the stairs seems to have been derived from reliefs by Donatello, as for example that of the "Dance of Salome" (Lille, Musée Wicar). See Knapp, p. 166.

(8) Other attempts have been made to find prototypes for the Virgin of the Stairs by citing works of the fifteenth century. The first was by Vasari, who stated (1568, p. 27) that Michelangelo wanted to "contrafare la maniera di Donatello." Bode took up this thesis (*Ital. Bildh.*, p. 57, and *Flor. Bildh.*, p. 174), indicating as a model for the work of Michelangelo a relief found in the Dreyfuss collection at Paris, which he assigned to the youthful works of Desiderio da Settignano. This composition he supposed to have been derived from a similar one by Donatello and noted in support of his theory a relief in the Louvre from the School of Donatello which shows the same motif. A similar work, though not identical, by Donatello is the "Virgin in the Clouds" *136* in the Boston Museum. Bode concluded that there probably existed an exact model by Donatello which was copied in the Louvre relief and in the relief which he attributed to Desiderio. Finally he pointed out, as proof that Michelangelo studied the relief by "Desiderio," a drawing—then in the Heseltine and later in the Oppenheimer collection in London (*Vasari Society*, 1924, Pl. IV)—which according to him is by Michelangelo and which he believed to be a study after the relief attributed to Desiderio in the Dreyfuss collection. This theory was taken up again by Strzygowski (*Studien*, pp. 207*ff*).

The thesis of Bode and Strzygowski was refuted by Wölfflin (*Madonnenreliefs*, pp.

107ff). He showed that the relief in the Dreyfuss collection is a modern forgery, and that the drawing of the Oppenheimer Collection is not by Michelangelo but from the shop of Bandinelli. He published another drawing by Bandinelli in the Uffizi, no. 1527, which is also a copy of the motif of the Dreyfuss relief. He cited further a plaster relief, of better proportions, which served as a model for the forged Dreyfuss relief and for the drawing of the Oppenheimer Collection, and he noted the existence of two other examples, one in Italy and one in the Victoria and Albert Museum. (The original of these plaster reliefs is the marble in the Victoria and Albert Museum.) Wölfflin maintained that the author of these compositions was not Desiderio but an artist working at the beginning of the sixteenth century who was already under the influence of Michelangelo. Finally Liphart ("Le Sculpteur Francesco Ferrucci et Léonard de Vinci," *G.d.B.A.*, LXVI, 1924, pt. I, pp. *7ff*) attributed the relief of the Dreyfuss collection to Francesco di Simone Ferrucci. He noted that the child in the Dreyfuss relief is copied from a sketch of Leonardo (Brit. Mus., London).

This group of Madonnas in profile can be further completed by the addition of a marble copy in the Musée Calvet in Avignon (cf. E. Ybl, *G.d.B.A.*, LXIII, 1931, pp. *298ff*) and by three drawings, one by Fra Bartolommeo (Munich, Kupferstichkabinett, No. 2166), the other attributed to Pietro Perugino (Florence, Uffizi, No. 56r) and finally one from the atelier of Bandinelli (Louvre, cf. de Liphart, *Beaux Arts*, II, 1924, p. 278). This latter is almost identical with the Oppenheimer drawing but somewhat less fine in quality.

Concerning the sources of inspiration of the so-called "Desiderio" relief, it should be noted that the figure of the Virgin derives unmistakably from Donatello's Virgin in the Clouds in Boston while the Child, as mentioned above, is most probably a copy after Leonardo's pen-drawing in the British Museum for the Benois Madonna at Leningrad. It has generally been supposed on the contrary, however, that Leonardo copied the Christ Child from the "Desiderio" relief (cf. Maclagan, *Catalogue of the Victoria and Albert Museum*, 1932, p. 42, No. A 84-1927). This hypothesis seems very unlikely, because the rapid sketches of Leonardo have the spontaneous character of an invention, whereas the rather rigid Child in the relief looks like a copy. (The influence of Leonardo's Child on the paintings of the late fifteenth and early sixteenth centuries has been studied by G. Gronau, *Z.f.b.K.*, XXIII, 1912, pp. *253ff*.)

If one admits that the Child in the "Desiderio" relief is copied after Leonardo's drawing we have a *terminus post quem* for the reliefs. They cannot date earlier than the end of the 1470's, and consequently these works cannot be attributed to Desiderio, who died in 1464. Also the inferior quality of the marble reliefs speaks against Desiderio's being the artist. Wölfflin, who was the first to doubt the attribution to this master, seems to go too far, however, in supposing the Dreyfuss relief a modern forgery. It appears to be rather the work of a late Quattrocento imitator of Desiderio's style. The identification of this artist with Francesco Ferrucci by de Liphart seems unlikely, because of the dif-

ferences in style which distinguish the Dreyfuss and London reliefs from the works attributed to Ferrucci, such as the Madonna of the Via Cavour and that of the Foulc collection in Paris (now in the Pennsylvania Museum of Art in Philadelphia).

The similarity between these Madonnas and that of Michelangelo consists only in the fact that the Virgin is represented full-length and seated in profile; the attitude itself is quite different. The Virgins of Donatello and of "Desiderio" are leaning toward the child, while the Virgin of Michelangelo is seated in an upright position— an attitude rare in the fifteenth century. Only one work can be cited where the Madonna is seated in an analogous position and that is the Virgin of Maestro Andrea (identified formerly as Andrea Bregno, recently as Andrea dell'Aquila; see W. Valentiner, "Andrea dell'Aquila, painter and sculptor," *Art Bulletin*, XIX, 1937, p. 503). This work is independent of that of Michelangelo but seems to have been inspired by the same antique prototype, which would explain the apparent resemblance between the two.

Although we believe that in spirit and pose the Virgin of the Stairs was inspired by antique stele rather than by fifteenth century Madonnas, we do not deny that as to the technique ("rilievo schiacciato"), Vasari rightly pointed out the close connection with Donatello's reliefs (cf. the Virgin in the Clouds in Boston).

(9) One finds in this work a whole series of motifs which Michelangelo uses in later works. Thus the marked torsion in the position of the boy on the stair is found later in one of the figures in the Battle of Cascina. The two other boys in the left background are repeated by Michelangelo in the putti on the lateral pilasters of the thrones of the Prophets and Sibyls of the Sistine Ceiling (Wölfflin, *Jugendwerke*, p. 8). The distracted gesture of the hands of the Virgin clasping her veil is taken up again in the figure of Moses, who in similarly preoccupied manner runs his fingers through his beard. Finally, the attitude of the Child, with his muscular back turned toward the spectator and his arm flung behind him, appears again in inverted position in the half reclining torso of the figure of Day of the Medici Chapel. The motif of the arm and the limp hand with the palm turned out reappears in the inert arm of the Dead Christ of the Florence Pietà, as Wölfflin has observed (*Jugendwerke*, p. 7).

(10) CHRONOLOGY: Vasari (1568, p. 27), mentions the work as among those executed while Michelangelo was living with Lorenzo the Magnificent. He says that Michelangelo did it "[es]sendo giovanetto" and mentions this fact immediately after the "Battle of the Centaurs."

The technique, composition and plastic conception are more primitive than in the Battle of the Centaurs. In spite of the admirable skill with which the combination of the forms as a whole is rendered, the details lack precision. The hands and feet are without structure and as though made of clay. There is a certain lack of equilibrium in the disposition of the forms throughout the area of the relief. While some spaces are left void, a detail such as the Virgin's halo has been crowded from the field and allowed

to penetrate into the border. Furthermore, Condivi (p. 28) says of the Battle of Centaurs, "appena haveva finita quest' opera chel Magnifico Lorenzo passò di questa vita." From this it can be deduced that the Battle of the Centaurs was the last work done by Michelangelo at the Court of the Medici and hence the Virgin of the Stairs must be earlier. Nevertheless, except for Wölfflin (*Jugendwerke*, p. 5) who dates the relief in ca. 1491 before the Battle of the Centaurs and Knapp, pp. 165*f*, and Mackowsky, pp. 18*f*, who concur, scholars (i.e. Frey, *Ma.*, 1, Thode, *Kr. U.*, 1, Justi, *Ma.*, *N.B.*) have continued to follow Vasari and date it after the Battle of the Centaurs. The opinion of Brinckmann (*Barockskulptur*, p. 18), who curiously enough interprets the staircase as a Venetian bridge and dates the relief in 1494 during Michelangelo's sojourn in Venice, remains isolated.

(11) TECHNIQUE: Vasari, in his Preface (ed. Milanesi 1, p. 157) distinguishes three different types of relief: "mezzo rilievo" which has three planes of figures, "basso rilievo" without much plasticity, and with perspective and landscape, and "rilievo stiacciato" or "schiacciato" which is almost entirely flat and where little more than the design of the figure is given ("non hanno altro in se, che 'l disegno della figura"). In the Virgin of the Stairs there is a kind of synthesis of the two last—it is "rilievo schiacciato" but contains the effect of perspective. In this it approaches certain reliefs by Donatello, for instance the "Assumption" (Naples, S. Angelo a Nilo) and the "Virgin in the Clouds" in the Boston Museum. Vasari (1568, p. 27), in fact, says that Michelangelo "[voleva] contrafare la maniera di Donatello." But the manner in which he treats space differs from that of Donatello. In the latter the illusionistic effect diminishes the sense of the material of marble. Michelangelo deliberately emphasizes it by means of a composition built up on planes parallel to the original surface plane of the marble. The planes thus repeat, accenting it, this ideal surface plane and at the same time follow the natural structure of the stone which is built up in layers.

2 The fine hatchings to be seen in the unpolished portions of the relief reveal the fact that Michelangelo worked with an extremely fine-toothed chisel, and that he modified the direction of these hatchings according to the sculptured planes and without observing any rigid pattern.

(12) COPIES: Copy in bronze, executed for Lionardo Buonarroti, when he presented the original to Cosimo I. Florence, Casa Buonarroti (Fanfani, *Spigolatura*, p. 33).

Copy in clay. Berlin, Deutsches Museum. No. 210.

(13) MAIN BIBLIOGRAPHY: Wölfflin, *Jugendwerke*, pp. 5*ff*; Frey, *Ma.*, 1, pp. 109*ff*; Thode, *Kr. U.*, 1, pp. 10*ff*; Justi, *Ma.*, *N.B.*, pp. 32*ff*.

II. BATTLE OF THE CENTAURS

Florence, Casa Buonarroti.
High relief in marble.
H. 84.5 cm.; W. 90.5 cm.

(1) CONDITION: The relief, left unfinished by the artist, is in excellent condition
except for the border (right, left and below), which has been restored in clay apparently *3*
at the time when the relief was set in the wall of the Casa Buonarroti, about 2½ cm.
having been added at the bottom in clay.

(2) ATTRIBUTION: Unsigned. Mentioned by Condivi (pp. 26f), and by Vasari (1568,
p. 27). The attribution to Michelangelo has never been questioned.

(3) HISTORY: The work is mentioned for the first time in a letter of March 7, 1527,
of Giovanni Borromeo, Florence, to Marchese Federigo Gonzaga, Mantua: "Io ho facto
per mezzo d'uno amico mio amicitia com Michelagnolo schultore et sono in qualche
praticha com lui. Et spero havere [per il Marchese] certo quadro di figure nude che
combatteno, di marmore, quale havea principiato ad instantia d'un gran signore ma
non è finito. È braccia uno e mezo a ogni mane, et così a vedere è cosa bellissima, e vi
sono più di 25 teste e 20 corpi varii et varie actitudini fanno. Mi è parso sino qui havere
facto un bel passo che habbi voluto mostrarmelo, che non mostra cosa alchuna ad al-
chuno." (cf. A. Luzio, *La Galleria dei Gonzaga venduta all' Inghilterra nel 1627-1628.*
Milan, 1913, p. 248.)

The relief was the property of the Buonarroti family. Condivi (1553, p. 28),
"Questa sua opera anchor si vede in Firenze in casa sua"; Vasari (1568, p. 27),
"Ella [*scil.* the Battle of the Centaurs] è hoggi in casa sua tenuta per memoria da
Lionardo suo nipote"; Borghini in 1584 (*Riposo,* III, p. 50), "La battaglia d' Ercole co'
Centauri, opera maravigliosa . . . la quale è oggi appresso a Lionardo Buonarroti suo
nipote." Bocchi-Cinelli in 1591-1592 (*Bellezze di Firenze,* p. 348), "Nella casa di
Lionardo Buonarroti di mano di Michelagnolo si vede una battaglia de' Centauri in
un marmo di un braccio e mezzo per ogni verso." Bottari (1730 in Borghini, III, p. 51,
note 1), "Questa scultura fu collocata da Michelagnolo il giovane, figluolo di Lionardo,
e pronipote del gran Michelagnolo, nella prima stanza della sua Galleria, dove pure si
conserva al presente appresso il clarissimo e dottissimo signor Senatore Filippo Buonar-
ruoti." Fabbrichesi (1858, *Guida,* no. 14), "Cosimo Buonarroti a legué la maison
[Casa Buonarroti] avec ses collections à la ville [de Florence] le neuf février 1858."

(4) SUBJECT: Condivi (p. 26), and Vasari (1568, p. 27), say that Michelangelo ex-
ecuted this relief at the suggestion of Poliziano, but they do not agree on the title.
Condivi calls it "Il Ratto de Deianira e la zuffa de' Centauri"; Vasari, "La battaglia di
Hércole co i Centauri." In an attempt to reconcile this double tradition of the early
biographers it has generally been supposed that Michelangelo represented in the relief
a fusion of the two myths of Hygin, i.e. fables 33 and 34 (Frey, *Q.F.*, p. 83, and Thode,

Kr. U., I, pp. 8*ff*). This hypothesis, however, is quite artificial and is further unlikely since none of the motifs described by Hygin are represented by Michelangelo. More convincing is Wickhoff's proposal (*Antike im Bildungsgange*, pp. 408*ff*) that Condivi simply made a mistake and said the "Abduction of Deianira" when he should have said "Deidameia" or "Hippodameia" and that the relief represents the Battle of the Centaurs as recounted by Ovid, *Metamorphoses*, XII, 1.210*ff*. Wickhoff erred, however, in identifying the central figure as Perithous, for this figure is a centaur, as Strzygowski (*Studien*, pp. 207*ff*) rightly pointed out. If one interprets the relief in this sense, then the three principal figures agree with the description by Ovid. First, in the center is the Abduction of Deidameia or Hippodameia. In the translation of Ovid's *Metamorphoses* by Francesco Giovanni Bonsignori, made about 1370/80 and published in Venice in 1497, the event is described as follows: "Uno de gli centauri ardea de duplicata luxuria: cioe damore & p[er] ebrieza de vino. Alhora lo centauro se levo su: & *prese e portava via la sposa*. Poi tutti li altri Centauri ogniuno portava la sua." The figure in the foreground seizing a woman and with arm raised is in fact a centaur, for the legs of a horse can be distinguished beneath the left arm of the woman. The figure attempting to free Hippodameia may be Perithous. Theseus, preparing to throw an object toward the right in defense of Perithous, is described thus: "Theseo vedendo questo se levo su e tolse una angistara che a caso era li e p[er]cosse el centauro." In Michelangelo's relief Theseus is apparently holding a block of stone instead of a vase. One cannot identify with certainty the figure of Eurythion. He could be the centaur laying hold on Hippodameia. But most probably he can be identified with the central figure of the relief who raises his arm against Theseus. In this case the centaur abducting Hippodameia would seem to be a subordinate acting at the command of his master.

It is not a literal illustration of Ovid but a sort of sovereign choice of three principal moments of the event, i.e. the rape of the woman, the combat between Perithous and the Centaurs, the presentation of Theseus, who comes to help Perithous. These principal themes are surrounded by the fallen centaurs below, and the rape of the woman above. The victory of Perithous becomes palpable by the aid of Theseus and an older bearded man whose face recalls the antique busts of Socrates, and by the representation of the vanquished centaurs, who fill the lower part of the relief. While a literal illustration, as for example that of Piero di Cosimo in the Ricketts Collection in London (Schubring, *Cassoni*, No. 385, pl. 90) gives only isolated scenes, Michelangelo has succeeded by his sovereign method in accenting the three most important moments of the Rape, to suggest the totality of the event.

Michelangelo was probably familiar with the fable of Ovid through Boccaccio's book *Della Genealogia degli Dei*, trans. G. Betussi da Bassano, Venice, 1564 (Fr. Lorenzini ed.), p. 155*v*: "Ovidio . . . vuole che havendo *Perithoo* menato per sposa *Hippodamia*, & celebrandosi le nozze, egli pose i Centauri nella entrata della casa a mangiare, i quali per la crapula divenuti ebbri, & lascivi di lussuria, con soverchio ardire incominciarono

mettere le mani nelle donne, et havendo Eurito preso Hippodamia per volerla menar via, Perithoo & Theseo si mossero contra loro . . ."

This work of Boccaccio was the classic handbook of antique mythology in Italy at that time. The first edition was published in 1472. It was not until the middle of the sixteenth century that other lexicons on mythology appeared to replace Boccaccio's book in popular favor. These were the books of Lilio Gregorio Giraldi (1548) and Natali Conti (1551). Concerning these mythologists, see Frank L. Schoell, "Les mythologistes italiens de la Renaissance," in *Revue de littérature comparée*, IV (1924), pp. 5*ff* and J. Seznec, *La Survivance des Dieux Antiques*, London, 1940. The earliest detailed description of the Centauromachy is to be found in Bocchi-Cinelli, *Bellezze di Firenze*, p. 348.

(5) ANALOGIES: The influence on the composition of certain representations of battle subjects on antique sarcophagi is apparent. The complete filling of the field with figures symmetrically disposed, the triple axes—a central one, here accented by the principal figure, Eurythion, and two lateral ones, and the groups of the conquered in the corners, are especially notable in this connection. See for example, the "Battle *142* of the Romans and Barbarians" in the Museo delle Terme (Helbig, 1320). The attitudes of some of the figures are also inspired in large part by antique reliefs, as has been shown by Wickhoff, *Antike im Bildungsgange*, pp. 408*ff*, and the same motifs which Wickhoff cites from Greek reliefs can be found also on several Roman sarcophagi (as Walter Horn has pointed out in a paper not yet published). The figure of Theseus resembles in attitude that of the Discobolus (Hekler, op. cit., p. 203, mentions antique gems as furnishing analogies). The slight resemblance of this figure to the Bellerophon (Vienna) by Bertoldo di Giovanni on which Bode insists (*Flor. Bildh.*, p. 328), seems to be a coincidence. The attitude of the Centaur Eurythion is derived likewise from antiquity. A similar attitude is found on an antique sacrificial altar, today lost, but known from a painting by Filippino Lippi, "The Virgin and Saints" in the Nerli Chapel, Santo Spirito, Florence (A. Scharf, *Filippino Lippi*, Vienna, 1935, p. 209, Pl. XLI). In the painting the altar appears as the throne of the Virgin.

The heads of the women in the background of the relief reveal the influence of Donatello. For example, the head of the woman to the left of Eurythion, with her hair flying, recalls those of Donatello's bronze relief of the "Crucifixion" in the Bargello. On the other hand, the constantly repeated proposals that the relief by Bertoldo di Giovanni representing a battle of horsemen (Bargello) has striking resemblances to *143* the work of Michelangelo (Bode, *Flor. Bildh.*, p. 328) do not seem convincing. The composition in this relief lacks the accents of the central and lateral axes; it is, rather, continuous from left to right.

(6) The composition of this relief persists throughout Michelangelo's life. It appears later in the Battle of Cascina and in the sketches for the story of the Brazen Serpent

[135]

(Frey, *Handz.*, 51), designed perhaps to decorate the lunettes of the Medici Chapel, and finds its ultimate development in the composition of the Last Judgment.

The seated centaur in the lower left corner, whose head falls against his right hand, will be repeated by Michelangelo in the middle of the 'twenties in his drawing of the Resurrection of Christ, Louvre (Frey, *Handz.*, 40).

(7) CHRONOLOGY: The phrase of Condivi (p. 28) "appena haveva finita quest'opera [*scil.* the Battle of the Centaurs] chel Magnifico Lorenzo passò di questa vita," would seem to indicate that Michelangelo worked on the relief during the year 1492, and that he left it unfinished at the death of Lorenzo. As has been said above (see Virgin of the Stairs: I, 10), nearly all scholars, except Wölfflin, Knapp and Mackowsky, have dated the work too early, placing it before the Virgin of the Stairs.

(8) TECHNIQUE: "Mezzo rilievo," in the terminology of Vasari, with three planes of figures. The technique is in part reminiscent of the reliefs of Nicola and Giovanni Pisano (Pulpits at Siena and Pistoia) especially in that the figures seem to be merely differentiations within the material itself and not separate elements applied to a background. This character of material homogeneity is even more pronounced in the work of Michelangelo, where, through the simple medium of leaving the stone uncut behind the heads, arms and legs of the figures even in highest relief, the rough material itself acts as a kind of unifying element binding the figures to the background.

The whole composition is perfectly adapted to the originally convex surface of the block. The lateral figures are disposed on a receding plane while the central figures are in particularly high relief. Michelangelo conserved jealously the original form of the block, retaining here again a kind of border on three sides.

In the upper part of the relief a strip about 8 cm. wide has been left almost uncut. Frey (*Q.F.*, p. 82) supposed that Michelangelo planned, and perhaps even began to work on, a row of figures which he himself later suppressed while the work was in process. This assertion, however, seems hardly likely, for the composition is closed throughout the whole width of the relief at the height of the arm of Eurythion. It seems rather that Michelangelo renounced from the beginning the utilization of the entire height of the block, which in its proportions was poorly adapted to a battle composition, and merely refrained from destroying the upper part of the block through his respect for the material itself.

As is characteristic of his early works the execution of the details remains generalized in spite of the grandeur of the vision as a whole. The heads of almost rectilinear form, with low foreheads, and the unconscious expression of dreamers, are characteristic of the work of the young master. The only exception is the curious head of the bearded old man behind Theseus, which recalls antique portraits of Socrates.

(9) COPIES: Rubens, drawing. Rotterdam, Coll. Koenigs.
Rubens, drawing. The Hague, Coll. Lugt.

(10) MAIN BIBLIOGRAPHY: Wölfflin, *Jugendwerke*, pp. 10*ff*; Frey, *Ma.*, I, pp. 96*ff*; Thode, *Kr. U.*, I, pp. 8*ff*; Justi, *Ma., N.B.*, pp. 22*ff*.

III. THREE SMALL STATUES ON THE ARCA DI SAN DOMENICO, BOLOGNA. ANGEL, ST. PETRONIUS, ST. PROCULUS

Bologna, S. Domenico.
Marble statues in the round.
Measurements:

Angel: H. 51.5 cm. (with base) W. of base: 30.5 cm. D. of base: 16.5 cm.
St. Petronius: H. 64 cm. (with base) W. of base: 12 cm. D. of base: 12 cm.
St. Proculus: H. 58.5 cm. (with base) W. of base: 9.5 cm. D. of base: 10:5 cm.

(form of base is trapezoidal).

(1) CONDITION: *Angel.* In perfect condition, except for left foot, where three toes have been damaged and restored. [8, 10]

St. Petronius. The head has been broken off and replaced but not accurately, and it [13] is probable that the original inclination was less marked. The neck has been restored in clay. The upper part and inside of the tiara, and a piece of the left edge of the mantle [16] are broken. The nose has been slightly restored.

St. Proculus. A certain Fra Peregrino knocked the statue to the ground with a ladder [17] and it broke in pieces (as told by Fra Lodovico da Prelormo in a manuscript of August 4, 1572, published by Bonora, *Arca*, p. 28). The fragments were subsequently pieced together but the reconstruction was not exact. From the traces of the breaks, still visible today, it appears that the feet are in three pieces, the legs in two; the head forms a separate piece, and the right arm has been broken off and replaced. Originally there was probably a lance in the right hand. The feet have been partly restored and the part of the cloak across the left shoulder, and the border of the garment below the right arm, are damaged. Although the general attitude of the figure can not have been very different from what it is today (for the position of the two legs and the distribution of the weight can be clearly determined from the torso) the statue no longer represents exactly Michelangelo's original idea. In particular, the foot which does not carry the weight, the head, and the right arm have been replaced incorrectly.

(2) ATTRIBUTIONS: The statues of the Angel and of St. Petronius are mentioned by Condivi and Vasari (1568). Condivi (p. 36) says, "dove [l'Arca di San Domenico] [7] manchando due figure di marmo, cioè un S. Petronio et un angelo in ginocchioni con un candeliere in mano, domandando [*scil.* Giovanfrancesco Aldovrandi] Michelagnolo se gli dava il cuore di farle, et rispondendo di si, fece, che fusser date à fare à lui"; and Vasari (1568, p. 35), "Mancandoci [*scil.* on the Arca di San Domenico] un' angelo, che teneva un candelliere et un S. Petronio . . . [Aldovrandi] gli dimando se gli bastasse l'animo di fargli; rispose di si." Neither Vasari nor Condivi says which of the two

existing angels on the monument is the one by Michelangelo. This distinction was first made by Lamo in 1560 (*Graticola di Bologna*, p. 20), who indicated the angel on the right hand side: "Sopra l'altar vi sono dui angioli, de' quali Michelagnolo ne fece uno, ed è quello a mano dritta." Nevertheless, it was believed during the nineteenth century that the angel on the left hand side was one by Michelangelo—an error rectified by Padre Tommaso Bonora (*Arca*, p. 21).

13 The statue of St. Petronius was for a long time considered as having been executed only in part by Michelangelo. According to Fra Lodovico da Prelormo (1572) the figure was "quasi totta" by Michelangelo and this opinion is repeated by Pietro Lamo (loc. cit.), and by Giovanni Michele Pio (*Uomini Illustri di San Domenico*, 1588, col. 121). From the evidence of these sources, Bonora (op. cit.) concluded that the marble block was cut by Niccolò dell'Arca and only completed by Michelangelo. In our opinion the statue is entirely by the hand of the master.

17 The figure of St. Proculus was first attributed to Michelangelo by Leandro Alberti, *De Divi Dominici Calaguritani obitu et Sepultura*, Bologna, 1535, fol. 9. It was then mentioned in the *Memorie* of Fra Lodovico da Prelormo, 1572 (see below) and finally by Giovanni Michele Pio, 1588 (op. cit.). In modern literature it was first published as a work of Michelangelo by Bode, *Denkmäler*, Pl. 502. Karl Frey, *Ma.*, I, p. 206, and *Q.F.*, p. 131, believed incorrectly that it was executed by Niccolò dell'Arca and only retouched by Michelangelo; Bonora (op. cit., p. 33) attributed the sculpture to "Prospero Spani detto Clemente, Scultore reggiano, morto nel 1584." Foratti (*Ma. a Bologna*, pp. 191*ff*) believes that the work is not from the hand of Michelangelo.

(3) HISTORY: The monument of San Domenico consists mainly of a sarcophagus executed in 1265-1267 by Nicola Pisano and Fra Guglielmo da Pisa. This sarcophagus was originally supported by four columns each composed of three figures of angels. In 1411 it was taken from its original position in the lower church of San Domenico and placed in a chapel on the south side of the church. "Questa cappella dovette cedere il luogo a quella che ora si vede, edificata 1596, sul disegno di Floriano Ambrosini. . . . L'anno 1605, il 25 aprile, compiuta la nuova cappella, vi fu translatata l'Arca" (Bonora, op. cit., pp. 9*ff*). In 1469 Nicola da Bari, known as Niccolò dell'Arca, was commissioned to complete the decoration of the tomb and the upper part was put into place in 1473 (see Gualandi, *Memorie*, pp. 3*ff*). Niccolò died March 2, 1494. The predella, composed of three reliefs, and dating from 1532-1536, was the work of Alfonso Lombardi. Concerning the original position of the sarcophagus, Bonora (op. cit., p. 10) says: "Si saliva dal piano della chiesa per una scala, alla cui sommità era un' edicola ("cappelletta"), passata laquale, volgendo a sinistra vedevasi la cappella grande coll'Arca e dinanzi all'Arca l'altare non volto, come ai dì nostri, al mezzodì, ma all' Oriente." (Consequently at that time the light from the window in the south wall of the chapel fell upon the right hand side of the altar.)

The commission to execute the three missing statues was given to Michelangelo by Gian Francesco Aldovrandi, a nobleman of Bologna (Condivi, p. 34). For information on the life of Aldovrandi see Cherubino Ghirardacci, in *Historia di Bologna*, which reads as follows: "Gianfrancesco Aldovrandi, figlio di Nicolò . . . [pp. 228, 247] accompagna Giovanni Bentivoglio a Milano [1479, p. 221] . . . essendo dei Sedici è eletto podestà di Lucca per sei mesi [1482, p. 225]; è il pretore di Perugia [1485, p. 232], podestà di Firenze [1488, p. 244; this date should read 1486, see Frey, *Q.F.*, p. 5] interviene all' inaugurazione del naviglio da Bologna a Corticella [1494, p. 274]. Si reca con Alessandro Bentivoglio a Milano a complimentare il nuovo duca Lodovico Sforza [p. 283] . . . ha incarico dal Papa di liberare Bologna dei Bentivoglio e ridurrla sotto la Chiesa. È da Giulio II eletto dei quaranta Consiglieri e Riformatori della Città. Per incarico del Senato accompagna Giulio II a Roma [1507]."

The statuettes of Michelangelo on the tomb of San Domenico have been mentioned by:

Leandro Alberti, 1535, op. cit. This text has been reprinted by Bonora, op. cit.

Condivi, p. 36, cited above. In addition, Condivi mentions the price paid for the work, which amounted in all to 30 ducats, 18 for the St. Petronius and 12 for the Angel.

Pietro Lamo, *Graticola*, 1560, p. 20, cited above.

Vasari, 1568, p. 35, cited above.

Fra Lodovico da Prelormo, *Memorie*, 1572 (*Archivio privato di San Domenico, Bologna*, no. 861, fol. 24 r., listed under the year 1572, and not 1537 as incorrectly stated by Thode, *Kr.U.*, i, p. 32): "Sciendum tamen est quod imago Sancti Petronii quasi totta, et totta imago Sancti Proculi, et totta imago illius Angeli qui genua flectit et e posto sopra il parapeto che fece Alphonso scultore, qual è si è verso le fenestre, queste tre imagine ha fatto quidam Juvenis Florentinus nomine Michaelangelus imediate post mortem dicti magistri Nicolai. Si quis aut desiderat videre pacta et questiones de totta fabrica hui Arche:—legat librum edificorum quet folio 126 e perchè questa scrittura de l'archa la ho ritrovata in più luoghi per tanto è anco scritta a car. 84, 86, 87, alli 4 d'Agosto . . . essendo io Fra Ludovico già per spatio di 45 anni Archista et d'età circa 80 anni e deboliss° et . . . non potendo far più le fatiche che si richiedono a questo scto ufficio dell'archa. . . ." (The first half of this document as far as "post mortem Nicolai" was published incorrectly by Bonora, op. cit.; the second half is published here for the first time.) Concerning Fra Lodovico, Bonora, op. cit., p. 13 note says: "Fra Lodovico da Prelormo, per un' mezzo secolo circa era custode dell'Arca di S. Domenico, nato ca. 1492 in Prelormo, morì ca. 1580."

Giovanni Michele Pio, 1588, op. cit., col. 121: "[Da Michelangelo Buonarroti] la statua di San Procolo, quella d'un angelo et buona parte di quella di San Petronio, prima rimase imperfetta."

(4) SUBJECT: *Angel*: The contract of Niccolò dell'Arca calls for the making of two statues "duorum angelorum super scabello cum candelabris in manibus" (Gualandi,

Memorie, p. 30). This motif of the kneeling angel holding a candle was widely used during the Renaissance in Tuscany. Such examples may be cited as the angels of Matteo Civitali (Lucca, Cathedral, Chapel of the Blessed Sacrament), Benedetto da
156 Majano (Siena, S. Domenico), Luca della Robbia (Florence, Cathedral, Old Sacristy), and the school of della Robbia (Florence, Museo Bardini).

The manner in which the candlestick is held, with the cloth of the gown covering the hand, corresponds to liturgical customs according to which relics were thus held.

(5) *St. Petronius*: the archbishop of Bologna and patron saint of the city was traditionally represented as an archbishop with a model of the city on his arm and the crosier in his hand. He appears thus, for example, in a fourteenth century relief (Venturi, *Storia*, IV, fig. 688), in a painting by Francesco Cossa (Bologna, Museo Civico), and in one by Lorenzo Costa (Bologna, Museo Civico). In the statue by Jacopo della Quercia, as in that by Michelangelo, the crosier has been omitted. (For the influence of Jacopo della Quercia's St. Petronius, see below.)

(6) *St. Proculus*: who died as a martyr before the gates of Bologna in 303, is another patron of the city. He is represented as a soldier holding a lance or a banner. See, for example, the stained glass window in the Chapel of St. Anthony, in S. Petronio at Bologna. Michelangelo's statue follows the iconographic tradition, and originally the right hand probably held a lance or a banner.

(7) ANALOGIES: The figure of the Angel, kneeling with candlestick in hand, was to
157 balance the figure by Niccolò dell'Arca already existing on the monument. The measurements of the two are identical, the only difference being that the base of the angel of Michelangelo is one centimeter less in depth than that of the figure by Niccolò dell' Arca. But the garment and the form of the candlestick of Michelangelo's angel are entirely different and the artist seems to have been inspired here by Florentine tradition. In fact, the figure bears a certain resemblance to the kneeling angel of Luca della
156 Robbia in the Sacristy in Florence (cf. Frey, *Ma.*, I, p. 213). The sleeves of the gown are tighter than in the figure by Niccolò dell'Arca and the folds across the shoulder emphasize the form of the shoulder underneath. The folds over the left leg which carry the eye across and around, accentuating the three-dimensional character, are in sharp contrast to Niccolò dell'Arca's treatment, where a strong horizontal plait holds the eye within the closed contour of the silhouette. The form of the candlestick with its fluted stem, the manner in which the angel holds it with the right arm almost encircling it, and finally the head, with rather short hair following the contour of the head (in contrast to the long curls of Niccolò dell'Arca's figure) are all motifs reminiscent of the della Robbia statue. To emphasize the most prominent parts of the human structure and to subordinate bodily covering to them is an old tradition of Florentine art. In the treatment of the forms of the Bologna Angel, however, the influence of della Quercia is added to the Florentine structural conception.

10 In style the connections with della Quercia are evident. The type of head recalls the

Adam in the Quercia relief representing Adam at work after the expulsion from Eden (cf. Wickhoff, *Antike im Bildungsgange*, p. 430). The drapery, with its soft, ample forms, likewise betrays the influence of della Quercia; see, for example, the drapery of the kneeling Balthasar in the Epiphany scene in the relief on the main portal of San Petronio. (For the influences of della Quercia on Michelangelo in general, see also C. Cornelius, *Jacopo della Quercia*, Halle, 1896, pp. 189*ff*. Concerning della Quercia, see B. I. Supino, *Jacopo della Quercia*, Bologna, 1926; P. Bacci, *Jacopo della Quercia*, Siena, 1929; J. Lányi, "Quercia-Studien," *Jahrbuch für Kunstwissenschaft*, 1, 1930, pp. 25*ff*.) The dependence of Michelangelo's Angel on a relief depicting Nike carrying a candelabrum pointed out by Grünwald (*Antike*, pp. 125*ff*) was refuted by Panofsky (*Ma. Literatur*, col. 27) since the Nike relief in question is, according to Robert, for the most part a modern forgery.

(8) *St. Petronius*: Gualandi (*Memorie*, p. 30) and Wickhoff (*Antike im Bildungs-gange*, p. 430) have already noted the influence on this figure of della Quercia's statue of the saint on the main portal of the Church of San Petronio. Foratti (loc. cit.) points out analogies with the St. Eligius by Nanni di Banco, which, however, lack conviction. *159* *160*

(9) *St. Proculus*: with the cloak falling over and behind the shoulder, may be asso- *161* ciated with Donatello's St. George (Bargello); see Bode, *Flor. Bildh*, p. 319. The *162* tunic recalls that of the David of the Casa Martelli (now Philadelphia, Widener Collection). Foratti (loc. cit.) thinks the figure is inspired by the San Vitale of Niccolò dell'Arca on the Arca di S. Domenico.

(10) The angry expression on the face of St. Proculus anticipates that of Michelangelo's marble David, the Moses, and the Brutus; cf. the author, *Brutus*, pp. 23*ff*.

(11) CHRONOLOGY: The three statuettes were executed during Michelangelo's stay in Bologna between the autumn of 1494 and the end of 1495. The somewhat cursory treatment of detail in the figure of the Angel, recalling that of the Virgin of the Stairs, suggests that it was the first of the three to be executed. The second in point of time seems to have been the St. Petronius where the modelling of the hands betrays a desire on the part of the artist to suggest the underlying anatomical structure (in contrast to the wax-like form of the hands of the Angel). Here, too, the sharp chiseling of the lines of the face is in contrast with the more generalized rendering in the face of the Angel. (Frey, *Ma.*, 1, p. 211, believed the St. Petronius was executed before the Angel.) Finally, in the St. Proculus the details are executed with increased precision and minuteness, in particular the lines in the forehead, the forceful hands, and the small ornaments on the tunic. Because of this, this statue seems to have been executed last.

(12) TECHNIQUE: White marble, almost transparent, polished surface on all three statuettes. Certain parts, as the beard of St. Petronius, the hair of the Angel and of St. Proculus, indicate that Michelangelo was still making use of the drill.

(13) MAIN BIBLIOGRAPHY: Wölfflin, *Jugendwerke*, pp. 14*ff*; Frey, *Ma.*, 1, pp. 194*ff*; Thode, *Kr. U.*, 1, pp. 32*ff*; Justi, *Ma.*, *N.B.*, pp. 46*ff*.

IV. BACCHUS

Florence, Bargello.
Marble statue in the round.
H. 203 cm. (with base); 184 cm. (without base).

21 (1) CONDITION: The surface, originally polished, has lost its smooth finish. At the
beginning of the sixteenth century the right hand was broken off and a drawing, exe-
169 cuted between 1532 and 1535 by Martin van Heemskerck (Codex Berolinensis, Berlin
Kupferstichkabinett, fol. 72a), of the statue as it stood in the Garden of Antiquities of
Jacopo Galli, shows the hand missing. It is missing likewise in the engraving by Cornelis
170 Bos. But Condivi (p. 42) described the figure as having "nella destra una tazza in guisa
d'un che voglia bere," a fact confirmed by Vasari (1568, p. 43), and Borghini (1584,
Riposo, III, 52) who mentions "un Bacco che ha una tazza nella man destra." In a bronze
171 copy of the sixteenth century in the Bargello, attributed to Pietro da Barga, the figure
holds a cup in the right hand. Both hand and cup of the original today correspond to
this old copy. They are of the same marble as the figure and seem to be by Michelangelo
himself. (cf. Wölfflin, *Jugendwerke*, p. 28; J. Springer, "Ein Skizzenbuch von M. van
Heemskerck," *J.d.p.K.*, v, 1884, p. 331, says: "Die Hand des Bacchus ist durch das
Handgelenk abgebrochen gewesen, jedoch mit der Statue gleichen Materials und
gleicher Arbeit. Der durch einen Unfall entstandene Schaden mochte wohl durch
Michelangelo selbst wiederhergestellt worden sein.") Thus between 1532-1535, the date
of van Heemskerck's drawing, and 1553, when Condivi described the statue, the
original piece seems to have been replaced.

In the Cambridge sketchbook of a Netherlandish artist, executed about 1550-1553
for an English patron we find a sketch of the Bacchus with the inscription half in
Italian and half in English—"Scoltur de Michelangeli the which was buried in the
grownd and fond for antich." (Cambridge, Trinity College, VII, fol. 14). J. J. Boissard
(*Romanae urbis topographie & antiquitatum*, Frankfort, 1597-1662, I, pp. 34-35) relates
that Michelangelo destroyed an arm of the Bacchus in order to give the statue an
antique appearance. This legend is a derivation of the well-known anecdote of Condivi
and Vasari concerning the Cupid. Concerning the legend of Boissard see J. Springer,
loc. cit., and Panofsky, *Ma. Literatur*, col. 56, note 90.

(2) ATTRIBUTION: The statue is unsigned. The attribution to Michelangelo has never
been questioned. It has been mentioned by: Ulisse Aldovrandi, *Delle statue antiche
. . .* (written about 1550 and published in 1556), p. 172; Vasari, 1550, p. 42; Condivi,
1553, p. 42; Vasari, 1568, pp. 41, 43.

(3) HISTORY: The statue was originally in the possession of Jacopo Galli, a Roman
169 nobleman and amateur collector of antiquities, and was set up in the garden of the
Casa Galli in Rome. The Casa Galli stood in the Rione Parione, near the Church of
S. Lorenzo in Damaso, near the Vicolo dei Lentari. The Galli collection of antiquities

was probably begun in the fifteenth century by the banker Giovanni Galli. (cf. R. Lanciani, *Storia degli Scavi*, I, pp. 107*ff*; J. Springer, op. cit., pp. 329*ff*; Hübner, *Le Statue di Roma*, Leipzig, 1912, p. 100.)

We find a description of the antiques in the Galli Gardens by Ulisse Aldovrandi, op. cit., pp. 172*f*: "Più à dentro in uno giardinetto si trova un bel Bacco ignudo in pie con ghirlanda di hellera, ò di vite in capo: ha da man manca un satirello sopra un tronco assiso, e con amendue le mani si pone in bocca de' grappi de l'uva, ò hellera, che ha il Bacco in mano: Il satirello ha i piè di capra, e le orecchie medesimamente, ha le corna anche e la coda. Questa è opera moderna di Michele Angelo fatta da lui, quando era giovane."

Condivi (p. 42), reports having seen the statue in the house of Giuliano and Paolo Galli.

The drawing in the Cambridge book of sketches, mentioned above, places the statue in the Villa Madama (cf. A. Michaelis, *J. d. D. Arch. Inst.*, VII, 1892, p. 95, and Hübner, loc. cit., who gives the correct date for this book of sketches—about 1550-1553).

Francesco de' Medici purchased the Bacchus from the Galli family through Diomede Lioni for 240 ducats. (cf. *Giornale della Depositeria, R. Archivio di Stato*, Florence, under the date 1571-1572, cited by Gotti, *Le Gallerie di Firenze*, Florence, 1872, p. 83), and it was then transported to Florence.

In 1730 Bottari (in Borghini, *Riposo*, III, p. 52, note 1), records it as being "nel corridore della Galleria del Granduca." The statue was moved to the Bargello in 1873.

(4) SUBJECT: *Iconography*. Condivi (p. 40) describes the statue as "un Bacco . . . la cui forma et aspetto corrisponde in ogni parte al' intentione delli scrittori antichi." Such attributes, indeed, as the wreath of grapes and vines on the head, the cup held high, the tiger or lion skin, and the figure of a satyr eating grapes, are all actually derived from the representational tradition of antiquity; see, for example, the Bacchus with grapes and a cup, Museo delle Terme (Reinach, I, p. 388, no. 1633); Bacchus with lion skin, Naples (Reinach, I, p. 387, no. 1627); Bacchus with a satyr, Museo Chiaramonti—Vatican (Reinach, I, p. 388, no. 1632 A., to which Wickhoff called attention); *174* Bacchus with a satyr eating grapes, Rome, Villa Albani (cf. Lanckoronska, *Antike* *173* *Elemente*, pp. 183*ff*).

In the analysis in the text is discussed the distribution of the three heads in a spiral, which suggest three different stages of life, i.e. death—as the lion's mask, the renewal of life—as the satyr's face, and the decline of life—as the Bacchus. Michelangelo represents Bacchus as the human incarnation of the vine which takes its force from the earth, and which, like vegetation, revives with the spring. This idea of the cosmic processes was probably inspired by Boccaccio's *De Genealogia Deorum* (Venetian ed., 1564, pp. 92*r ff*): "Ma per ritornar di novo à i sensi fisici sotto favola coperti, dico, che alcuni vogliono per Baccho deversi intendere il vino; et così Semele si pigliera per la vite; laquale per Giove, cioè per lo calore, congiunto nello sparso humor della terra, che

trahe l'humidita per li rami della vite, rende quella pregna, cioè morbida, et gonfia & ne inracemi i suchi, et humori, si come in conceputo ventre: alhora viene fulminata, quando appropinquandosi il calore dell'auttunno. . . . Diciamo Semele esser pregna di Giove, quando nella primavera veggiamo la vite per opra del caldo gonfiarsi; & alhora è folminata, per lo disusato calore della state viene arsa: onde con i pampani aperti manda fuori i frutti & incomincia spumare, il che si congiunge al ventre di Giove, cioè el diurno calore. . . ." On this conception of Bacchus in antiquity, see Walter F. Otto, *Dionysos*, Frankfurt A.M. (1933), K. Kerényi, *Dionysos und das Tragische in der Antigone*, Frankfurt A.M. (1935), and *Gedanken über Dionysos, Studi e Materiali di Stor. delle Religioni*, 1935.

The ambiguous form of the body of Bacchus is already celebrated in antique poetry (Daremberg-Saglio, p. 630).

Michelangelo's Bacchus is conceived as a garden figure which accounts for the fact that it is the only one of Michelangelo's works which can be said to have a "multiple" point of view. The block had a triangular base. This interpretation of Bacchus as the incarnation of cosmic processes is apparently unique in the art of the Renaissance. In the few examples earlier than Michelangelo, Bacchus had always been conceived as the God of Revelry; see, for example, the bronze statuette of Bacchus by Francesco di Giorgio (Vienna, Kunsthistorisches Museum, pub. by L. Planiscig, "Bronzi inediti d'autori ignoti," *Dedalo*, XII, 1932, p. 748), and the print attributed to Botticelli (A. Warburg, *Ges. Schriften*, I, p. 67). The same interpretation is found later in representations of Bacchus done after Michelangelo's; for example, those by Jacopo Sansovino (Florence, Bargello), by the same artist (Washington, National Gallery of Art) and by a follower of Giovanni da Bologna (London, Victoria and Albert Museum, Cat. No. 7676-1861).

(5) ANALOGIES: The statue is a synthesis of reminiscences of della Quercia and antique influences. The ensemble, with the S-curve of the profile silhouette, recalls some of the figures of della Quercia, for example, the Eve in the Creation of Eve (cf. the writer, *Studien*, p. 107). For the classical affinities of the statue, see above and Lanckoronska, op. cit.

(6) The lost statue of Hercules apparently prepares the way for the Bacchus. No drawings have been preserved.

(7) The spiral torsion of the satyr, with the arm crossing the torso, becomes a favorite motif of Michelangelo in later works; for example: the Madonna Doni, the Christ of S. Maria sopra Minerva, the Apollo-David of the Bargello.

(8) CHRONOLOGY: The figure was executed during Michelangelo's first visit to Rome, after June 25, 1496, and probably before the Pietà of St. Peter's. In fact, the treatment of form—for example, in the trunk of the tree and the hair of the satyr—still preserves here something of that quality of softness which characterized the works executed in Bologna.

Probably this is the figure which Michelangelo intended to begin on July 4, 1496 in Rome as a commission of the Cardinal Riario (Milanesi, p. 375), and which he finished in a year (Milanesi, p. 3). It was refused by the Cardinal and bought by Jacopo Galli (see Wilde, *Eine Studie*, p. 54). Frey (*Ma.*, I, p. 285), and Thode (*Kr. U.*, I, pp. 46ff), and Knapp (p. 167), also date the statue before the Pietà. Wölfflin (*Jugendwerke*, pp. 26f), on the other hand, places it later than the Pietà on the grounds of what he claims to be an extraordinary precision in execution, but he, too, supposes it to be a project undertaken during the first months that Michelangelo was in Rome. Mackowsky (pp. 31f), believes that the two works were executed simultaneously.

(9) TECHNIQUE: The surface was originally polished. The modelling of the torso is extremely rich and in particular the suggestion of the softness of the fleshy parts has been rendered with exceptional mastery. The drill has been used on the hair, eyes, the trunk of the trees, the lion skin and the grapes.

(10) COPIES: Small bronze, attributed to Pietro da Barga, Florence, Bargello. *171*

Small bronze. Formerly Paris, Coll. M. LeRoy (cf. *Les Arts*, 1908, no. 10, et Migeon, *Cat. Coll. LeRoy*, III, no. 14).

Small bronze, Berlin, Deutsches Museum (cf. F. Goldschmidt, *Die Italienischen Bronzen in Berlin*, 1914, Cat. no. 104).

Small bronze, Vienna, Kunsthistorisches Museum (cf. Planiscig, *Die Bronzeplas-* *172* *tiken*, Vienna, 1923, Cat. no. 231, pp. 133ff: Florentine, second half of sixteenth century).

Drawing, Vienna, Albertina. (cf. Portheim, *Rep.f.Kw.*, XII, 1889, p. 143. Planiscig. loc. cit.)

Drawing by M. v.Heemskerck, Cod. Berolinensis, fol. 72a. (cf. Michaelis, *J.d.D.* *169* *Arch. Inst.*, VI, 1891, p. 153 and VII, 1892, p. 95; Chr. Hülsen und H. Egger, *Die römischen Skizzenbücher von Marteen van Heemskerck im Königlichen Kupferstich-kabinett zu Berlin*, Berlin, 1913, Vol. I, Pl. 74a.)

Drawing in the book of sketches, Cambridge, Trinity College, VII, fol. 14.

Engraving, Cornelis Bos. *170*

(11) MAIN BIBLIOGRAPHY: Wölfflin, *Jugendwerke*, pp. 26ff; Frey, *Ma.*, I, pp. 285ff; Justi, *Ma.*, *N.B.*, pp. 73ff; Thode, *Kr. U.*, pp. 46ff.

V. PIETÀ

Rome, St. Peter's Chapel of the Pietà.
Marble in the round.
H.: 174 cm.; Greatest width of the base: 195 cm.; Greatest depth of the base: 64 cm.

(1) CONDITION: Excellent except for left hand, four fingers of which were broken off. *30* These were restored in 1736 by Giuseppe Lironi: "20 dicembre 1736. Scudi 9 moneta per tant' importa un suo conto di aver rifacto le quattro dita alla mano sinistra della

Maria SSma. della Pietà" (*Archivio della Fabbrica di S. Pietro*, Mandati 424, p. 74). Wittkower (*Journal of the Warburg Institute*, July 1938, p. 80), who published this document, thinks that the restoration of Lironi is not exact, and that it changes the intended expressiveness of the Virgin's gesture, giving it a rhetorical character instead of the original feeling of resignation and submission. He says it is possible to reconstruct the true gesture with the help of old copies and engravings. But in these the left hand varies. The oldest copy, the engraving of Bonasone (Salamanca) done in 1547, which appears to be the most exact, shows a left hand most similar to Lironi's restoration on the statue. The little finger and fourth finger are partly closed, and the index and middle fingers are extended. In the engraving of Cavalieri (1564) all four fingers are partly closed. Since this gesture is not in the style of Michelangelo, it is probable that in this period the fingers were already broken off, and that Cavalieri invented the gesture of his copy. It would seem that Lironi, in restoring the hand, followed lines suggested by fragments which remained on it and so arrived at the same result as the first copy. We may consider his restoration generally exact.

(2) ATTRIBUTION: Signed, on the ribbon across the breast of the Virgin "Michaelagelus. Bonarotus. Florentin. Faciebat."

(3) HISTORY: This work was commissioned by Cardinal Jean Bilhères de Lagraulas (also named Jean de Villiers de la Groslaye). He was born about 1430 or 1440 in the château de Lagraulas in Fezensac, the son of Manaud de Bilhères, Seigneur de Fezensac. At one time abbot of Pessan in the diocese of Auch, he was bishop of Lombez in 1473, abbot of St. Denis in 1474, and cardinal of St. Sabina in 1493, by appointment of Alexander VI. He faithfully served kings Louis XI and Charles VIII in Spain, Germany and at Rome. He died in Rome on August 6, 1499 (cf. Charles Samaran, *La Maison d'Armagnac au XVe Siècle*, Paris, 1907, p. 191, note 2; also P. Fiel, "La Pietà di Michelangelo e la Capella di S. Petronilla in S. Pietro," *Illustrazione Vaticana*, IV, 1933, pp. 753ff). This Cardinal Jean Bilhères de Lagraulas was the first Frenchman to give an order to Michelangelo (cf. Dorez, *Nouv. Recherches*, 1917, pp. 205ff).

The idea of ordering this work seems to have been considered before November 18, 1497. The Cardinal wrote a letter on this date (Milanesi, p. 613, note) to a certain Anziani of Lucca. In it he asks that they help Michelangelo who is going to Carrara in his search for marble. Frey (*Ma.*, I, p. 131) notes that apparently Michelangelo does not seem to have made this trip. In fact, he was still in Rome on the tenth of March 1498, as proved by a letter he sent from there on that date (Milanesi, p. 59).

Apparently Michelangelo arrived in Carrara late in March of 1498. A letter was written by the Cardinal at that time to the Marchese Alberico Malaspina, Seigneur of Massa-Carrara, asking him to permit the breaking and transporting of a block of marble, and promising to pay for it. This letter is lost, but its contents were repeated in a following letter, of April 7, 1498, in which the Cardinal asked the Signoria of Florence for the

protection of Michelangelo in Carrara (Milanesi, p. 613, note). The government of Florence wrote to Alberico Malaspina immediately after receiving this letter (Frey, *Q.F.*, p. 140). On the same date, April 18, 1498, they answered the Cardinal's letter (Frey, *Q.F.*, p. 140). After this correspondence a definite contract was arrived at.

The contract for the Pietà ("Pietà . . . cioè una Vergene Maria vestita con Christo morto in braccio") is dated August 27, 1498 (Milanesi, pp. 613*f*). The intermediary was Jacopo Galli. The sculpture was to be finished in one year "dal dì della principiata opera," and the salary was fixed at 450 gold ducats. Jacopo Galli promised that the Pietà would be "la più bella opera di marmo che sia hoge in Roma."

The group was first erected in old St. Peter's, in one of the chapels of the church of St. Petronilla (also called the Chapel of the Kings of France). St. Petronilla was situated on the south side of the transept of old St. Peter's (indicated by D on the plan of Alpharanus, published by M. Cerati, *De Basilicae Vaticanae . . .* , Rome, 1914, Pl. I); for information about the church of St. Petronilla, see Fra Maria Torrigio, *Le sacre grotte vaticane* (2nd edition, Rome, 1639), pp. 147*ff*, and Fil. M. Mignanti, *Istoria della sacrosanta patriarcale Basilica Vaticana* (Rome, 1867), I, pp. 118*ff*. We do not know exactly in which of the chapels of St. Petronilla the Pietà was erected.

When the church of St. Petronilla was destroyed because of work on the new building planned by Bramante, the group was transferred to the Cappella della Vergine Maria della Febbre, which was the first chapel on the south side of old St. Peter's (no. 148 on the plan of Alpharanus). In this chapel Condivi (p. 42) and Vasari (1550 and 1568, p. 43) saw the work.

Pope Gregory XIII (1572-1585) had the group transferred to the Choir of Sixtus IV (fourth chapel on the south side, designated "q" on the plan of Alpharanus), where it was erected at the altar. Grimaldi gives a description of the Pietà in this place (cf. *coa. Barber. lat.* 2733, folio 129*v ff*, published by M. Cerrati, op. cit., p. 78, note 3). The only extant drawing to reproduce the Choir of Sixtus IV was done by Grimaldi (cf. A. Schmarsow, *Joos von Gent und Melozzo da Forli*, Leipzig, 1912, p. 181). In this drawing there is a Pietà at the altar, but it is not exactly that of Michelangelo. Since the drawing is apparently only a sketch made from memory, it is possible, in spite of its incorrectness, that Grimaldi had Michelangelo's Pietà in mind.

In 1749 the group was moved to the first chapel on the north side of St. Peter's, now called Cappella della Pietà. It was placed on a pedestal of red marble bordered with a band of white, a pedestal obviously too high for the group. Behind the figures, against a background of yellow marble bordered in black, was placed a cross of white marble. This served to give the illusion that the episode happened at Golgotha; this pictorial effect was clearly not the intention of Michelangelo.

Conte Alessandro Sforza di Piacenza, in 1637, presented two baroque angels holding a crown, which were placed above the head of the Virgin, and disfigured the group. In 1927 at the suggestion of the author, the angels with crown were removed.

For information as to the successive locations of the Pietà, see *Descrizione della Sacrosanta Basilica Vaticana*, ed. Questa, Rome, 1828, pp. 34-35.

(4) SUBJECT: The group of the Pietà of two figures was known in Italy from the first half of the fourteenth century (cf. painting in the Museo in Trapani, and that in the former Collection LeRoy, Paris). This group is developed from two sources. First we have the isolation of the group of Mary and Christ in Byzantine representations of the Mourning over Christ Crucified, and later there is an assimilation of the seated Madonna with Child into the Pietà type, the grieving Mother who holds her dead Son on her knees, and thinks back to the time when she held the Child for the first time. During the Middle Ages in Italy, as in the North, there were fashioned Pietàs in which the size of Christ's figure was reduced so as to give the impression of a child (cf. W. Körte, *Deutsche Vesperbilder*, pp. 8*ff*). [Addenda, No. 8]

This last conception was also made known by mystics like Bernardo da Siena and Suso (cf. W. Pinder, "Die dichterische Wurzel der Pietà," *Rep. f. Kw.*, XLII, 1920, pp. 145*ff*; and H. Swarzenski, "Quellen zum deutschen Andachtsbild," *Z. f. Kg.*, IV, 1935, pp. 141*ff*). At the end of the fifteenth century, in the years 1480-1490, that is, just at the time Michelangelo received his commission for the Pietà, that subject was very popular at Florence, as proved by a whole series of such works then being executed by Jacopo del Sellaio, Perugino, Raffaellino del Garbo, Giovanni della Robbia and the school of Ghirlandaio (cf. A. Scharf, "Studien zu einigen Spätwerken des Filippino Lippi," *J. d. p. K.*, LII, 1931, pp. 209*ff*, and Bode, *Flor. Bildh.*, pp. 321*ff*). In all these representations the body of Christ is stretched horizontally across the Virgin's knees, while on either side of her St. John and Mary Magdalene support his head and feet.

Michelangelo in his Pietà goes back to the older type of the seated Madonna, but he succeeds, without reducing the natural proportions of the body, in giving the impression that the Virgin holds her Child in her arms. He achieves this effect by giving a great amplitude to the knees of the Virgin, and by bending in two places the delicate body of Christ, which is thus harmoniously subordinated in the triangular silhouette of the ensemble.

In all previous representations of this theme the Virgin was shown as a matron, but Michelangelo depicts her as a young woman. While formerly the theme was that of the *compassio Mariae*, Michelangelo represents the Virgin with an expression of ineffable resignation. Here she bows before her destiny. Such an ideal of heroic motherhood is a type of the Renaissance, such as that expressed in a letter of Alessandra Macinghi-Strozzi written after the death of her son (cf. *Lettere ai Figlioli*, ed. Papini, p. 45). Varchi (*Due lezzioni*, p. 116) supposes an influence of Dante in the Pietà of Michelangelo.

There is an anonymous letter dated March 19, 1549, written on the occasion of the

177 inauguration of the copy of Michelangelo's Pietà in Sto. Spirito in which Michelangelo is accused of having expressed Lutheran ideas in his Pietà, "Si scoperse in Sto. Spirito

una Pietà . . . et si diceva che lorigine veniva dallo inventor delle porcherie, salvandogli larte ma non devotione, Michelangelo Buonarroto. Che tutti moderni pittori et scultori per imitare simili caprici luterani altro oggi per le sante chiese non si dipigne o scarpella altro che figure da sotterrar la fede et la devotione; ma spero che un giorno Iddio manderà e sua santi a buttare per terra simile idolatre come queste" (Gaye, II, p. 500). This document is very characteristic of the spirit of the Counter Reformation and its judgment of the art of Michelangelo.

(5) ANALOGIES: The composition recalls the Italian Pietàs of the fourteenth century, for example, that of the Museo in Trapani. It is not necessary to look for German influence in the work, as does Pinder (op. cit., and *Die Pietà*, Leipzig, 1922), although Michelangelo must certainly have known the Northern group of Pietàs, such as the little German example dating from the end of the fourteenth century which is still today preserved in the church of San Domenico in Bologna. Michelangelo must have known this specific work when he executed the statuettes on the tomb of San Domenico.

The oval head of Mary, and the gestures of the left hand, show the influence of Leonardo's Christ in the Last Supper, as is pointed out by Wölfflin (*Jugendwerke*, p. 25, note). Also, the diagonal band across the breast was derived from the drapery of the same figure. The head of Christ, with its delicate beard and mustache seems to be inspired by Verrocchio (Head of Christ, Victoria and Albert Museum), while the arrangement of the hair in the form of a triangle, a device which gives a very special spirituality to the head, recalls Leonardo.

(6) The only previous work of his which prepares the way for the Pietà is the Virgin of the Stairs, from which comes the idea of the head veil, and the way the drapery is placed in folds on the shoulder, repeating the curve of the shoulder.

(7) The Madonna of Bruges is developed from the Pietà (cf. analysis of the Madonna of Bruges).

(8) CHRONOLOGY: The work was begun after August 27, 1498, the date of the contract (Milanesi, p. 613). On this day the sum of 150 ducats was given to Jacopo Galli according to the contract. This sum was to be paid before the work was begun. Therefore we may deduce that up to this date Michelangelo did not work on this group.

The exact date of its completion is unknown, but the Pietà must have been nearly finished before May 1499. Indeed, by this date Filippino Lippi had executed three sketches for his Pietà for the Certosa di Pavia, two of them now in Fogg Museum, Cambridge, and one in the Louvre, sketches which already reveal certain influences from the composition of Michelangelo (cf. Scharf, op. cit., pp. 217*ff*). Scharf, who rightly observed these influences, dates the sketches between 1497 and 1499. In 1497 the work of Michelangelo had not yet been begun. In May, 1499, the work of Filippino had still not been delivered and it is most probable that at this date he had executed only the projects for his work.

The group was certainly executed after the statue of Bacchus. The forms are more

precise and the execution more refined. The body of Christ shows a more profound grasp of anatomy. Wölfflin alone (*Jugendwerke*, pp. 22*ff*) supposes that this work was completed earlier than the Bacchus.

(9) TECHNIQUE: The whole surface is polished. All lines of the composition are rounded, so that light on the polished surface falls softly, and models the forms gently, giving an ivory-like impression very dissimilar to that of the sharp light-dark contrast in Baroque art.

177
178
(10) COPIES: Copies in marble: by Nanni di Baccio Bigio, Florence, S. Spirito, gift of Luigi del Riccio, friend of Michelangelo, unveiled in 1549, see Vasari, ed. Milanesi, VII, p. 552; by Lorenzetti, gift of Apollonia Schütz, 1531, Rome, S. Maria dell' Anima, see Vasari, ed. Milanesi, VII, p. 552; by Battista Vázquez, 1561, Avila, Cathedral.

180
Copies in bronze: by Gregorio Rossi in 1616, Rome, Sant' Andrea della Valle, Capella Strozzi; small copy, early seventeenth century, New York, Frick Collection, no. 35.

Small copy in terracotta. London, Victoria and Albert Museum, no. 8381, 1863.

176
Engraving by G. Bonasone and Antonio Salamanca, 1547.

179
Engraving by Giovanni Battista de Cavalieri, 1564.

Free copy. Drawing by Giulio Clovio. London, British Museum.

(11) MAIN BIBLIOGRAPHY: Wölfflin, *Jugendwerke*, pp. 22*ff*; Frey, *Ma.*, I, pp. 299*ff*; Justi, *Ma., N.B.*, pp. 86*ff*; Thode, *Kr. U.*, pp. 56*ff*.

VI. DAVID

Florence, Accademia delle Belle Arti.
Marble in the round.
H.: 410 cm.; H. of the little base: 24 cm.; D. of the base: 38 cm.; W. of the base: 44 cm.

(1) CONDITION: While the statue was being moved on the night of May 14, 1504, it was hit with stones (see L. Landucci, *Diario Fiorentino dal 1450 al 1516*, pub. by Jodoco del Badia, Florence, 1883, p. 268; and A. Lapini, *Diario Fiorentino dal 252 al 1596*, pub. by G. O. Corazzini, Florence, 1900, p. 61; for the unveiling of the statue see also Giovanni Cambi, *Historie*, pub. in *Delizie degli eruditi Toscani*, Florence, 1785-1786, XXI, p. 203; and Scipione Ammirato, *Istorie Fiorentine*, written in 1574, and published in Florence, 1641, III, p. 276). On April 26, 1527, when the Medici were being put out of Florence and quarrels were taking place, a chair, thrown from the Palazzo della Signoria, broke the left arm of the statue in three pieces. These pieces were carried by Francesco Salviati and Vasari to the home of Salviati's father, who preserved them until Duke Cosimo I had them put back in place (Vasari, ed. Milanesi,
36
43
VII, 8). The marks of this break are still visible in the forearm, hand and fingers of the left arm. The right hand was also damaged, and its middle finger is a modern restoration.

The David became roughened by continued exposure to the elements. Because of this, in 1866, a committee was called upon to decide what should be done with the statue in order to preserve it. The findings of this committee were published by Gotti (II, pp. 41-45). The poor condition of the statue caused it to be removed, in 1873, to the Accademia delle Belle Arti.

(2) ATTRIBUTION: Not signed. Mentioned in the contract (Milanesi, pp. 620ff), and also by Vasari, 1550 (p. 48), Condivi (p. 48), and Vasari, 1568 (p. 49).

(3) HISTORY: The David of Michelangelo was executed from a block which had belonged for a long time to the Opera del Duomo, and which was originally designated for a statue that was to decorate one of the buttresses of the Cathedral. This is not the first David intended for the Cathedral, and transported later to the Palazzo della Signoria. On February 20, 1408, a century before Michelangelo's commission to do such a work, Donatello was charged with executing a statue "ad honorem David profeta" (G. Poggi, *Il Duomo di Firenze*, Berlin, 1909, no. 406). He finished it in June, 1409. This marble David was put into place on the buttress, but after a short time, probably because it was found to be too small, it was removed to the Magazzini dell'Opera (Poggi, op. cit., no. 413). It was now decided to execute the buttress figures in terracotta, and Donatello was given the task of representing a Joshua (Poggi, op. cit., nos. 414-415). This figure was erected on the first buttress of the apse, which was opposite the Via dei Servi (cf. fresco by Poccetti-Poggi, op. cit., p. xxii, fig. 2). In 1416, the marble David of Donatello was demanded by the *Priori* of the Palazzo della Signoria, and was soon sent to the Palazzo, where it was set up in the Sala dei Gigli (Poggi, op. cit., nos. 425 and 427).

The idea of decorating more of the buttresses was not abandoned, and in 1463 Agostino di Antonio di Duccio was charged with executing "uno gughante overo Erchole per porre in sullo edifitio . . . di quella grandezza . . . che chorisponda a quello che è sopra alla porta . . . che va a' Servi [that is, the Joshua by Donatello]," (Poggi, op. cit., no. 437). In November of this year, this figure was finished, and in 1464 the Operai of the Cathedral commissioned Agostino di Duccio with making another giant statue, nine braccia high (about 520 cm.) in four pieces of marble (Poggi, op. cit., no. 441). The sculptor went to Carrara and brought back a block of marble in one piece, and demanded special compensation for his extra effort (Poggi, op. cit., no. 444). This compensation was given to him, but it seems that after having commenced the statue, he abandoned work on it. According to Milanesi (Vasari, VII, p. 153 note) a document exists in the Opera di S. Maria del Fiore, indicating that it was Bartolommeo di Pietro called Baccellino and not Agostino di Duccio who carved the statue wrongly. In May 1476, the Operai commissioned Antonio Rossellino to finish it but with no results (Poggi, op. cit., no. 446). On July 2, 1501, a document tells us the Operai decided to look for a master who was capable of finishing the block of marble, called "David" which had been badly begun (Poggi, op cit., no. 448). The story in Vasari, 1568, p. 49,

[151]

which contradicts this fact is consequently without value. On August 16, 1501, this master was found in the person of Michelangelo (Poggi, op. cit., no. 449 and Milanesi, p. 620). Michelangelo was ordered to complete the statue in two years, at a monthly salary of 6 gold florins. On September 13, 1501, Michelangelo began work (Poggi, op. cit., no. 449, and Milanesi, p. 620). According to two documents of February 25 and February 28, 1502, the price of the statue was raised to 400 ducats (Milanesi, p. 620 note). At this time the statue was half finished. Payments on account to Michelangelo are mentioned on March 5, 1502 (st. c.); June 28, 1502; December 25, 1502; December 30, 1502; April 24, 1503 and on June 30, 1503 (cf. Frey, *Studien*, p. 107).

(4) On January 25, 1504 (Gaye, II, p. 455, and Milanesi, p. 620 note), when the work was nearly finished, a commission, the majority of whom were artists, was invited at the request of Michelangelo and the consuls of the Arte della Lana to make suggestions concerning the best place to erect the statue. About thirty were invited, and among them were the greatest artists of Florence, such as Andrea della Robbia, Cosimo Rosselli, David del Ghirlandaio, Simone del Pollaiuolo (Cronaca), Filippino Lippi, Botticelli, Giuliano and Antonio da Sangallo, Andrea Sansovino, Francesco Granacci, Piero di Cosimo, Leonardo, Perugino, Lorenzo di Credi. Opinions differed greatly (cf. pp. 96*ff*). Michelangelo was not present at the sitting of the commission, but the final decision, to place the statue neither on the buttress, nor near the Cathedral nor in the Loggia dei Lanzi, but in front of the Palazzo della Signoria, where Donatello's Judith was located, seems to have been originally the idea of Michelangelo (cf. C. Neumann, "Die Wahl des Platzes für Michelangelos David in Florenz im Jahr 1504," *Rep. f. Kw.*, XXXVIII, 1916, pp. 1*ff*). Borghini in his *Riposo*, written in 1584 (I, p. 136), on the other hand, says that Michelangelo intended to place the statue in a niche so that one could not see what he called a defect of the shoulders and he continues "ma poi fu messo con suo [scil. Michelangelo] poco soddisfaccimento, dove ora si vede." This opinion is shared by Panofsky (*Ma. Literatur*, cols. 27*ff*) who believes that Michelangelo intended to place the statue in a niche in the Loggia dei Lanzi. On the 1st, the 28th and on the 30th of April 1504, Simone del Pollaiuolo was ordered to take the statue from the workroom of the Cathedral to the Palazzo della Signoria (Frey, *Studien*, pp. 107*f*). The transportation lasted from May 14 through May 18, 1504 (Gaye, II, p. 464). According to Vasari (p. 51) Giuliano and Antonio da Sangallo executed a "castello di legname" in which the statue was taken before the Palazzo. On May 28, 1504 (Milanesi, p. 620 note) it was commanded that the Judith of Donatello be removed from the Palazzo, and that the David be erected in its place. The same decision about the position of the David is related in a second document dated May 29, 1504 (Gaye, II, p. 463). On the 8th of June 1504, Michelangelo's statue was erected in front of the Palazzo (Gaye, II, p. 464). On June 11, 1504 (Gaye, II, p. 463, and Milanesi, p. 620 note) Simone del Pollaiuolo and Antonio da Sangallo were commissioned to execute the base for the statue. Reproductions of the old *ringhiera* before the Palazzo della

Signoria are found in a painting of the Martyrdom of Savonarola by an anonymous Florentine in the Palazzo Corsini; in a relief on the Torre dei Girolami (reproduced in Lensi, *Palazzo Vecchio*, Florence, p. 30), and in the fresco of Ghirlandaio in Sta. Trinità (reproduced in Lensi, op. cit., p. 31). On September 5, 1504 (Frey, *Studien*, p. 109) 770 lire were ordered paid to Michelangelo for his work, then finished. On September 8, 1504: "Fu fornito el gigante e scoperto di tutto" (Landucci, *Diario*, sub Sept. 8, 1504).

The statue was transported between the dates July 31 and August 4, 1873 (Gotti, II, p. 50) from the front of the Palazzo to the Accademia delle Belle Arti.

(5) SUBJECT: While no link exists between the iconographic tradition of the fifteenth century and Michelangelo's representation of David, there are certain resemblances in form and content between this David and antique figures of Hercules. The fifteenth century represents David in accordance with the Bible, as a young boy. It accentuates in him the aspect of a youthful hero, with sword and helmet, and almost always clad in armor; the head of Goliath is laid like a trophy of victory at his feet. He is always shown at the completion of his heroic deed (cf. Donatello, Bellano, Bertoldo, Antonio Pollaiuolo and Andrea del Verrocchio; see also Michelangelo's sketch [No. 16], for the bronze David, which follows the fifteenth century Florentine type), the only exception to this last being on the relief by Ghiberti in the Porta del Paradiso.

The David by Michelangelo is a young man, and, contrary to the tradition of the fifteenth century, completely nude. The sculptor has suppressed all the usual attributes except the sling-shot, and even this is hidden behind the back of the figure. There exist several theories as to how David could make immediate use of the sling-shot (Thode, *Kr. U.*, I, pp. 81*ff*). These are based on the supposition that the statue represents the moment before the flinging of the stone. However, the figure actually holds the stone in the right hand, and the end of the sling-shot in the left; consequently, the sling-shot cannot be used immediately. It is necessary to deduce that Michelangelo did not wish to represent a definite historical moment in the life of David. He wished to incarnate in this figure the essence of his character, strength and courage. To express this idea, Michelangelo has associated his David with the Hercules type who revealed these traits more clearly. Already, in the Middle Ages and early Renaissance, Hercules and David were considered as co-types, and both as the symbolic personification of Fortitude. Thus, Nicola Pisano represents on the pulpit in the Baptistry of Pisa, Fortitude inspired by the antique Hercules figure-type (cf. Hercules sarcophagus of the Museo delle Terme, C. Robert, *Die antiken Sarkophag-reliefs*, Berlin, 1890, Vol. III, pt. 1, Pl. XXIX, no. 103; Tolnay, *Michelangelostudien*, pp. 108*f*). We find Hercules as the symbol of Fortitude on the Cathedral of Modena, with the inscription "Hercules fortis," and also in the literature of the Middle Ages (see Fulgentius, *Metaforalis*, ed. Liebschütz, Leipzig, 1926, p. 124). And, on the other hand, we find David called "manu fortis" (the expression "manu fortis" seems to go back to St. Jerome; see Franz

198b

214

36

37

196

195

Wutz, *Onomastica Sacra*, Leipzig, 1914, I, pp. 170*f*; see also Berchorius, *Rep. Mor. s.v.* David). Dante (*Monarchia*, II, IX, l. 11*ff*) says that victory of David over Goliath corresponds to victory of Hercules over Anteus. Also, on a cassone painting of the school of Pollaiuolo (once in the Spiridon collection, *Cat. Coll. Spiridon*, Berlin, 1929, no. 61; Schubring, *Cassoni*, nr. 340, Pl. 81) David and Hercules are represented as the Jewish and pagan types of Fortitude. In the mid-sixteenth century Hercules is called "manu potens" by Giraldus, *Syntagma, Historiae Deorum*, col. 324. It will be recalled that Hercules was considered during the Renaissance also as the master of Fortuna (cf. Giordano Bruno, *Spaccio della bestia triumphale*, Dialogue II, pt. 3, and Cassirer, *Individuum und Kosmos in der Philosophie der Renaissance*, Leipzig, 1927, p. 77). The fusion of Hercules and David-types was also motivated in Florence by the fact that since the end of the thirteenth century Hercules, whose image is found carved on the old seals of the Florentine republic (cf. note 110, p. 57) was considered as a patron of the city.

In Michelangelo's case, the idea of associating David with Hercules was well prepared, since Hercules had already played a role in the history of the statue. Agostino di Duccio, before he began the block of David, executed a gigantic Hercules in terracotta ("gughante overo Erchole . . . in forma et maniera di profeta," Poggi, op. cit., no. 437). Thus in the Gothic project, the idea of associating a Hercules with a David already existed. The Hercules was represented by Agostino di Duccio, according to the documents, in the form of a prophet, and this signifies, as pointed out by Lanckoronska, *Antike Elemente*, pp. 183*ff*, that the figure was enveloped in the traditional flowing cloak. On the other hand, a document (Poggi, op. cit., no. 449) mentions that on the block of the David there was a knot at the breast, and that Michelangelo began by cutting off this knot. Lanckoronska explained the existence of this knot on the block by the fact that Agostino wished to garb his David with a cloak. The idea of representing David completely nude, therefore, originated with Michelangelo and is explained by his desire to associate David with Hercules.

After the David was erected in front of the Palazzo, the Signoria about 1508 proposed to have Michelangelo execute a Hercules as a companion piece (Vasari, ed. Milanesi, VI, p. 148). The marble for this second statue arrived in 1525 (Gaye, II, p. 464), but he did not finish it. In 1534, Bandinelli took over the commission and executed the statue now standing before the Palazzo (Hercules and Cacus).

The large open space between the legs of Michelangelo's David, which Vasari (p. 49) erroneously suggested was caused by a hole in the block of marble, is explained by the figure's derivation in type from antique statues of Hercules, like, for example, that of the sarcophagus of the Museo delle Terme, or the statue of Hercules in the Palazzo Giustiniani, Rome (Lanckoronska, op. cit., fig. 8). Another source of inspiration which explains the accentuation of the difference in the two sides, right and left, one being strong and on guard, the other open and unprotected, is found in the symbolic sense

195

given to the two sides as far back as antiquity. Antique myths explained the right side as masculine and active, the left as feminine and passive (see J. J. Bachofen, *Mutterrecht und Urreligion*, ed. R. Marx, Leipzig, n.d., pp. 98 and 143). The Middle Ages has a theological interpretation; the right side is protected by God, the left is weak and exposed to evil. In the Franciscan book *Meditationes vitae Christi*, there is a passage in reference to the Psalms to which Wilde draws attention (*Eine Studie*, p. 57), which speaks of this difference of the two sides. The theory of Brockhaus (*Michelangelo*, pp. 12ff) who pointed out the influence on Michelangelo's statue of the sermons of Savonarola on David, was rightly rejected by Thode (*Kr. U.*, I, p. 83). After its erection, the statue was considered a political and moral symbol of the town of Florence. It was called by Vasari (1568, pp. 49 and 51) "insegna del Palazzo," and he says further that "as David defended his people and governed with justice, so should this city be defended with courage and governed with justice."

(6) ANALOGIES: The Hercules most similar to the David is that on the sarcophagus in the Museo delle Terme, already mentioned. Other figures of Hercules of the same type are the Hercules of the Palazzo Giustiniani at Rome, and the two gigantic Hercules in the Vatican and the Museo delle Terme (see Lanckoronska, op. cit.). The motif of the right hand, slightly bent at the wrist, is derived from Donatello's Zuccone and Jeremiah on the Campanile in Florence. The resemblance between the David and the Magdalene of Duccio's Three Marys at the Tomb at Siena, which was mentioned by Wilde (op. cit., p. 51), is probably explained not by a direct influence, but by the fact that Duccio's figure goes back, through Nicola Pisano, to antique inspiration.

(7) The motif of the right leg was prepared for in a study of a nude (No. 15), as was the right arm (No. 16). The expression on David's face is derived from the Proculus in Bologna (Bode, *Flor. Bildh.*, p. 319, has observed the resemblance in facial expression with the St. George of Donatello).

(8) A similar composition with closed left side, and open right, appears again in the Moses. The facial expression reappears in the Moses and Brutus (see the writer, *Brutus*, pp. 23ff).

(9) CHRONOLOGY: The David was begun on September 13, 1501 (Poggi, op. cit., no. 449; Milanesi, pp. 622f). The statue was finished in April 1504. The date of the first public showing of the statue in front of the Palazzo was September 8, 1504.

(10) TECHNIQUE: We have seen that the statue was executed from an old block of the fifteenth century, not chosen by the artist. This explains why the side view is too narrow and not truly Michelangelesque. It is the only statue by him that has not a typical side view, and a real three-dimensional character.

In the torso he has accentuated the muscles and bony structure, and not, as in the earlier Bacchus, the fleshy parts. The style is much more firm and hard, and as characteristic of this change, we may note the different treatments of the tree stump, which, in the Bacchus seems made of some soft stuff, and in the David is harsh and rough.

(11) COPIES: Drawings: By Leonardo, Windsor Castle (Thode, *Kr. U.*, I, p. 79; E. Solmi, "Il 'David' di Leonardo e il 'David' di Michelangelo," *Rassegna d' Arte*, XII, 1912, pp. 128*ff*; Solmi erroneously supposes that Leonardo's drawing is earlier and inspired Michelangelo's David) [Addenda, No. 9]. By Raphael, back view, London, *200* British Museum (Thode, *Kr. U.*, I, p. 79). By Raphael, Oxford (Fischel, no. 82, p. 107). By Bandinelli, Florence, Uffizi (Thode, *Kr. U.*, I, p. 79).

201 Giovanni Bandini detto dell'Opera, Florence, Cathedral. On the marble railing of the choir, one of the prophets is a free copy of the David. (Concerning Giovanni Bandini cf. Middeldorf, in *Rivista d'Arte*, XI, 1929, pp. 481*ff*; the connection of the figure with Michelangelo's David was not yet observed.)

201b Wax statuette inspired by Michelangelo's David. Mid-sixteenth century, attributed formerly to Benvenuto Cellini (the head probably nineteenth century). Boston, Museum of Fine Arts.

202 Bronze statuette. Late sixteenth century. Paris, Louvre, Thiers Collection (Thode, *Kr. U.*, I, p. 81).

(12) MAIN BIBLIOGRAPHY: Wölfflin, *Jugendwerke*, pp. 33*ff*; Justi, *Ma., N.B.*, pp. 129*ff*; Thode, *Kr. U.*, I, pp. 75*ff*.

VII. MADONNA OF BRUGES

Bruges, Church of Notre Dame.
Marble in the round.
H.: 128 cm. including base; H.: 119 cm. without base (base oval, smaller end at front).

(1) CONDITION: Generally excellent. Two small pieces broken off at right side of
48,46 Virgin's head-veil; edge of left arm-hole of Virgin's mantle is damaged.

(2) ATTRIBUTION: Not signed. In the past, the attribution of this work to Michelangelo was doubted because both Condivi (p. 54) and Vasari (1568, p. 55) describe this Madonna as of bronze, and Vasari calls it a tondo. But their descriptions must necessarily have been made without ever seeing the work, and therefore need not be considered dependable. The Madonna was sent to Flanders in 1506, and Condivi was born about 1525. Vasari, in his first edition (1550), does not even mention it, and in his second (1568) he follows Condivi's description (1553), except to call the work a tondo.

The arguments in favor of the attribution of this Madonna to Michelangelo have been established by A. de Montaiglon ("La vie de Michelange," *G. d. B. A.*, XIII, 1876, pp. 252*ff*). Springer (*Raffael und Michelangelo*, I, p. 30) and Wölfflin (*Klass. Kunst*, p. 45) observed that the statue in its secondary parts reveals a weaker hand, an opinion not shared by this writer.

(3) HISTORY: We do not know exactly where or at what time Michelangelo executed this statue. In a letter he wrote from Rome, January 31, 1506, to his father in Florence (Milanesi, pp. 6*f*), he mentioned a Madonna of marble ("Nostra Donna di marmo")

and asked his father to send it to their home in Florence and to allow no one to see it. This work was probably the Madonna of Bruges.

Certainly the Madonna was mentioned in a letter of August 13, 1506, written by Giovanni Balducci to Michelangelo at Florence (Gotti, II, p. 51; see Frey, *Handz.*, p. 45, for the date of the letter). Balducci indicates to Michelangelo how the statue could be sent to Viareggio and from there "to Flanders, that is to say, to Bruges" to the heirs of Giovanni and Alessandro Moscheroni & Co., in the care either of Francesco del Pugliese, whom he recommends, or of Giuliano d'Adamo. The statue is not named as a Madonna in the letter, but the reference to Moscheroni & Co. leaves no doubt that he is speaking of the Madonna of Bruges.

The statue was erected in the Church of Notre Dame in Bruges, in the chapel of the "langhe Moeder Gods," formerly called the Chapel of St. George, and also the Chapel of the Mouscron. It is now called the Chapel of the Blessed Sacrament.

A document is preserved in the state archives of Bruges (*Archives des Etats, Littera F.*, No. 117) which tells that Alexander Mosaren (Mouscron) ordered a new altar constructed, with a "sumptuous tabernacle" in which was to be placed "an excellent statue of the Virgin, very costly and precious," and he demanded that it always remain in the same location. This document was first cited in connection with Michelangelo by the writer (*Michelangelostudien*, p. 113 note) but it had been first published by J. Gailliard (*Inscriptions funéraires et monumentales de la Flandre occidentale*. Arrondissement de Bruges, I, pt. 2. Bruges, 1866, pp. 282f). There is no possible doubt that the work mentioned in this document is the Madonna of Bruges. Concerning Alexander Mouschron, see: *Registres des sentences civils*, 1489-1490, fol. 20v, no. 1, pub. in *Cartulaire de l'ancienne Estaple de Bruges*, ed. L. Gilliodts van Severen, Bruges, 1904, vol. I; sub Apr. 17, 1490, it is mentioned that Alexander Mouschron & Co. was engaged in buying and selling English cloth and had establishments in Rome and in Florence.

On April 7, 1521, Dürer saw this work in Notre Dame, and reports it in the "Tagebuch der Reise in die Niederlande" (see K. Lange and F. Fuhse, *A. Dürer's Schriftlicher Nachlass*, Halle, 1893, p. 156: "Darnach sahe ich das alabaster Marienbild zu unser Frauen, das Michael Angelo von Rohm gemacht hat").

Marcus van Waernewyck (I, ed. 1560) says that the statue cost 4,000 guldens, and that "they were going to place behind it a wall decoration of which Jan de Heere of Ghent had made the plan and his son Lucas the drawing." (Quoted from Thode, *Kr. U.*, I, p. 60.)

According to the inscription on a tombstone in the ground before the altar, restored in 1829, a certain Peter Mouscron (Petro Moscron), in the year 1571, had commissioned these mural decorations, in black and white marble. They exist today.

The statue was carried to Paris by the army of Napoleon, but was returned in 1815 (see Weale, *Guide de Bruges*, 1864).

(4) SUBJECT: The Madonna is again the sibylline type, like the Virgin of the Stairs. The idea of placing the Christ Child between the knees of His mother is exceptional. Michelangelo seems to approach in this, as well as in the severe vertical axis of the position, an artistic conception of the Middle Ages—the Platytera, or Virgin who carries the Child in her bosom. In the ordinary Platytera type the Child is surrounded by a mandorla. For examples we may note the seated Platytera which occurs in the Etchmiadzin Gospels and for standing types see Kondakoff, *Ikon. der Madonna*, II,
208 pp. 306, 307, 314. But late Byzantine art (Kondakoff, op. cit., I, fig. 607) and the early
207 Renaissance (e.g. Donatello Madonna, Padua, S. Antonio) interpreted the mandorla at times in a realistic sense, and transformed it to drapery. Such an interpretation prepares the way for the composition of the folds which surround the Child in the Madonna of Bruges.

(5) ANALOGIES: M. L. Gengaro ("Rapporti tra scultura e pittura nella seconda metà del quattrocento: Benedetto da Majano"; *Boll. d'Arte*, XXX, 1937, pp. 46*off*) notes a resemblance between the Madonna of Bruges and the Madonna by Benedetto da Majano, in the Oratorio della Misericordia at Florence, but this resemblance is not so significant, and it is more possible that Michelangelo had derived his Virgin, as we shall see later, from the one in his own Pietà group. The exceptional motif of the Christ-child represented between the knees of the Madonna is found previous to Michelangelo's work in a Virgin by Cosimo Tura (New York, Pratt Coll.). This resemblance, however, is to be explained rather by coincidence than by direct influence.

(6) The figure of Mary was developed from the figure of the Virgin of the Pietà in St. Peter's. The head-veil and, in reversed position, the mantle on the shoulder and the motif of the foot raised on a stone, are similar. A sketch of the general idea for the drapery of the mantle, which covers the upper right leg of the Virgin, is repeated in
101 a sketch by Michelangelo in the Museum Condé, Chantilly (Tolnay, *Arch. Buon.*, p. 450). Here the drapery falls into a large fold, which drapes the upper part of the leg, and after encircling it, is caught under, and then falls down.

100 Concerning the sketch in ink, in our opinion about 1506 (Frey, *Handz.*, 45), see our Catalogue of Drawings (No. 24).

109 For the sketches of children (Frey, *Handz.*, 91) and the inscription "chosse de Bruges," see our Catalogue of Drawings (No. 21).

(7) The motif of the Child with his arm laid across his breast, and with his head bent on the opposite side, will become one of the favorite motifs of the artist. One finds it again in the Madonna Doni, in the Christ of the Santa Maria sopra Minerva, in the Victory group, and in the David-Apollo in the Bargello. The Virgin anticipates the Delphic Sibyl of the Sistine ceiling. [Addenda, No. 10]

(8) CHRONOLOGY: The exact date of the execution of the work is not known, but Michelangelo probably began the statue in the spring or summer of 1501, in Florence, just before the marble David.

The delicate execution of certain details, such as the slender-fingered hands, the sleeve with buttons, and the neckbrooch, recall the sensitive manner of the Pietà. On the other hand, the symmetrical and severe drapery folds of the head-veil and at the bosom announce the classic style of the David.

Scholars differ concerning the chronology of this work. Wilson (*Life and Works*, p. 43), Symonds (*Life*, I, pp. 74*ff*), and Thode (*Kr. U.*, I, pp. 59*ff*) date it at the "Roman" period of the Pietà. Grimm (*Leben Michelangelos*, I, pp. 212*f*) dates it about 1502; Springer (*Raffael und Michelangelo*, I, pp. 29*f*) between 1501 and 1505; Wölfflin (*Jugendwerke*, pp. 38*ff*) places it at the time of the execution of the David between 1501 and 1504; and Frey (*Handz.*, p. 35) about 1503 or later. Woltmann ("Michelangelos Madonna in Bruges," *Z.f.b.K.*, I, 1866, pp. 223*f*) and Brinckmann (*Barockskulptur*, I, pp. 39*f*) believe that it was done at the time of the Cascina, about 1504, basing this opinion on the sketch of the Madonna of Bruges in London (No. 24), whose *115* other figures, by Michelangelo, appear in the Cascina.

(9) TECHNIQUE: Of white polished marble executed in the same fine technique as the Pietà. On the back, execution is raw, showing marks of the chisel. [Addenda, No. 11]

(10) COPIES: Vincenzo Danti, Virgin, tomb of Carlo dei Medici, Cathedral of Prato (reproduced in Grünwald, *Florentiner Studien*, Pl. 8). The Virgins of Garofalo, Modena; G. Reni, Dresden, and Maratta, Florence, Pal. Pitti, are also inspired by the Madonna of Bruges (cf. Kurz, in *Burl. Mag.*, 1945, p. 52).

Breydel-Epitaph (1642), Bruges Cathedral, fourth pillar of the choir: copy reduced. *204*

Rombaut Pauli (Pauwels, 1625-1700), Ghent, Church of St. Michael, right transept. *205* The Child wears a sort of loin-cloth.

Pierre-Antoine Verschaffelt (1710-1793), grave monument of Bishop Maximilian *206* Van der Noot, Ghent, Cathedral of St. Bavon, free copy.

Hans Burgkmair, Madonna and Child, (1509) Nürnberg, Germanisches Museum, inspired by the Madonna of Bruges, as pointed out by Alfred Neumeyer, "Burgkmair und Michelangelo," *Münchener Jahrb.*, v (1928), pp. 64*ff*.

A. Benson, *Caritas*, Berlin, Deutsches Museum, inspired by Michelangelo's Bruges Madonna, as pointed out by W. Krönig, "Brügge und Michelangelo," *Berliner Museen*, LIII (1932), pp. 60*f*.

P. Bruegel the Elder, Epiphany, London, National Gallery, also derived from the Madonna of Bruges, as pointed out by Tolnay, *Pierre Bruegel l'Ancien*, Brussels, 1935, p. 52.

Jan Lievens, Christ Child, after Bruges Madonna, Paris, Louvre, reproduced in H. Schneider, *J. Lievens*, Haarlem, 1932, Pl. XIV. A cast of the Child of the Bruges Madonna existed in the atelier of Rembrandt, as indicated in the inventory of 1656, "a Child by Michelangelo." It is this cast which was the model for Lievens's painting.

(11) MAIN BIBLIOGRAPHY: Wölfflin, *Jungendwerke*, pp. 38*ff*; Justi, *Ma.*, *N.B.*, pp. 101*ff*; Thode, *Kr. U.*, I, pp. 59*ff*.

VIII. MADONNA OF BARTOLOMMEO PITTI

Florence, Bargello.
Marble relief, tondo (not perfectly round).
Greatest width: 82 cm.; Greatest height: 85.5 cm.

50 (1) CONDITION: Excellent, except for small defects in the border caused by the nails which fasten it to the wall.

ATTRIBUTION: Not signed. Mentioned for the first time by Vasari (1550, p. 54); also by Varchi (*Orazione*, 1564) and Vasari (1568, p. 55).

(2) HISTORY: Vasari (1568, p. 55) says that this relief was made by Michelangelo for Bartolommeo Pitti, and was afterwards given by Fra Miniato Pitti, his son, of Monte Oliveto to Luigi Guicciardini. Fra Miniato Pitti was, according to Vasari, "a connoisseur of cosmography, of many sciences and above all, of painting." He was in communication with Michelangelo, as proven by a letter he wrote to Vasari on October 10, 1563 (C. Frey, *Vasari, Lit. Nachlass*, II, p. 9). Varchi (*Orazione*, 1564), saw this work in the home of Pietro Guicciardini, nephew of Luigi.

In May, 1823, the relief was bought by the Gallery of Florence, and from there it came in 1873 to the Bargello (Vasari, ed. Milanesi, VII, p. 157 note).

(3) SUBJECT: The Virgin is again a Sibylline Madonna, who sees peril, and seems to protect the Child. She holds him under the arm, and her cloak is around his back. On a band around her forehead is embossed a cherub. The motif was not invented by
207 Michelangelo. The Madonna of Donatello in the Santo at Padua also has on her head a sort of crown formed of cherubim. Another example may be found in A. Rossellino, Madonna and Child, Washington, National Gallery of Art. The cherub signifies the "gift of knowledge" in the sense of a prophetic faculty. (cf. Dionysos Areopagita, *Hier. Coel.* VII, §1). The motif of the book she holds on her knee is known in art before this (cf. Virgins by Botticelli in the Louvre, Uffizi, and at Berlin). The contrast between the gravity of the Virgin and the innocence of the two children is like that in the Virgin of Bruges.

(4) ANALOGIES: The sitting position, and the details of the drapery, above all the
217 curving folds around the legs, are inspired by the Prudenzia by della Quercia on the Fonte Gaia, Siena, Palazzo Pubblico (see the author, *Thieme-Becker*; and Wilde, *Eine Studie*, p. 58). The attitude of the Child, who leans against the leg of the Mother, was derived from the figures of mourning genii in antiquity, like that on the Phaedra
218 sarcophagus, so-called, "of the Contessa Beatrice," Pisa, Campo Santo (cf. Steinmann, *Madonnenideal*, pp. 169ff; and Wilde, op. cit., p. 58). The head of St. John seems inspired by the head of a young Centaur as, for example, that in the Museo Capitolino (Winter, p. 382, fig. 2).

The idea for the composition in round form seems influenced by Signorelli's Holy
224 Family in the Uffizi.

(5) We have identified the preparatory sketch for this relief with a sketch preserved at Chantilly, Musée Condé (cf. the writer, *Arch. Buon.*, pp. 452*ff*). Concerning the 98 development of the sitting position, between the drawing and the relief, see text, p. 102.

The rather disdainful expression on the face of the Virgin is developed from the face of the marble David.

(6) The Delphic Sibyl in the Sistine Ceiling is derived from this relief (Wölfflin, *Jugendwerke*, p. 45). The folds, in the form of rings around the legs, Michelangelo used later in the Jesse of the Sistine Ceiling. The idea of uniting in a triangular composition two opposing life-principles at the base which are synthesized at the top (see text) recurs in the Prophets and Sibyls with their genii of the Sistine Ceiling, in the Medici Tombs, and in the central group of the Last Judgment.

(7) CHRONOLOGY: The massive form and simplified details date the work around 1504-1505. The figure is more developed from the stylistic point of view than the marble David, and approaches already the style of the St. Matthew; one finds the same massiveness of form and rectangular construction. Wölfflin (*Jugendwerke*, pp. 43*ff*), Justi (*Ma., N.B.*, pp. 184*ff*), Thode (*Kr. U.*, I, p. 115) date this relief before the London tondo; Springer (*Raphael und Michelangelo*, I, p. 321, note 13), Mackowsky, p. 52, Knapp, p. 169, and M. Hauptmann (*Der Tondo*, Frankfurt a.M., 1936, pp. 163*ff*) date this work later.

(8) TECHNIQUE: The form of the block was originally convex, and at the greatest thickness (i.e. the block on which the Madonna sits) is 16 cm. The parts of the relief in the center are in high relief, and at the sides the forms go more and more into low relief, due to the original convexity of the tondo. To give a greater volume to the figures, Michelangelo made the background concave, and allowed the head of the Madonna to project beyond the border of the relief.

The head, bosom and lower parts of the Virgin's figure, the whole Christ Child, and the figure of St. John, were executed with a fine-claw tool. The Virgin's right sleeve was executed with one less fine. The rough parallel lines at left and right background are executed with a chisel. Next to the Virgin's head at right and left the raw material has not been much treated. (cf. A. Grünwald, *Florentiner Studien*, Pl. 24.)

(9) COPIES: Raphael, Caritas, predella. 1507. Rome, Vatican.

Raphael, drawing for the Caritas, Vienna, Albertina (cf. Gronau, *Raphaels Floren-* 219 *tiner Tage*, Pl. x). Cf. E. Wind, "Charity," *Journal of Warburg Institute*, I, 1938, pp. 322*ff*. Wind erroneously relates Raphael's predella and drawing of Caritas with Michelangelo's lunette of Jehoshaphat on the Sistine Ceiling and supposes that neither the predella nor the drawing are by Raphael, and dates both after 1512. The predella, however, is 1507, that is, at the time of the Deposition, formerly above. Wind overlooked the fact that Raphael was inspired by Michelangelo's Bargello tondo. Consequently his doubt in the attribution to Raphael's early period is groundless. (The drawing seems to be a copy). [Addenda, No. 12]

(10) MAIN BIBLIOGRAPHY: Wölfflin, *Jugendwerke*, pp. 43*ff*; Justi, *Ma., N.B.*, pp. 184*ff*; Thode, *Kr. U.*, I, pp. 114*ff*.

IX. MADONNA AND CHILD WITH ST. JOHN, EXECUTED FOR TADDEO TADDEI

London, Royal Academy of Fine Arts.
Marble relief, tondo.
Diameter: 109 cm.

(1) CONDITION: Unfinished. Broken off under left arm of the Virgin and behind
54 back of St. John.

(2) ATTRIBUTION: Not signed. Mentioned by Vasari (1550, p. 54), Varchi (*Orazione*,
1564), and again by Vasari (1568, p. 55). The authenticity of this relief has never been
57, 58 questioned. However, in its details, see, for example, the faces or the right arm of the
Christ Child, and the folds of the Madonna's cloak, it seems to have been retouched by
the hand of an apprentice (see Tolnay, *Thieme-Becker*, p. 518).

(3) HISTORY: Varchi (*Orazione*, 1564) and Vasari (1568, p. 55) say that this relief
was executed by Michelangelo for Taddeo Taddei, and that it was preserved in the
home of the latter's heirs in Florence. Taddeo Taddei is mentioned in a letter by
Raphael written to his uncle Simone Ciarla, published by Fischel, *Raphaels Zeichnun-
gen*, p. 176, no. 163. Raphael says that he is much obliged to Taddeo Taddei. In the
early nineteenth century it was in the Wicar collection in Rome (cf. the letter of Wicar
to Pietro Benvenuto pub. in G. Campori, *Lettere artistiche inedite*. Modena, 1866, p.
405). In 1823 it was bought by Sir George Beaumont and removed to London. He pre-
sented the work to the Royal Academy (cf. Thode, *Kr. U.*, I, pp. 115ff, and W. Sandby,
The History of the Royal Academy of Arts, London, 1862, II, p. 410).

(4) SUBJECT: A Madonna with the Child Jesus and St. John is represented but in a
more dramatic way than in the Bargello tondo. The little St. John holds a goldfinch in
his hand. Jesus in fear, turns to his Mother. The Virgin, with her right hand, tenderly
touches the shoulder of St. John to hold him off.

The motif of the goldfinch is known to fourteenth century art in Florence, for ex-
ample in the polyptych by Bernardo Daddi, in the Academy in Florence. Here the bird
is held as a sort of attribute by Jesus. In Michelangelo the idea is changed. The fear of
Jesus before the bird seems to anticipate the fear of his later destiny. The resigned fig-
ure of the Virgin seems to look beyond all this little drama to the Passion of Christ. She
is again the Sibylline type. [Addenda, No. 13]

(5) ANALOGIES: The composition, which shows the Virgin seated on the ground,
seems to have been derived from a bronze plaque, attributed to Donatello, of which
an example is at the Louvre, another in Berlin, Deutsches Museum (cf. Bode, *Flor.
Bildh.*, p. 120, and *Klass. der Kunst, Donatello*, 2nd ed., p. 93). The Child Jesus is nearly
exactly imitated from an antique putto type, one of which may be seen on a piece of
fresco, preserved in the Museo Nazionale, Naples (Room 88, not numbered, near no.
221 9325); another on a Medea sarcophagus (cf. Robert, *Die antiken Sarkophag-reliefs*,
Berlin, 1890, II, Pls. 62-64). The connection between the Madonna tondo and the

Medea sarcophagus was observed by Panofsky, *Iconology*, p. 172 and by Walter Horn in an unpublished paper on Michelangelo and the Antique, Hamburg, 1931.

(6) Two preparatory sketches for the little St. John may be found in (No. 21). *109*

(7) A similar composition appears in the drawing, (No. 33). This drawing *123* is probably also a project for a tondo. Wilde (*Eine Studie*, pp. 60f) shows that the Virgin in this drawing is inspired by a Sibyl of Giovanni Pisano in Pistoia. Unconvincing is the hypothesis of Popp (*Bemerkungen*, pp. 134ff), who suggests that the figure of Anne was retouched by Michelangelo in the epoch when he worked on the Medici Madonna. The figure of Ozias in the Sistine Ceiling was developed from that of the Virgin of this relief.

(8) CHRONOLOGY: This relief is mentioned by Vasari, together with the Bargello tondo. It would seem to have been executed a little later, ca. 1505-1506. Wölfflin (*Jugendwerke*, p. 48) has rightly indicated the arguments in favor of this date: first, that the relief is half again as big as the Bargello tondo; second, that the dramatic composition cannot be considered as an invention *previous* to the Bargello tondo; finally, that the disposition of the figures written within the circle is more perfect. Thode (*Kr. U.*, i, p. 116) concurs with Wölfflin in this opinion.

(9) TECHNIQUE: Executed from a relatively deep but not flat block. The figure of the Christ Child is worked with a claw tool. The head and cloak of the Virgin and the figure of St. John are worked less. The right hand of the Virgin is only slightly indicated in the background, which is unfinished, and worked with a simple chisel.

(10) COPIES: Raphael, Bridgewater Madonna (cf. Wölfflin, *Jugendwerke*, p. 49), inspired by the Christ Child.

Raphael, Galatea, Rome, Villa Farnesina, putto in foreground.

Raphael, Madonna del Cardellino, Uffizi, motif of the St. John with the goldfinch.

See also Raphael's drawings in Paris, Florence and British Museum representing *222, 223* Virgins. (See Gronau, *Raphaels Florentiner Tage*, Pl. XI.) The Paris drawing was considered a copy by Fischel (no. 96).

Gianfrancesco Rustici, relief of Madonna, Florence, Bargello, inspired by the tondo of Michelangelo.

(11) MAIN BIBLIOGRAPHY: Wölfflin, *Jugendwerke*, pp. 47ff; Justi, *Ma., N.B.*, pp. 185ff; Thode, *Kr. U.*, i, pp. 115ff.

X. MADONNA DONI

Florence, Galleria degli Uffizi (No. 1456).
Tempera on panel.
Diameters: vertical 91 cm.; horizontal 80 cm.

(1) CONDITION: Across right arm of Virgin and left leg of St. Joseph, are cracks later *59* restored. Condition otherwise excellent.

[163]

(2) ATTRIBUTION: Not signed. Mentioned for first time in a letter of A. F. Doni to Alberto Lollio, August 17, 1549 (Bottari, *Raccolta*, III, p. 347); Vasari (1550, p. 40); Condivi (p. 54); Vasari (1568, p. 55).

(3) HISTORY: Executed at the command of Agnolo Doni, "cittadino fiorentino, amico suo [*scil*. Michelangelo]" (Vasari, p. 55). Agnolo Doni, born in 1476, was descended from an old popolani family which had played a prominent role in Florentine history as early as the thirteenth century. They were wool weavers. Agnolo had a house on the Corso de' Tintori, in the S. Croce quarter, which had been purchased by his father and which he had remodelled. He was twice appointed Prior, once in 1511 and again in 1529. He died in 1539. In the registry under the date of his death it is noted: "Agnolo di Francesco Doni . . . veramente homo da bene." He was well known as an art-lover (see R. Davidson, "Das Ehepaar Doni und seine von Raffael gemalten Porträts," *Rep. f. Kw.*, XXIII, 1900, pp. 211*ff*). In 1503, or early in 1504, he married Maddalena di Giovanni Strozzi, born February 19, 1489 (see Ridolfi, *Archivio storico dell' arte*, IV, p. 423). The portraits by Raphael of Agnolo Doni and his wife (Florence, Pitti) were executed about 1506 (see Gronau, *Klass. der Kunst, Raffael*, Stuttgart, 1919, pp. 226*f*), that is, approximately three years later than Michelangelo's tondo. According to Condivi (p. 54), the price for the painting was 70 ducats; Vasari (1568, pp. 55, 57) says that Michelangelo asked 140 ducats. In the letter of Anton Francesco Doni to Alberto Lollio, August 17, 1549 (see above), the tondo is mentioned as in the house of Agnolo Doni. He writes, "sopra tutto fatevi mostrare un tondo d'una Nostra Donna in casa d'Agnol Doni, e vi basti solo che io dica: Egli è di mano del Maestro de' Maestri." Varchi (*Orazione*, 1564) saw the painting at the house of Gianbattista Doni, the son of Agnolo. Bocchi-Cinelli (*Bellezze di Firenze*, p. 275) likewise saw the painting there. Bottari (in Borghini's *Riposo*, III, p. 52, note 2) saw the painting in the gallery of the Grand Duke of Florence.

The Tondo was already in the *Tribuna* in 1635, according to the manuscript inventory taken in this year (no. 433). (See *Galleria degli Uffizi. Elenco dei Dipinti*, Firenze 1921, p. 57.)

(4) SUBJECT: In type the Virgin, very different from the other Madonnas of Michelangelo, is a sturdy woman, with bare arms and feet, and without the head-veil. The representation was doubtless executed from a male model. This supposition is confirmed by the head, which is that of a young man, and by the masculine form and muscular arms. It is the first time that Michelangelo transposed ideal masculine beauty to feminine. In this he anticipates the Sibyls of the Sistine vault.

The head of Joseph seems to have been derived from antique portraits of Euripides (cf. Naples, Museo Nazionale). In the background Michelangelo shows a group of nude young athletes, inspired by the Signorelli tondo of the Virgin and Child (Uffizi). In Signorelli these figures are shepherds; Michelangelo, on the other hand, appears to signify the pagan world, separated by a wall from the Holy Family.

224

Vasari (1568, p. 55) gives a description of the motif of the group which does not seem correct. It is the Virgin who receives the Infant from Joseph and not, as Vasari says, Joseph who receives him from Mary.

In the text we have based our discussion on the exceptional posing of the Child on the Virgin's shoulder. In the Middle Ages this motif signified the superiority of the upper figure and at the same time his derivation from the lower. Christ belongs to the world *sub gratia* as above the world *sub lege* to which the Virgin and Joseph belong by birth. And these two worlds are contrasted to the world *ante legem* which Michelangelo represents by the Ephebian youths behind the wall. Thus Michelangelo synthesizes in this composition in globe form all the spiritual development of humanity.

The gaze of the Virgin, by which Vasari was much moved, is again the "prophetic glance," but here a hopeful one—for she sees the Saviour as victorious hero of the world to come.

Brockhaus (*Michelangelo*, p. 5) thinks that the pose of the Virgin contains an allusion to the name of the Doni family; she receives the Child from the hands of St. Joseph—as if to say *"doni"* (give). This interpretation seems a little far-fetched, as the Virgin does not address Joseph, but contemplates the Child.

(5) ANALOGIES: The motif of the Madonna seated on the ground is probably from certain antique statues, like the Astragal-player (London, British Museum, and Berlin, Altes Museum). The way the Virgin holds the Child seems to come from the manner of carrying vases, in antique art; the gesture is common today among Carrarese women as they carry their water jars. From antiquity, too, comes the victory fillet about the Child's head. The tondo composition derives from the tondi of Signorelli (Uffizi). In the fifteenth century tondo composition, the figure is almost always standing, or half-length. After Donatello, Signorelli seems to have been one of the first to choose seated figures to fill the circular space. Michelangelo uses this motif. (Concerning Italian tondo compositions, see Warburg, *Ges. Schriften*, I, pp. 64f, and M. Hauptmann, *Der Tondo*, Frankfurt a.M., n.d.). The landscape was probably inspired by Flemish landscapes of the early sixteenth century (for example, Patinir), where there was a similar disposition with the sea in the center and the banks on either side. However, Michelangelo has simplified the type and omitted the usual richness of detail, giving it a more Italian character. Probably in this transformation he intended to create a certain resemblance to the coast of Carrara.

(6) The motif of the arm across the breast and the inclined head of the Christ Child comes from the Child of the Bruges Madonna. The head of Joseph is based on studies from life, made about five years earlier, and which we have in the drawings at Oxford (No. 10, 12). In executing the painting, however, Michelangelo seems to have also derived his type from ancient portraits of Euripides. The head of the youth in the left background is derived from the head of the youth in the Oxford drawing (No. 10).

224

83, 84

127 Concerning the study for the head in red chalk (Frey, *Handz.*, 52) see the author, *Codex Vaticanus*, p. 192 note and Vol. II, No. 45.

(7) The Virgin is the first example of the enlarging of bodily forms such as we find later in the Sistine ceiling, in the Sibyls. Already Wölfflin (*Jugendwerke*, p. 54) remarked that the Doni Madonna is "the sister of the Sibyl Erythrea." The heads and the bodies of these two figures are almost identical, and the costumes as well are very similar. The movement of the arm of the Doni Madonna will be further developed in the Delphic Sibyl. Finally, the head of the last prophet, Jonah, was executed in reverse

127 from the red chalk study of the Madonna's head (Frey, *Handz.*, 52, see the author, *Codex Vaticanus*, pp. 194*f*). The drawing seems to be more powerful than the head of the Doni Madonna. Because of this it seems to us that it was executed after the Doni Madonna and used again for the Jonah.

The background figures are the precursors of the slaves of the first project for the Tomb of Julius II and for the nudes of the Sistine ceiling. Michelangelo used the motif of the young man with legs crossed, in the right background, in one of the slaves in the Julius Tomb (see Beckerath drawing). The nude youth seated in the right background is developed in the *ignudo* to the left above the prophet Isaiah (and not, as Wölfflin believes, in the one to the right above the Erythrea). The head of the second young man at the left may be found in the nude over the prophet Joel in the Sistine ceiling.

225 (8) CHRONOLOGY: In the old frame of the painting, we find the crescents of the Strozzi arms. Giovanni Poggi (*Kunstchronik*, N.F. XVIII, 1907, col. 299), who discovered this old framing, deduced from this that the painting was a wedding gift on the occasion of the marriage of Maddalena Strozzi to Agnolo Doni, which took place at the end of 1503 or the beginning of 1504. Concerning the original framing of this painting, see also Elfried Bock, *Florentinische und Venezianische Bilderrahmen*, Munich, 1902, pp. 78*f*. Bock points out that the ornament of this frame is almost identical with the Sienese frame now in London, Victoria and Albert Museum. Five symmetrically arranged heads in the round, however, take the place of the rosettes found on the frame from Siena. This motif is obviously inspired by Ghiberti's Porta del Paradiso. Occasionally such heads appear on other frames of this period, as, for example, in that of Antonio Barili in Siena, San Francesco, reproduced by Bock, op. cit., p. 70. The five heads in Michelangelo's frame correspond to the compositional scheme of the painting and to his iconographical program. At the lowest level are two sibyls' heads, above two prophets' heads, and finally, at the top is the head of Christ, all emphasizing again the world epochs *ante legem, sub lege,* and *sub gratia.* Wölfflin (*Jugendwerke*, pp. 54 and 56) dates the painting from the same years, although at that time the framing was unknown. Berenson (*Drawings*, I, p. 195) and Baumgart (*Contributi*, p. 350) believe that the Doni tondo must have been painted after and not before the cartoon because so complex a motif is never found in Michelangelo's work between 1501-1505.

Poggi's and Wölfflin's dating is supported by the note in P. Gaurico, *De Sculptura,*

Florence, January, 1504, which says, "Michelangelus Bonarotus, etiam pictor"; this can refer only to this panel since no other painting was done by the artist before January, 1504. [Addenda, No. 14]

The relation between the Doni tondo and the St. Matthew (Florence, Accademia delle Belle Arti) which it anticipates, as well as that with the Tomb of Julius II, is rendered plausible by two drawings (Nos. 34, 35). The drawing No. 35 shows three sketches. One is a drawing for the right arm of the St. Matthew (and not as Frey believes, for the marble David); another is a bearded head which Berenson already has related to the Moses of the Julius Tomb; the third is a sketch of a nude youth in a contorted movement (this nude was erroneously considered by Frey and Berenson as a sketch for the Hamman of the Sistine Ceiling; see Catalogue of Drawings). It was probably made after a little wax model of a slave for the tomb with half the right arm missing. The violent turning of the head and the leg twisting in the opposite direction is in the same spirit as the spiral movement of the Doni Madonna.

No. 34 shows a sketch for one of the slaves of the Tomb of Julius II, and the study of a *putto*, similar in posture to the Christ Child of the Doni Madonna, and with the same curly hair, which we do not find before (see, for example, the earlier putti sketches, No. 21).

(9) TECHNIQUE: Tempera on panel (Wilson, *Life and Works*, p. 60; Ricci, *Michelangelo*, pp. 31f, and Justi, *Ma., N.B.*, p. 175, say erroneously that it is oil; see, however, David Thompson, *Materials of Mediaeval Painting*, London, 1936, pp. 47f; and Doerner, *Malmaterial*, Stuttgart, 1938, pp. 198, 272). The extraordinary clearness of the modelling and the force of the red-outlined contours of the nude parts give the impression of sculptural plasticity. There are no deep shadows, only half shadows lit by reflection. There is no diffused light, but spots of light which emphasize the swelling of forms and which give the effect of polished marble. Light and shadow serve only to bring out plastic values, and the suggestion of a plastic substance, in contrast to the soft *chiaroscuro* of contemporary artists for whom light and shade served to envelop and relate the forms.

(10) COLORING: The coloring of this painting is completely exceptional for the time. Contemporary artists liked the harmony of warm colors which they enveloped in a *sfumato*. In contrast the painting of Michelangelo is made up of cool, clear colors, which give the impression of "colored marble." He used, at the same time, changing color values. Mary's pink gown changes to clear yellow, where the light touches it, her light blue mantle becomes white, and its green lining turns to golden yellow. Joseph's yellow robe changes to orange in the shadow; the upper part of the garment is a cool gray which lightens to white. The sky and the mountains in the background are a very light, transparent blue.

Michelangelo puts in relief the beauty of the colors by a play of contrast. The pink of the Virgin's blouse is accented by the small blue brooch at her bosom, as the blue

[167]

of her mantle is relieved by a little spot of pink gown which projects from beneath it on the ground. This cool, clear coloring had a very important influence on Florentine Mannerists such as Bronzino, Rosso, Pontormo, and Vasari, as has been remarked by Wölfflin (*Jugendwerke*, p. 55).

(11) COPIES: Raphael, The Entombment (1507), Rome, Galleria Borghese: Women in the right background copied after the Doni-Virgin.

A Flemish copy of the sixteenth century in a rectangular composition, with a different landscape. Cambridge, Massachusetts, Fogg Museum.

(12) MAIN BIBLIOGRAPHY: Wölfflin, *Jugendwerke*, pp. 52*ff*; Justi, *Ma., N.B.*, pp. 175*ff*; Thode, *Kr. U.*, I, pp. 117*ff*.

XI. ST. MATTHEW

Florence, Accademia delle Belle Arti.
Marble in the round. Unfinished.
H. of the block: 271 cm.; W. at bottom of base: 71 cm.; D. of base: 58 cm.

(1) CONDITION: Unfinished but perfectly preserved.

63 (2) ATTRIBUTION: Not signed. Contract made on April 24, 1503 (Milanesi, pp. 625*f*). Mentioned by Vasari (1550, p. 54); Condivi (p. 176); and Vasari (1568, p. 55).

(3) HISTORY: April 24, 1503, is the date of a contract (Milanesi, pp. 625*f*, and Gaye, II, pp. 473*ff*) in which the Consuls of L'Arte della Lana, in the presence of Giuliano da San Gallo and Simone del Pollaiuolo (Cronaca) charged Michelangelo with executing twelve apostles in Carrara marble, each 4¼ braccia high, for the Cathedral of Florence. According to the contract, Michelangelo was commissioned to execute the twelve statues in twelve years, one a year, and was to receive two gold florins each month. These twelve statues were to be erected in the choir chapels of the cathedral, to replace the apostles already painted there by Bicci di Lorenzo, or at some other place to be determined in the future by the Consuls of L'Arte della Lana. (Condivi, p. 176, says of the location "dodici apostoli, quali dovevano andare dentro à dodici pilastri del Duomo," which would seem to indicate that by that time the "some other place" had been decided upon.) A house was to be erected for Michelangelo "pro habitatione" on the corner of the Via de' Pinti and Via della Colonna from a model by Simone del Pollaiuolo in collaboration with Michelangelo (Gaye, II, pp. 473*ff*; Milanesi, pp. 625*f*). On June 12, 1503, Cronaca received from the Operai the definite commission to execute this house. On July 5, 1503, the Operai paid a sum of money to Bernardo Perselli, owner of the property on which the house was to be erected, as compensation. On February 27, 1504, Cronaca was charged for a second time to consult with Michelangelo about the completion of the house (Archivio dell'Opera, published in C. de Fabriczy, "Simone del Pollaiuolo, il Cronaca" in *J. d. p. K.*, XXVII, 1906, Bh., p. 48 and Frey, *Studien*, pp. 109f).

The marble for the apostles was cut at Carrara. For the most part Matteo di Cucca-

rello took charge of the work there and received on several occasions during the year 1504 certain sums of money as salary; for example: on August 3rd and on December 19th and 23rd, 1504 ("[per] una statua d'uno apostolo [venuta all'opera]"); on April 26th and 29th, 1505, a sum of 160 gold florins for the cutting and transportation from Carrara to Florence of four statues of apostles (Archivio del Opera del Duomo, mentioned in Frey, *Handz.*, text, p. 9 and Frey, *Studien*, pp. 109*f*).

Michelangelo did not have the time to dedicate himself to the fulfilling of this commission; it seems that he only executed several drawings, of which one is still preserved (No. 19). On December 18, 1505, he obtained a release from his contract (Gaye, II, p. 477). The house on the Via de' Pinti was rented to other persons (Gaye, II, p. 477). In the summer of 1506, as Michelangelo was again in Florence, he seems to have taken up the plan again. In fact, Soderini, in a letter of November 27, 1506, to the Cardinal di Volterra (Gaye, II, pp. 91*f*) said that Michelangelo was working on the twelve apostles. Shortly after this date Michelangelo was obliged to go to Bologna. On November 29 (?), 1506, he met Pope Julius II at Bologna. Only after he returned to Florence did he rent (March 18, 1508) the house on the Via de' Pinti (Gaye, II, p. 477), probably with the intention of now executing the apostles. But after a few weeks, he accepted the invitation of the Pope to decorate the Sistine Ceiling in Rome.

The St. Matthew statue was preserved in the Opera del Duomo where Vasari (1550, p. 54, and 1568, p. 55) and Varchi (*Orazione*, 1564) saw it. Not until 1834 was the St. Matthew removed from this place, when it was put in the Accademia delle Belle Arti.

The other Apostles, not executed by Michelangelo, which were called for in the contract were given in charge of the following artists: Jacopo Sansovino, Andrea Sansovino, Benedetto da Rovezzano, B. Bandinelli, Andrea Ferrucci and Giovanni Bandini whose works are still to be found in the Cathedral of Florence (Gaye, III, pp. 119*ff*). The marble block for one of these apostles is mentioned in an unpublished letter of September 28, 1516, by Michele di Piero (called Battaglino), Pietrasanta to Michelangelo, Carrara, in the Archivio Buonarroti. We quote the most important sentences: "Per questo v'aviso come io cavo uno apostolo pre comessione de l'operai. . . . O cominciato a fare dua tagliate in una lungeza di venti bracia e groseza d'uno braco e mezo. . . ."

(4) SUBJECT: The expression of the face resembles the rebellious slave in the Louvre, and the twisted position of the body gives the impression of its being bound by invisible chains—an amazing conception for an apostle. Michelangelo was charged in March, 1505 (Milanesi, pp. 426, 429) with executing the project for the Tomb of Julius II. One finds in the figures of the slaves of this Tomb the same twisted body position, and facial expressions similar to that of the St. Matthew (note especially in the Beckerath drawing of the Tomb, the pose of the figure at the extreme left, and the face of the second figure to the left side of the façade). Concerning the first project of the Tomb, see Panofsky, *Julius Tomb*, pp. 561*ff*. Julius II cancelled his order for the Tomb in the

spring of 1505. It would seem that Michelangelo then used for the St. Matthew the ideas he had in mind for the slaves which he was unable to execute. Justi's explanation (*Ma., N.B.*, p. 205) for the unusual representation of the apostle—that it shows "the moment of his call by Christ"—does not seem convincing.

(5) ANALOGIES: Grünwald (*Antike*, pp. 130*f*) is of the opinion that the St. Matthew is derived from the Pasquino. Fechheimer (*Donatello und die Reliefkunst*, Strassburg, 1904, pp. 82*ff*) and Francovich ("Appunti su Donatello e Jacopo della Quercia," *Boll. d'arte*, IX, 1929-1930, pp. 145*ff*) believed that there was a relationship with Donatello's Abraham and Isaac on the Campanile of the Cathedral of Florence. Ollendorf ("Der Laokoon und Michelangelo's gefesselter Sklave," *Rep. f. Kw.*, XXI, 1898, pp. 112*ff*) is of the opinion that Michelangelo was probably influenced by the Laocoön, which was discovered January 14, 1506, and which Michelangelo, in the company of Giuliano da San Gallo, had seen a short time later (Bottari, *Raccolta*, III, p. 474).

Besides the already mentioned ideas for the "Tomb" which the master used, it is not improbable that Michelangelo was also inspired by the relief of the Apostles by Jacopo della Quercia, on the baptismal font of the Baptistry of Siena. The motif for the thumb stuck in the belt, seen on Michelangelo's figure, is derived from Quercia's relief of the Presentation, in the Baptistry of Siena, or from Donatello's Zuccone on the Campanile in Florence.

(6) Study for the right arm of the St. Matthew (No. 35) until now erroneously considered as a study for the arm of the David. Position of the figure is developed from the studies for the slaves of the Tomb of Julius II (see above).

(7) The legs of the young slave of the Boboli Gardens are developed from the St. Matthew. One of the bearded slaves of the Boboli Gardens is developed from the upper part of the Matthew.

(8) CHRONOLOGY: The statue was probably begun in the summer of 1506, as Ollendorf (op. cit., pp. 112*ff*) has rightly pointed out. It is separated in time from the David by the important period in Rome. The date is based on Soderini's letter of November 27, 1506 (Gaye, II, p. 91). Stylistically, the Matthew, with its massive and large forms, is a forerunner of the style of the Sistine Ceiling. The severe angular folds of drapery resemble those of the Bargello tondo, but in a more developed manner.

In contradiction to the proposed date of 1506 is a letter written by Michelangelo eighteen years later to Fattucci (Milanesi, p. 426), which says that he discontinued work on the twelve apostles because of his invitation to Rome in 1505, but that one of the apostles was then already begun. According to this, the St. Matthew must have been executed before his trip to Rome in 1505. Thode (*Kr. U.*, I, pp. 91*ff*) and Baumgart (*Contributi*, pp. 353*f*) agree with Ollendorf (op. cit.) in dating the sculpture in the summer and fall of 1506; Wölfflin (*Jugendwerke*, p. 58) dates it before October, 1504 (beginning of the Cartoon).

(9) TECHNIQUE: Unfinished. Head is still half in block of the marble. Left hand

slightly defined. Processes of technique are described by Vasari (1568, p. 55, and ed. Milanesi, I, p. 154); Benvenuto Cellini, *Trattato della Scultura*, Milan, 1927, p. 228; Wentzel and Vermehren, Die Arbeitsweise Michelangelos, *Kunst und Künstler*, x, 1912, pp. 243*ff*; A. Hildebrand, *Das Problem der Form*, Strassburg, 1913, pp. 101*ff*; Tolnay, *Michelangelostudien*, p. 103, note 2; Baumgart, *Contributi*, pp. 353*f*. The artist began on one of the large sides of the rectangular block and penetrated into its depths. He began by the left knee, and then outlined the left hand. First he defined the general outlines with the chisel, and then worked over the neck, the torso, the left leg and right arm. He penetrated only half the depth of the head. (For further details on the technique, cf. text, p. 114.) Michelangelo speaks in some of his poetry about his method of working in marble. Cf. Frey, *Dicht.*, No. LXXXIII, LXXXIV, CI, CXXXIV. 64, 65

Concerning the significance of the "unfinished" in the works of Michelangelo, see A. Bertini, "Il problema del non finito," *L'Arte*, n.s., I, 1930, pp. 121*ff*; V. Mariani, " 'L'aspra catena' in Michelangelo," *Cultura*, January, 1931; A. Bertini, "Ancora sul non finito di Michelangelo," *L'Arte*, n.s., II, 1931, pp. 172*ff*; S. Bettini, "Sul non finito di Michelangelo," *La Nuova Italia*, VI, pp. 6*ff*; C. Arù, " 'La veduta unica' e il problema del non finito in Michelangelo," *L'Arte*, n.s., VIII, 1937, pp. 46*ff*. [Addenda, No. 15]

The first biographers (Condivi, Vasari) explain the fact that Michelangelo left the greater number of his works unfinished sometimes by the external circumstances, sometimes by the artist's dissatisfaction with his work. Modern critics have generally explained this fact by the "unrealizability" of his projects. Bertini (p. 133) says that Michelangelo certainly regarded his unfinished statues as incomplete, since his artistic ideal was the power of "rilievo"; he could not finish them "perchè, procedendo oltre, ne avrebbe diminuito l'intensità lirica. . . ." Up to this point, we believe that Bertini interpreted better than his adversaries the significance of the "unfinished" in Michelangelo. On the other hand, it is difficult to admit with him that the tortured movement of his figures is an expression of the artist's mood of dissatisfaction during his work. It seems to us rather that Michelangelo has embodied in his figures a more general human experience having an objective significance. (Cf. text, pp. 113*ff*.)

(10) COPIES: Drawing by Raphael, London, British Museum. Cf. Gronau, *Raffaels Florentiner Tage*, Pl. VIII. 245

A free copy is in the figure of St. Peter in the altar by G. Santacroce, Naples, Chiesa di Monte Oliveto. 246

Jacopo Sansovino was inspired to reproduce the motif of the hand holding the book in the statue of St. Anthony of Padua, Bologna, San Petronio, and in the statue of St. James Major, Florence, Cathedral.

Giovanni Bandini in the statue of St. James Minor, Florence, Cathedral, reproduces the pose of the St. Matthew.

(11) MAIN BIBLIOGRAPHY: Wölfflin, *Jugendwerke*, pp. 56*ff*; Justi, *Ma., N.B.*, pp. 202*ff*; Thode, *Kr. U.*, I, pp. 91*ff*.

CATALOGUE OF DRAWINGS

N.B. In this catalogue we have tried to present the youthful drawings of Michelangelo in chronological order and to distinguish between the originals and those which are apocryphal. We have omitted those which, in our opinion, appear to be falsely attributed. We made exception for only a few drawings for the Battle of Cascina, since they are in such a poor condition that it is impossible to determine whether they are merely reworked originals or simple copies.

CATALOGUE OF DRAWINGS

1. *Triton*. Charcoal on the wall. Settignano, Villa Michelagniolo.

Berenson, *Drawings*, 1462a; Frey, *Q. F.*, p. 18; Thode, *Kr. U.*, 1, p. 5; Wilson, *Life* 67
and Works, pp. 9f; Symonds, *Life*, 1, p. 19; Tolnay, *Michelangelostudien*, pp. 95ff.

A large piece of the wall mortar at the breast, and a small piece at the right shoulder have fallen off. The whole lower body below the hips is missing. The face is blurred; the curves at the right which seem intended as pendants to the wind-blown cloak are by a later hand; likewise a few rough strokes in the middle of the cloak.

This drawing was mentioned for the first time by Gori in his Condivi edition, Florence, 1746, p. 99: "Molti de' primi disegni fatti da Michelangelo ancor fanciullo sul muro, per suo instinto e piacere, prima che di proposito applicasse alla Pittura, ho io veduti nelle stanze dell'ultimo piano della sua casa in Firenze, e in quelle della sua Villa a Settignano, e torno torno alle pareti de' terrazzi, condotto a vedergli del Senator Filippo; i quali mostrano chiaramente quel che Iddio voleva da lui, e quanto eccellente poi collo studio sarebbe divenuto. Questi trastulli virtuosi ancor si conservano, e ne' luoghi additati se posson vedere." Today there are no wall drawings left in Settignano except the Triton. Likewise there are none in Florence in the Buonarroti house. (The actual house in the Via Ghibellina was rebuilt for Michelangelo's nephew by Pietro da Cortona [Limburger, p. 28] on the site of two houses bought by Michelangelo, and so under no circumstances can the drawings mentioned by Gori be by the child Michelangelo.)

The work is mentioned by C. J. Cavallucci in *Ricordo al Popolo Italiano*, p. 214: "nella villa Buonarroti a Settignano . . . vedesi ancora sul muro presso il focolare il *Satiro* disegnato col carbone, da Michelangelo." Wilson also describes the figure as a Satyr holding a leather bottle in the raised hand, and ascribes the drawing to Michelangelo's mature period. Symonds follows Wilson, also calling the figure a Satyr and believes it dates from the period when Michelangelo was in Ghirlandaio's atelier and that it was later worked over by the master himself. Berenson follows our designation considering the figure a Triton, but interpreting the object in the right hand as a drinking horn: "Proportions and action belong to the period between Sixtine Chapel and Last Judgment." He finds the Cavalieri drawings especially close to the Triton.

Frey and Thode reject the attribution to Michelangelo without giving their reasons.

The drawing was first published by the author. He sought at that time to date it at around 1489 when Michelangelo was a pupil in the Giardino Mediceo. Now he is disposed to put it earlier, before Michelangelo's entrance into Ghirlandaio's atelier.

Because of the fragmentary condition it is difficult to determine what the figure represents. It seems to us most probable that it represents a Triton or Sea-Centaur and that the object in the raised right hand is a jawbone. The motif of the wind-filled cloak resembling a sail has its origin in late antiquity. (See C. Morgan, "The motif of a

figure holding in both hands a piece of drapery which blows out behind or over the figure," *Art Studies*, VI, 1928, pp. 163ff). The motif was then used by the artists of the late Quattrocento, e.g. Botticelli, Ghirlandaio, Pollaiuolo, as a symbol expressing agitation in the manner of the ancients. Warburg (*Botticelli*, p. 16) and Saxl ("Rinascimento dell'Antichità," *Rep. f. Kw.*, XLIII, 1922, p. 221) have pointed out this motif in contemporary literature, e.g. in Poliziano, *La Giostra*, v, lines 109ff and Leonardo, *Trattato della Pittura*, ed. Ludwig, I, p. 524.

The drawing seems to have been inspired by an antique relief or sarcophagus or by a Quattrocento copy of one. Such antique reliefs or sarcophagi were studied in ateliers in Florence, as attested by the frescoes by Ghirlandaio in Santa Maria Novella, e.g. the Sacrifice of Zacharias in the Temple and the Visitation (in the latter, on the right, there is an antique sarcophagus with a Triton; this is not the direct model for Michelangelo but a similar one may be assumed) and by some drawings after antique sarcophagi in the *Codex Escurialensis*, e.g. fol. 5v and fol. 15v, both after sarcophagi with sea-gods (see H. Egger, ed., *Codex Escurialensis, ein Skizzenbuch aus der Werkstatt des Domenico Ghirlandaio*, Vienna, 1905, 1906).

We date the drawing hypothetically before 1488, i.e. before entering Ghirlandaio's atelier. This is based on stylistic criteria; the proportions, e.g. the thin arms and the motif of out-stretching action are fully in the spirit of late Quattrocento. Since we seek to date the copies after Giotto and Masaccio at the time of Michelangelo's study with Ghirlandaio, we must consequently assume that the Triton preceded them.

Vasari in the first edition (1550, p. 12) says: "[Michelangelo] molto da se stesso nella sua fanciullezza attendeva a disegnare per le carte e pe' i muri."

For further discussion of this drawing see text, p. 69.

68 2. *Copy after two figures from the Ascension of St. John the Evangelist by Giotto in the Cappella Peruzzi in Santa Croce*. Pen. Paris, Louvre. H. 317 mm.; W. 204 mm.

Berenson, *Drawings*, 1587; Frey, *Handz.*, 1; Thode, *Kr. U.*, III, 481; Demonts, *Dessins*, 1; Popp, *Bemerkungen*, pp. 141f; Wilde, *Eine Studie*, p. 46; Tolnay, *Michelangelostudien*, pp. 99ff.

The left side of the sheet is cut, and it is restored in the middle (a small piece at the sleeve is pasted in). Besides the brown ink there are also a few strokes in black ink; the latter probably not by Michelangelo. Michelangelo first copied the left leg of the young apostle exactly, but subsequently made a *pentimento* (cf. text p. 66).

126 On the verso, there is a hitherto unobserved red chalk sketch for a left arm probably done by Michelangelo sometime later, ca. 1505, than the drawing here under discussion. (A piece of paper which had been pasted over the whole back of this sheet was removed in 1932 at the author's suggestion, and the sketch became visible.)

70 There is a copy after the same figures of Giotto's fresco by Bandinelli in the Uffizi (no. 560). The comparison with Michelangelo's drawing is instructive; Bandinelli

lessened the substantiality of the draperies and concentrated his attention on the external dramatic effect. Compare the middle figure with its heightened pathos in contrast to Giotto.

This and the following four drawings, almost all studies after Giotto and Masaccio, were first attributed to Michelangelo by Friedrich von Portheim ("Beiträge zu den Werken Michelangelos," *Rep. f. Kw.*, XII, 1889, pp. 140*f*). Vasari (1568, p. 29) mentions that Michelangelo for many months in the Carmine made drawings after Masaccio's frescoes. Likewise Cellini in his *Autobiography* (p. 30) notes Michelangelo's drawings after Masaccio. Only Morelli ("Handzeichnungen italienischer Meister," *Kunstchronik*, N. F., III, 1891-1892, pp. 290*f*) doubts the attribution to Michelangelo, but with insufficient arguments.

The revival of the great old Tuscan art tradition was a general spiritual current which also appears in literature at the same time. At the head of the movement for revival of the "lingua volgare" and high esteem for its greatest poets—Dante, Petrarch, Boccaccio —stood the young Lorenzo the Magnificent. See his letter to Federigo d'Aragona, 1466 (published in *Opere di Lorenzo de' Medici*, ed. Simioni, Bari, 1913, I, p. 5). The same tendency is to be found in Pietro Bembo, *Della volgar lingua*, Milan, 1810, Libro I, p. 27; Castiglione, *Il Cortegiano*, Libro I, Cap. 32; Varchi, "L'Ercolano" in *Opere*, I, Milan, 1834, Quesiti 6 and 9.

As evidence of Lorenzo's admiration for Giotto and Masaccio may be regarded the fact that in his art collection in the Palazzo in the Via Larga there were, beside works of antiquity, Byzantine art, Dutch paintings of the fifteenth century and Italian of the Quattrocento, also two pictures by Giotto and two panels by Masaccio (cf. the inventory of the Palazzo Medici, published by Müntz, *Les Collections des Médicis au 15ème siècle*, Paris, 1888).

In regard to the study of Giotto's and Masaccio's frescoes by the masters of the fifteenth century, see Vasari, ed. Milanesi, II, p. 299: "Tutti i più celebrati scultori e pittori . . . studiando in questa cappella [*scil.* the Brancacci Chapel] sono divenuti eccellenti e chiari: cioè Fra Giovanni da Fiesole, Fra Filippo [Lippi], Filippino [Lippi], Alesso Baldovinetti, Andrea del Castagno, Andrea del Verrocchio, Domenico del Grillandaio, Sandro di Botticello, Lionardo da Vinci, Pietro Perugino, Fra Bartolommeo di San Marco, Mariotto Albertinelli, ed il divinissimo Michelagnolo Buonarroti, Raffaello . . . il Granacci, Lorenzo di Credi, Ridolfo del Grillandaio, Andrea del Sarto, il Rosso [Fiorentino], il Franciabigio, . . ." etc.

The drawings after Giotto and Masaccio were usually considered Michelangelo's earliest preserved works and dated generally in the period of his apprenticeship with Ghirlandaio, 1488. (Cf. Portheim, op. cit., pp. 140*f*; Frey, *Q. F.*, p. 19; *idem.*, *Ma.*, I, p. 33, and *Handz.*, sub respective numbers; Thode, *Kr. U.*, I, pp. 3*f*.)

Berenson suggests for his no. 1587—i.e. our No. 2—the date around 1492. Wilde assumed that the drawings date from 1489. Popp (*Bemerkungen*, pp. 134*ff* and 169*ff*)

assumed that the different drawings date from different times of Michelangelo's youth and also that some of them were later reworked by Michelangelo. This latter statement is based on the observation that in some of the drawings various inks are used. However, this hypothesis has proved untenable; it is a question of simultaneous use of different inks (see the author, *Arch. Buon.*, p. 455, note 70).

Vasari (1568, p. 29) mentions the studies by Michelangelo after Masaccio first in connection with the works which Michelangelo did when he was a guest of Lorenzo, 1490-1492. The author followed this dating in *Michelangelostudien*, p. 96; but he would like to return now to the old view that the drawings Nos. 2-5 date from the Ghirlandaio period, 1488, since after Michelangelo's entrance into the school of the Giardino Mediceo the antique influence was to dominate.

Pen drawing technique is defined by Benvenuto Cellini ("Sopra l'Arte del Disegno" in *Trattato della Scultura* ed. Milan, 1927, p. 249) as made "con la penna stietta, intersegando l'una linea sopra l'altra; e dove si vuol fare scuro si soprapone più linee, e dove manco scuro con manco linee; tanto che e' si viene a lasciar la carta bianca per e lumi." Cellini's definition can be applied to the technique of the early pen drawings with cross-hatching by Michelangelo, which the artist took over from Ghirlandaio. He differs, however, by his rejection of calligraphic independence of the lines, of every decorative caprice. Each line serves only to bring out the form. (See further notes on the technique in the text, pp. 67*f*.)

72 3. *Copy after the figure of St. Peter in the act of handing the coin to the sailor from Masaccio's fresco, the Tribute Money, in the Brancacci Chapel.* Pen. Munich, Kupferstichkabinett. H. 395 mm.; W. 197 mm.

Berenson, *Drawings*, 1544; Frey, *Handz.*, 11; Thode, *Kr. U.*, III, 380; Panofsky, *Handzeichnungen*, no. 1; Popp, *Bemerkungen*, pp. 139*f*; Wilde, *Eine Studie*, p. 47; Tolnay, *Michelangelostudien*, pp. 99*ff*.

This is a much cut sheet, restored above on the right. Beneath the pen drawing are a few red-chalk strokes. Below at the right, is an arm in red-chalk. None of the red-chalk work is by Michelangelo.

For further discussion of this drawing see No. 2 and text, p. 66.

74 4. *Three standing clothed male figures.* Pen. Vienna, Albertina. H. 201 mm.; W. 294 mm.

Berenson, *Drawings*, 1602 (recto); Frey, *Handz.*, 23; Thode, *Kr. U.*, III, 525; Popp, *Bemerkungen*, p. 142; Wilde, "Zur Kritik der Haarlemer Michelangelo-Zeichnungen," *Belvedere*, XI (1927), p. 147; Tolnay, *Michelangelostudien*, pp. 99*ff*.

Formerly considered a copy of a lost work by Ghirlandaio by Wickhoff ("Die italienischen Zeichnungen der Albertina," *J. d. A. K.*, XIII, 1892, No. 150), Portheim (loc. cit.), and Frey (*Handz.*, text p. 14). Berenson and Wilde (op. cit., p. 147, and *Eine*

Studie, pp. 46*f*) assume that the model was Masaccio, probably his lost frescoes in the Sagra di San Carmine. In the Casa Buonarroti there is preserved a red-chalk drawing, no. 187, which also shows a copy of the same figures, but not by Michelangelo, and which makes it still more probable that the model was Masaccio. Panofsky and Wilde were the first to draw attention to this drawing. (Our reproduction is from a photograph which Dr. Panofsky kindly furnished.) **73**

The two rear figures in Michelangelo's drawing may have been added somewhat later by the artist. Best reproduction in: Meder, *Albertina-Facsimile*. Italiener, Vienna, 1923, pl. 9.

For further discussion of this drawing see No. 2 and text, pp. 66*f*.

5. *Kneeling figure on the reverse of the above drawing.* Pen. Vienna, Albertina. **76**
H. 201 mm.; W. 294 mm.

Berenson, *Drawings*, 1602 (verso); Frey, *Handz.*, 22; Thode, *Kr. U.*, III, 525; Popp, *Bemerkungen*, p. 142; Wilde, "Zur Kritik der Haarlemer Michelangelo-Zeichnungen," *Belvedere*, XI (1927), p. 147; Tolnay, *Michelangelostudien*, pp. 99*ff*.

This drawing may have been done by Michelangelo shortly before the recto drawing. It is probably also after Masaccio, as Berenson and Wilde assume. Meder's hypothesis (*Handz.*) that the model was a figure by Francesco Pesellino seems improbable.

For further discussion of this drawing see No. 2.

6. *The Alchemist.* Pen and lapis. London, British Museum. H. 211 mm.; W. 328 mm. **77**
Berenson, *Drawings*, 1522; Frey, *Handz.*, 41; Thode, *Kr. U.*, III, 348; Popp, *Bemerkungen*, p. 142; Wilde, *Eine Studie*, p. 47; Tolnay, *Michelangelostudien*, pp. 99*ff*.

The interpretation of the figure is problematical. The object in the outstretched hand is interpreted as a globe or ball (Frey, *Handz.*, text p. 25). Berenson (*Drawings*, I, p. 186, and no. 1522) describes the figure as a "sage or astrologer holding out a sphere. He wears a pilgrim's hat." Berenson dates the drawing about 1500.

Frey believes the drawing is a copy after Ghirlandaio, dates it in the same time as Nos. 2-5, but finds it somewhat further advanced. He believes it was originally done in the period of the apprenticeship with Ghirlandaio and that Michelangelo later reworked it with pen, perhaps in the Sistine period, 1508-1510.

It is possible that the figure represents an alchemist. Compare Dürer's drawing of an alchemist: F. Lippmann, *Zeichnungen von Albrecht Dürer*, Berlin, 1887-1905, No. 456, and E. Panofsky, *Dürers Stellung zur Antike*, Vienna, 1922, p. 41. The object in the hand may be a skull.

On the verso (Frey, *Handz.* 42) several sketches, not by Michelangelo.

For further discussion of this drawing see No. 2 and text, p. 67.

7. *Sketch of a nude seen from the back; sketch of a pair of legs; sketch of a right hand.* **78**
Pen. Florence, Archivio Buonarroti (Cod. II-III, fol. 3*v*).

Tolnay, *Arch. Buon.*, pp. 424ff, 466 (here published for the first time).

Drawn on an undated letter of Michelangelo's brother, Buonarroto. On the recto is a rough draft of a statement (Dichiarazione) by Michelangelo, of May 22, 1501, concerning the Piccolomini monument in Siena (Milanesi, p. 615). Evidently Michelangelo must have written the "dichiarazione" on the paper which already contained the letter. It is possible that he made the sketches immediately after receiving the letter of Buonarroto and before the "dichiarazione," that is, at the end of his Roman sojourn or when he had already arrived in Florence in the spring of 1501. Two inscriptions in Michelangelo's hand are written across the sheet. One—"la morte e'l fin d'una prigione scura"—is taken from Petrarch's *Trionfo della Morte* (ch. ii, v. 34) and is significant for the interpretation of the Slaves of the Julius Tomb (see Tolnay, *Sklavenskizze*, p. 83); the second phrase read: "La voglia in voglia e ella a poi la dogl[ia]."

The pair of legs is in the position of the ancient dancing Silenus (cf. Winter, fasc. 8/9, p. 267; fasc. 10, p. 316, fasc. 12, p. 343). The subtle lines of these sketches, so different from the decisive lines of his Florentine studies, give us an idea of his style during the Roman period from which no other drawing is preserved.

79 8. *Sketch of a left arm.* Pen. Florence, Archivio Buonarroti (Cod. ii-iii, fol. 3r).
Tolnay, *Arch. Buon.*, p. 466 (here published for the first time).
Concerning the date of this sketch see the remarks for the preceding drawing.

81 9. *St. Anne with the Virgin and Christ Child.* Pen. Oxford, Ashmolean Museum. H. 254 mm.; W. 177 mm.

Robinson, *A critical account*, no. 22; Berenson, *Drawings*, 1561 (recto); Thode, *Kr. U.*, iii, 406 (recto); Colvin, *Oxford Drawings*, ii, pl. 9a; Panofsky, *Handzeichnungen*, no. 2; Tolnay, *Arch. Buon.*, p. 454.

Probably executed in Florence in the spring or summer of 1501 when Leonardo's cartoon was on exhibition in the convent of SS. Annunziata, and not toward 1504 as Robinson and Thode suppose.

The group composition in Michelangelo's sketch recalls, however, the drawing of
80 St. Anne by Leonardo in the Louvre, rather than the cartoon in the Royal Academy in London.

83 10. *Study of a nude seen from the back; five studies of heads.* Written in Michelangelo's hand; "Le[on]ardo." Pen. Oxford, Ashmolean Museum. H. 254 mm.; W. 177 mm.

Robinson, *A critical account*, no. 22; Berenson, *Drawings*, 1561 (verso); Thode, *Kr. U.*, iii, 406 (verso); Colvin, *Oxford Drawings*, ii, pl. 9b; Tolnay, *Arch. Buon.*, p. 454.

The ink is the same as that used for the drawing of St. Anne on the recto. The

sketches must therefore be similarly dated, probably in the spring or summer of 1501, and not in 1504 (Thode), nor 1505 (Berenson). The head of the bearded man reappears twice on another sheet, No. 12. (These sketches were taken up again by Michelangelo in ca. 1505 when he was executing the Joseph of the Doni Madonna. One of the Ephebian youths in the right background of the Doni Madonna is after the sketch here of the head of a curly haired youth.)

The study of the nude back seems to be inspired in its pose by Leonardo's red-chalk drawing at Windsor. The head of the curly haired youth also recalls Leonardo's 82 drawing (cf. *Leonardo, Klassiker der Kunst*, pp. 113, 224, 260).

11. *Study of a nude back; sketch of a shoulder with left arm; sketch of a left arm;* 85 *sketch of a right leg.* Pen. Oxford, Ashmolean Museum. H. 237 mm.; W. 193 mm.

Robinson, *A critical account*, no. 21; Berenson, *Drawings*, 1560 (recto); Thode, *Kr. U.*, III, 405 (recto); Colvin, *Oxford Drawings*, III, pl. 5a; Tolnay, *Arch. Buon.*, p. 454.

The drawing must be of the same period as the St. Anne and its verso, that is in the spring or summer of 1501, and not ca. 1504 (Thode), nor 1505 (Berenson). No direct connection with the Cascina cartoon exists.

There is in the Louvre a copy after a lost drawing by Michelangelo from the same 282 epoch, representing two studies of backs, very similar to that in Oxford.

There is a copy after a lost drawing of Michelangelo representing a study of arms, in the Albertina. Another copy, less fine, is preserved in Montpellier. The original of 284 these drawings is from the same period.

12. *Triton with winged helmet; three sketches of heads.* Pen. Oxford, Ashmolean 84 Museum. H. 237 mm.; W. 193 mm.

Robinson, *A critical account*, no. 21; Berenson, *Drawings*, 1560 (verso); Thode, *Kr. U.*, III, 405 (verso); Colvin, *Oxford Drawings*, III, pl. 5b; Tolnay, *Arch. Buon.*, p. 454.

The drawing must be dated in the same period as the verso of the St. Anne since the same model served for the studies of the bearded man—hence, in the spring or summer of 1501, and not in 1504 (Thode), nor 1505 (Berenson). The Triton wears a helmet inspired perhaps by a Leonardo drawing in Windsor (see *Leonardo, Klassiker der Kunst*, p. 168). The motif of the Triton with fins for legs is perhaps derived from antiquity (Reinach, *Rep.*, I, p. 94).

13. *Study of a nude man in act of digging; two busts seen from behind; study of a* 87 *shoulder repeated three times.* Pen. Paris, Louvre. H. 265 mm.; W. 188 mm.

Berenson, *Drawings*, 1585 (verso); Frey, *Handz.*, 25; Thode, *Kr. U.*, III, 474 (verso); Tolnay, *Arch. Buon.*, p. 454.

The drawing is stylistically identical with the Oxford drawings (see particularly the

study of a nude back) and must consequently be dated ca. 1501. It cannot be dated at the time of the Sistine Ceiling, as proposed by Berenson, who relates the motif of this figure to that of the digging Noah in the Drunkenness of Noah, as well as to the figure of the youth at the extreme left in the Sacrifice of Noah. Michelangelo reverted to the motif of this early drawing as he executed these figures on the Sistine ceiling, as Frey pointed out. Frey's belief that the figure of the digging man was executed after a living model does not seem convincing. Only certain details are studied from life—see especially the shoulder; but the motif as a whole recalls, in reversed position, the digging Adam of della Quercia's S. Petronio relief. Frey dates this drawing ca. 1504.

86

On the top at the left in the handwriting of Michelangelo is a fragment of poetry in the style of Petrarch, published in Frey, *Handz.*, text, p. 16.

On the recto of this leaf is No. 16.

88

14. *Mercury-Apollo; rough sketch of a putto carrying what appears to be a sack.* Pen. Paris, Louvre. H. 399 mm.; W. 210 mm.

Berenson, *Drawings*, 1588; Frey, *Handz.*, 87; Thode, *Kr. U.*, III, 477; Demonts, *Dessins*, no. 5; Tolnay, *Arch. Buon.*, p. 454.

This drawing raises an iconographical problem. Until now it has been described as a Mercury, Orpheus, or an Apollo (Berenson, Frey). In truth, the drawing contains two versions which can be distinguished by the two different inks used; the first version of the relaxed right arm is in the brown ink with which the body is drawn, while the second version with the arm folded across the chest, as well as the added left arm and lyre, is in gray. It is very probable that Michelangelo originally intended the figure as a Mercury (see the winged helmet) and then transformed it by the addition of the lyre, into an Apollo. It was inspired perhaps by an antique figure, possibly a statue of the type of the Mercury of the Palazzo Altemps (Reinach, *Rep.*, I, p. 370, no. 1512*b*).

On the other hand this drawing may be a souvenir of the lost Apollo-Galli, executed during the first Roman period (cf. XVII).

89, 90

The youth to the left is derived from a figure in the Cesi Garden. (See Panofsky, *Ma. Literatur*, col. 23.)

The drawing must be dated ca. 1501 because of the close stylistic relation with the Oxford drawings and not, as Berenson proposes, in 1505, nor during the period of the Sistine Ceiling, nor as Frey, Thode, and Demonts propose, in 1504.

The motif of the youth was used later by Michelangelo as one of the figures of the Flood on the Sistine Ceiling, as Berenson pointed out.

On the verso of this leaf is No. 34.

92

15. *Study of a nude.* Pen. Paris, Louvre. H. 325 mm.; W. 168 mm.

Berenson, *Drawings*; 1590 (recto); Frey, *Handz.*, 88; Thode, *Kr. U.*, III, 498 (recto); Tolnay, *Arch. Buon.*, p. 454.

The motif is derived from the Dioscuri of antique sarcophagi (e.g. the Sidamara sarcophagus) and not as Frey and Thode suppose from the Apollo Belvedere. The Dioscuri of the Capitoline are also somewhat similar. Michelangelo used the right leg and torso of this figure in the marble David; hence the drawing should be dated before September 13, 1501—the date when he began work on the David, and not 1504 as Frey and Thode believe. Berenson, who dates it in 1513, relates it to a slave in the Louvre for the Julius Tomb.

On the verso of this leaf is No. 35.

16. *Rapid sketch for the bronze David; study for the right arm of the marble David.* Pen. Paris, Louvre. H. 265 mm.; W. 188 mm.

Berenson, *Drawings,* 1585 (recto); Frey, *Handz.,* 24; Thode, *Kr. U.,* III, 474 (recto); Meder, *Handz.,* p. 365; Demonts, *Dessins,* no. 3; Tolnay, *Arch. Buon.,* p. 454.

The sketches may have been executed ca. September 13, 1501, when Michelangelo began work on the marble David, and August 12, 1502, the date of the contract for the bronze David. It should be observed that there are differences in technique between the carefully executed study for the marble David and the rapid sketch for the bronze David. The identification of the rapid sketch with the bronze David was first made by Frederic Reiset "Un bronze de Michelange," reprinted from *L'Athenaeum Français,* II (1853). Meder (p. 365) believes that the rapid sketch was not a pure invention, but made after a small wax model for the bronze David.

On this page Michelangelo wrote "Davicte cholla fromba e io chol larcho. Michelagniolo" and "Rocte lalta cholonna el verd . . ." from Petrarch, sonnet 229.

On the verso of this leaf is No. 13.

17. *Study after antique model and after Masaccio* (?). Pen. Chantilly, Musée Condé. H. 387 mm.; W. 263 mm.

Berenson, *Drawings,* 1397 (recto); Frey, *Handz.,* 2; Thode, *Kr. U.,* III, 7 (recto); Popp, *Bemerkungen,* p. 138; Tolnay, *Arch. Buon.,* p. 457 note.

The study of the nude woman, in rear and side view, is probably after the central figure of the monument of the Three Graces in Siena (Libreria Piccolimini) with which the pose is related. Two drawings, one in the Casa Buonarroti and the other in the Louvre, seem to be made after the same model. According to Berenson these studies are after the Venus de' Medici, and according to Frey after the Venus of the Casa Carpi; neither supposition is convincing in view of the difference here in the contraposto position. The nude figure, to the left, of a bearded man is perhaps after an antique faun (as Berenson and Frey have supposed). The right hand sketch of drapery appears to be after an antique herme. The draped figure in the center, which was added after the other sketches were already on the sheet, is perhaps after an undetermined figure by Masaccio—possibly from the lost Sagra di S. Carmine frescoes (as

suggested by Berenson). The head of the second figure to the right, a nude in profile, has been restored on a separate sheet of paper pasted on to the original. [Addenda, No. 16]

The drawing somewhat more developed than the Oxford studies, must probably be dated about 1503, just before the two sketches in the verso. Heretofore, this drawing was always dated too early, ca. 1495 by Berenson, 1496-1497 by Frey, 1492-1494 by Thode, and ca. 1500 by Popp.

On the verso of this leaf is No. 18.

97 18. *Two sketches, one for the Bargello Tondo.* Pen. Chantilly, Musée Condé. H. 387 mm.; W. 263 mm.

Berenson, *Drawings*, 1397 (verso); Frey, *Handz.*, 2v; Thode, *Kr. U.*, III, 7 (verso); Tolnay, *Arch. Buon.*, pp. 450ff (here published for the first time).

The large seated figure is not by Michelangelo but by a pupil; only the two small sketches are by the master and represent a different motif, and are not repetitions of 98 the large figure as Frey and Thode believe. The small figure below and to the left is probably a study from life, ca. 1503, taken up again by Michelangelo for the Virgin of 99 the Bargello Tondo (for date and relation to the tondo, see Tolnay). The upper contour of the head to the level of the eyes has been added by another hand; a few lines on the left arm are also later additions. The right leg of this figure was used later but in reversed position for the Delphic Sibyl of the Sistine Ceiling, ca. 1508.

101 The small sketch to the right, below, was apparently executed by Michelangelo just before the other one on the same sheet. The drapery here reveals reminiscences of the Bruges Madonna. We propose a date of ca. 1503, on the basis of the stylistic relation with the Apostle (No. 19) which can be dated accurately.

On the recto of this leaf is No. 17.

103 19. *Study for an apostle, probably the St. Matthew; rapid sketch of a battle of horsemen for the Cascina cartoon.* Pen. London, British Museum. H. 183 mm.; W. 177 mm.

Berenson, *Drawings*, 1521 (recto); Frey, *Handz.*, 13a; Thode, *Kr. U.*, III, 346 (recto); Tolnay, *Arch. Buon.*, p. 454.

The sketch of the apostle should be dated ca. 1503-4; the contract for the twelve apostles was drawn up on April 24, 1503. This is perhaps a first sketch for the St. Matthew, as Berenson proposed. The motifs of the raised leg with the foot resting on a base, of the hand holding a book, as well as the idea of representing arms and feet bare all reappear in the statue. In the statue, executed approximately three years later, the expression is of course completely transformed.

106 The sketch of the battle scene must have been one of the first sketches for the whole composition and not as Berenson proposed for a group in the background. It was executed at the moment when Michelangelo was influenced by Leonardo's Anghi-

ari Battle, and before he abandoned the idea of representing a battle of horsemen (see p. 108). This battle composition must have been drawn first; the rough sketch of the apostle followed; and finally he made the more elaborate sketch for the apostle.

In the Uffizi there is a copy of the figure of the apostle from this drawing. *104* This leaf which also contains the copy of a nude in black chalk, and several *116* other pen sketches cannot be considered as a *bona fide* copy, but must be an early forgery. [Thode (*Kr. U.*, III, 346) and Brinckmann (*Zeichnungen*, no. 8) consider this to be an original by Michelangelo.]

That forgeries of Michelangelo's drawings existed even during his lifetime, can be proved by a hitherto unpublished letter from Piero Roselli to Michelangelo in Florence, February 4, 1525. The forger mentioned in this letter is Giuliano Leni (or Leno) who was a helper of Bramante and later curator of St. Peter's. The forged drawing with which this letter was concerned was a sketch for the façade of the palace of the Card. Santiquattro (see Appendix VI).

Above the drawing of the Apostle are written in the handwriting of Michelangelo fragments of poetry and the beginning of Psalm 53:3 (cf. Kurz, *Burl. Mag.*, 1945, p. 52), published in Frey, *Handz.*, text, p. 9.

On the verso of this leaf is No. 20.

20. *Sketch of two capitals and ornament of a mask.* Pen. London, British Museum. *107* H. 183 mm.; W. 177 mm.

Berenson, *Drawings*, 1521 (verso); Frey, *Handz.*, 13b; Thode, *Kr. U.*, III, 346 (verso); Tolnay, *Arch. Buon.*, p. 454.

Michelangelo used this ornament on the extreme left square block on the Julius Tomb, a block which was executed ca. 1505. The connection between the drawing and *108* this block was pointed out by the author (*Arch. Buon.*, p. 420, note 39) who also proposed a date of 1505 for the block, rather than 1512/13. Berenson wrongly believes that these sketches are by a pupil.

In the right lower corner, are written fragments of poetry in the handwriting of Michelangelo, published in Frey, *Handz.*, text, p. 9, and Frey, *Dicht.*, CLXVI, 9.

On the recto of this leaf is No. 19.

21. *Sketches of children, including two for the St. John the Baptist of the tondo in* *109* *the London Royal Academy.* Pen, on green prepared paper. London, British Museum. H. 377 mm.; W. 229 mm.

Berenson, *Drawings*, 1481 (verso); Frey, *Handz.*, 91; Thode, *Kr. U.*, III, 336 (verso); Brinckmann, *Zeichnungen*, 18.

The sketches have a green prepared background. (The recto is white.) The green tone of the paper is rarely used by Michelangelo. It is found again in Nos. 24 and 25, and in Frey 43*r* and *v*. Across the sheet is written, not in Michelangelo's hand: "Chosse

de bruges ch—." The inscription obviously refers to the Bruges Madonna and dates probably from the summer of 1506 when the statue was in Michelangelo's studio ready to be shipped to Flanders. See Michelangelo's letter of January 31, 1506 (Milanesi, p. 6) and that of Giovanni Balducci of August 13, 1506 (Gotti, II, p. 51—published here, however, with incorrect date; the correct date is given in Frey, *Handz.*, p. 91). The studies of children on this sheet are not all of the same period. The four sketches in the upper half seem to be made about 1502/3 while three on the lower half seem to be somewhat later, ca. 1504/5. The two central figures, studies for the little St. John of

54 the tondo in London, are identical in pose with the figure of the relief, but these bodies are more twisted. The sketch at the left on the lower half is, in our opinion, the work of a pupil.

The sketches were perhaps made in part from nature to serve as a kind of repertoire of childish movements to be used by the artist in his work.

On the recto of this leaf is No. 23.

112 22. *Study of a nude seen from the back.* Pen. Florence, Casa Buonarroti. H. 411 mm.; W. 286 mm.

Berenson, *Drawings*, 1418; Koehler, *Schlachtkarton*, p. 165; Frey, *Handz.*, 26; Thode, *Kr. U.*, III, 65; Tolnay, *Thieme-Becker*; Wilde, *Eine Studie*, pp. 41ff.

This study is not made from nature, but, as Wilde has proved, from the antique. It is the study of one of the figures of a sarcophagus relief representing the labors of Her-

111 cules [see the sarcophagus fragment in the Lateran]. There is no direct connection with the Cascina composition, as Berenson, Koehler, and Thode suppose. However, stylistically, the drawing must be dated at the time of the Cascina, ca. 1504-1505, and not in the first years of the Cinquecento, as Frey suggests.

A sixteenth century copy after this drawing is preserved in the Cabinet des Estampes in the Bibliothèque Nationale, Paris (B. 3a reserve fol. 61); a second copy is in the Kupferstich-Kabinett in Munich.

114 23. *Study of a nude, in the pose of the Apollo Belvedere.* Pen. London, British Museum. H. 377 mm.; W. 229 mm.

Berenson, *Drawings*, 1481 (recto); Frey, *Handz.*, 92; Thode, *Kr. U.*, III, 336 (recto); Brinckmann, *Zeichnungen*, 10; Popp, *Bemerkungen*, p. 170; Tolnay, *Arch. Buon.*, p. 455.

In spite of the use of different inks the drawing was executed by Michelangelo at one time. Contrary to what Popp believes, the dark ink is the earlier. Michelangelo then continued with the lighter one. (Popp dates the lighter part in 1501 and supposes that Michelangelo retouched the sketch with the darker ink at the end of 1503.) On the basis of style the drawing may be dated ca. 1504-1505.

113 It seems to be a sketch from memory after the Apollo Belvedere. The pose is some-

what transformed, but the head adheres to the Apollo type. (See the sketch from the Apollo Belvedere in the Codex Escurialensis.) The connection with the Dioscurus of Montecavallo, proposed by Frey, seems unlikely.

This study does not seem to have been made directly for the Battle of Cascina, as Berenson, Thode, and Brinckmann suppose, but it is an independent study. However, the pose was again used in the central figure of No. 24.

There is a sixteenth century copy of this drawing in Oxford.

On the verso of this leaf is No. 21.

24. *Three pencil sketches of nudes; ink sketch from memory after the Bruges* *115*
Madonna. On green prepared paper. London, British Mus. H. 315 mm.; W. 285 mm.
Berenson, *Drawings*, 1479 (recto); Frey, *Handz.*, 45; Thode, *Kr. U.*, III, 307 (recto); Brinckmann, *Zeichnungen*, 9; Popp, *Medici Kapelle*, pp. 160-162.

According to the proportions of the nudes the drawings must have been executed about 1503 (see the ephebian youths in the background of the Doni Madonna), and not in the period of the Sistine Ceiling (Frey), nor the period of the Medici Chapel (Popp). It is possibly a version for the central group of the Cascina cartoon (Brinckmann, Berenson); the standing figure would then be intended for that of Manno Donati (this figure has the pose of No. 23). Frey, *Handz.*, 51, a drawing for the Brazen Serpent, where Michelangelo again takes up this motif, somewhat transformed, seems to have been executed ca. 1530; the proportions and style are completely different from this sketch and seem closer to the Cavalieri drawings.

The poses were for the first time correctly interpreted by Brinckmann: the left figure is seated on a river bank and seems to be fastening his sandal, the right figure holds a sword, and the central figure is standing on the bank [and is not held by the other two figures as Berenson and Frey wrongly described it, perhaps influenced by the copy in the Louvre]. *283*

The pen sketch of the Virgin is in its motif almost identical with the Bruges Madonna, *100, 102*
but it is in a more developed style. It seems to be a memory sketch made by Michelangelo ca. 1506, at the time when he wrote his letter concerning the Bruges Madonna to his father (Milanesi, p. 6). Berenson also observes a difference of style between the statue and the drawing, but he dates the latter in the period of the Last Judgment.

On the verso of this leaf is No. 25.

25. *Pencil sketch of a nude seen from the back (repetition of the nude of No. 24);* *116*
ink sketches for putto, in rear and front views; ink sketch of a left leg. On green prepared paper. London, British Museum. H. 315 mm.; W. 285 mm.
Berenson, *Drawings*, 1479 (verso); Frey, *Handz.*, 46; Thode, *Kr. U.*, III, 307 (verso); Popp, *Medici Kapelle*, pp. 160-162; Tolnay, *Arch. Buon.*, p. 441.

The sketches of the putti date from ca. 1505-1506. They are more developed in

technique (see the long hatchings) and style (see the curly hair) than the children in No. 21, but they are not as late as Frey believes, placing it in the epoch of the Sistine Ceiling, nor Popp who dates it at the time of the Medici Chapel.

The study of a leg is, together with the inscribed verses, in another and lighter ink, and is in a more developed style, possibly from 1520-1525.

The pencil sketch of the nude is a repetition of the recto, No. 24, in a somewhat more developed style.

The verses in the handwriting of Michelangelo are published in Frey, *Handz.*, text, p. 27, and Frey, *Dicht.*, XXII.

On the recto of this leaf is No. 24.

104 There is a copy of this sketch of the nude in the Uffizi.

117 26. *Nude seen from the back, in pen; two right shoulders seen from the back, in black chalk*. Florence, Casa Buonarroti.

Berenson, *Drawings*, 1656; Thode, *Kr. U.*, III, 18.

This original sketch by Michelangelo, never before reproduced, was considered by Berenson as a copy after the Oxford drawing, No. 28. It is in reality a rapid sketch on the basis of which Michelangelo made a more elaborate drawing from which the Oxford study was copied. The motif is not exactly reproduced in the Battle of Cascina, but it may be a study originally destined for the cartoon and subsequently suppressed.

118 27. *Sketch of a horseman and a nude*. Black chalk. Oxford, Ashmolean Museum. H. 263 mm.; W. 173 mm.

Robinson, *A critical account*, no. 19; Berenson, *Drawings*, 1559 (recto); Frey, *Handz.*, 201a; Thode, *Kr. U.*, III, 403 (recto); Panofsky, *Handzeichnungen*, 3.

This weak sketch seems to be made by the copyist of the verso. The sketch has always been considered an original of Michelangelo, intended for the background of the Battle of Cascina. Panofsky notes that the motif of the youth seen from the rear goes back to the Discobolus of Myron. The figure which repeats the motif of the nude of the verso is drawn after the horse was made and its connection with the horse can hardly be explained.

On the verso of this leaf is No. 28.

119 28. *Nude, seen from the back*. Pen. Oxford, Ashmolean Museum. H. 263 mm.; W. 173 mm.

Robinson, *A critical account*, no. 19; Berenson, *Drawings*, 1559 (verso); Koehler, *Schlachtkarton*, p. 142; Frey, *Handz.*, 202; Thode, *Kr. U.*, III, 403 (verso); Colvin, *Oxford Drawings*, v, 9; Panofsky, *Handzeichnungen*, 4.

The drawing seems to be a copy of a lost one by Michelangelo. A sketch of the motif is to be found in the drawing in the Casa Buonarroti No. 26.

On the recto of this leaf is No. 27.

29. *Two studies of nudes, front and profile, for Battle of Cascina.* Pen. Vienna, Albertina. H. 272 mm.; W. 199 mm. *122*

Berenson, *Drawings*, 1604 (recto); Koehler, *Schlachtkarton*, pp. 153-155, fig. 90; Frey, *Handz.*, 61; Thode, *Kr. U.*, III, 528 (recto); Brinckmann, *Zeichnungen*, 14.

The drawings have been reworked by a later hand and it is therefore difficult to pass judgment on their authenticity. The lines lack the spontaneity of a Michelangelo original, and it is possible that we have here merely a sixteenth century copy. Frey dates it from ca. August 1504-February 1505.

On the verso of this leaf is No. 30.

30. *Torso, rear view, of one of the figures from the Battle of Cascina.* Black chalk and white. Vienna, Albertina. H. 272 mm.; W. 199 mm. *120*

Berenson, *Drawings*, 1604 (verso); Koehler, *Schlachtkarton*, pp. 153-155; Frey, *Handz.*, 62; Thode, *Kr. U.*, III, 528 (verso); Brinckmann, *Zeichnungen*, 13.

The drawing has been completely retouched by a modern hand so that nothing of Michelangelo's original drawing, if it existed underneath, is now visible.

On the recto of this leaf is No. 29.

31. *Study of a seated nude, for the Battle of Cascina.* Pen. London, British Museum. H. 412 mm.; W. 281 mm. *121*

Berenson, *Drawings*, 1476; Koehler, *Schlachtkarton*, p. 156; Frey, *Handz.*, 103; Thode, *Kr. U.*, III, 335; *Vasari Society*, II, IX, 1; Brinckmann, *Zeichnungen*, 11.

The drawing is a copy of a lost original by Michelangelo.

32. *Kneeling woman, seen from the back, bearing a head on a platter; probably the servant with the head of Holophernes or of St. John the Baptist; sketch of the head of a bird, and of a vase.* Pen. Paris, Louvre. H. 325 mm.; W. 260 mm. *124*

Berenson, *Drawings*, 1579 (verso); Frey, *Handz.*, 28; Thode, *Kr. U.*, III, 461 (verso); Popp, *Bemerkungen*, p. 138; Tolnay, *Arch. Buon.*, p. 455.

Executed ca. 1505, only slightly before the recto, and not before 1503 as Thode believes, nor at the time of the Sistine Ceiling as Berenson and Frey suppose.

Since the sketch is made on the leaf from a ledger of the bank of Donato di Bertino and Buonarroto, Frey assumes that the drawing must be made after 1513 when he believes that Buonarroto entered the firm. He does not give sufficient proof, however, that Buonarroto could not become a partner at a much earlier date. The character of the handwriting of this book is in any case quattrocentesque.

On the recto of this leaf is No. 33.

33. *St. Anne, Virgin and Child; sketch of a nude man; sketch of a head in profile.* *123* Pen. Paris, Louvre. H. 325 mm.; W. 260 mm.

Berenson, *Drawings*, 1579 (recto); Frey, *Handz.*, 27; Thode, *Kr. U.*, III, 461 (recto); Demonts, *Dessins*, no. 7; Brinckmann, *Zeichnungen*, 3; Popp, *Bemerkungen*, p. 135; Tolnay, *Arch. Buon.*, p. 455; Wilde, *Eine Studie*, p. 60.

The sketch of the St. Anne, Virgin and Child seems to be a project for a tondo composition which Michelangelo never executed, and from the style may be dated 1505-1506. Popp's hypothesis that there is a question of two independent sketches, one being the Virgin and Child, made ca. 1500, and the second representing St. Anne, ca. 1524-1525, when he reworked the other two figures at the time of the Medici Madonna, was refuted by Tolnay. The drawing was dated either too early or too late. Thode and Brinckmann date it ca. 1502/3, while Berenson, Frey, and Demonts date it ca. 1511-1513. That the figure of the Virgin is inspired by one of the sibyls of Giovanni Pisano's Pistoia pulpit was pointed out by Wilde.

The sketch of the nude is from the same epoch, ca. 1505/6, and recalls in its powerful forms, the style of the St. Matthew. Berenson believes it is probably a study for a David, made ca. 1509 or 1511.

At the right of the Virgin, in the handwriting of Michelangelo, fragments of poetry, published in Frey, *Handz.*, text, p. 17.

On the verso of this leaf is No. 32.

110 34. *Sketch of a slave; sketch of a putto and a cherub; several sketches by pupils.* Pen. Paris, Louvre. H. 399 mm.; W. 210 mm.

Berenson, *Drawings*, 1588 (verso); Frey, *Handz.*, 63; Thode, *Kr. U.*, III, 477 (verso); Tolnay, *Sklavenskizze*, p. 81 and note.

The sketch for the slave of the Julius Tomb is not for the Dying Slave but for a proposed companion figure for the first project, never completed, and dates, on the basis of style, ca. 1505-1506.

The putto, corresponding in style with its violent contraposto and its curly hair to the Child of the Doni Madonna, is perhaps a sketch from memory after the lost S. Giovannino (see Catalogue of Lost Works, p. 199).

The study of the cherub can probably be connected with the cherub's head on the forehead of the Madonna of the Bargello tondo.

The large nude is a tracing from the Apollo-Mercury on the recto, apparently executed by the same pupil who did the other sketches on this sheet.

At the right of the sketch of the slave, in the handwriting of Michelangelo, a copy of the beginning of Petrarch's sonnet to Laura, no. CCXXX, published in Frey, *Handz.*, text, p. 35.

On the recto of this leaf is No. 14.

125 35. *Study for the right arm of St. Matthew; sketch of a nude; sketch of a bearded head, perhaps for the Moses of the Julius Tomb.* Pen. Paris, Louvre. H. 325 mm.; W. 168 mm.

Berenson, *Drawings*, 1590 (verso); Frey, *Handz.*, 64; Thode, *Kr. U.*, III, 498 (verso); Panofsky, *Ma. Literatur*, col. 23; Demonts, *Dessins*, no. 4; Tolnay, *Arch. Buon.*, p. 455.

The study of an arm is for the right arm of St. Matthew and not for the marble David as Berenson proposes, nor for the nude youth to the right and above the Delphic Sibyl of the Sistine Ceiling as Thode believes.

The sketch of a nude is a sketch from memory inspired by the action motif of the Laokoön and possibly executed after a wax model which Michelangelo made for himself (see the broken arm). Until now this sketch was wrongly related with the Hamman of the Sistine Ceiling by Berenson, Frey, Thode, Panofsky, and Demonts.

The bearded head is possibly, as Berenson supposes, a preliminary study for the Moses of the Julius Tomb and not the head of Noah for the Sacrifice of Noah as Thode suggests. The sketches should be dated ca. 1505-1506.

At the right of the sketch of the nude, several words written by Michelangelo, published in Frey, *Handz.*, text, p. 36.

On the recto of this leaf is No. 15.

F. Baumgart's article, "Die Jugendzeichnungen Michelangelos bis 1506," in *Marburger Jahrbuch für Kunstwissenschaft*, x, 1937 (pub. in 1939), pp. 209*ff*, which became available to the author only after the completion of the first edition, contains some judicious remarks concerning the youthful drawings of Michelangelo, and in several instances he arrives at the same dating.

CATALOGUE OF LOST WORKS

XII. HEAD OF A FAUN

Formerly Florence, Giardino Mediceo. Now Lost.
Marble.

(1) Executed during Michelangelo's stay in the Giardino Mediceo (1489).

Vasari, 1550, p. 23, says: "si mise a contrafare con uno pezzo di marmo una testa antica, che v'era." Condivi, pp. 20 and 22: "considerando [*scil.* Michelangelo] un giorno la testa d'un Fauno in vista già vecchio, con lunga barba e volto ridente . . . si propose di ritrarla in marmo . . . lo condusse a perfettione, di sua fantasia, suplendo tutto quello che nel antico mancava, coiè la bocca aperta a guisa d'huom che rida. . . ." Then follows the anecdote according to which Lorenzo de' Medici observed that Michelangelo should remove the teeth from the faun head. Vasari, 1568, pp. 23 and 25, repeats Condivi.

(2) The only reproduction of the Head of a Faun by Michelangelo is to be found in the fresco by Ottavio Vannini, Presentation of Head of a Faun by Michelangelo to Lorenzo de'Medici, Florence, Palazzo Pitti. In this fresco, done in the first half of the seventeenth century, the faun's head is of an antique type (see, for example, Reinach, *Rep.*, I, p. 412, no. 1742; the fresco by Vannini was first mentioned by Thode, *Kr. U.*, I, p. 6). This Head of a Faun fits well the description given by Condivi; however, it is impossible to say whether it actually reproduces the lost work of Michelangelo, or whether it is merely a fantasy of Vannini. *253*

(3) The Head of a Faun, by Michelangelo, was erroneously identified with a Mask of a Faun in the Bargello, which, to judge from its style, must date from around 1600. *252* The mask is first mentioned in the Medici inventory of 1699. It is said that Filippo Buonarroti offered the work to the gallery of the Grand Duke. The work is described and published as being Michelangelo's by Mariette in Condivi, Gori edition, p. 60. Doubts were expressed as to its authenticity by Frey, *Q. F.*, p. 91, and Thode, *Kr. U.*, I, p. 6 (Thode dates the work in the seventeenth century).

A. Venturi, *Storia*, X, pt. II, pp. 2*ff* and *L'Arte*, XXV, 1922, pp. 177*ff* would identify Michelangelo's Head of a Faun with the Head of a Cyclop in the Bargello, a poor piece of sculpture of the second half of the sixteenth century.

XIII. CRUCIFIX

Formerly Florence, Santo Spirito. Now Lost.
Wood.
A little less than life-size ("Poco meno chel naturale," Condivi, p. 30). The copy in the sacristy of Santo Spirito is 80 cm. high.

(1) Executed probably between April 8, 1492 (after the death of Lorenzo de' Medici) and November 20, 1492 (date of commission for Perugino's crucifix for Santa Maria *148* Maddalena dei Pazzi, the first work inspired by Michelangelo's crucifix). Frey, *Q. F.*,

p. 106, dates Michelangelo's crucifix after September 3, 1496, but the document on which he bases his deduction merely says that on September 3, 1496, the prior of Santo Spirito proposed "to sell one of the crucifixes of the church." This sale was effected, however, as a means for the church to meet its debts (see the document published by Frey) and not, as Frey supposed, because Michelangelo's crucifix was to take the place of the one sold.

(2) Michelangelo made the crucifix for the prior of Santo Spirito, who had given him the opportunity to make anatomical studies (Condivi, p. 30; Vasari 1550, p. 39; Vasari, 1568, p. 31). [Addenda, No. 17]

It was originally "sopra il mezzo tondo dello altare maggiore" (Vasari, 1550, p. 39 and Vasari, 1568, p. 31), i.e. "over the arch of the high altar." It appears in a drawing by
151 Giovanni Antonio Dosio, in the Museo Topografico di Firenze, no. 6746, where it can be distinguished on the arch of the original choir screen behind the high altar (cf. Tolnay, *Michelangelostudien*, p. 117). In this drawing, however, the crucifix is so small that conclusions as to the details of its appearance cannot be made. In the years 1600-1607, when Giovanni Caccini's new high altar was erected, with its multi-colored marble decoration and new choir screen, the crucifix was removed, and it was no doubt at this time that it was placed in the sacristy. G. Richa, *Notizie istoriche delle chiese Fiorentine*, 1761, IX, p. 55, describes it as being in the sacristy, stating, however, that it was to be placed again in the choir of the church. "All'altare [of the church choir] eravi il Crocifisso di Michelangelo, che è destinato per collocarsi al coro di Chiesa, ma sin' ora sta in Sagrestia."

(3) A copy of the lost crucifix by Michelangelo may be recognized in the wooden crucifix, somewhat less than life-size (height 80 cm.) which is still preserved in the
145, 146 sacristy of Santo Spirito in the middle niche of the wooden wardrobe which is dated
147 1584. This crucifix, with its head and knees bent in opposite directions—with its legs tightly closed together, and with the loin cloth knotted on the right hip, is in contrast to the axial composition of the fifteenth century crucifixes in Florence. [Addenda, No. 18]

Just at the time when the Santo Spirito crucifix was made by Michelangelo in 1492, its contraposto type replaced the older type in Florentine art, and we find the new motif in an almost uninterrupted series of sixteenth century crucifixes; we may, therefore, assume that they were inspired by a single famous example. The earliest known copy
148 of the new type is by Perugino in the crucifix commissioned November 20, 1492, for Santa Maria Maddalena dei Pazzi, and unveiled April 20, 1496. It cannot be an invention of Perugino, since his earlier crucifix, now in the National Art Gallery in Washington, shows the older axial type. On the other hand, it is to be noted that Michelangelo in his later crucifixes (as, for example, in the one for Vittoria Colonna, Frey, *Handz.*, 287), follows the motif of the contraposto type. Other examples of the new type are the crucifixes by Bendetto da Maiano (Florence, Cathedral, between 1492-1497),

Fra Bartolomeo (Museo di San Marco), Albertinelli (Certosa), Benvenuto Cellini (Escorial), Baccio da Montelupo (Santa Maria Novella, 1501; San Lorenzo, choir; San Marco; Arezzo, Badia); Jacopo del Duca (Tabernacle, Naples, Museo Nazionale); Giovanni da Bologna (Impruneta, and Florence, Santissima Annunziata), and Pietro Tacca (Prato, Cathedral; Pisa, Cathedral; Genoa, Santa Maria di Carignano; and Siena, San Vigilio).

150

The crucifix in the sacristy of Santo Spirito is too weak in detail to be attributed to Michelangelo himself and seems rather a reproduction of the lost original (cf. also Tolnay, *Michelangelostudien*, p. 117). According to verbal information from the prior of Santo Spirito, the original was lost early in the nineteenth century.

145, 146

(4) Thode (*Kr. U.*, I, pp. 18*ff*) seeks to identify the wooden crucifix of Michelangelo with the one which is now on the high altar in Santo Spirito. This hypothesis has already been correctly refuted by Wickhoff (*Kunstgeschichtliche Anzeigen* I, 1904, pp. 99*ff*). He dates this wooden crucifix erroneously in the eighteenth century, while on the contrary it seems to be in the style prevailing ca. 1580-1600. Thode's hypothesis was refuted also by L. v. Bürkel, "Zur Frage des Crocifisso in S. Spirito," *Z. f. b. K.*, N.F., xv, 1904, pp. 297*ff*, and by C. v. Fabriczy, "Kritisches Verzeichnis Toskanischer Holz- und Tonstatuen," *J. d. p. K.*, xxx, 1909, Bh. p. 37, no. 125.

149

Kriegbaum in Thieme-Becker, *Künstlerlexikon*, sub B. da Montelupo, supposes that the creator of the new type of crucifix at Florence was B. da Montelupo. But the earliest crucifix by Montelupo in Santa Maria Novella is dated 1501, nine years later than the copy by Perugino.

XIV. HERCULES

Formerly Fontainebleau, Jardin de l'Etang. Now Lost.
Marble.
H. 4 braccia (ca. 232 cm.).

(1) According to Condivi (p. 28) and Vasari (1568, p. 29) the statue was executed after the death of Lorenzo de' Medici, i.e., after April 8, 1492, and certainly before 1494, when Michelangelo left Florence for Bologna. Frey, *Q. F.*, p. 103, maintains with insufficient arguments, that the statue was completed in 1495.

(2) Originally in the possession of the Strozzi family. In 1529 it was sold through Agostino Dini (1463-1548, agent of Filippo Strozzi) to Giovanni Battista della Palla, "pourvoyeur ordinaire" to Francis I of France, who sent the statue to Paris. Henri IV had it taken to the Château de Fontainebleau. He caused the statue to be set upon a new base in the middle of the Jardin de l'Etang (Estang). This was probably in 1594, the year in which the Jardin de l'Estang was created. Here the statue with its new base was seen and described by Père Dan in *Trésor des Merveilles de Fontainebleau*, 1642, livre II, ch. xx, p. 177. In the reign of Louis XIV, the Jardin de l'Estang was destroyed, in 1713, according to Abbé Guilbert, *Description historique des Châteaux de Fontainebleau*,

Paris, 1731, II, pp. 86*ff.* Michelangelo's statue has been lost since that time. The inventory of the Château of 1733 makes no mention of it. (Cf. F. Herbet, *Le Château de Fontainebleau*, Paris, 1937, p. 136.) J. J. Champollion-Figeac, *Le Palais de Fontainebleau*, Paris, 1866, p. 157, publishes a note by Félibien (*d.* 1733) on the statue.

152 (3) The only reproduction upon which one can base an approximate idea of the Michelangelo statue is an engraving by Israel Silvestre (died 1691; cf. Nagler *"Künstlerlexikon,* XVIII, pp. 430*ff,* no. 29). It shows the Jardin de l'Estang, in the center of which is the Hercules, seen only from behind, on a pedestal bearing the monogram of Henri IV. (This engraving is first published in Tolnay, *Michelangelostudien,* p. 121.) The few other views of the Jardin de l'Estang which we have, are even less satisfactory for our purpose than the Silvestre engraving. These are (1) a view of the garden by Nicolas Perelle, *Vue de la Cour des Fonteines et du Jardin de l'Estang à Fonteine-*
153 *Bleau,* in *Les Oeuvres des Perelles desinateurs et graveurs,* IV, p. 24; (2) a bird's-eye view of the Château de Fontainebleau with the Jardin de l'Estang in the midst of which is
154 the statue of Hercules; engraving by Alexander Francini and Michel Asinius of 1614. Paris, Bibl. Nat., Cabinet des Estampes; (3) engraving by Tommaso de Francini, published in Dan, op. cit. One copy in Berlin, Bib. des Kunstgewerbe Museums.

152 The reproduction of Silvestre allows us to draw two conclusions: (1) that Michelangelo's Hercules was a large figure standing in simple contraposto, relying on the ancient prototypes (cf. Reinach, *Rep.* I, p. 468, no. 1969a), and not on the conventional Quattrocento type of Hercules with its loose form (cf. Hercules statuettes by Pollaiuolo and Bertoldo in Berlin, Kaiser-Friedrich Museum). The right hand of Michelangelo's Hercules probably held a club resting on the ground, while the left probably held the golden apples of the Hesperides. A lion skin is knotted on the right shoulder and is brought diagonally over the whole left half of the body, closing the silhouette and emphasizing the plasticity of the figure; (2) Previous attempts at reconstruction of Michelangelo's Hercules (cf. Justi, *Ma., N.B.,* pp. 43*ff,* and R. de Liphart-Rathshoff, "L'Ercole di Michelangelo e un disegno del Beccafumi" in *Rivista d'Arte* XV, 1933, pp. 93*ff*) based on the figure in the second niche on the left of the Amphitheatre of the Giardino Boboli must be abandoned.

XV. SAN GIOVANNINO

Formerly in the possession of Lorenzo di Pierfrancesco de' Medici. Now Lost.
Marble.
H. Unknown.

(1) According to Condivi (p. 36) and Vasari (1568, p. 37), who follows Condivi, Michelangelo made the statuette of San Giovannino after his return from Bologna to Florence at the end of 1495 or early 1496. Frey (*Ma.,* I, p. 236, and *Q. F.,* pp. 122*f*), assumes, without sufficient evidence, however, that the statue was already begun at the end of 1493 or the beginning of 1494 and was completed at the end of 1495 or early 1496.

(2) The only ancient sources are a short notice by Condivi, p. 36: ". . . Lorenzo di Pierfrancesco de' Medici alquale inquel mezzo Michelagnolo haveva fatto un San Giovannino"; and a short mention in the second edition of Vasari, p. 37: "fe [ce] per Lorenzo di Pierfrancesco de' Medici di marmo un S. Giovannino."

Since Vasari gives no report of the statue in his first edition and since his remark in the second edition is practically the same as Condivi's, he does not seem to have known it himself but merely to have taken it over from Condivi.

In the unpublished manuscript, no. 4041, fol. 374, of the Bibliothèque de l'Arsenal in Paris, of 1756, there is the following notice: "On se souvient qu'autre fois Monsieur de Vassenar avoit la envie d'acquerir la fameuse teste de marbre de St. Jean par Michel-ange qui estoit le principal ornement du célèbre cabinet de Girardon; elle a passé depuis en plusieurs mains, elle appartient aujourd'hui a M. Du Mont, Peintre du Roy es de l'Académie Royale de peinture, qui loge place de Vendôme chez M. le Président du Tugny où on peut la voir; il en fera bonne composition." [This was, however, the "Head of St. John on a Charger," reproduced in an engraving "La fameuse teste de marbre de St. Jean par Michelange" (cf. O. Kurz in *Burl. Mag.*, 1945, p. 52).

(3) The expression San Giovannino, diminutive of San Giovanni, indicates that it was a childlike or youthful figure of St. John. If it is a child statue then it is possible that a drawing of a "bambino" by Michelangelo (No. 34; ca. 1505/6) gives us a pre- *110* sentation of the motif, for this figure was taken over into the Madonna of Manchester in London, as a St. John. (The connection between the bambino of Michelangelo *278* [No. 34] and the St. John of the Manchester Madonna was recognized by Popp, "Garzoni Michelangelos," *Belvedere*, 1925, pp. 8ff.) The hypothesis that it may perhaps go back to the lost San Giovannino has already been advanced by the author in *Thieme-Becker*.

If the statue of Michelangelo was a youthful figure, it is probable that it had the same pose as the child in the drawing (No. 34), since several copies of a youthful St. John in this pose are preserved from the sixteenth century; e.g. Bandinelli's drawing, St. John, *165* Louvre, 7625; the pose here is almost the same in reverse as in Michelangelo's drawing (No. 34); it is a contrapostal figure with, characteristically for Michelangelo, the arm reaching in the opposite direction from the head (a pose which we also see in the Christ Child of the Bruges Madonna, Doni Madonna, and fully developed in the Christ of Santa Maria sopra Minerva and in the David-Apollo in the Bargello); the St. John of Cortellini in S. Domenico of Bologna, the St. John of Pietro Bernini in Pizzo Calabria, *166* Chiesa di San Giorgio, and S. Andrea della Valle in Rome (published in *Bolletino d'Arte*, 1935, pp. 546 and 548).

(4) Recent attempts to identify the lost statue by Michelangelo with the statue of St. John the Baptist at Berlin, that of the Morgan Library and that of Úbeda cannot be maintained.

The statue of St. John at Berlin was attributed to Michelangelo by W. Bode, "Die *260-263* Marmorstatue Johannes des Täufers von Michelangelo," *J. d. p. K.*, II, 1881, pp. 72ff,

[199]

and *Flor. Bildh.*, pp. 312*ff*; W. Henke, "Der Giovannino des Michelangelo im Berliner Museum," *Preussiche Jahrbücher*, LXVIII, 1891, pp. 44*ff*; Symonds, *Michelangelo* I, pp. 48*ff*; Frey, *Ma.*, I, pp. 225*ff*; Justi, *Ma.*, *N.B.*, pp. 59*ff*; Thode, *Kr. U.* I, pp. 34*ff*.

Wölfflin, *Jugendwerke*, pp. 69*ff*, shows with excellent arguments that this attribution is untenable, and gives in *Klass. Kunst*, p. 50, the statue at Berlin hypothetically to Giralomo da Santa Croce, Neapolitan sculptor, who lived about 1502-1537. This attribution was repeated by G. Lorenzetti (*Dedalo*, III, 1922/3, pp. 14*ff*).

A. Grünwald ("Über einige unechte Werke Michelangelos," *Münchner Jahrb.* v, 1910, pp. 28*ff*) supposes that the statue was executed toward 1620 and that its author was Domenico Pieratti. Finally Gamba ("Silvio Cosini," *Dedalo*, x, 1929, pp. 228*ff*) attributed the figure at Berlin to Silvio Cosini (ca. 1495—after 1547). None of these attributions seem convincing. The figure is very close to the statue of a youth in the Louvre (Collection Schlichting) wrongly attributed to Pierino da Vinci, and to the David of Francavilla, also in the Louvre. In any case, the Giovannino in Berlin with its delicate form and manneristic pose seems to be executed in the last quarter of the sixteenth century. Additional bibliography concerning the attribution to Michelangelo can be found in Steinmann, *Bibliographie*, nos. 913, 968, 1177, 1203, 1756.

256-259 The statue in the Morgan Library was attributed to Michelangelo for the first time by W. R. Valentiner ("Michelangelo's Lost Giovannino," *Art Quarterly*, I, 1938, pp. 25*ff*; the author is indebted to Dr. Valentiner for the photographs of this statue which are reproduced in this volume). Ulrich Middeldorf attributed the figure hypothetically to G. F. Rustici (*Burlington Magazine*, LXVI, 1935, p. 72). However, the statue is a typical work of Silvio Cosini. One finds in the works of this garzone of Michelangelo the same head with open mouth and dreamy expression, the same softly flattened folds, the same characteristic button motif which joins the drapery above the knee, and from which the drapery folds back on each side. (See, for example, the angel on the monument of Antonio Strozzi, Florence, Santa Maria Novella, ca. 1524; and his angels with candelabras in the Cathedral of Pisa.) The San Giovannino of the Morgan Library seems to be an early work of Cosini, executed at the period when he worked for Michelangelo in the Medici Chapel, in the mid-'twenties. The resemblance of this work with the St. John statues of the Quattrocento, e.g. the Bargello St. John (once attributed to *163* Donatello and now with some reason to Desiderio da Settignano) or the St. John of *164* Benedetto da Maiano in the Palazzo Vecchio, is not astonishing in this period.

164b The statuette at Úbeda, Capilla del Salvador, was attributed to Michelangelo for the first time by M. Gómez-Moreno, *La Escultura del Renacimiento en España*, Barcelona [1931], pl. 9. It shows Michelangelo's youthful style and technique and may be a copy of the early sixteenth century. The author cannot express an opinion on this statuette since he does not know the original.

XVI. THE SLEEPING CUPID

Formerly in the Coll. of Isabella d'Este, Mantua. Now lost.
Marble.
4 spanne in length (ca. 80 cm., see letter of A. M. de Mirandula quoted below).

(1) Michelangelo finished the Cupid around the end of April or the beginning of May 1496. See Frey, *Ma.*, I, p. 241.

(2) Michelangelo executed this statuette for himself. First it came into the hands of the art dealer Baldassarre del Milanese in Rome, who offered it for sale as an antique work. This is confirmed by two letters of Anton Maria de Mirandula to the Marchesa Isabella d'Este Gonzaga of Mantua (June 27, 1496 and July 23, 1496; both letters are published in Frey, *Q. F.*, p. 137). In the first the Count Mirandula writes that some people consider the Cupid to be antique, others modern. In the second he says it is modern, but that everyone thought it antique because it is so perfect.

We know from a letter by Michelangelo himself (Milanesi, p. 375) that in 1496 he wanted to get the Cupid back from Baldassarre, but the latter refused to give it up. He seems to have set up this statuette in the house of Cardinal Ascan Maria Sforza, in the Banchi Vecchi for public exhibition. At that time, Isabella d'Este Gonzaga had her attention drawn to it by the Count de Mirandula (cf. above quoted letters). But she does not seem to have accepted the opportunity to purchase it at this time. Apparently the work was bought by Cesare Borgia, Cardinal of Valencia (1496). Thence it came into the collection of the Duke Guidobaldo da Montefeltre, who placed it in his palace in Urbino. When, in 1502, Cesare Borgia defeated Guidobaldo, the statuette came back into his possession.

July 22, 1502, the Cupid, together with an antique Venus, were bought by Isabella d'Este di Mantova through her brother Ippolito d'Este (cf. the letters of June 30, July 22, 1502, Gaye, II, pp. 53/4). In Mantua the Cupid is mentioned in the inventories of 1542, 1573, 1586, 1599, 1627. (See A. Venturi, *Archivio storico dell'Arte*, I, 1888, pp. 1ff.)

From Mantua the statuette finally was sold to King Charles I of England in 1631. (See A. Venturi, loc. cit.; Frey, *Ma.*, I, p. 237; A. Luzio, *La Galleria dei Gonzaga venduta all'Inghilterra*, Milano, 1913, pp. 157, 165.)

Vasari, in his first edition (1550, p. 37), says the Cupid was buried in a Roman vineyard to give it an antique appearance, a story which he retells after Paolo Giovio (cf. Vasari, ed. Frey, pp. 403f) who wrote about 1540.

Condivi (p. 36; repeated by Vasari, 1568, p. 37) reports that Michelangelo, at Lorenzo di Pierfrancesco de' Medici's suggestion, gave the statuette an antique appearance. Furthermore, it is stated that the statuette was sold as an antique work by the art dealer Baldassarre del Milanese to Cardinal Raffaello Riario for 200 ducats. Having acquired it, the Cardinal became doubtful about the authenticity of the work and sent a nobleman to Florence to investigate the matter. Pretending to be looking for a sculptor for Rome,

he came to Michelangelo, who admitted that he had created the Cupid. To prove his artistic ability, the artist drew a hand on the spur of the moment. This drawing of a hand is mentioned by Mariette in Condivi, ed. Gori, p. 68, and by Bottari, *Raccolta*, III, p. 199. The drawing is today preserved in the Albertina in Vienna but was already rightly attributed by Wickhoff and Frey, *Ma.*, I, p. 244, to Passerotti.

This whole story of Condivi, partially repeated by Vasari in his second edition (Vasari, however, omits the story of the nobleman and the drawing of the hand), seems to be apocryphal. [Addenda, No. 19]

(3) The oldest written record in which the motif of the Cupid is described is the above-mentioned letter of A. M. de Mirandula of June 27, 1496: "uno putto, cioè uno Cupido, che si ghiace et dorme posato in su una sua mano; è integro et è lungo circa 4 spanne, quale bellissimo. Chi lo tene antiquo et chi moderno. . . ."

In the inventory of Mantua, 1627, the statue is mentioned as "un amorin che dorme sopra un sasso."

The descriptions of M. Equicola, Tricelius, Pighius and the poems of Niccolò d'Arco, B. Castiglione, J. B. Mantuanus, Ippolito Capilupo which J. P. Richter ("Michelangelos Schlafender Cupido," *Z. f. b. K.*, XII, 1877, pp. 129ff and 170ff) related to Michelangelo's statue, actually refer to an antique Cupid which Isabella d'Este acquired in 1505 (cf. Thode, *Kr. U.*, I, p. 41).

(4) A reproduction of Michelangelo's lost Cupid is perhaps to be recognized in Tintoretto's painting, "Vulcan surprising Venus and Mars," Munich, Alte Pinakothek. The motif fits the old descriptions well, and moreover it is well known that Tintoretto did collect wax reproductions of Michelangelo's works and it is possible that he also obtained a reproduction of the Cupid of Mantua (see the author, *Thieme-Becker*). This hypothesis was supported by J. Wilde's observation (*Eine Studie*, p. 53) that the same Cupid figure also appears in two other pictures, one of which actually comes from the atelier of Giulio Romano, thus plainly pointing to Mantua (Giulio Romano, Childhood of Jupiter, London, National Gallery, and Madonna and Child, London, Bridgewater Gallery). Wilde adds that if this hypothesis is correct, Michelangelo's figure was a copy of an antique, for there are late Roman copies of this marble, and even a sixteenth century copy in bronze (formerly in Collection Castiglione, Vienna) which undoubtedly go back not to Michelangelo but to an antique work.

Probably the antique model for Michelangelo's Cupid was the Sleeping Cupid which Giuliano da Sangallo in 1488 brought with him from Naples as a gift of King Ferdinand I to Lorenzo de' Medici. This work was consequently exhibited later in the collections of Lorenzo, where young Michelangelo could easily have studied it (cf. Vasari, ed. Milanesi, IV, p. 273; Ch. Blanc, *G.d.B.A.*, XIII, 1876, p. 55). [Addenda, No. 20]

(5) There are attempts to identify Michelangelo's Cupid with one in Mantua, Accademia Virgiliana (see Symonds, *Michelangelo*, I, pp. 50ff) and with a Cupid in Turin (Konrad Lange in *Z. f. b. K.*, XVIII, 1883, pp. 233ff and 274ff and idem, *Der Schlafende*

Amor des Michelangelo, Leipzig, 1898). They were correctly refuted by Venturi, loc. cit., Wölfflin, *Rep. f. Kw.*, XXII, 1899, pp. 70*f*, Frey, *Q. F.*, pp. 134*ff* and Thode, *Kr. U.*, I, pp. 38*ff*.

A later representation of Cupid by Michelangelo is to be found in the lower right corner of the red-chalk drawing the "Bersaglieri" (ca. 1530), a copy after a lost drawing by Michelangelo. However, the pose of this Cupid cannot be identical with that of the early Cupid, since the latter had its head resting on the hand, according to the descriptions.

XVII. CUPID-APOLLO OF JACOPO GALLI

Formerly in the collection of Jacopo Galli. Now Lost.
Marble.
Life-size.

(1) Executed by Michelangelo during his Roman period, June 1496-May (?) 1501.

(2) The statue is mentioned by Condivi (p. 42). He says, without further details, that Jacopo Galli wanted Michelangelo to make "un Cupidine" for him.

Vasari (1568, p. 41) takes over this note (in his first edition there is no mention of it) and adds: "un Cupido di marmo quanto il vivo," i.e. a standing, life-size figure. Lomazzo, *Trattato*, 3rd ed., 1884, p. 96, repeats Condivi. There is another notice in U. Aldovrandi, *Delle statue antiche* (written 1550, published 1556, p. 172). In the description of the Casa Galli and its art treasures he mentions after the description of Michelangelo's Bacchus a second Michelangelo statue of which he says: "et uno Apollo intiero, ignudo con la pharetra e saette à lato: et ha un vaso a i piedi. E opera medesimamente di Michele Angelo." (Michaelis was the first to publish this note, in "Der sogennante Cupido Michelangelo's im South Kensington Museum," *Z. f. b. K.*, XIII, 1878, pp. 158*ff*.)

"Intiero ignudo" is an expression for a life-size, standing figure (cf. Kriegbaum, *J. d. Kh. Slg. Wien*, N.F., III, 1929, pp. 247*ff*). Boissard, *Romanae urbis topographiae*, 1597-1602, I, p. 34, repeats Aldovrandi's notice.

There is an evident contradiction between Condivi and Vasari, who speak of the work as a Cupid, and Aldovrandi, who calls it an Apollo. Wickhoff (*Antike im Bildungsgange*, p. 17) pointed out that in the Renaissance an Apollo might well be confused with a Cupid because the attributes, quiver and arrows, are common to both. It seems probable that this is only a confusion of the subject and both are one and the same statue, because both sources describe a life-size, standing figure, in the collection of Jacopo Galli. Also Aldovrandi, who lists all the works in the collection, mentions only this statue and the Bacchus as by Michelangelo.

Perhaps the Apollo-Cupid was formed from the marble block which Michelangelo bought for five ducats and mentions in his letter of August 18, 1497 (Milanesi, p. 4).

(3) Since Aldovrandi's description is more complete than those of Condivi and Vasari, and since it is certain that it is a life-size, standing figure, it seems to us probable that it is an Apollo, not a Cupid. No reproduction of this lost statue is preserved.

88 Among Michelangelo's drawing there is a sheet, Louvre, (No. 14) from ca. 1501 on which there stands a nude, youthful, masculine figure, with a violin in the left hand. It was originally drawn by Michelangelo as a Mercury but later transformed to an Apollo. It is not impossible that we may have here a souvenir of the "Apollo" statue.

264-267 (4) The attempt to identify the Cupid in the Victoria and Albert Museum, London, with the Jacopo Galli Cupid (see E. Maclagan, *Art Studies*, 1928, pp. 3ff, with complete bibliography) must be rejected, since it is not a life-size, standing figure as required by the sources, but a kneeling figure. This statue is a work of the latter half of the sixteenth century, which probably originally crowned a fountain and its artist is Vincenzo Danti (cf. Kriegbaum: *J. d. Kh. Slg. Wien*, N.F., III, 1929, pp. 247ff). Perhaps it is the work of Danti mentioned in a letter, November 23, 1577 (Gaye, III, p. 402). [Addenda, No. 21]

Herbert Horne advanced the convincing hypothesis that this London statue is not a Cupid but a Narcissus (see Horne's letter to Maclagan in Maclagan, op. cit., p. 7).

XVIII. STIGMATIZATION OF ST. FRANCIS

Formerly Rome, S. Pietro in Montorio, first chapel on left. Now Lost.
Tempera on panel.

This work was executed by Michelangelo during his first stay in Rome, between June 1496-May (?) 1501. Vasari, 1550, pp. 39f: "Dipinse nella maniera antica una tavola a tempera d'un S. Francesco con le stimate, che è locato a man sinistra nella prima cappella di S. Piero a Montorio in Roma." The work is mentioned too by the Anonimo Magliabechiano, ed. Frey, Berlin, 1892, p. 129.

Vasari, 1568, p. 41, says that the painting was executed by the barber of Cardinal Riario after a cartoon furnished by Michelangelo. Varchi, *Orazione funerale*, repeats Vasari, 1550. Boissard, *Topografia Romae*, I, p. 10, mentions briefly this work.

Today there is in the first chapel at the left a Stigmatization of St. Francis, fresco by Giovanni de' Vecchi (1536-1614). This painting is not at all in the style of Michelangelo; this does not, however, preclude the possibility that the general outlines of its composition may reflect those of Michelangelo's work. (Cf. F. Titi, *Descrizione delle pitture, sculture e architetture ... in Roma*. Roma, 1763, p. 40; M. de la Lande, *Voyage en Italie*, Paris, 1768, IV, p. 334.)

XIX. BRONZE DAVID

Formerly Château de Bury; Château de Villeroy. Now Lost.
Bronze.
H. 2¼ braccia (see contract).

(1) On June 22, 1501, Pierre de Rohan, Maréchal de Gié, through the offices of the Florentine ambassadors in France (Lyon) requests that the Signoria have a copy of Donatello's bronze David made for him (Gaye, II, p. 52). A contract with Michelangelo, who was given this commission, is dated August 12, 1502. Probably shortly afterwards Michelangelo made the sketch No. 16. April 29, 1503 Michelangelo is paid 20 gold florins; that is, he had probably at least begun the figure at that time. October 10, 1503 he was paid another 20 gold florins. On June 30, 1508 the bronze David was still unfinished ("imperfecto"). On October 24, 1508 the statue was given the final touches ("rinettato") by Benedetto da Rovezzano. November 6, 1508 the statue is finished and packed for sending to France via Livorno.

(2) Pierre de Rohan, Maréchal de Gié, came to Florence in 1494 with the army of the French king, Charles VIII. He dwelt with the king in the Palazzo Medici in the Via Larga which had been vacant since the Medici had been driven out of the city. In the court of the palace there was at that time the bronze David of Donatello (which was transferred October 15, 1495 to the court of the Palazzo della Signoria; see Landucci, *Diario*, sub October 15, 1495, and Kauffmann, *Donatello*, p. 159). On June 22, 1501 (Gaye, II, p. 52) the maréchal asked, through the Florentine ambassadors to the French king, that the Signoria have a bronze figure of David made similar to the one in the court of the palace of the Signoria (Donatello), the cost of which he would pay.

Pierre de Rohan (1451-1513) was a lover of the arts. This is proved, for example, by the letter of the Signoria to the Florentine ambassadors in Milan, of November 10, 1499 (Gaye, II, pp. 52*f*), according to which the Signoria had bought for him seven marble heads and two bronze heads of which one was supposedly of Charlemagne. In a letter of Giovanni Francesco Gonzaga, marchese di Mantova, of February 8, 1503 (see Gotti, I, pp. 27, 38, and Dorez, *Nouv. Recherches*, pp. 206*ff*) he told his ambassador in France that he would send him a painting (it must have been a bas-relief) representing Vulcan in bronze to be offered in his name to the maréchal.

On July 2, 1501, the Signoria wrote to its ambassadors in France (Gaye, II, p. 54) that it was looking for an artist who could make the bronze David, but there was a lack of good masters. It assures them, however, that it will look further. On July 17, 1501, one of the ambassadors writes to the Signoria (Gaye, II, p. 55) that the maréchal urges him every day to remind the Signoria of the David. The Signoria finally, to please the maréchal, turned the work over to Michelangelo and closed a contract with him on August 12, 1502 (Gaye, II, p. 55, and Milanesi, p. 624; there are slight differences in the two publications—the last words are omitted by Milanesi). According to the con-

tract, the figure was to be a bronze David, 2¼ braccia high, which Michelangelo was to deliver in six months. The material was to be put at his disposal and later he was to be paid 50 gold florins.

On December 14, 1502 (Gaye, II, pp. 58ff) the ambassadors write again to urge the speedy execution of the work. December 31, 1502, the Signoria answers the ambassadors (Gaye, II, p. 59) that every day it hastens the work and that it has already paid out the expenses. January 13, 1503 (Gaye, II, p. 59) the ambassadors write to the Signoria that a month delay would not matter if only the figure were finally executed. January 28, 1503 (Gaye, II, p. 59) the Signoria answers that the work on the statue shall not be interrupted at all. April 12, 1503 (Gaye, II, p. 59) the ambassadors write that the statue is urgently desired. On April 29, 1503, Michelangelo was paid 20 gold florins on account of the bronze David (Vasari, ed. Milanesi, VII, p. 346, Prospetto Cronologico). On April 30, 1503 (Gaye, II, pp. 59f) the Signoria answers that the statue will be supplied on St. John's day if Michelangelo keeps his promise, which is not very certain. It asks whether the statue should be sent over the Alps or by sea.

June 19, 1503 (Gaye, II, p. 60) the ambassadors write that the maréchal orders that it be sent via Livorno by sea. July 19, 1503 (Gaye, II, p. 60) the Signoria writes to Alessandro Nasi in Mâcon, that the statue cannot yet be sent because it is not finished. August 25, 1503 (Gaye, II, p. 60) Alessandro Nasi asks in the maréchal's name that the statue be completed as soon as possible. October 10, 1503 (Vasari, ed. Milanesi, VII, p. 346, Prospetto Cronologico) 20 gold florins are paid to Michelangelo on account of the bronze David.

February 23, 1504 (Gaye, II, pp. 60f) one of the ambassadors writes to the Signoria that the maréchal asks that the statue be sent to Livorno. On April 1, 1504 (Gaye, II, p. 61) there is a repetition of the same request.

Shortly after, the maréchal fell out of favor with the French king. He had to retire to Toulouse and his office was suspended for five years (see the letter of Francesco Pandolfini to the Signoria, February 18, 1508—Gaye, II, p. 101). On September 27, 1505 (Gaye, II, pp. 77-79) Pandolfini writes from Paris to the Signoria criticizing it for not having sent the statue which was destined for the maréchal to him because he fell out of grace, for it would have been commendable if it had not abandoned him along with *fortuna*.

June 30, 1508, Pietro Soderini, Gonfaloniere, writes to Giovanni Ridolfi (Gaye, II, p. 101) that the David is unfinished because Michelangelo had to go away to Rome to work for Julius II. The David was in a condition satisfactory to no one.

Meanwhile it seems that the treasurer, Florimont Robertet, took steps to get the statue for himself. Since the Signoria owed the King of France money, it was to its interest to be on good terms with the treasurer.

August 24, 1508 (Gaye, II, p. 102) Soderini writes in his notes that the bronze David is to be finished by Michelangelo by All Saints' Day.

September 2, 1508, Tommaso di Balduccio, commandatore, writes from Florence to Michelangelo in Rome (unpublished, see Appendix II) that the "gonfaloniere [Soderini] had me called and tells me to inform you that he would greatly desire that you should come here because it is necessary to finish your bronze David quickly. If you cannot come, . . . give us soon a hint who would seem to you the most suitable of the masters here to complete your statue, for he [Robertet] seems to be angry. As the gonfaloniere remarked to me, the statue must be presented to him and it must be done soon. Thus you can earn no admiration."

Michelangelo's answer to this letter is not preserved, but we know from other documents (see below) that Benedetto da Rovezzano was charged with finishing the statue—perhaps on Michelangelo's advice.

September 11, 1508 (Gaye, II, p. 102) Soderini notes that the David will be delivered on the designated date (All Saints'). September 22, 1508 (Gaye, II, p. 102) Soderini notes that work is being done on the David and he hopes to have the statue in Livorno on All Saints' Day.

September 24, 1508 (Gaye, II, p. 105) Giovanni Ridolfi asks the Signoria to send the statue to Robertet gratis, and to ask Robertet to set it up in Blois in the court of one of the new palaces. October 24, 1508 (Gaye, II, p. 102) it is reported that the David has been cleaned ("rinettato") and that only with difficulty was anyone found capable of finishing the statue. October 26, 1508 (Gaye, II, p. 106) one hears that the David is to be sent in a week to Livorno via Cascina. November 4, 1508 (Gaye, II, p. 106) the David is almost finished. Finally November 6, 1508 (Gaye, II, p. 106) the David is finished, packed up, and sent away.

November 13, 1508 (Gaye, II, pp. 105-106) Ridolfi and Nasi write to the Signoria in answer to a lost letter of September 27, that they hear that the David will soon be sent. Robertet will set up the figure in the court of his house in Blois on a marble column and have the Florentine coat-of-arms put on this base. This house in Blois is the Hôtel d'Alluye. November 21, 1508 (Gaye, II, p. 106) there is again a request for speedy delivery of the David. December 26, 1508 (Gaye, II, p. 106) the ambassadors report that Robertet finally has received notice that the statue has been sent.

January 3, 1509 (Vasari, ed. Milanesi, VII, p. 353, Prospetto Cronologico) Benedetto da Rovezzano was paid ten gold florins for the David "poured by Michelangelo and completed by Benedetto."

January 4, 1509 (Gaye, II, p. 108), Soderini writes to the ambassadors that there was never any talk of sending a "fornimento"—i.e. a marble base, as well. February 3, 1509 (Gaye, II, p. 108) the ambassadors answer Soderini that there is no need for another word about the base.

From the Hôtel d'Alluye in Blois the statue was removed later (date unknown) to the middle of the court of the Château de Bury near Blois. From here it was taken in the middle of the seventeenth century to the Château de Villeroy near Mennecy (Seine

et Oise). Cf. A. de Montaiglon, *G. d. B. A.*, XIII, 1876, pp. 242ff and Thode, *Kr. U.*, I, p. 86.

Since that time all trace of the statue has been lost. According to the inventory of the succession of Florimont Robertet (cf. Eugène Grésy, "Inventaire des Objets d'Art Composant la Succession de Florimont Robertet, dressé par sa veuve le 4 Âout, 1532," in *Memoires de la Société des Antiquaires de France*, Vol. X, 1868, pp. 58-60), there was found on the pedestal of Michelangelo's statue some verses by Michelangelo which are said to have been translated by Ronsard (published also by Thode, *Kr. U.*, I, p. 85).

214 (3) The only certain source for reconstruction of the bronze David is the drawing in the Louvre, No. 16. It was first recognized as a sketch for the bronze David by F. Reiset ("Un bronze de Michelange," *L'Athenaeum Français*, II, 1853). This sketch may have dated from shortly after the conclusion of the contract, August 12, 1502. In this drawing Michelangelo carries out the idea of Donatello's David in accordance with the maréchal's wishes (see Donatello's bronze David in the Bargello and also his bronze *213* model of the David of the Casa Martelli in Berlin; the latter observation from Mackowsky).

In the execution it seems that Michelangelo has developed the idea in a more personal manner. There are, however, only insufficient reproductions available for reconstruction of the final version.

First there is on the lower part of the drawing of the catafalque of Michelangelo *211* (Milan, Ambrosiana) a very rapid little sketch representing the bronze David (hitherto unnoticed). So much is clearly visible: that it corresponds, in the posture with one leg bent, to the sketch No. 16—to be sure it seems here to be the left leg that is raised rather than the right one, as in No. 16.

We have furthermore two engravings by Ducerceau, *Les plus excellents bâtiments de* *210* *France*, 1576, folios 124 and 125, showing the Château de Bury, in which we find Michelangelo's statue represented on a column in the middle of the court. Unfortunately the reproduction is so small that we can get only an approximate idea of the pose of the figure. It seems that the weight falls on the right leg and the left leg is bent. In the right hand there is held a sword and the left seems to be raised, holding the head of Goliath (the motif is not completely clear; in folio 124 the left arm seems to be raised whereas in folio 125 neither raised arm nor sword is recognizable). If folio 124 cor- *212* rectly reproduces the motif, we may conclude that Cellini in his Perseus statue in the Loggia dei Lanzi took it over from Michelangelo.

(4) Several other attempts to reconstruct the lost statue have been made, but they are not convincing because they take as their basis certain statuettes hypothetically ascribed to Michelangelo. These attempts are the following: first, to reconstruct the statue on *215* the basis of a bronze statuette once in the collection of Charles de Pulszky, now in the Louvre. Courajod, "Le David de bronze du Château de Bury," *Gazette Archéologique*, X, 1885, p. 77, considered it a reduction of Michelangelo's model by Benedetto da

[208]

Rovezzano. Recently, Bode, *Italienische Kleinbronzen*, Kleine Ausgabe, 1922, p. 7, ascribed it to Donatello as a first study for the David of the Casa Martelli. The motif of the Pulszky statuette goes back to Donatello's small bronze study for the David in the Casa Martelli. However, the statuette cannot be by Donatello but must be dated ca. 1500-1510.

Secondly, a small bronze statuette in the Amsterdam Museum was assumed to be a model for Michelangelo's bronze David by M. A. Pit ("Le David de Michel Ange au Château de Bury," *Revue de l'art ancien et moderne*, II, 1897, pp. 455*ff*). This weak statuette may have been executed at the end of the sixteenth century and has nothing to do with Michelangelo's bronze David.

Thirdly, the small model of David in the Casa Buonarroti in Florence was connected *286-287* with the bronze David by A. Bayersdorfer (*Leben und Schriften*, Munich, 1902, pp. 84*ff*), an attribution which was rejected by Thode, loc. cit.

Thode, *Kr. U.*, I, p. 89, accepted the attribution to Michelangelo of the drawing, No. 16, the statuette at Amsterdam and at the Louvre, and believed that they give three phases in the evolution of the motif. This view can hardly be accepted since the three works show differing motifs apparently all independent of each other.

XX. BATTLE OF CASCINA

Cartoon for a fresco in the Sala del Consiglio of the Palazzo della Signoria, Florence. Now Lost.

Size: "ignudi più grandi del naturale" cf. the Inventory of the Palazzo in Turin, 1635, No. 697.

(1) On October 4, 1503, the Signoria ordered that Leonardo da Vinci be given the key to the Sala del Consiglio, that he might begin his work of the *Battle of Anghiari*. On February 28, 1504, the Signoria paid for the work necessary for the preparation of the hall. On May 4, 1504, the authorities closed the contract with Leonardo. In the spring of 1505 Leonardo moved into the Sala del Consiglio, that is, he began work on the fresco. In May 1506, Leonardo was granted a three months' leave and went to Milan. On May 12, 1506, Leonardo released himself from all obligations to the Signoria by giving up the money he had laid down as surety (Gaye, II, pp. 88-89; M. Herzfeld, *Kritische Berichte*, 1938, pp. 33*ff*).

The exact date of Michelangelo's commission for the fresco for the Sala del Consiglio in the Palazzo della Signoria is not known. Michelangelo says later (1524) in a letter to Fattucci (Milanesi, p. 426) that he received the commission "in the second year of the pontificate of Julius II" and that he was to get 3,000 ducats for the work.

On October 31, 1504, the paper for Michelangelo's cartoon was paid for (Gaye, II, p. 92 and Frey, *Studien*, pp. 133*f*, no. 193, 194).

[209]

On December 31, 1504, the work for limning together the paper of the cartoon and other "spese minute" were paid for (Gaye, II, p. 93 and Frey, *Studien*, pp. 133*ff*, no. 198, 199, 200, 202, 205). At that time Michelangelo was working on the cartoon, as must be assumed from the phrase ". . . el cartone che fa Michelagnolo."

On February 28, 1505, the Signoria paid 280 lire as advance salary for the "painting of the cartoon"—*di dipignere el chartone* (Gaye, II, p. 93). The sentence has always been wrongly interpreted in the literature as payment for the cartoon, whereas it was really an advance sum for the *painting* of the fresco. The date gives a *terminus ante quem* for completion of the cartoon. Condivi (p. 74) and Vasari (1568, p. 75) report that the cartoon was completed in three months, which agrees well with this document and with Michelangelo's words in the letter of 1524 (Milanesi, p. 426) that he had finished the cartoon before he left for Rome "as all Florence knew." From March 1505 to April 17 of the same year Michelangelo was in Rome to discuss the project of the Julius sepulchre. From the end of May to the end of November 1505 he was in Carrara procuring marble for this monument. Between these two journeys Michelangelo seems to have again taken up work on the *Battle of Cascina* and, it appears, to have begun the fresco, as we can conclude from the letter of Giovanni Balducci of May 9, 1506 (Gotti, II, p. 52).

During his absence, on August 31, 1505 the "panchoncelli" on which to place the cartoon were paid (Gaye, II, p. 93 and Frey, *Studien*, no. 234).

November 27, 1506, Pietro Soderini writes (Gaye, II, p. 92): "[Michelangelo] ha principiato una storia per il pubblico [palazzo] che sarà cosa admiranda." From this sentence it is clearly indicated that Michelangelo had at that time begun the *painting* because, as we have seen above, the cartoon was already completed before February 28, 1505. (Thode's assumption, *Kr. U.*, I, p. 95, that this letter referred to the cartoon, and that Michelangelo completed this work in the summer of 1506, is consequently untenable.) In his later correspondence Michelangelo mentions the cartoon twice, once in a letter of July 2, 1508 (Milanesi, p. 92) and again in a letter of July 31, 1508 (Milanesi, p. 95).

(2) The cartoon was at first in "una stanza nello spedale de' tintori a Santo Onofrio" (Vasari, 1550, p. 56; Vasari, 1568, p. 57). The cartoon was later in the Sala del Consiglio of the Palazzo della Signoria. It is mentioned as being here in two letters of Michelangelo, July 2, 1508 (Milanesi, p. 92) and July 31, 1508 (Milanesi, p. 94). In a hitherto unpublished letter of September 2, 1508, by Tommaso di Balduccio in Florence to Michelangelo in Rome (see Appendix II) we learn that the cartoon by Michelangelo was drawn (probably copied) by someone during the absence of Balduccio. In 1510 it is mentioned as still being in the Palazzo della Signoria by Albertini, *Memoriale*, 1510. Finally, Vasari also reports that the cartoon was originally located in the Sala del Consiglio (Vasari, 1550, p. 58; 1568, p. 59).

Then the cartoon was placed in the Sala del Papa near Santa Maria Novella (cf. Condivi, p. 76, and Vasari, p. 61). The transport of the work hither probably took

place in 1512—as Koehler, *Schlachtkarton*, p. 118, supposes—in connection with the changing of the constitution of the town and its disastrous consequences on the Palazzo Vecchio. cf. Landucci, sub December 12, 1512.

From the Sala del Papa the cartoon was removed to the great upper hall of the Palazzo Medici. (Cf. Vasari; Benvenuto Cellini; Borghini, *Riposo*.) This removal probably took place, as Koehler assumes, in 1515. Landucci reports that the pope on his solemn entry into Florence November 30, 1515, stayed in the old dwelling-place of the popes, that is in the Sala del Papa near Santa Maria Novella, which was redecorated for the occasion. Documents concerning this redecoration are published by Frey, *Studien*, nos. 250, 251, 252, 253. It may be assumed that the cartoon of Michelangelo was taken out at this time.

In the Palazzo Medici the cartoon was, either purposely or out of carelessness, divided into separate pieces. This mutilation probably took place between the summer of 1515 and the spring of 1516, for Vasari (1550, p. 60) says that the cartoon, during the illness of the Duca Giuliano (August 1515-March 1516), was torn to pieces by the copying artists. (Vasari, 1568, p. 364, tells in the *Vita* of Bandinelli that the cartoon was already destroyed in 1512 and that Bandinelli was responsible for this act. But this, as Koehler rightly remarks, is mere artists' gossip.)

The separate pieces of the cartoon were scattered in different places (Vasari, 1568, p. 61).

In Mantua were "alcuni pezzi in casa di Messer Uberto Strozzi" (Vasari). This report is supported by a letter of Guglielmo Sangalletti to Niccolò Gaddi of the 18th of February, 1575 (Bottari, *Raccolta*, III, p. 315) according to which Uberto Strozzi wished to sell "quei cartoni di Michelagnolo" to the Grand Duke Cosimo I. These fragments of the cartoon were used by Rubens, when, in 1604-6, as artist of the court of Mantua, he painted his Baptism of Christ for the Jesuit Church of this city (today in Antwerp, Museum). Four figures on the right side are freely copied after Michelangelo's cartoon.

Other fragments of the cartoon came to Turin to the Duke of Savoy in the beginning of the seventeenth century. According to the *Cronaca Modenese* of Giovanni Battista Spaccini these cartoons were burned on the 7th of April, 1621 (cf. G. Campori, *Raccolta di cataloghi ed inventarii*, Modena, 1870, p. 74). But all the pieces cannot have been destroyed, for in 1631 in the inventory of the Castello "li due ca[r]toni di Michelangelo" are mentioned. One finds a more exact description of these two pieces in the inventory of the Palazzo of Turin of 1635—under no. 696 a description of the two figures in the back at the left and under no. 697 a description of the three figures in the left foreground: "no. 696 "Huomo ignudo in faccia; altro vestito di corazza in schena col rondacchio, e la spada sotto a' piedi: grandi più del naturale." No. 697 "Tre huomini ignudi più grandi del naturale, uno che fa schena all'altro, il quale sta per salire poggiando col ginocchio e la mano su la schena di un altro, che gli fa sgabello." (Cf. *Le Gallerie Nazionali Italiane*, III, 1897, p. 62.)

Another piece of the cartoon must have been in Florence toward the end of the sixteenth century. Benedetto Varchi, *Orazione*, 1564, says that pieces of the cartoon are "tenuti cari in Firenze, e altrove, come le cose sante." Borghini, *Riposo*, I, pp. 10*f*, says that "un altro pezzo di cartone" was preserved in the Villa del Vecchietto near Florence.

(3) The best critical treatment of the literary sources is that by Koehler, *Schlachtkarton*, the results of which we summarize here.

Chronologically Vasari's descriptions of the cartoon occupy the first place. Both editions agree except for one non-essential point (in the edition of 1568, he strikes out the words "chi tirava su uno e chi calzandosi . . ."). Vasari could not have known the original cartoon as a whole, since he did not come to Florence until 1524. His description is evidently based on a copy, probably on the one made in 1542 by Bastiano da Sangallo called Aristotile on the advice of Vasari himself. In 1544, when Vasari was in Mantua, he may have become acquainted with the fragments then in the possession of Uberto Strozzi. Koehler rightly assumes that the leaf-crowned old man, who is about to put on his stockings, was among these fragments, for this is the only figure of which Vasari, as though from an autopsy, gives a fairly exact description.

The description of the cartoon in Benvenuto Cellini's *Autobiography*, pp. 29*f*, written in 1558-1559, resembles that of Vasari and was probably written under his influence. He emphasizes the contrast between Leonardo's battle of horsemen ("battaglia di cavalli") and Michelangelo's cartoon of an infantry scene ("fanterie").

Benedetto Varchi, *Orazione*, pp. 17*f*, despite individual differences uses on the whole the same disposition in his description as Vasari, as Koehler has proved. Thus it is probable that his description is not independent of Vasari. His single new information is that fragments of the cartoon are preserved in Florence.

Borghini, *Riposo*, III, pp. 52*f*, follows Vasari's account.

The inventory of the Palazzo at Turin of 1635 (*Le Gallerie Nazionali Italiane*, III, 1897, pp. 62*f*) gives, as mentioned above, only the description of two fragments, but is valuable as being the only one made from the original.

The literary sources thus provide us with close descriptions of only six figures: one figure (the leaf-crowned old man) is described in detail by Vasari and five are in the Turin inventory. For the composition as a whole, there is only one source, Vasari, and it is based upon a copy (cf. Koehler).

115 (4) The drawing No. 24, may be a first sketch for the central group of the Battle of Cascina. Three nude male figures are represented. In the center on a mound, probably on the bank of the river, stands a motioning figure, which is probably a first version of Manno Donati giving the alarm. Beside him at the left is a figure seated on the shore pulling on his stockings. From this figure Michelangelo later developed the garland-crowned old man. The right figure with its back turned walking toward the shore, holds a sword in the left hand (the motif was first correctly interpreted by Brinckmann, *Michelangelo Zeichnungen*, p. 18). From this figure Michel-

angelo developed in the final version the figure with its back turned buttoning on his trousers. In the Louvre there is a late sixteenth century copy of No. 24. The copyist has *283* falsely interpreted the motif of the three figures, by assuming that the lateral figures supported the central one on their hands.

Michelangelo later drew the figure with its back turned (No. 24), with changed leg position (No. 25) and then used in his composition the Brass Serpent (cf. Popp, *Die* *116* *Medici Kapelle*, Munich, 1922, pp. 158*ff*. Popp, however, dates fig. 115 in the 'twenties, which does not appear stylistically justified).

The motif of the motioning Manno Donati appears again in the study (No. 23), *114* one of Michelangelo's most beautiful pen drawings of a nude. (Concerning the connection between the two drawings, cf. Brinckmann, op. cit., p. 18.)

(5) The few studies for the cartoon are mostly preserved in such poor condition that a conclusion concerning their authenticity is impossible. These studies are: A pen *122* drawing with a sketch of Manno Donati and the warrior seen in profile beside him at the right. The drawing was later almost completely reworked.

Drawing in black chalk, a study for the nude figure with back turned in the back- *120* ground. This drawing was much altered in the seventeenth century.

Torso seen from the rear. Hitherto unpublished pen sketch in the Casa Buonarroti. *117* A figure not used directly in the cartoon, but possibly the first conception of figure 120. There are two copies of this motif, one in black chalk with the addition of a horseman, *118* and another which seems to be a copy of a more elaborate lost drawing by Michelangelo. *119*

Finally there is a pen drawing of the figure turning toward the back in the fore- ground of the cartoon, in my opinion a copy after a lost drawing by Michelangelo (cf. *121* Nos. 29, 30, 26, 27, 28, 31).

(6) For the reconstruction of the cartoon as a whole there is only one dependable source, the grisaille panel in the possession of Lord Leicester in Holkham. It is prob- *232* ably identical with the one by Bastiano da Sangallo, which the latter made in 1542 on the advice of Vasari. (Passavant, *Kunstreise durch England*, Frankfurt a.M., 1833, and Waagen, *Kunstwerke und Künstler in England*, Berlin, 1838, p. 511, believe the grisaille to be only a copy of Bastiano da Sangallo's work.)

The trustworthiness of the grisaille in Holkham is supported by the fact that the motifs agree with Vasari's description. The five figures at the left are known through the description of the inventory of the Palazzo in Turin, 1635. Also nine figures are known from engravings and at least eight have the same relationship as in the grisaille (Marc Antonio Raimondi, B. 487, Les grimpeurs; idem B. 472, the garland- *233* crowned old man; Agostino Veneziano, B. 463, the figure fastening his trousers; idem B. 423, representing five figures of the cartoon, among them the three central fig- *235* ures in the middle-foreground just under Donati, the garland-crowned figure to the right, the one fastening his trousers to the left; idem, B. 426, La Carcasse, with the figure

reminiscent of the *Dioscures* of Montecavallo). A final confirmation of the exactitude of the grisaille is a drawing which has lately come to light in England (Fenwick Collection, London) and which Mr. A. E. Popham kindly called to our attention. This drawing, which is independent of the grisaille, contains all the figures of the latter work with the exception of one (the man putting on his armor at the extreme left). In this copy one finds besides in the left background the approaching enemy, foot-soldiers and some horsemen, which Vasari and Varchi mention. But this scene seems to have been added by the copyist on the basis of Vasari's and Varchi's description, for, as we have shown in the text, the episode illustrated by Michelangelo did *not* demand the representation of the enemy (cf. Villani, *Chronicle* Bk. 11, chap. 97). Albertini (*Memoriale,* 1510) says expressly: "Nella sala grande nuova del Consiglio maiore . . . è una tavola di Fra Philippo, li *cavalli* di Leonardo Vinci, et li *disegni* di Michelangelo."

234

The mention of the horsemen by Vasari and Varchi is probably to be explained by the fact that Vasari had seen drawings of horsemen by Michelangelo, which may have played a part in the earliest stage of the composition, as is assumed by Justi, *Ma., N. B.,* p. 158, and K. F. Suter, *Das Rätsel von Leonardos Schlachtenbild,* Strassburg, 1937, pp. 72*ff.* There is preserved, in fact, a rapid sketch which represents a battle of horsemen (No. 19). It is generally assumed by writers on Michelangelo that this is a sketch for the background of the cartoon. This hypothesis, however, seems very unlikely, since the drawing shows symmetrical and completely closed composition. Therefore it seems more probable that it is a first drawing for the fresco, done at a time when the artist, inspired by Leonardo's sketches for the Battle of Anghiari, was thinking of painting a battle of horsemen. Popp assumes that Michelangelo originally planned a second fresco beside the other, showing a battle with horsemen. As we shall see, this hypothesis is hardly acceptable, since there was no space on the wall for such a second fresco.

106

105

Other sketches of horsemen, which have generally been considered as sketches for the cartoon, are not for this work. Some are merely by a pupil (e.g. Frey, *Handz.,* 142); some, by Michelangelo, are to be dated later (Frey, *Handz.,* 132, 141, both ca. 1525, as Popp has proved and Frey, *Handz.,* 99, which, as Frey correctly assumes, is from the period of the *Paolina*).

Justi (*Ma., N. B.,* pp. 151*ff*) and Popp (*Leonardo Zeichnungen,* p. 48) have pointed out that the grisaille in Holkham is a complete reproduction of the cartoon; Koehler and Foratti have assumed that the grisaille represents only a part of it. Koehler thinks that the grisaille is to be supplemented at the left by four more figures (Koehler, *Schlachtkarton,* pp. 148*ff*), which are contained in the drawing in the Uffizi ascribed to Allori. Koehler's main argument is that the composition in the grisaille is asymmetric. He assumes that the composition of the cartoon was symmetrical and that the central axis was originally the figure with its back turned fastening his trousers. He

232

275

does not take into consideration the fact that the fresco was not intended for the center of the wall in the Sala del Consiglio (which was to be occupied by Leonardo's Battle of Anghiari), but at the side and therefore that an asymmetrical composition was justified. Secondly, he does not mention that, according to Villani's *Chronicle*, the central figure must be the captain, Malatesta, who in fact in the grisaille is in the center of the composition. Koehler gives no reasons to support his unusual hypothesis. He seems to be under the influence of the copyists of the Albertina and the Uffizi drawings, who in fact placed this quite secondary figure in the center. Finally, he gives only one argument for his believing that the four figures, which he would like to add at the left, are authentic. He maintains that the third figure from the left is identical with Michelangelo's drawing (No. 22), but, apart from the fact that the position of the head is quite different, Wilde, *Eine Studie*, pp. 41*ff*, has shown that the drawing (No. 22) is a sketch of a figure of Hercules copied by Michelangelo from an ancient sarcophagus.

274

112
111

Koehler's whole thesis in regard to the four figures of the drawing in the Uffizi thus falls down; as to the three others, there exists no proof that they were originally in Michelangelo's cartoon. A further difficulty consists in the fact that the supplement suggested by Koehler brings the fresco to the unusual proportions of 1:2¼. On the other hand, Aldo Foratti (*Rassegna d'Arte*, VII, 1920, pp. 240*ff*) has proposed in an article that the grisaille is to be supplemented on the right by the horsemen mentioned by Vasari and Varchi, while believing that the left side of the composition in the grisaille is complete. Foratti does not explain in detail how he imagines he can supplement the composition.

The drawings in the Albertina and in the Uffizi, which contain the whole composition, do not come into consideration as bases for a reconstruction. The sketch in the Albertina: Thausing (*Z. f. b. K.*, XIII, 1878, pp. 107*ff*, 129*ff*) introduced it into literature as a first sketch from the hand of Michelangelo, and used it as a basis of reconstruction. Likewise Justi (*Ma., N. B.*, p. 163) regards the drawing as an original sketch. Koehler (*Schlachtkarton*, p. 145), on the contrary, has proved convincingly that it is a weak copy. We believe it to have been made from memory (Popham, *Burl. Mag.* LXXXVI, 1945, pp. 89*f*, ascribes the drawing to Perino del Vaga). Although the various motifs repeat those of the cartoon, hardly two figures occur here in the same combination as in the grisaille. Koehler has shown that the artist was above all interested in transforming the prototype into a symmetrical, well balanced composition. This goal he achieved through displacement of the figures. As centrum he arbitrarily took the figure with its back turned fastening on his trousers. To the right and left he closed the composition with upright figures. "Drei Hauptakzente . . . dazwischen etwas Füllwerk, vor allem überall Klarheit und ja keine Ueberschneidung" (Koehler).

274, 275

The architectonic sketch at the upper left of the same sheet was made by the artist earlier, and does not belong to the same composition, as has sometimes been wrongly assumed (Justi, Herzfeld). Koehler supposes it to be a sketch from memory of a North

Italian decoration. Popham, *Burl. Mag.* LXXXVI, 1945, pp. 89f, brings this drawing into relation with Perino del Vaga's activities in the Chapel of St. John the Baptist and St. George, in Pisa (c. 1534-1538). The architecture in the background of the sketch is, according to Popham, Perino del Vaga's sketch for his proposed decoration of the wall of the Chapel of St. John and St. George.

275 The drawing in the Uffizi was originally ascribed by Berenson (1397C) to Allori. In the second edition of his book, however, he attributes it to Michelangelo, as do Jacobsen-Ferri and Justi. But Koehler has shown that the drawing can be by neither Michelangelo nor Allori. Convincing as this opinion is, still one cannot agree with Koehler's dating of the drawing in the beginning of the century: "weil man in der Zeichnung noch beträchtliche Züge der alten Florentiner Zeichnungstradition findet."

 The right and left sides of the drawing are very different: at the right, where the artist copied five figures from the cartoon, the composition is flat and the movements of the figures are, in spite of their violence, closed within themselves; the left, where the artist supplemented from his own fantasy, the composition is deeper and the movements of the figures are the vehement, fluid ones of the Early Baroque. To soften the contrast between the two sides he changed the movement of the climbing figure to one of crawling—a movement reminiscent of certain figures in the *Last Judgment*—especially of the angel in the lunette at the upper left. This borrowing shows that this drawing cannot be dated before the middle of the century. The style of the drawing is similar to that of Daniele da Volterra.

 (7) The question where Michelangelo intended to place his fresco cannot be answered with complete certainty. And yet it is of the greatest importance in judging whether the grisaille in Holkham is a complete or only fragmentary reproduction.

 Vasari remodelled the Sala del Consiglio (between 1563 and 1572). (A drawing of
237 the remodelled Sala del Consiglio, attributed to G. A. Dosio, is preserved in the Uffizi.) How the hall looked ca. 1504 we learn from a description of Vasari in the *Vita* of Cronaca. It was twelve braccia lower. Albertini states that it was 104 braccia long and 40 braccia wide and this agrees approximately with the dimensions given by Vasari (Vita del Cronaca): 90 braccia long by 38 braccia wide. (To the length given by Vasari must be added 2x8 braccia, that is the oblique angles of the walls which Ammanati and Bandinelli later concealed by built-in walls.) Thus the length of the east wall was 90 + 8 + 8 = 106 braccia. The surfaces of the walls were 61, 86x12, 17 meters (cf. Herzfeld, op. cit.). On the exterior of the Sala del Consiglio, on the north wall, one
228, 229 can see the contours of the former windows. There is a walled-up window, rounded at the top and surmounted by a circular one, between the two present windows. Probably the windows of the west and east walls had the same form and size. On the southern
230, 231 exterior wall the old windows are no longer recognizable.

 Where were Leonardo's and Michelangelo's works to be placed? The sources contradict each other. Some say that the frescoes were on opposite walls, that is, that Leonardo

and Michelangelo were each given a whole lateral wall to decorate. Vasari says in his *Vita* of Michelangelo that: "Pietro Soderini . . . gli fece allogazione d'una parte di questa sala; onde fu cagione che egli facesse . . . l'altra facciata" and Varchi, *Orazione*, repeats in different words: "il Gonfaloniere . . . n'allogò una facciata . . . a Leonardo, . . . e l'altra facciata (a Michelangelo)." Michelangelo's words in his letter to Fattucci (1524, Milanesi, p. 426) are ambiguous: "io avevo tolto a fare la metà della sala del Consiglio di Firenze, cioè a dipignere." They can be interpreted, as the Leonardo scholars have hitherto done (A. E. Popp, Maria Lessing, Maria Herzfeld), namely, that Michelangelo was assigned the wall opposite Leonardo; one can also explain the passage as meaning that he was commissioned to decorate half of the whole surface which was to be painted.

In the description by Vasari in the *Vita* of Cronaca, he says expressly that the altar-wall was pierced by four windows, whereas the Gonfalonieri-wall had only two. From this one must conclude that the altar-wall could not contain a large fresco and that Michelangelo's and Leonardo's frescoes were meant for the same (the Gonfaloniere) wall. Koehler saw this correctly, but did not draw conclusions as to which place Michelangelo's fresco and to which Leonardo's was destined. The Gonfaloniere-wall was divided by the two windows into three sections. An almost square center field was framed by two rectangular lateral fields. The Battle for the Flag by Leonardo, on account of its quadratic composition, must have occupied the middle position. For the right field Leonardo probably planned the cavalcade and the struggle on the bridge, which compositions are preserved in his sketches. Therefore Michelangelo's composition must have been intended for the left rectangular section. Popp says rightly: "Die Grisaille in Holkham gibt die linke Hauptszene vollständig wieder . . . Die Szene ist asymetrisch componiert, weil sie mit dem Pendant einer zweiten ebenso grossen Darstellung rechts rechnete." This scene at the right was not, however, as Popp thought, a fresco by Michelangelo with the beginning of a battle with horsemen (Popp assumes that Michelangelo was given the *whole* wall opposite Leonardo to paint), but Leonardo's Battle of Anghiari.

238-240

Another argument that Michelangelo as well as Leonardo was given the Gonfaloniere-wall to decorate is that the subject of these frescoes was the glorification of the profane history of the city and therefore much more in place here than on the altar-wall, which was perhaps to be decorated with smaller religious frescoes.

It is no counter-argument to say that the juxtaposition of the works of Michelangelo and Leonardo on the same wall might have offended the artistic sensibilities of the spectators of the day, for at the end of the fifteenth century many different artists were commissioned to decorate the *same* walls of the Sistine Chapel and the fact that these frescoes by different hands are side by side does not disturb the harmony of the whole.

(8) Represented is the battle between the Florentines and Pisans on the outskirts of Cascina, July 29, 1364, which was won by the Florentines. Michelangelo did not,

232

however, illustrate the battle itself but the alarm by means of which Manno Donati wished to prepare the camp for a possible approaching danger. The scene is exactly described in Filippo Villani's *Cronaca*, Libro xi, Chap. 97 (edition Florence, 1826, pp. 286*ff*): "a dì 29 di luglio anni 1364 . . . messer Galeotto Malatesti capitano de' Fiorentini . . . la mattina s'accampò ne' borghi di Cascina presso di Pisa . . . e infra il giorno per lo smisurato caldo le tre parti e più dell'oste . . . s'era disarmata, e quale si bagnava in Arno, quale si sciorinava al meriggio, e chi disarmandosi in altro modo prendea rinfrescamento. E il capitano, sì perchè molto era attempato, sì perchè del tutto ancora libero non era della terzana, se n'era ito nel letto a riposare senza avere considerazione quanto fosse vicino all'astuta volpe . . . e tutto che al campo fossono fatti serragli, deboli erano, e cura sufficiente non era data a chi li guardasse; il perchè avvenne, che il valente cavaliere messer Manno Donati, come colui a cui toccava la faccenda nell'onore, . . . conosciuto il gran pericolo in che il campo stava, . . . mosso da fervente zelo incominciò a destare il campo, a dire, noi siamo perduti, e con queste parole se n'andò al capitano, e lo mosse a commettere in messer Bonifazio Lupo e in altri tre e in lui la cura del campo." Galeotto Malatesta, the ill captain of the Florentines, is probably to be recognized in the reclining figure, who has just awakened from sleep and is unwinding a cloth from his head, immediately to the left of Donati. This figure is the real central figure of the composition.

At the moment of Manno Donati's alarm the enemy was not yet visible. This explains the absence of the opposing force in Michelangelo's composition, as well as the confusion of the soldiers who are uncertain from which direction the enemy will come, some awaiting it from the left, some from the right.

(9) The composition as a whole with nude figures arranged in three successive strata is a resumption of the problem of the Battle of Centaurs.

Probably Michelangelo had known the composition of battling nude men by Pollaiuolo (two engravings) and Verrocchio (lost drawing mentioned by Vasari cf. Wölfflin, *Klass. Kunst*, p. 53), and the frescoes of Signorelli at Orvieto in the Capella Brizio.

The poses of some of the figures are directly inspired by antique statues: the garland-crowned old man was inspired by a Hellenistic gem (cf. Hekler, p. 207; Pl. 1, fig. 7/8); the forward charging figure on the right side of the composition is, in the pose of the Dioscurus of Montecavallo (cf. Wilde, *Eine Studie*, p. 59, figs. 16 and 17).

(10) The motif of the man climbing upward Michelangelo used later in the Deluge of the Sistine Chapel in one of the figures climbing up on the ark of Noah (cf. Koehler, *Schlachtkarton*, p. 165). Likewise the motif of the forward bending figure looking into the water occurs in the Deluge fresco.

The upward climbing figure is used once more in the Last Judgment at the left among those ascending toward heaven; likewise the motif of the forward bending figure is found here (cf. Steinmann, *Sixtinische Kapelle*, ii, p. 550; Aldo Foratti, *Rassegna*

d'Arte, VII, 1920, pp. *240ff*; Tolnay, "Le Jugement Dernier," *Art Quarterly*, 1940, p. 131).

(11) For further copies after the cartoon, see Koehler, *Schlachtkarton*, pp. *150ff*, and Thode, *Kr. U.*, I, pp. *100ff*.

Two drawings in Haarlem, Teyler Museum (Frey-Knapp, *Handz.*, 303, 305), which were for a long time considered as originals, are only copies after the cartoon as Brinckmann (*Zeichnungen*, nos. 84, 85, and *Z. f. b. K.*, LIX, 1925-1926, pp. *219ff*) has demonstrated. Panofsky, *Bemerkungen*, pp. *27ff*, attributes these drawings hypothetically to Perino del Vaga or to Giovanni da Udine.

Heretofore unobserved is the Baptism of Christ attributed to Daniele da Volterra in the chapel of Giovanni Riccio in S. Pietro in Montorio. Here the figure of the Baptist is an almost exact copy of the figure in the third plane at the right side of the cartoon. The two nude figures at the right of the painting are free variations of two figures in the Cascina. (The painting was attributed by Vasari to Daniele da Volterra and by Nibby, *Itinerario istruttivo di Roma*, Rome, 1865, p. 445, to Leonardo Milanesi.)

XXI. BRONZE STATUE OF JULIUS II

Formerly on the façade of San Petronio, Bologna. Now Lost.
Bronze.

H. varying reports. According to the old chroniclers the statue was 9 to 10 feet high; Vasari speaks of a statue 5 braccia high and Michelangelo, in a letter of 1524 (Milanesi, p. 427) claims it was 7 braccia.

(1) November 10, 1506, Julius II entered Bologna in triumph after the defeat of the Bentivoglio. November 21, 1506, the Cardinal of Pavia writes to the Signoria of Florence to send Michelangelo to Bologna since the Pope wants him to do "several works." November 27, Soderini gives Michelangelo letters of recommendation (Gaye, II, pp. *91ff*).

Apparently on November 29, 1506 Julius II receives Michelangelo in Bologna and gives him the commission for the bronze statue, for which he is to receive 1000 ducats (Milanesi, p. 427). Michelangelo hires three helpers, Lapo d'Antonio of Florence (who on December 10, 1506 got permission to go to Michelangelo in Bologna), the bronze-pourer, Lodovico di Guglielmo del Buono, called Lotti and Pietro Urbano (Milanesi, p. 8).

Julius II at about the same time commissioned a stucco statue which was to be put up on the façade—"sopra l'aringhiera grande"—of the Palazzo degli Anziani (B. Podestà, "Intorno alle due statue erette in Bologna a Giulio II," in *Atti e memorie della Regia Deputazione di storia patria di Romagna*, V, 1867, p. 109). This statue also showed

Julius II, seated, with the key in his left hand, giving the benediction with his right. It was larger than life-size.

Friano degli Ubaldini, *Cronaca di Bologna*, describes the stucco statue as follows: "era [*scil.* the statue] a sedere suso una scrana de legnamo molto ben dopinta e in la man stanca avea la chiave et con la man drita deva la benedizione, che sopra avea uno chapelo . . . la qual imagine era di mazor grandeza che non un huomo" (published in Podestà, p. 109). In the chronicle of Gasparo Tagliacozzi it is described thus: ". . . l'imagine della sua Beatitudine . . . stava a sedere sopra una carega regale . . ." (Podestà, loc. cit.).

This stucco statue was set up in the palace of the Anziani on December 17, 1506 (see the Chronicles of Fileno dalle Tuatte and M. A. Bianchini).

The artist who made this statue is not named in the chronicles. Podestà believes it may have been Alfonso Lombardi, because he was famous for stucco work. It is striking that the descriptions fit the motif of the later bronze statue by Michelangelo and it is therefore possible that it was made following a little model that Michelangelo had made, perhaps as a test of how the bronze statue would appear. It is to be remembered that in the above mentioned letter, the Cardinal of Pavia said the Pope wanted "*alcune opere*" done.

This stucco statue was destroyed on May 22, 1511 (see the Chronicles of Fra Leandro Alberti, Bianchini, F. degli Ubaldini, in Podestà, op. cit.).

January 29, 1507, the Pope visited Michelangelo's atelier (Milanesi, p. 65). This atelier was located in a room of the Pavaglione ("la stanzia del Pavaglione posta dietro della chiesa [of S. Petronio]"; Podestà, p. 108). In the same room, Menganti later made his statue of Gregory XIII. On the day of the Pope's visit, Michelangelo chased Lapo and Lodovico away, but thought of taking Lodovico back later (Milanesi, pp. 8 and 65).

February 22, 1507, Julius II leaves Bologna (P. de Grassis, *Diarium Curiae Romanae*, sub February 22, 1507). At the end of March Michelangelo informs his family that he will pour the statue in about a month (Milanesi, pp. 71-74).

April 28, 1507 the wax model is finished (Milanesi, p. 148). For the pouring he hires a Frenchman (Milanesi, p. 75). Michelangelo tries to get as another helper for the pouring Bernardino d'Antonio del Ponte of Milan, who on May 15 got permission to go to Bologna (Gotti, I, p. 63) and arrived there about May 26th (Milanesi, p. 76).

Between June 20 and July 1, 1507 there came the first pouring which was unsuccessful. The figure formed only up to the girdle while the rest of the bronze remained in the oven. The oven had to be destroyed and remade (Milanesi, pp. 78-79). Before July 9 there was the second, successful, pouring. On July 9 Bernardino departs for Florence (Milanesi, p. 80). At the end of July the statue was freed from the pouring frame (Milanesi, p. 84). August 21, 1507, Soderini writes to Malaspina, that Michelangelo is at the end of the work (*Misc. dell' Arte*, I, p. 139). Michelangelo did not think he could finish before All Saints' Day (Milanesi, p. 85). On November 10, 1507,

Michelangelo writes that he is working day and night (Milanesi, p. 88). January 13, 1508, the tabernacle on the façade above the portal of San Petronio is complete. (Podestà, loc. cit.) As early as August 7, 1507, Nicola di Giovanni pittore had been paid "per la pittura della nicchia del papa supra faciatam ecclesiae Santi Petronii" (A. Gatti, *La Fabbrica di S. Petronio*, Bologna, 1889). February 15 the statue is brought into San Petronio. February 18, 1508, Michelangelo says the statue is not yet put up (Milanesi, p. 89). February 21, 1508, the statue is placed on the façade of San Petronio. See the letter of the Riformatori to the ambassadors of Bologna in Rome, published by Podestà, p. 107, "questa sera e stata tirata la statua della effigie di N. S. al loco preparato sopra la porta grande nella facciata della Chiesa de San Petronio. . . ." On the margin "Prima d'esser levata ad alto e stata tre giorni nella chiesa." The event was celebrated in Bologna with bells and illumination. March 18, 1508: "A ore 15 per punto d'astrologia fu scoperta la statua di bronzo de Papa Giulio II posta nel frontespizio della Chiesa di San Petronio" (A. Gatti, op. cit.).

May 21, 1511 the Bentivoglio with the help of French troops came back to Bologna. Annibale Bentivoglio became the Signore of the city. The statues of the pope were destroyed, the stucco statue on May 22, 1511, and the bronze on December 30, 1511. (More complete description of the destruction of the statue in F. degli Ubaldini and Fra Leandro Alberti pub. by Podestà, p. 121.)

The wall of the church was broken through from inside, and the bronze statue was hurled down. January 9, 1512 there was put up a canvas painting of God the Father in place of the statue. The statue was sent to Ferrara because Duke Alfonso d'Este wanted it. Fileno dalle Tuatte says: "[la statua] fu rotta et mandata a Ferrara a fare de le bombarde et in quelo logo fu dipinto uno Dio Padre" (Podestà, p. 119).

Friano degli Ubaldini reports: "et la testa fu menata e ruzolata per terra et per piazza insino in palazo nela monizione da poi fu mendata a Ferrara perche el Duca Alfonso da Este la volse" (Podestà, loc. cit.).

Various notes concerning small works on the statue in the Archivio di San Petronio, from January 7, 1507, to August 21, 1508, published by Podestà, op. cit., pp. 124*f* and by A. Gatti, *La Fabbrica di San Petronio*, Bologna, 1889. In a letter dated February 24, 1508 by Giov. Sabadino, Bologna to Isabella d'Este, Mantova, the statue is thus described: "su la façata alta Templi divi Petroni, sopra la piaca ne l'ordinato loco la statua de bronzo vota del Papa sedente come in cathedra, alta 9 piedi e meço et ponderis librarum quatuordecim millia" . . . (pub. R. Renier, *Giornale storico della Letteratura italiana*, XI, 1881, p. 211). More information concerning the fragments of the statue after its destruction can be found in G. Campori, "Michelangelo e Alfonso d'Este" in *Atti e Memorie della R. Deputazione di Storia Patria di Emilia*. N.S., VI, 1881, pp. 127*ff*.

To sum up, Michelangelo began work for the bronze statue after November 29, 1506. The wax model was completed on April 28, 1507. The second successful pouring took place before July 9, 1507. The statue was finished on February 15, 1508, and it

was raised to the niche on the façade above the main portal of S. Petronio on February 21, 1508. On March 18, 1508, the work was unveiled.

(2) To the question of exactly where the statue was put up, the old chroniclers answer: "[la statua] era nella fazada de Santo Petronio, in una fenestra granda cornixada de maxegno [macigno] et sopra avea una banda granda dorata con uno scritto che dixeva: Julio Secondo pontifize maximo." Today the niche is gone and no trace of it is visible. This is explained by the fact that the façade has been strengthened in the meantime. (Actually it was already decided on August 3, 1587, to vault the middle aisle. Nothing came of it then, but between 1626 to 1627 (February) there was again a decision to vault the aisle. On October 16, 1647, the vault "della prima crociera" was completed—at that time the façade also had to be strengthened. (Documents pub. by Podestà, op. cit., p. 128.) The space where the statue was placed was above the main portal and below the original window (originally there was an occhio there). Thus it was about on the apex of the arch which belongs to the new restoration.

The most complete description of the motif of the statue is given by Fra Leandro Alberti: "Era la figura di Papa Julio II, con le vesti pontificali seduta sopra un seggio dando la benedizione; sotto li piedi vi fu scolpito in una menzola di marmo: Julius II pont. max." Friano degli Ubaldini describes it thus: "La imazina de papa Julio II, laquale guardava in piazza, et havea la chiave in man, con l'altra man feva el segno et in testa avea el segno regale. . . ."

The description in the chronicle "Novacula" agrees with these two also, pub. by Steinmann, *Sixtinische Kapelle*, ii, p. 34, note 4. [Addenda, No. 22]

From these descriptions it may be seen that Michelangelo's statue belonged to the type of the "statue d'onore" of the popes.

The most important representative of this type in the second half of the fifteenth century is the sitting bronze statue of Innocent VIII by Pollaiuolo in Saint Peter's.

(3) How Michelangelo's statue may have looked can be seen, we believe, from a drawing by Bandinelli in the Louvre. It is a project for a monument for Clement VII which seems to go back in its motif to Michelangelo's statue. In this drawing the Pope is shown seated in a dramatic pose with left leg extended and the right bent inward and resting on a raised base. The right arm is lifted in an abrupt gesture ("atto fiero") a gesture "in which it is not clear whether it is giving blessing or malediction" (Vasari, 1568, p. 81) and which according to Michelangelo meant "che [il papa], l'annunziava il popolo di Bologna perchè fussi savio." In the lowered left hand he holds—according to Michelangelo's original plan—a book. Before the completion of the statue Michelangelo is supposed to have asked the Pope "se dovessi porre un libro nella sinistra" (Vasari, p. 83). In the finished statue the book was replaced by a key, as we know from the chronicles. Thus Bandinelli's drawing goes back probably to a drawing or the small model in wax of Michelangelo's. The motif of the right leg bent inward and the left thrust forward is found in the same dramatic contrast also in Michelangelo's sitting

figures, both before and after the bronze Julius II; it exists in the first version of the Moses of the Julius tomb (1505) and later in the prophet Daniel on the Sistine Ceiling. The motif is already modestly advanced in Pollaiuolo's statue and is then developed by Michelangelo.

In Menganti's sitting statue of Gregory XIII (1578) on the façade of the Palazzo *250*
Publico in Bologna the motif of Michelangelo's statue finds an echo. [Addenda, No. 23]

Michelangelo's statue seems to have been a direct forerunner of the prophets of the Sistine Ceiling.

Steinmann's (*Sixtinische Kapelle*, II, pp. 34*ff*) attempt at reconstruction on the basis of the Statue of Julius III in front of the cathedral in Perugia, as well as W. Hager's *249*
(*Die Ehrenstatuen der Päpste*, Leipzig, 1929, pp. 36*ff*) on the basis of the prophets of the Sistine Ceiling are not convincing.

The coat of arms of Julius II, on the pedestal of the statue is mentioned in a document from August 14, 1508, as executed by Giovanni pittore (See Gatti, loc. cit.).

There exists in the Museo Municipale of Bologna a large stone insignia which carries *251*
the interlaced oak of the Rovere family. This may perhaps be identified as the coat-of-arms, which was originally beneath Michelangelo's statue. (See the author in *Michelangelostudien*, p. 122.) It is in the shape of a *tête de cheval* a form common from the end of the fifteenth century. But here the rather geometric, concave form used in the Quattrocento (see e.g. the Rovere insignia on the Cancelleria) is replaced by one that is more narrow in the lower part and swells out in the upper, to take on an almost organic form such as is characteristic of other arms by Michelangelo (see those above the main entrance, interior, of the Church of S. Lorenzo and above the central window in the Palazzo Farnese).

XXII. DAGGER

Formerly in the possession of Filippo Strozzi, in Florence. Now Lost.

In a letter from Bologna, dated December 19, 1506 (Milanesi, p. 61) Michelangelo mentions for the first time this work which he is to execute for Pietro Aldobrandini, of Florence. On January 22, 1507 (Milanesi, p. 63), Michelangelo writes that he has had the dagger blade made by the best master of Bologna. On February 1, 1507 (Milanesi, p. 67) Michelangelo says that as soon as the work is finished he will send it by a trustworthy man. On February 24, 1507 (Milanesi, p. 69) he writes that he has yet to have the dagger gilded. On March 6, 1507 (Milanesi, p. 70), Michelangelo reports that the dagger is finished. We next learn that Aldobrandini was not content with the dagger (Milanesi, p. 71). Michelangelo, somewhat offended, writes to his brother Buonarroto to offer the dagger to Filippo Strozzi (Milanesi, pp. 73, 75).

For the history, see also Thode, *Kr. U.*, II, p. 242.

CATALOGUE OF APOCRYPHAL AND FALSELY
ATTRIBUTED WORKS

N.B. False attributions erroneously identified with lost works of Michelangelo will be found in the Catalogue of Lost Works.

XXIII. THE PICCOLOMINI ALTAR

Siena, Cathedral.

H.: each figure about two braccia; the statues toward the top were to be somewhat taller, those below somewhat shorter, according to the contract (see below).

(1) The Piccolomini Altar was to be erected near the *Porta della Libreria* in the Cathedral of Siena by Cardinal Francesco Todeschini-Piccolomini (later Pope Pius III). The Cardinal was a great friend of the arts and letters. The famous *libreria* in the Cathedral of Siena he had had decorated with ten frescoes by Bernardo Pinturicchio. In his last will of April 30, 1503, shortly before he was elected to the papacy, he said that he wished to erect a monument to his memory and that of his great-uncle Pius II, and that he would designate it as his own future grave monument if it would not be possible to be buried in Rome. He added that he had allocated the work to Maestro Andrea, sculptor, for a price of 2000 gold florins of which Maestro Andrea had received 417. (The testament is published by P. Rossi, "La Ressurrezione attribuita a Michelangelo del Monumento Bandini-Piccolomini nel Duomo di Siena" in *Rass. d'Arte Senese*, VII, 1911, pp. 3ff.)

The name of Maestro Andrea also appears in the earliest document mentioning the altar, the letter from Platina (the celebrated author of the *Vite dei Pontefici*) to Lorenzo the Magnificent of May 15, 1481 (Gaye, I, p. 273). In this letter Platina recommends Maestro Andrea to Lorenzo the Magnificent and asks him to grant unhindered passage through Florentine territory for the marble destined for the Piccolomini altar. The altar was constructed in 1485, according to the inscription on the monument. Maestro Andrea is identical with Andrea Bregno, a Lombard sculptor, as Schmarsow has shown ("Meister Andrea," *J. d. p. K.*, IV, 1883, pp. 18 *ff*).

There is an unnoticed drawing of the altar by Giuliano da San Gallo to be found in his *Taccuino Senese* (see Ridolfo Falb, *Il Taccuino Senese di Giuliano da San Gallo*, Siena, 1902, Pl. 20; here published as "Roman Building"). This drawing is not made after the finished work, but rather after a project for it, and thus gives a version prior to the execution. This is proved by the variations from the finished monument. The altar is lacking in the lower niche. At the top, left and right, there are lacking the coats-of-arms of Pius II and Pius III, in place of which there are candelabra. The coats-of-arms in the lowest fields, left and right, still have the old form of the *tête de cheval*.

When Andrea Bregno was eighty years old in 1501, the Cardinal Piccolomini, it seems, first turned to Pietro Torrigiani and then to Michelangelo for the execution of the sculpture which was to decorate the monument.

The earliest document concerning the sculpture dates from May 22, 1501 (Milanesi, p. 615); it is a letter in which Michelangelo gives further suggestions for two clauses in the now lost first draft of the contract offered him by the Cardinal. The first suggestion concerns the judgment on the perfection of the figures created by the artist.

Michelangelo suggested that the Cardinal might call an artist and that he himself could name a second artist, each to judge the quality of the work. In case of disagreement these two artists could choose a third and abide by the decision of the majority. The second suggestion concerns the determination of the day from which the period of three years allotted for the execution of the fifteen statuettes should be reckoned. It should be the day on which the Cardinal would lend 100 gold ducats to Michelangelo which would be an advance payment for the last three statuettes. These suggestions were accepted by the Cardinal as is proven by the contract which was signed on June 5, 1501 by the Cardinal Francesco Piccolomini, by Michelangelo on June 19, and by Jacopo Galli as guarantor, on June 25. (Milanesi, pp. 616ff, published the copy in the archives in Siena; the original document is preserved in the Archivio Buonarroti, cod. II-III, fol. 2, and not lost as A. Rota, in his article quoted below, thought.) According to the contract Michelangelo was supposed to make fifteen statuettes of Carrarese marble in three years. The statues were to be executed in Florence; and since the Cardinal could not inspect them personally, he was to have the right to have the statues examined by a sculptor in regard to their quality, in which case Michelangelo might also send a representative. In case of disagreement, a third would be chosen. Personal execution and completion of the statues by Michelangelo and first-rate quality are expressly bargained for in the contract: "et sieno [le statue] di più bontà, meglio conducte, finite et a perfectione, che figure moderne sieno hogi in Roma." Michelangelo agrees to take on no other work during the three years which might delay progress on the altar. Before beginning the statuettes, he was to go to Siena and take measurements personally. After completion of the fifteen statuettes, he must return to Siena and install them personally. A drawing must precede the execution of each figure. An immediate advance of 100 gold ducats is to be deducted from the last three statues, says Jacopo Galli, who guarantees the loan. Furthermore, the Cardinal will pay figure for figure 33 1/3 gold ducats, making a sum of 500 gold ducats for the fifteen statuettes.

The apostles and saints to be represented are decided upon by the Cardinal. At the very top there was to be a Christ, two braccia and one palmo high because of the distance from the observer. In the "tribuna," that is, in the upper niche where there now stands a Madonna, there were to be three figures: again Christ, two braccia and four dita high, flanked by St. Thomas and St. John the Evangelist, each two braccia high. At the extremities of the cornice, that is, to the right and left of the upper niches, were to be two little angels with trumpets, each two braccia less four dita. The head and drapery of a figure of St. Francis, begun by Pietro Torrigiani, was to be completed by Michelangelo out of "friendliness" ("per suo honore et cortesia et humanità"). This figure is in the lower niche on the left in the monument.

In the center of the iconographic program there stood the Resurrection (the Christ resurrected and the angels with trumpets), well suited for a grave-monument.

Of the sixteen statues (Michelangelo was to make fifteen plus the St. Francis), nine

were destined for the niches (six in individual niches and three in the large *tribuna*), *186*
two, the angels, at the extremities of the cornice, and five at the top where the bases
are still visible (two above the segmental pediments of the side, and three above the
central tympanum).

In an apocryphal letter of "1511 to Bernardo Piccolomini," preserved in a copy of
1755 (Milanesi, *Documenti per la storia dell'arte Senese*, III, pp. 26-27), the following
saints are cited in addition to the above: Sts. Peter, Paul, Gregory, Pius, James the
Elder, John the Baptist, Andrew, Agnes, Catherine, and Sebastian. (This makes a
total of seventeen instead of sixteen statues, possibly an error by the eighteenth century
copyist.)

After the death of Pius III (October 18, 1503), the heirs, Jacopo and Andrea Piccolo-
mini, brothers of Francesco, declare that they wish to keep the contract with a few
changes. The work is mentioned in this document of September 15, 1504, as unfinished,
"opus infectum" (Milanesi, pp. 616-618). A month later, when the three years were
past, a new contract was ratified on October 11, 1504. Meanwhile, Michelangelo had
sent four statues to the heirs, apparently the Sts. Paul, Peter, Pius, and Gregory which *194, 188, 191,*
192
are still on the monument. He receives for them the agreed payment, and the statues
are found to be of the quality demanded. (We will see from a later letter that the four
statues were not personally executed by him.) The other eleven statues he agrees to
deliver in the course of the next two years (Milanesi, p. 627). The 100 ducats which
were paid in advance would be charged against the next three figures to be delivered.

From a letter of June 28, 1510 (Steinmann, *Sixtinische Kapelle*, II, p. 715), which
Michelangelo's father sent to him in Rome, and which has not been considered hitherto
in connection with the history of this monument, it is seen that Michelangelo gave
the four statues to Baccio da Montelupo to do. Lodovico writes that Matteo di
Cuccarello, a stone cutter, visited him and said that he "fecie venire più tempo fa 4 pezzi
di marmo per tuo [*scil.* Michelangelo] chonto per fare quelle fighure del Chardinale di
Siena e che non le volendo tu, gliele faciesti dare a Baccio de Montelupo." Matteo
asked Baccio to pay for the four pieces of marble, but Baccio said that he had already
paid Michelangelo for them. Since these blocks were for the figures to be executed for
the "Cardinal of Siena" and not for his heirs, we must assume that it is a question of
the four statues still on the monument and not blocks for statues which Michelangelo
had yet to execute.

In an undated letter of January 1512 (?) (Milanesi, p. 19) (for the date see Vol. II,
Appendix no. 57), Michelangelo asks his father not to spend the 100 ducats which
he has sent to him because he wishes to return them to the heirs of the Cardinal of
Siena.

In the above mentioned apocryphal letter of "1511" (Milanesi, *Documenti per la
storia dell'arte Senese*, III, pp. 26-27, in a copy of 1755) the writer says that he believes (!)
Michelangelo has finished four statues, Sts. Peter, Paul, Pius, Gregory, because he

has sent the drawings for them ("credo lui [Michelangelo] ne abbia finite quattro, cioè S. Pietro, S. Paolo, S. Pio e S. Gregorio perchè di tante mandò il disegno"). Then we hear that on "December 5, 1537," in a document likewise apocryphal and preserved in a copy of 1755 (Milanesi, *Documenti*, p. 25; and Vasari, ed. Milanesi, VII, p. 385) the heir of Pius III, Antonio Maria Piccolomini, transfers to Paolo di Oliviero de' Panciatichi of Pistoia his rights to the 100 ducats which Michelangelo owed because of the advance for the work which he never did. On December 10, 1537, Antonio Maria Piccolomini tells Michelangelo of this transfer and asks for the drawings for the altar (Frey, *Briefe*, p. 344). There follows a further procrastination. May 1, 1561, Michelangelo wants to settle the affair which bothers him. Paolo Panciatichi tells where the papers in connection with the altar can be found (Frey, *Briefe*, p. 382).

September 20, 1561, Michelangelo (Milanesi, p. 362) asks his nephew Lionardo to make a search for the copy of the contract of 1504. He says, "detta opera per certe differenze restò sospesa ca. 50 anni sono. . . . Vorrei aconciar detta cosa, a ciò che dopo me ingiustamente non fussi dato noia a voi." On November 30, 1561 he acknowledges to Lionardo the receipt of the contract of 1504 and of a letter of A. M. Piccolomini (Milanesi, p. 363; it appears from these letters that Michelangelo was being threatened with a suit by the heirs).

Two months after Michelangelo's death, April 6, 1564, the nephew Lionardo bought eight credits in the bank, Monte della Fede, for 800 gold ducats. But April 21, 1564, he cedes one of these credits of 100 ducats to the heirs of Pius III as repayment of the advance to Michelangelo in connection with the contract for the fifteen statues for the Piccolomini monument in Siena (see A. Rota, "Michelangelo e il Monte della Fede" in *Archivi d'Italia e Rassegna internazionale degli Archivi*, IV, 1937, pp. 27ff). This document refers to that of 1501. To reconcile Michelangelo's soul, Lionardo pays 100 ducats that the artist owed to the heirs and recognizes expressly that "ex aliis dictus d. Michelangelus non fecerit dictum opus."

193 (2) From the above quoted documents it is seen that the St. Francis is a work by Torrigiani (see the contract of June 5, 1501 and the letter of "1511"), that the four statues of Sts. Peter, Paul, Pius and Gregory were made by Baccio da Montelupo (letter of June 28, 1510) after drawings by Michelangelo (Milanesi, pp. 616 ff). There arises,
194 however, a difficulty in connection with the St. Paul (on the upper left), the style of which varies from that of the other three statues.

Through these documents there is finally cleared up the question of the authorship of the statues of the Piccolomini monument, which could not be explained until all the documents were examined together. Those scholars who rested their belief on the early documents of 1501-1504 have held that the four figures of Peter, Paul, Pius and Gregory were authentic works of Michelangelo; for example: Thode, *Kr. U.*, I, pp. 67ff; Venturi, *Storia*, X, 2, pp. 27ff; Toesca, *Enciclopedia italiana*, sub Michelangelo. Those who took as their point of departure an analysis of the style rejected these statues and

ascribed them to pupils: Wölfflin, *Jugendwerke*, pp. 77*ff*; Rossi, *Rassegna d'arte Senese*, VII, 1911, pp. 11*ff*; Wilde, *Eine Studie*, p. 56; Rota, op. cit. A compromise between these two opinions is that of Schmarsow (op. cit., p. 18) which considers the upper left hand figure and the lower right hand figure as works of Michelangelo, while the other figures are attributed to pupils. That the Madonna in the middle upper niche is a Sienese work of the fourteenth century and inserted in the Piccolomini monument from another work was rightly ascertained by P. Rossi, op. cit., pp. 3*ff*.

Among the four statues, that of St. Peter in the lower right niche is most closely *188-190* related to Michelangelo's style of 1501 to 1504. Here not only does the drawing point to the master, but it is even possible that Michelangelo himself worked over the head of the figure by Baccio da Montelupo (see Tolnay, *Thieme-Becker*, where the author called the figure St. James. Rota, op. cit., has corrected this error). [Addenda, No. 24]

XXIV. RED TERRACOTTA FIGURE OF A NUDE YOUTH

Florence, Casa Buonarroti. Inv. no. 413.
H. 49 cm.

Right arm destroyed.

Vasari (ed. Milanesi, pp. 152*f*) speaks in general of "piccioli modelli di cera o di terra o di stucco" which the sculptors of the Renaissance executed before they made large models "grande quanto quella stessa figura che si cerca di fare di marmo." Vasari twice mentioned small models in referring to Michelangelo. In the introduction (ed. Milanesi, I, p. 177, and Vasari, 1568, p. 307) he says "egli [Michelangelo] prima di terra o di cera ha per questo uso fatti i modelli." The second time (Vasari, 1568, p. 250) he says that Michelangelo made a gift of "modegli e di cera e di terra" to Antonio Mini.

Already in the middle of the sixteenth century the model in the Casa Buonarroti was *286, 287* copied in a red chalk drawing, now in the Uffizi, which shows the figure from the rear. *291* The model appears a second time in a portrait of Michelangelo made by an unknown master in the early seventeenth century in the Casa Buonarroti. There it is represented *292* among other original works surrounding the master. The right arm is visible. The figure seems, however, to be made of bronze.

In spite of these old replicas we do not believe that the statuette in the Casa Buonarroti is an original work of Michelangelo. The appearance of an original terracotta model may be determined from the model of Hercules and Cacus in the Casa Buonarroti, published by Wilde ("Zwei Modelle Michelangelos für das Julius Grab," *J. d. Kh. Slg. Wien*, 1928, pp. 119*ff*). The technique of the statuette of the youth is very different. The manner of treatment especially the modelling of the legs, knees and left arm is too weak to be attributed to Michelangelo. It seems to be merely a copy of a lost model of the master, executed by the same artist who made the copy in the Victoria and

Albert Museum after the Hercules and Cacus group mentioned above (reproduced in Brinckmann, *Barock Bozzetti*, Frankfurt a.M., 1923, pl. 3). Brinckmann, op. cit., p. 42, has already expressed doubt about the attribution of this statuette to Michelangelo, while Bode, Bayersdorfer, Fabriczy, Thode, and Knapp attribute it to Michelangelo himself.

Generally it was supposed that this statuette was a model for the marble David. Already in the inventory from 1553 to 1568 of the *Guardaroba* of Duke Cosimo I of Florence in the Archivio di Stato in Florence (published by Steinmann, *Bibliographie*, p. 432), it is described, "uno modello di stucco del Gigante di Michelagniolo." However, Bayersdorfer (*Leben und Schriften*, Munich, 1902, pp. 84ff) contests the connection with the marble David and believes that the statuette should be related to the bronze David of Michelangelo, an unlikely supposition since the bronze David was in its motif inspired by Donatello's David according to the request of the Marechal de Gié. Thode (*Kr. U.*, I, p. 79, III, no. 581) supposes that the statuette was made in the period of the marble David, but was the model for another sculpture which Michelangelo never executed. Fabriczy ("Kritisches Verzeichnis toscanischer Holz- und Tonstatuen bis zum Beginn des Cinquecento," *J. d. p. K.*, xxx, 1909, Bh. p. 40, no. 142) contests the dating in the early period and suggests the period of the Medici Chapel, insisting that the expression of the head recalls that of the Victory group. Brinckmann, op. cit., p. 42, who objects to the attribution to Michelangelo, says that the figure recalls the work of the master after 1520.

We believe that the lost original could have been made in the period of the Doni Madonna, ca. 1505-1506. The proportions of the supple body recall the nude figures in the background of this painting.

There exist besides the already mentioned Uffizi drawing and the portrait of Michelangelo, two bronze copies, one from the middle of the sixteenth century in Berlin, and the other from the end of the same century in Zurich. In both copies the right arm has been added in imitation of the left arm of the marble David.

289
290

XXV. SO-CALLED MODEL FOR THE DAVID IN WAX

Florence, Casa Buonarroti. Inv. no. 422.
H. 55 cm.

Both arms missing.

Several breaks in the legs and neck. The right leg seems to be falsely restored. Originally its position was probably nearer to the left leg.

288 This statuette was generally considered as a model for the marble David, but Thode, *Kr. U.*, I, p. 79, III, no. 589, contested this and thought that the statuette was a project for one of the slaves of the Julius Tomb. Brinckmann (op. cit., p. 26) considers it an original by Michelangelo and dates it in the period of the marble David. The execution

is too weak, however, to be attributed to the master. It is probably a copy of a lost *bozzetto* which was executed ca. 1505 and could be, as Thode supposes, intended for one of the slaves of the first project of the Julius Tomb.

There are four red-wax models in the Victoria and Albert Museum in London, which are considered as probable studies for the marble David by E. Maclagan-M. Longhurst, *Victoria and Albert Museum. Catalogue of Italian sculpture*, London, 1932, nos. 4106-1854 David; 4109-1854 right arm; 4110-1854 right leg; 4111-1854 left leg. See also E. Maclagan, *Burl. Mag.* XLIV, 1924, pp. 4*ff*. These weak models which differ technically very much from the only authentic model of Michelangelo in the Casa Buonarroti have the slender proportions of the works of the mannerists from about 1570-1580. They were already rejected by Thode, *Kr. U.*, I, p. 80 and III, p. 284.

XXVI. CRUCIFIXION OF ST. ANDREW

Florence, Bargello.
Marble relief.

Originally the work was conserved in the Opera di Santa Maria del Fiore. In 1823 the work was transferred to the Gallery of the Grand Duke. From there it was taken to the Bargello (see L. Dami, "Un opera misconosciuta di Michelangelo," *Dedalo*, VII, 1926-1927, pp. 29*ff*).

Mentioned for the first time as a work of Michelangelo in the Inventory of 1825 of the Gallery of the Grand Duke. The work was a second time attributed to Michelangelo by Dami, op. cit., who dates it ca. 1501. Thode, *Kr. U.*, II, p. 510, doubts that it is a work by Michelangelo and attributes it to B. Bandinelli. Popp, *Die Medici Kapelle*, p. 130, attributes the work (in our opinion correctly) to Niccolò Tribolo.

XXVII. APOLLO AND MARSYAS

New York. Art dealer.
Marble relief.
H. 40 cm., W. 30 cm.

This work was first published as Michelangelo by Bode, "Eine Marmorkopie Michelangelos nach dem antiken Cameo mit Apollo und Marsyas," in *J. d. p. K.*, XII, 1891, pp. 167*ff*. Also attributed to Michelangelo by H. Mackowsky (*Michelangelos frühstes Werk*, privately printed, 1929), who gives the complete bibliography concerning the work. The attribution is refuted by almost all scholars (see Frey, *Q.F.*, pp. 95*ff*). This crude work seems to be that of a dilettante, who in his style was already under Michelangelo's influence, and who executed the work about 1520/30. The technique differs much from that of Michelangelo. Michelangelo never removes the edge of the original outline of the block in his reliefs; such a removal occurs here.

[233]

The composition of this relief goes back to an antique gem which belonged about 1428 to Cosimo de' Medici. We know that the gem was set in gold by Ghiberti, who added an inscription (see Schlosser, *Ghiberti's Denkwürdigkeiten*, 1912, I, p. 47). The antique gem is now lost but there exist several copies of it done in the fifteenth and sixteenth centuries; for example, one in the Museo Nazionale in Naples and four bronze copies in Berlin. Concerning the use of the motif in monumental sculpture see Müntz, *Les précurseurs de la Renaissance,* p. 196. This work was discovered by Carl E. von Liphart in Florence at the end of the nineteenth century.

XXVIII. APOLLO STATUETTE

Berlin, Deutsches Museum.
Marble.
H. 68 cm.

268-270 First published and attributed to Michelangelo by Bode, "Eine Apollo-statuette Michelangelos im Berliner Museum," *J. d. p. K.*, XXII, 1901, pp. 88*ff.* According to Bode, the statuette dates from after 1500. It comes from the Borghese Collection in Rome. Justi, *Ma., N.B.*, pp. 41*ff*, considers the statuette to be by Michelangelo, yet he dates it before 1492. In his opinion, the statuette is made upon an antique model, as is the gem of Apollo and Marsyas. Thode, *Kr. U.*, I, pp. 14*ff*, agrees that it should be attributed to Michelangelo, and dates it shortly after the Battle of Centaurs. F. Schott-müller, *Staatl. Museen zu Berlin. Die Italienischen und Spanischen Bildwerke der Renaissance u. des Barocks.* Berlin, 1933. No. 240: "Letztes Drittel des 16. Th-s."

On the other hand, Frey, *Q.F.*, pp. 98*ff*, has expressed doubts as to the authenticity of the work because of the weakness of its execution.

Michelangelo's method of working in marble is imitated in the statuette. The attitude of the figure, however, is unmotivated; the right hand is leaning upon a tree, while the whole body is in a relaxed contraposto. The statuette is carved from a shallow block, which gives no side views, in contrast to Michelangelo's preference for deep blocks. While the ensemble gives an impression of roughness, the details (legs, feet, and face) are extremely delicate, and therefore do not resemble the works of Michelangelo.

XXIX. DYING ADONIS

Florence, Bargello.
Marble.

273 This statue is first mentioned by Borghini, *Riposo*, III, p. 126, as being by Vincenzo de' Rossi, with whose style it coincides completely. This correct attribution is renewed and supplemented with sound arguments by Grünwald, "Über einige unechte Werke Michelangelos," *Münchner Jahrbuch*, V, 1910, pp. 22*ff.* Before Grünwald, Wölfflin,

Jugendwerke, p. 84, had already expressed doubts as to its attribution to Michelangelo. J. v. Schlosser, *Werke der Kleinplastik in der Skulpturensammlung des A. H. Kaiserhauses*, Wien, 1910, p. 7, attributed the Adonis to Vincenzo Danti, an attribution which was rejected by Grünwald, *Florentiner Studien*, pp. 21ff.

For the first time this work was attributed to Michelangelo by Cambiagi, *L'Antiquario Fiorentino*, Firenze, 1765. p. 244.

XXX. ST. SEBASTIAN

London, Victoria and Albert Museum, no. 7561—1861.
Marble.
H. 91.5 cm.

The statuette came from the Gigli Collection in Florence. See Migliarini, *Museo di sculture ... posseduto da O. Gigli*, Florence, 1854. 271

The statuette was attributed to Michelangelo by J. C. Robinson, *South Kensington Museum. Italian Sculpture. Descriptive Catalogue*, London, 1862, pp. 145ff.

E. Maclagan and M. Longhurst, *Victoria and Albert Museum. Catalogue of Italian sculpture*. London, 1932, p. 132, no. 7561-1861: "Dr. Middeldorf has recently suggested that the figure is by Tribolo on the ground of its similarity in style with a statue of Victory in the Palazzo Alessandri at Florence."

XXXI. BACCHUS WITH AMPELOS

Florence, Uffizi.
Marble.
A restored antique sculpture.

The restoration of this antique torso was attributed to Michelangelo by Bode, 272
J. d. p. K., II, 1881, pp. 76ff. Bode follows here a suggestion of Bayersdorfer. Wölfflin, *Jugendwerke*, p. 74, has refuted this attribution with excellent arguments. Grünwald, "Über einige unechte Werke Michelangelos," *Münchner Jahrbuch*, V, 1910, pp. 28ff, attributed the work rightly, in our opinion, to Giovanni Caccini. C. Gamba, "Silvio Cosini," *Dedalo*, X, 1929-1930, p. 240, credits Cosini with the work of restoration. M. Neusser, "Antikenergänzungen der Florentiner Manieristen," *Wiener Jahrbuch für Kunstgeschichte*, VI, 1929, pp. 27ff, opposes the attribution to Michelangelo and concurs with Grünwald in attributing it to G. Caccini. The antique nucleus of the statue is a replica of the so-called Narcissus. Neusser supposes that Caccini followed probably in his restoration the composition of a now lost group by Vincenzo de' Rossi representing a Bacchus and Satyr, described by Borghini, *Riposo*, III, p. 125, and by Baldinucci, *Notizie dei professori del disegno*, III, p. 485. (For further bibliography see Neusser, p. 32, note 14.)

PAINTINGS FALSELY ATTRIBUTED TO
MICHELANGELO'S YOUTH

THERE exists a group of six paintings, all executed by the same hand, and which are wrongly attributed to Michelangelo. They seem to be by a sculptor; the manner in which the figures are posed on a pedestal, the closed silhouette, the treatment of the hair and the folds of drapery indicate an artist who was accustomed to working in marble. He was strongly influenced by Michelangelo, from whom he took his types and his poses, but he sought to reconcile the Michelangelesque elements with those of "classic" Florentine artists, notably Bugiardini, Franciabigio, Sogliani and Granacci. The earliest of these works already under the influence of the Sistine Ceiling may be dated about 1515; the latest influenced by the Florentine mannerists (Pontormo), about 1535.

These works are:

277 XXXII. Virgin with Christ-Child and St. John the Baptist, London, private collection, published by G. Fiocco as being by Michelangelo in "Un'altra pittura giovanile di Michelangelo," *La Critica d'Arte*, II, 1937, pp. 172*ff*.

276 XXXIII. Virgin with Candelabrum, Vienna Academy, considered by C. J. Holmes, "Where did Michelangelo learn to paint?" *Burl. Mag.*, XI, 1907, pp. 235*ff*, as the work of a Ferrarese master at the end of the fifteenth century; by B. Berenson, *Drawings*, I, p. 253, as a work of Bugiardini; by A. E. Popp, "Garzoni," *Belvedere*, VIII (1925), pp. 6*ff* and Eigenberger, *Katalog der Akademie d. Bild. Künste*, Vienna, p. 251, as a work of Antonio Mini.

XXXIV. Virgin, Swiss private collection, hitherto not published, and mentioned by G. Fiocco, *Critica d'Arte*, II, 1937, pp. 172*ff*.

278 XXXV. Manchester Madonna, London, National Gallery, attributed to Bugiardini by Berenson, loc. cit.; to Michelangelo by Holmes, loc. cit. and Fiocco, loc. cit.; to Jacopino del Conte by A. Venturi, *L'Arte*, XXXV, 1932, pp. 332*ff* and *Storia*, IX, 6, p. 233, and to Antonio Mini by A. E. Popp, loc. cit. The first to express doubts on the attribution of this work to Michelangelo was Wölfflin, *Jugendwerke*, pp. 79*ff* who rightly pointed out that this work is made in imitation of Michelangelo's style of 1501-1505.

110 The Saint John is made after a drawing by Michelangelo, No. 34 (Popp). The singing angels in the second plane are probably inspired by Luca della Robbia. [Addenda, No. 25]

279 XXXVI. Virgin with Children, Dublin, National Gallery, attributed to Michelangelo by G. Fiocco, "La data di nascita di F. Granacci," *Rivista d'Arte*, XIII, 1931, pp. 3*ff*, 109*ff*. [Addenda, No. 26]

281 XXXVII. Burial of Christ, London, National Gallery, attributed to Michelangelo by Berenson, *The Florentine painters of the Renaissance*, New York, 1896, p. 122;

280 Holmes, loc. cit.; to Battista Franco by F. Antal, *Z. f. Kg.*, I, 1932, p. 383; to Carlone by

A. E. Popp, loc. cit., who indicated the connection between the kneeling women at the left with a drawing in the Louvre, J. C. Robinson in *The Times*, Sept. 1881, attributed the work to Bandinelli. Wölfflin, *Jugendwerke*, p. 82, showed with excellent arguments that the work cannot be attributed to Michelangelo, but brings together types from different periods of Michelangelo's works, especially of the late paintings of the Sistine Ceiling. [Addenda, No. 27]

280

Concerning the probable connection between the composition of the Burial in London and the Burial of Rogier Van der Weyden in the Uffizi see: A. Goldschmidt, "Michelangelos Grablegung in London und Rogier v. d. Weyden" in *Sitzungsberichte der Berliner Kg. Gesellschaft*, Dec. 11, 1903, no. VIII, pp. 56ff and A. Warburg, *Ges. Schriften*, I, p. 215 and p. 381.

The most likely of these attributions is that of Popp, that the paintings are by Antonio Mini, who was a "garzone" in the service of Michelangelo from the autumn of 1523 to the autumn of 1531. We have no painting signed by Mini, and his drawings are less precise than the work in these paintings. It is possible, that one of the other garzoni of Michelangelo, for example Silvio Falconi, Pietro Urbano or Tiberio Calcagni, might have done the paintings. (Concerning Antonio Mini, cf. also Appendix III.)

APPENDICES

INTRODUCTION TO APPENDICES

A large portion of the correspondence written to Michelangelo remains still unpublished in the Archivio Buonarroti. We shall publish these letters in the notes and appendices of the different volumes of this work, always giving the most relevant part of each letter, except for certain outstanding ones which we publish in full. On the other hand, in the case of letters which have no direct connection with Michelangelo, but which concern only the private affairs of the correspondent, we give only the name of the writer and the date. Thus we shall have, together with that which has already been published, the complete correspondence of Michelangelo as far as it has been preserved. [A critical edition of the correspondence by Giovanni Poggi is now in preparation.]

I wish to characterize briefly the importance of the material which we have here: it comprises precious information on the association of Michelangelo with the clergy, whose letters influenced the master's spiritual views, notably his conceptions of Fortuna-Fatum, and of spiritual love as it is found expressed later in his poetry. The letters give us new proof that Michelangelo did not work according to a program laid down by his patrons, but that the latter, with the breadth of mind appropriate to their period, allowed him a free hand in the matter of the invention of his works. One letter contains information on the much-discussed question of whether there were contemporary forgeries of the master's work. A letter by Cornelia Colonelli reveals the religious habits of Michelangelo. Several of them show the goodness of character of Michelangelo, always ready to assist the needy, and the touching solicitude with which he watched the destiny of the children of his faithful servant Urbino. Other letters are interesting because they contain biographical details, especially concerning family affairs. We find, finally, new information about the following works of Michelangelo: the cartoon of the Cascina Battle; the bronze David; the Apostles; the façade of San Lorenzo; the Tomb of Julius II; the statue of Christ in S. Maria sopra Minerva; the Medici Chapel; the Library of San Lorenzo; the "pergamo" of San Lorenzo and several projects never executed.

My sincere thanks are due to Soprintendente Comm. Giovanni Poggi, director of the Casa Buonarroti, who kindly gave me permission to examine, copy, and publish the letters; and also to Professor Mary Pittaluga and Professor C. Fasola, director of the Uffizi Library, who did much to facilitate my research.

I. Hypotheses Concerning the Origin of Michelangelo's Style

ALREADY in the oldest biographers, in Condivi and Vasari, we find two opinions about the origin of Michelangelo's style. In Condivi's account (p. 12), Francesco Granacci, Michelangelo's youthful friend, plays the leading role in Michelangelo's early development. This view was recently taken up by G. Fiocco, "La data di nascita di F. Granacci e un'ipotesi michelangiolesca," *Rivista d'Arte*, XIII, 1931, pp. *3ff* and *109ff* and "Una altra pittura giovanile di Michelangelo," *La Critica d'Arte*, II, 1937, p. *172ff*. Fiocco shows that Granacci was six years older than Michelangelo; he attributes to Michelangelo's earliest period a Madonna in the National Gallery, Dublin, and seeks to show the influence of Granacci in this work. In his second article, Fiocco attributes two other works to the same period, a Madonna in a Swiss private collection (not published) and a Madonna in London, also in a private collection.

Fiocco's hypothesis does not hold, however, because the Madonna in the National Gallery, Dublin, as well as the one in the private collection in London, is by the master of the Manchester Madonna in London (see Catalogue of Falsely Attributed Works, p. 236).

Vasari (pp. *13ff*) on the other hand, emphasized the influence of Ghirlandaio on Michelangelo's artistic beginnings. This view was followed especially by K. Frey, *Ma.*, I, pp. *26ff*. However, neither Vasari nor Frey succeeds in showing direct influence by Ghirlandaio on Michelangelo's earliest works.

C. J. Holmes, "Where did Michelangelo learn to paint?" *Burlington Magazine*, XI, 1907, pp. *235f* did not consider the earliest works of Michelangelo but occupied himself with the Bologna period and assumed influence from the Ferrara school. He believes the Manchester Madonna and the Burial belong to Michelangelo's Bologna period. He attributes the Vienna Tondo to a minor artist of the Ferrara school (see Catalogue of Falsely Attributed Works, p. 236).

Our hypothesis, namely, that Michelangelo's earliest style contains the influence of Pollaiuolo, in addition to a very personal interpretation of antiquity, is sustained by the fact that this Pollaiuolesque style component is perceptible not only in the Triton (No. 1), but also breaks through repeatedly in Michelangelo's further development; e.g. in the Doni Madonna, the Battle of Cascina and even in the Last Judgment.

II. Concerning the Bronze David and the Battle of Cascina

THERE is a letter in the Archivio Buonarroti from Tommaso di Balduccio "commandatore" in Florence to Michelangelo in Rome of September 2, 1508. The bronze David and the Cascina cartoon are mentioned in this letter.

". . . [Il] signor Gonfalonere mi fe' chiamare, e dice che io ve facia intendere che arebe disidero grande voi venisi qua, perchè bisogna finire e tosto el vostro Davete di bronzo. Quando none potesi venire, che arebe caro voi lo finissi, voi faciate di darci aviso tosto chi pare a voi sia più a vostro proposito sia per finirlo di questi maestri sono qui, perchè questo vi parà in furia; secondo che il Gonfalonere m'acenna, a'si a donare e questo à esere presto. Si chè no ne pigliate amiratione nessuna.

"E mi istato deto che è v'è suto [stato] iscrito, come e' cartone e suto disegnato. Io v'ò attenuto la fede, ma è vero ch'è suto disegnato, e la cagione si è che io andai in Bardano per 8 giorni, lasciai la chiave a Messer Agnolo [Manfido]. . . ."

NOTE: Tommaso di Balduccio, held, together with Agnolo Manfido one of the two heralds of the city, keys to the great hall of the Signoria of Florence, in which Michelangelo's Cascina cartoons were then preserved (see Milanesi, p. 95 and the letter of Agnolo Manfido, November 12, 1510, Frey, *Briefe*, p. 19). To these the word "cartone" here refers. By "gonfaloniere" is meant Pietro Soderini.

The "Davete di bronzo" mentioned in the letter is the bronze David executed by Michelangelo on the commission of Pietro Soderini for Pierre de Rohan and which was not completed until November 6, 1508.

According to this letter, somebody copied the cartoon of the Cascina. This person seems to have been the Spaniard Alonso Berruguete. Michelangelo recommended him to Buonarroto in a letter of July 2, 1508 (Steinmann, *Sixtinische Kapelle*, II, p. 700, no. 20). But in a letter of July 31 of the same year (Steinmann, loc. cit., no. 25) he expressed his satisfaction on hearing that the Spaniard was not allowed to see the cartoon. The above quoted letter shows that the Spaniard did succeed in making the copy. This fact is reported by Vasari (ed. Milanesi VI, p. 137; VII, p. 161) who says that this was done ca. 1512, while the letter shows that it was done at the end of August or the beginning of September 1508. We know from a letter of 1512 that Alonso was ill in 1512 (Steinmann, loc. cit., no. 80).

THERE are many proofs of Michelangelo's generosity toward other artists. Vasari (1568, p. 247) disputed the common opinion that Michelangelo was reluctant to help other artists. "E questi che dicano, che non voleva insegnare, hanno il torto, perchè l'usò sempre a suoi famigliari et a chi dimandava consiglio." He mentions Piero Urbano Pistolese, Antonio Mini, and Ascanio Condivi and in another place (p. 256) he says that Michelangelo helped Menighella "pittore dozzinale," Goffo di Valdarno, and Topolino. He says that Michelangelo gave drawings to Sebastiano del Piombo and Gherardo Perini (p. 250). We know, on the other hand, that he helped Benvenuto Cellini and Tribolo (Frey, *Briefe*, p. 260).

This list can be augmented by some unpublished letters in the Archivio Buonarroti.

1. There are letters by Vettorio (Vittorio) di Buonacorso Ghiberti (b. 1501 in Florence, d. 1542), great-nephew of Lorenzo Ghiberti and himself a sculptor and architect. (Concerning Vettorio Ghiberti see Vasari, ed. Milanesi, II, pp. 246, 249 and VII, p. 334.) Ca. 1520-1521 he was in Naples, where he executed marble busts for the façade of the Palazzo Gravina (Palazzo della Posta). One of his letters sent to Michelangelo on November 19, 1521, is published in Frey, *Briefe*, p. 183. There remain three other letters in the Archivio Buonarroti, the first one of October 21, 1520, written from Naples to Michelangelo, no address given. "Non [ho] trovato li marmi mia c[h]'io ò fatto cavare costà [i.e. in Florence]."

The second letter of November 30, 1520, from Naples to Michelangelo in Florence contains the sentence ". . . Idio grazia, e marmi m'è avisato arivorno insino 10 giorni, sono qui a salvamento."

The third letter of July 7, 1521, still from Naples to Michelangelo in Florence, is the most interesting because it shows that he hoped that Michelangelo would furnish him two models for making figures and aid him in his work. We quote the most important sentences of the letter:

". . . Pietro (vostro garzone) mi dis[s]e c[h]'io no dubitasi, che quando avevo preso a fornito gnen' avisasi, ce farebe c[h]e voi m'aresti deto facesi dui figure sul vostro modelo e co l'aiuto vostro. . . . Però Julano Bug[i]ardini, no molto tempo pasato, ebi una sua letera per la quale mi risponde . . . con voi avere fato la racomandazione . . . che voi gli domandasti a che termine io avevo l'opera. . . ."

2. Another artist who was helped by Michelangelo was Valerio Belli (b. ca. 1468, d. 1546), a carver of glyptics from Vicenza. He generally worked from the drawings of other artists or from ancient gems. The two letters in the Archivio Buonarroti show that Michelangelo allowed drawings to be sent to him from which he could carve. The letters are briefly mentioned without the dates, yet not published, in Gotti, I, p. 145. The first letter is written by Valerio "che intalia le corniole in Vicenza" to Michelangelo in Florence, on January 10, 1521. He says, ". . . Vogliate . . . dare quelo desegno

me avete promiso al portatore di questa . . . e sarete causa che io farò una opera che me farà onore. . . ." The other letter is written on April 21, 1521. He repeats in it the demand of the first letter and continues "Siate contento de volerme far quel desegno che me prometeste, . . . perche io ho . . . una belisima pietra grande in ne la quale voria taliare questo disegno che me farete. . . ." [Addenda, No. 28]

3. Antonio di Bernardo Mini was an apprentice of Michelangelo between the end of 1523 and the middle of November 1531 when he left, apparently because of a love affair, for France where he died in 1533. Michelangelo gave him many drawings, the cartoon of the Leda, and small models before he departed. The greatest part of his correspondence is published in Frey, *Briefe*, pp. 313*ff* and in the excellent study by Dorez, *Nouv. Recherches*, I, pp. 448*ff*. This does not include an undated letter in the Archivio Buonarroti written apparently after May 8, 1532, for he speaks of recovering from an illness which is mentioned in a letter published by Frey, *Briefe*, p. 319 of this date. He says, ". . . io guarisco e spero d'esere guaritto fra pochi giorni. . . . No penso dì e notte se none a voi. . . ."

Some light on the love affair of Antonio Mini which may have been the reason for his departure from Florence is drawn from an unpublished letter by Giovanbattista Mini, his uncle, to Michelangelo. This letter is dated January 14, 1530 (*stile comune* 1531), but no place of origin or destination is mentioned. (Another letter from him addressed to B. Valori, was published by Gaye, II, p. 229, and by Gotti, I, p. 210.)

". . . non voglio manchare di darvi notizia di quello che segue circha a Antonio Mini a fine che voi . . . facciate qualche rimedio a le sue pazie . . . e questo si è, che 'n tendiamo per chosa cierta che m'è venuto a trovare uno amicho mio espresamente e dicie ch'egli è per torre per donna una fanciulla de' Caccini che sta in Pinti, e pare che la toglia per innamoramento e con poca dota. Questa è una grande pazia . . . per tuti e rispeti no lo dovrebe fare. Io vi pregho quanto so e posso, no li laciate fare ciò e arei charo se fusi posibile di parlargli. . . ."

There is another unpublished letter in the Archivio Buonarroti by Giovanbattista Mini in "chasa" to Michelangelo in "chasa" of May 17, 1532. He encloses with his letter a letter from Antonio Mini and asks for a meeting with Michelangelo.

4. That Michelangelo introduced Sofonisba Anguissola to art and that he gave her general advice—furthermore, that he may have sent her drawings from time to time which she attempted to color in oil—is proved by two letters to Michelangelo in the Archivio Buonarroti from her father, Amilcare Anguissola in Cremona. We publish here the extracts of these letters:

(a) May 7, 1557. Amilcare Anguissola, Cremona to Michelangelo, Rome: ". . . ci fa obligatissimo, è l'avere inteso l'onorata et amorevole affezione ch'egli à e dimostra a Sofonisba, io dico quella mia figliuola, alla quale ce ò io fatto principiare ad exercitarsi nell'onoratissima virtute del dipingere . . . pregaròlo che siccome per sua innata cortesia

e bontate la si è degnata nelli suoi ragionamenti per il passato questa mia figliuola introdurli, la se degna nell'avvenire alcuna volta . . . ancora introdurla . . . ve dignati mandarli uno vostro disegno perchè lei lo colorisse in olio, con obligo de rimandarlo di propria sua mano fidelmente finito . . . gli dedico essa Sofonisba per sua serva e figliuola. . . ."

(b) May 15, 1558. Amilcare Anguissola, Cremona to Michelangelo, Rome: ". . . trà tanti oblighi ch'io ho al S. Iddio, nel numero delli primi pongo, [ch'io] viva a tempo con tanti miei figliuoli, che uno tanto excl.mo gientilomo sopra ogni altro virtuosissimo veramente se degna laudare et giudicare le pitture fatte di mia figliuola Sofonisba. . . ." (Both letters are also published by the author in *Sofonisba Anguissola*, pp. 115*ff*.) [Addenda, No. 29]

Other letters prove Michelangelo's generosity toward the poor and needy. This characteristic of the artist seems to have been well known, as is witnessed by several already published letters and by the following hitherto unpublished correspondence which contains thanks for favors rendered or demands for aid.

5. Ser Raffaello da Ripa asked Michelangelo to aid one of his friends in a letter of July 14, 1529, place unknown. Raffaello is also mentioned in Michelangelo's records in 1533 (see Maurenbrecher, *Aufzeichnungen*, p. 143). The main part of the letter follows: "Desidero che voi adiutate uno mio grande amico che è Scriptore all'arcivescovado, che ha mancati dua volte: è Ser Benedecto di Francesco d'Albizo, che va per Sta Maria Novella, sotto il Lione rosso."

6. In a letter of April 6, 1532, written in the "Casa de lo Ill. Sig. Andrea Doria, principe di Malfi [in Genoa]" to Michelangelo in Florence, Silvio di Giovanni da Giaparelo, a servant formerly in Michelangelo's employ, offers his services to the master, saying ". . . e già appresso a due anni che me ritrovo in Genua al servizio dello Imo Sig. A. Doria. . . ." The contents of this letter are almost exactly repeated in another letter by Silvio dated April 13, 1532, published by Pini, *Scrittura*, pl. 132.

7. Madalena di Thomasso dal Borgo, Casteldurante, wrote to Michelangelo in Rome on October 28, 1562, thanking him for the three *scudi d'oro* which she received as alms from Michelangelo.

8. On August 12, 1563, Piero Bettini of Casteldurante wrote to Michelangelo in Rome thanking him for credits ("crediti") which Michelangelo extended to his son. Piero Bettini is mentioned in Frey, *Briefe*, pp. 387*f*. There is another unpublished letter by him of November 24, 1561 in the Archivio Buonarroti (see below).

9. In the Archivio Buonarroti are unpublished letters by Cornelia Colonelli, Giulio Brunelli, and Giovanni Francesco Amadore, called Fattorino, which bear witness to Michelangelo's generosity. Cornelia Colonelli was the wife of Francesco di Bernardino, called Urbino, of Casteldurante, the faithful servant of Michelangelo who entered his service shortly after Antonio Mini's departure for Lyons in November 1531 and remained with him until his death on December 3, 1555. In his will of November 14,

1555, published by Gotti, II, pp. 127*ff*, Urbino carefully arranged the disposal of his property among his heirs. He named Michelangelo the first of three executors of his last wishes, appointing him guardian of his first child, Michelangelo, named after the artist, and another whose birth was soon expected and who was named Francesco, after the father. Michelangelo took his position as guardian very seriously and administered the affairs of the widow and children until his death. Cornelia had only mediocre gratitude for the kindness shown her. About four years after Urbino's death, January 10, 1559, Cornelia announced to Michelangelo that she was to be married to Giulio Brunelli, a doctor of law from Gubbio who was at that time *Podestà* of Casteldurante, a rich, respectable and learned man (see Frey, *Briefe*, pp. 350*f* and 360*f*). Michelangelo at first did not give his consent to the marriage and did not answer her letter. However, the marriage took place at the end of April, 1559 (see Dorez, *Nouv. Recherches*, II, pp. 179*ff* and Gotti, I, pp. 338*ff*).

The main parts of the unpublished letters follow.

(a) No date (at the end of May or June, 1557 or 1558?), Cornelia Colonelli [Casteldurante] wrote to Michelangelo in Rome. ". . . a chi io dò li denari non fanno il buon ofizio et penso che proceda da quelli di casa. . . ."

NOTE: Probably allusion to Pier Filippo and Giovanni Francesco Amadore, called Fattorino, the two other guardians of Urbino's children of whom Cornelia has complained in other letters (see below). Giovanni Francesco Amadore was the brother of Urbino. Concerning him see Frey, *Briefe*, pp. 363, 365*f*, 368*ff*, 376, 384*ff*.

(b) April 19, 1558, Cornelia Colonelli in Casteldurante to Michelangelo in Rome. ". . . noi avemo comperato una possessione comodissima al podere. . . ."

(c) April 19, 1558, Cornelia Colonelli and Giovanni Francesco Amadore in Casteldurante to Michelangelo, no address. ". . . Vostri putti Michelagnolo et Francesco stanno bene, son vivaci. . . ."

NOTE: The Michelangelo and Francesco mentioned here are the children of Urbino.

(d) June 24, 1558, Cornelia Colonelli in Casteldurante to Michelangelo in Rome. She excuses herself for not having answered Michelangelo sooner but she has been ill. She has received the 97 *scudi d'oro* which Michelangelo sent her by Pasquino and has bought a piece of land with the money. She has finished paying for the field.

(e) August 7, 1558, Cornelia Colonelli in Casteldurante to Michelangelo in Rome. ". . . Questi di passati mio patre ebbe una vostra, a piede della quale erano due righe a me in particulare. Io la ringrazio grandissimamente del suo buon consiglio, so che per l'affezione che lei me porta, che me consigliava amorevolmente; niente di meno non è sucesso la cosa perchè forse anco non era ordinato da Iddio. Queste sono cose che sempre, come scriveva V.S. se devono fare con orazione e pregare Iddio che facci quello sia per il meglio, il che s'è fatto quanto più devotamente s'è potuto. Non essendo successo, dovemo pensare al fermo che la divina Maiestà non ne abbia fatta disposizione. . . .

"Mio patre, mia matre, Michelagnolo e Francesco ve se racomandano."

Note: It is not clear what she refers to in the letter. This letter is interesting because it once again reveals Michelangelo's religious customs. He advised her to pray.

(f) April 8, 1559, Cornelia Colonelli in Casteldurante to Michelangelo in Rome.

". . . Quanto al vendere il Monte della Fede, io non ho per ancora parlato con Pier Filippo, pure senza che io gli parli altrimente, in questo caso farete pur voi tutto quello che cognioscerete esser utile per questi putti. . . ."

Note: Michelangelo placed the money which Urbino had left in the Monte della Fede, in Florence. (See Milanesi, p. 607.) This letter of Cornelia indicates that she wished to take the money from the Monte della Fede.

(g) June 15, 1559, Giulio Brunelli of Gubbio in Casteldurante to Michelangelo in Rome. He writes that since summer has come he has decided not to visit Michelangelo but he hopes that Michelangelo will soon become acquainted with him and will be pleased with him,

". . . si per conto de detta donna Cornelia, si ancora per causa de' putti, alli quali sempre arò l'occhio, come si fosseno miei propri. . . . Io già dui anni sono me dottorai in Perugia, e subbito me ne venni a questa podesteria . . . e stia sicuro che li putti di Francesco hanno racquistato un altro patre."

The last sentence quoted above was published by Frey, *Briefe*, p. 365. Giulio Brunelli, as we said, was the second husband of Cornelia.

(h) December 24, 1559, Giulio Brunelli in Casteldurante to Michelangelo in Rome. He wishes some information on Cornelia's dowry and he makes plans for the disposition of this money. ". . . Sapiate certo che li putti da me non sono per avere mai male nissuno; penso che d'amore e carità se averanno raquistato il padre. . . ."

(i) April 27, 1560, Cornelia Brunelli in Casteldurante to Michelangelo in Rome. She proposes to buy a piece of land for the children with the money in the Monte della Fede. She regrets that Michelangelo does not have good servants, but in case of necessity she, and her husband as well, are ready to go to him in Rome. The children are becoming "grandi e cativi."

Note: The proposition to buy a piece of property was carried out as shown in the letter in Frey, *Briefe*, p. 387.

(j) January 7, 1561, Cornelia Brunelli in Casteldurante to Michelangelo in Rome. She complains of Pier Filippo and Fattorino. She proposes to acquire a third of the "podere" for the children. Until now, she has received from her dowry only about 200 florins from which about 40 were spent for food for the children. She asked Michelangelo:

"faciate che io sapia qual sia il mio o in denari, o in possessioni, come meglio parerà a voi che torni più comodo a questi figlioli, perchè qui parlo con Pier Felipo, parlo con il Fatorino, ognuno non si vole travagliare. . . ."

(k) March 26, 1561, Cornelia Brunelli in Casteldurante to Michelangelo in Rome. She was present at the death of her father on March 17. He died "come un santo, con

[248]

tutti li Santissimi Sacramenti ordinati da la Santa chiesa . . . ha fatto testamento e lasciato patrona mia madre del tutto in vita sua. . . ." Pier Filippo wants to be paid for expenses incurred on his visit to Michelangelo in Rome to discuss the finances of the children of Cornelia.

(l) March 28, 1561, Fattorino and Giulio Brunelli in Casteldurante to Michelangelo in Rome. They are in litigation with Giolla, former wife of Rosso, who seems to have in hand a good part of the money of the children. They ask Michelangelo for another copy of the mandate made by him personally for Fattorino. Pier Filippo wishes to be relieved of his responsibility toward the children. They also ask for the testament in legal form.

(m) August 13, 1561, Fattorino, no place, to Michelangelo in Rome. ". . . havemo fatto el contratto [concerning the purchase of property] como vederà per mano di publico notario."

(n) September 4, 1561, Fattorino in Casteldurante to Michelangelo in Rome. He sends the contract of the purchase of the property. There is another letter of Fattorino, dated February 25, without the year, to Michelangelo, now in the Archivio Buonarroti, concerning this same matter.

(o) November 24, 1561, Piero Bettini (or Bettino) [in Casteldurante] to Michelangelo, no place. ". . . Sopra la ratificazione che deve Cornelia moglie de Messer Giulio a Vra Signoria. . . ."

(p) December 12, 1561, Giulio Brunelli in Pesaro to Michelangelo in Rome. ". . . ratificazione deli dinari [of the purchase of the property]."

(q) December 15, 1561, Cornelia Brunelli, no place, to Michelangelo, no place. She sends him the ratification of the contract of the purchase of property and asks him to take the money from the Monte to pay for the land.

(r) December 19, 1561, Giulio Brunelli in Pesaro to Michelangelo in Rome. See next letter.

(s) February 26, 1562, Giulio Brunelli, no place, to Michelangelo, no place. He asks again for money from the Monte to pay for the land. Cornelia has given birth to a child.

(t) July 19, 1562, Giulio Brunelli in Casteldurante to Michelangelo in Rome. Letter of no importance.

(u) March 30, 1563, Giulio Brunelli in Casteldurante to Michelangelo in Rome. This is the last letter from Giulio Brunelli. There is a still later letter from Cornelia Brunelli on April 12, 1564, addressed to Lionardo Buonarroti, nephew of Michelangelo, now in a private collection in France, published by Dorez, *Nouv. Recherches*, II, p. 183.

THERE are two unpublished letters and another partly published in the Archivio Buonarroti which testify to Michelangelo's spiritual ties with members of religious orders and which reveal their influence on the artist's spiritual views.

1. The first one is a letter by Fra Lorenzo Viviani written from "Bologna la Grassa" to Michelangelo in Florence on March 15, 1507 (*stile comune* 1508). Fra Lorenzo was, as he says in his letter, a Florentine by origin and a preacher, probably in the Dominican order. The letter (Archivio Buonarroti, Cod. XI, no. 770) follows:

"Ebi più fa una tua, vista e letta tanto volentieri da mme, quanto so che tu medesimo to lo stimi. Però non ti farò troppi onbroni, dominator mundi.

"A tutti quelli che furno partefici del carnascalino dalla tua buona memoria in vita lasciaron. De' tua affanni, mè seppe tanto male del mondo; e per tanto se' tu imbrodolato di fango e mai in brodo di capponi; sè tu cascato e la bestia adossoti e noi per ristoro cascamo adosso ad altri, idest a dua fagiani per vendicare tua onta e laus deo che tu e noi salvi siamo sin de tanti pericoli. Credo a ogni modo le nostre oratione e digiuni e vigilie t'abbino non poco giovato: éssi è fatto volentieri che ne eravamo tenuti.

"La tua a Piero gliene mandai e credo l'arà auta più fa detto ti mandò e panni tua—cioè un fardello con le lettere che lo debbi avere auto per tempo e questa lettera adesso mandatami che a lui va, forse glie ne darò in persona, che piacendo a Dio domattina parto per Ferrara e sarò fra 15 dì di ritorno, che qui ò da fare cattiva quaresima.

"Intendo per questa tua de' 11 di questo, stimi essere libero da Roma e fai pensiero venire a la volta di qua. Emi tanto a grato, quanto mio fratello proprio vedessi, e tanto più, quanto honore e utile andrai per acquistare; che Dio quello ch'è 'l nostro meglio ne indirizzi. Intendo siate in pace e tranquillità che m'è somma consolazione sentire la patria mia giubbilare; che bene non ci possi stare, son pure fiorentino. Qui e per tutte queste bande e di là da Po sono in gran travagli chi di loro medesimi dubita chi di suo stato e chi d'una cosa e chi d'altra; e in effetto a mio giudizio mi pare che chi à più roba e stato, à più pensieri; chè non v'è meglio, chi lo può fare, starsi a quello che la fortuna innanzi gli pone, e tutto in buona parte accadesse, accettarlo; Non dico però aspettando la manna; aiutarsi per tutte le vie giuste e oneste che altro non resta di noi, idest degli uomini virtuosi la fama, che secondo el nostro potere è necessario o morire secondo che la nostra coscienza ci conforta o lassa meritare secondo le nostre opere di qua fatte. Dirai forse in questa mia lettera ch'io salti d'Arno in Bacchillione: non te ne maravigliare, perchè questo mondo d'oggi va così agli svarioni. Lorenzo ti saluta e ricordati quando parli al gonfaloniere, abbi a mente la sua faccenda. Òllo confortato stia a buona speranza, che tu non lo dimenticherai, perchè lui dissemi tu averlo alla partita di qua dimenticato: dissigli, fu all'improvisa e che se non n'avessi auto bisogno di cavalcatura el simile a me facévi: è restato contento a tuo avviso.

"Quando vedi Raffaello mio fratello, salutalo per mia parte; questo dico perchè nè della lettera per te mandatoti, nè di dua altre alui non ò risposta, in modo fo conto non gli dare più fastidio: che bene è vero quello che diceva Coriolano romano, ch'è gran dolore essere vecchio e fuore della patria e mendico d'amici. Livio nella prima Deca. E pure Dio del tutto sia laudato e sempre ringraziato, che ò speranza non mi abbandonerà e così lo prego.

"Dirai t'abbi stracco con tante circunferenzie fo teco a fidanza che la leggi quando tempo t'avanza. Starei teco più, ma perchè è sonato a predicha, non posso. Abbimi per iscusato. Un altra volta ti ristorerò. À piaceri tuoi. . . ."

NOTE: The phrase "Credo a ogni modo le nostre oratione e digiuni e vigilie t'abbino non poco giovato," refers probably to Michelangelo's trip from Bologna to Florence. Concerning Michelangelo's custom of having prayers said for him, see Milanesi, pp. 76 and 88, and our text, p. 39.

The expression "saltare d'Arno in Bacchillione" is to be found in Dante, *Inferno*, Canto xv, 1.113: "fu trasmutato d'Arno in Bacchiglione"; the names of rivers being substituted for those of the towns, i.e. Florence and Vicenza respectively, but is probably used here merely figuratively to signify jumping from one subject to another.

Concerning the remarkable juxtaposition of medieval fatalistic conception of Chance (Fortuna) as identified with Destiny (Fatum) with the Renaissance search for personal fame and the belief in man's ability to guide his own destiny, see the text, pp. 39*f*. The identification of Fortuna with Fatum reappears later in Michelangelo's poetry, for example Frey, *Dicht.*, LVIII:

"Fortuna e 'l tempo dentro a vostra soglia
Non tenta trapassar. . . ."

On the other hand, conception of Fame, as the only end which remains after life is expressed in Frey, *Dicht.*, XVIII:

"La fama tiene gli epitaffi a giacere;
non va né innanzi né indietro,
perchè son morti, e 'l loro operare fermo."

This verse is inscribed on the drawing, Frey, *Handz.*, 9, with projects for the Medici Chapel.

2. Another important proof of the influence of the clergy on Michelangelo's spiritual views is an unpublished letter by Frate Lorenzo delle Colombe from Rome to Michelangelo in Florence of August 16, 1516, now in the Archivio Buonarroti. In this, the only extant letter from Frate Lorenzo to Michelangelo, it is seen that he inspired the conception of spiritual love as found later in Michelangelo's poems. The mystical concept of the love of God as here expressed was transformed by Michelangelo into Platonic love in his poems dedicated to his friend Cavalieri (Frey, *Dicht.*, CIX, 19 and XLIV). This

idea of love reappears in the religious poems of Michelangelo's late period, e.g. Frey, *Dicht.*, CXL. We quote the main part of the letter:

". . . intendo (per una tua) essere arrivato a salvamento . . . mi pare sia confermata infra noi una fratellanza perpetua per avere tu riconosciuto, visitando el mio padre come tuo proprio. . . . Sai che lo amore non è terminato da luogo o tempo, massime quello di Idio; et più che tale amore transforma l'uno in l'altro, cioè l'amante nella cosa amata, et fa mutua penetrazione d'animi: però sendo io in te per lo amore ti porto, ti penetro et intendo, se pensi, se parli, se scrivi: et questo ti basti. Amiamoci dunque nel Signore, come habbiamo fatto in fino adesso, et intenderemo et conosceremo el tutto et la verità, et la vedremo ad faccia ad faccia, se viviamo bene et Cristianamente, attendendo ad scolpire in te col mazzuolo delle buone et virtuose opere la impronta di Cristo Crucifisso per noi; la quale si fa in fede e per fede informata di carità santa; nella quale Idio ti conservi et aderesca in dies. Vale et ama. . . ."

3. Finally there is a letter of April 13, 1518 by Frater Maximilianus Gratianus prothonotarius et abbas ex abbatia Camaiorese to Michelangelo in Pietrasanta concerning the boundaries of the property held by the abbey. The first part of this letter to the words "tra Pietrasanta et Camaiore . . ." is published by Frey, "Studien zu Michelangelo," *J. d. p. K.*, XVII, 1896, p. 13.

"Chiarissimo Michelagnolo. S'io volessi o pensassi, con lenocinio et dolcezza di laudi muovervi, ben sapria dir cò buone ragioni et exempli delle opere vostre, chè Apelles non fu miglior pictore, nè Praxitele ve averia tolto lo scarpello, nè Lisippo ve averia superato nei metalli, nè alcun altro in nel plasmar di terra, artificio iudicato archetipo et genitore exemplare in tutte le belle opere di metallo, di saxo e de pictura: aggiugneria la continentia e 'l riposo, la modestia et la mansuetudine, discurrendo per mille altre parti degne di gran commendatione, nate tucte et nutrite de benigno influxo, solertia, ingegno et bontà incomparabile. Ma per la servitù che insieme havemmo con la felice recordatione de papa Julio, nudamente et senza alcun colore di rectorica scrivendo, vi pregho, che avendo a andare mastro Donato [Benti] con voi o senza, a veder le confine di Marina tra Pietrasanta et Camaiore [published by Frey until here], siate contento fare o persuadere a lui che faccia relazione del vero.

"Et in vostra informazione dico, che essendo in antico intrecciati li territorii dei detti luoghi, el Marchese di Mantua, arbitro, li dirizzò e divise, tirando una linea dritta da un termine che era preso a Motrone in fino alla fontana di Rotaio, dove sono certe †[croci?] et perchè il tratto era lungo dui altri commissari, de saputa e consenso delle parti, furono posti in mezzo iij altri termini. Depoi furono svelti quel termine de motrone e due altri di quelli di mezzo.

"È manifesto, come ben sapete, che volendoli reponere ai luoghi suoi, conviene tirare una linea dalla fontana a quel termine che resta in piedi, di quelli di mezzo, e de lì adirittura alle acque salse, e dove batte la linea repiantarli. . . .

"Pertanto iudico esser meglio per la pace di questi populi che la confine si termini dal mare ad ditto fonte, come di sopra è ditto, con termini e fosse adirittura che partissino absolutamente i territorii senza lassarvi scrupolo alcuno. Et circa questo caramente vi prego vogliate affaticarve per la verità e per il dovere in servizio di Dio e anche per amor mìo. Et siate contento venirvene con Mastro Donato a starvene un dì domesticamente meco e bene valete."

V. Influence of Patrons in the Formal and Iconographic Conceptions of Michelangelo's Works

THE question of how much Michelangelo was influenced by his patrons in the formal and iconographic conceptions of his works may be answered by a study of the contracts and several letters to and by Michelangelo. It seems that he was always granted great freedom in this respect. Documents do not exist which could prove that the patrons imposed a detailed program on him (as modern critics sometimes assume). On the contrary they were contented to establish only a few general lines of the work and allowed him to carry out his own preferences. In treating the Sistine Ceiling the author has already insisted on this point, referring to the letter of Michelangelo written to Fattucci, probably at the end of December, 1523 (Milanesi, p. 427 and Tolnay, "La volta della Cappella Sistina," *Boll. d'Arte*, XXIX, 1936, pp. 389*ff*). Concerning the freedom accorded to Michelangelo while executing the Medici Chapel, the author has published a letter by Domenico Buoninsegni of December 28, 1520 in which he writes to Michelangelo that the Cardinal "dicie che sa, che ve ne intendete più di lui e a voi se rapporta" (Tolnay, *Cappella Medicea*, pp. 43*ff*). The liberality of his patrons from this point of view is very characteristic of the spirit of the Renaissance. To illustrate this attitude we can quote another unpublished letter from Domenico Buoninsegni in Rome dated February 14, 1517, to Michelangelo in Carrara in which he writes that he sent the letter of Michelangelo of January 29, 1517 (Milanesi, pp. 381*ff*), to the Cardinal:

". . . la mandai al Cardinale . . . e visto quanto dite circa l'esser suto variato el modello dal disegno che faciesti, m'a detto che voi in tutto e per tutto exequiate la fantasia vostra, che a quella se ne rimettono, e non abbiate rispetto nè a Baccio nè alcun altro che una volta el vostro disegno satisfa loro più che alcun altro. . . ."

The letter of Gabriello Pachagli in Paris to Michelangelo, January 31, 1519, may also be quoted. He writes that Francis I would like to have a work done by Michelangelo and he continues, "je n'ai pas de conseils a vous donner, car vous êtes sage et prudent et saurez prendre le meilleur parti. . . ." (Gotti, II, p. 58.)

VI. Copy or Forgery?

IN CONNECTION with the Uffizi drawing (Thode, *Kr. U.*, III, 215) which contains the *104*
copy of the pen sketch of an apostle, London, No. 19, and the copy in lapis after *103*
another drawing in London, No. 24, a nude seen from the back, the question is raised *115*
as to whether it is a *bona fide* copy or a true forgery. The manner in which the copyist
has disposed the sketches on the sheet and deliberately imitated the different techniques
of the master shows that he made this drawing, not for the purpose of having a copy
of a Michelangelo drawing, but a forgery which attempts to give the impression of a
sheet of the master. That forgeries existed even during the lifetime of Michelangelo can
be proven by an unpublished letter in the Archivio Buonarroti of February 4, 1525
by Pietro di Giovanni Roselli in Rome to Michelangelo in Florence. Pietro di Giovanni
Roselli was a friend of Michelangelo in the papal court and an enemy of Bramante and
his clique. From 1528 to 1531 he was "capomaestro e stimatore" in the "fabbrica di
San Pietro." In the letter quoted below there is a question of the forgery of a project
by Michelangelo for the façade of a palace (probably the palace of Cardinal Santi-
quattro). The forger was Giuliano Leni (or Leno). He was first an aid to Bramante
in the execution of St. Peter's. Later he was mentioned in the account books of St.
Peter's between 1513 and 1525 as "curatore." He died in 1530 or 1531. We quote
the main part of the letter:

". . . Di qua ne 'ene disputa assai pel conto di S^to Pietro come pe letere del vostro
prete, el quale fane facende di quane: . . . Io gli òne fatto onore e cortesia e mesolo
in ciello per vostro amore apresso a ttuti li cardinali che io pratico e masimo apresso al
cardinale di Santi 4; . . . El buono merito che lui me ne voleva rendere si ène che lui
aveva messo innanzi al Card. di Santi 4, Giuliano Leni per fare la facata dinanzi di
Trevertino; e volela levare a Domenico mio figliolo e a mene che òne durato fatica
più di oni a conducere talle opera. . . . Lui, come el prette vostro ane fatto fare uno
ischizo o vero disegno di detta facata, e die averla fatta Michelagniolo Buonarroti . . .
parmi istrano, che lui metta tal carico addosso di voi . . . [dicevo] che lui mi mostri
questo disegno che io conoscerone bene la mana vostra: e lui non l'à mai voluto piune
mostrare. . . . Lo disegno éne come la casa dove abitava Raffaello d'Urbino dirim-
petto Adriano, con quelle bugne di rilievo fatte di tuffo o prieta a usanza di Roma
come la prieta di tuffo, e sopra le bugne un' regolone e le colonne di sopra a detto
regolone con architrave e frego e cornice. . . ."

NOTE: Concerning the question of sixteenth century forgeries, see the discussions of
Panofsky "Kopie oder Fälschung," *Z. f. b. K.*, LXI, 1927-28, pp. 221*ff*, A. E. Popp,
"Kopie oder Fälschung," *Z. f. b. K.*, LXII, 1928-29, pp. 54*ff*, and Panofsky, "Noch
einmal Kopie oder Fälschung," *Z. f. b. K.*, LXII, 1928-29, pp. 179*ff*. According to
Panofsky, during the entire sixteenth century there were no known cases of copies
made with intent to deceive (Panofsky, "Kopie oder Fälschung," I, p. 238), while Popp

insists that there were already forgeries at that time and mentions those which Calvaert and Pomponio made ca. 1570. The letter published here shows that similar forgeries existed as early as 1525.

The "vostro prete" mentioned in the letter is Giovanfrancesco Fattucci. On February 8, 1525 (cf. Frey, *Briefe,* pp. 246*f*), Fattucci wrote to Michelangelo: "Ora circa a Santiquatro vi dico . . . quello che e' desidera si è, che e' vorebe fare la faciata del suo palazo, et pensa di fare bozi in fino al primo finestrato, o come stessi piu meglio. Se voi gli potessi fare un poco di disegnio, penso, che sarebe cosa bella, et sarebegli carissimo. Fate una porta nel mezo della faciata con dua finestre ferrate, con dua altre di sopra a dua palchi, con una cornice al tetto a vostro modo." (cf. also Thode, *Kr. U.,* II, p. 205.)

Further unpublished letters may be found in the notes: 13, 16, 20, 23, 27, 35, 36, and sub XI, 3 of this volume.

BIBLIOGRAPHICAL ABBREVIATIONS

Albertini, *Memoriale* F. Albertini, *Memoriale di molte statue et picture nella città di Firenze*, 1510, ed. Milanesi, Guasti, Florence, 1863.

Aldovrandi, *Delle statue antiche* U. Aldovrandi, Delle statue antiche, che per tutta Roma in diversi luoghi e case si veggono, in L. Mauro, *Le antichità de la città di Roma*, Venice, 1556.

Art Bull. The Art Bulletin.

Baumgart, *Contributi* F. Baumgart, "Contributi a Michelangelo," in *Boll. d'Arte*, xv, 1935, pp. 344*ff*.

Berenson, *Drawings* B. Berenson, *The Drawings of the Florentine Painters*, 2nd ed., Chicago, 1938.

Bocchi-Cinelli, *Bellezze di Firenze* M. F. Bocchi, *Le bellezze della città di Firenze* . . . scritte già da M. F. Bocchi, ed ora da M. G. Cinelli, ampliate, et accresciute, 2nd ed., Florence, 1677.

Bode, *Denkmäler* W. v. Bode, *Denkmäler der Renaissance-Skulptur Toscanas*, Munich, 1892-1905.

Bode, *Flor. Bildh.* W. v. Bode, *Florentiner Bildhauer der Renaissance*, 4th ed., Berlin, 1920.

Bode, *Ital. Bildh.* W. v. Bode, *Italienische Bildhauer der Renaissance*, Berlin, 1887.

Bonora, *Arca* T. Bonora, *L'Arca di San Domenico e Michelangelo Buonarroti*, Bologna, 1875.

Borghini, *Riposo* R. Borghini, *Il Riposo*, Florence, 1584; 5th ed., Reggio, 1826/27.

Bottari, *Raccolta* G. Bottari, *Raccolta di lettere sulla pittura, scultura ed architettura* . . . , 2nd ed., Milan, 1822-1825.

Brinckmann, *Zeichnungen* A. E. Brinckmann, *Michelangelo-Zeichnungen*, Munich, 1925.

Brinckmann, *Barockskulptur* A. E. Brinckmann, *Barockskulptur*, i, Handbuch der Kunstwissenschaft, Berlin (1919).

Brockhaus, *Michelangelo* H. Brockhaus, *Michelangelo und die Medici-Kapelle*, 2nd ed., Leipzig, 1911.

Buonarroti, *Descrizione* F. Buonarroti, *Descrizione del albero genealogico della nobilissima familglia de' Buonarroti* . . . , published in Condivi, ed. Gori, pp. 87*ff*.

Burl. Mag. The Burlington Magazine.

Cellini, *Autobiography* B. Cellini, *La vita*, ed. P. d'Ancona, Milan, n.d.

Colvin, *Oxford Drawings* S. Colvin, *Drawings of the old masters in the University galleries and in the Library of Christ Church, Oxford*, Oxford, 1907.

Condivi *Le Vite di Michelangelo Buonarroti scritte da Giorgio Vasari e da Ascanio Condivi*, ed. K. Frey, Berlin, 1887.

Condivi, ed. Gori Ascanio Condivi, *Vita di Michelagnolo Buonarroti*, 2nd ed., Florence, 1746.

Daremberg-Saglio C. Daremberg and E. Saglio, *Dictionnaire des antiquités grecques et romaines . . .* 5 vols., Paris, 1877-1919.

Demonts, *Dessins* L. Demonts, *Musée du Louvre. Les dessins de Michel Ange*, Paris (1922).

Dorez, *Nouv. Recherches* L. Dorez, "Nouvelles Recherches sur Michel-Ange et son entourage," in *Bibliothèque de l'Ecole des Chartes*, LXXVII, 1916, pp. 448-470; LXXVIII, 1917, pp. 179-220.

Fabbrichesi, *Guida* A. Fabbrichesi, *Guida della Galleria Buonarroti*, Florence, 1865; here quoted after the French edition of 1875.

Fanfani, *Spigolatura* P. Fanfani, *Spigolatura Michelangiolesca*, Pistoia, 1876.

Fischel, *Raphaels Zeichnungen* O. Fischel, *Raphaels Zeichnungen*, Berlin, 1923*ff.*

Foratti, *Ma. a Bologna* A. Foratti, "Michelangelo a Bologna," in *Atti e memorie della R. Deputazione di Storia Patria per le Provincie di Romagna*, Bologna, 1918.

Frey, *Briefe* K. Frey, ed., *Sammlung ausgewählter Briefe an Michelagniolo Buonarroti*, Berlin, 1899.

Frey, *Denunzia* K. Frey, "Denunzia dei beni della famiglia de' Buonarroti," in *J. d. p. K.*, VI, 1885, pp. 189-201.

Frey, *Dicht.* K. Frey, ed., *Die Dichtungen des Michelagniolo Buonarroti*, Berlin, 1897.

Frey, *Handz.* K. Frey, *Die Handzeichnungen Michelagniolos Buonarroti*, 3 vols., Berlin, 1909-1911.

Frey-Knapp, *Handz.* F. Knapp, *Die Handzeichnungen Michelagniolos Buonarroti. Nachtrag*, Berlin, 1925.

Frey, *Ma.*, I K. Frey, *Michelagniolo Buonarroti. Sein Leben und seine Werke.* Vol. I. Michelagniolos Jugendjahre, Berlin, 1907.

Frey, *Q. F.* K. Frey, *Michelagniolo Buonarroti. Quellen und Forschungen zu seiner Geschichte und Kunst.*, Berlin, 1907.

Frey, *Studien* K. Frey, "Studien zu Michelagniolo Buonarroti," in *J. d. p. K.*, XXX, 1909, Bh. pp. 103*ff.*

Frey, *Vasari, Lit. Nachlass* *Der literarische Nachlass Giorgio Vasaris*, ed. K. Frey, 2 vols., Munich, 1923-1930.

G. d. B. A. *Gazette des Beaux-Arts.*

Gaye G. Gaye, *Carteggio inedito d'artisti dei secoli* XIV. XV. XVI., Florence, 1839-1840.

Gotti A. Gotti, *Vita di Michelangelo Buonarroti*, Florence, 1875.

Grimm, *Leben Michelangelos* H. Grimm, *Leben Michelangelos*, 19th ed., Stuttgart, 1922.

Gronau, *Raphaels Florentiner Tage*. G. Gronau, *Aus Raphaels Florentiner Tagen*, Berlin, 1902.

Grünwald, *Antike* A. Grünwald, "Über einige Werke Michelangelos in ihrem Verhältnisse zur Antike," in *J. d. A. K.*, xxvii, 1907/1909, pp. 125*ff*.

Grünwald, *Florentiner Studien* A. Grünwald, *Florentiner Studien*, Dresden, n. d.

Gualandi, *Memorie* M. Gualandi, *Memorie originali riguardanti le Belle Arti*, Bologna, 1840-1845.

Hekler A. Hekler, "Michelangelo und die Antike," in *Wiener Jahrbuch für Kunstgeschichte*, vii, 1930, pp. 201*ff*.

Helbig W. Helbig, *Führer durch die Sammlungen klass. Altertümer in Rom*. 2 vols.. Leipzig, 1913.

Holroyd, *Michelangelo* C. Holroyd, *Michael Angelo Buonarroti*, 2nd ed., London, 1911.

J. d. A. K. *Jahrbuch der Kunsthistorischen Sammlungen des Allerhöchsten Kaiserhauses*.

J. d. D. Arch. Inst. *Jahrbuch des Kaiserlich Deutschen Archaeologischen Instituts*.

J. d. Kh. Slg. Wien *Jahrbuch der Kunsthistorischen Sammlungen in Wien*, N. F.

J. d. p. K. *Jahrbuch der preussischen Kunstsammlungen*.

J. f. Kg. *Jahrbuch für Kunstgeschichte. Kunsthistorisches Institut des Bundesdenkmalamtes*. Vienna.

Justi, *Ma., N. B.* C. Justi, *Michelangelo. Neue Beiträge zur Erklärung seiner Werke*, Berlin, 1909.

Justi, *Michelangelo* C. Justi, *Michelangelo. Beiträge zur Erklärung der Werke und des Menschen*. Leipzig, 1900.

Kallab, *Vasaristudien* W. Kallab, *Vasaristudien*, Vienna and Leipzig, 1908.

Kauffmann, *Donatello* H. Kauffmann, *Donatello*, Berlin, 1935.

Knapp F. Knapp, *Michelangelo* (Klassiker der Kunst), 4th ed., Stuttgart and Leipzig, 1912.

Koehler, *Schlachtkarton* W. Koehler, "Michelangelos Schlachtkarton," in *Kunstgesch. Jahrbuch d. k. k. Zentral-Kommission*, i, 1907, pp. 115*ff*.

Körte, *Deutsche Vesperbilder* W. Körte, "Deutsche Vesperbilder in Italien," in *Kunstgesch. Jahrbuch der Bibliotheca Hertziana*, i, 1937, pp. 1*ff*.

Lamo, *Graticola* P. Lamo, *Graticola di Bologna ossia descrizione delle pitture, sculture e architetture di detta città fatta l'anno 1560*, Bologna, 1844.

Lanciani, *Storia degli scavi* R. Lanciani, *Storia degli scavi di Roma e notizie intorno le collezioni romane di antichità*, Rome, 1902-1912.

Lanckoronska, *Antike Elemente* K. Lanckoronska, "Antike Elemente im Bacchus Michelangelos und in seinen Darstellungen des David," in *Dawna Sztuka*, i, 1938, pp. 183*ff*.

Landucci, *Diario* L. Landucci, *Diario Fiorentino dal 1450 al 1516*, published J. del Badia, Florence, 1883.

Leonardo, *Trattato della Pittura* Leonardo, *Trattato della Pittura*, ed. Ludwig, Vienna, 1882.

Limburger W. Limburger, *Die Gebäude von Florenz*, Leipzig, 1910.

Mackowsky H. Mackowsky, *Michelangelo*, 4th ed., Berlin, 1925.

Maurenbrecher, *Aufzeichnungen* W. Maurenbrecher, *Die Aufzeichnungen des Michelangelo Buonarroti im Britischen Museum*, Leipzig, 1938.

Meder, *Handz.* J. Meder, *Die Handzeichnung*, 2nd ed., Vienna, 1923.

Milanesi *Le·lettere di Michelangelo Buonarroti*, ed. by G. Milanesi, Florence, 1875.

Panofsky, *Bemerkungen* E. Panofsky, "Bemerkungen zu der Neuherausgabe der Haarlemer Michelangelo-Zeichnungen durch Fr. Knapp," *Rep. f. Kw.*, XLVIII, 1927, pp. 25ff.

Panofsky, *Iconology* E. Panofsky, *Studies in Iconology*, New York, 1938.

Panofsky, *Handzeichnungen* E. Panofsky, *Handzeichnungen Michelangelos*, Leipzig, 1922.

Panofsky, *Julius Tomb* E. Panofsky, "The first two projects of Michelangelo's Tomb of Julius II," in *Art Bull.*, XIX, 1937, pp. 561ff.

Panofsky, *Ma. Literatur* E. Panofsky, "Die Michelangelo Literatur zeit 1914," in *J. f. Kg.*, Vienna, I, 1921-1922, Buchbesprechungen, cols. 1ff.

Pastor, *Geschichte* L. v. Pastor, *Geschichte der Päpste seit dem Ausgang des Mittelalters*, III, Freiburg, 8th and 9th ed., 1924.

Pini, *Scrittura* C. Pini, *La scrittura di artisti italiani*, Florence, 1869-1876.

Poggi G. Poggi, *Il Duomo di Firenze*, Berlin, 1909.

Popp, *Bermerkungen* A. E. Popp, "Bermerkungen zu einigen Zeichnungen Michelangelos," in *Z. f. b. K.*, LIX, 1925-1926, pp. 134ff and 169ff.

Popp, *Medici Kappelle* A. E. Popp, *Die Medici Kapelle Michelangelos*, Munich, 1922.

Reinach, *Rep.* S. Reinach, *Répertoire de la statuaire grecque et romaine*, Paris, 1920.

Rep. f. Kw. *Repertorium für Kunstwissenschaft*.

Ricci, *Michelangelo* C. Ricci, *Michelangelo*, 2nd ed., Florence, 1921.

Ricordo al Popolo Italiano Michelangiolo Buonarroti, *Ricordo al Popolo Italiano*, Florence, 1875.

Robb, *Neoplatonism* N. A. Robb, *Neoplatonism of the Italian Renaissance*, London [1935].

Robinson, *A critical account* J. C. Robinson, *A critical account of the drawings by Michel Angelo and Raffaello, in the Galleries in Oxford*, Oxford, 1870.

Roscher W. Roscher, ed., *Ausführliches Lexikon der griechischen und römischen Mythologie*, Leipzig, 1884-1937.

Schubring, *Cassoni* P. Schubring, *Cassoni; Truhen und Truhenbilder der italie-
nischen Frührenaissance*, Leipzig, 1915.

Springer, *Raffael und Michelangelo* A. Springer, *Raffael und Michelangelo*, 3rd ed.,
Leipzig, 1895.

Steinmann, *Bibliographie* E. Steinmann and R. Wittkower, *Michelangelo Biblio-
graphie*, Leipzig, 1927.

Steinmann, *Madonnenideal* E. Steinmann, "Das Madonnenideal des Michelangelo,"
in *Z. f. b. K.*, N. F., VII, 1896, pp. 169*ff* and 201*ff*.

Steinmann, *Sixtinische Kapelle* E. Steinmann, *Die Sixtinische Kapelle*, II, Munich,
1905.

Strzygowski, *Studien* J. Strzygowski, "Studien zu Michelangelos Jugendentwicklung,"
in *J. d. p. K.*, XII, 1891, pp. 207*ff*.

Symonds, *Life* J. A. Symonds, *Life and Works of Michelangelo Buonarroti*, 3rd ed.,
2 vols., London, 1925.

Thode, *Kr. U.* H. Thode, *Michelangelo. Kritische Untersuchungen über seine Werke*,
3 vols., Berlin, 1908-1913.

Tolnay, *Arch. Buon.* C. de Tolnay, "Die Handzeichnungen Michelangelos im Ar-
chivio Buonarroti," in *Münchner Jahrb.*, V, 1928, pp. 450*ff*.

Tolnay, *Brutus* Tolnay, "Michelangelo's Bust of Brutus" in *Burl. Mag.*, LXVII, 1935,
pp. 23*ff*.

Tolnay, *Cappella Medicea* Tolnay, "Studi sulla cappella Medicea," in *L'Arte*, Ns. V.,
1934, pp. 5*ff* and 281*ff*.

Tolnay, *Codex Vaticanus* Tolnay, "Die Handzeichnungen Michelangelos im Codex
Vaticanus," in *Rep. f. Kw.*, XLVIII, 1927, pp. 157*ff*.

Tolnay, *Ma. Studies* Tolnay, "Michelangelo Studies," in *Art Bull.*, XXII, 1940, pp.
130*ff*.

Tolnay, *Michelangelostudien* Tolnay, "Michelangelostudien. Jugendwerke," in
J. d. p. K., LIV, 1933, pp. 95*ff*.

Tolnay, *Sklavenskizze* Tolnay, "Eine Sklavenskizze Michelangelos," in *Münchner
Jahrb.*, V, 1928, pp. 20*ff*.

Tolnay, *Sofonisba Anguissola* Tolnay, "Sofonisba Anguissola and her relationship to
Michelangelo," in *Journal of the Walters Art Coll.*, IV,
1941, pp. 115*ff*.

Tolnay, *Thieme-Becker* Thieme-Becker, *Allgemeines Künstlerlexikon*, sub Michel-
angelo.

Varchi, *Due lezzioni* B. Varchi, *Due lezzioni nella prima delle quali si dichiara un
sonetto di Michelagnolo Buonarroti*, Florence, 1549.

Varchi, *Orazione* B. Varchi, *Orazione Funerale fatta, e recitata da lui pubblicamente
nell' essequie di Michelagnolo Buonarroti in Firenze, nella Chiesa
di San Lorenzo.* Florence, 1564.

Vasari, 1550 and 1568 *Le Vite di Michelangelo Buonarroti scritte da Giorgio Vasari e da Ascanio Condivi*, ed. K. Frey, Berlin, 1887.

Vasari, ed. Milanesi *Le Opere di Giorgio Vasari*, 9 vols., ed. G. Milanesi, Florence, 1878-1885.

Venturi, *Storia* A. Venturi, *Storia dell'Arte Italiana*, X2, Milan, 1936.

Warburg, *Botticelli* A. Warburg, *Sandro Botticelli*, Frankfurt a.M., 1892.

Warburg, *Ges. Schriften* A. Warburg, *Gesammelte Schriften*, 2 vols., Leipzig, 1932.

Wickhoff, *Antike im Bildungsgange* F. Wickhoff, "Die Antike im Bildungsgange Michelangelos," in *Mitteilungen des Instituts für Oesterreichische Geschichtsforschung*, II, 1882, pp. 408-435.

Wilde, *Eine Studie* J. Wilde, "Eine Studie Michelangelos nach der Antike," in *Mitteilungen des Kunsthistorischen Institutes in Florenz*, IV, 1932, pp. 41*ff*.

Wilson, *Life and Works* C. H. Wilson, *Life and Works of Michelangelo Buonarroti*, London, 1876.

Winter F. Winter, *Kunstgeschichte in Bildern*, I. Das Altertum. Leipzig, n. d.

Wolf R. Wolf, *Documenti inediti su Michelangelo*, Budapest, 1931.

Wölfflin, *Jugendwerke* H. Wölfflin, *Die Jugendwerke des Michelangelo*, Munich, 1891.

Wölfflin, *Klass. Kunst* H. Wölfflin, *Die Klassische Kunst,* 6th ed., Munich, 1914.

Wölfflin, *Madonnenreliefs* H. Wölfflin, "Florentinische Madonnenreliefs," in *Z. f. b. K.*, N. F., IV, 1893, pp. 107*ff*.

Z. f. b. K. *Zeitschrift für bildende Kunst.*

Z. f. Kg. *Zeitschrift für Kunstgeschichte.*

ADDENDA

1. Page 5. A typical letter of Lodovico is one of February 14, 1500 (Steinmann, *Sixtinische Kapelle,* II, pp. 787f) full of complaints concerning the difficulties of his daily life and showing his conception of his son's art as a source of revenue: "Io o grandissimo piacere, chettu abbi onore, ma pure mi sarebbe vie maggiore, se vi fussi lutile. . . ."

2. Page 5. Cf. H. Grimm, "Michelangelo's Mutter und Stiefmutter," *J.d.p.K.,* VI, 1885, pp. 185ff. The fact that Michelangelo was only six years old when he lost his mother may perhaps explain some features of his character.

3. Page 7. Because of Giovansimone's fear of Michelangelo, it is said that in 1508 he left Florence for Spain and Portugal. At the end of 1508 he was in Lisbon. In 1512 he was again in Italy (cf. Gotti, II, p. 19).

4. Page 44, note 14. Concerning the relationship of the Buonarroti family with the Dominicans, cf. the document of October 5, 1509, published in Steinmann, *Sixtinische Kapelle,* II, p. 712, no. 46.

5. Page 48, note 29. Indirect descendants of the family are still living in Florence.

6. Page 52, note 59. F. Albertini mentions briefly the Garden in his *Memoriale,* 1510: "Nel giardino de' Medici sono assai cose antique venute da Roma. . . ."

7. Page 52, note 69. Concerning Savonarola's presence at Lorenzo's death, cf. R. Ridolfi, "La Visita del Savonarola al Magnifico Morente," in *Archivio Storico Italiano,* LXXXVI, 1928, pp. 205ff.

8. Page 148. A possible third source of the Pietà compositions of the late Middle Ages seems to have been the fresco (now destroyed) in S. Paolo fuori le Mura (Cod. Barb.Lat. 4406, pl. 131) which was originally over the entrance door, and which showed an angel supporting on his knees the body of Christ. The Virgin was later substituted for the angel.

9. Page 156. K. Clark, *Catalogue of the Drawings of Leonardo da Vinci at Windsor Castle,* Cambridge, 1935 (no. 12591R), also recognized that Michelangelo's statue influenced Leonardo's drawing, thereby refuting Solmi. He dated the Leonardo drawing about January 1504.

10. Page 158. The motif of the Child in the Madonna of Bruges reverts to antiquity. A drawing exists by Pisanello (Milan, Ambrosiana) which was made after an ancient group (now lost), and in which the Child has a very similar pose (reproduced by Degenhart, *Pisanello,* Vienna [1940], illus. 31). *203b*

11. Page 159. For a back view of the Madonna of Bruges (made after a cast), cf. John G. Phillips, *The Metropolitan Museum of Art, Bulletin,* n.s. I, 1942, pp. 47ff, with interesting folds in the sweet late Gothic style, which speak in favor of our dating.

12. Page 161. The fact that the drawing for the Caritas in Vienna is a copy after Raphael was first noted by Schönbrunner—Meder, *Handzeichnungen aus der Albertina,* Vienna, 1893ff, no. 1420. The influence of Michelangelo's Bargello Tondo on the

Caritas drawing after Raphael was observed by Fischel, *Raphaels Zeichnungen*, IV, 1923, nos. 181-182.

13. Page 162. That the captured goldfinch was considered in the early sixteenth century as a symbol of death (and was used by Michelangelo to presage Christ's death) may be supported by the following note of Leonardo: "Il calderugio dà il titimalo ai figliuoli ingabbiati: prima morte che perdere libertà." ("The goldfinch gives a poisonous herb to its caged young: death rather than loss of liberty.") Cf. J. P. Richter, *The Literary Works of Leonardo da Vinci*, Oxford, 1939 (2nd ed.), II, p. 309, Misc. 1316.

14. Page 167. Michelangelo's name appears in print for the first time in this note of P. Gaurico, six years before F. Albertini's *Memoriale* (1510), which has been previously considered (cf. Steinmann, *Bibliographie*, p. 4) the first book to contain Michelangelo's name. Gaurico's book is dedicated by the printer to Laurenzio Strozzi, of the family of Maddelena Strozzi—a fact which also speaks in favor of Poggi's hypothesis. (In *Thieme-Becker* the author followed this earlier dating, ca. 1503-1504, proposed by Poggi. In the first edition of this volume he tried to date the Doni Virgin ca. 1506, a statement which he can no longer consider correct. The meticulous technique of this painting also speaks in favor of the early date.)

15. Page 171. Concerning the significance of the "unfinished" in the works of Michelangelo, cf. also the older literature: Vasari, 1568, pp. 281*f* and 244; Desmarets de St. Sorlin, *Promenades de Richelieu ou les Vertus Chrétiennes*, Paris, 1653, p. 3 (poem on the two Slaves now in the Louvre, in which the problem of the "unfinished" is also mentioned); La Fontaine, Letter to his wife, of September 12, 1663, with a poem on the "unfinished" in *Oeuvres*, IX, p. 247. (The last two authors are mentioned by Dörken, *Geschichte des Französischen Michelangelobildes*, Bochum, n.d.)

16. Page 184. The left knee of the man at the left has also been restored.

17. Page 196. The crucifix of Santo Spirito was first mentioned in F. Albertini, *Memoriale* (1510): "Il crucifixo del choro di Michelagnolo."

18. Page 196. The wardrobe in the sacristy was done by Sebastianus Pintelius (cf. F. Schottmüller, *Furniture of the Italian Renaissance*, New York [1928], p. xxvii).

19. Page 202. De Thou, who was in Mantua in 1573, gives another version of this anecdote which is published in Condivi ed., Gori, p. xiv, and Steinmann, *Bibliographie*, p. 363.

20. Page 202. A similar ancient sleeping Cupido was in the villa of Cardinal Cesi, where it was copied between 1572 and 1577 by the French sculptor Pierre Jacques (cf. Reinach, *L'Album de P. Jacques, sculpteur de Reims, dessiné à Rome de 1572-77*, Paris, 1902, pl. 4 bis).

21. Page 204. The similarity of the pose of the London Cupido to the ignudo at the right above Ezekiel on the Sistine Ceiling was noted by Wölfflin, *Jugendwerke*, p. 32; cf. also Michelangelo's drawing, Frey, *Handz.*, 121.

22. Page 222. In this chronicle the statue is mentioned as being in "una capela marmorina," i.e. a marble niche on the façade of San Petronio.

23. Page 223. The statue of Paul V by N. Cordier in Rimini is also probably under the influence of Michelangelo's bronze statue of Julius II (reproduced in Venturi, *Storia,* x, part III, p. 663).

24. Page 231. After the completion of the first edition of this work, the interesting article of W. R. Valentiner ("Michelangelo's Statuettes of the Piccolomini Altar in Siena," *Art Quarterly,* v, 1942, pp. 3*ff*) became available to the author. Valentiner arrives at quite different conclusions in his article. According to him, the four statuettes of the Piccolomini Altar were executed by Michelangelo himself between June 19, 1501, and October 11, 1504. He states that the four blocks mentioned in the letter of June 28, 1510, were intended for the three statuettes in the Tribuna, and the last figure missing in the side niches of the Piccolomini Altar. He also believes that Michelangelo intended the Madonna of Bruges (which he dates in the winter of 1504-1505) for the large upper central niche of the Altar, instead of the originally planned group of the three statuettes (Christ, St. Thomas, St. John the Evangelist), provided by the contract. Finally, according to Valentiner, the Apostle Sketch in London (No. 19) was meant for the left-hand statuette (St. Thomas) on the Tribuna of the Siena Altar—and not for one of the Apostles in the Cathedral of Florence. F. Kriegbaum, "Le Statue di Michelangiolo nell' altare de' Piccolomini a Siena," *Michelangiolo Buonarroti nel IV. Centenario del Giudizio Universale,* Florence, 1942, pp. 86*ff*, attempts to ascribe all four statuettes to Michelangelo. He does not, however, take into account all the preserved documentary material.

25. Page 236. The Manchester Madonna was attributed to Granacci by Frizzoni, *Arte Italiana nel Rinascimento,* 1891, p. 265, and by F. Knapp, *Michelangelo, Klass. der Kunst,* 3rd ed., p. 178. Recently K. Clark, *One Hundred Details from Pictures in the National Gallery,* London, 1938, pls. 81, 92, again attributes this painting to Michelangelo, dating it ca. 1494.

26. Page 236. The Dublin Virgin was attributed to Granacci by M. Logan, *Revue archéologique,* IV, part II, 1903, pp. 21*ff*. Gronau (in *Thieme-Becker* sub Granacci) dated the panel ca. 1506.

27. Page 237. K. Clark, op. cit., pl. 94, again attributes the Burial of Christ to Michelangelo, dating it ca. 1505.

28. Page 245. The second letter of April 21, 1521, is reproduced in Pini, *Scrittura,* pl. 136, and in Steinmann, *Bibliographie,* p. 442 and pl. 6. Both letters are mentioned in Morsolini, *Atti del Regio Istituto Veneto,* ser. IV, II, 1886, pp. 1117*ff* and E. Kris, *Steinschneidekunst in der Italienischen Renaissance,* Vienna, 1929, I, pp. 48*ff*.

29. Page 246. A drawing by Sofonisba Anguissola is described by Vasari (ed. Milanesi, IV, p. 297) representing a child bitten by a crayfish. This drawing was identified correctly by Longhi, Pinacotheca, I, 1928-1929, p. 301, with the drawing published by H. Voss, *Zeichnungen der Italienischen Spätrenaissance,* Berlin, 1928, pl. xv, who attributed it erroneously to Santi di Tito.

30. For further Addenda cf. the author's "Notes Concerning *The Youth of Michelangelo*: A Reply," *Art Bull.* XXVII, 1945, pp. 139*ff*.

31. After the revision of this volume, the following book and article became available to the author:

Aldo Bertini, *Michelangelo fino alla Sistina*, 2d edition, Turin 1945. Intelligent summary of the results of the most important research done on Michelangelo's works up to 1512.

J. Wilde, "The Hall of the Great Council of Florence," *Journal of the Warburg and Courtauld Institutes*, VII, 1944, pp. 65*ff*. Reconstruction of the Great Council Hall and determination of the places of the frescoes of Leonardo and Michelangelo. The windows are reconstructed on the basis of the observation made in this book, p. 216 and Illustrations 228 and 229. He comes to the same conclusion, namely that both Leonardo's and Michelangelo's frescoes were meant for the east wall, whereby Michelangelo's fresco was to occupy the field at the left and Leonardo's the field at the right. He differs from the author, however, in supposing that there was no fresco in the central field.

INDEX

INDEX

225; Raphael, drawing of Virgin, 163, Fig. 223; Madonna del Cardellino, 104, 163; Signorelli, tondi of Holy Family, 103, 110, 160, 164, 165, Fig. 224; Rogier van der Weyden, Burial of Christ, 237

Via Cavour, Ferrucci, Madonna and Child, 131

Via dei Bentaccordi, 4, 11, 50 n. 42

Via Ghibellina, house, 42, 171

Fontainebleau, Jardin de l'Estang, 81, 197

Foratti, 138, 141, 214, 215

Forteguerri, Giulio, 46 n. 27

Fortuna-Fatum, 39 f, 59 n. 136, 241, 251

Francesca, Sora, Badessa del Mᵒ di Boldrone, 45 n. 23

Francesco, first herald of Florence, 97

Francesco, son of Urbino, 247

Francesco del Pugliese, 157

Francesco di Giorgio, Bacchus, Vienna, Kunsthistorisches Museum, 144

Franciabigio, 177, 236

Francini, Alexander, engraving, 198, Fig. 154

Francini, Tommaso de, engraving, 198

Francis I of France, 197, 254

Franco, Battista, 236

Francovich, 170

Frankfort a. M., Städtische Skulpturensammlung, Pietà, 92, Fig. 181

Frey, 44 n. 16, 50 n. 43, 53 n. 80, n. 81, 54 n. 86, 56 n. 104, 58 n. 124, 138, 141, 145, 146, 159, 167, 175, 178, 179, 182, 183, 184, 186, 187, 188, 189, 190, 191, 195, 196, 197, 198, 200, 201, 202, 203, 234, 242

G

Gaddi, Niccolò, 211

Gaddi, Taddeo, Crucifix, Florence, Sta. Croce, refectory, 81

Gaillard, 157

Galli, Giovanni, 27, 143; Giuliano, 143; Jacopo, 27, 55 n. 97, 56 n. 100, 91, 142, 145, 147, 149, 203, 228; Paolo, 143

Gamba, 200, 235

Genazzano, Mariano da, 27

Gengaro, 158

Genoa, Sta. Maria di Carignano, Pietro Tacca, Crucifix, 80, 197

Ghent, St. Bavon, Pierre-Antoine

Verschaffelt, grave monument of Bishop Maximilian Van der Noot, 159, Fig. 206; St. Michael, Rombaut Pauli, Virgin, 159, Fig. 205

Ghibelline, 42 n. 8

Ghiberti, Lorenzo, 118, 234; doors, Florence, 13, 78, 153, 166; Vettorio di Buonacorso, 244; busts on façade, Naples, Palazzo Gravina, 244

Ghirlandaio, Davit di Tommaso di Currado, 14, 51 n. 50, 152; Domenico, 12, 14, 15, 26, 51 n. 50, n. 55, n. 56, 63, 64, 65, 67 f, 71, 126, 148, 175, 176, 177, 179, 242; frescoes, Sta. Maria Novella, 176; fresco, Florence, Sta. Trinità, 153; study for Epiphany, Florence, Uffizi, 68, Fig. 75; Ridolfo, 14, 64, 177

Giannotti, Donato, 49 n. 36, 50 n. 43

Giaparelo, Silvio di Giovanni da, 246

Giolla, 249

Giotto, 63, 67, 68, 177; frescoes, Florence, Sta. Croce, Cappella Peruzzi, 66, 176 ff, Fig. 69

Giovanni pittore, 223

Giovio, Paolo, 201

Giraldi, Lilio Gregorio, 135

Giraldus, 154

Girolami, Cavaliere, 42 n. 3

Giuliano d'Adamo, 157

Giusto d'Anghiari, 4

Gondi, Piero, 56 n. 104

Gonfaloniere, 3, 5, 6, 42 n. 9

Gonzaga, Marchese Federigo, 133; Giovanni Francesco, 205

Gori, 175

Graces, Three, antique, Siena, Cathedral, Libreria Piccolomini, 71, 183, Fig. 95

Granacci, Francesco, 12, 14, 16, 17, 48 n. 30, 51 n. 48, n. 56, 64, 152, 177, 236, 242

Grassis (Grassi), Paris de, 34

Gratianus, Frater Maximilianus, 9, 251 f

Gregory III, pope, 147, 220

Grimaldi, sketch of interior of St. Peter's, Vatican, Biblioteca Vaticana, 147, Fig. 175

Grimm, 56 n. 104, 159

Grünwald, 141, 170, 200, 234, 235

Gualandi, 141

Guelph party, 3, 11, 42 n. 8, 107

Guglielmo da Pisa, Fra, sarcophagus for Tomb of St. Dominic, Bologna, San Domenico, 23, 138

Guicciardini, Luigi, 160; Michele di Niccolò, husband of Francesca, 7, 45 n. 23; Pietro, 160

Guilbert, Abbé, 197

H

Haarlem, Teyler Mus., drawings, copies after Michelangelo's Battle of Cascina, 219

Hager, 223

Hague, The, Coll. Lugt, Rubens, drawing, copy of Battle of Centaurs, 136

Hauptmann, 161

Heere, Jan de, 157; Lucas de, 157

Henke, 200

Heemskerck, Martin van, Codex Berolinensis, Berlin, Kupferstichkabinett, 142, 145, Figs. 89, 169

Henry II, emperor of Holy Roman Empire, 46 n. 25

Henry IV, king of France, 197

Hippodameia, 77, 134

Holkham Hall, Coll. Lord Leicester, grisaille, 107, 213 ff, Fig. 232

Holmes, 236, 242

Holroyd, 125

Horn, 163

Horne, 204

Hygin, 133 f

I

Impruneta, Collegiata, Giovanni da Bologna, Crucifix, 80, 197, Fig. 150

J

Jacobsen-Ferri, 216

Jacopo Antiquario, 52 n. 69

Jerome, saint, 153

Julius II, pope, 22, 25, 31, 34, 36, 37, 38, 41, 55 n. 96, 57 n. 114, n. 115, n. 116, 58 n. 120, n. 122, n. 123, 59 n. 129, n. 137, 169, 206, 219 ff, 252

Julius III, pope, 52 n. 72, 223

Justi, 108, 128, 161, 170, 200, 214, 215, 216, 234

K

Kansas City, Nelson Art Gallery, Tiziano Aspetti, St. John, 86, 199

Knapp, 132, 136, 145, 161, 232

Koehler, 186, 211, 212, 215, 216

Kraus, 56 n. 104

Kriegbaum, 197

THE ILLUSTRATIONS

LIST OF ILLUSTRATIONS

Frontispiece. Attributed to Daniele da Volterra: Portrait of Michelangelo. Milan, Castello Sforzesco, Museo Archeologico ed Artistico.

35. Pietà. Detail: head of Christ.
36. David. Florence, Accademia delle Belle Arti (Cat. No. VI). Front view.
37. David. Rear view.
38. David. Side view.
39. David. Side view.
40. David. Detail: head. Front view.
41. David. Detail: head in profile.
42. David. Detail: torso.
43. David. Detail: right hand.
44. Madonna of Bruges. Bruges, Church of Nôtre Dame (Cat. No. VII). Front view.
45. Madonna of Bruges. Side view.
46. Madonna of Bruges. Side view.
47. Madonna of Bruges. Detail: head of the Virgin. Front view.
48. Madonna of Bruges. Detail: head of the Virgin in profile.
49. Madonna of Bruges. Detail: head of the Christ Child.
50. Madonna of Bartolommeo Pitti. Florence, Bargello (Cat. No. VIII).
51. Madonna of Bartolommeo Pitti. Detail: head of the Virgin.
52. Madonna of Bartolommeo Pitti. Detail: head of St. John.
53. Madonna of Bartolommeo Pitti. Detail: head of the Christ Child.
54. Madonna of Taddeo Taddei. London, Royal Academy (Cat. No. IX).
55. Madonna of Taddeo Taddei. Detail: head of the Virgin, three quarter.
56. Madonna of Taddeo Taddei. Detail: head of the Virgin in profile.
57. Madonna of Taddeo Taddei. Detail: head of the Christ Child. Front view.
58. Madonna of Taddeo Taddei. Detail: head of the Christ Child in profile.
59. Madonna Doni. Florence, Galleria degli Uffizi (Cat. No. X).
60. Madonna Doni. Detail: nude figures in left background.
61. Madonna Doni. Detail: nude figures in right background.
62. Madonna Doni. Detail: Christ Child and head of Virgin.
63. Saint Matthew. Florence, Accademia delle Belle Arti (Cat. No. XI).
64. Saint Matthew. Side view.
65. Saint Matthew. Side view.
66. Saint Matthew. Detail: head.

DRAWINGS BY MICHELANGELO AND RELATED WORKS

67. Michelangelo: Triton. Settignano, Villa Michelagniolo (Cat. No. 1).
68. Michelangelo: Copy after two figures from the Ascension of St. John the Evangelist by Giotto. Paris, Louvre (Cat. No. 2).
69. Giotto: Detail from the Ascension of St. John the Evangelist. Fresco. Florence, Santa Croce, Cappella Peruzzi.

70. Baccio Bandinelli: Copy after Giotto's Ascension of St. John the Evangelist. Florence, Galleria degli Uffizi.

71. Masaccio: Detail from the Tribute Money; St. Peter handing the coin to the sailor. Fresco. Florence, S. Maria del Carmine. Cappella Brancacci.

72. Michelangelo: Copy after Masaccio's St. Peter handing the coin to the sailor. Munich, Kupferstichkabinett (Cat. No. 3).

73. Unknown artist ca. 1520-1530: Copy probably after one of Masaccio's lost frescoes in the Sagra del Carmine. Detail. Florence, Casa Buonarroti.

74. Michelangelo: Copy probably after one of Masaccio's frescoes in the Sagra del Carmine. Vienna, Albertina (Cat. No. 4).

75. Ghirlandaio: Study of a kneeling figure for the Epiphany in the Uffizi. Florence, Galleria degli Uffizi.

76. Michelangelo: Kneeling figure probably after Masaccio. Vienna, Albertina (Cat. No. 5).

77. Michelangelo: "The Alchemist." London, British Museum (Cat. No. 6).

78. Michelangelo: Sketch of a nude seen from the back; sketch of a pair of legs; sketch of a right hand. Florence, Archivio Buonarroti (Cat. No. 7).

79. Michelangelo: Sketch of a left arm. Florence, Archivio Buonarroti (Cat. No. 8).

80. Leonardo da Vinci: St. Anne with the Virgin and Christ Child. Black chalk and ink drawing. Paris, Louvre.

81. Michelangelo: St. Anne with the Virgin and Christ Child. Oxford, Ashmolean Museum (Cat. No. 9).

82. Leonardo da Vinci: Nude seen from the back. Red chalk drawing. Windsor Castle, Royal Library (By gracious permission of H.M. the King of England).

83. Michelangelo: Study of a nude seen from the back; five studies of heads. Oxford, Ashmolean Museum (Cat. No. 10).

84. Michelangelo: Triton with winged helmet; three sketches of heads. Oxford, Ashmolean Museum (Cat. No. 12).

85. Michelangelo: Study of a nude back; sketch of a shoulder with left arm; sketch of a left arm; sketch of a right leg. Oxford, Ashmolean Museum (Cat. No. 11).

86. Jacopo della Quercia: Adam digging. Detail from the relief in Bologna, San Petronio.

87. Michelangelo: Study of a nude man digging; two busts seen from behind; study of a shoulder repeated three times. Paris, Louvre (Cat. No. 13).

88. Michelangelo: Mercury-Apollo; rough sketch of a putto carrying what appears to be a sack. Paris, Louvre (Cat. No. 14).

89. Marteen van Heemskerck: Drawing after an ancient fountain figure in the Cesi garden. Berlin, Kupferstichkabinett.

90. Ancient fountain figure from the Cesi garden, Rome.

91. Sidamara sarcophagus. Detail: one of the Dioscuros. Constantinople, Museum.

92. Michelangelo: Study of a nude. Paris, Louvre (Cat. No. 15).

93. Michelangelo: Rapid sketch for the bronze David; study for the right arm of the marble David. Paris, Louvre (Cat. No. 16).

94. Michelangelo: Studies after antique models; study after Masaccio (?). Chantilly, Musée Condé (Cat. No. 17).

95. Ancient statue of the Three Graces. Siena, Libreria Piccolomini.

96. Unknown master of mid-sixteenth century: Studies after an ancient female figure. Paris, Louvre.

97. Michelangelo: Two sketches, one for the Bargello Tondo. Pupil of Michelangelo: Seated figure, probably of a prophet. Chantilly, Musée Condé (Cat. No. 18).

98. Michelangelo: Sketch for the Bargello Tondo. Detail of figure 97.

99. Michelangelo: Bargello Tondo. Florence, Bargello.

100. Michelangelo: Memory sketch of the Bruges Madonna. Detail of figure 115 (Cat. No. 24).

101. Michelangelo: Drapery sketch. Detail of figure 97.

102. Michelangelo: Madonna of Bruges. Bruges, Notre Dame.

103. Michelangelo: Study for an apostle, probably the St. Matthew; rapid sketch of a battle of horsemen for the Cascina cartoon. London, British Museum (Cat. No. 19).

104. Unknown imitator of Michelangelo: Copies after Michelangelo's study for the St. Matthew and after a nude seen from rear. Florence, Galleria degli Uffizi (see Cat. No. 19).

105. Leonardo da Vinci: Sketch for the Battle of Anghiari. Venice, Galleria della Accademia.

106. Michelangelo: Sketch for the Battle of Cascina. Detail of figure 103.

107. Michelangelo: Sketches of two capitals and ornamental mask for the Tomb of Julius II. London, British Museum (Cat. No. 20).

108. Michelangelo: Ornamental marble relief on one of the blocks of the Tomb of Julius II. Rome, San Pietro in Vincoli.

109. Michelangelo: Sketches of children, including two for the St. John the Baptist of the tondo in the Royal Academy. London, British Museum (Cat. No. 21).

110. Michelangelo: Sketch of a slave for the Julius Tomb; sketches of a putto and cherub. Pupil of Michelangelo: Several sketches. Paris, Louvre (Cat. No. 34).

111. Ancient Hercules sarcophagus. Fragment. Rome, Museo del Laterano.

112. Michelangelo: Study of a nude seen from the back. Florence, Casa Buonarroti (Cat. No. 22).

113. Unknown artist of the late fifteenth century: Drawing after the Apollo Belvedere. Codex Escurialensis.

114. Michelangelo: Study of a nude in the pose of the Apollo Belvedere. London, British Museum (Cat. No. 23).

115. Michelangelo: Pencil sketches of three nudes; ink sketch from memory after the Bruges Madonna. London, British Museum (Cat. No. 24).
116. Michelangelo: Pencil sketch of a nude seen from the back; two ink sketches for a putto; ink sketch of a left leg. London, British Museum (Cat. No. 25).
117. Michelangelo: Pen sketch of nude seen from the back; two black chalk sketches of a right shoulder seen from the back. Florence, Casa Buonarroti (Cat. No. 26).
118. Unknown artist: Copy after a drawing of Michelangelo of a horseman and a nude. Oxford, Ashmolean Museum (Cat. No. 27).
119. Unknown artist: Copy after Michelangelo. Nude seen from the back. Oxford, Ashmolean Museum (Cat. No. 28).
120. Michelangelo (?): Rear view of one of the figures of the Battle of Cascina. Vienna, Albertina (Cat. No. 30).
121. Unknown artist: Copy after Michelangelo. Study of a seated nude for the Battle of Cascina. London, British Museum (Cat. No. 31).
122. Unknown artist: Copy after Michelangelo. Two studies of nudes for the Battle of Cascina. Vienna, Albertina (Cat. No. 29).
123. Michelangelo: St. Anne, Virgin and Child; sketch of a nude man. Paris, Louvre (Cat. No. 33).
124. Michelangelo: Kneeling woman seen from the back. Paris, Louvre (Cat. No. 32).
125. Michelangelo: Study for the right arm of St. Matthew; sketch of a nude; sketch of a bearded head. Paris, Louvre (Cat. No. 35).
126. Michelangelo (?): Red chalk study for a left arm. Paris, Louvre (Cat. No. 1, verso).
127. Michelangelo: Red chalk study for a head. Florence, Casa Buonarroti.

WORKS RELATED TO THE ART OF MICHELANGELO

128. Michelangelo: Virgin of the Stairs. Detail. Florence, Casa Buonarroti.
129. Michelangelo: Moses of the Julius Tomb. Detail. Rome, San Pietro in Vincoli.
130. Michelangelo: Giorno of the Medici Tomb. Florence, Medici Chapel. Detail: mirror image.
131. Michelangelo: Pietà. Florence, Cathedral. Detail.
132. Greek stele of the fourth century B.C. Munich, Glyptothek.
133. Copy of Greek stele of the fourth century B.C. Florence, formerly in Palazzo Medici Riccardi.
134. Donatello: Madonna di Casa Pazzi. Berlin, Kaiser Friedrich Museum.
135. Maestro Andrea (Andrea dell'Aquila ?): Virgin with Child. Rome, Ospedale di Santo Spirito.
136. Donatello: Virgin in the clouds. Boston, Museum of Fine Arts.
137. Desiderio da Settignano (?): Virgin with Child. London, Victoria and Albert Museum.

138. Fra Bartolommeo: Virgin with Child. Drawing. Munich, Kupferstichkabinett.
139. Attributed to Pietro Perugino: Virgin with Child. Drawing. Florence, Galleria degli Uffizi.
140. Copy after Baccio Bandinelli: Virgin with Child and putti. Drawing. Paris, Louvre.
141. Baccio Bandinelli: Virgin with Child and St. Joseph. Drawing. Florence, Uffizi. Detail.
142. Ancient sarcophagus relief: Battle of the Romans and Barbarians. Rome, Museo delle Terme.
143. Bertoldo di Giovanni: Battle of Horsemen. Florence, Bargello.
144. Piero di Cosimo: Battle of Centaurs. London, Collection Charles Ricketts.
145. Copy after Michelangelo: Crucifix. Front view. Florence, Santo Spirito, sacristy.
146. Copy after Michelangelo: Crucifix. Side view. Florence, Santo Spirito, sacristy.
147. Copy after Michelangelo: Crucifix in its setting in armorie. Florence, Santo Spirito, sacristy.
148. Perugino: Crucifix. Florence, Santa Maria Maddalena de' Pazzi. Detail.
149. Unknown artist of the late sixteenth century: Crucifix. Florence, Santo Spirito, choir.
150. Giovanni da Bologna: Crucifix. Impruneta, Collegiata.
151. Giovan Antonio Dosio: Interior of the Church of Santo Spirito in Florence. Drawing. Florence, Museo Topografico.
152. Israel Silvestre: View of the Jardin de l'Estang in Fontainebleau with rear view of the lost Hercules by Michelangelo. Print from 1649 (Cat. XIV). Dresden, Kupferstichkabinett.
153. Nicolas Perelle: View of the Jardin de l'Estang in Fontainebleau. Print. Dresden, Kupferstichkabinett.
154. Alexander Francini: View of the Château of Fontainebleau. Print from 1614. Paris, Bibliothèque Nationale, Cabinet des Estampes.
155. Michelangelo: Kneeling angel with candelabrum. Bologna, San Domenico.
156. Luca della Robbia: Kneeling angel with candelabrum. Florence, Cathedral, Sagrestia vecchia.
157. Niccolò dell'Arca: Kneeling angel with candelabrum. Front view. Bologna, San Domenico.
158. Niccolò dell'Arca: Kneeling angel with candelabrum. Rear view.
159. Michelangelo: Saint Petronius. Bologna, San Domenico.
160. Jacopo della Quercia: Saint Petronius. Bologna, San Petronio.
161. Michelangelo: Saint Proculus. Bologna, San Domenico.
162. Donatello: Saint George. Florence, Bargello.
163. Desiderio da Settignano: Young Saint John the Baptiste. Florence, Bargello.

164. Benedetto da Maiano: Young Saint John the Baptiste. Florence, Palazzo della Signoria, Sala dell'Orologio.

164b. School of Michelangelo: Young Saint John the Baptiste. Úbeda, Capilla del Salvador.

165. Baccio Bandinelli: Young Saint John the Baptiste. Drawing. Paris, Louvre.

166. Pietro Bernini: Saint John the Baptiste. Pizzo Calabro, San Giorgio.

167. Giulio Romano: Childhood of Jupiter. Detail. London, National Gallery.

168. Tintoretto: Vulcan surprising Venus and Mars. Detail. Munich, Alte Pinacothek.

169. Marteen van Heemskerck: The antique garden of Jacopo Galli. Berlin, Kupferstichkabinett.

170. Cornelis Bos: Print after the Bacchus of Michelangelo. Vienna, Albertina.

171. Pietro da Barga: Small bronze copy of Michelangelo's Bacchus. Florence, Bargello.

172. Unknown Italian artist of the mid-sixteenth century: Small bronze copy of the Bacchus of Michelangelo. Vienna, Kunsthistorisches Museum.

173. Antique statue of Bacchus with satyrs and putti. Rome, Villa Albani.

174. Antique statue of Bacchus with satyr. Rome, Museo Vaticano.

175. Grimaldi: Sketch representing the choir of Sixtus IV in Saint Peter's with the Pietà of Michelangelo (?). Rome, Biblioteca Vaticana.

176. Antonio Salamanca: Print after Michelangelo's Pietà in Saint Peter's (1547). Paris, Bibliothèque Nationale.

177. Nanni di Baccio Bigio: Copy after Michelangelo's Pietà in Saint Peter's. Florence, Santo Spirito (1549).

178. Lorenzetti: Copy after Michelangelo's Pietà in Saint Peter's. Rome, Santa Maria dell'Anima (1531).

179. Giovanni Battista de' Cavalieri: Print after Michelangelo's Pietà in Saint Peter's (1564).

180. Unknown artist of the early seventeenth century: Small bronze copy of Michelangelo's Pietà in Saint Peter's. New York, Frick Collection. (Courtesy of the Frick Art Gallery.)

181. North Italian master, ca. 1460: Pietà from San Savino near Cremona. Frankfurt a.M., Städtische Skulpturensammlung.

182. Attributed to Niccolò dell'Arca: Pietà. Rome, Museo di Castel Sant'Angelo.

183. Ercole de Roberti: Pietà. Drawing. London, British Museum.

184. Leonardo da Vinci: Last Supper. Detail: Christ. Milan, Santa Maria delle Grazie.

185. Ercole de Roberti: Pietà. Liverpool, Royal Institution and Corporation.

186. Andrea Bregno: Piccolomini Altar. Siena, Cathedral.

187. Giuliano da San Gallo: Sketch of the Piccolomini Altar. Siena, Library.

188. Baccio da Montelupo: Saint Peter on the Piccolomini Altar, made after a drawing of Michelangelo. Front view. Siena, Cathedral.

189. Baccio da Montelupo: Saint Peter on the Piccolomini Altar. Side view.

190. Baccio da Montelupo: Saint Peter on the Piccolomini Altar. Side view.

191. Baccio da Montelupo: Saint Pius on the Piccolomini Altar.

192. Baccio da Montelupo: Saint Gregory on the Piccolomini Altar.

193. Pietro Torrigiani: Saint Francis on the Piccolomini Altar.

194. Baccio da Montelupo: Saint Paul on the Piccolomini Altar.

195. Antique Hercules sarcophagus. Detail. Rome, Museo delle Terme.

196. Nicola Pisano: Fortitude. Pisa, pulpit of the Baptistry.

197. Michelangelo: Marble David. Florence, Accademia delle Belle Arti.

198a. Stefano Bonsignori: Plan of Florence in the year 1584. Detail: San Marco and the Medici Garden (no. 49). Florence, Museo Topografico.

198b. Unknown artist of the early sixteenth century: Piazza della Signoria. Detail: Palazzo della Signoria and the Loggia dei Lanzi. Florence, Galleria Corsini.

199. Leonardo da Vinci: Memory drawing after Michelangelo's marble David. Windsor Castle, Royal Library.

200. Raphael: Young warrior in the pose of Michelangelo's marble David. Drawing. Oxford, Ashmolean Museum.

201. Giovanni Bandini detto dell'Opera: A prophet in the pose of Michelangelo's marble David. Florence, Cathedral, Choir.

201b. Unknown artist (attributed to Cellini): Wax statuette in the pose of Michelangelo's marble David. Boston, Museum of Fine Arts. (By courtesy of the Boston Museum.)

202. Unknown French (?) artist of the last third of the sixteenth century: Small bronze copy of Michelangelo's marble David. Paris, Louvre, Collection Thiers.

203. Michelangelo: Bruges Madonna. Bruges, Church of Notre Dame.

203b. Pisanello: Drawing after ancient statue (Detail). Milan, Ambrosiana.

204. Unknown artist: Copy of Michelangelo's Bruges Madonna on the Breydel epitaph (1642). Bruges, Cathedral.

205. Rombaut Pauli (Pauwels): Copy of Michelangelo's Bruges Madonna. Ghent, Saint Michel.

206. Pierre-Antoine Verschaffelt: The Mausoleum of Bishop Maximilian Van der Noot. Ghent, Cathedral of Saint Bavon.

207. Donatello: Virgin and Child. Padua, Sant'Antonio.

208. Unknown Byzantine artist: Virgin and Child, St. Nicholas and St. Anthony. Vatican, Pinacoteca.

209. Benedetto da Maiano: Virgin and Child. Berlin, Kaiser Friedrich Museum.

210. Ducerceau: View of the Château de Bury. Detail: court of the château with the bronze David of Michelangelo in the center. From Ducerceau's *Les plus excellents bâtiments de France*, 1576, p. 125.

211. Unknown artist: Sketch of the catafalque of Michelangelo. Milan, Ambrosiana.

212. Benvenuto Cellini: Statue of Perseus. Side view. Florence, Loggia dei Lanzi.

213. Donatello: Small bronze model for the David of the Casa Martelli. Berlin, Kaiser Friedrich Museum.

214. Michelangelo: Sketch for the bronze David. See figure 93. Paris, Louvre.

215. Unknown artist early sixteenth century: Small bronze figure of David. Formerly Collection Charles de Pulszky. Paris, Louvre.

216. Michelangelo: Tondo of Bartolommeo Pitti. Florence, Bargello.

217. Jacopo della Quercia: Prudence. From the Fonte Gaia. Siena, Palazzo Pubblico.

218. Antique Phedra sarcophagus, called Sarcophagus of the Contessa Beatrice. Detail. Pisa, Campo Santo.

219. Raphael (copy after): Drawing for the Caritas. Vienna, Albertina.

220. Michelangelo: Tondo of Taddeo Taddei. London, Royal Academy.

221. Antique Medea sarcophagus. Detail. Mantua, Museum.

222. Copy after Raphael: Virgin and Child. Drawing. Detail. Paris, Louvre.

223. Raphael: Sketches for a Virgin and Child. Florence, Galleria degli Uffizi.

224. Signorelli: Virgin and Child. Tondo. Florence, Galleria degli Uffizi.

225. Michelangelo: Madonna Doni with the original frame. Florence, Galleria degli Uffizi.

226. Giorgio Vasari: View of the Sala del Consiglio. Florence, Palazzo della Signoria.

227. Giorgio Vasari: View of the Sala del Consiglio.

228. North exterior wall of the Palazzo della Signoria, directly outside of the Sala del Consiglio. Florence.

229. North exterior wall of the Palazzo della Signoria, directly outside of the Sala del Consiglio. Florence.

230. South exterior wall of the Palazzo della Signoria, directly outside of the Sala del Consiglio. Florence.

231. South exterior wall of the Palazzo della Signoria, directly outside of the Sala del Consiglio. Florence.

232. Bastiano da San Gallo (?): Copy after Michelangelo's cartoon for the Battle of Cascina. Grisaille panel. Holkham, Lord Leicester Collection.

233. Marc Antonio Raimondi: Les Grimpeurs. Print after three figures of Michelangelo's cartoon. Bartsch, no. 487. Florence, Galleria degli Uffizi.

234. Unknown artist: Copy after Michelangelo's cartoon of the Battle of Cascina. London, Collection Fenwick.

235. Agostino Veneziano: Five figures for the cartoon of the Battle of Cascina. Print. Bartsch, no. 423. Florence, Galleria degli Uffizi.

236. Daniele da Volterra (?): Baptism of Christ. Rome, San Pietro in Montorio. Chapel of Giovanni Riccio.

237. Attributed to Giovanni Antonio Dosio: View of the Sala del Consiglio. Drawing. Florence, Galleria degli Uffizi.

238. Leonardo da Vinci: Sketches for the Battle of Anghiari. Venice, Galleria della Accademia.
239. Leonardo da Vinci: Sketches for the Battle of Anghiari. Venice, Galleria della Accademia.
240. Leonardo da Vinci: Sketch probably for the Battle of Anghiari. Windsor Castle, Royal Library (By gracious permission of H.M. the King of England).
241. Michelangelo: St. Matthew. Florence, Accademia delle Belle Arti.
242. Antique statue: the Pasquino. Rome.
243. Jacopo della Quercia: Relief of a prophet on the baptismal font. Siena, Baptistry.
244. Donatello: Lo Zuccone. Florence, Campanile of the Cathedral.
245. Raphael: Sketch after Michelangelo's St. Matthew. London, British Museum.
246. Girolamo Santa Croce: St. Peter in the pose of Michelangelo's St. Matthew. Naples, Chiesa di Monte Oliveto.
247. Baccio Bandinelli: Drawing for a monument of Pope Clement VII. Detail. Paris, Louvre.
248. Antonio and Pietro del Pollaiuolo: Funeral monument of Pope Innocent VIII. Detail: seated statue of Pope Innocent VIII. Rome, San Pietro.
249. Vincenzo Danti: Seated statue of Pope Julius III. Perugia.
250. Entrance to the Palazzo Pubblico in Bologna with the seated statue by A. Menganti of Pope Gregory XIII.
251. Coat-of-Arms of Julius II. Bologna, Museo Civico (not exhibited).

FALSELY ATTRIBUTED WORKS

252. Unknown artist, late sixteenth or early seventeenth century: Head of a faun. Florence, Bargello.
253. Ottavio Vannini: Presentation of head of a faun by Michelangelo to Lorenzo de' Medici. Fresco. Florence, Palazzo Pitti.
254. Unknown artist, early sixteenth century: Apollo and Marsyas. Relief. New York, Art dealer.
255. Attributed to Niccolò Tribolo: Martyrdom of St. Andrew. Relief. Florence, Bargello.
256. Silvio Cosini: The young Saint John the Baptist. Front view. New York, Morgan Library.
257. Silvio Cosini: The young Saint John the Baptist. Rear view.
258. Silvio Cosini: The young Saint John the Baptist. Side view.
259. Silvio Cosini: The young Saint John the Baptist. Side view.
260. Unknown artist of the last quarter of the sixteenth century: Young St. John the Baptist. Front view. Berlin, Kaiser Friedrich Museum.

261. Unknown artist of the last quarter of the sixteenth century: Young St. John the Baptist. Rear view.
262. Unknown artist of the last quarter of the sixteenth century: Young St. John the Baptist. Side view.
263. Unknown artist of the last quarter of the sixteenth century: Young St. John the Baptist. Side view.
264. Vincenzo Danti: Cupid. Front view. London, Victoria and Albert Museum.
265. Vincenzo Danti: Cupid. Side view.
266. Vincenzo Danti: Cupid. Side view.
267. Vincenzo Danti: Cupid. Side view.
268. Unknown artist of the sixteenth century: Statuette of Apollo. Front view. Berlin, Deutsches Museum.
269. Unknown artist of the sixteenth century: Statuette of Apollo. Rear view.
270. Unknown artist of the sixteenth century: Statuette of Apollo. Side view.
271. Unknown artist: St. Sebastian. London, Victoria and Albert Museum.
272. Restored antique sculpture: Dionysus with satyr. Florence, Galleria degli Uffizi.
273. Vincenzo de' Rossi: Dying Adonis. Florence, Bargello.
274. Unknown artist: Memory sketch after Michelangelo's cartoon of the Battle of Cascina. Vienna, Albertina.
275. Attributed to Alessandro Allori: Memory sketch after the cartoon of the Battle of Cascina. Florence, Galleria degli Uffizi.
276. Unknown artist of the first half of the sixteenth century: Virgin with candelabrum. Vienna, Academy.
277. Unknown artist of the first half of the sixteenth century: Virgin with Christ Child and St. John the Baptist. London, private collection.
278. Unknown artist of the first half of the sixteenth century: Manchester Madonna. London, National Gallery.
279. Unknown artist of the first half of the sixteenth century: Virgin with Child and St. John the Baptist. Dublin, National Gallery.
280. Unknown artist of the first half of the sixteenth century: Study for one of the female figures of the Burial of Christ. Paris, Louvre.
281. Unknown artist of the first half of the sixteenth century: Burial of Christ. London, National Gallery.
282. Unknown artist: Copy representing backs, probably after a lost drawing of Michelangelo in the style of figure 83. Paris, Louvre.
283. Unknown artist: Copy after Michelangelo's drawing in figure 115. Paris, Louvre.
284. Unknown artist: Copy probably after a lost drawing of Michelangelo, representing studies of arms. Vienna, Albertina.
285. Unknown artist: Copy probably after a lost drawing of Michelangelo, representing a nude seen from the rear. Vienna, Albertina.

286. Attributed to Michelangelo: Terracotta model of a nude figure. Front view. Florence, Casa Buonarroti.

287. Attributed to Michelangelo: Terracotta model of a nude figure. Rear view.

288. Attributed to Michelangelo: Wax model of a nude figure. Florence, Casa Buonarroti.

289. Unknown artist of the mid-sixteenth century: Small bronze copy after figure 286. Berlin, Kaiser Friedrich Museum.

290. Unknown artist of the late sixteenth century: Small bronze copy of figure 286. Zurich, Schweizerisches Landesmuseum.

291. Unknown artist of the mid-sixteenth century: Study after figure 287. Florence, Galleria degli Uffizi.

292. Unknown artist of the early seventeenth century: Portrait of Michelangelo, with small terracotta model in figure 286. Florence, Casa Buonarroti.

PHOTOGRAPHIC SOURCES

PHOTOGRAPHIC SOURCES

PLATES

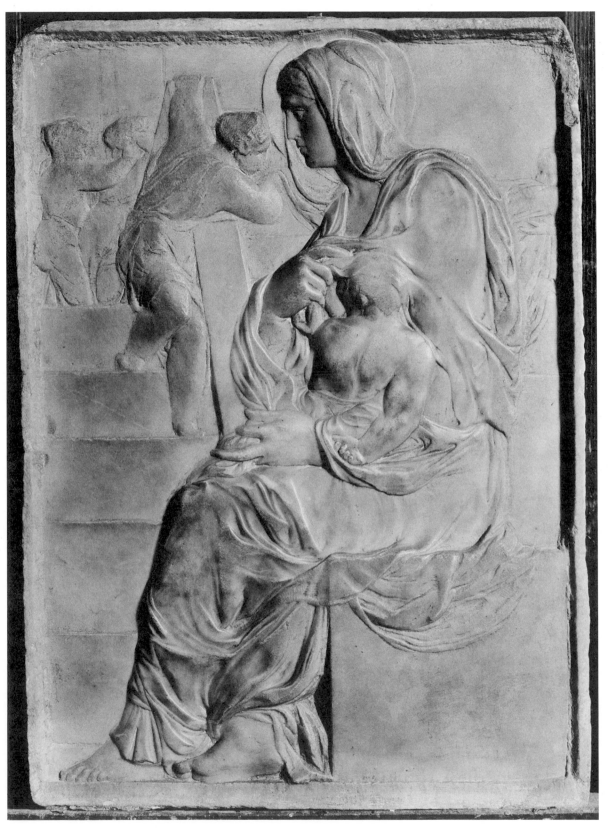

1

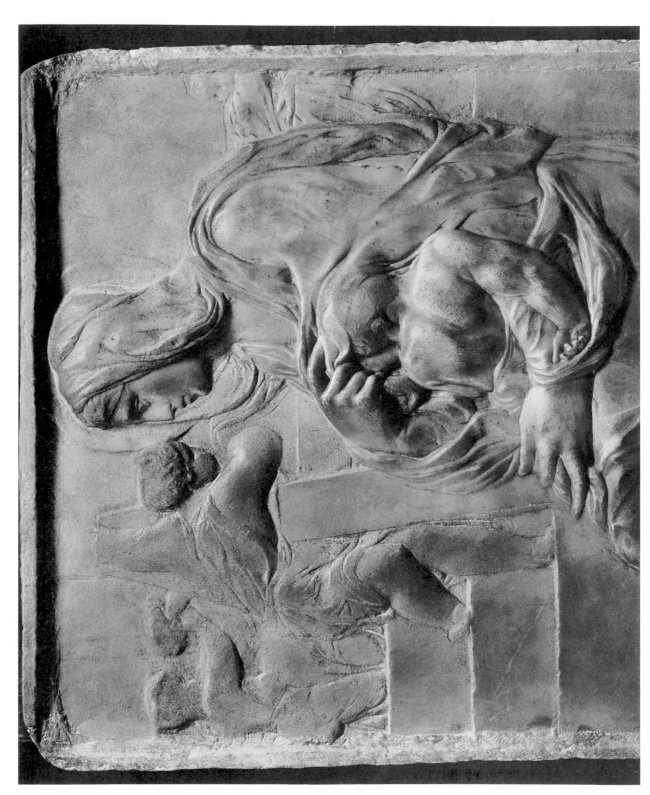

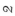

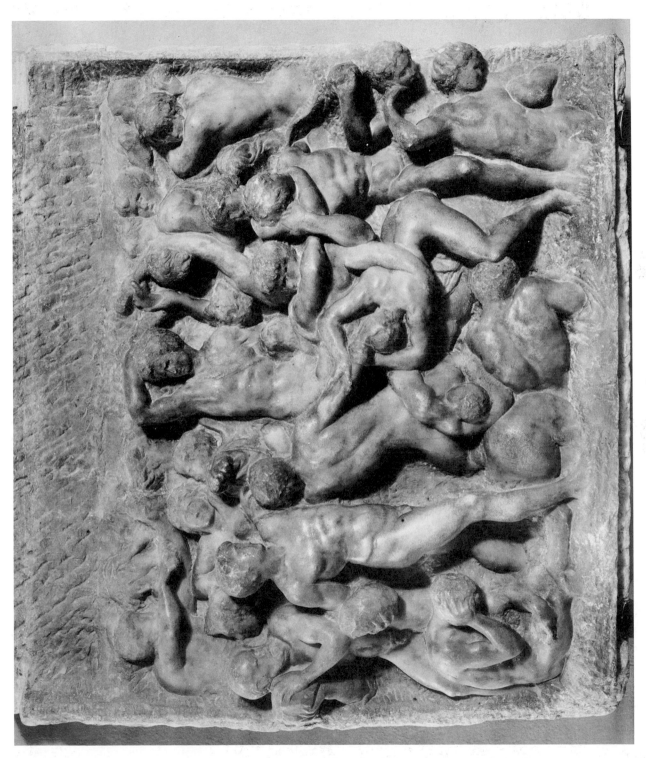

3

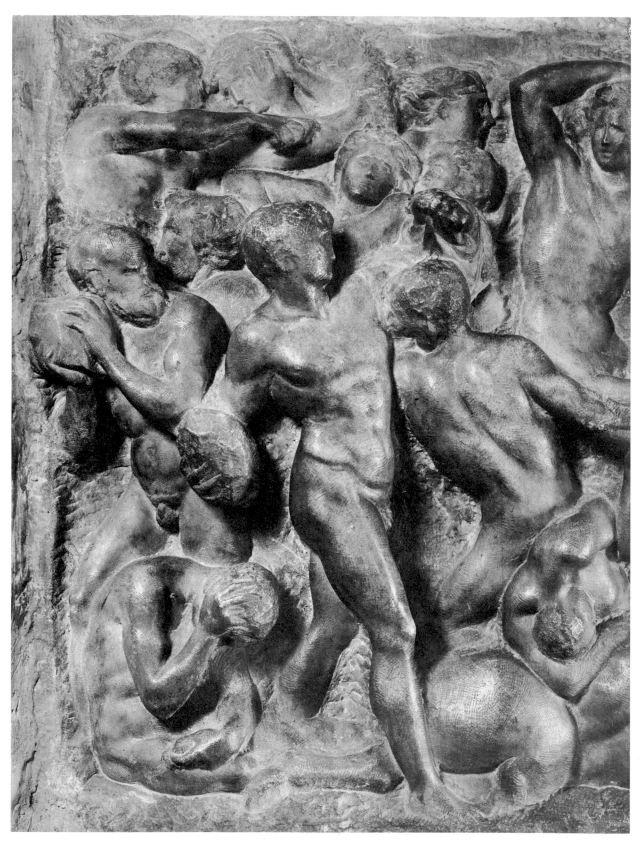

4

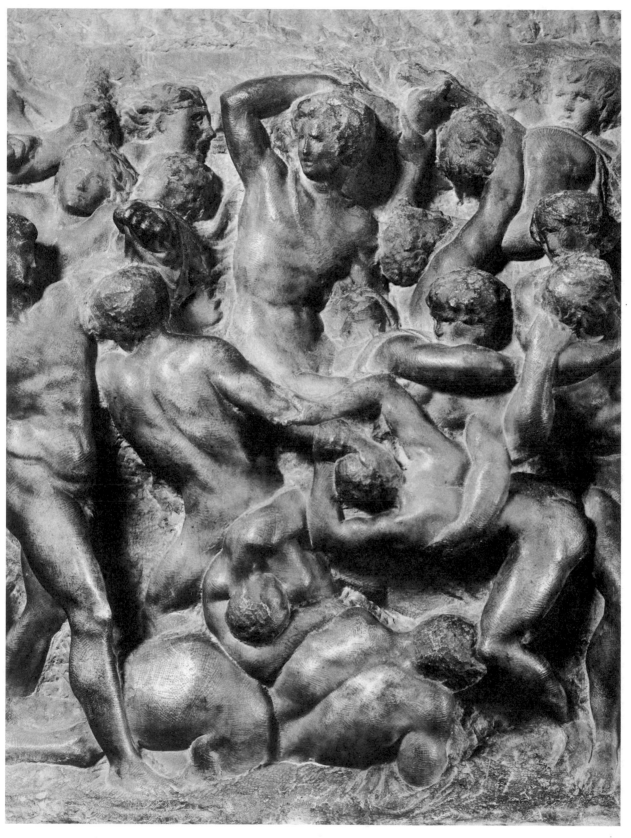

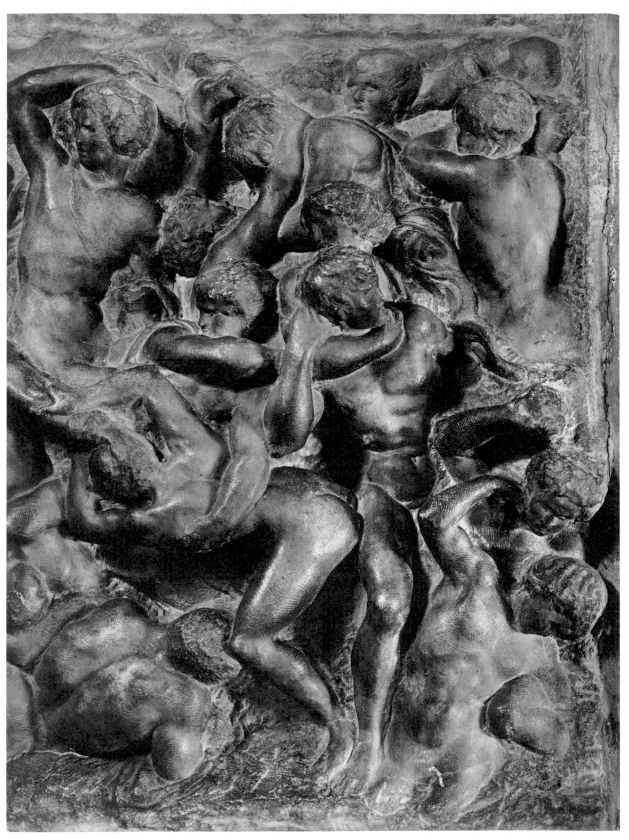

6

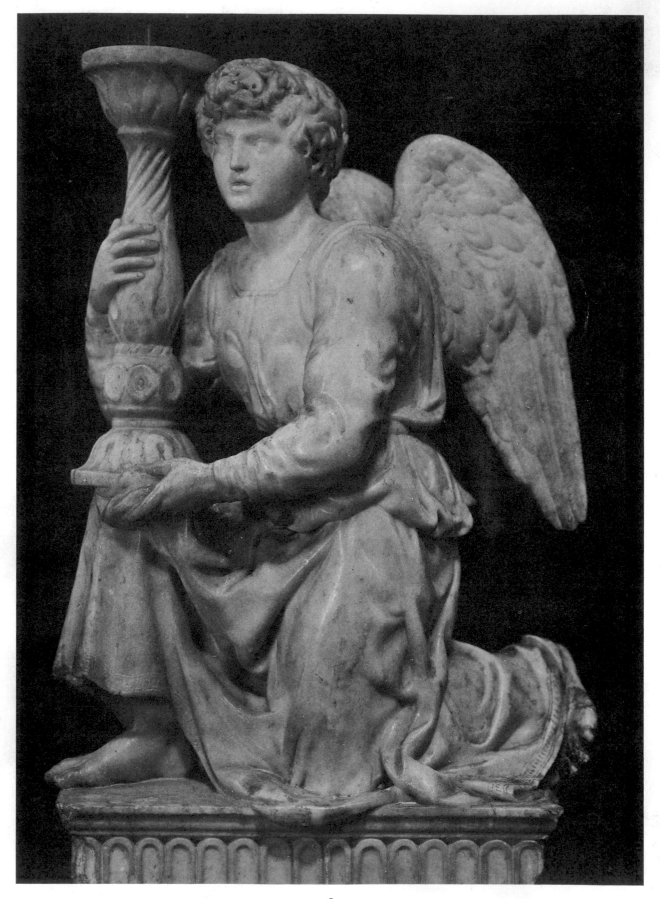

8

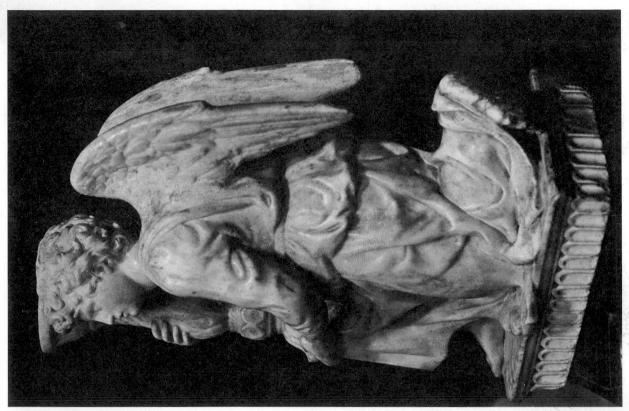

10

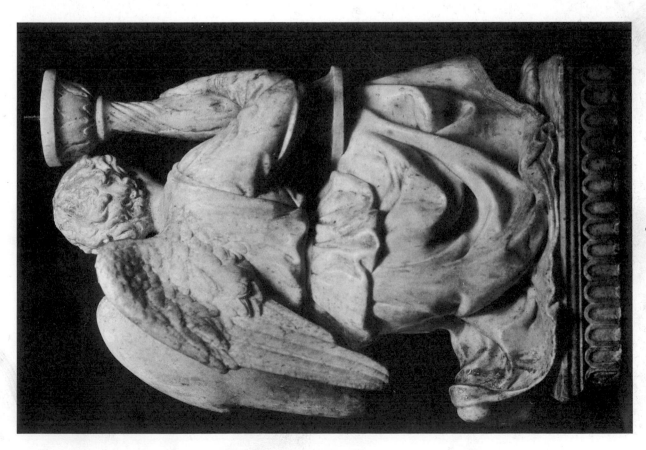

9

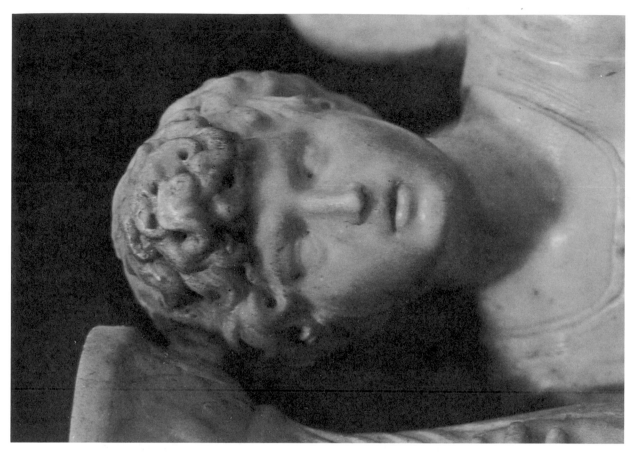

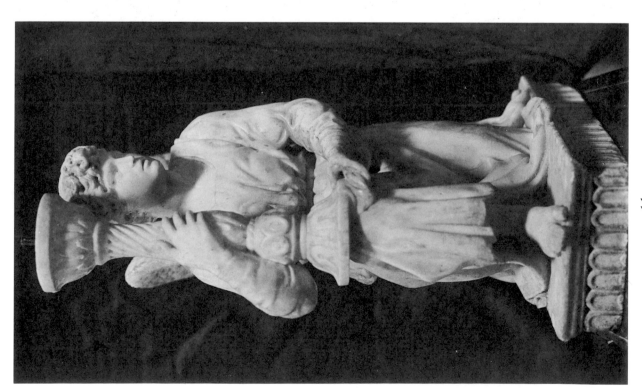

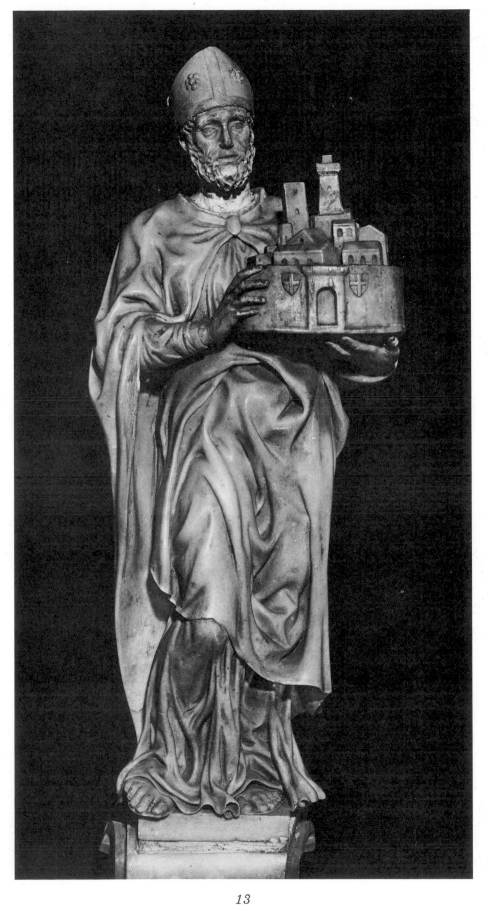

13

15

14

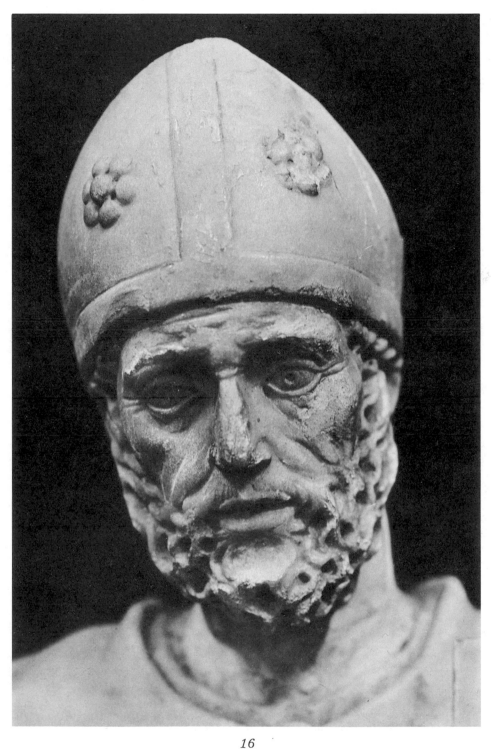

16

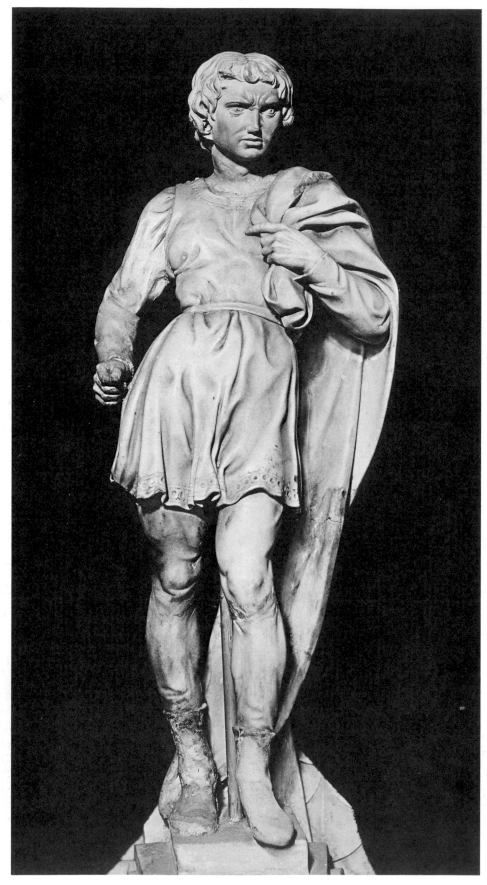

17

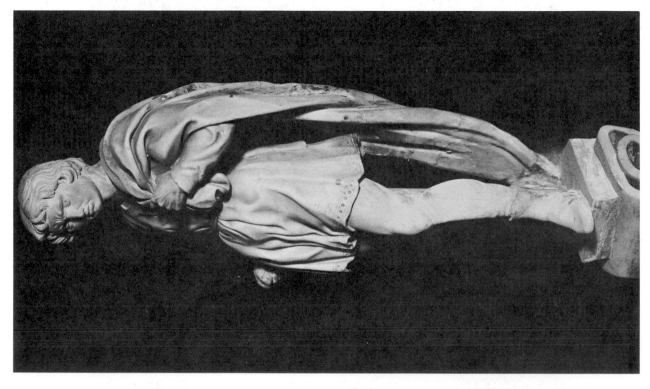

19

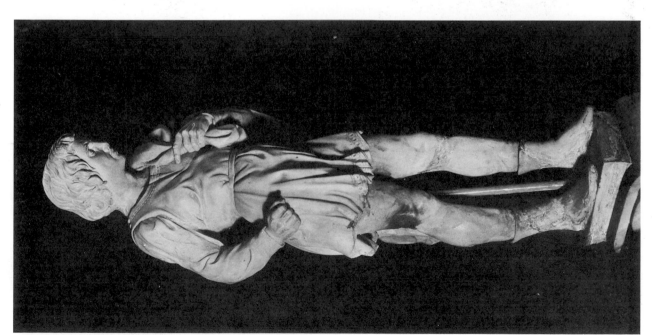

18

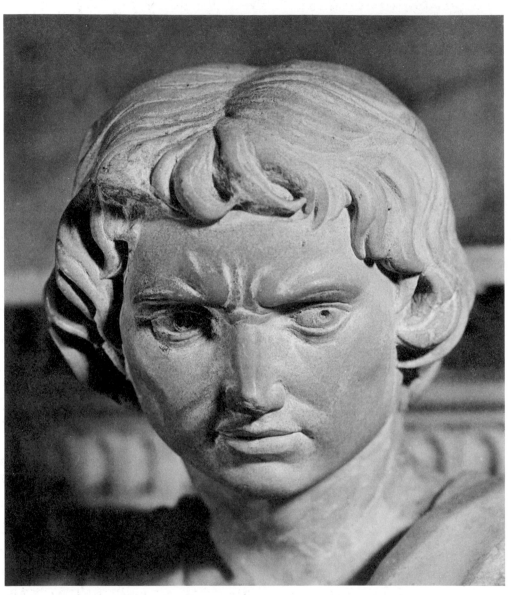

20

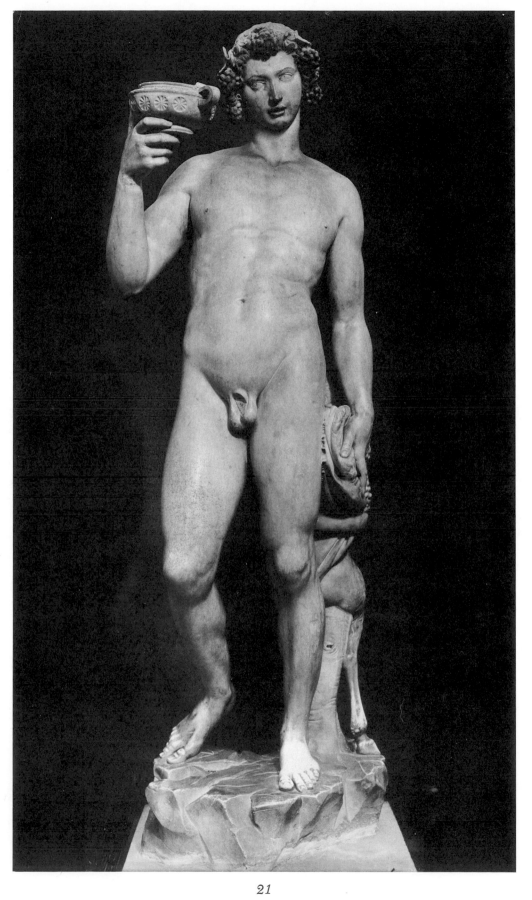

21

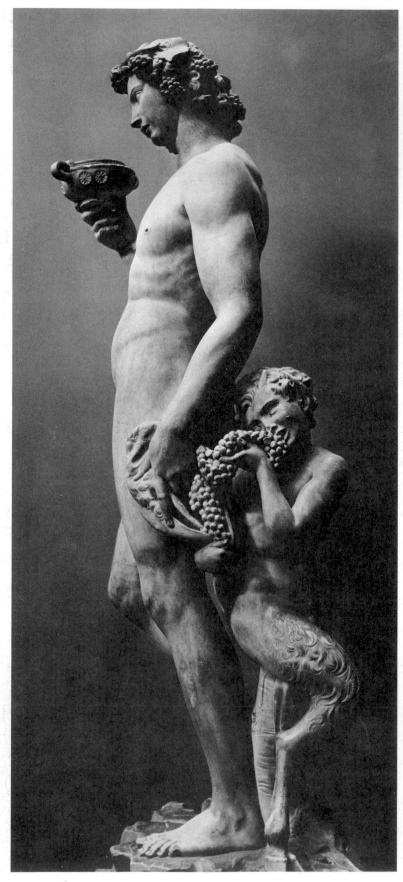

22

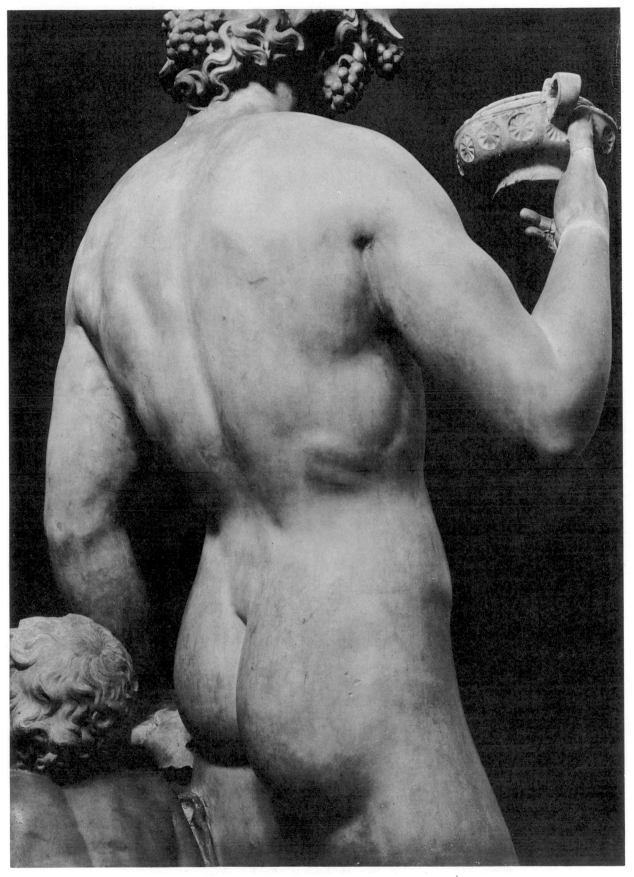

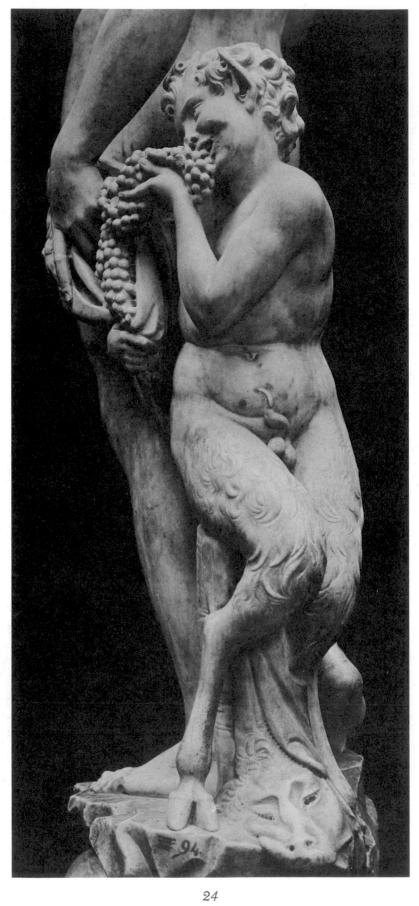

24

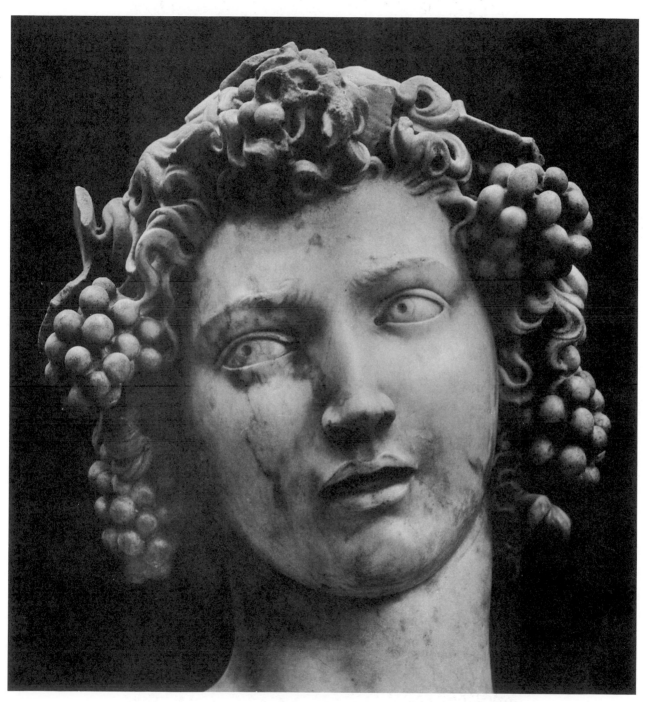

25

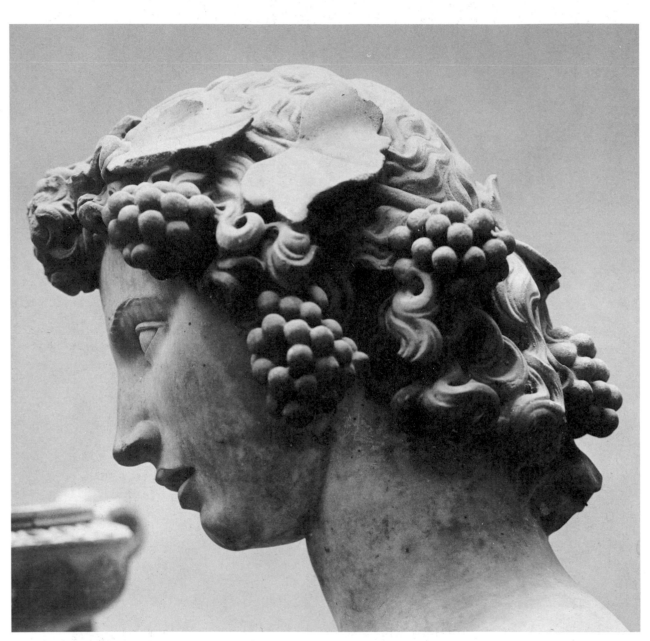

26

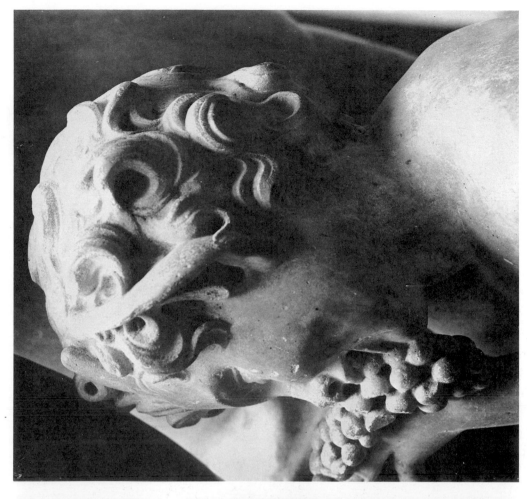

28

27

29

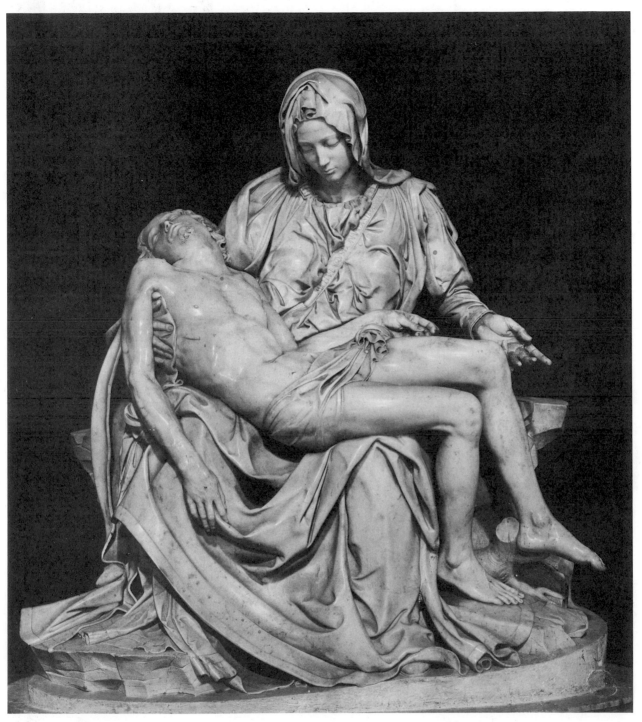

30

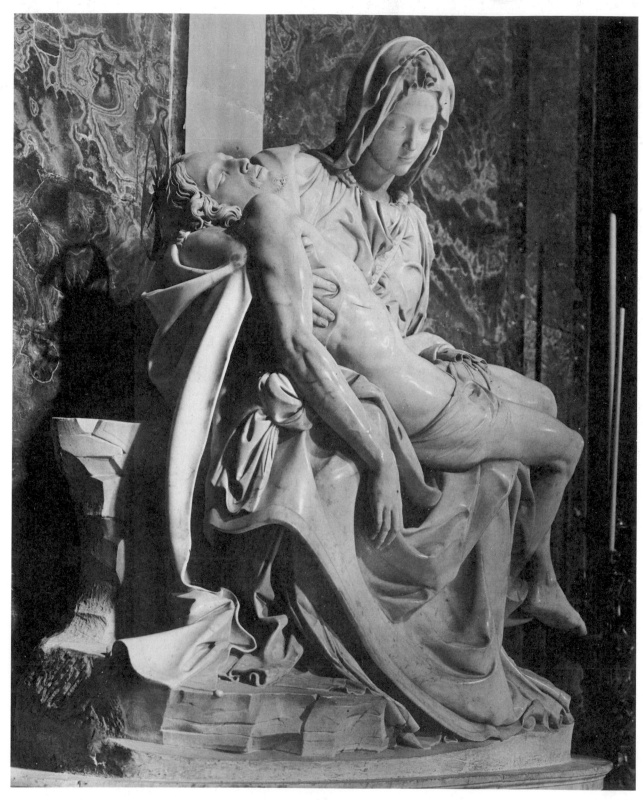

31

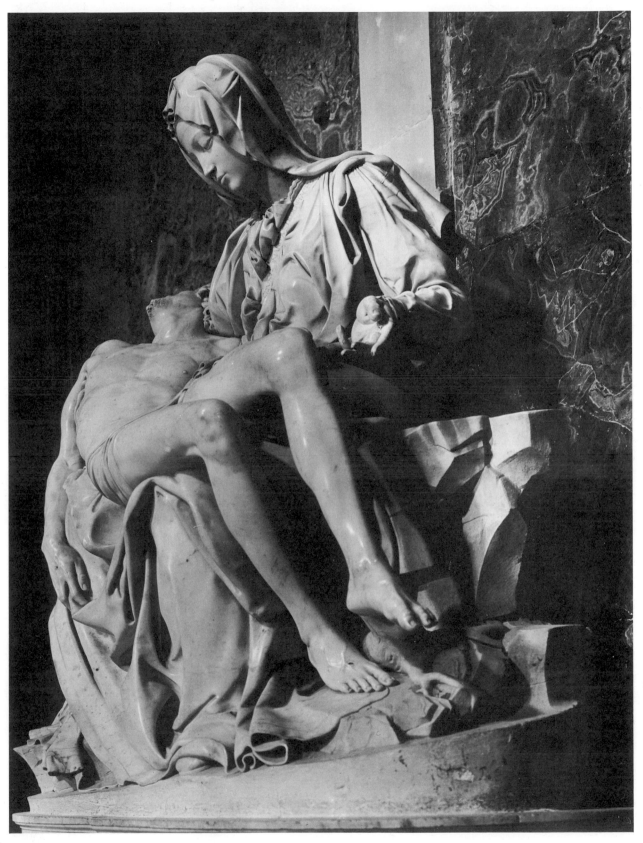

32

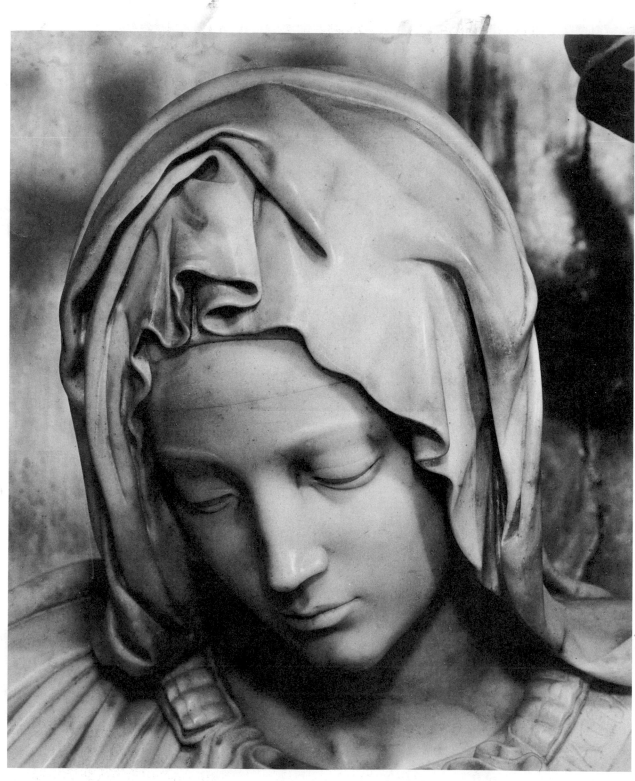

33

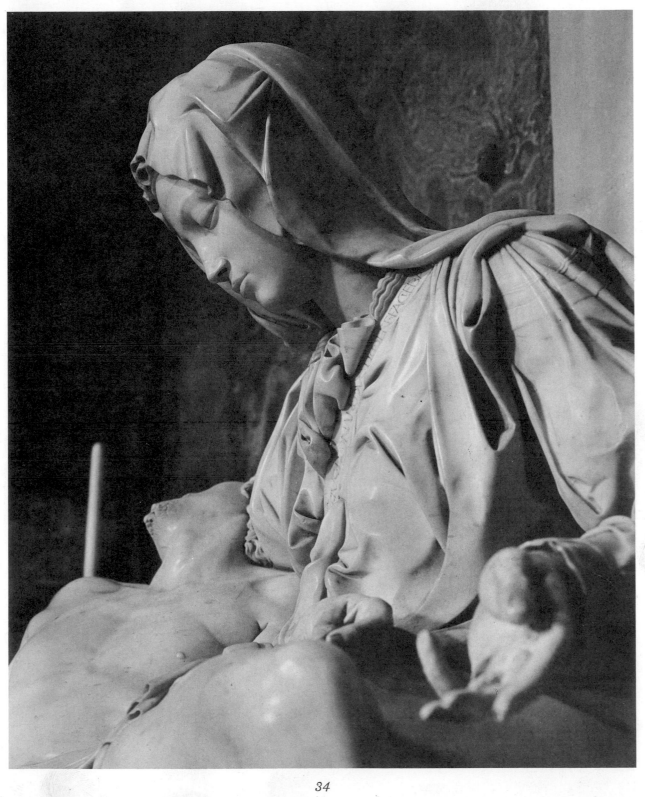

34

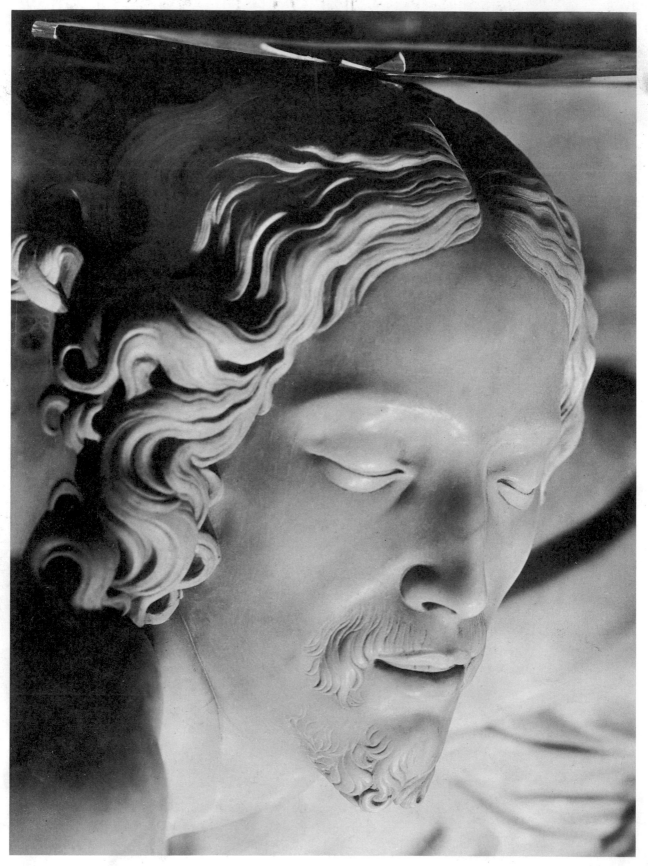

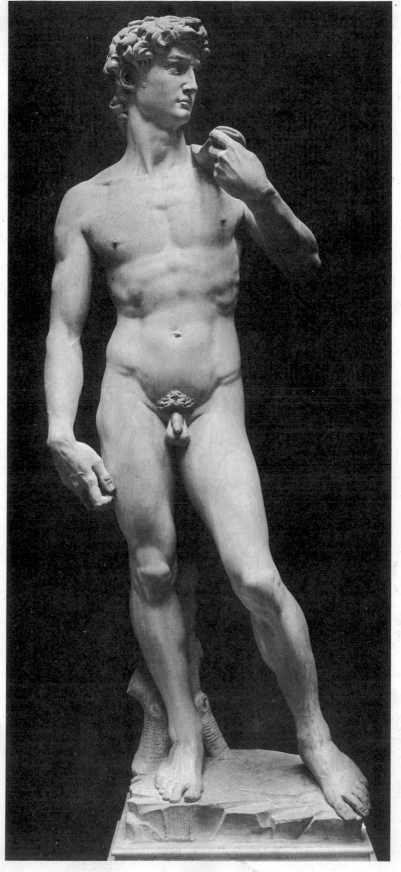

36

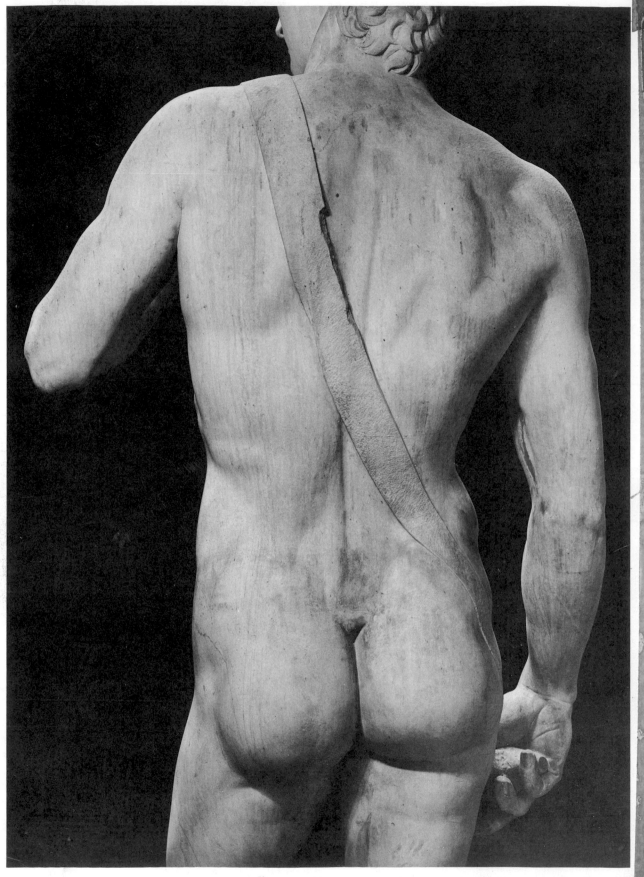

37

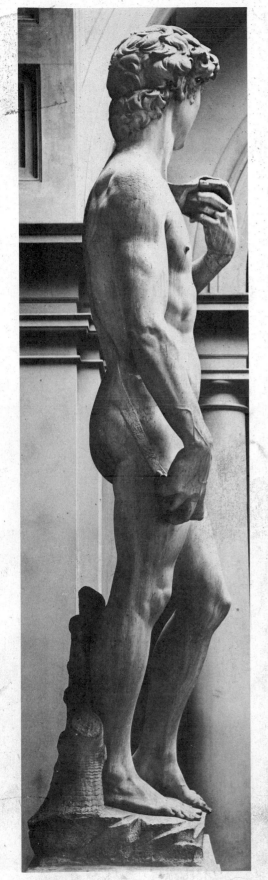

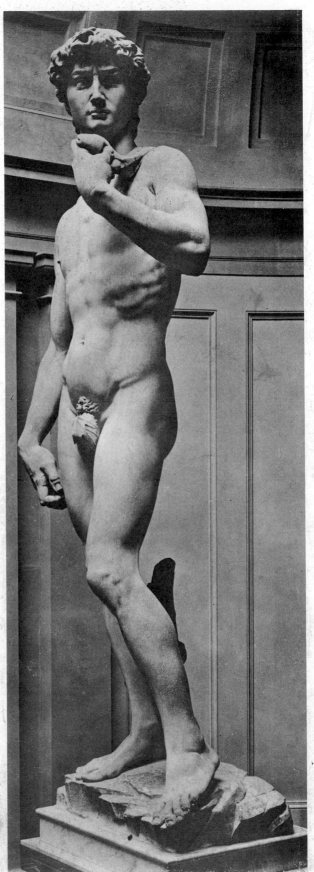

38

39

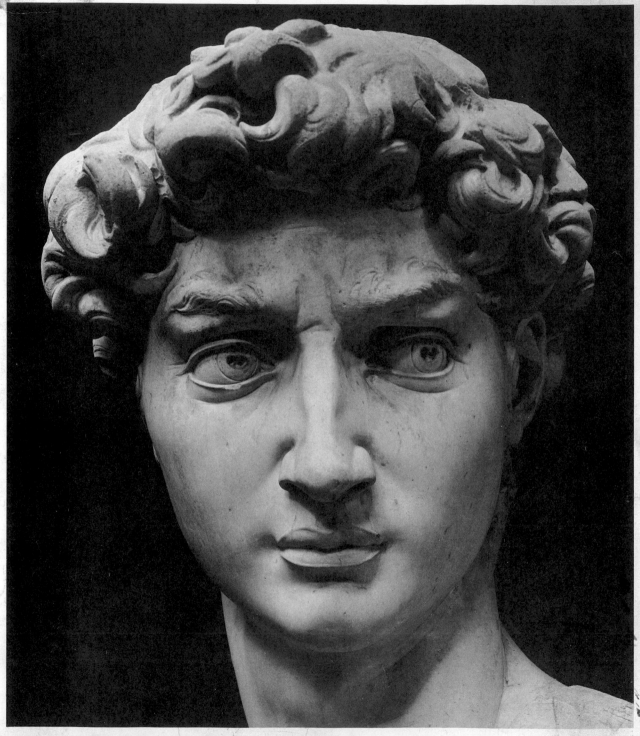

40

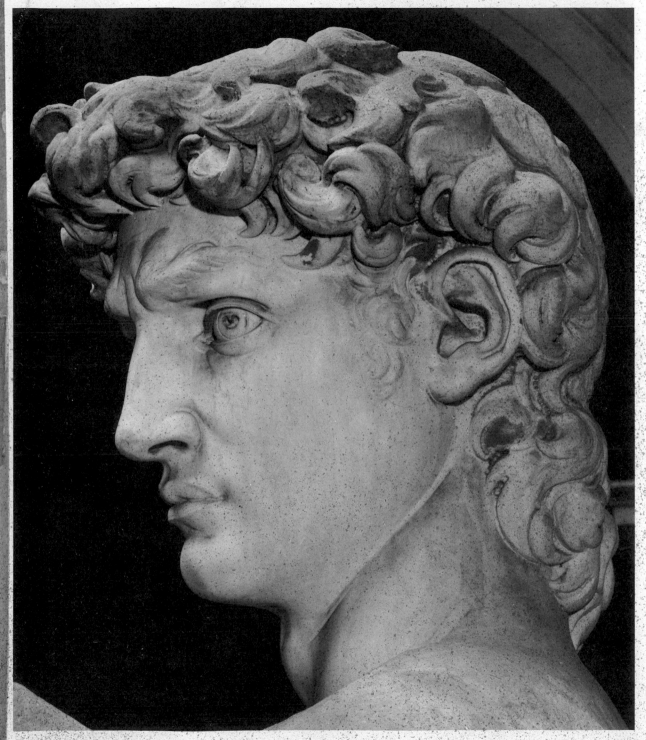

41

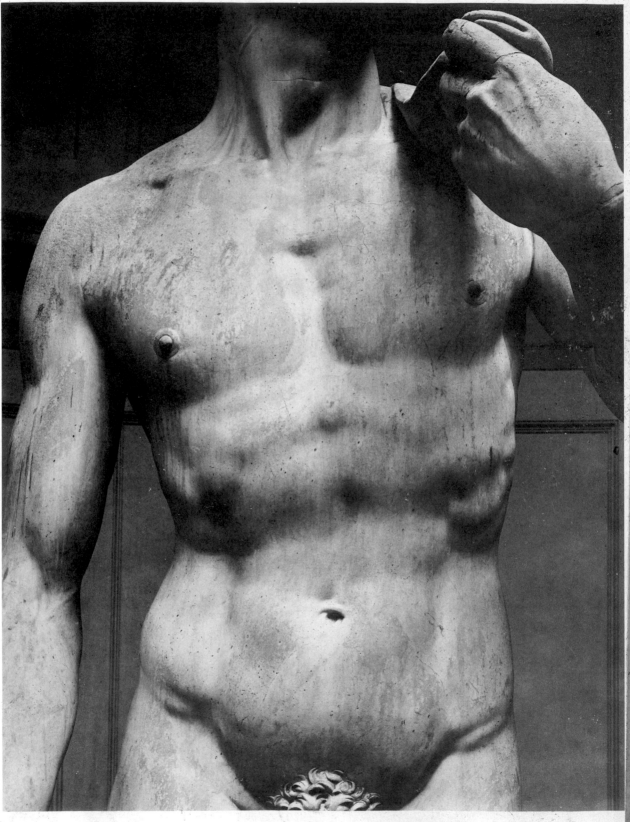

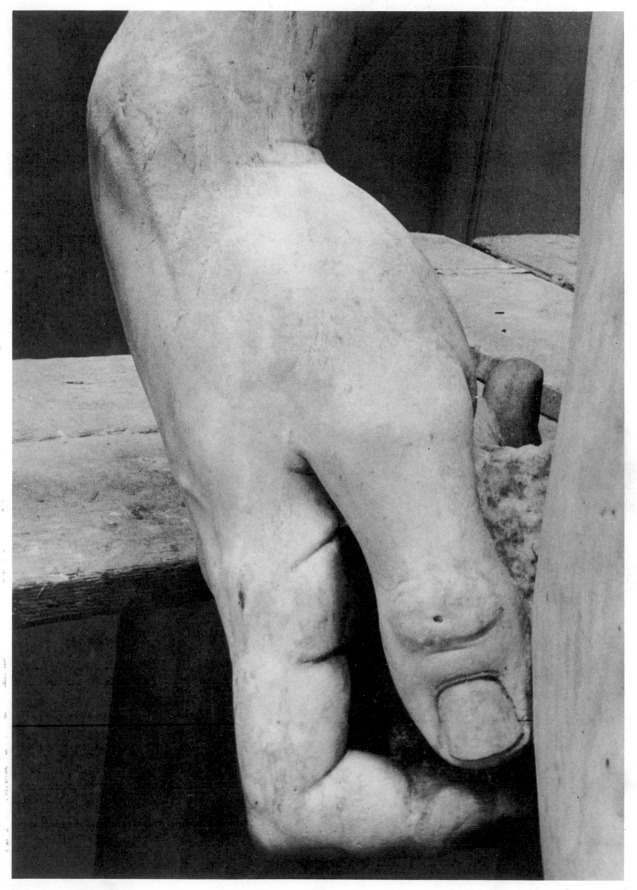

43

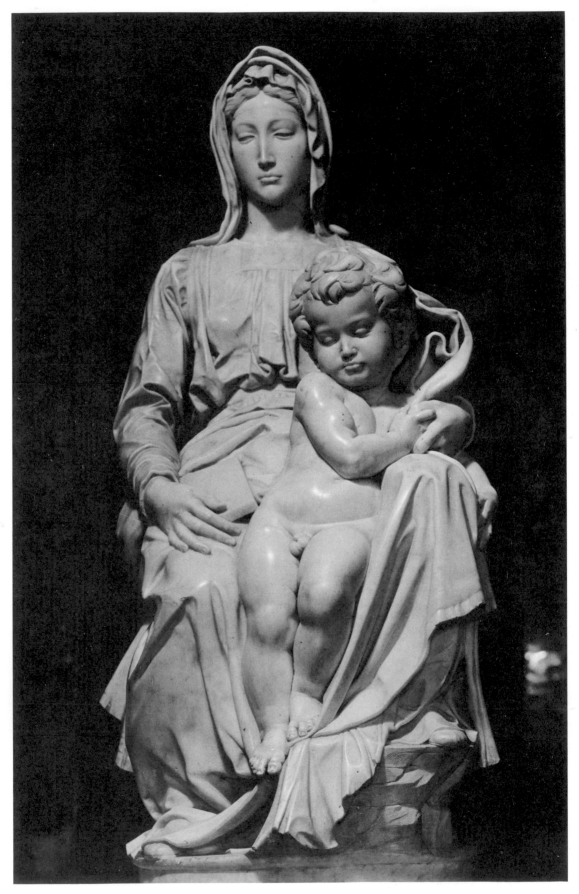

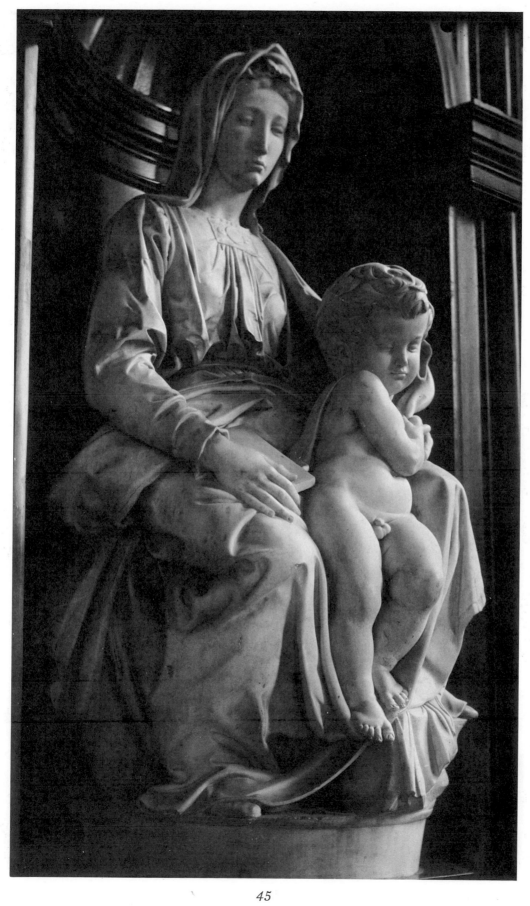

45

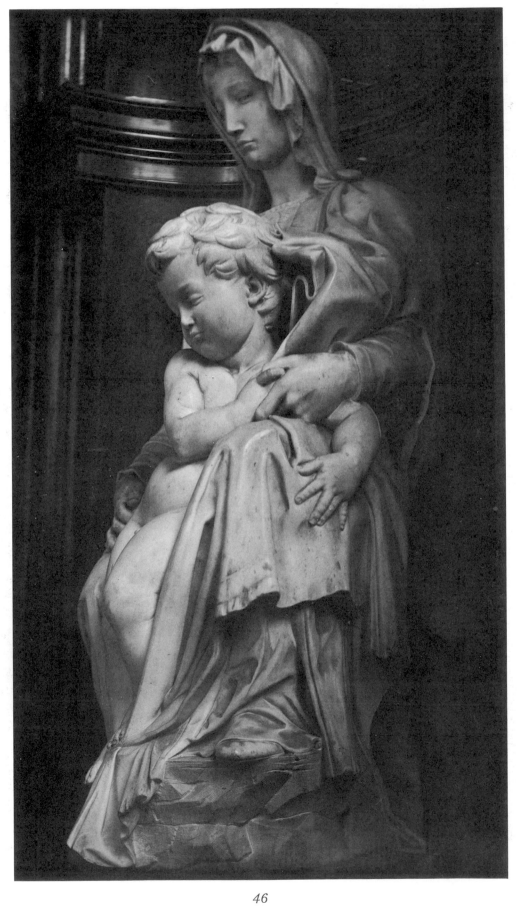

46

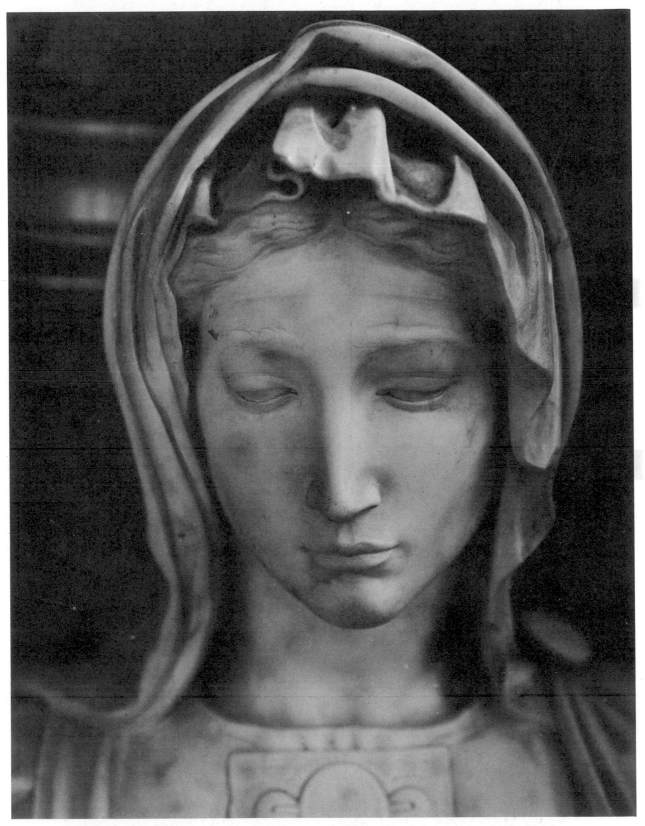

47

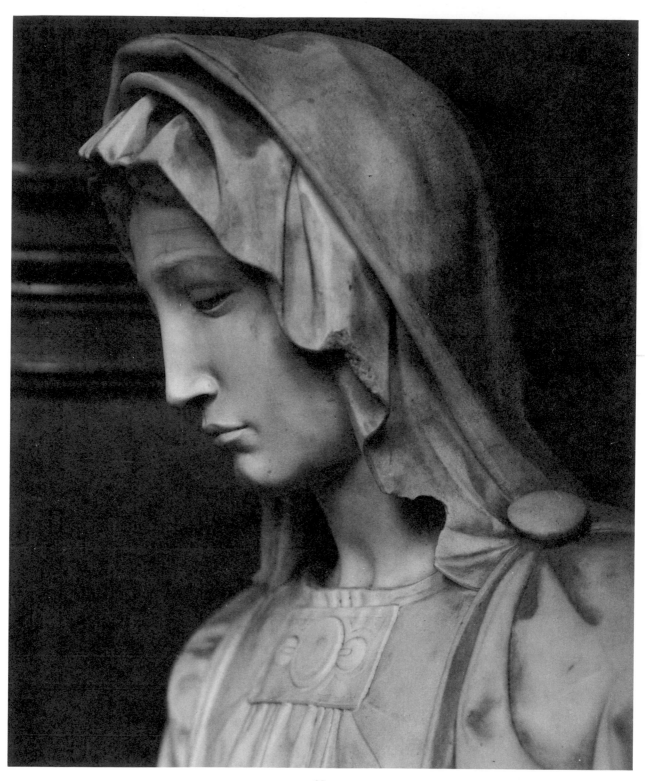

48

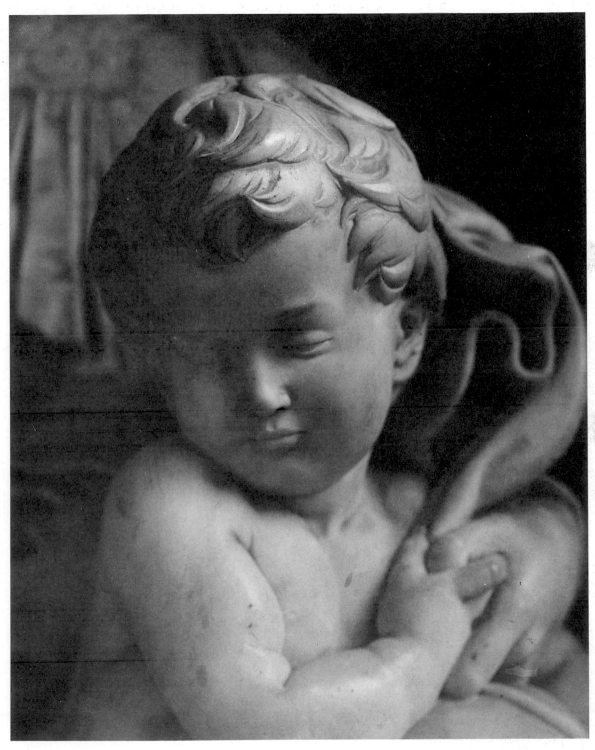

49

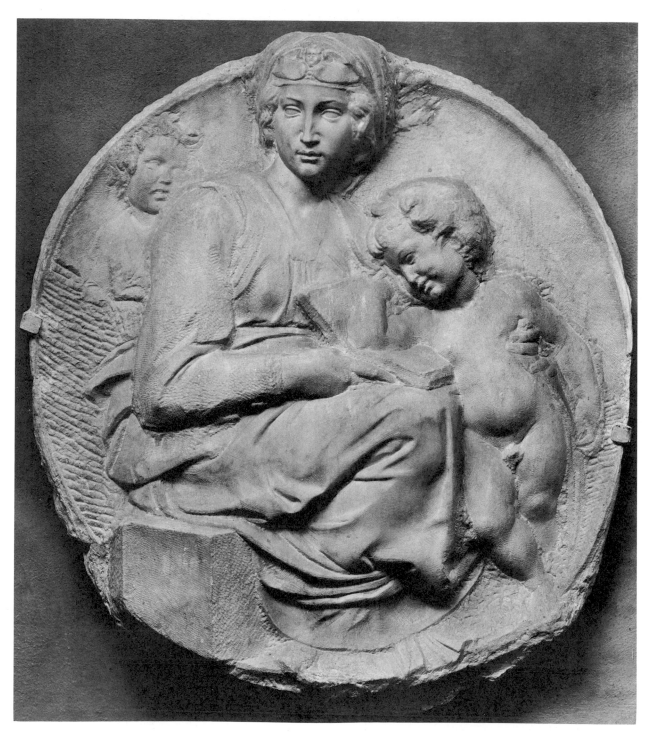

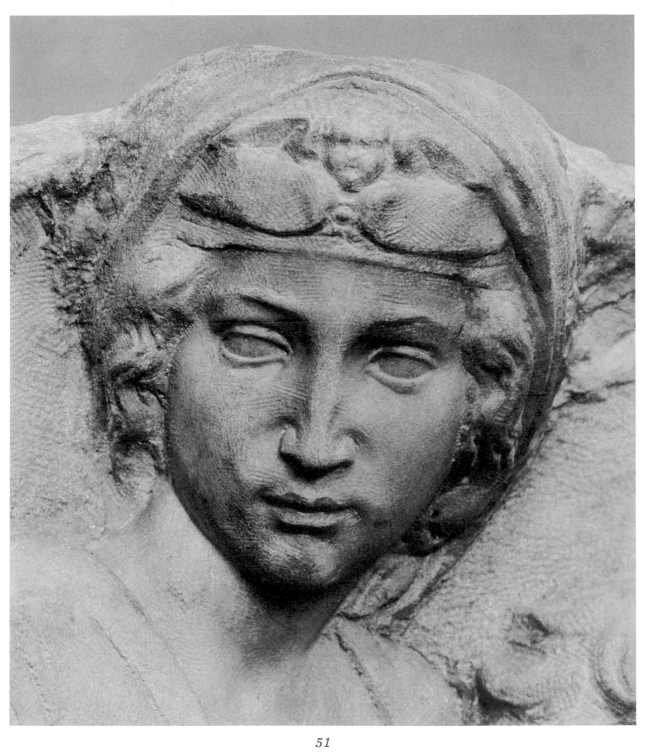

51

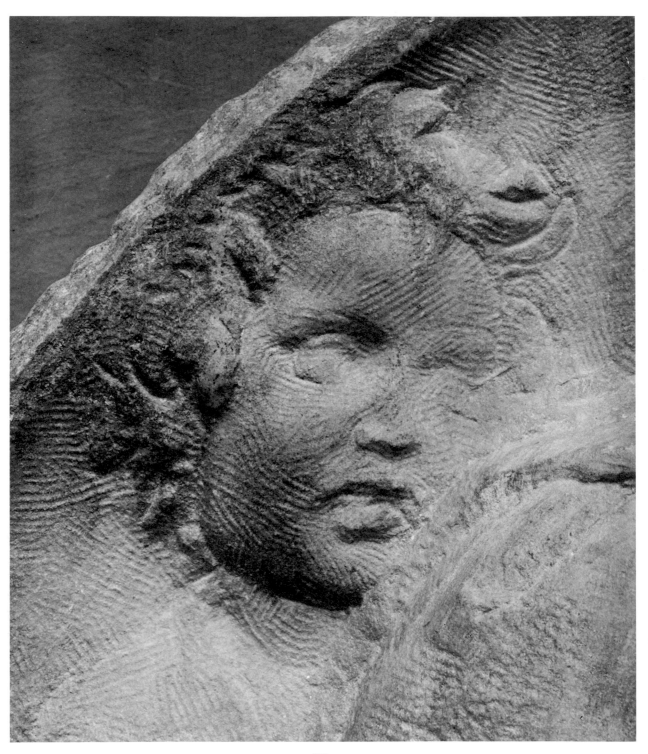

52

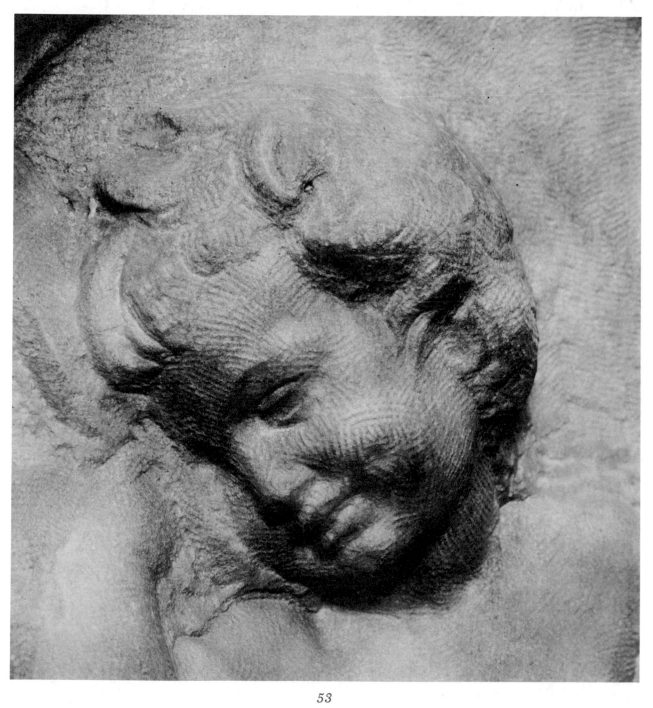

53

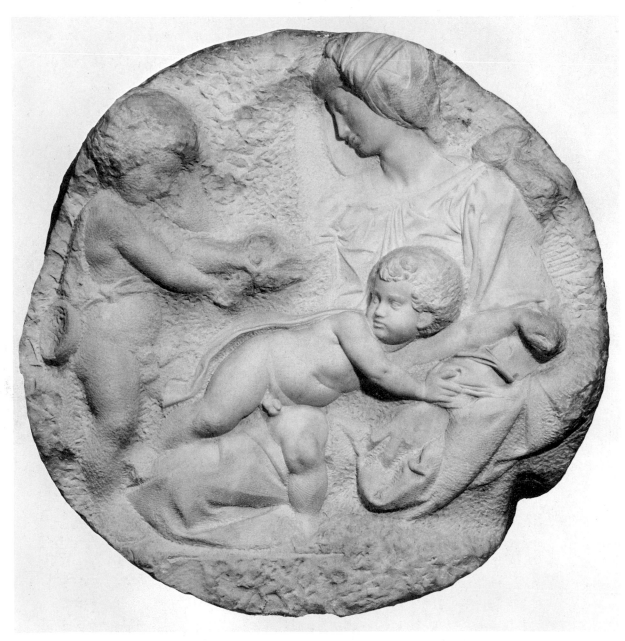

54

56

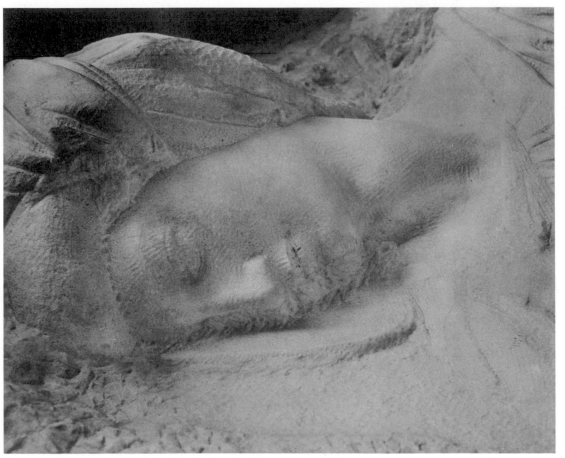

55

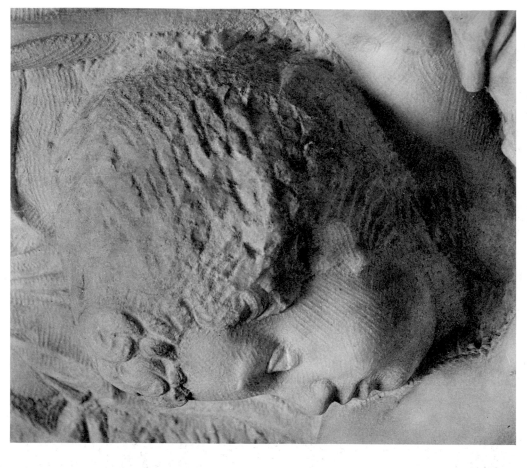

58

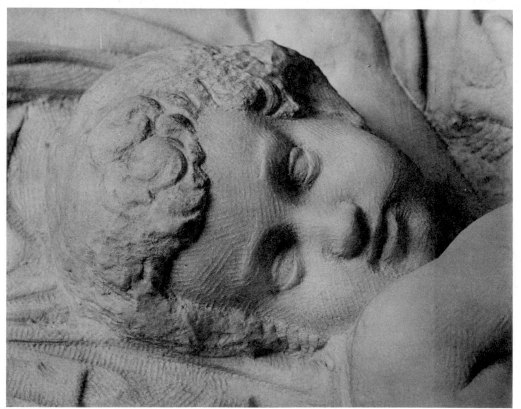

57

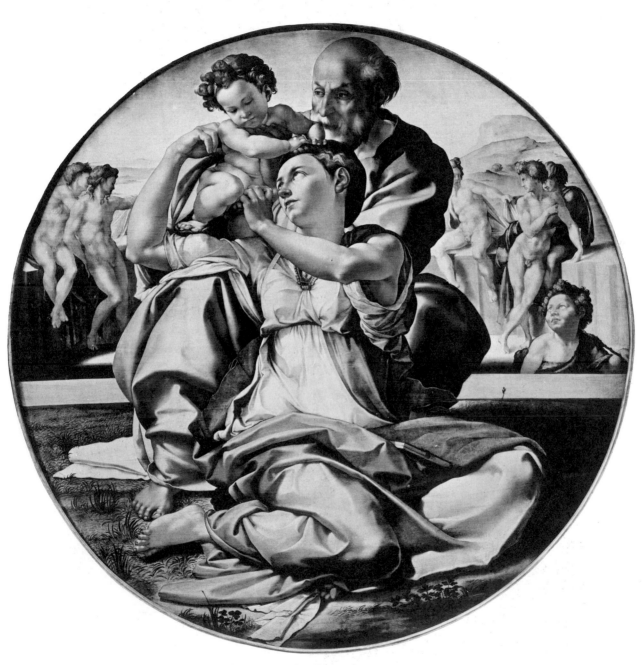

59

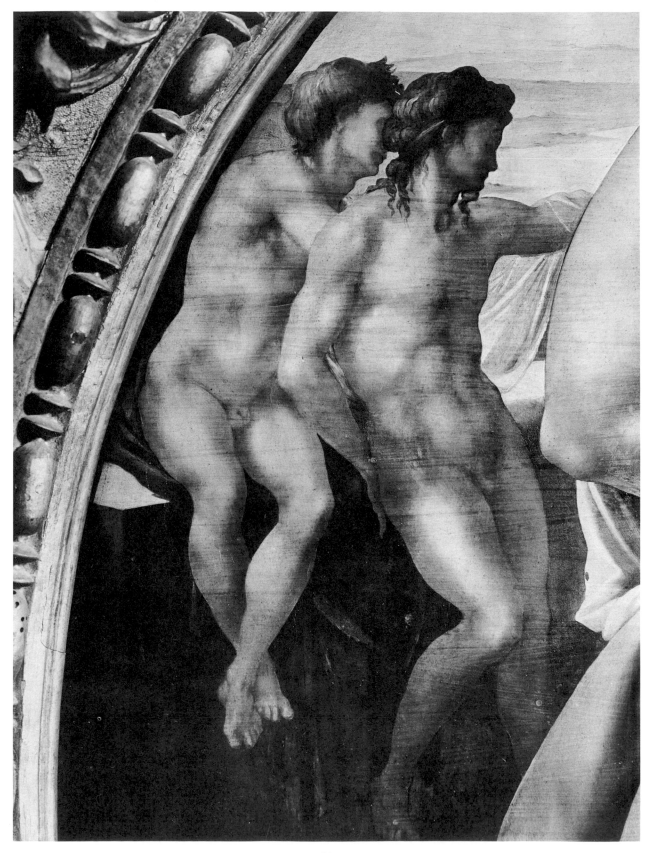

60

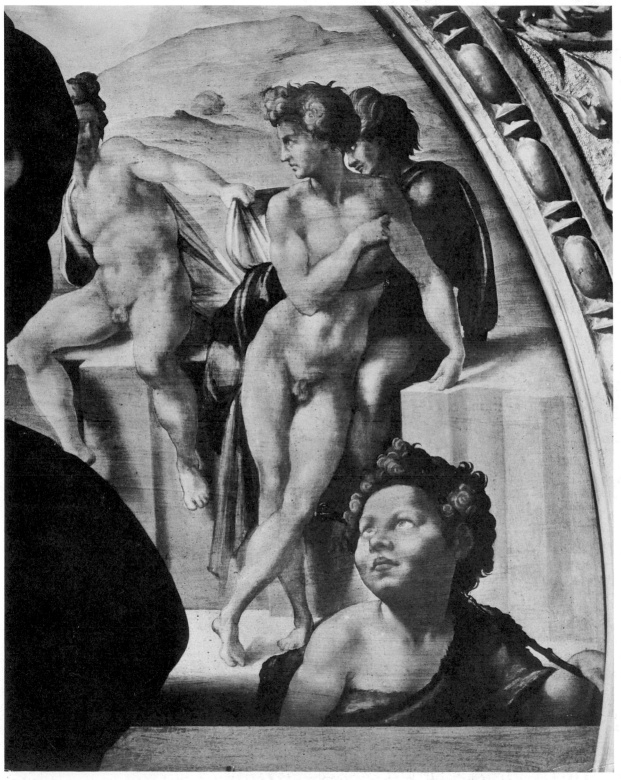

61

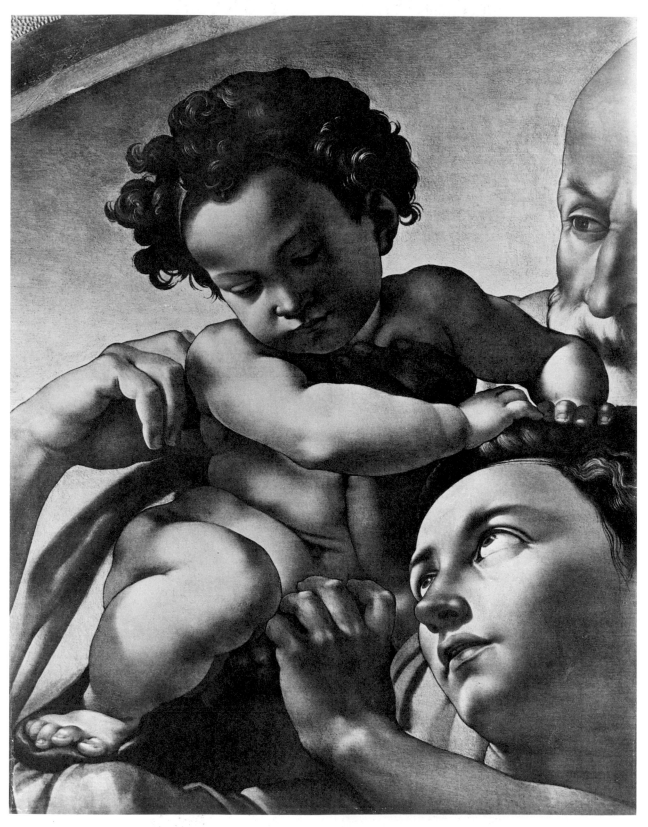

62

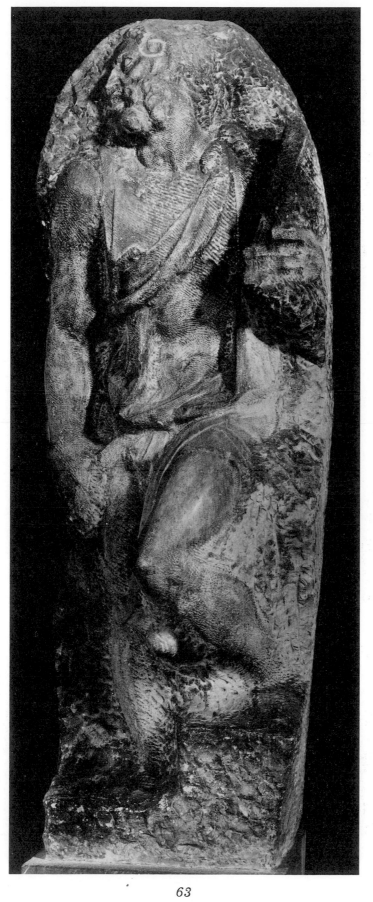

63

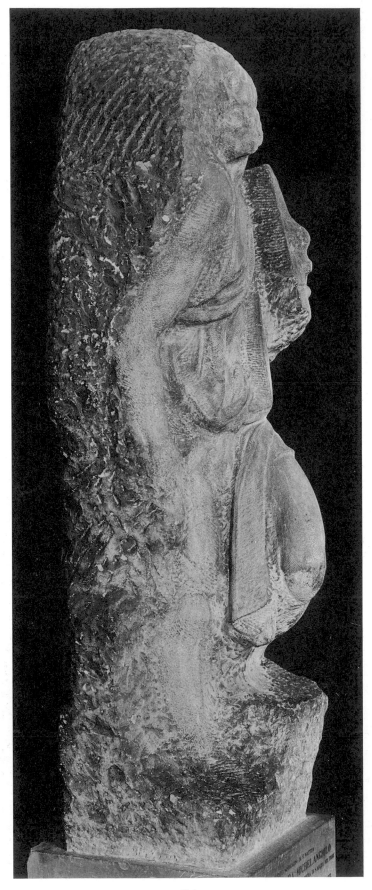

64

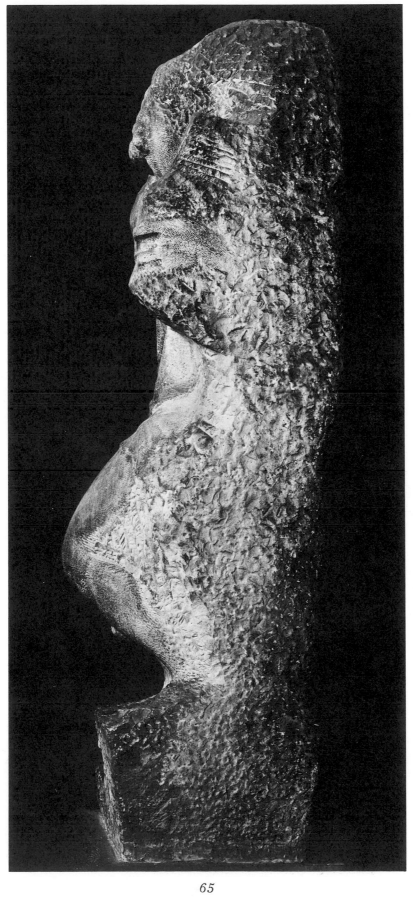

65

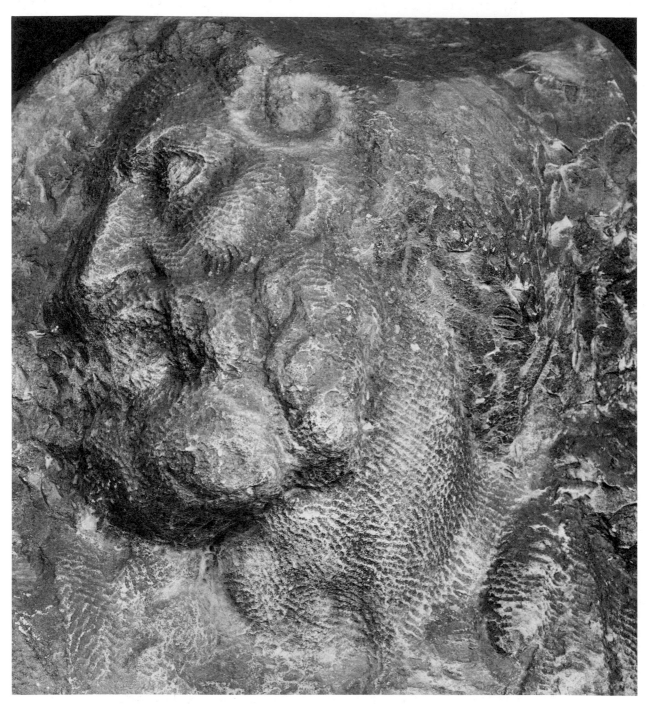

66

67

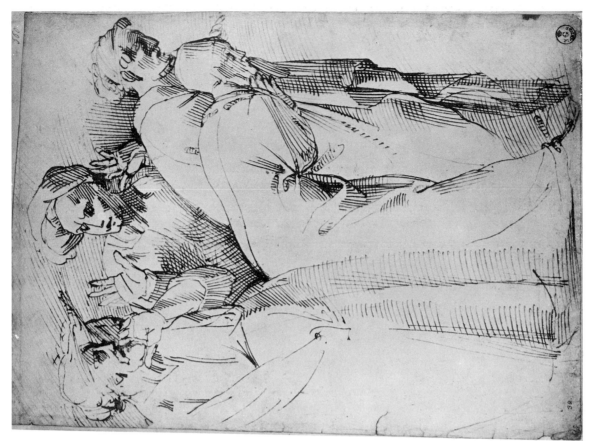

70

69

72

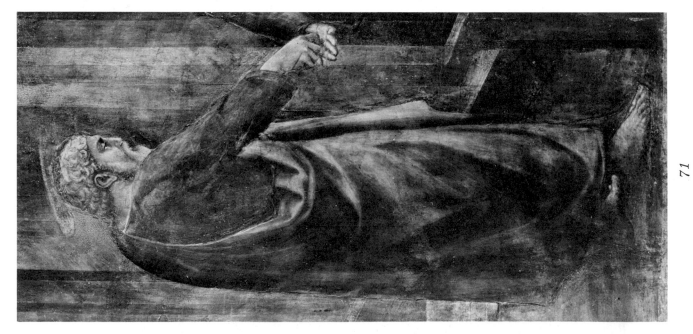

71

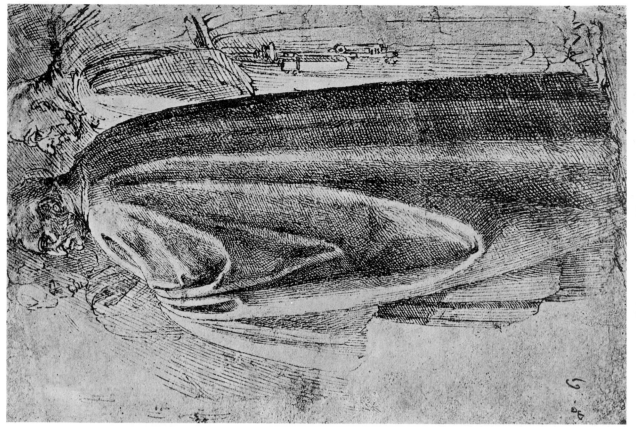

74

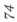

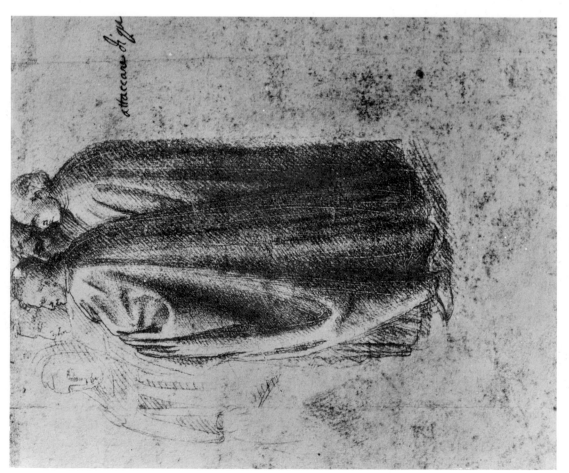

73

76

75

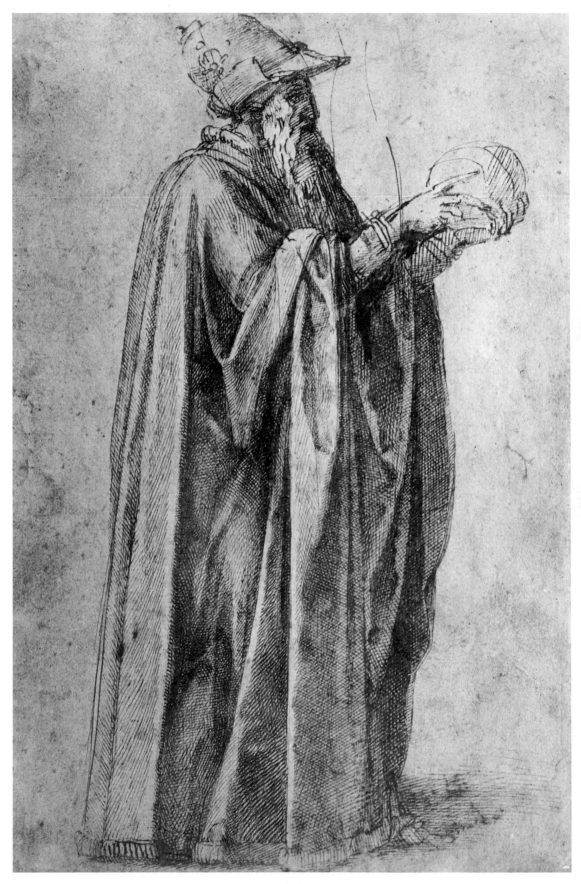

79

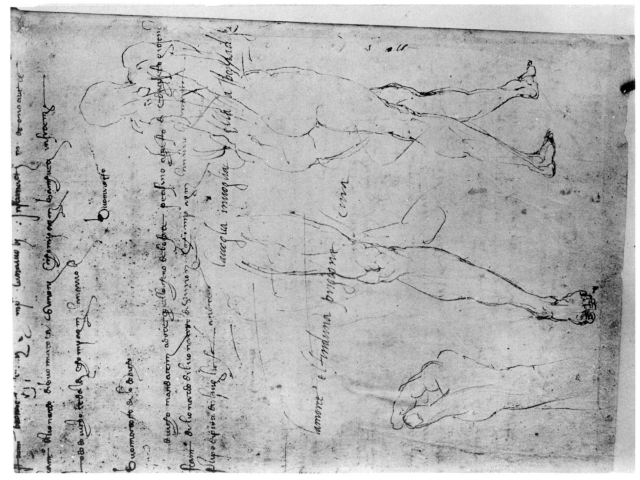

78

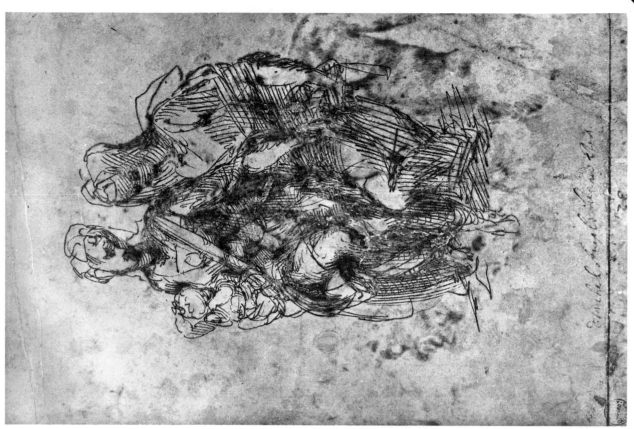

81

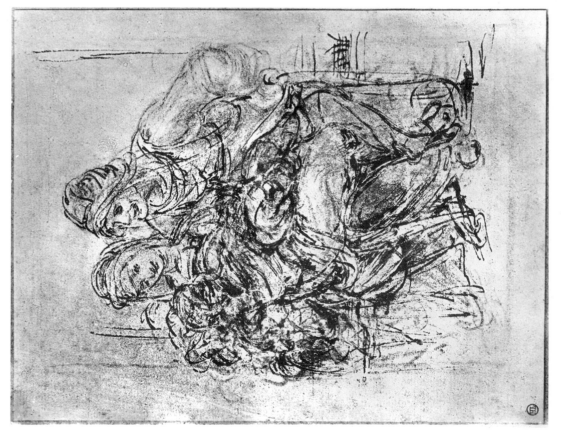

80

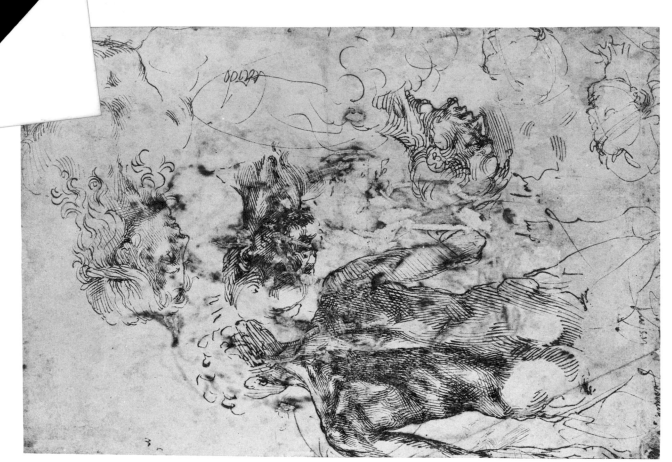

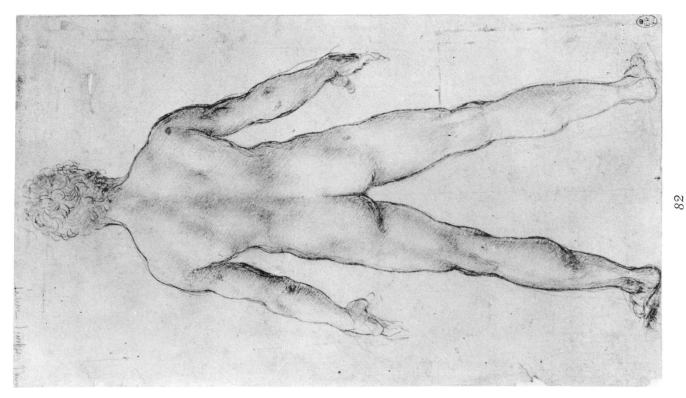

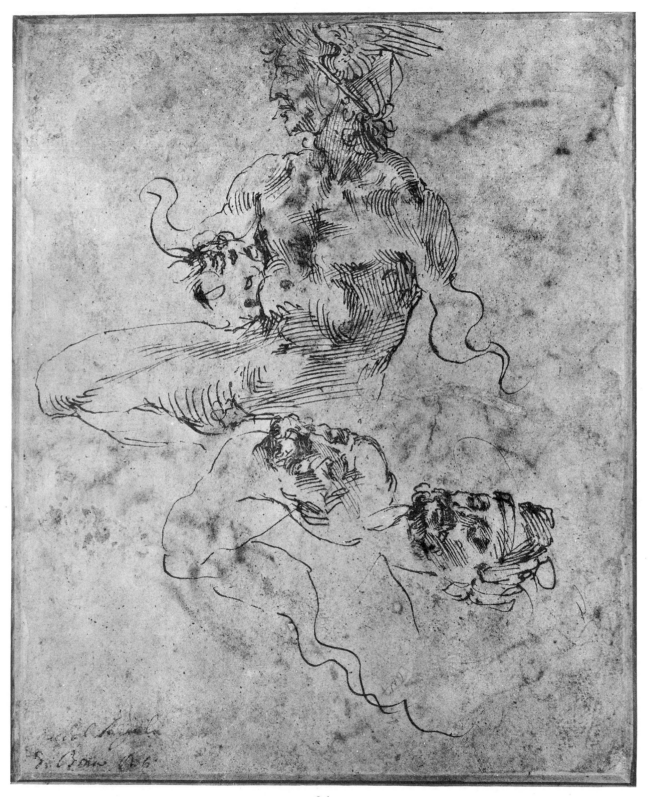

84

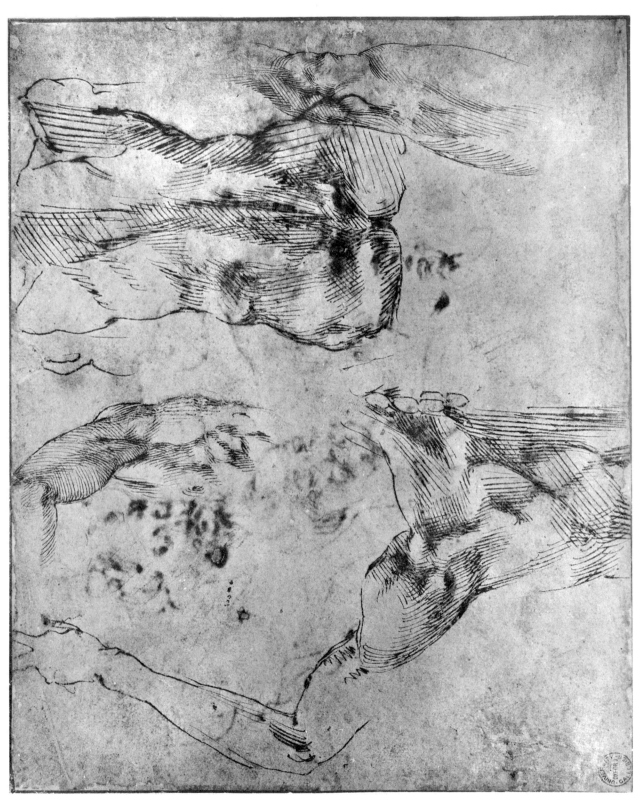

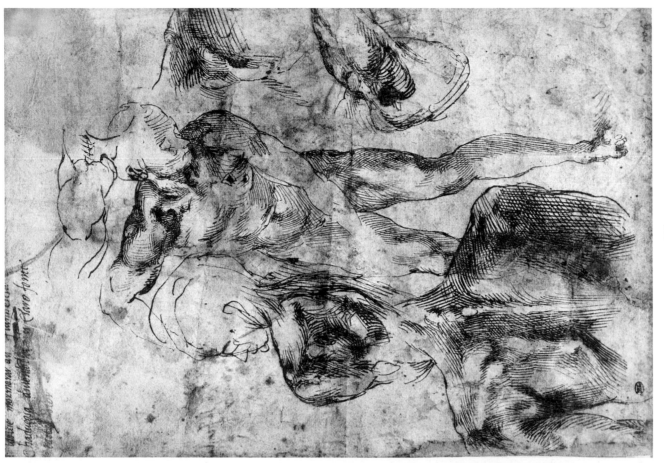

87

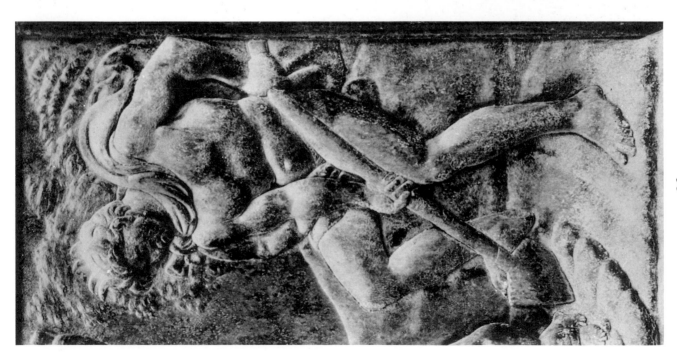

86

88

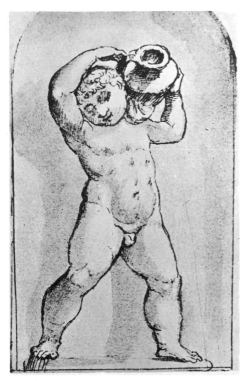

89

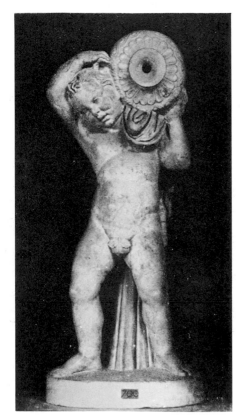

90

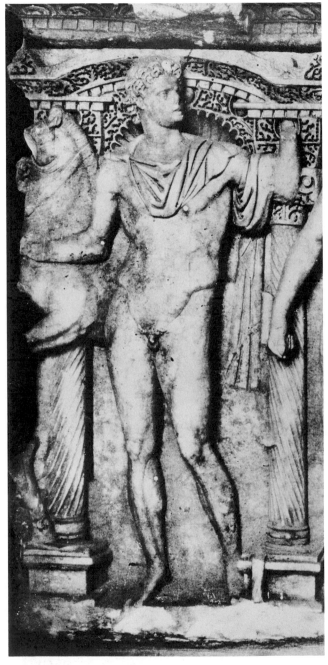

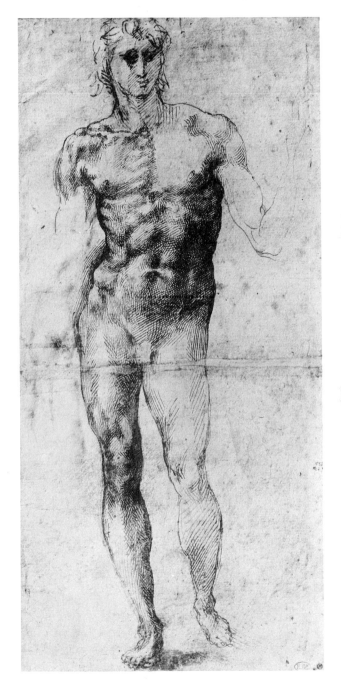

91 92

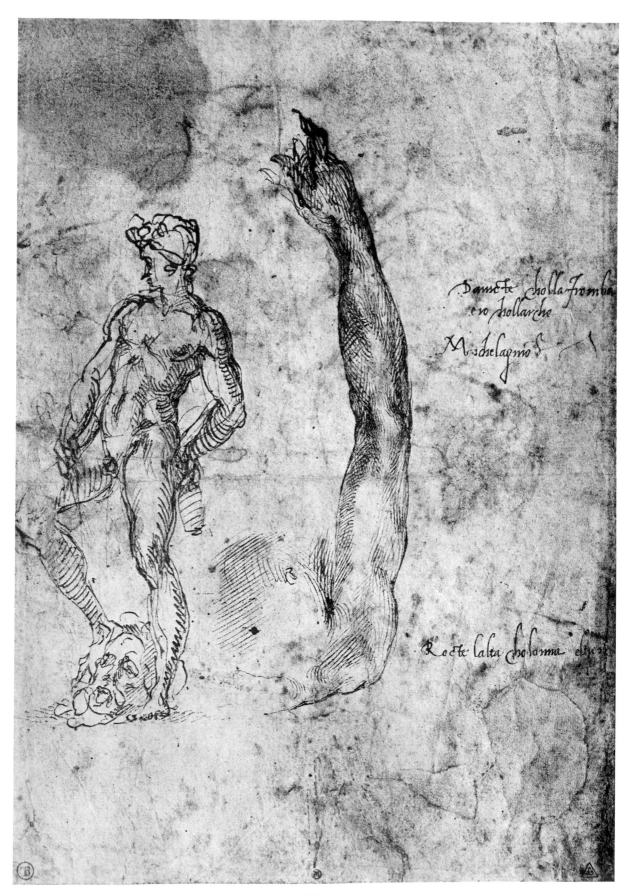

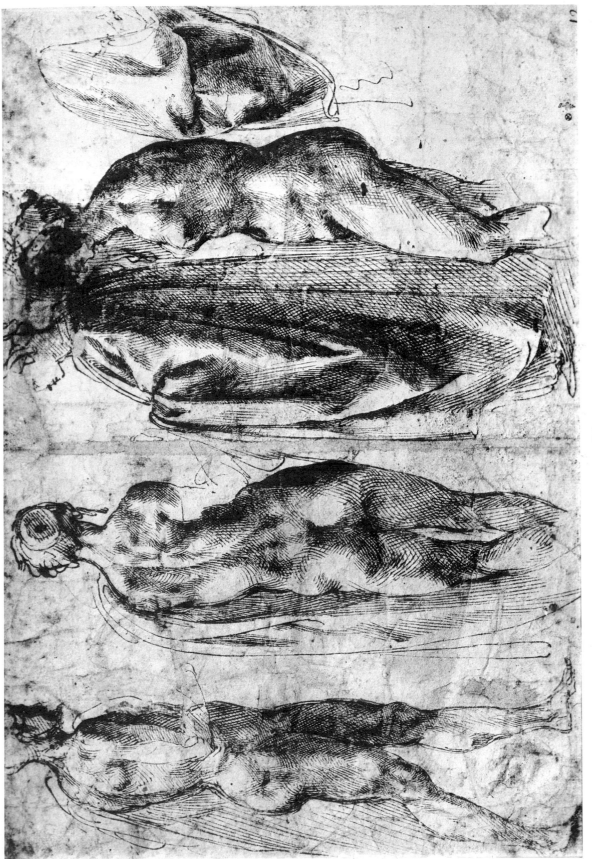

94

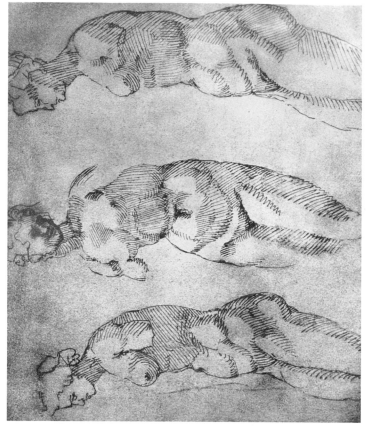

96

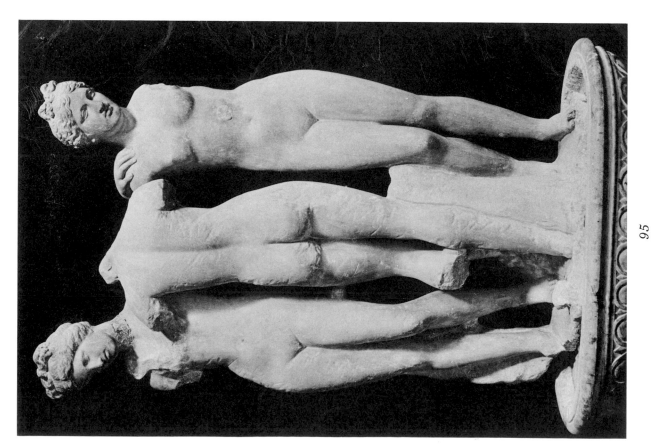

95

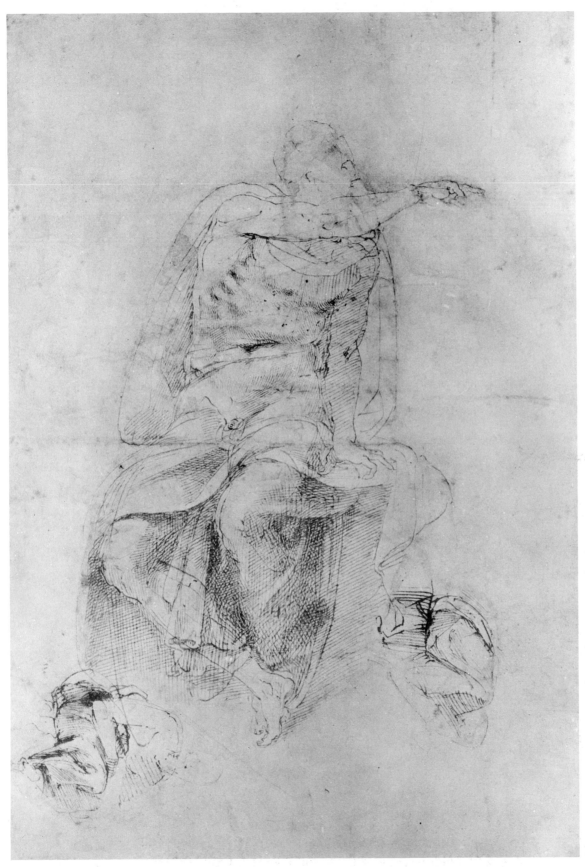

97

99

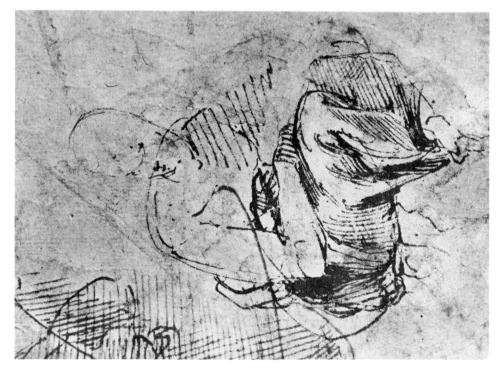

98

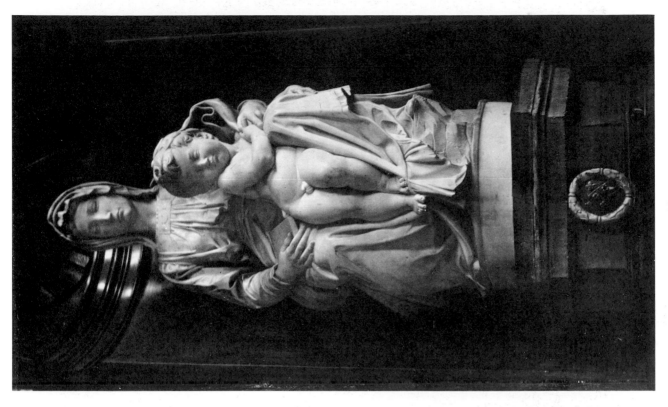

102

100

101

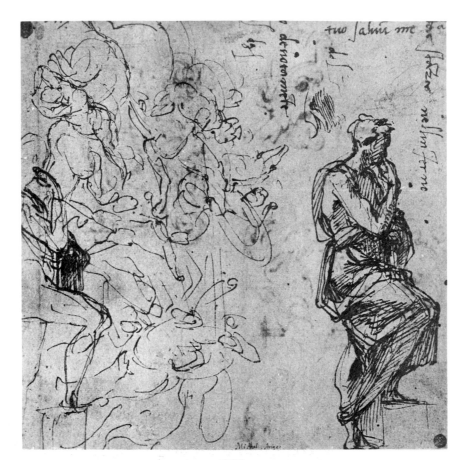

103

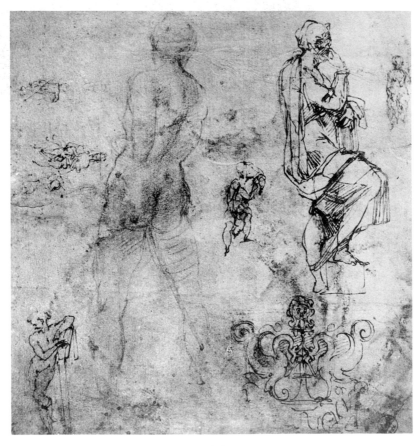

104

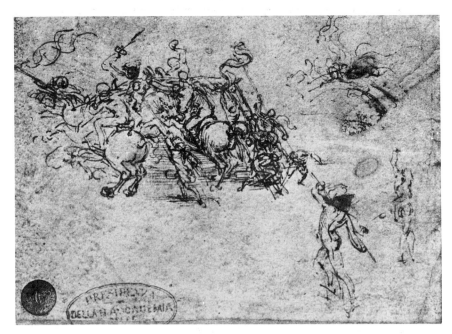

105

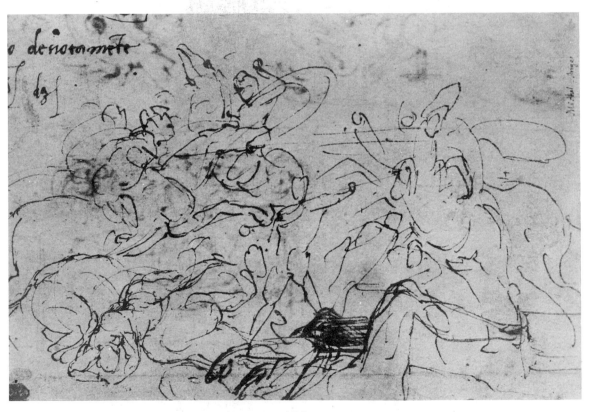

106

108

107

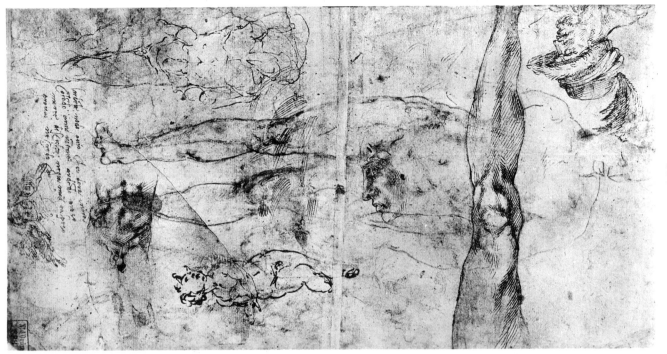

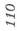

110

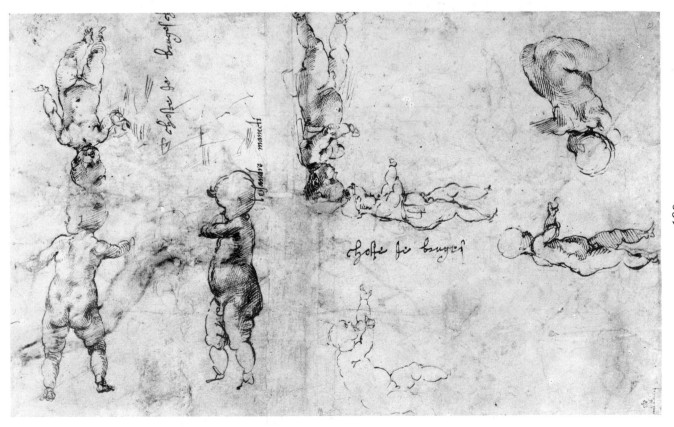

109

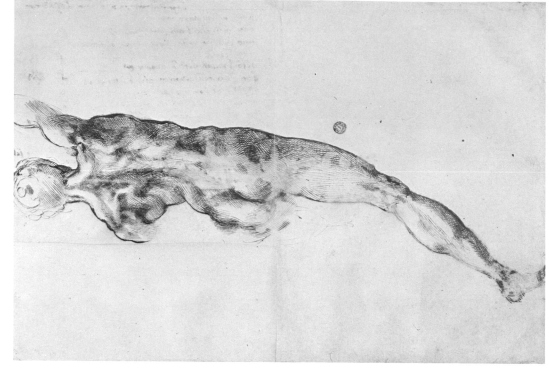

112

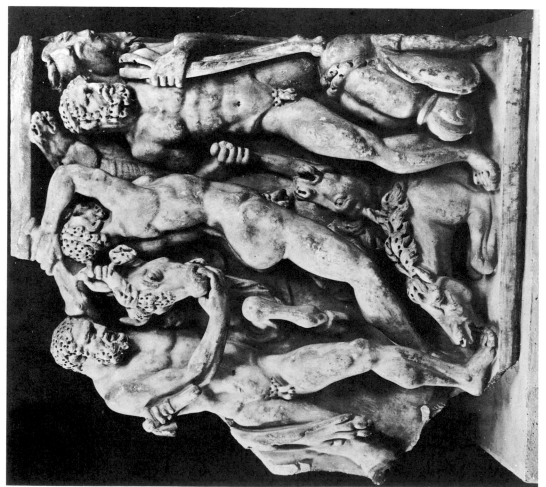

111

114

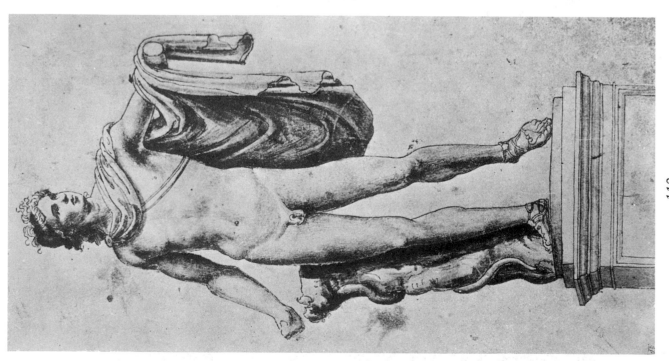

113

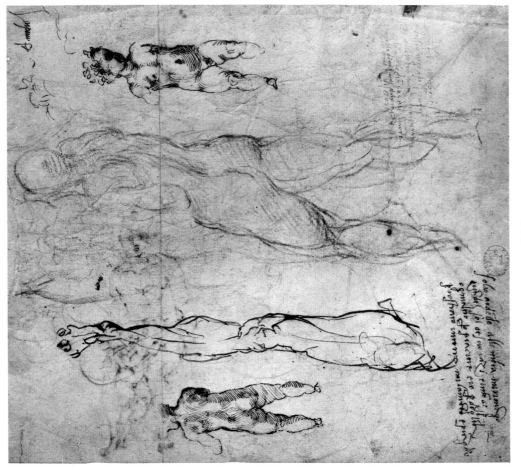

116

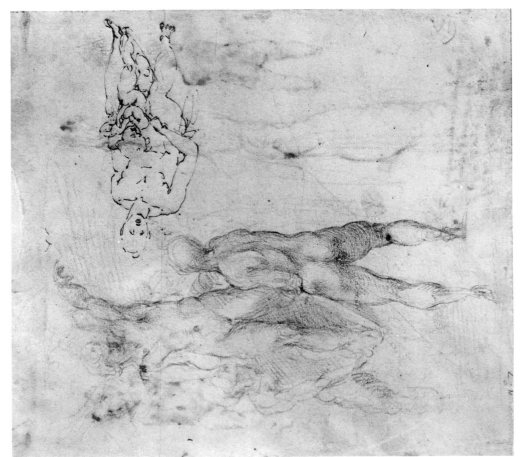

115

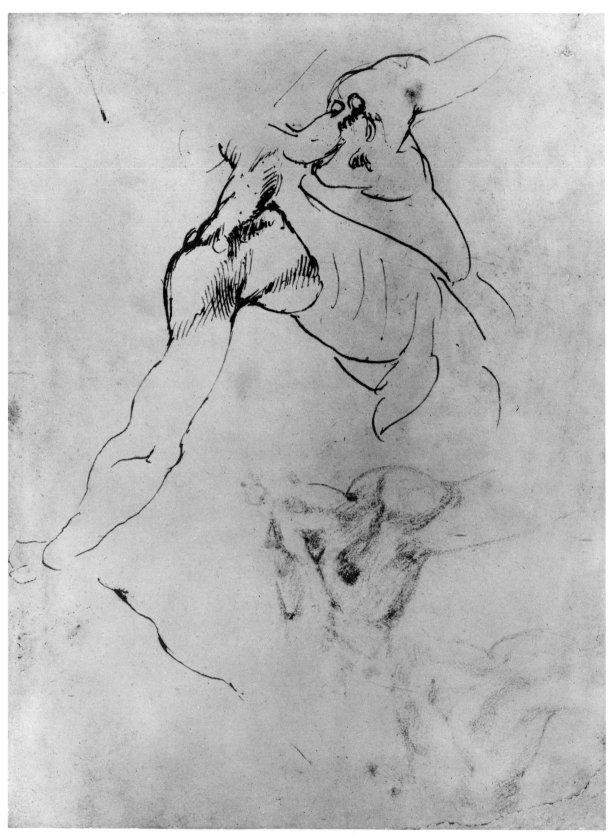

117

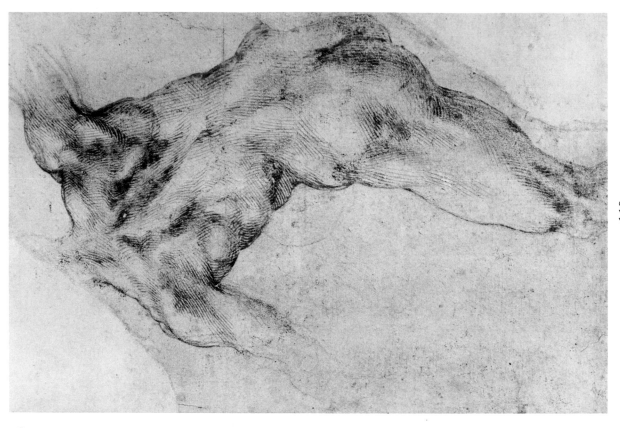

119

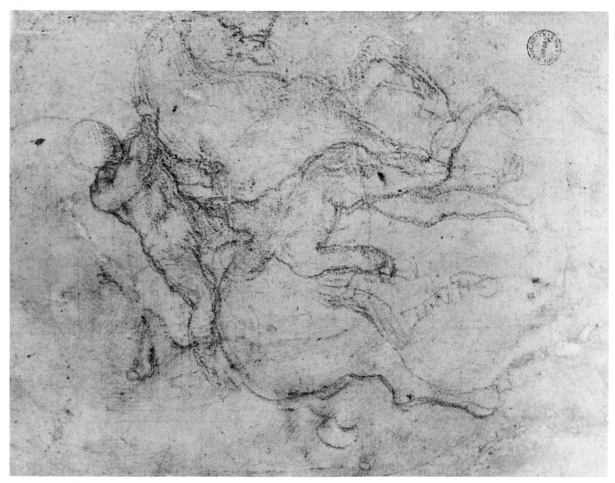

118

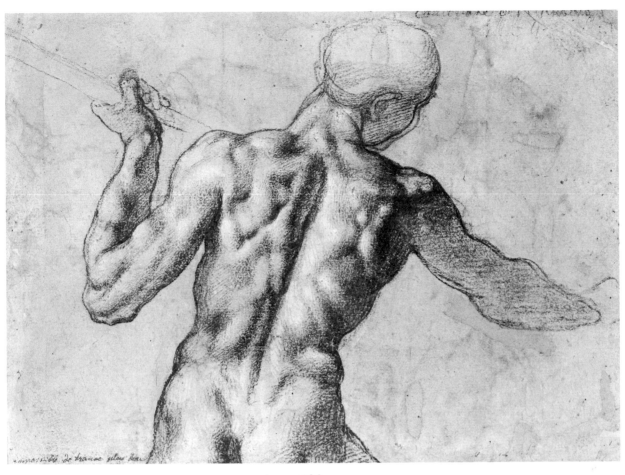

120

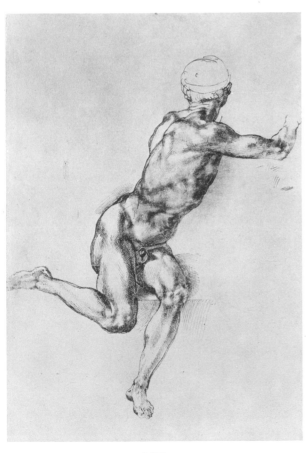

121

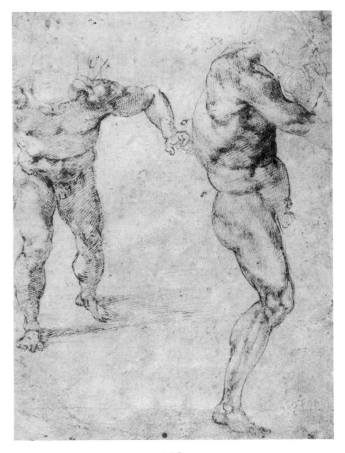

122

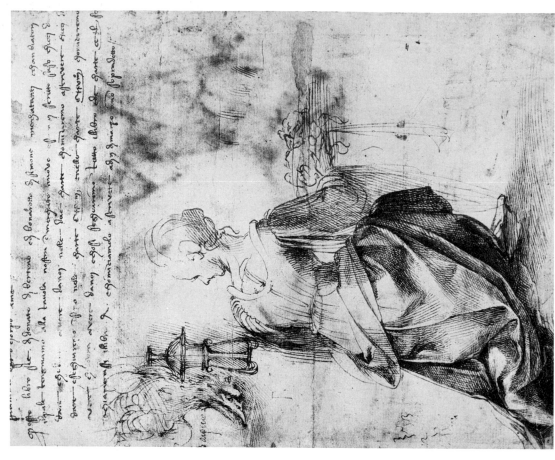

124

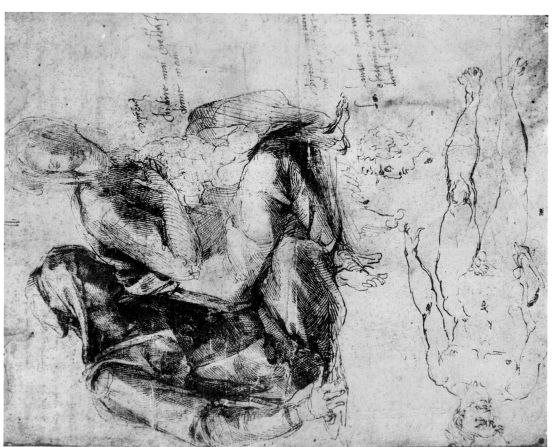

123

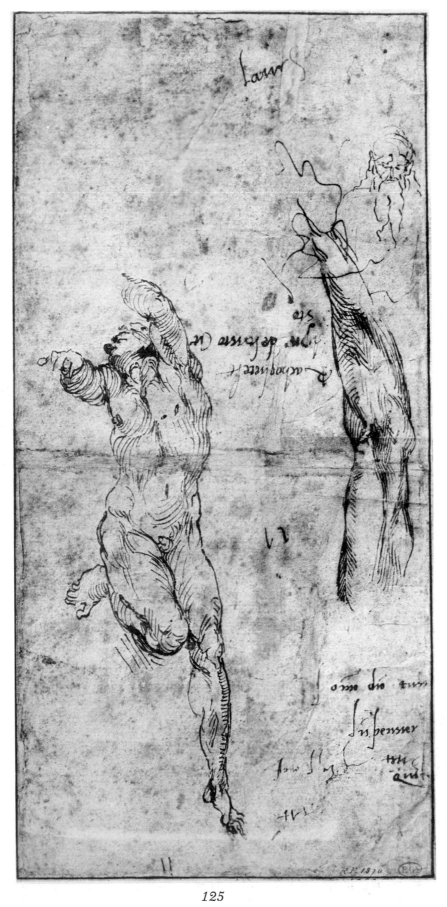

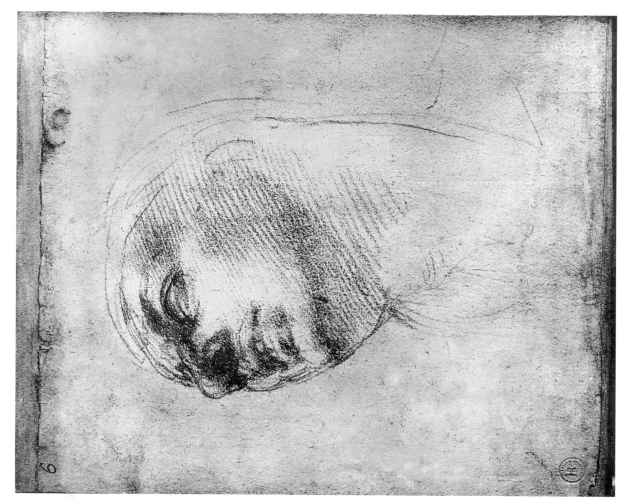

127

126

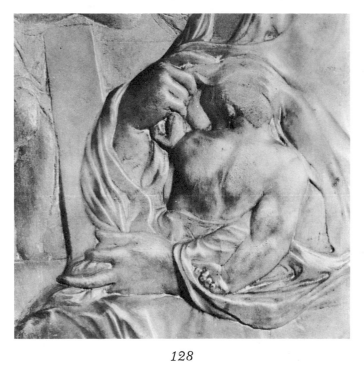

128

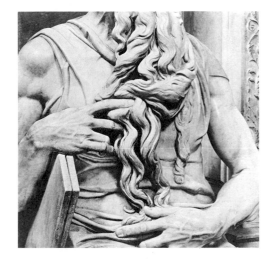

129

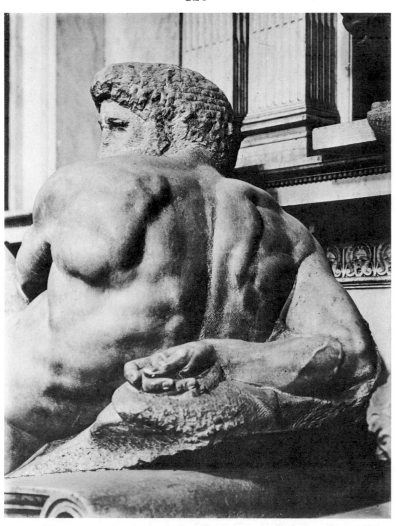

130

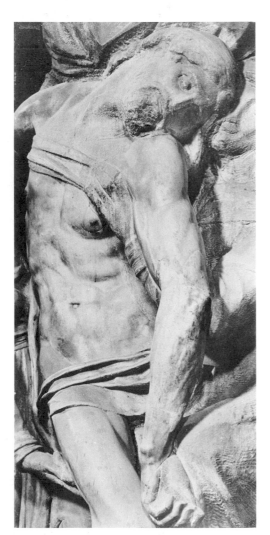

131

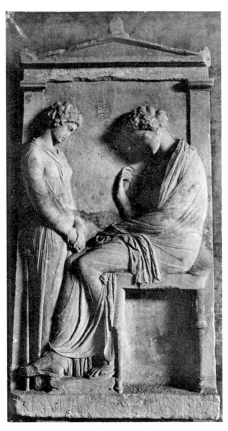

132

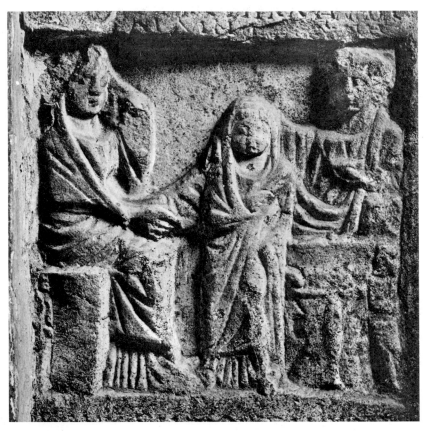

133

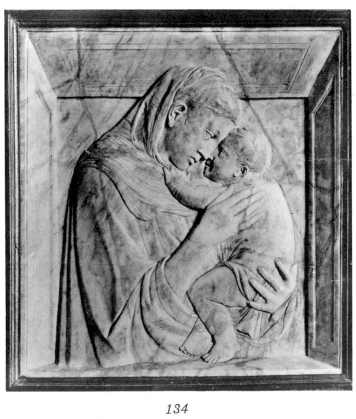

134

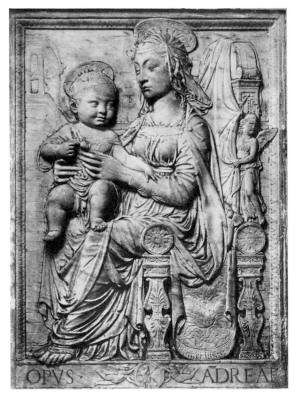

135

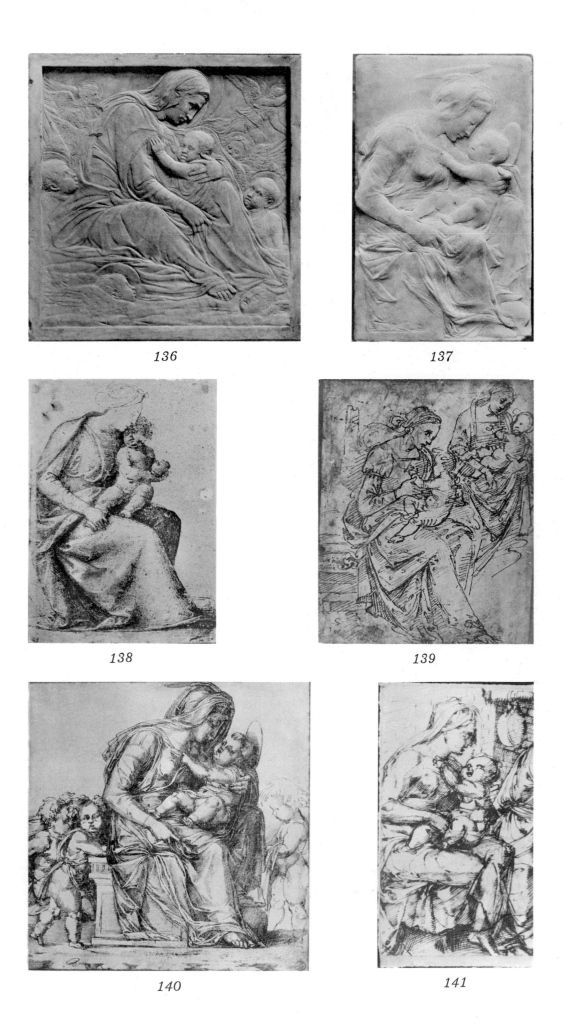

136

137

138

139

140

141

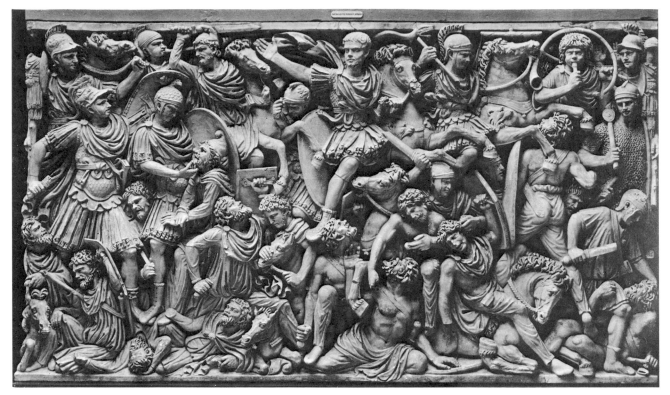

142

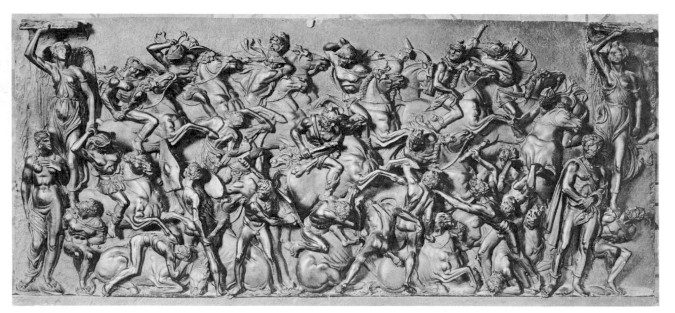

143

144

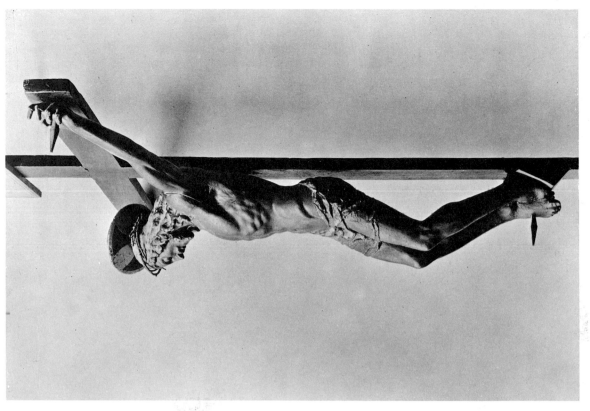

146

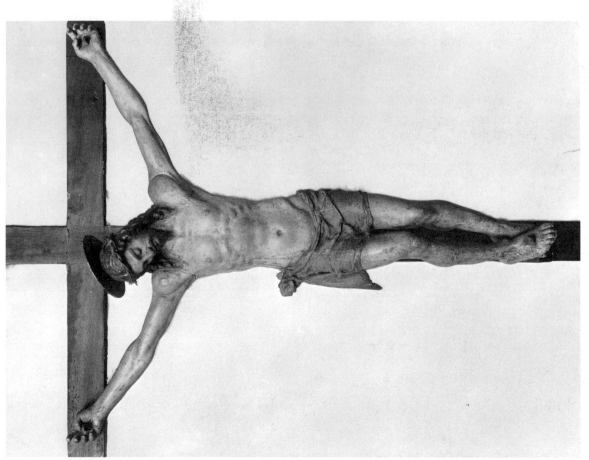

145

147

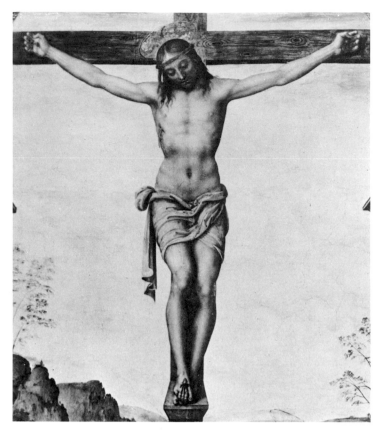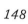

148

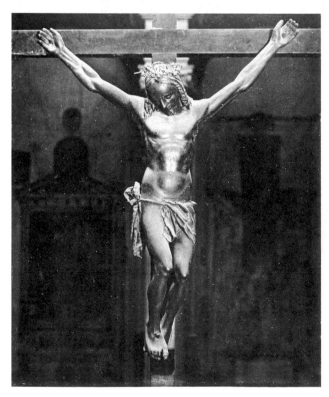

149

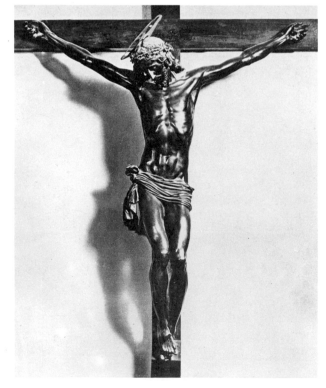

150

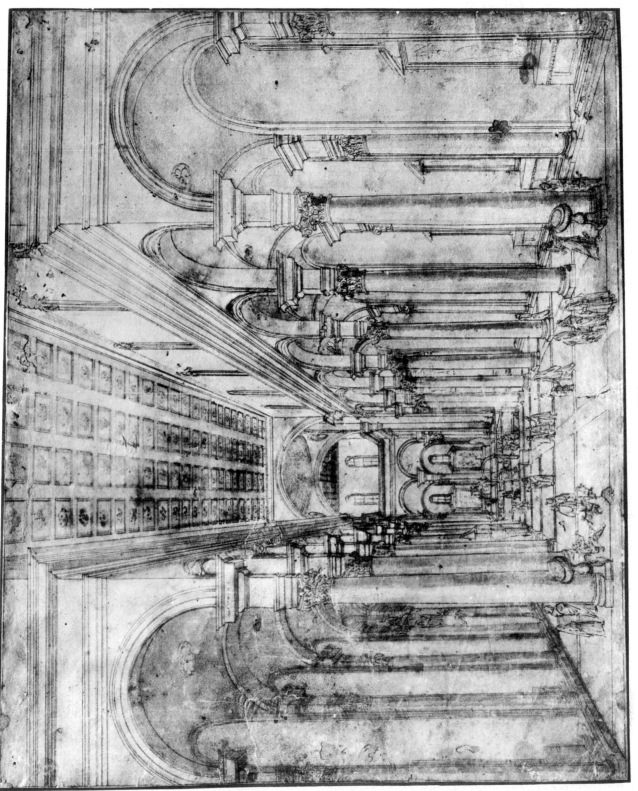

151

154

152

153

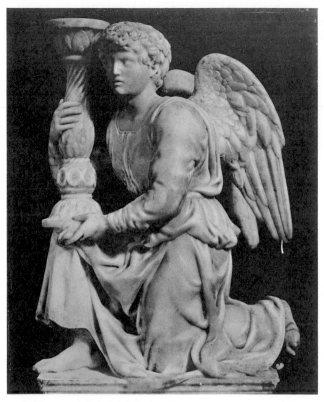

155

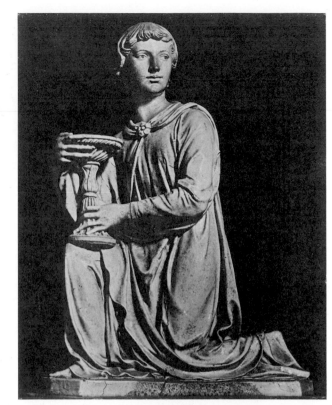

156

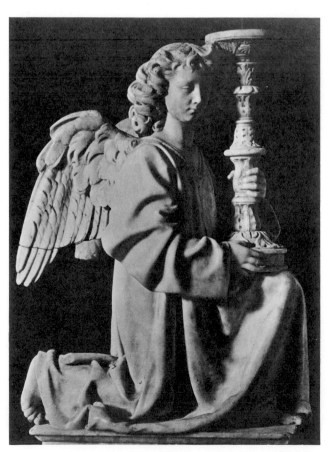

157

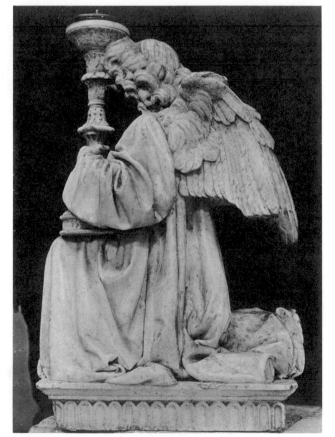

158

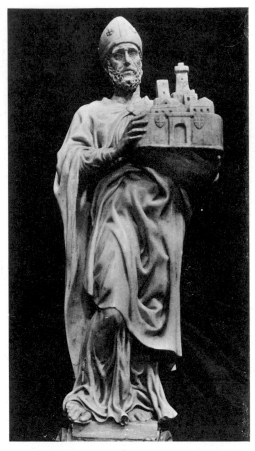

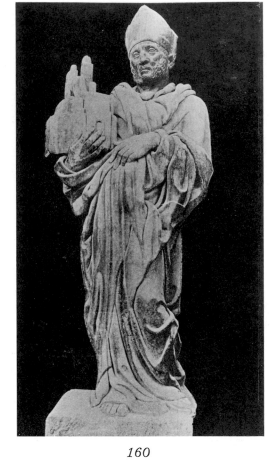

159

160

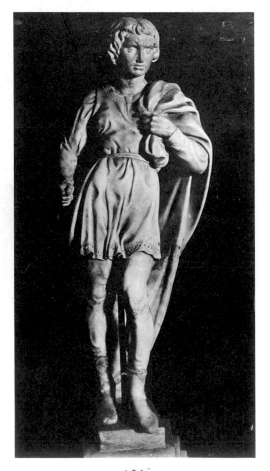

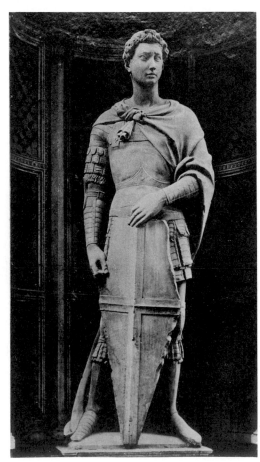

161

162

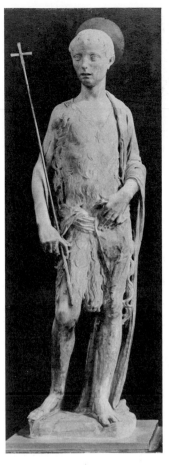

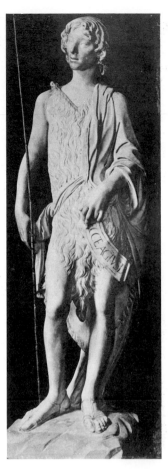

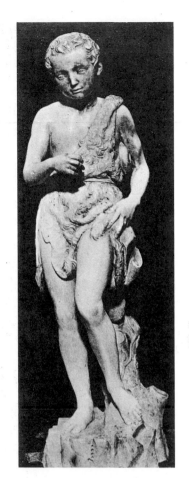

163 164 164b

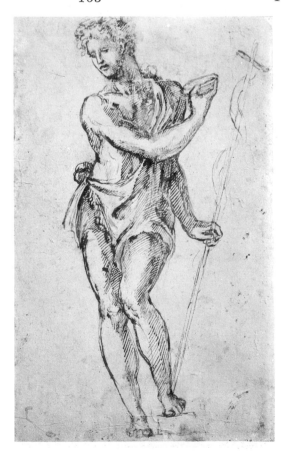

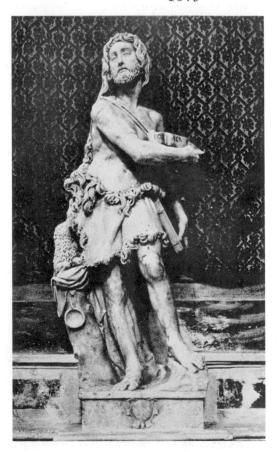

165 166

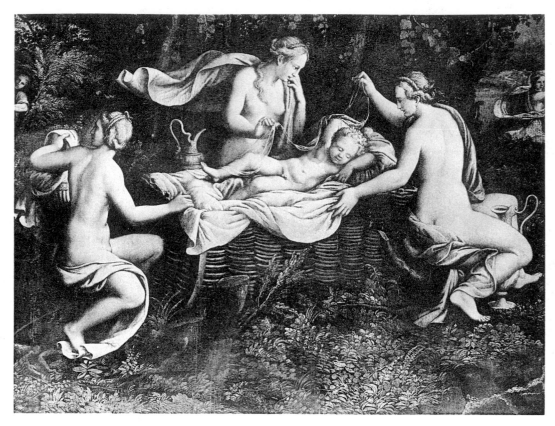

167

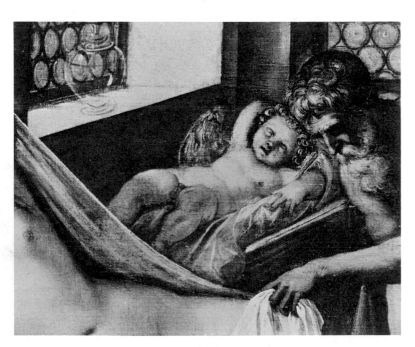

168

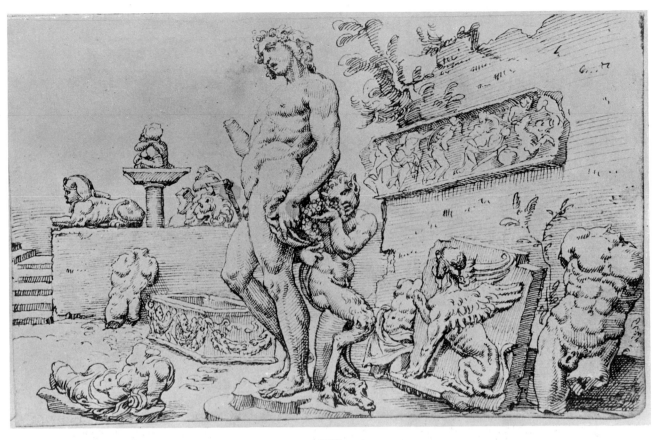

169

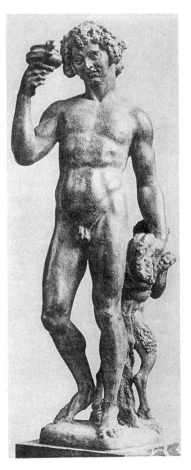

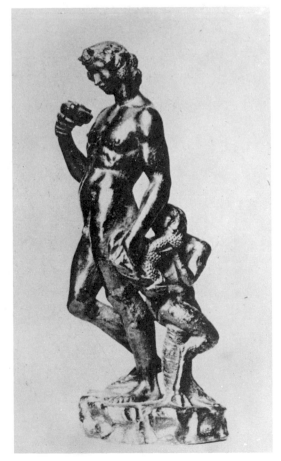

170 171 172

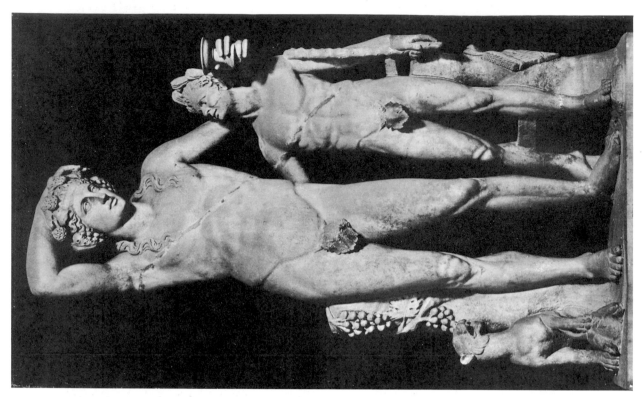

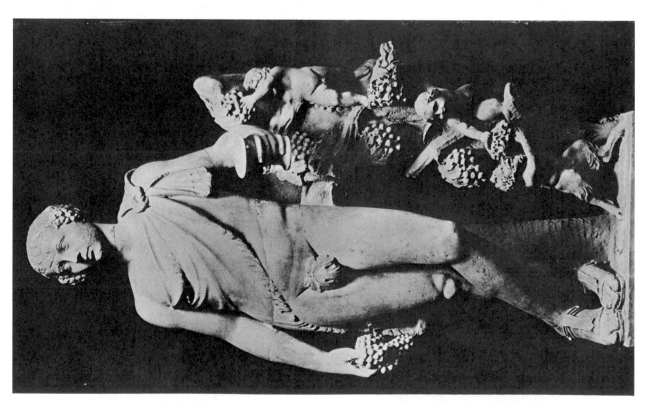

175

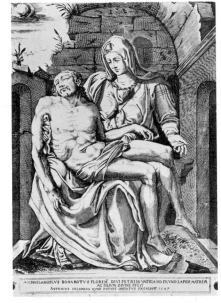

176

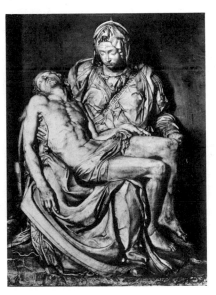

177

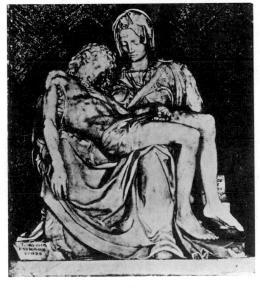

178

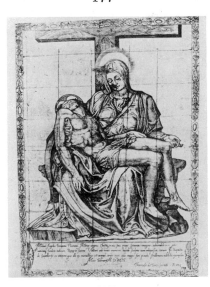

179

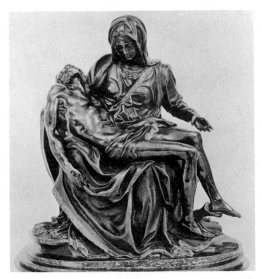

180

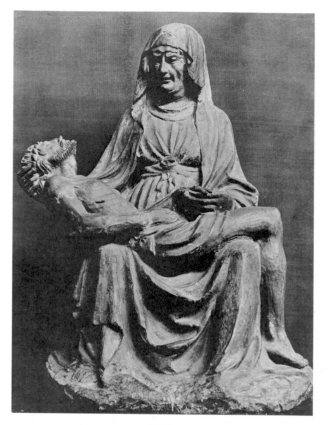

181

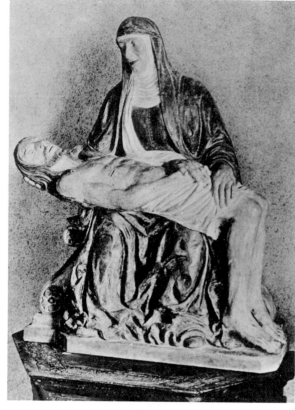

182

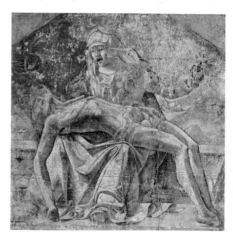

183

184

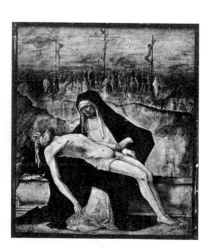

185

187

186

188

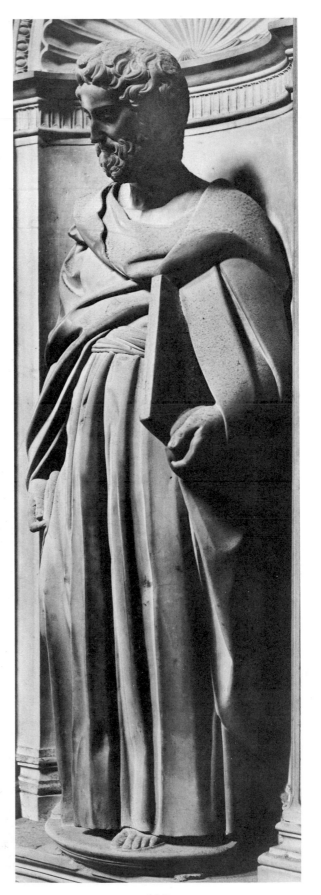

189 190

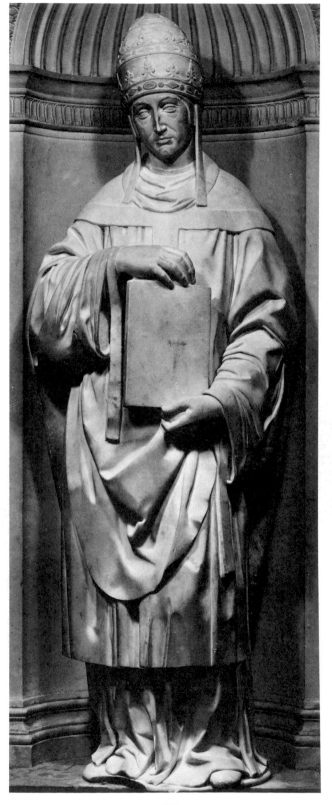

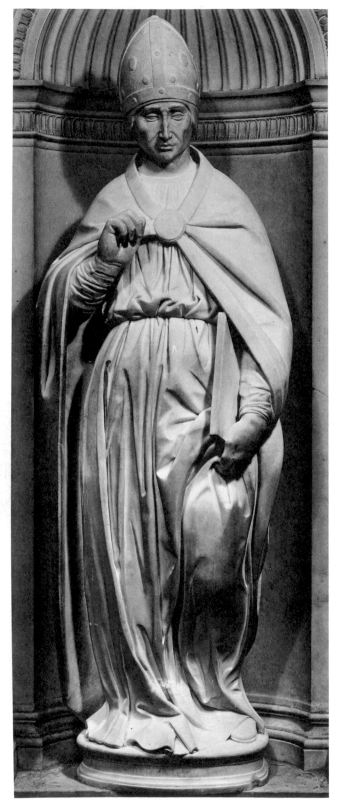

191 192

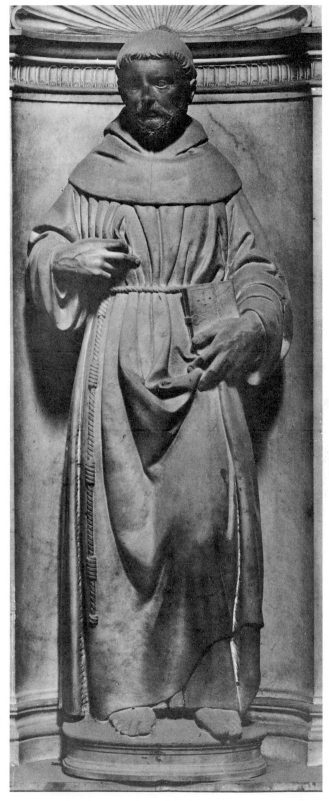

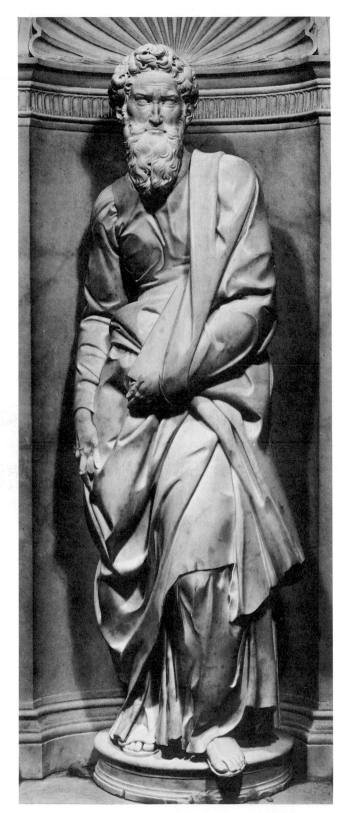

193 194

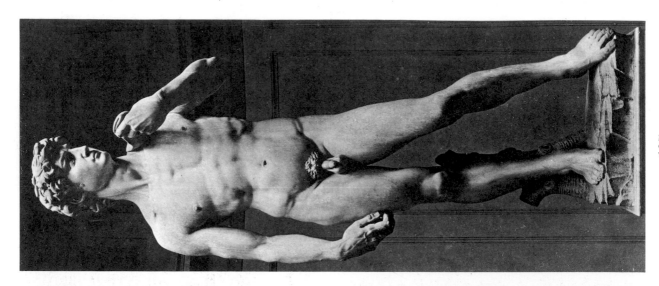

197

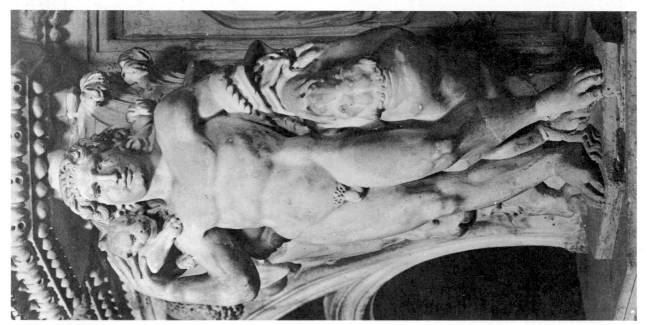

196

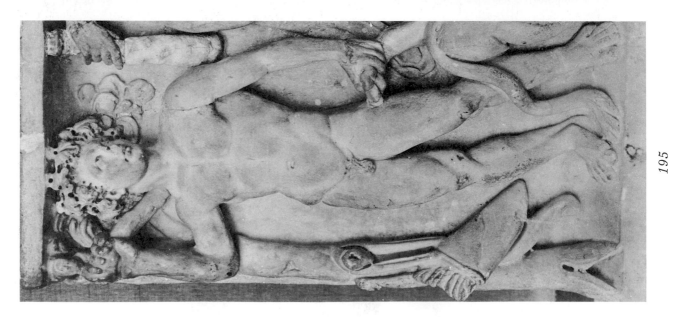

195

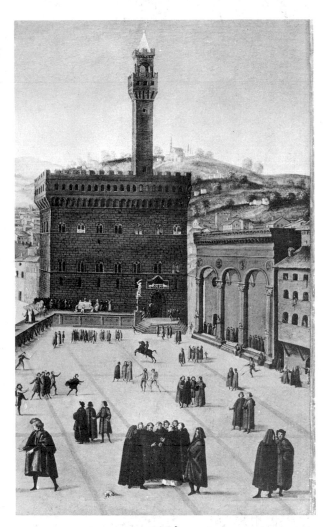

198a

198b

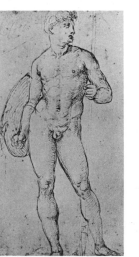

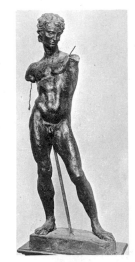

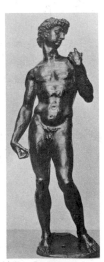

199 200 201 201b 202

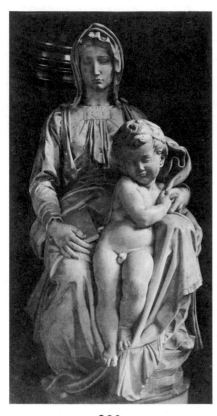

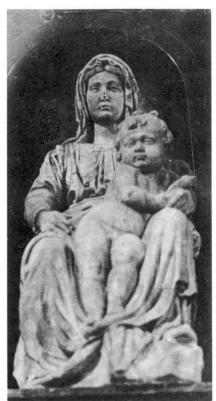

203b

203

204

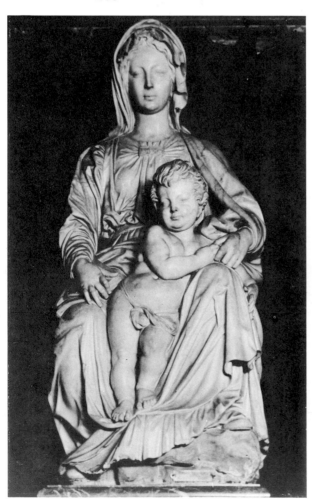

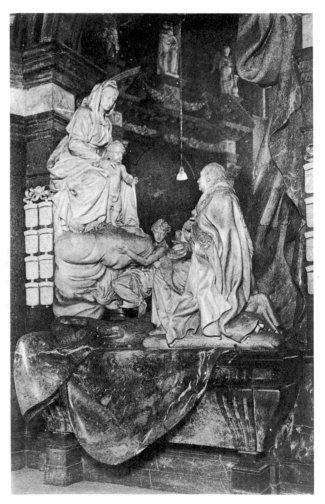

205

206

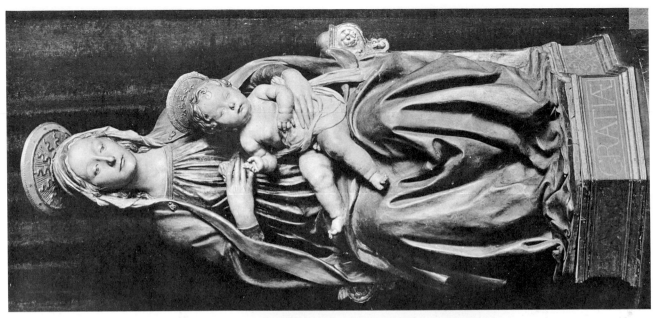

209

208

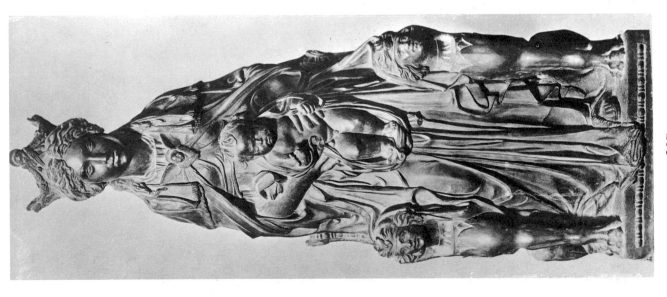

207

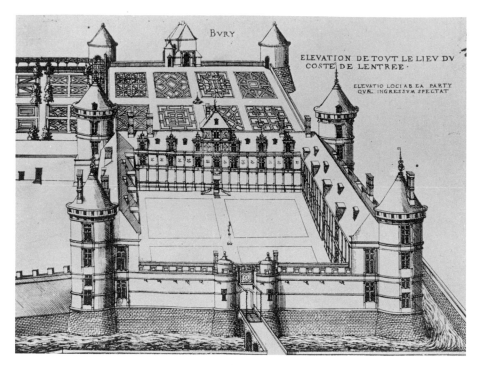

210

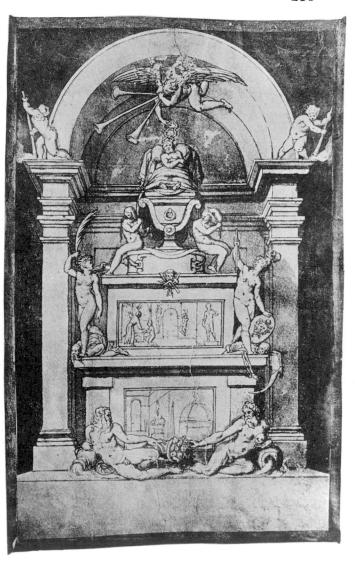

211

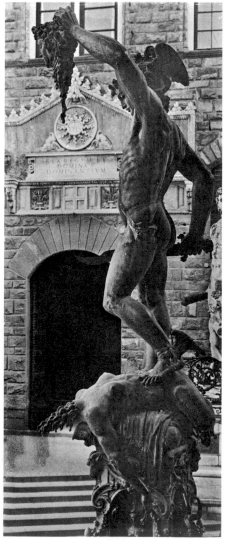

212

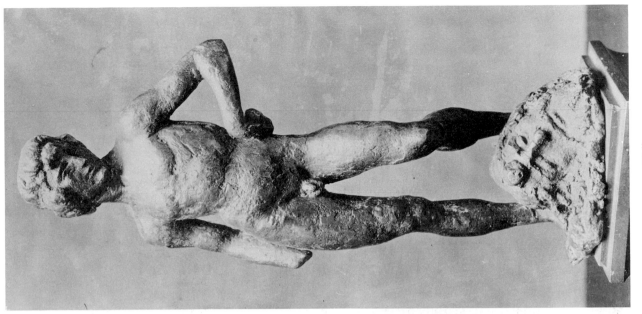

215

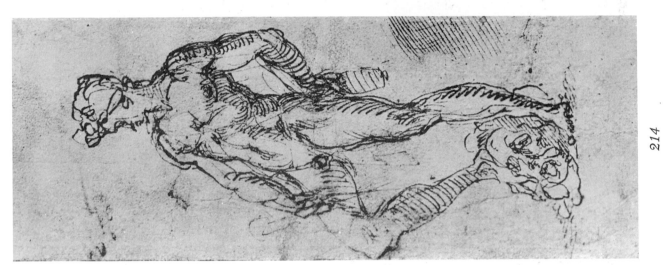

214

213

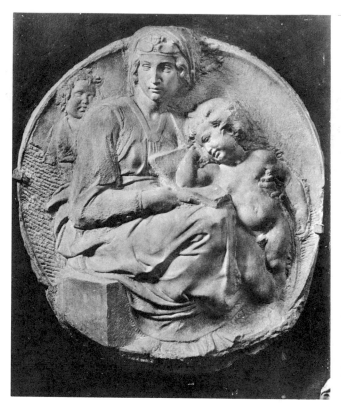

216

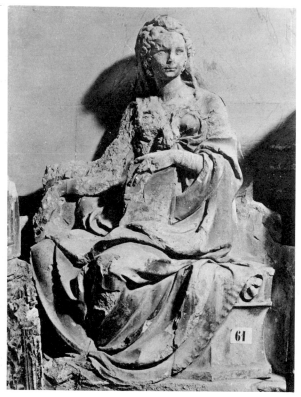

217

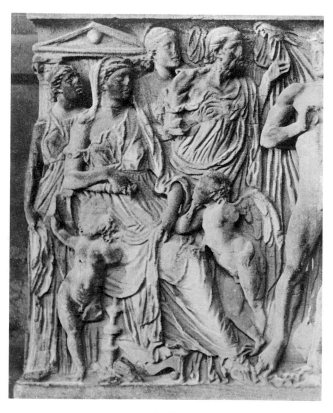

218

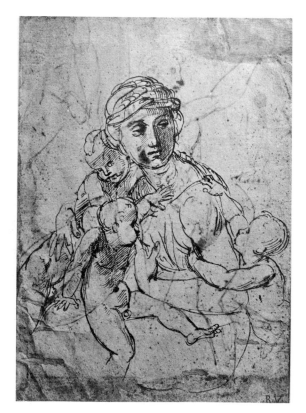

219

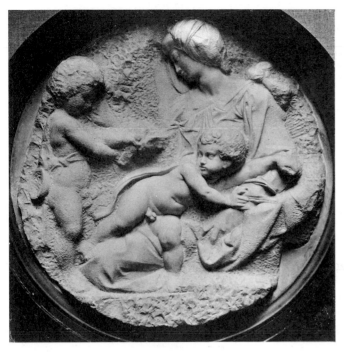

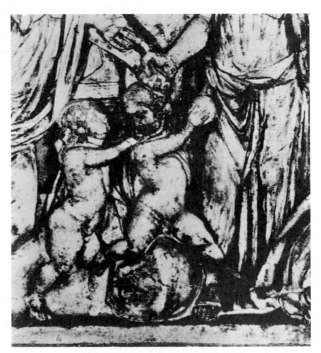

220

221

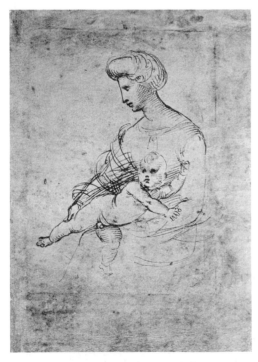

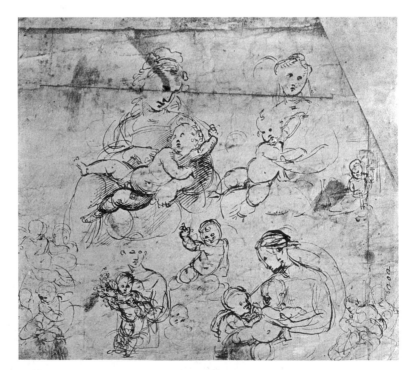

222

223

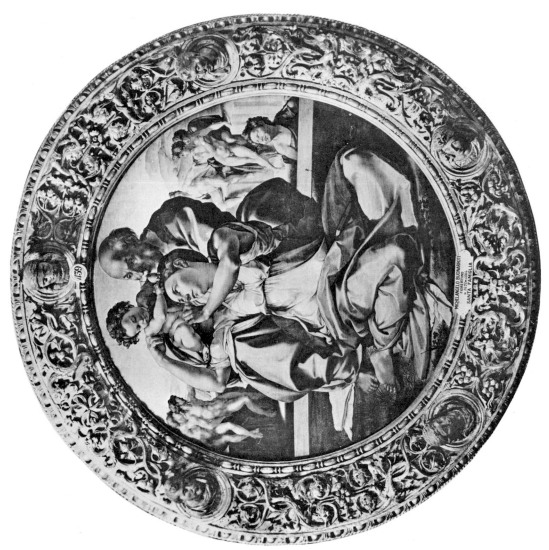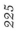

225

MICHELANGELO BUONARROTI
FIORENTINO
V. 19 COLORI
SANTA FAMIGLIA

224

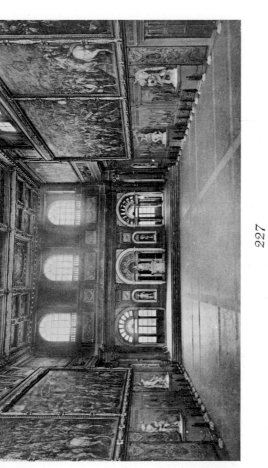

226

227

228

229

230

231

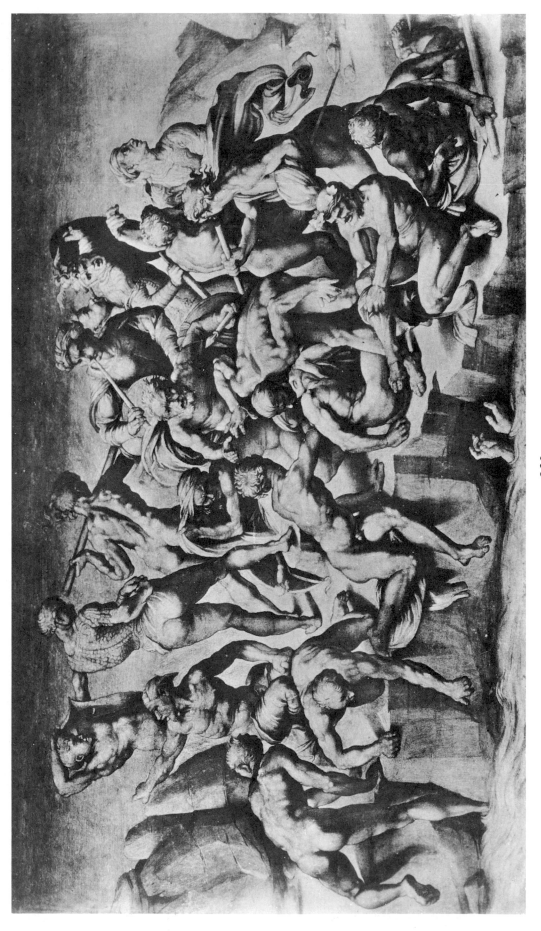

232

234

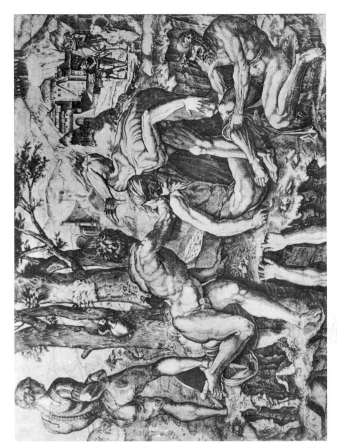

235

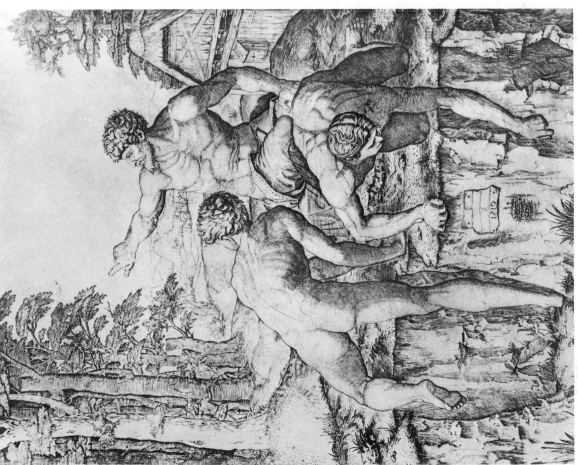

233

237

236

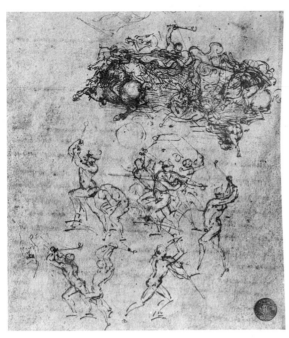

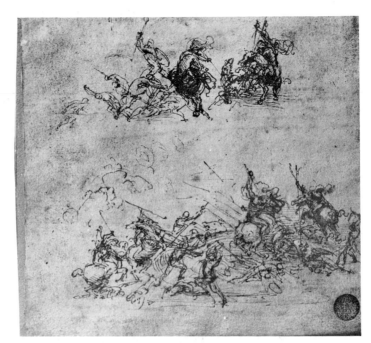

238

239

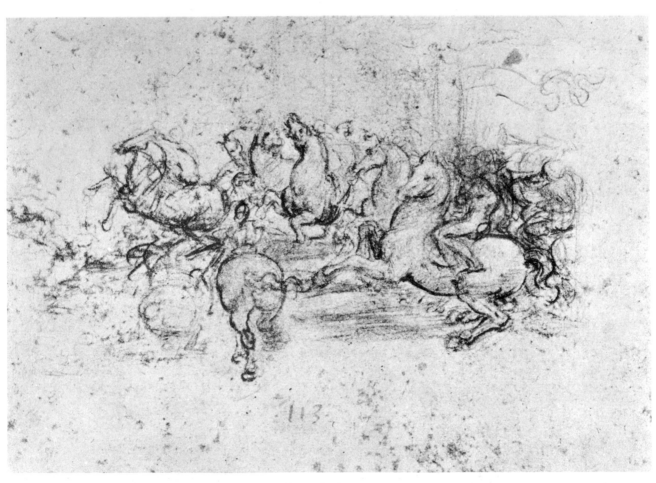

240

241

242

243

244

245

246

247

248 249

251

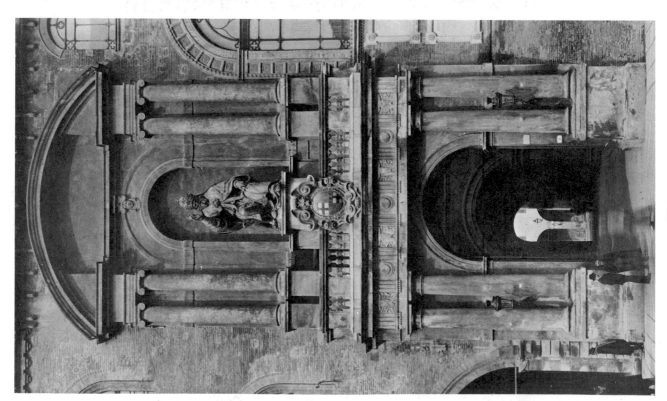

250

252

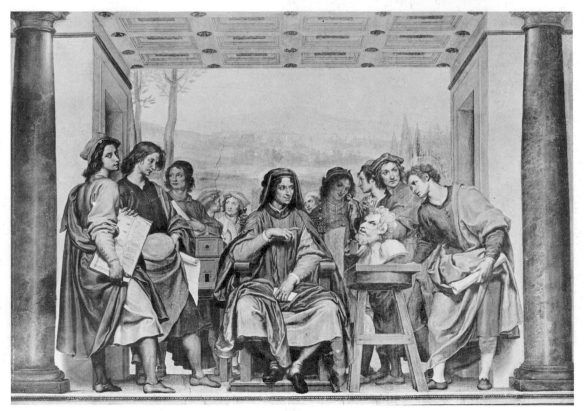

253

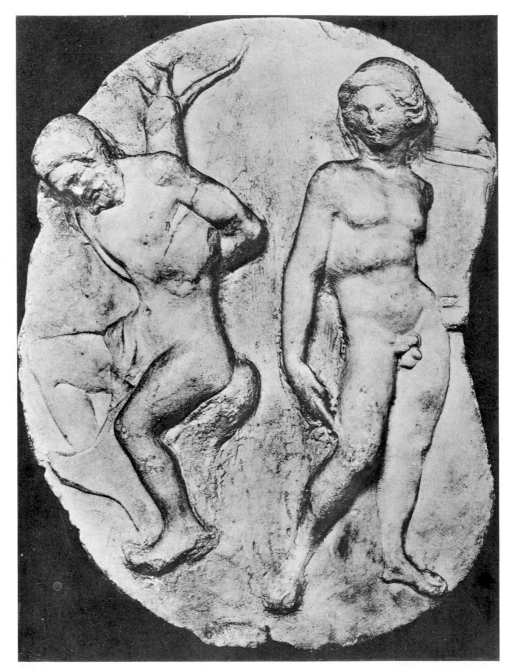

254

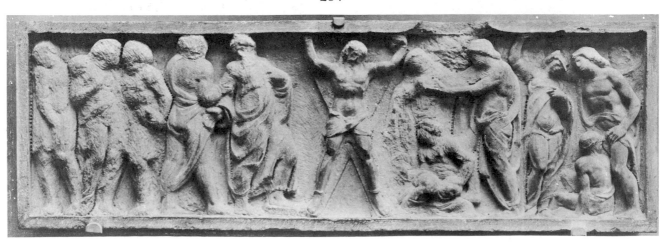

255

256

257

258

259

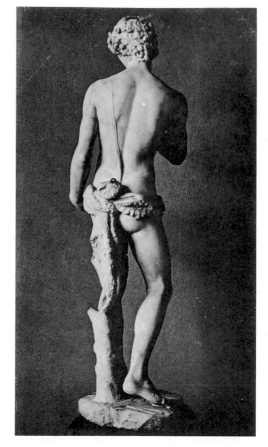

260

261

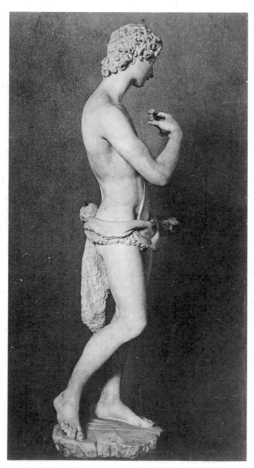

262

263

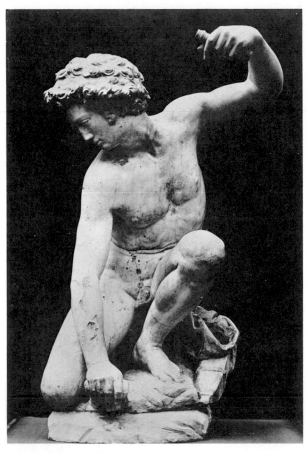

264

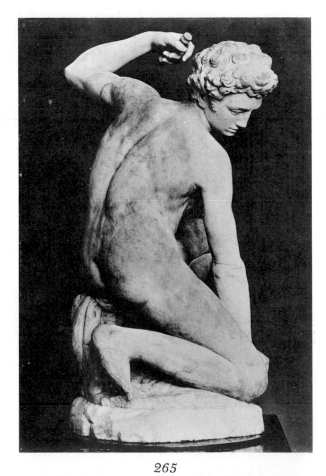

265

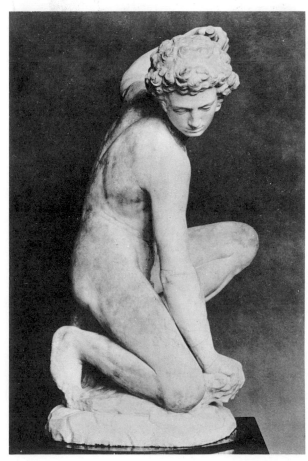

266

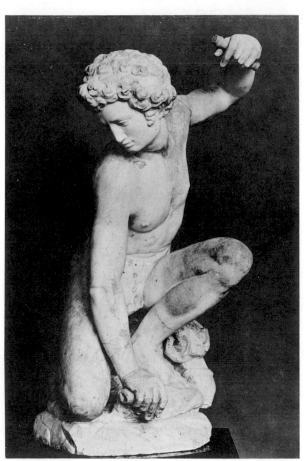

267

270

269

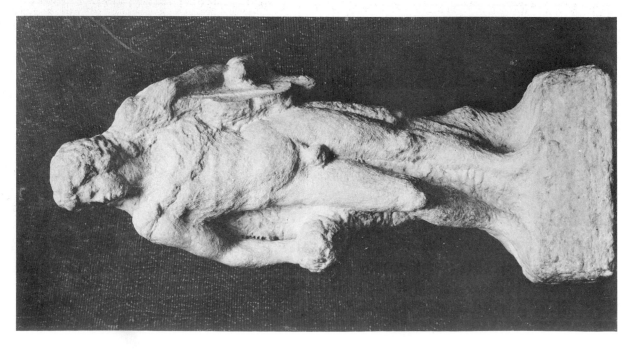

268

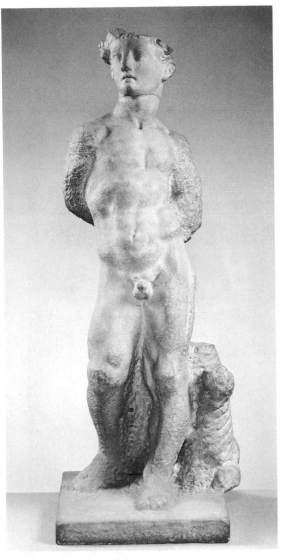

271

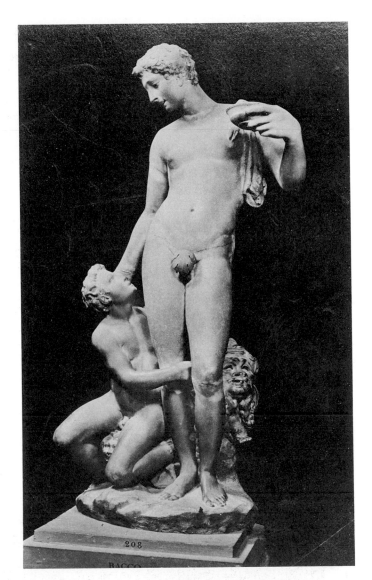

272

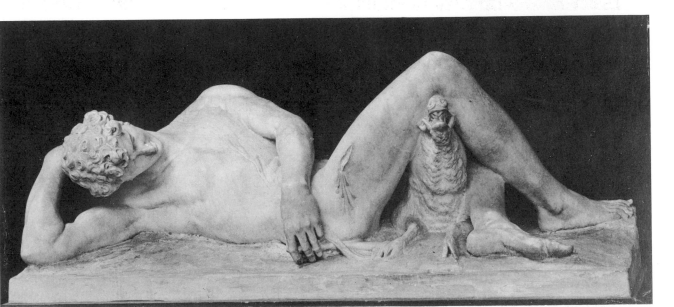

273

274

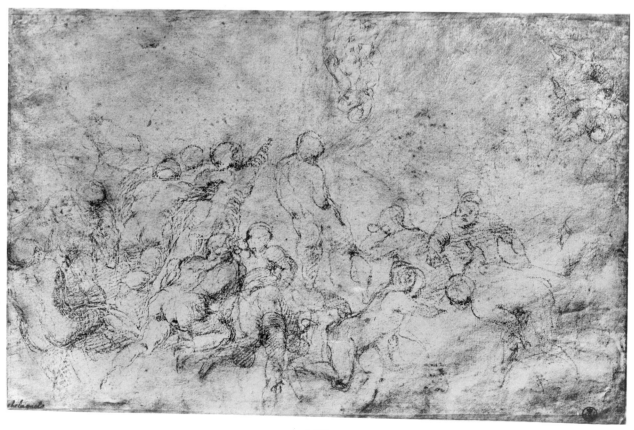

275

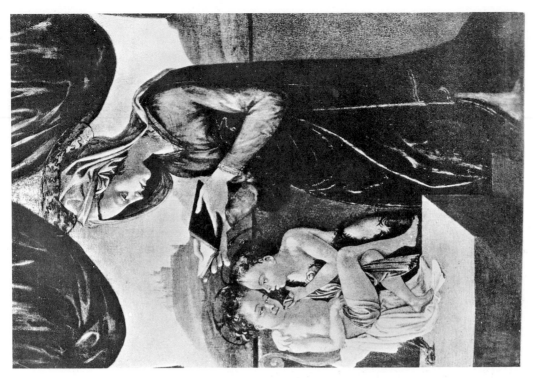

277

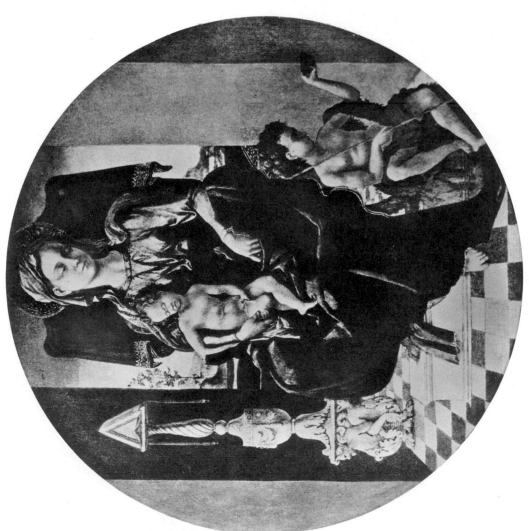

276

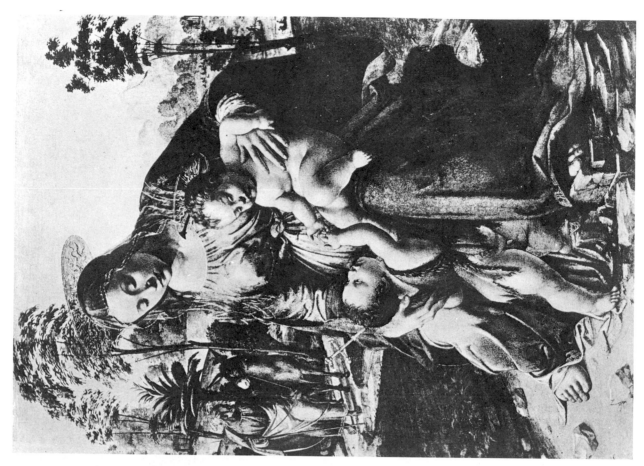

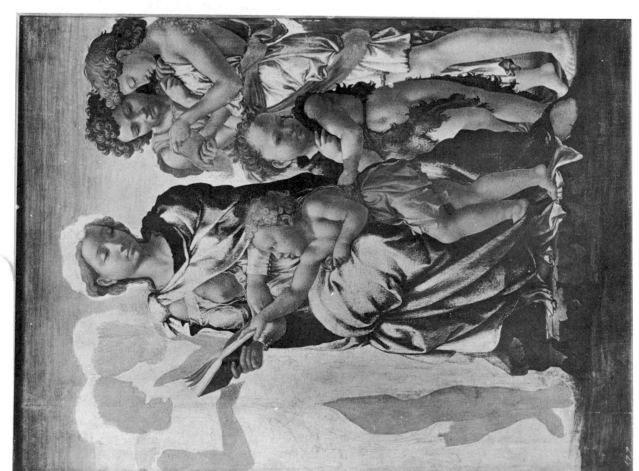

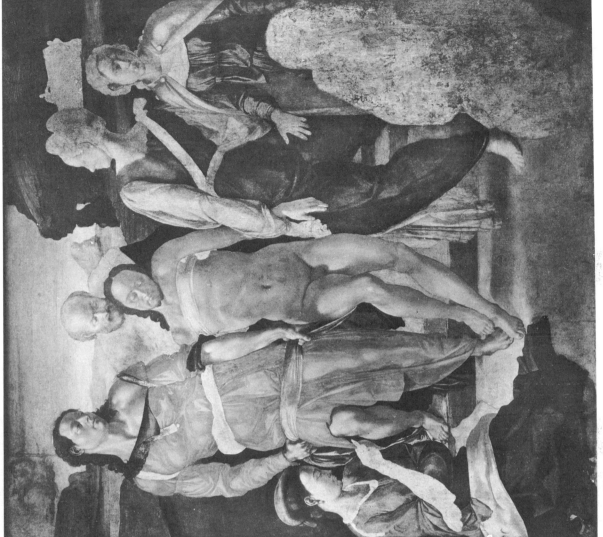

281

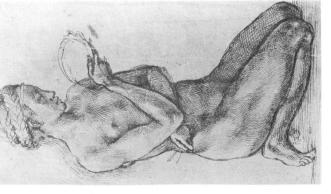

280

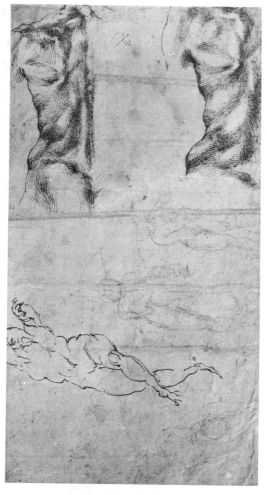

282

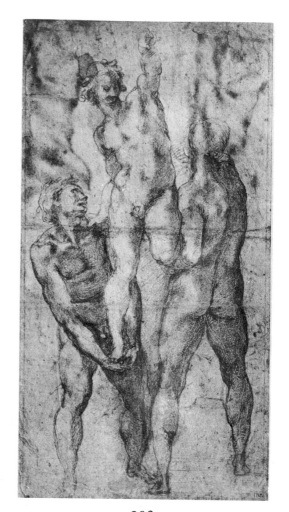

283

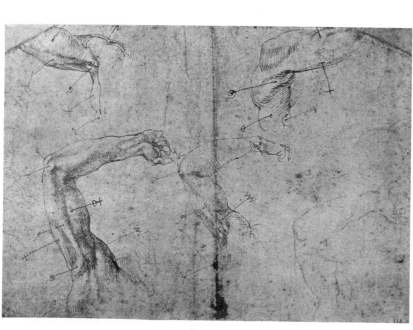

284

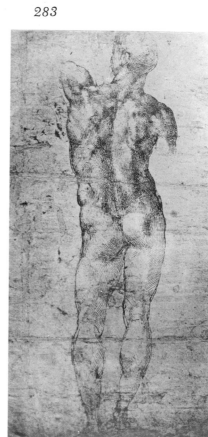

285

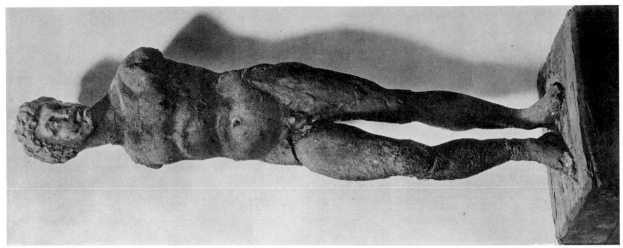

288

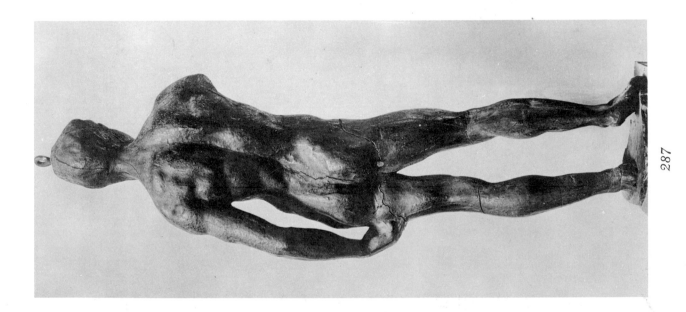

287

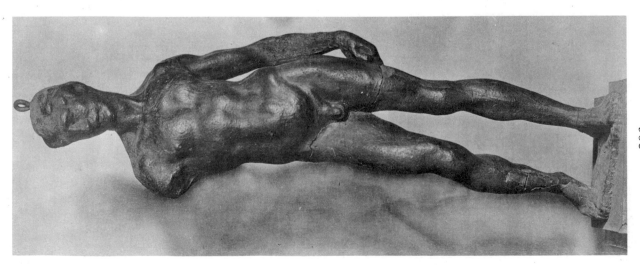

286

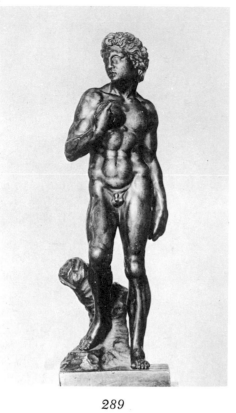

289

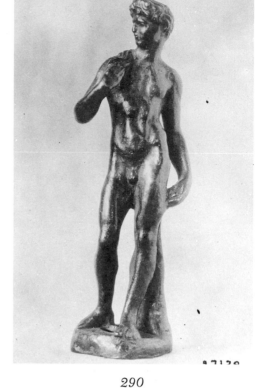

290

291

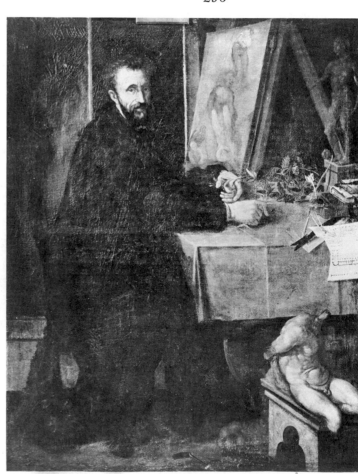

292